GREAT MASTERS
of WESTERN
ART

JORDI VIGUÉ

WATSON-GUPTILL PUBLICATIONS/NEW YORK

First published in the United States in 2002 by
Watson-Guptill Publications,
a division of VNU Business Media, Inc.,
770 Broadway, New York, N.Y. 10003
www.watsonguptill.com

Original title: Grandes Maestros de la Pintura. Maestros Occidentales
© 2002 Gorg Blanc, S.L.
Via Augusta, 63
08006 Barcelona, Spain
www.gorgblanc.com

Library of Congress Control Number: 2002008298

ISBN: 0-8230-2113-0

Editor-in-chief: Virgin Stanley
Photographic archive: Archivo Gorg Blanc, S.L.
Graphic design: Paloma Nestares
Photographic documentation: Albert Muñoz
Publishing coordinator: Miquel Ridola

Printed in Spain
Gráficas Iberia, s.a., Barcelona

1 2 3 4 5 6 8 9/ 09 08 07 06 05 04 03 02

Preface

The history of art in general and painting in particular is the history, in its broadest sense, of society. It is a mirror of the social situation of people, their lifestyle, their lust for power, as well as their ideas, interests, and feelings; and of course, their tastes, their sense of aesthetics, and their manner of expressing themselves.

A painting is never simply a cold, inert object appearing out of a void, with no context. It expresses much more than what the eyes of the beholder see. Beneath its physical state lies a complex world expressed in a cryptic language that must be deciphered for the work to be understood in its full dimensions.

Whatever the theme, period, style, or technique, a painting is the manifestation of the artist's emotions, the expression of a message, and the materialization of a specific manner of communicating. The history of painting is the history of humanity expressed directly through the profound and passionate sentiments of the artist. It is certainly a subjective chronicle, no less than any other, but it is also a first-hand document, sincere and illustrative, of how the painter was affected by specific circumstances.

Since painting is the manifestation of artists' innermost feelings, a pictorial work reflects, consciously or not, their true selves, and reveals their mind and spirit, character, tastes, and ways of seeing, feeling, and interpreting.

The above premise has guided the entire creation of this book, and the reader should use it as a leitmotif, as background music, when consulting it.

The book provides the materials with which to contemplate the art of painting and its creators in their various facets (personal, professional, social, etc.), as in a kaleidoscope. In addition to the subject of each painting, executed in a certain technique and style, the book discusses the specific circumstances or situations captured in it, or the stories incorporated, in a way that the reader may more fully understand and appreciate it.

This work deals only with art of known authorship. Art from prehistoric times, the classical period, and even the high medieval period are not included because they are not attributed to any specific person. The limitations of this volume have produced a selection of 75 masters, the choice of which was not only difficult, but inevitably disputable. We sought to represent all geographical regions of the Western world, every period from the Gothic thereafter, and every movement of importance. Although we were obliged to exclude some artists of merit, the significance of those who are included is unquestionable, either for the importance of their works or because they have contributed in some significant manner to the history of art. We consider the book to contain a significant and balanced selection faithfully reflecting the course of painting over the years.

In addition to offering an array of information and details for students of art as well as enthusiasts, the aim of this work is to provide a browseable tool by which to learn about and thoroughly enjoy painting. We are glad that this dream has had the opportunity of becoming a reality and we hope it will become a companion with which you will spend many enjoyable hours.

Jordi Vigué

Contents

Introduction .. 9

Giotto *(1267-1337)* 21
Jan van Eyck *(~1390-1441)* 27
Fra Angelico *(~1395-1455)* 33
Masaccio *(1401-1428)* 39
Piero della Francesca *(~1416/17-1492)* 45
Giovanni Bellini *(~1429-1516)* 51
Andrea Mantegna *(1431-1506)* 57
Sandro Botticelli *(1445-1510)* 63
Hieronymous Bosch *(~1450-1516)* 69
Leonardo da Vinci *(1452-1519)* 75
Albrecht Dürer *(1471-1528)* 81
Lucas Cranach, the Elder *(1472-1553)* 87
Michelangelo *(1475-1564)* 93
Giorgione *(1478-1510)* 99
Raphael *(1483-1520)* 105
Titian *(1488-1576)* 111
Hans Holbein, the Younger *(1497-1543)* 117
Correggio *(~1489-1534)* 123
Tintoretto *(1518-1594)* 129
Pieter Brueghel, the Elder *(~1525-1569)* 135
Veronese *(1528-1588)* 141
El Greco *(1541-1614)* 147
Caravaggio *(1573-1610)* 153
Peter Paul Rubens *(1577-1639)* 159
Frans Hals *(1580-1666)* 165
Artemisia Gentileschi *(1593-1652)* 171
Nicolas Poussin *(1594-1665)* 177
Francisco de Zurbarán *(1598-1664)* 183
Anthony Van Dyck *(1599-1641)* 189
Diego Velázquez *(1599-1660)* 195
Claude Lorraine *(1600-1682)* 201
Rembrandt *(1606-1669)* 207
Vermeer *(1632-1675)* 213
Jean-Antoine Watteau *(1684-1721)* 219
Giovanni Battista Tiepolo *(1696-1770)* 225
Jean-Baptiste-Siméon Chardin *(1699-1779)* 231
François Boucher *(1703-1770)* 237

Jean-Honoré Fragonard *(1732–1806)* . 243
Francisco de Goya *(1746–1828)* . 249
Jacques-Louis David *(1748–1825)* . 255
Élisabeth Vigée-Lebrun *(1755–1842)* . 261
William Blake *(1757–1827)* . 267
William Turner *(1775–1851)* . 273
Jean-Auguste-Dominique Ingres *(1780–1867)* 279
Théodore Géricault *(1791–1824)* . 285
Camille Corot *(1796–1875)* . 291
Eugéne Delacroix *(1798–1863)* . 297
Honoré Daumier *(1808–1879)* . 303
Jean-François Millet *(1814–1875)* . 309
Gustave Courbet *(1819–1877)* . 315
Rosa Bonheur *(1822–1899)* . 321
Jean-Léon Gérôme *(1824–1904)* . 327
Camille Pissarro *(1830–1903)* . 333
Édouard Manet *(1832–1883)* . 339
Edward Burne-Jones *(1833–1898)* . 345
James Abbott McNeill Whistler *(1834–1903)* 351
Edgar Degas *(1834–1917)* . 357
Winslow Homer *(1836–1910)* . 363
Paul Cézanne *(1839–1905)* . 369
Claude Monet *(1840–1926)* . 375
Berthe Morisot *(1841–1895)* . 381
Pierre-Auguste Renoir *(1846–1919)* . 387
Paul Gauguin *(1848–1903)* . 393
Odilon Redon *(1840–1916)* . 399
Vincent van Gogh *(1853–1890)* . 405
Georges Seurat *(1859–1891)* . 411
Gustav Klimt *(1862–1918)* . 417
Henri de Toulouse-Lautrec *(1864–1901)* 423
Henri Matisse *(1869–1954)* . 429
Pablo Picasso *(1881–1973)* . 435
Amedeo Modigliani *(1884–1920)* . 441
Georgia O'Keeffe *(1887–1986)* . 447
Egon Schiele *(1890–1918)* . 453
Jackson Pollock *(1912–1956)* . 459
Andy Warhol *(1928–1987)* . 465

Index . 471

Every period in our history is characterized by specific circumstances that are at once the cause and effect of ideas, politics, fashion, and art. There is no clearer manifestation of these than painting.

When you visit a museum, you are bombarded by an intense, overwhelming, and interminable set of images that often make you forget that each painting belongs to a specific period, having its own history and creator, and that this creator experienced passion, reaped success, and suffered bitter sorrows and disappointments, all of which the painting reflects in a more-or-less explicit manner.

Once you are fully aware of this, the first step has been taken toward comprehending art, and a painting can no longer be contemplated without sentiment. Each work is unique, arising under specific circumstances, and incorporates an entire personal universe.

This book takes you on a journey through the long history of painting, with the aim of providing insight into the circumstances that determined choice of subject matter and styles and characterized the manner of feeling and expression in each period.

High Middle Ages

The Roman period, in which realism predominated, was followed by Byzantine art. The first Christian pictorial representations derived from the Roman currents, although the Christian works from the early centuries are very basic, full of symbolic elements and ornamental motifs. Within Christian art, Byzantine art, which acquired its own personality and characteristics, was marked by a reluctance to represent realistic images. In the 5th century, the emphasis lay in creating art solely for a religious objective. Art was dehumanized, imbued with mystery and symbolism, and presented in a timeless world. So that nothing would escape this objective, a detailed set of norms was gradually developed to which everything had to be scrupulously adapted and from which no one could deviate. Representations, icons, the distribution of scenes and figures within the whole, identifying attributes, symbols, and even settings were preestablished. Gestures were more important than three-dimensional form as seen in the static, frontal figures found in Byzantine art.

Romanesque art inherited the strict norms of Byzantine painting. It only gained richness through the adoption of new iconographic motifs that were extracted from stories of martyrdom and bestiaries, and through ornamental elements and elements borrowed from popular traditions and legends as well as from native cultures, which each geographic area incorporated in order to approach the populace, profoundly conditioned by their beliefs and traditions.

As with Byzantine art, Romanesque painting, no matter where it arose or to which school it belonged, and whether it consisted of miniatures, frescos, or tempera on wood, always corresponded to an identical formula, as it had to abide by the rule *Nihil innovetur nisi quod traditum est* (Nothing must be changed from tradition).

The expansion of Romanesque painting owed much to the success that Lombard architecture had throughout Western Europe. Its large wall spaces facilitated the execution of extensive mural compositions, and it required the construction of baldachins around the altar table to protect it, front and side panels to cover it, and predelas to enrich it with representations of scenes from the lives of Jesus, the Virgin Mary, or

saints. It also contained beams that provided perfect support for sculptures, always with the image of a crucified Christ as the main figure. The subjects in these works were represented in enamel and gold, and in illuminated texts created in large monasteries, often under the influence of rich Oriental and Muslim patterns.

Romanesque painting had an eminently pedagogical function and a catechistic aim. It was elementary. A line was used to outline the forms and the various areas, which were painted in flat colors. Perspective did not matter, nor did proportions or a natural distribution of elements. The most important figure was rendered in large dimensions and the least important in a small size, though logic would require their sizes to be different according to their placement within the work. The figures were static and simplified for the common people to more easily comprehend the religious lesson intended. The scenes were always distant, solemn, and imbued with a certain air of mystery.

In the midst of feudalism, it was logical that the idea transmitted be that of a magnificent, authoritarian God enthroned in an aureole of majesty, defender of an immutable order and judge of good and evil, that is, of those who obeyed him and those who did not.

Gothic Period

Gothic art developed between the Romanesque and Renaissance periods throughout northern, central, and western Europe, reaching as far as the Middle East.

During this period, feudalism gradually disintegrated and, with it, its closed mentality and iron discipline. The artisans in the hamlets and the merchants who were doing business throughout the Mediterranean contributed to broadening minds and making everything that had previously been immutable relative through their contact with other people and other modes of thought. True to their origins, they identified with common people, their lands, and their daily lives. The mentality of the age and of its art, and of painting in particular, slowly evolved until a significant change occurred: the majestic forms and stylized, allegorical images of Romanesque-Byzantine art became human, with increased realism in representations of both figures and their backgrounds, whether these consisted of landscapes or architectural elements. Humanity and everything living, suffering, and sentient became the great protagonists. In the scenes represented, there was a primacy of pattern and rhythm, decorative line, and color, creating an air of sensuality.

Naturally, considering its geographical situation in the heart of the Mediterranean and its historical precedents as the centuries-long seat of the Roman Empire, this change began in Italy, from where it expanded throughout Europe, developing regional characteristics. For instance, the merging of Northern and Italian traditions gave rise to the International Gothic, with its increased use of symbolism.

Conceptually, although Gothic art was based on the linear schematism of the Romanesque, in which everything was based on the line surrounding a spot of color, increasing knowledge of perspective and anatomy led artists in the Gothic period to consider the figure, and surrounding objects and architecture, as interrelated elements rather than isolated, independent ones. Fresco decorations continued in spite of the fact that the new architectural style left little space for them. In churches and cathedrals, large apertures filled with stained glass windows replaced the extensive wall surfaces of the Romanesque style. Paintings on wood, on the other hand, became prevalent and especially significant in large altarpieces.

On wood panels, color and light acquired a new dimension, though the use of gold to emphasize the idea of richness was frequent. Drawing still prevailed, although the movement of the scenes, the rhythm and sensuality of the general conception, as well as the lines comprising each image gradually gained protagonism. The incorporation of relief invited the observer to touch the work instead of simply viewing it.

The Gothic style appeared in painting in the last third of the 13th century in Italy. It emerged in Rome, where Pietro Cavallini (~1240-~1330) focused on color and the search for new artistic paths, though he was still strongly influenced by Byzantine and Romanesque art. Cimabue (~1240-~1302), one of the most significant artists of the 13th-century Florentine School, made a major advance by initiating a period of transition, which produced painters such as Duccio of Siena (1255/1260-~1318), creator of stylized and melancholy Byzantine-like figures; Simone Martini (~1284-1344), who continued Duccio's style; and Ambrogio Lorenzetti (~1290-1348), whose style, along with that of his brother, Pietro, was a symbiosis of Sienese (with its taste for details, "cold" drawing, sense of rhythm, and noble character) and Florentine art (emphasizing liberalization of the Byzantine formulas and the introduction of naturalism).

All of them progressively transformed the Byzantine concept of art (ascetic, distant, spiritual, and mystical—a mirror of the world of divinity), and lent it an increasingly Western air (with its approximation of man and what is natural, representing a "near" and accessible, although learned, world) until, with the emergence of Giotto (1267-1337) in Florence, the style became so far removed that the rupture with the Byzantine tradition was practically complete. With his concern for perspective, anatomy, and light and the majesty of his representations, Giotto exercised a profound influence on the majority of Florentine and Sienese painters of the 14th century and marked the evolution of both schools.

Between the 14th and 15th centuries, Gothic art flourished in Flanders. Its realism and attributes, which can be seen in the *The Ghent Altarpiece* (see p.29) by Jan van Eyck (~1390-1441), owed much to the influence of the merchant middle class. Instead of large mural paintings, the Flemish Gothic tended to produce small, transportable polyptychs used as votive elements during trips.

Later, Rogier van der Weyden (1399/1400-1464), a highly dramatic painter belonging to the naturalistic Flemish movement, and his disciple Hans Memling (1430/40-1494) humanized their representations and used a revolutionary medium, oil. This medium, known since medieval times and developed by artists such as Masaccio and Jan van Eyck, offered many advantages, including smoother transitions than tempera could achieve, and greater color and brilliance than opaque, matte fresco. It was gradually improved and consolidated as a medium.

On the Iberian Peninsula, well connected with other regions of Europe, the Gothic style was characterized by a tendency toward austerity and drama, a relic of the Romanesque era. Indeed, there were many styles within the Gothic period, according to the geographic region and its commercial and cultural relations. Franco-Gothic arose toward the mid-13th century and lasted until well into the 14th century. Italian Gothic arose in the latter half of the 14th century in the Kingdom of Catalonia-Aragon, with representatives such as the internationally renowned Ferrer Bassa, the brothers Jaume and Pere Serra, and, in Castilla, Sánchez de Rojas and Rodríguez de Toledo. Schools of Flemish Gothic prospered on the Iberian Peninsula as well, in Catalonia, Valencia, Aragon, Salamanca, Leon, etc., as did the International Gothic. The role of Catalan Gothic was very distinguished. Its representatives were among the most eminent names within European painting of the time, known for the high quality of their work.

In France, whose art incorporated the Italian influence through the papal court in Avignon, Gothic painting was closely tied to large manufacturing centers producing tapestries, stained glass, and manuscripts. Important representatives of French Gothic were the miniaturist Jean Pucelle (14th century); the Limbourg brothers (Pol, Herman, and Jean), from the early 15th century, to whom the introduction of the landscape is attributed; André Beauneveu (~1330-~1440), creator of important funerary pieces; and Jacquemard de Hesdin (14th century-~1410), whose style was similar to Pucelle's but with significant Italian influences. From the courts of Paris and Burgundy arose two schools that, both for the quality and the quantity of their works, exercised a great deal of influence on other European courts from the 14th to 15th centuries and were often adopted as models. In the School of Burgundy, significant works were executed by Melchior Broederlam, a Flemish painter active between 1381 and 1401, who worked for both Louis de Mâle, Count of Flanders, and Louis the Daring, Duke of Burgundy; Jean Malouel (~1370-1419), who worked for Elisabeth of Bavaria and Philip II (the Daring), who greatly contributed to the expansion of International Gothic, and Henri Bellechose (? - ~1441), who worked for Jean the Fearless.

In the 15th century, Flemish influence gave rise to a great deal of regional schools. Jean Fouquet (~1420-1477/81), Enguerrand Quarton (active in Provence between 1444 and 1466), and Nicolas Froment of Uzés (~1435-1483/86) were very significant artists.

In Central Europe, German art, though profoundly influenced by Italy and France, remained faithful to popular genre scenes and medieval legends. Its naturalistic painting, fond of anecdotes partial to representing everyday life, festivities, popular customs, ways of life, fantasy, etc., reached its maximum splendor in the 14th and first half of the 15th centuries, especially in Bohemia.

The Renaissance

When it seemed that the Gothic had become entrenched in Europe, Italy once again produced a new ideology based on ancient Roman culture and inspired by humanism, a cultural movement that gave precedence to human reason over divine revelation. Renaissance art arose from a rapidly evolving civilization interested in learning about reality, history, and especially humanity. It proclaimed through art the central role of the human being in life, beauty, religion, virtue, and reason.

The fictitious concepts of the Byzantine-influenced Gothic and its mellifluous and poetic Franciscan religiosity—derived from the spirit of St. Francis of Assisi—reestablished the forms and volumes of classical antiquity, thereby giving way to the balance and serenity that centuries earlier had characterized Greek and Roman art. It was adopted by the Florentine school in particular in order to bring art (particularly religious art) closer to the spectator. There was a great concern for investigating and advancing science and for applying its rules to art. Anatomy, drawing, perspective, the canon of proportions, light, shadows, color, and geometry were studied in depth to achieve a greater and more sublime representation of the human body.

In the late 13th and 14th centuries, when Byzantine or Gothic styles still dominated, Italian art was touched by this new spirit. The humanist Pico della Mirandola (1463-1494) placed humanity in the center of existence and promoted a culture focused on the human body, mind, and aesthetic, with its idealization as the ultimate being in the universe.

This humanism appeared in the various Italian republics, where the important families in power gathered the finest representations of culture and art of the time in

their courts. It had specific characteristics, according to the region. Hence, Florentine painting was famous for the polemic between the Gothic and Neo-Platonic ideals, according to which God is an inaccessible being, of which one can only know what He is not. Man can bring himself closer to God by caring for his body (proportion and shape) and his intellectual aptitudes (music, literature, art, philosophy, and love). The Venetian School was distinguished by its liberation from Byzantine schemes in order to bring art closer to the spectator. Mantua and Ferrara concentrated on the study of archeology and anatomy. In Urbino, art focused on the antithesis of intellectualism (in which the human being thinks, rationalizes, and decides) and dogmatism, an order established in order to neutralize and oppress the mind. Naples, as well as Sicily and Lombardy, struggled to free itself from the last vestiges of International Gothic.

Antonio Pisano (~1395-~1455) cultivated a humanism halfway between the courtly tradition of International Gothic and the study of nature and classical antiquity. Paolo Uccello (1397-1475) created works that revealed his great capacity for assimilation and original expression of the Tuscan artistic culture of his time. Masaccio (1401-1428) assimilated the new artistic influences of his time and, when International Gothic was still at its height, continued the pictorial innovation begun a century earlier by Giotto. Piero della Francesca (1416/17-1492) created works with an architectural sense of form and pictorial composition. These eminent artists broke ground in a direction that would later be continued by Andrea Mantegna (1431-1506), a great innovator of perspective; Giovanni Bellini (~1429-1516), whose harmonious paintings offered intimate views of religion while distancing themselves from the analytical spirit of the 15th century; Sandro Botticelli (1445-1510), whose artwork represented the exaltation of a decorative, elegant, and aristocratic aesthetic; and many others.

Outside of Italy, the new artistic forces did not influence painting until the 16th century. In the Netherlands, artists such as Brueghel (~1525-1569), deeply influenced by the developments in Italy, attempted to apply the spirit and ideas of the movement to the art of their country, from which a unique art, with autonomous roots and a Renaissance outlook, was born.

In Germany, the Renaissance was represented by the painter and engraver Albrecht Dürer (1471-1528) and the portraitist Hans Holbein (1497-1543). In Spain, the Gothic workshops of Catalonia lost the importance that had made them famous. Instead, Spanish art had a revival in Castille, to which the Italian painters were summoned by the king and queen. Thus, the medieval religious roots of Spanish art were accompanied by Italian mysticism. In France, there was a tendency toward Mannerism and a consolidation of portraiture, especially in painters that were close to the court and aristocracy.

Though portraiture had arisen in the Gothic period as an independent genre, it became prominent during the Renaissance. Representations of nature also grew in importance, having previously served only as a complement but gradually moving toward the independent genre of landscape. The oil medium and the use of canvas as a support became widespread.

The Renaissance was a splendid yet ephemeral eruption of creativity. In the 16th century, it reached its zenith with Leonardo da Vinci (1452-1519), Michelangelo (1475-1564), Raphael (1483-1520), and the great artists of the Venetian School, especially Titian (1488-1576). Yet, underlying the balance and deliberation of the classicism they represented, a thorough analysis of the works of these painters reveals the beginnings of great changes that would occur immediately thereafter.

Mannerism

The Renaissance had attained a milestone that was surpassed by the great masters of the Cinquecento as soon as it was reached. In general terms, Mannerism was an anti-classical artistic style that came into being in the 1520s and lasted until 1600. The term "Mannerism" had been used by Giorgio Vasari when referring to the followers of Michelangelo as painting "a la maniera" of the Master.

This style was characterized by a struggle between classicism and anti-classicism. Form was undone through the figure; idealism became concrete and acquired a fantastic, unusual language with a great tendency toward eccentricity and confusion. In Mannerist painting, architectural elements were employed to conceal space rather than to define it, perhaps as a ploy to increase the viewer's curiosity. Mannerism broke with conventional compositional norms and divorced function from form.

Mannerism's highly conceptual formulation, which was based more on the content than on the visual image, explains why it only developed in restricted, aristocratic milieus. It gradually dissolved the Renaissance spirit arising from the new Neo-Platonic theses.

Philosophers like Marsilio Ficino (1433-1499), director of an academy in Florence, were dedicated to reestablishing Neo-Platonic thought, which fused Christianity with ancient mythology. Though in Mannerism, as in the Renaissance, everything revolved around humanity, it was not idealized and magnificent, but rather preoccupied and tormented. At the time, Italy was experiencing a spiritual crisis that culminated in the Counter-Reformation, for which Mannerism was an artistic flagship.

Mannerism flourished in two important centers: Rome, among the disciples of Raphael Sanzio (Giulio Romano, Baldassare Peruzzi, Perin del Vaga), and Mantua, where the Palazzo del Te, one of the most emblematic works of this style, is still extant. The mural decoration of the Palazzo was executed in part by Francesco Primaticcio (1504-1570), a disciple of Giulio Romano (1499-1546), its constructor. Along with Rosso Fiorentino (1495-1540), a creator of refined, elegant works imbued with affectedness and grandiloquence, Primaticcio established the School of Fontainebleau in France, which exercised great influence abroad.

Among all the Italian centers of artistic culture, Venice suffered the least from the effects of Mannerism because Venetian art was born and developed from the ideas that characterized European painting of the Seicento. In Florence, it didn't prosper, as Florentine art was characterized by a more popular streak.

In Spain, the foremost representatives of this style were Pedro Machuca (~1490-1550), possibly a disciple of Michelangelo and a representative of early Mannerism, and Luis de Morales (1510-1586), with his painstakingly executed works characterized by their peculiar color scheme and their elongated figures. El Greco (1541-1614), however—learned, solemn, dramatic, and eminently Mediterranean—can be considered the foremost representative of this style.

In Prague, the court of Rudolph II attracted the Milanese painter Giuseppe Arcimboldo (1527-1593), now remembered for his grotesque portraits composed of still life elements, such as *Rudolph II as Vertumnus,* the god of horticulture, assembled out of fruit, flowers, and corn. His work, along with those of Bartholomäus Spranguer (1546-1611), with his Italianate mythological, historical, and religious works, and Hans von Aachen (1552-1615), a representative of late Mannerism in Germany, carried formal frenzy and confusion to extremes.

Baroque Art

The Baroque period, lasting through the 17th century, arose in part out of the Catholic reaction to the Protestant Reformation. The Reformation and new scientific discoveries brought about a thorough transformation of all values and, amid a profoundly dramatic environment full of contrasts, determined an important figurative change from the previous Renaissance period. While in the Rennaissance, proportions, shapes, harmony, and a global concept of science and culture reigned, the Baroque was a manifestation of exacerbated expressionism, through dynamic and passionate forms.

Both politically and socially, this period is characterized by the demands of Counter-Reformation doctrine, in other words an absolutism of church and state based on a theocratic concept of power. The most significant exponents of this ideology were the popes in Rome and the court of Louis XIV in Versailles.

Among the most significant characteristics of Baroque painting were the evolution of the Renaissance style toward pictorial forms, the change from a closed, symmetrical composition to one of open, asymmetrical distribution, the search for unity over individuality, and the combination of a diagonal composition, light, and color to create a unified whole.

Both religious and mythological scenes were highly dramatic, with emotions and theatricality prevailing in appearances and attitudes, lending the images a certain air of mystery.

Because the papacy patronized art on a large scale, the Baroque was felt most intensely in Italy. Ambitious young artists emerged to create this new style. Foremost among them was Caravaggio (1573-1610), whose work is characterized by a radical new realism. Others came from the School of the Carracci, as well as from Venice, where Giovanni Battista Tiepolo (1696-1770) stood out, famous for his grandiloquent paintings and representing both the culmination and the end of formal Baroque.

The Baroque period in Spain coincided with a time of maximum artistic splendor, although the great empire that stretched across the land was very depressed by this time. The Valencian, Andalusian, and Madrid Schools paved the way for the realism of the first half of the 17th century and the following colorist Baroque of the second half. With the exception of Velázquez, Spanish Baroque artists scrupulously followed the ideology of the Counter-Reformation. They almost exclusively painted religious scenes and reflected in them the sentiment of the most genuine Spanish character, charged with sensuality, a certain sobriety, and an evident interest in catering to the tastes of the Church and the nobility. Profane art was limited to the genre of portraiture.

In the 17th century, Spain produced painters as important as Jusepe Ribera (1591-1652), a disciple of Caravaggio whose highly realistic works were characterized by compositional balance through drawing and color; Francisco Ribalta (1565-1628), whose works often contained a sculptural conception of forms; Diego Velázquez, (1599-1660), with his mythological scenes interpreted in a singular manner; and Francisco de Zurbarán (1598-1664), with his exceedingly formal style.

In Flanders, strongly influenced by Spain at that time, religious scenes and portraits also predominated. There Peter Paul Rubens (1577-1640) had few rivals. Influenced by what he experienced and saw in Italy, especially the paintings of the 16th-century Venetian School and the humanist and religious ideology of the Jesuits, he managed to find the appropriate formula by which to incorporate Flemish painting into the

Baroque. Other eminent artists were Jacob Jordaens (1593-1678), whose works—represented with great vitality and sensuality—reflected his attentive observation of popular events, and Anthony van Dyck (1599-1641), the author of excellent portraits who became famous for his treatment of the figure—severe, somewhat melancholic, and distant.

Dutch art of the 17th century was rooted in the middle class and abounded in still lifes, landscapes, genre scenes (scenes from everyday life such as family, festivities, and customs) and portraits. The most remarkable figures from this country were Jan Vermeer (1632-1675), with his own, unique technique and orientation, limited to painting interiors with a concept of light and color very different from that of Rembrandt; Gerard Terborch (1617-1681), notable for the psychological studies of his figures; and Rembrandt (1606-1669), whose intimism and ideological force—helped by impeccable technique—contrasted with the intended affectation and ideology of power of the Flemish School and of the Catholic and aristocratic tendencies of the 17th century, in which artificiality and a predilection for grandeur predominated.

In France, a tendency toward mythological scenes was represented by Nicolas Poussin (1594-1665), whose classicist aesthetic was anchored in mythological and historical subjects, whereas Claude Lorraine (1600-1682) created atmospheric, richly colored landscapes in which the human figure is secondary. The first half of the 17th century was one in which centralism was ever stronger, in investigation as well as in the arts. The most famous artists were comissioned by the Surintendence des Bâtiments and sent to l'Academie de France in Rome, which was controlled by the powers in Paris. As a reaction against the ornamental profusion of religious works, the so-called "goût français," established and religious, was born. Portraiture also flourished, represented by the vigorous, brilliant, and refined works of Hyacinthe Rigaud (1659-1743) and by Quentin de la Tour (1704-1788), well known for his representation of the sitter's personality.

In the 18th century, this style incorporated oriental influences. Genre scenes increased, especially pastoral images, and pallid, attenuated tones predominated, leading to the Rococco style.

In England, genre scenes and portraits prevailed, the former particularly outstanding in works by William Hogarth (1697-1764), who showed an interest in the scenography—from everyday life—of paintings. Portraiture was represented by Joshua Reynolds (1723-1792), who introduced classical scenes in his portraits, and Thomas Gainsborough (1727-1788), in whose portraits the landscape and sitter were closely interrelated. Two names stand out in importance: Joseph-Mallord-William Turner (1775-1851), whose work already revealed a strong romanticism, searching for a light and movement that heralds prematurely the Impressionist ideas, and John Constable (1776-1837), with landscapes more concerned with atmosphere than with concrete details of the scene. The works of these two artists were a milestone for modern art and would exercise a great influence on the Impressionists.

Rococco

During the first half of the 18th century, a style appeared that was characterized principally by its combination of shapes from nature (leaves, branches) with elements from Oriental, especially Chinese, art. This style was called Rococco, which—to many art historians—is no more than the final period of the Baroque.

The origins of the Rococco were to be found in France, in the Regency and Louis XV styles that were characterized by their opulence, interiorism, elegance, refinery, and freedom of decoration. These were in harmony with the spirit of the court and high society.

As a consequence of the importance of France in that period and the influence its court had on the rest of Europe, the spirit of the Rococco took roots in various countries, manifesting itself differently in each place.

The most representative painters of the Rococco were Jean-Antoine Watteau (1684-1721), François Boucher (1703-1770), and Jean-Honoré Fragonard (1732-1806). Watteau was a veracious, if somewhat light, painter, whose works catered to the tastes of the high society of the moment: practicing double standards of morality while maintaining forms; using ambiguity and insinuation; but always with a delicate touch.

Boucher was more direct and crude, although his work—in which ever more lightly clad women abound (realistic in the Greek manner)—was very celebrated by the high society of the time. Fragonard, the last representative of the Rococco style, was a master of female grace. In his paintings, courtesan frivolity is a constant, eroticism is ever present, and women are exhibited presenting their best attributes, converting them into powerful objects of desire, although with great subtlety and savoir-faire.

Neoclassicism

Neoclassicist art was severe, unemotional, and based on the intellect, arising from a reaction to the ornate and aristocratic emphasis of the late Baroque. Political upheavals of the 18th century—the American Revolution of 1776 and the French Revolution of 1789—gave birth to the modern world, in which traditional authority was to be replaced by reason and the common good. In art, this meant a return to classical forms and themes, which had been abandoned by the Mannerists.

Neoclassicism was inspired by the discoveries made in the various archeological excavations of the ancient cities of Pompeii and Herculaneum.

The concept of Neoclassicism was more intellectual than stylistic, and, as Rome was its center, it focused more on ancient Roman art (stereotyped, conventional, and dependent) than classical Greek culture (genuine, intellectual, and very elaborate). The prevailing aspects of its ideology were: a set of closed, strict, and perfectionistic norms, minutely regulated; a rigid style with a variety of stereotypes (themes, postures, treatment of light and color); and its aim to spread new political tendencies opposed to traditional monarchic principles. A simple observation of Neoclassical painting is enough to reveal the strict values that entered into play and that could by no means be transgressed.

Some of the most eminent artists within Neoclassicism were Anton Raffael Mengs (1728-1779) and Johann-Joachinn Winkelmann, who met in Rome in 1755; Jacques-Louis David (1748-1825), who was the real force behind plastic Neoclassicism, in which all the factors related to esthetics were meticulously adapted to certain precepts; Pierre-Paul Prud'hon (1758-1823), whose refined works were executed in *chiaroscuro* (the play of contrasts between light and shade) and *sfumato* (blending the tone of one element into the next so apparent borders disappear); Baron Antoine-Jean Gros (1771-1835), a disciple of David who interpreted the latter's style so well as to become a bridge between Neoclassicism and romanticism; and Jean-Auguste-Dominique Ingres (1780-1867), held by many to be

a legend of perfection and balance in drawing and a representative of its supremacy over color.

To obtain a clear overview of the place of Neoclassicism within the history of art, it helps to recall its relations to other movements in the various countries where it arose: in France, it was related to the Baroque Classicist fashion; in Spain, to the Romanist style; in Italy, to the most purist Baroque; and in Great Britain, to neo-Palladianism.

Neoclassical painting was profoundly defined by sculpture, evident in both the style adopted for rendering the human figure, with carefully executed, generally static volume and the structure of buildings that often accompanied them, along with a clear adoption of plastic solutions and models, with themes, compositions, and treatment of light and color established in order to attain idealistic and allegorical works with an air of cold sophistication. Forms and subject matter derived from classical antiquity predominated, the line and drawing prevailed, and there was a certain disregard for color.

Neoclassicism was a short-lived movement, soon replaced by the less intellectual and more popular romanticism, though it existed until the 19th century with certain variations.

 # Romanticism

In the last decades of the 19th century, an artistic and spiritual movement arose that extended throughout Europe and brought great changes in life and art. Romanticism in art did not possess a coherent ideology as did the literature of the period. In general terms, it was characterized by a poetic and sentimental vision, the antithesis of the traditional vision inspired in the formulations of classical art.

According to the characteristics and traditions of the regions where it arose, romanticism manifested itself in different ways, often with substantial variations from one place to another.

Romanticism was based on a series of principles, at times contradictory, that constituted its diffident ideology: the material goodness of the person and the exaltation of cultural values; individualism and a religious sentiment upholding the unity of social life; subjectivism and the awareness of the people; etc. In fact, romanticism did not consist of the logical and coherent development of a single idea. It was a way of thinking, feeling, and poeticizing, as well as a way of life. In painting, romanticism manifests individualism, subjectivism, expressiveness, vigor, mystery, fantasy, and mysticism.

It is generally considered that Romanticism became fashionable with the exhibit of *The Raft of the Medusa* (see p.285) by Théodore Géricault (1791-1824) at the 1819 Paris Salon. This scene of a shipwreck, with the twisted, writhing bodies of the castaways, depicts the romantic's appreciation for dramatic events presented on large canvases. However, the appeal to the private world of fantasy and emotion characteristic of romanticism had already been initiated by other artists. Among them were the Italian Giambattista Piranesi (1720-1778), with his highly personal, elaborate works overflowing with imagination; the Swiss Heinrich Füssli (1741-1825), considered by many as the precursor to a new aesthetic sensibility based on fantasy and supernatural visions; the Englishman William Blake (1757-1827), whose work reflected a sharp social conscience denouncing scientific rationalism that, in his opinion, paved the way for the catastrophe that was the industrial revolution; and

the Spaniard Francisco de Goya (1746-1828), a singular painter and great master, difficult to classify within the tendencies of his time, yet a precursor to the main movements, among them, romanticism.

Realism

Realism arose in the mid-19th century as an artistic attitude attempting to represent the different aspects of reality as it was, without the distortion of idealization and personal interpretation.

The realist movement was born in France and spread quickly through Europe and to the United States, eventually resulting in the birth of Impressionism. Among its causes was the strong influence of photography, recently invented, and scientific positivism. This view asserted that only scientifically verified fact was real and that knowledge could only be attained through the "scientific method," rather than through revelation, intuition, or imagination. It was also stimulated by the new ideologies prevailing in Europe, according to which episodes of everyday life were as valid a subject matter as those found in history or mythology. As such, realist art often incorporated a specific message, generally one of social protest.

Among the principal representatives of realism were Gustave Courbet (1819-1877), a faithful representative of the intellectual and social preoccupations of his time (the situation of the lower social classes, questioning academic norms and conventions, and opting for a free and disinhibited art); Honoré Daumier (1808-1879), famous for his caricatures, through which he exercised caustic criticism against everything oppressing the poor; Jean François Millet (1814-1875), whose works were a clear reflection of the hard life led by the humble peasants; Adolf von Menzel (1815-1905), whose industrial scenes are marked by a cold style and excessive wealth of details; and the artists of the Hague School, an informal group of Dutch landscape painters.

Impressionism

In the last quarter of the 19th century, an aesthetic movement was born in France that constituted the culmination of naturalism. It was based on the rendering of prosaic, everyday subjects as if taken in a snapshot, with fleeting, spontaneous visions containing the most substantial aspects of reality, with a special attention to the effects of light and color and dispensing with the details.

An appreciation of Japanese engravings, with their novel and until-then unimaginable images, alteration of conventional symmetry, loose, fresh brushstrokes, the influence of light on colors—which were generally applied pure to be blended by the eye of the viewer—were some of the principal characteristics of Impressionist art.

The movement was based on works by previous artists, but primarily took root in France under the impulse of Édouard Manet (1832-1883), through his work and the discussions of them that took place in certain Parisian cafés. The movement took its name from Claude Monet's work, *Impression: Sunrise*, exhibited at the 1872 Paris Salon. The group as such introduced itself in 1874, through an exhibit organized by the Société Anonyme Coopérative des Artistes, consisting of works by Edgar Degas (1834-1917), Jean-Baptiste-Armand Guillaumin (1841-1927), Claude Monet (1840-1926), Bérthe Morissot (1841-1895), Auguste Renoir (1841-1919), Camille Pissarro (1830-1903), and Alfred Sisley (1839-1899).

Impressionism made several important contributions to painting: The appreciation of landscapes painted plein air and themes from everyday life as motifs; enhancement of the substantial to the detriment of detail in order to arouse feelings and evoke rather than depict; attention to the instantaneous, immediate, and fleeting; and cinematographic framing. This movement constituted a great change in art history and the basis for the subsequent proliferation of styles, schools, and concepts of painting that evolved from the last years of the 19th century onward.

Impressionism was the manifestation of the new aesthetic of transience and vagueness upheld by a significant sector of the society at the time, and its ideas put in doubt everything that hinted of norms, stereotypes, and closed structures.

The Avant-garde

The series of artistic manifestations arising at the end of the 19th century was known by this generic name. These tendencies marked a period that was especially critical for art, as they questioned everything created previously, seeking new paths, approaches, and forms of expression.

Already under Impressionism, many established ideas began to be questioned. Cézanne's art, some works by Monet, and Pointillism began to chip away at the establishment. Individual tendencies and styles arose that, following the innovative air of Impressionism, incorporated new concepts into art that soon won adepts in France as well as abroad, among both artists and the public.

Despite the great disparity of criteria, the need to create, the search for new forms of expression, and an increasing appreciation of color and the gesture of the stroke seemed to be what moved all of the avant-garde in their search for innovative, varied objectives. Names such as Van Gogh (1853-1890), Gauguin (1848-1903), Toulouse-Lautrec (1864-1901), etc., movements such as the Sezession, with Klimt (1862-1918) and Egon Schiele (1890-1918); and artists such as Matisse (1869-1954), Picasso (1881-1973), etc. initiated paths that opened many horizons: Expressionism, Synthetism, the Nabis, Cubism,... until Abstraction was reached in a clear demonstration that the horizon of artistic creativity has no limits and the path of investigation is infinite, limited not by periods, geographical bounds, or any type of barrier. Among many others, O'Keeffe (1887-1986), Pollock (1912-1956), and Warhol (1928-1987) are a clear demonstration of this boundlessness.

*　　*　　*

This succinct voyage through the history of art demonstrates the ever-present necessity of human nature to express itself in all ages and reflects artists' constant efforts to find the most faithful manner of expressing what they felt. History never stops: every period has its vicissitudes and characteristics. Humanity changes and, with it, its sentiments and manners of thinking, making everything become relative. The result is that, throughout history, every period and every situation has created its own manner of expression and style. In each period, painters have transmitted their sentiments through their works in their own, personal language. Knowing how to interpret this language in every work is what makes sense of art and lends the viewer the opportunity to scrutinize the artist's inner world.

GIOTTO

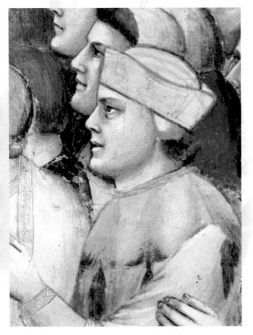

Self-portrait in The Last Judgment *(detail), a fresco cycle in the Arena Chapel (Capella Scrovegni), Padua.*

Giotto (Giotto di Bondone) is widely regarded as one of the first modern painters to break with the static and allegorical style dominant in the medieval period. He was influenced by the neo-Byzantine style of Pietro Cavallini and the Northern Gothic art of Arnolfo di Cambio, leading him to develop a more natural style of painting.

Together with Nicola and Giovanni Pisano, Giotto began to place special emphasis on relative aspects of volumetry, the superimposition of planes in the distance, and sought to integrate the background and figure into a unitary whole. He was a painter, architect, and student of Cimabue in Florence, and associated with the most illustrious men of his day, including Dante and Petrarch.

Giotto's revolution in painting led the way for all the Western art that followed. His highly innovative color technique, based on clarity and transparency, ushered in a broad-based, tempered distribution of light and shadow. The artist breathed life, movement, and expressiveness into figures, which until then had been rendered as static and distant, substituting their monotonous attire with more natural garments, in accordance with the subject represented. Giotto's new type of art heralded a great change in aesthetics and a move toward greater realism and expressiveness in the subjects represented.

- **1267** Born at Colle di Vespignano, near Florence, the son of a humble peasant.

- **1280** Trains in the studio of Cimabue. Accompanies his master on his travels and assists him in works such as the decoration of the Church of San Francesco of Assisi.

- **1290** Begins work on the decoration of the Upper Basilica, which was to take five years to complete.

- **1295** Works in Rome, where he designs the *Navicella*, or *Ship of the Church*, a mosaic for St. Peter's Church, among others.

- **1298** Undertakes a mosaic for Cardinal Stefaneschi.

- **1300** To mark the occasion of the first Jubilee , paints the fresco of the old church of St. Peter, which no longer stands. At San Giovano de Laterano, Giotto paints a fresco, of which a fragment still exists, depicting Boniface VIII announcing the Jubilee. Takes advantage of his stay in Rome to become more acquainted with classical painting and the work of Pietro Cavallini, who some regard as his Roman master.

- **1302** Travels to Padua, where he paints the frescos in the basilica of San Antonio and undertakes the decoration of the Arena Chapel (Capella Scrovegni) of the Church of Santa Maria, Arena.

- **1315** Begins work on the fresco of the chapels of Bardi and Peruzzi of the Church of Santa Croce, Florence.

- **1317** Paints various works in Padua, such as the decoration of the Palazzo della Regione, now lost.

- **1327** Receives a commission from Duke Carlos of Calabria to paint his portrait for the Palazzo della Signoria.

- **1328** Becomes court painter to Robert of Anjou, Naples, where he stays until 1333, completing a variety of works.

- **1334** Returns to France, where he is named capomaestro (overseer) of works of all public buildings, including the Opera di Santa Reparata and the Duomo. Moves to Milan to work for master of the city, Azzone Visconti.

- **1337** Dies January 8 in Florence, before his audience with Benedict XIII, who had requested his presence in Avignon. He is buried with full honors at Santa Reparata chapel.

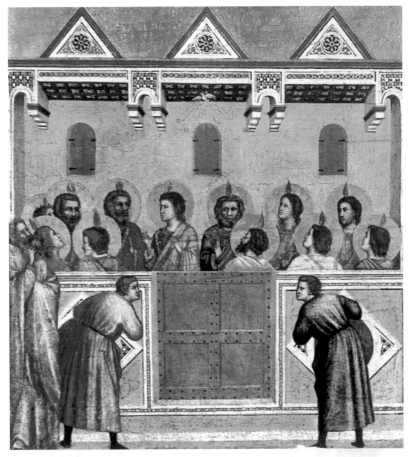

Pentecost

(~1306–1312)
tempera on wood
18 x 17 in (45.5 x 44 cm)
National Gallery, London

This panel, which formed part of a series on the New Testament, is innovative both in concept and execution. To highlight the scene and lend it an air of solemnity, the artist crowned the picture with a baldachin below which the apostles stand behind a low enclosure. They are distributed across the picture so that all their faces can be seen.

The apostles appear to be looking in various directions, rather than directly at the Holy Spirit, which is represented by a dove. The figures in the foreground, followers of the apostles, are shown in different attitudes. Two appear to be speaking about what is happening, while the figures on the far left stare in the direction of the Holy Spirit. The movement of the subjects in this work contrasts with traditional representations, whose figures are static and removed.

Curiously, Giotto did not comply with the rules of perspective or draw his figures to scale, so that the figures in the foreground are slightly smaller than the apostles standing behind them. This is undoubtedly a vestige of the medieval style of painting. Giotto soon moved toward a more realistic perspective, which, combined with his ability to seize an instant and render it in a realistic manner, makes his art fresh and lends it immediacy.

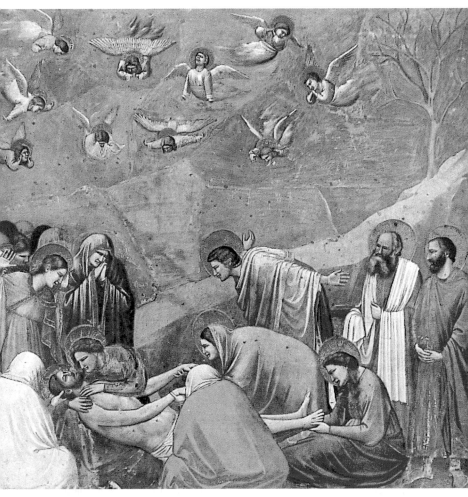

In this fresco, the body of the dead Christ has been rendered with great naturalism, without the rigidity of earlier representations. His arms have clear physical weight, made obvious by the bending of the raised wrists. The head is tilted back slightly, held by a saint and by a mourner, portrayed with her back to the viewer.

The fleshtones are remarkable; the skin is modeled with blues, browns, and greens, accentuating its volumes and shadows. This interest in natural flesh colors was to become palpable among the majority of painters of nudes working after Giotto. This painting is also remarkable for the drama and solemnity of the scene, the highly expressive faces of the figures, and the detailed drapery of their multicolored clothes.

The Lamentation

(~1303–1306)
fresco
73 x 79 in (185 x 200 cm)
Arena Chapel (Capella Scrovegni), Padua

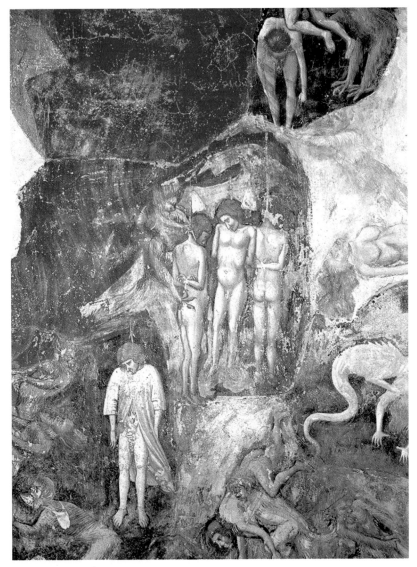

The Last Judgment (Hell)

(~1303–1306)
fresco
Arena Chapel
(Capella Scrovegni), Padua

Giotto is the first artist of the Trecento, the 14th century in Italian art and literature. He is one of the first artists to employ tonal ranges to model bodies instead of using flat expanses of color, working directly with light and dark tones that lend his figures a hitherto unknown realism and volume.

This scene is a detail of the mural decoration at the entrance to the Arena Chapel. It represents the punishment of the damned; Judas is the hanged figure on the lower left.

The three figures hanging in the center show the painter's mastery of draftsmanship and grasp of human anatomy, of particular note considering that each is viewed from a different angle. The figure at the top is remarkable for its modeling given that it is leaning forward so that complex foreshortening is required to render it in a realistic and natural way. The upper body actually seems to advance toward the viewer while the legs appear to recede into the void. This reflects a profound change in the artistic concepts of the time that makes the scene more expressive and incisive and frees the figures from their usual static quality, lending them freshness, dynamism, and aesthetic richness.

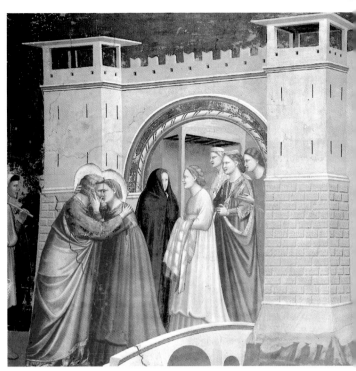

The Meeting of Joachim and Anna

(~1303–1306)
fresco
73 x 79 in
(185 x 200 cm)
Arena Chapel (Capella
Scrovegni), Padua

The small votive chapel of Enrico Scrovegni was decorated with a painting series on the life of Joachim and Anna, the parents of Mary, mother of Jesus. According to legend, they could not have children, but while the husband was praying in the mountains he had a vision that told him his wife would give birth to Mary. He immediately returned to his wife's side. Here the couple is embracing affectionately at the gates of Jerusalem. Giotto worked on this fresco with very few collaborators, which indicates his artistic maturity. The sobriety and dramatic intensity, the balanced spatial conception, the search for perspective, the new use made of light and color—all of these elements demonstrate Giotto's rupture with medieval tradition.

Madonna Enthroned

(~1310)
tempera on wood
128 x 80 in (325 x 204 cm)
Uffizi Gallery, Florence

This panel from the Ognisanti Church is considered to be one of the artist's masterpieces. The Virgin is humanized, pictured sitting on a throne with a baldachin. She is the focus of her entourage, whose faces are expressive and clothing is dynamic. The application of light and color are meticulously executed. The work has lost the rigidity of the Byzantine period, and the figures are much more natural and realistic. It is thus more familiar to the viewer.

Madonna and Child

(~1320)
tempera on wood
34 x 24.5 in (86 x 62 cm)
National Gallery of Art,
Washington, DC (Kress
Collection)

Although Giotto primarily created frescos, his works on wooden panels clearly have a character of their own. This panel has a classical compositional scheme, but the conception, aspect, and treatment of the figures have little to do with what the artist learned in his years of training. The Virgin is posing: she gazes, breathes, feels. She looks like a normal woman—familiar, delicate, and expressive. The Child is not as successful, but it is clear that the painter was concerned with movement. Mary's hands and the dynamism of her clothing are remarkable. This work is the result of the artist's inquiring spirit and his eagerness to find new forms of artistic expression.

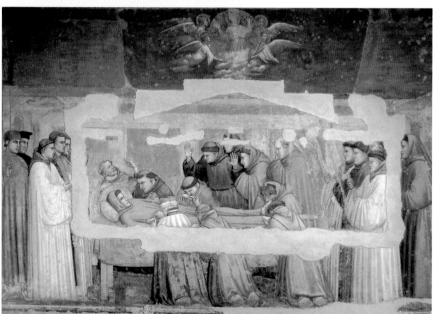

Death of Saint Francis

(~1320-1325)
fresco
110 x 177 in (280 x 450 cm)
Bardi Chapel, Santa Croce, Florence

This scene is part of the series on the life of St. Francis of Assisi decorating a chapel named after its patron, a Florentine banker. It reflects an effort to lend life and movement to the figures, which are represented in a space conditioned by schematically executed architectural elements.

St. Francis is on his deathbed, surrounded by his Brothers, who are overwhelmed by the appearance of the stigmas of Christ's passion on his arms and feet. A simple glance is enough to realize that Giotto has come a long way in thirty years.

JAN VAN EYCK

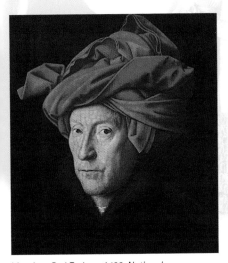

Man in a Red Turban, *1433, National Gallery, London. Traditionally considered a self-portrait.*

Van Eyck was obsessed with naturalism in art throughout his entire career. At the age of thirty, he began to advocate pictorial objectivity, which departed from the conventions of Gothic art that falsified many elements for the sake of rendering an idealization. Van Eyck sought reality in all fundamental elements and details, painting light and color as it really was.

This idea found a following among several of his contemporaries (among them Petrus Christus, Roger van der Weyden, and the Master of Flémalle), whose works exhibit the naturalism and realism propounded by van Eyck. This manner of painting soon gave rise to the Flemish school, among which were such illustrious painters as Bouts, van Goes, Memling, Hieronymus Bosch, Pieter Brueghel, Rubens, van Dyck, Jordaens, and Rembrandt.

In addition to experimenting with technique, van Eyck was also interested in polychromy and light, which required the use of a bright medium. He was a staunch follower of the formulas of the monk Théophile, inventor of oil painting. Van Eyck investigated the possibilities of painting in oil, which until then had been of only rudimentary use, and significantly improved it. Thereafter, oil paint became the pictorial medium par excellence.

In the history of painting there is "before van Eyck" and "after van Eyck."

- **~1390** Born in Maaseyck, a village near the River Meuse belonging to the diocese of Liège.

- **1423** Becomes court painter for the Count of Holland, in whose service he remains until the Count dies. His first known works include some miniatures, of which only *The Birth of St. John the Baptist* and *The Requiem Mass* remain, both in the Museo Civico, Turin.

- **1425** Following the death of the Count of Holland, becomes court painter for Duke Philip the III of Burgundy, who sends him on several missions.

- **1426** Moves to Lille. Makes two secret trips to Portugal to paint some portraits of the young Princess Isabel, whom the elderly Duke wants to marry.

- **1428** From October 19, 1428 to Christmas 1429, accompanies B. de Lannoy, the King's Ambassador, on a mission to Lisbon on behalf of the Duke to ask John I of Portugal for the hand of his daughter, Princess Isabel.

- **1430** Called by Duke Philip III of Burgundy to be court painter, moves to Bruges where he gets married. Undertakes various commissions including portraits and coloring the statues of the city council.

- **1431** Buys a house in Bruges.

- **1432** Paints the *Ghent Altarpiece (The Adoration of the Mystic Lamb)* for St. Bavo (Sint Baafs) Cathedral in Ghent (see p. 29).

- **1433** Works for the Duke of Burgundy at the Coudenberg Palace in Brussels. Finishes *Man in a Red Turban*, traditionally considered to be a self-portrait.

- **1434** Paints the portrait of Giovanni Arnolfini and his Wife *(The Arnolfini Portrait)*, perhaps his most famous work (see p. 31).

- **1439** Finishes a portrait of his wife, Margaretha.

- **1441** Dies in Bruges on July 9.

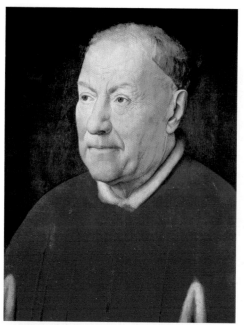

Cardinal Niccolò Albergati

(~1435)
oil on wood
13 x 10.5 in (34 x 27 cm)
Kunsthistorisches Museum, Vienna

Although this painting is traditionally held to be the portrait of Cardinal Albergati, there are some doubts as to the actual identity of the sitter. The preliminary drawing is in the Gemäldegalerie, Dresden.

This painting consists of two large areas of intense, saturated color (the black background and red clothing), leading the eye to the face, whose features have been meticulously painted. The expression on the sitter's face gives the viewer a sense of his inner emotions. Van Eyck painted numerous portraits that are so masterfully executed as to become a standard reference for this genre. This portrait is considered a masterpiece.

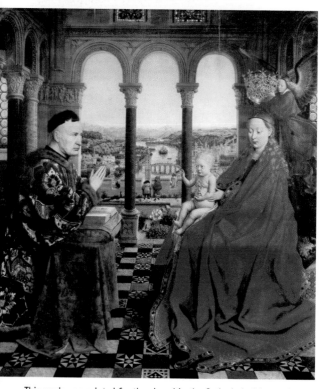

The Virgin and Child with Chancellor Rolin

(~1433)
oil on wood
26 x 24.5 in (66 x 62 cm)
Louvre, Paris

This work was painted for the chapel in the Cathedral of Autun. It was commissioned and funded by Chancellor Rolin, who appears kneeling before the Virgin. She is robed in a red cloak with a multitude of folds, holding the baby Jesus. The scene takes place in a luxurious chamber, and is bathed in a uniform, soft light. Both the faces and clothes of the figures are meticulously represented. The color is particularly intense in certain elements. A glance at the painting shows it: the red robe of the Virgin, the intense blue of the the angel's robe, the landscape backdrop, and so forth. Between the figures can be seen a varied, bright panorama in the background, cut through the middle by a river. Certain elements of the background are associated with the city of Liège, although some areas have been altered for compositional reasons.

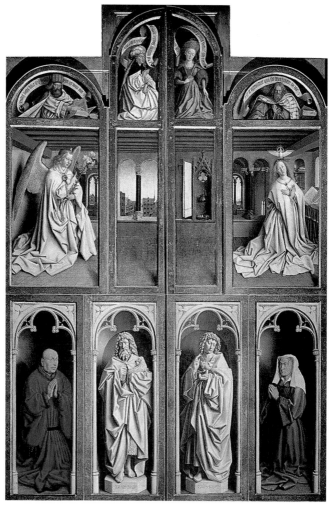

Because of an inscription on the frame, traditionally it was believed that Hubert, Jan's brother, had begun this altarpiece and Jan had completed it. However, recent studies show that the inscription is false, thus the work must be attributed exclusively to Jan.

> **The Ghent Altarpiece (closed)**
>
> (1432)
> oil and tempera on wood
> 138 x 87 in (350 x 223 cm)
> Saint Bavo Cathedral, Ghent

When the leaves are closed, the upper panel of the outer face shows an Annunciation scene divided into two compartments. It is set in a spacious room through whose windows a medieval city square is visible, with the Archangel Gabriel on the left and Mary on the right.

The lower frieze consists of four niche-like compartments, beautifully framed by Gothic lacework resembling arched windows. In the middle left compartment, St. John the Baptist is depicted and in the middle right compartment, St. John the Evangelist. Praying at either end are the patrons of the work, Jodocus Vydt, on the left, and his wife, Elisabeth Borluut, on the right.

The entire outer face of the polyptych has great compositional and chromatic unity, with the figures in a style that recalls sculpture rather than painting. The most important scene of the inner face polyptych is the Adoration of the Mystic Lamb in the lower area, whereas the figures of Adam and Eve appear in the upper area. The complexity of the iconography required specific characteristics. Hence, the lower compartments of the altarpiece represent a panoramic landscape with small figures, recalling miniature paintings. In the upper frieze, the figures are substantially larger, especially Adam and Eve.

Although this polyptych still evokes the Gothic style, it introduces a clearly Renaissance concept of the figure, especially on the outer face.

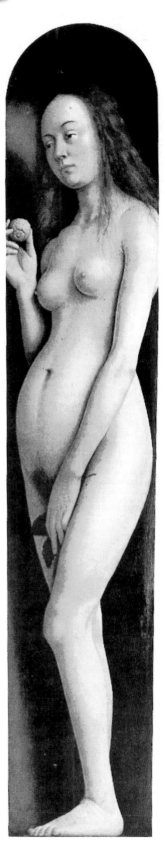

Eve (panel from The Ghent Altarpiece)

(1432)
oil and tempera on wood
84 x 14 in (213.5 x 36 cm)
Saint Bavo Cathedral, Ghent

This image of Eve comprises one of the inner compartments of *The Ghent Altarpiece* (see p. 29), also known as the *Polyptych of Ghent* or *Polyptych of the Adoration of the Mystic Lamb*. The images of Adam and Eve, tightly fitted into two adjoining compartments, constitute the first monumental nudes of northern Europe and contain a series of elements which define the Flemish school of the period.

In accordance with his principles, van Eyck leaves behind the conventions and idealism of the Gothic, which tended to falsify reality for the sake of symbolically idealizing the human figure. Eve is here presented in a realistic manner, as an ordinary woman. Van Eyck painted from a model and adapted the work to comply with the canons and rules of beauty in fashion at the time: her figure is stylized with narrow, sloping shoulders, small, firm breasts, a thin trunk, a rounded stomach that is still in accordance with the Gothic aesthetic, and long, thin legs.

Eve is holding a small apple in her right hand while she covers her pubis with a leaf held in her left hand, leaving abundant pubic hair visible. The figure fits in the narrow frame gracefully. To focus the viewer's interest on the body, he uses a dark background and soft tones that bring out the modeling of the figure. Van Eyck used the new technique of painting with a combination of white Bruges varnish mixed with linseed oil, solvent, and other ingredients, based on the recommendations made by the monk Théophile. This mixture, which allowed for more vivid and brilliant colors, soon became the basis for the new oil painting that would sweep Europe.

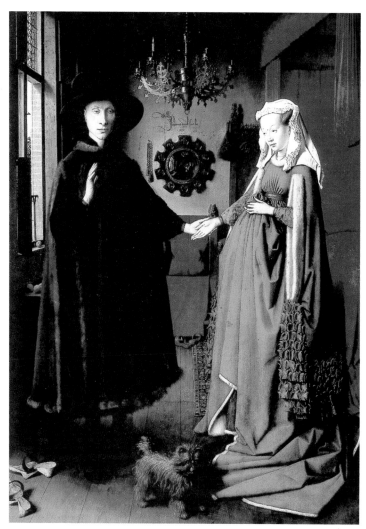

This is one of the most famous paintings of the 15th century Flemish school, as well as one of Jan van Eyck's most important works. Giovanni Arnolfini was a rich Italian merchant established in Bruges. This portrait is commonly thought of as a record of his betrothal to the daughter of an equally powerful Belgian family.

They stand in a luxurious domestic chamber, thought to be either the bedroom or main living room, which in those days would have included an ornate bed as its primary furnishing. The couple are touching hands. The man's dark clothes highlight his face; the woman's brilliant dress dominates the scene.

Despite the confined space, the scene has depth. On the far wall is a mirror, reflecting the couple and another figure, which is almost certainly the painter, who takes up the position of spectator at the door while carrying out the portrait. Above the mirror is an inscription: *Johannes de Eyck fuit hic* (Jan van Eyck was here). Van Eyck ingeniously uses two light sources, one to illuminate the figures and the other coming from the window behind them and illuminating the back of the room. The attention given to the couple does not eclipse his interest in the details in the background, meticulously rendered through a masterly application of light that lends volume, describes texture, and distributes highlights on the metal of the lamp and the frame of the mirror (probably made of leather).

Technically, this painting is remarkable for its layers of color and skillful interplay of transparencies. It is truly surprising that a painting from the first half of the 15th century can have so much color and detail and be so realistic. This style of painting had such a profound effect that for centuries it defined the Flemish school of painting and also influenced the German school.

Portrait of Giovanni Arnolfini and his Wife (The Arnolfini Portrait)

(1434)
oil on wood
32 x 24 in (82 x 60 cm)
National Gallery, London

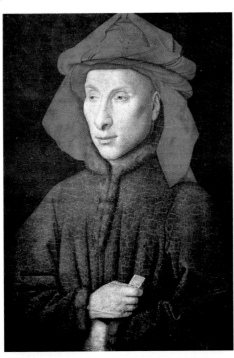

Portrait of Giovanni Arnolfini

(~1434)
oil on wood
11 x 7.5 in (29 x 20 cm)
Staatliche Museen, Gemäldegalerie,
Berlin

The fact that van Eyck made several portraits of Arnolfini leads us to believe that he was a good patron, that the artist was possibly his protégé, and that there was a close relationship between them. His extraordinary skill in manipulating the difficult, as yet underdeveloped medium of oil (the paint on this work is now cracked) is remarkable, and he manages to represent all the elements with incredible realism and detail. The folds of the robe, the texture of the collar and cuffs, the play of shadows that defines the turban, and the facial features all show the height of his skill and perfectionism, and demonstrate his total mastery of the medium, technique, and genre.

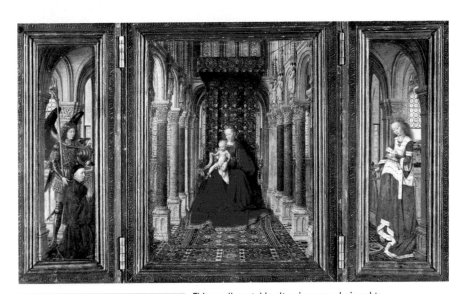

The Virgin and Child

(~1437)
oil on wood
12 x 22 in (31 x 55 cm)
Staatliche Kunstsammlung, Dresden

This small, portable altarpiece was designed to be taken on trips. It is divided into three compartments with a central panel and two lateral wings that can be opened or closed like doors. The central compartment portrays the Virgin and Child seated on a throne under a baldachin which is decorated with a rich tapestry brocaded in flowers. The left wing shows the Archangel St. Michael, wearing armor and holding a lance, presenting the kneeling patron, who commissioned this work. In the right wing, St. Catherine is holding a sword and a book, wearing a crown on her head. The three scenes are set in a sumptuous architectural milieu of columns and high arches that suggest the interior of a cathedral. Given the minimal scale of the triptych panels, the artist has achieved remarkable results in oil.

FRA ANGELICO

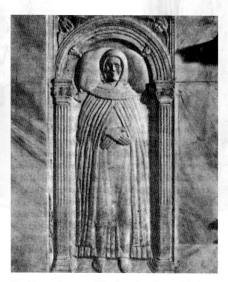

Marble tombstone of Fra Angelico, Santa Maria supra Minerva, Rome.

Fra Angelico (Fra Giovanni da Fiesole) was a highly spiritual man who considered himself a monk above all, with painting as a secondary calling. For him, art served to exalt religion; his work is possibly the last manifestation of medieval religious ideals. Though it is fundamentally Gothic in its conception, his art is innovative in its execution, revealing a humanist whose ideals are based on the importance of the individual and on scientific processes. He utilizes modern pictorial language, skillfully using light for aesthetic rather than naturalist ends.

Fra Angelico was the first European painter to paint a representation of a real landscape (a view of Lake Trasimeno from Cortona), and made two important contributions to the development of modern art: corporeality, which led him to follow a path parallel to that of Masaccio; and the expression of space through light and color. In his search for corporeality, the forms of his art became simplified and tangible, attaining weight and volume. He uses color to achieve an atmospheric luminosity of great effect.

The work of Fra Angelico was held in high esteem in Italy during his lifetime, but later unjustly denigrated to the point where he was considered a simplistic, mellifluous painter, and a narcissist. In 1540, Pope Paul II ordered some of his Vatican frescos to be destroyed. In reality, Fra Angelico struggled to defend the modernity in Art.

- **~1395** Born in Vicchio di Mugello, on the banks of the Mugello in Tuscany, near Vespignano, to a plebeian yet well-off family.

- **1417** In a document dated October 31, he is mentioned as a secular painter collaborating with S. Nicoló on the decoration of the Church of Santa Maria del Carmine in Florence.

- **1418** Still designated a secular painter on the receipt for an altarpiece for the Ghierardini Chapel in the Church of San Stefano al Ponte.

- **1423** Appears for the first time as Fra Giovanni of the Dominican Order of Fiesole on the payment receipt from the Santa Maria Nuova Hospital.

- **1424** Paints St. Jerome, clearly revealing Masaccio's influence.

- **1425** Paints the altarpiece for the Church of San Domenico da Fiesole, showing an affinity with Gentile da Fabriano.

- **1436** Is summoned to Florence to work on the San Marco Convent, whose restoration is funded by Cosimo de' Medici. Although the general conception of his art there is Gothic, the elements and details are wholly humanist and in keeping with scientific ideals.

- **1440** Cosimo and Lorenzo de' Medici commission an altarpiece for the high altar of the San Marco Convent in Florence.

- **1445** Pope Eugenius IV summons him to Rome, where he and his student, Benozzo Gozzoli, participate in the decoration of the Vatican's Chapel of the Holy Sacrament.

- **1447** Nicholas V assumes the papacy and grants him a stipend of 200 gold ducats. Decorates the principal chapel of St. Peter's Cathedral. Moves to Orvieto with his disciples, where he resides for two years, beginning *The Last Judgment* in the church cupola, which remains unfinished at his death.

- **1448** Appointed prior of the Fiesole Monastery, though he continues to paint in Fiesole and Rome.

- **1450** Executes a series of paintings in Rome that reveal the influence of the Vatican's grandeur.

- **1452** Refuses to paint the apse of the Prato Cathedral.

- **1455** Dies in Rome on February 18, at the pinnacle of fame. Buried in the Dominican Convent of Santa Maria Sopra Minerva.

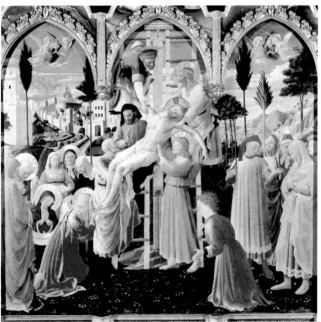

Deposition

(~1435)
oil on wood
106 x 110 in
(275 x 285 cm)
Museo di San Marco,
Florence

This work was executed during Fra Angelico's early period, when the Gothic aesthetic still permeated Florentine art. The composition is replete with figures organized according to a Gothic scheme, yet their poses, attire, and attitudes can be ascribed to new artistic trends. This work is conceived as a miniature. Despite the central group, the rest of the figures are somewhat dispersed.

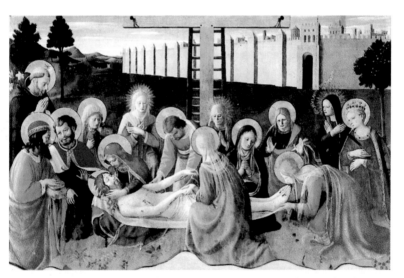

Lamentation

(1436)
tempera on wood
42.5 x 65 in (108 x 165 cm)
Museo di San Marco, Florence

Fra Angelico sought to create art that would evoke a reverential attitude in the viewer. The aim of the expressive faces and gestures are to move the spectator to prayer. His compositions are balanced. Naturalism is evident in the nude torso of Jesus, although it lacks the exhaustive anatomical study found in his other nudes. The flesh tones are not used to define muscles, and the limbs still show a certain tubular form, though the modeling of the shadows is more involved.

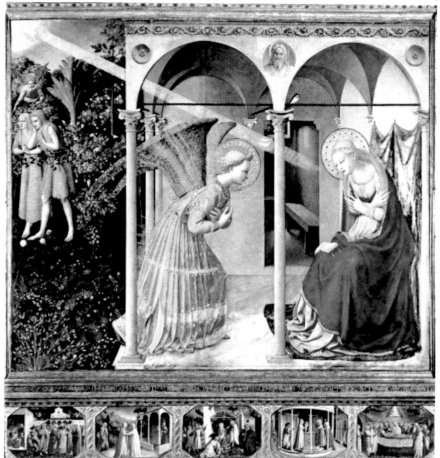

This is one of the most significant paintings by Fra Angelico, executed during his time at the Convent of San Marco in Florence. The painting was to be hung in a bedroom and consists of an entire altarpiece with a complex and elaborate iconography.

It represents the Annunciation, in which the Archangel Gabriel informs Mary that she is to bear a child who will be the Messiah. Both figures are enthroned in an open structure covered by an arched ceiling set on fine columns; each figure is framed in an archway.

The Annunciation

(~1445)
tempera on wood
75 x 75 in (194 x 194 cm)
Prado, Madrid

The Archangel demonstrates respect toward Mary, who, in turn, reflects humility and acquiescence to the will of God. The Almighty is represented as a circle of light in the upper left corner, from which a shaft of light penetrates the scene and falls upon Mary, a clear indication that her pregnancy was conceived by Divine grace.

Under the beam of light, Adam and Eve are being expelled from Eden by an angel because of original sin, an episode closely related to the Annunciation. On the predela, five scenes represent the life of Mary as a complement to the principal theme of the work. These are: her nuptials, her visit to see her cousin Elisabeth, the adoration of the Magi, the presentation of Jesus in the temple and her purification, and her death among the apostles.

The painting is a lesson in catechism. It is executed with meticulous attention to every detail. The figures are beautiful, with delicate skin, fine attire, and absorbed, spiritual attitudes. Fra Angelico wanted the public to relate to the figures and thus accept the religious message, hence, despite the figures' dignity and aura of faith, they do not hide their human nature.

The work demonstrates a clearly Gothic conception, but its execution diverges from the medieval aesthetic and heralds the changes brought about by the Renaissance. This style recalls a work from the Trecento, which constitutes one of its most charming peculiarities.

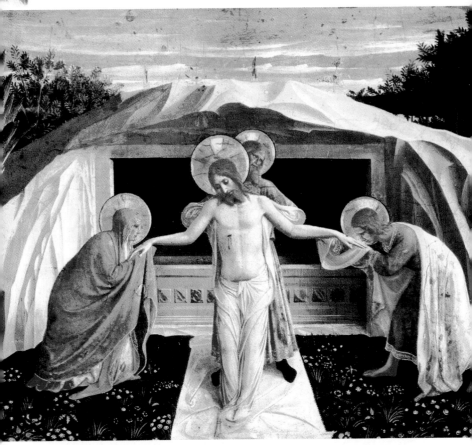

Entombment (Pietà)

(~1440)
tempera on wood
15 x 18 in (38 x 46.5 cm)
Alte Pinakothek, Munich

This scene is the central panel of five forming the predela of the altarpiece from the Church of the Convent of San Marco in Florence dedicated to the saints Cosmos and Damian, patron saints of the Medici family (Cosimo and Lorenzo de' Medici funded the altar). There is a great luminosity of forms, even in the shaded areas, possibly influenced by Domenico Veneziano, who practiced this method in Florence in 1439.

Painted a few years after *Lamentation* (p.34), this panel and successive ones breaks with previous tradition in two respects, in the presentation of the figure of Christ in a unique frontal view with foreshortening of his feet as they are advancing toward the viewer, and as a fine anatomical study. The treatment of light provides an ideal opportunity for Fra Angelico to model the figures and drapery, and creates a complexion rich in contrasts and highlights, allowing an admirable study of the muscle and bone structures.

Christ's anatomy has been idealized within an aesthetically beautiful and elegant scene, allowing the viewer to enter into a reverential state of meditation and prayer. The highly exaggerated style and color scheme used combine to create a delicate, clean, and vibrant work. The other parts of this panel can be found at the Louvre in Paris.

Saint Cosmas and Saint Damian Before Lisius

(~1440-1441)
tempera on wood
15 x 18 in
(38 x 45 cm)
Alte Pinakothek,
Munich

This panel is another part of the predela of the high altar of the Church of the Convent of San Marco in Florence. The majority of the altarpiece is exhibited at the Museo di San Marco in Florence, but the predela compartments are distributed among several museums in Vienna, Munich, and Paris.

This scene represents the moment when Saints Cosmas and Damian, shown on the left, and other good Christians, all represented with halos, go before the Prefect Lysias. Seated on his throne and accompanied by councillors and soldiers on the right, he interrogates the Christians and tries to make them renounce their faith. The composition is fully Renaissance in style, although some figures still recall the Gothic period.

The Virgin and Child

tempera on wood
29 x 20.5 in (74 x 52 cm)
Rijksmuseum, Amsterdam

Fra Angelico executed this painting toward the end of his life. It is more elaborate than his earlier work and exhibits a move toward Renaissance art. The Madonna is composed within a pyramid in which her simple blue cloak with its many folds provides a counterpoint to the ornate golden background decorated with geometrically simple black patterns. The objective of the painting is clear: to glorify the Virgin as the Mother of God, enthroned in all her majesty.

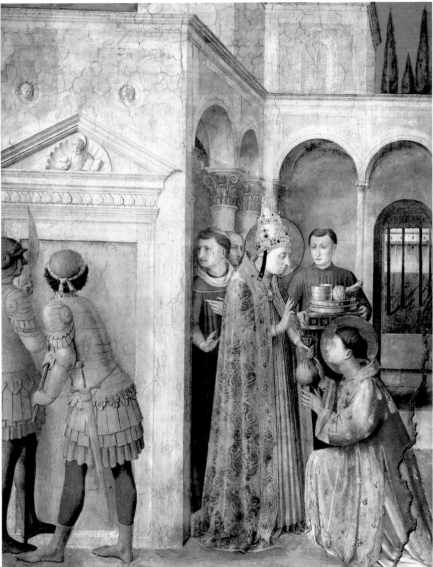

Saint Lawrence Receiving the Treasures of the Church from Saint Sixtus

(1447-1450)
fresco
107 x 81 in (271 x 205 cm)
Chapel of Saint Nicholas V,
Vatican City

In 1447, Fra Angelico was working in Rome on a number of Vatican commissions, including frescos for the Chapel of St. Nicholas V (also known as the Chapel of the Holy Sacrament and as the Pope's private chapel), and an apartment. All but the fresco in the Chapel have disappeared. Executed over the course of 1448, it represents different scenes from the lives of Saints Lawrence and Stephen.

St. Lawrence was archdeacon during the reign of Pope Sixtus II, and as such, he administered large quantities of money for the maintenance of Christian communities and for helping the poor. This painting depicts the moment in which the Pope gives him his comission. St. Lawrence accepting a small bag of money, applies Renaissance principles of a universal belief in science and culture. Architecture plays a key role, dominating the scene and dictating the composition and perspective. The static, solemn figures are arranged so that their placement adds to the aesthetics of the composition. They have been meticulously rendered with very realistic facial features and clothing. Fra Angelico's mastery of color is apparant in the golden hue that pervades everything in the scene. In this refined work, the light is soft, the shadows delicate, and the contrasts contained.

MASACCIO

Tribute to St. Peter *(detail), fresco, ~1425, Chapel of the Church of the Carmine, Florence. This figure is assumed to be a self-portrait of the painter.*

During his brief life, Massacio (Tomasso de Giovanni di Simone Guidi), the young genius who emerged from the Florentine school, became the pioneer of Renaissance painting.

In his zeal to reflect reality, he freed his artwork from exaggeration, subjective interpretation, and conventions and the hallmarks of the international Gothic. He renewed the representation of nature, giving it a prominent role and dramatically enthroning the human figure.

Taking up the new artistic experiments of his time, including the scientific methods of perspective developed by the architect Filippo Brunelleschi, Masaccio continued the pictorial innovation begun by Giotto a century earlier. He was also influenced by the sculptor Donatello, whose work reflected a thorough knowledge of anatomy and a classic sense of proportion.

Masaccio applied this understanding of three-dimensional form and perspective, and an understanding of the effects of lights and shadows, to create realistic interpretations of sacred scenes that are powerful, expressive, and dramatic.

By lighting his figures from a single source, he created the illusion of deep sculptural relief, lending them great character, emotional depth, and a hitherto unknown roundness of form.

Masaccio's work was highly influential among many painters of the 15th and 16th centuries.

- **1401** Born on December 21 in Castel San Giovanni, Tuscany, the son of a notary whose family name was Scheggia.

- **1406** His father dies and his brother is born.

- **1417** Documents indicate he is living in Florence, where he moves with his mother, whose second husband has just died.

- **1422** Enters the Florentine guild of doctors and pharmacists, to which painters must belong if they are to receive commissions. This indicates that, despite his youth, the painter has already finished his apprenticeship. He paints the *Triptych of the Virgin Among Saints and Two Angels* for the Church of San Giovenale in Cascia, his first known work of art, in which his innovative spirit is evident, the result of his affinity for the ideals of the Renaissance. He becomes acquainted with Brunelleschi and Donatello.

- **1423** In collaboration with Masolino da Panicali, he paints *The Virgin with St. Anne* (Uffizi Gallery, Florence).

- **1424** Joins the Compagnia di San Luca, an exclusive guild for painters.

- **1425** In collaboration with Masolino, he paints the *Polyptych of the Snows* for the Church of Santa Maria Maggiore in Rome, as well as the figures of St. Jerome and St. John the Baptist and the frescos of the San Clemente Basilica. Takes charge of the fresco of the Brancacci Chapel in the Church of Santa Maria del Carmine of Florence, collaborating with Masolino, who had initially been commissioned for the work but who left to undertake an important commission that he had received from Hungary. Of this work, he is attributed the scenes of *The Tribute Money, St. Peter Distributing Alms,* and *The Expulsion from Paradise,* which demonstrate a more decisive approach to the new ideas than the scenes painted by his colleague.

- **1426** Carries out the *Altarpiece of Pisa,* a polyptych for the chapel of St. Julian in the Church of Santa Maria del Carmine of Pisa, commissioned by the notary Giuliano degli Scarsi. The piece is now dismantled.

- **1427** Finishes the fresco for the Brancacci Chapel, in which his best works can be found. Paints *The Trinity,* a fresco for the Church of Santa Maria Novella in Florence, in which he presents the doctrine of God as three separate beings in one entity, through a real and contemporary image (see p. 43).

- **1428** Dies in Rome at the age of 27, possibly poisoned.

Saint Peter Baptizing the Neophytes

(~1425-1427)
fresco
100 x 64 in (255 x 162 cm)
Brancacci Chapel, Church
of Santa Maria del Carmine,
Florence

Masaccio's greatest surviving work is the fresco at the Church of Santa Maria del Carmine, Florence, a cycle from *The Life of St. Peter*. The rich Florentine merchant, Felice Brancacci, commissioned Masolino da Panicali to paint the mural of the chapel named after him. Masolino began working and finished several scenes, but then relinquished the job in favor of another commission he had received from Hungary and which required his presence there. Masaccio had already been working on the fresco in close collaboration with Masolino and was given the task of finishing the work.

This fresco, along with others that narrate the life of the saint, is one of the most renowned of the chapel. It shows the saint baptizing those recently converted to the faith. In contrast to those appearing in *The Expulsion from Paradise* (see opposite page), the nudes represented here are extremely beautiful, although Masaccio did not intend to idealize them. The artist's profound anatomical knowledge is evident, and the volumes of the muscles are perfectly modeled with a sound study of lights and shadows. These nudes manifest Masaccio's concept of spatial perspective, an aspect that fascinated the artist. In the foreground the colors are bright and contrasting, whereas in the more distant grounds, the tones fade through the effect of the atmosphere.

This chapel suffered a series of vicissitudes. In the 17th century, a project to renovate the church threatened to destroy it, and it was only saved thanks to the intervention of the Grand Duchess Victoria della Rovere, mother of the reigning Grand Duke Cosimo III. It was later vandalized and many paintings were lost due to renovations carried out in 1746-1748. There was a fire in 1771, which destroyed the rest of the church. At an indeterminate period, clothing was painted over the nudes to cover their "indecency." What can be seen today is the result of restoration carried out in 1990, which uncovered the original nudes and returned the original freshness and attractiveness to the paintings.

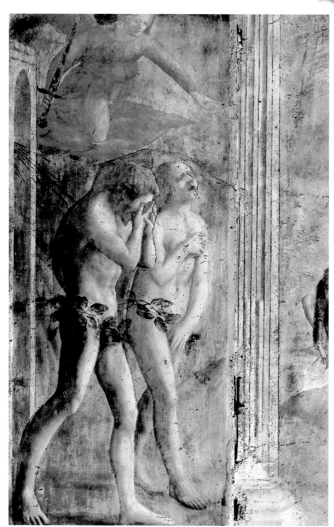

The Expulsion from Paradise

(~1425–1427)
fresco
35.5 x 81 in
(90 x 205 cm)
Brancacci Chapel,
Santa Maria del
Carmine, Florence

Masaccio's work in the Brancacci Chapel was not simply the continuation of Masolino's art. Whereas Masolino advocated luxury and meticulous detail in the fresco, Masaccio concentrated all of his interest in grouping people within a space in which they moved with spontaneity and force. He eliminated everything that was superfluous, reduced forms to sculptural elements subject to a skillful treatment of lights and shadows and, through perspective, incorporated the figure into the landscape.

In this scene, the human figure is represented with a new conception of anatomy, of movement, and of the immense human capacity to express feelings. Hence, this scene does not simply represent two nudes, but rather two human beings, with such elementary and simplified anatomical forms that they verge on expressionism. It is not just a matter of style, as the artist's intention was to reflect the shame and sorrow of Adam and Eve, weighed down by their sin while they are expelled from Eden, as well as to reflect the maximum possible expressiveness.

The dynamic of the two nudes is overwhelming. Although they do not have a beautiful anatomy, they maintain a very modern gestural rhythm for their period. Masaccio sought to reflect reality, not to stylize. Thus, these nudes consist of anatomical masses in which hard contrasts separate the two desperate figures and their limbs. The color scheme oscillates between a warm ochre, a deep yellow, and an intense red. The architectural elements are perhaps the only vestiges of classical antiquity that Masaccio has respected.

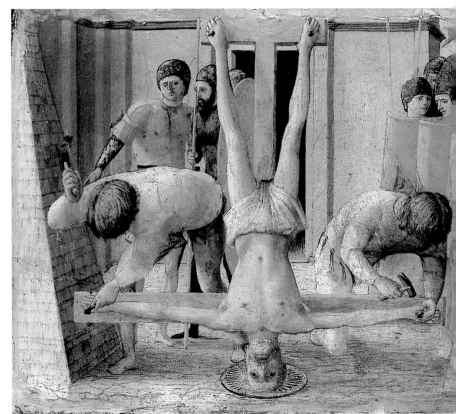

The Crucifixion of Saint Peter

(1426)
tempera on wood
8 x 12 in (21 x 30.5 cm)
Staatliche Museen,
Gemäldegalerie, Berlin

This scene forms part of the polyptych commissioned of Masaccio for the Church of Santa Maria del Carmine in Pisa. It was dismantled in the 17th century so that its panels could be sold separately and hence at a greater profit. Unfortunately, the extant panels are in different places, whereas the others have been lost. This is one of the scenes that narrates the martyrdom of the saints.

When Masaccio represents architectural backgrounds, he achieves excellent effects of depth, as is the case with the walls that surround this scene. The martyrdom of St. Peter represented here calls for a rigid figure due to the narrative and compositional requirements. St. Peter was crucified like Jesus of Nazareth, his teacher, but to avoid being placed like him, the apostle asked to be crucified upside down.

As in other crucifixions, the figure is shown from the front. At first sight, the artist seems to be regressing with respect to the development of the figure, especially considering the interest in gesture and dynamism evident in other works, but this is a false impression. Upon close observation of the nude, leaving aside the rigor of the symmetric and centered composition, the thoroughly studied anatomy comes to the fore, with volumes that precisely define each part of the body. The shadows do not show a defined muscle structure, but they do indicate the joints and the principal muscular and bone masses. The points of light in the shaded areas confer great realism to the nude, emphasized by the action of the executioners who are nailing the apostle's hands to the cross.

Despite the general simplicity of the scene, the aesthetic and humanist concepts of the Renaissance are evident, perfectly combined with the religious theme and the objective of rousing the viewer's devotion.

According to Catholic dogma, the idea of God falls into three images, the Father, the Son, and the Holy Ghost. In art, this subject matter has been rendered on countless occasions. Through its iconographic combination of the human figure and architectural elements, this fresco constitutes an eloquent expression of the humanist and holistic culture, the basic concepts of the Renaissance.

The Trinity is radically different from the contrived nature of the Gothic and reflects a new understanding of humanism and classicism, which were so important to artists of the Renaissance. The new concern for perspective is evident in his work, which includes this unusual treatment of the subject of the crucifixion.

The Trinity

(~1425-1428)
fresco
262 x 125 in (667 x 317 cm)
Santa Maria Novella, Florence

Masaccio's approach revolutionized the understanding of perspective in painting. In *The Trinity* he used two vanishing points, one for the Holy Trinity, represented by the white dove, and one at the eye level of the spectator. A large arch opens onto a barrel-vaulted alcove whose perspective lends depth to the scene, incorporating the figures into a specific spatial area. The technical mastery of the architectural background leads to the conclusion that the architect Brunelleschi, a good friend of the artist's, probably participated directly or indirectly, at least by contributing his advice.

The magnificence of the architecture heightens the impact of the crucified figure. On this occasion, Masaccio placed special attention on the use of light to sculpt the nude. In contrast to the figures in his other works, the anatomical details are evident, from the tensed muscles in the arms and shoulders to the protruding rib cage.

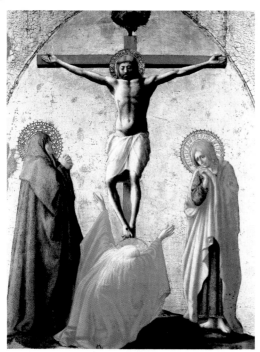

Crucifixion

(1426)
tempera on wood
33 x 25 in (83 x 63 cm)
Museo Capodimonte, Naples

This work formed part of the polyptych of the Church of Santa Maria del Carmine in Pisa. It has typically Gothic elements, such as the golden background, and other highly modern aspects, as in the treatment of the figures in space.

The figures are highly expressive, their gestures intensely dramatic, especially those of Mary Magdalene, in a pose of total dejection with her arms outstretched. The nude of Christ is separated from the background through the treatment of the shadows, which become dense, with few tonal values. The light that defines the complexion consists of highlights smoothly integrated with the shadows. The complexion of the figure, consisting of a delicate golden tone, contributes to the atmosphere.

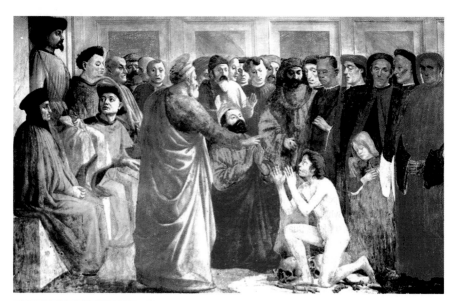

Peter Raises the Emperor's Son from the Dead (Raising the Son of Theophilus)

(1428)
fresco
Brancacci Chapel, Church of Santa Maria del Carmine, Florence

The scene shows the apostle raising the son of Theophilus, the Prefect of Antioch, from the dead, causing the inhabitants to convert to Christianity. In this work, the perspective of a great multitude of people who occupy the near entirety of the painting's surface area contrasts with that of the architectural elements such as the wall in the background rising above the heads of the crowd. The youth's adolescent body is remarkably realistic, its subtle modeling and delicate volumes achieved through a masterful application of light. Through the crowd of people dressed in distinguished attire and shown intent on what is happening, the artist wanted to show the importance of the miracle and its impact on the Prefect and his advisors and collaborators. The painter died before he finished this work. It was not until 1480-1490 that Filippino Lippi was commissioned to finish it.

PIERO DELLA FRANCESCA

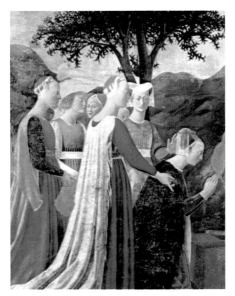

Adoration of the Holy Wood and the Meeting of Solomon and the Queen of Sheba *(detail)*, fresco, *135 x 299 in (336 x 747 cm), 1452, Church of San Francesco, Arezzo.*

Piero della Francesca trained in Domenico Veneziano's studio in Florence where he developed his palette of pale, sunwashed colors, though the naturalness of his figures owes a strong debt to Masaccio, whom he met while there. However, it was perhaps the influence of the architect, Leon Battista Alberti, that contributed to his focus on the pure, exalted beauty to be found in geometric perspective. Piero's evocative, sensitive portrayals of the world show the human figure situated in a realistically portrayed landscape. This was the first time the two disciplines were synthesized. Piero is known as the first humanist artist of the Quattrocento.

The accuracy of his portrayals of the natural landscape and architectural settings served to humanize the themes portrayed. His sophisticated use of color creates a reciprocal relationship between the figures and their environment which unifies the whole.

Piero was an eminently Mediterranean painter who managed to combine spontaneity with science and systematic formulation as had not been done before. His influence extended over many later generations, from the Quattrocento school of Ferrara, and the 16th-century Venetian school, to the painters of the late 19th-century (Seurat, Signac, etc.), for the way in which he conceived the work and decomposed the colors.

• **~1416/17** Born in Borgo San Sepolcro, in Umbria.

• **1439** Appears as an assistant to Domenico Veneziano on the invoices for the San Egidio choir frescos in Florence.

• **1445** The Compagnia della Misericordia, founded to carry out missions of mercy, commissions a polyptych named after it, now in the Pinacoteca Comunale, San Sepolcro.

• **1450** Works on frescos in the castle and Church of St. Augustine in Ferrara.

• **1451** Travels again to Ferrara, where he comes into contact with Rogier van der Weyden and influences the local school. Paints the fresco decoration of the Malatestino Temple.

• **1452** He is commissioned to execute the frescos of the San Francesco Church choir in Arezzo upon the death of Bicci di Lorenzo, who had been originally commissioned. He creates the fresco cycle, *The Legend of the True Cross,* which is considered his greatest masterpiece, and a fundamental Quattrocento painting.

• **1454** Begins the polyptych for the high altar of the Church of St. Augustine in Borgo.

• **1459** Executes various pictorial works in Rome, especially for Pope Pius II. *St. Luke the Evangelist* is the only work extant (Church of Santa Maria Maggiore, Rome).

• **1460** Federigo da Montefeltro, the Duke of Urbino, commissions portraits of himself and his second wife, Battista Sforza (see p. 49).

• **1466** Concentrates his artistic activity in his native region and at the court in Urbino. The congregation of the Nunziata d'Arezzo commissions him to execute its standard.

• **1468** Leaves Borgo due to the plague and settles in Bastia.

• **1469** Moves into the home of Giovanni Santi, the father of Raphael, in Urbino.

• **1474** Writes two treatises on the mathematics of art for the Duke of Urbino: *De Prospectiva Pingendi* and *Libellus de V Corporibus Regularibus.*

• **1480** Is appointed head of the renowned St. Bartholomew Guild in Borgo.

• **1486** Goes blind.

• **1492** Dies on October 12 in Borgo San Sepolcro.

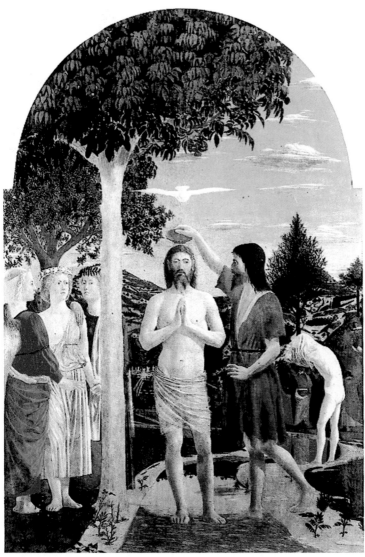

The Baptism of Christ

(~1445)
tempera on wood
65 x 46 in (167 x 116 cm)
National Gallery, London

This is one of Piero's earliest extant paintings in which both the human figure and the landscape play important roles, in accordance with Masaccio's concept.

This work is archetypal of Quattrocento art both for its naturalist study and use of perspective. The illuminated figure of Christ, depicted being baptized by his disciple John the Baptist, stands out in the center of the composition. Above his head is a dove representing the Holy Spirit. The three winged figures on the left correspond to three angels lacking their usual attributes—such as a halo—an allusion to the pact between the Eastern Orthodox and Roman Catholic Churches at the Ecumenical Council of Florence (1439), which treated three basic questions: The Filioque (the nature of the Holy Spirit), the Greek Epiclesis (invocations to God in order to protect people), and the supremacy of the Pope over all the Christian churches.

The composition is balanced with a coherent distribution of masses. The execution of the nude figures shows Piero's great virtuosity in modeling realistically sculptural anatomies, and the white light shrouding the bodies helps them become a cohesive part of the overall landscape. The naturalism and movement of the figure undressing in preparation to receive baptism shows Piero's facility in rendering realistic movement. Christ's serenity and immobility highlight's his focal position as the main object in the image.

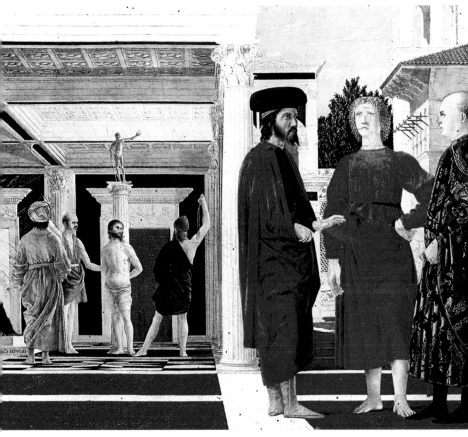

In 1455, Piero had been contracted by the Duke of Ferrara to decorate several halls of his castle with frescos. While there, he met Rogier van der Weyden, who introduced him to Flemish painting. This work, painted for the Church of San Francesco in Arezzo, shows the influence of the detailed work of the Flemish school, as well as studies on perspective.

Nonetheless, it is quite original in many aspects. The artist's new knowledge of the laws of perspective allowed him to experiment with this panel, diverging from the popular iconography of the scene.

The Flagellation of Christ

(1455)
tempera on wood
23 x 32 in (59 x 81.5 cm)
Galleria Nazionale delle Marche, Urbino

Rather than being centered, Christ is placed on the left and somewhat in the background, although the composition immediately leads the eye to him. His body is accurately proportioned, yet he is strangely short in stature in comparison with his tormentors. The illumination is accurate, considering the fact that this is an interior—the light enters the room and touches the figures from one side and the cast shadows are soft, providing volume in the modeling of the muscles.

The painting juxtaposes two events: the flagellation of Christ and the conspiracy of 1444 to kill Oddantonio, stepbrother of Federigo da Montefeltro. The stepbrother appears on the right, flanked by two advisors who are plotting against him. With their evil advice, they spiritually "flagellate" the young prince before leading him to his death. In this painting, the artist has created a parallel between Oddantonio and Jesus.

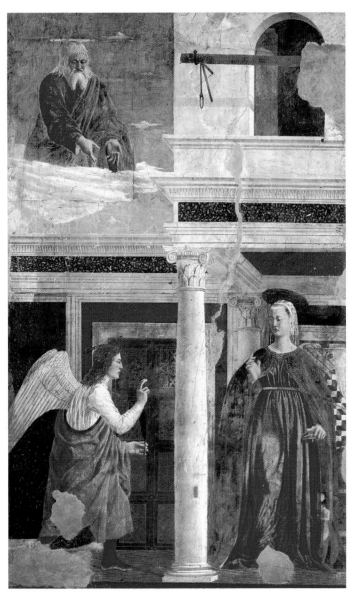

The Annunciation

(1455)
fresco
129.5 x 76 in (329 x 193 cm)
Church of San Francesco, Arezzo

The fresco cycle, *The Legend of the True Cross*, decorating the choir of the Church of San Francesco, is considered Piero's masterpiece. This scene depicts the moment when the archangel Gabriel announced to Mary that she would conceive the son of God. It is arranged as a series of squares and rectangles following a geometric pattern of elements, creating a strong sense of rhythm. Each figure in this scene inhabits a distinct architectural setting. The flat patterns of primitive art are combined with the singularly simple execution of the figures, a characteristic typical of Florentine art. The addition of perspective provides great unity through the architecture. Their somewhat affected poses make the brightly colored figures rather mysterious. The work is technically outstanding with its creation of atmospheric distance.

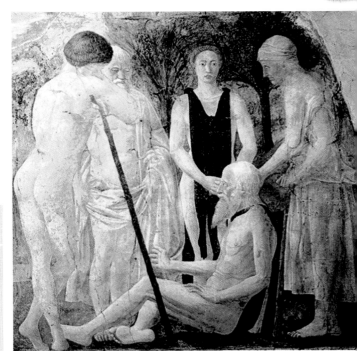

The Death and Burial of Adam

(1452-1466)
fresco
153.5 x 294 in
(390 x 747 cm)
Church of San
Francesco, Arezzo

This scene is a part of the fresco cycle, *The Legend of the True Cross.* According to one legend, Adam died at the age of 930. Here, he is depicted as a very old man sitting on the ground. Knowing that he is close to death, he asks his son Seth to seek the seed of forgiveness, which the Archangel Michael promised him and Eve when they were expelled from Eden for committing the original sin. Behind him, attentive and resigned, Eve holds her husband's head. These nudes are treated with great realism, accentuated by the light, which lends them a sculptural aspect demonstrating that Piero has moved beyond the Gothic aesthetic.

Duke of Urbino

(~1465-1470)
tempera on wood
18.5 x 13 in (47 x 33 cm)
Uffizi Gallery, Florence

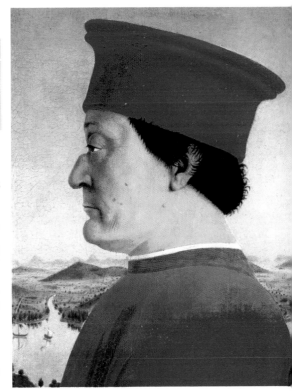

This former condottiero, a sort of war-lord, became the Duke of Urbino in 1445, a year after some shady events and machinations led to the death of his stepbrother Oddantonio. In Urbino, he established a humanist court of utmost importance to the Renaissance. In 1437, he married Gentile Brancaleoni, but he was widowed in 1457. He commissioned Piero to do a pair of portraits of himself and his second wife, Battista Sforza, whom he married in 1460. It is a typical Quattrocento portrait from central Italy: a static bust in profile. True to his universal ideals, the painter uses the background to incorporate a new element: a landscape that is remarkable for its composition and colors, which lends the figure context and new meaning.

Hercules

(1465)
fresco
59.5 x 49.5 in (151 x 126 cm)
Isabella Stewart Gardner
Museum, Boston

This fleshy Hercules, painted with his characteristic attributes —a club and the skin of the Lion of Nemea—is one of Piero's most erotic nudes. The figure has been modeled with light such that it verges on the sculptural. The dark background focuses attention on the figure and enhances its sense of three-dimensional relief. Shadows softly model some parts of the body, whereas the brightest areas are enveloped in a luminous halo that produces the optical illusion of volume.

The realistic portrayal of Hercules shows the artist's knowledge of human anatomy. Although the accurate proportions, the deft treatment of light, and the sophisticated execution of the joints are significant details, the most remarkable aspect of this fresco is the marked eroticism of the figure. The lion skin in reality does not cover Hercules's nudity, but rather "undresses" him even more than if he were naked. Hence, the knot made with the legs of the lion skin is situated exactly over the genital area, giving an exhibitionist impression.

GIOVANNI BELLINI

Presentation at the Temple *(detail), 1459, Galleria Querini Stampalia, Venice. The painter has included himself in the right-hand corner.*

Giovanni Bellini began his artistic training in his father, Jacopo Bellini's, studio, and remained under his influence until Jacopo's death in 1470. His artwork of the years immediately following was profoundly influenced by his brother-in-law, Andrea Mantegna, evident in its hard lines, sharp contours, and cool colors.

In 1475–1476, the Sicilian painter Antonello da Messina introduced oil painting techniques to Venice, which allowed for the use of richer, warmer, and brighter colors without the need for harsh shadows. Bellini, who had been working in tempera, quickly mastered this new medium. His work began to draw away from the analytic spirit of the 15th century as his paintings became suffused with luminous light, creating an arcadian harmony between man and nature.

The combination of skilled draftsmanship and sumptuous, beautiful colors, such as his use of whites and blues to bring out the pink in the subjects' complexions, typify Bellini's mature work. His intimate treatment of religious themes and the general secularization of his art, treatments that came to characterize 16th-century Venetian painting, also reflect the desires of his primary patrons—he was the chief painter in Venice for nearly thirty years.

Bellini's studio was renowned, and his pupils included Giorgione, Titian, Palma Vecchio, and Sebastiano del Piombo. His work influenced the development of Renaissance art for many decades, marking the end of the medieval Gothic period and the transition to what has become known as the Venetian style.

- **~1429** Born in Venice. Possibly the bastard son of Jacopo, as his wife only mentions Gentile and Nicola in her will. Nor does he live with the family, another factor supporting this assumption. He works in his father's studio alongside his brother, Gentile, from a very young age.

- **1459** Works on an independent commission at the parish church of Saint Lio, Venice.

- **1470** His father, Jacopo, dies. He probably continues working in his brother, Gentile's, studio. From this time he begins painting Madonnas (the first may be housed at the Museo Malaspina, Pavia), which reveals his humanist spirit. They are accompanied by luminous skies and treated with a palette of light, intense colors.

- **~1472** In collaboration with his brother Gentile, he paints a lunette for the chapel of the ducal palace in Venice.

- **~1475** Paints the triptych of the Santa Maria Gloriosa dei Frari Church in Venice.

- **1478** With his brother, Gentile, he paints *The Doge Mocenigo at the Virgin's feet* (destroyed in a fire in 1867), giving thanks for the salvation from the bubonic plague.

- **1479** Gentile travels to Turkey to work on a new commission. Giovanni takes over the completion of a fresco at the ducal palace in Venice. Upon Gentile's return to Venice two years later, he assists in completing the paintings alongside Giovanni. These paintings are destroyed in 1547.

- **1484** Becomes a member of the Scuola de San Giovanni.

- **1487** Paints the *Madonna degli Alberetti* (Galleria dell'Accademia, Venice). The Madonna theme reappears in his art with some frequency.

- **~1488** Paints *Virgin Mary Among Saints,* an altarpiece for the Church of San Giobbe in Venice (see p. 53).

- **1492** Works on the decoration of several halls of the ducal palace in Venice, assisted by his student Francesco Bissolo.

- **1500** In addition to religious paintings, introduces new themes: *Venus, or Lady at Her Toilet* (Kunsthistorisches Museum, Vienna) (see p. 56); *Feast of the Gods* (National Gallery, Washington); and others.

- **1516** Dies in Venice.

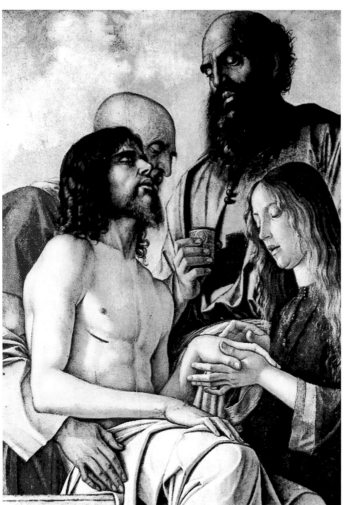

The Entombment

(1470-1475)
oil on canvas
42 x 33 in (107 x 84 cm)
Pinacoteca Vaticana,
Vatican City

In this scene illustrating the burial of Christ, Bellini has represented a classical religious scene using a new, more humanist style, making the subject more readily accessible to the spectator. Christ is presented as an attractive young man, with a golden complexion that contrasts with the more natural flesh tones of the figures surrounding him. Bellini has fully dispensed with the ashen complexion normally used to illustrate Christ's entombment, and begun his trajectory towards a more naturalized representation of the Christ figure in painting.

In later works, such as his Pietà of 1508, the complexion is even more natural and fully removed from the steely highlights we see here. Bellini's ability to understand and express the human figure is further evidenced by the harmonious and balanced modeling of the characters in the painting, whose static, sculptural aspect and grave expressions invite meditation. The obvious theatricality of the point-of-view and composition serve to highlight the artist's intention to show Christ as human, rather than to distance the viewer from the events portrayed, as is often the case in other works on the same theme. This work radiates an air of intimacy alongside the religious devotion which can almost certainly be ascribed to the taste of his clients, the rich, bourgeois families of Venice.

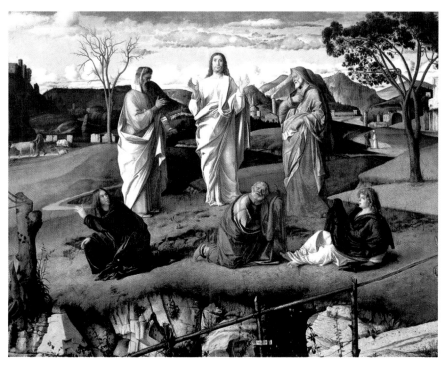

The Transfiguration

(~1475)
oil on canvas
45 x 59.5 in (115 x 151.5 cm)
Museo Capodimonte, Naples

Wholly removed from medieval representations, the artist creates a scene in an open space in which he combines figures and landscape with architectural elements, in accordance with the new aesthetic conception of the Renaissance. The figures of Jesus, Moses, and Elias appear almost sculptural in their three-dimensionality, enhanced by the folds of their garments. Those of Jesus are the most pronounced.

Considering the period in which this canvas was executed, the treatment of color is extremely important: vivid, intense and sharp tones (in Jesus' garments, the sky), are used with such decisiveness that many artists were enthralled by the novelty, and a manner of painting began that would define the so-called early Renaissance School of Venice.

Virgin Mary Among Saints

(~1485)
oil on wood
185.5 x 101.5 in (471 x 258 cm)
Galleria dell'Accademia, Venice

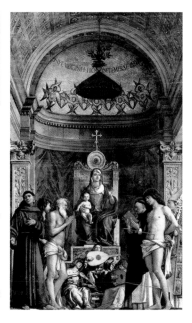

In this scene of the San Giobbe altarpiece, the figures are located in an apse, an enclosed space in which the light and shadows mingle with the golden tones of the mosaics above the Virgin and with the complexions of the Saints, Job (on the left) and Sebastian (on the right). The walls of the apse are decorated with high medieval motifs.

Though the figures strike somewhat affected poses, the nudes, in particular, are exquisitely rendered, with superb foreshortening and naturalistic realism. Regardless of the religious theme, the sensuality with which the human body is treated is remarkable. This physicality and sensuality of the human figure became one of the central features of the renaissance nude from the 16th century onward.

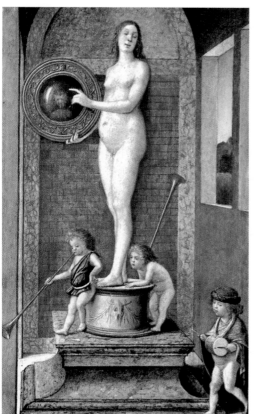

Allegory of Inconstant Fortune

(~1490)
tempera on wood
13 x 8.5 in (34 x 22 cm)
Galleria dell'Accademia,
Venice

Bellini has placed the female figure in an austere setting to enhance it, a fully Renaissance concept. The various architectural elements and the woman's pose add a note of sophistication in accordance with her allegorical meaning. The slight twist in the torso is interesting, as is the curious anatomy, with the small breasts and slender limbs, combined with a large belly and buttocks that recall Gothic nudes. As in other works, Bellini exhibits his mastery in treating space. Although the space is small, the figures fit comfortably, with a certain freedom of movement.

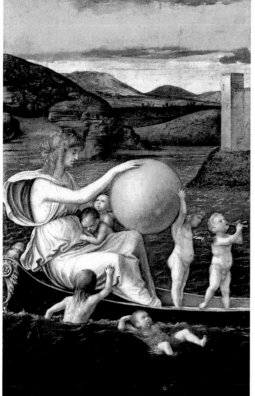

Allegory of Prudence

(~1490)
tempera on wood
13 x 8.5 in (34 x 22 cm)
Galleria dell'Accademia, Venice

This panel combines a series of elements typical in Bellini's works: the classical figure of the woman in a static pose, dressed in a garment with many folds; a group of children whose ingenuousness increases the symbolic value of the scene; and an open landscape nearly bereft of vegetation, with a sky at twilight in languid blue tones. This sky gives rise to an atmosphere of unease and mystery. He uses tones appropriate to the complexions of the children's bodies, providing chromatic balance. Although this is a theme with religious roots (Prudence, along with Justice, Fortitude, and Temperance are the four theological virtues), the concept and treatment recall mythological representations.

Doge Leonardo Loredan

(~1501–1504)
oil on canvas
24 x 18 in (61.5 x 45 cm)
National Gallery, London

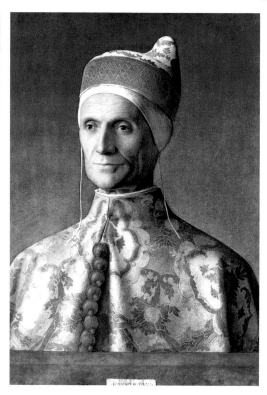

Bellini was so famous that he was entrusted to paint the portraits of the most important people of the time, of which this is an excellent example. In the 16th century, the Doge was the highest dignitary in Venice.

It is a technically outstanding painting and shows an extraordinary degree of perfection. The complexion of the Doge's expressive face is enhanced by the cool overall tones and the pale blue background. Both the human aspect of the Doge and his majestic presence are manifest.

The painting is absolutely realistic, with even the smallest of details in both the face and the rich, brocaded garment executed meticulously. The modelling, chromatic range, shadows, and sense of light are done superbly.

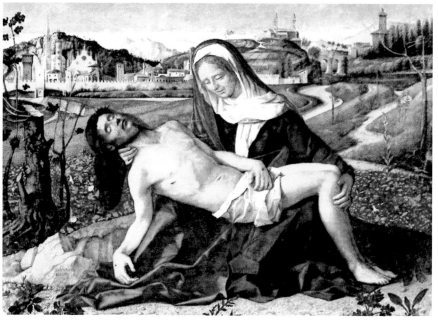

The drama of the tragedy depicted in this image is increased by its contrast with the landscape in the background, with its variety of buildings, some of them sumptuous. Bellini has treated the figures of Christ and the Virgin Mother with great respect and devotion, revealing their profound grief without references to blood, the crown of thorns, or other details that could make the image more heartrending. Christ appears as a slender, Apollonian young man, held by a deeply sorrowful Virgin Mother.

Pietà

(1508)
oil on wood
25.5 x 34 in (65 x 87 cm)
Galleria dell'Accademia, Venice

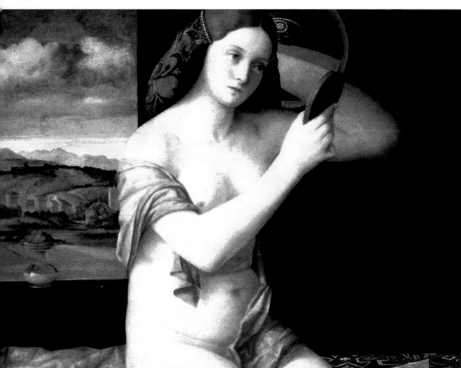

Venus, *or* Lady at Her Toilet

(1515)
oil on canvas
24.5 x 31 in (62 x 79 cm)
Kunsthistorisches Museum,
Vienna

This work contains all the elements that define the Venetian style of painting and which can be seen in a great number of representations from the 16th century onwards. The essential elements in this painting—the interior, the landscape, and the figure—are combined and interrelated superbly. This sensual and elegant nude has a strong, meticulously executed anatomy that retains a monumental and idealized air, in the manner of classical representations of mythological figures.

The image is enhanced by the dark background on the right and the dense landscape on the left, in a golden tone that fits perfectly with the complexion. The treatment of the latter lends the figure a milky, radiant aspect which will later be taken up by Ingres. Though the anatomy of the figure is correct, it is apparent that Bellini's interest lay more in the sinuous forms, as is apparent through the rhythms of the drapery and hair. The mirror the woman is holding involves the viewer as an indiscrete observer of what is normally an intimate scene, accentuated by the round mirror behind her showing the beauty of the ornament in her hair. In his mature work, Bellini's great skill as a draftsman and his delicate and detailed style allow him to reveal the psychology of his figures. His Italianizing paintings, that englobe many Renaissance traits, tend toward smoothness and harmony. In his later years, Bellini adopts the techniques of his younger contemporaries, though without incorporating their strict classicism.

ANDREA MANTEGNA

Bronze bust of Mantegna at the painter's tomb at the Church of San Andrea, Mantua.

Mantegna was one of the most important artists of the early Renaissance. The interest in classical Greece and Rome that was dominant in Padua at the time is apparent in his art.

His rendering is nearly sculptural and conveys an intense sense of the drama enacted in the scenes. The figures he paints display an accentuated humanism within environments laden with decorative themes and architectural elements. They have a grandiose conception, containing noble, emotive figures of austere tenderness, as well as archaeological evocations. His barren, rocky landscapes remain in the Trecento style.

Mantegna's paintings often evoke mythological themes and represent the classical world with singular skill. His work exercised notable influence on the artistic centers of Verona, Venice, and Lombardy. His scientific, linear perspective and his use of trompe l'oeil, possibly borrowed from ancient Pompeian works, are remarkable. They pave the way for a period of experimentation that will not cease until well into the Baroque. His great influence is particularly evident in works by Cosimo Tura, Jacopo de Montagna, Ercole de'Roberti, Vivarini, and Carlo Crivelli. Albrecht Dürer and several other German artists also appear to have been influenced by Mantegna.

- **1431** Born in Isola de Carturo, near Padua, Veneto.

- **1441** According to available documents, he lives in Padua where he trains in the studio of his adoptive father, the painter Francesco Squarcione, after the death of his parents.

- **1448** Paints the altar of Santa Sofia and receives the commission to paint half of the Ovetari Chapel in the Church of Eremitani, in Padua, along with Nicolas Pizzolo.

- **1449** Lionello d'Este, Lord of Ferrara, summons him to Ferrara, requesting a portrait of himself with the feudal lord Folco de Villafora, a friend of his.

- **1450** Carries out frescos on the story of St. Christopher for the Church of Eremitani.

- **1453** Marries Nicolasia Bellini, daughter of the painter Jacopo and sister of the painters Gentile and Giovanni. Executes an altarpiece for the Chapel of San Lucas, in the Church of Santa Giustina in Brera.

- **1460** Influenced by his father-in-law, Jacopo Bellini, and by Donatello, completes a large altarpiece for the Church of St. Zeno in Verona (see p. 58), funded by the notary-in-chief Gregorio Correr. He moves to Padua to work for the Podesta (Governor) Antonio Marcello. Is appointed court painter to the Marquis Ludovico III de Gonzaga, who summons him to Mantua to complete the palace chapel. Paints the portrait of Francesco Gonzaga.

- **1472** Completes his most important work in the Camera degli Sposi in Mantua (see p. 60), which includes portraits of his patrons, the Gonzaga family.

- **1480** After a trip to Rome, he paints the fresco cycle *Triumphs of Caesar* for one of the halls in the palace of Federico I de Gonzaga, Duke of Mantua.

- **1488-90** Commissioned by Pope Innocent III to decorates the Chapel of Belvedere (destroyed in the 18th century).

- **1492** Receives a significant extension of property from Francesco Gonzaga in payment for his works.

- **1497** By commission of Isabella d'Este, duchess of Mantua, paints *The Struggle between Virtue and Vice* for her El Parnaso Palace.

- **1506** Dies in Mantua on September 3.

Altarpiece of Saint Zeno

(1457–1460)
tempera on wood
189 x 177 in (480 x 450 cm) (including frame)
Church of Saint Zeno, Verona

Saint George

(~1460)
tempera on wood
26 x 12.5 in (66 x 32 cm)
Galleria dell'Accademia, Venice

This work contains several features that are unusual for Mantegna's oeuvre, namely, the varied and rather splendid landscape in the background, the garland of leaves and fruit, and the manner in which the saint's right hand and the head of the dragon protrude beyond the architectural frame.

Another remarkable aspect is the placement of the saint in a contrapposto to allow a better view of the landscape, with his dead enemy at his feet. It is a representation of a protective hero in glorious victory. The scene is dynamic and the color scheme lends it variety and visual appeal.

This work, commissioned in 1456 by the notary-in-chief Gregorio Correr, was executed by the artist alone. The altarpiece consists of six compartments, distributed within a structure sculpted with architectural elements.

Mantegna was inspired by Donatello's work on the theme of St. Anthony of Padua. In the upper level are three compartments, with the central panel representing the Virgin with Child surrounded by saints. The lower compartments contain three scenes: The Agony in the Garden, Crucifixion on the Calvary, and The Resurrection. The great balance and seriousness of the whole is the result of a carefully thought-out arrangement and organization, in which the principal protagonists above are integrated into an architectural setting, with the simple, barren landscapes below providing context.

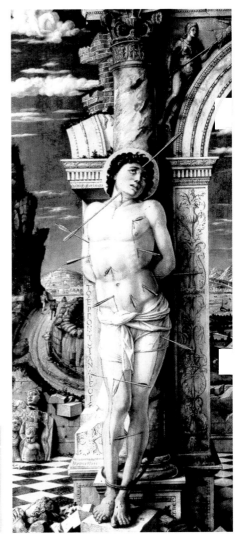

Saint Sebastian

(~1455–1467)
tempera on panel
27 x 12 in (68 x 30 cm)
Kunsthistorisches Museum, Vienna

St. George and St. Sebastian were extremely popular in the early Renaissance, a period dominated by the plague and other calamities. The circumstances surrounding the lives of these saints were especially conducive to their exploitation and interpretation by artists. Western culture was both provincial and fundamentalist, and the representation of religious figures such as Adam, Christ crucified, or St. Sebastian were practically the only possibilities for artists to paint a male nude, which explains the large number of works in which they appear.

The figure of St. Sebastian was seen as embodying the epitome of the ideal of male beauty. In this painting, Mantegna created one of his most stunning and sensual nudes. The artist portrays a figure of magnificent proportions, sexually ambiguous, and profoundly sensual. Despite the many arrows in St. Sebastian's body, Mantegna only shows a few drops of blood, making the scene less gruesome and the figure of the saint more sublime.

Mantegna was quite knowledgeable about classic archeological ruins, and was able to adapt the architecture to the requirements of the figure, establishing a close relationship between the two. The panel was executed in meticulous detail throughout, and shows a concern for space and perspective. The floor consists of black-and-white flagstones laid out in a checkerboard pattern, recalling the work of Piero della Francesca. The work is signed in Greek and was executed in Mantua.

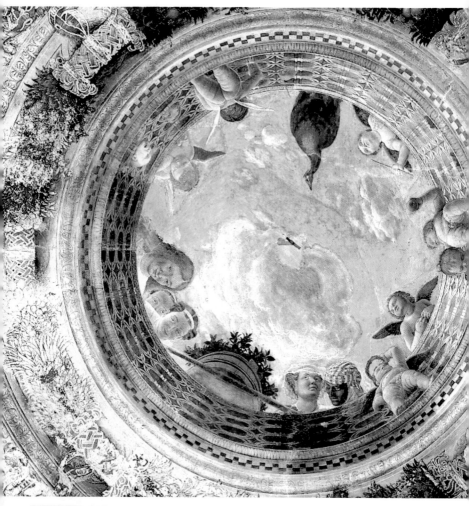

The Bridal Chamber (Camera degli Sposi)

(~1473)
fresco
106 in diameter (270 cm)
Ducale Palace, Mantua
(detail)

This cupola fresco is part of the so-called *Camera degli Sposi*, or *The Bridal Chamber*, Mantegna's most important work. It was commissioned by the Gonzaga family, his patrons from 1459. It was the first work ever to combine trompe l'oeil effects with scenes of contemporary life.

Mantegna incorporated portraits of different members of the Gonzaga family, scenes of events at court, and themes of contemporary life in Tuscany, which he organized with a series of pilasters and medallions, crowned with a cupola fresco. These were the first portraits of regular members of society painted in the Renaissance. Around the base of the cupola is a trompe l'oeil balustrade with various figures peering down, whose aspect and build can be ascribed within Renaissance canons and conceptions, along with the other figures in the composition.

The date of this highly original work is not certain, though it was probably executed over a period of several years (four to ten), and was definitely completed by 1474. It brought Mantegna enormous success and unanimous recognition, deeply impressing Bramante and Correggio, and probably inspiring Leonardo da Vinci.

This striking painting was made in the artist's studio provided by the Gonzaga family, and, according to the 17th-century French chronicler Félibien, was exhibited in Cardinal Mazzarino's art gallery in Rome. The originality of the point of view makes it one of the most important works of the Italian Renaissance.

This work scandalized society at the time for representing Jesus with such excessive realism and for not dignifying his image. The mastery of perspective and geometry are remarkable. The reclining body is wholly in the Renaissance style, with realistic proportions. Using preestablished measurements, Mantegna applied mathematical laws for the reduction of the measurements following the laws of perspective, with a central vanishing point providing an extreme and powerful foreshortening.

The viewer contemplates the dead figure of Christ from an unprecedented position, with the wounds on his hands and feet visible, a sunken abdomen, his mouth ajar, and a pale, deathly complexion. Such an extremely realistic image represents death in all its crudeness, although lacking details such as blood that would make it appear gruesome or theatrical. The observer cannot remain indifferent to this highly dramatic and profoundly striking work.

For its magnificent anatomical study characterized by a hard, nearly sculptural style, it can be considered among the artist's major masterpieces.

The Dead Christ

(~1501)
tempera on canvas
26 x 31 in (66 x 81 cm)
Pinacoteca di Brera, Milan

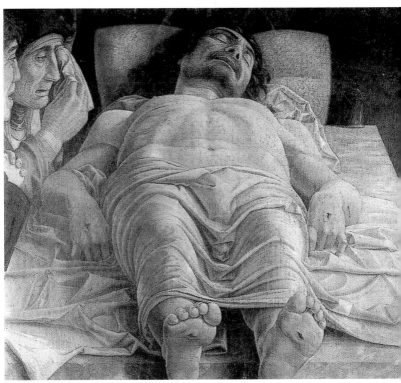

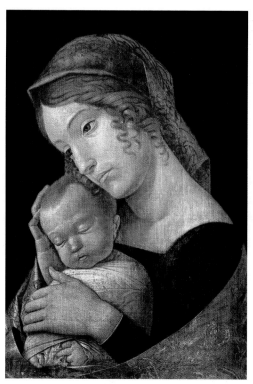

Madonna with Sleeping Child

(~1454)
oil on canvas
43 x 32 cm
Staatliche Museen,
Gemäldegalerie, Berlin

The elliptical composition of this painting lends the two figures an air of tenderness perfectly suited to the theme. The Madonna's face expresses candor while the Child sleeps tranquilly in his mother's arms. This is a very effective psychological study.

The texture of the canvas shows through this unfinished painting. For an underpainting, Mantegna used *verdaccio,* a high-quality wash-drawing that, if continued, would have provided a final appearance of lacquer or glaze.

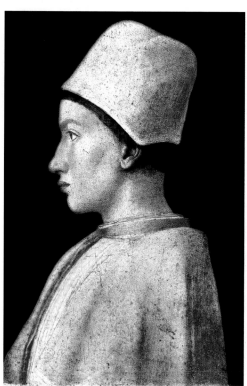

Francesco Gonzaga

(~1460)
oil on panel
10 x 7 in (25 x 18 cm)
Museo Capodimonte, Naples

This is one of Mantegna's traditional portraits. On a dark background, he painted a vivid representation of Pisanello Gonzaga, a cardinal, in a profile pose, customary until about 1470.

Apart from the hair and the garment visible under the cape, the artist uses a palette limited to different intensities of pink, meticulously applied to model and define the facial features and the folds of the cape. The figure's expressive face reveals something of the personality of the sitter, an accomplishment that only an artist with Mantegna's familiarity with portraiture could achieve.

SANDRO BOTTICELLI

The Epiphany *(detail), tempera on wood, 44 x 53.6 in (111 x 134 cm), 1475, Uffizi Gallery, Florence. Self-portrait of the painter featured in one of his works.*

Botticelli's art can be divided into two periods, each of which coincides with the style dominant in Florence at the time.

During the Medici period (1469-1492) his work is vibrant and adheres to the beliefs of the Neo-Platonic mystics of the Florentine court. The Neo-Platonists believed that the soul could reach union with God through the contemplation of beauty, and that all revelation, whether from mythology or Christianity, was one. Thus, Botticelli's art is luminous and drawn with clean, clear lines. He exalts the aristocratic aesthetic art for art's sake in contrast to the faithful representation of reality characteristic of previous Florentine artists.

Botticelli's second period begins in 1485, inspired by the Dominican monk, Savonarola's, vehement sermons against the excesses of the Medici court. This later work focuses on condemning a pagan society greedy for luxury, power, and all manner of pleasures. His art returns to traditional religious themes and begins to decline, moving towards simplicity and archaism. This moralizing artwork is the final expression of his mystical sentiment.

In his best works, including *Primavera* (see p. 65) and *The Birth of Venus* (see p. 67), Botticelli revives mythological themes forgotten in the Middle Ages, treating them with the same reverence found in traditional religious paintings. It is important to recognize that Botticelli was not a mere copyist of nature nor a creator of fatuous fantasies. He translated the humanist debate of the Medici court, in which human reason was given precedence over God's revelation, into visions of sheer poetry.

- **1445** Born in Florence, the son of a tanner.

- **1465** Becomes an assistant to Fra Filippo Lippi.

- **1470** Establishes his studio in Florence. His works show the influence of Piero and Antonio Pollaiuolo. He revives mythological themes forgotten in the Middle Ages.

- **1474** Moves to Pisa to collaborate with Gozzoli on the frescos of the cemetery.

- **1475** With Andrea del Verrocchio, collaborates on designing the decoration of a tournament organized by Giuliano de' Medici.

- **1481** Summoned by Pope Sixtus IV to paint the Sistine chapel in Rome along with Perugino, Pinturicchio, Cosimo Roselli, and Ghirlandaio.

- **1482** Returns to Florence, where he paints some of his best works, among others, *Pallas and the Centaur* (see p. 66), and *The Birth of Venus* (see p. 67). This is the apogee of his art.

- **1490** Undergoes a profound moral crisis probably brought about by the sermons of Savonarola, the Dominican monk who would rule Florence after the death of Lorenzo de' Medici in 1492, leading him to destroy a significant amount of his mythological works. This crisis may have caused his change in style, becoming simpler and more archaic, with a predominance of religious themes. Begins a series of ink drawings for Dante's *The Divine Comedy*, his last commission from his patron, Lorenzo de' Medici.

- **1501** When his final artistic period begins, Leonardo, Raphael, and Michelangelo are the great painters of the period. Their work heralds a new era in Florentine art and eclipses all else, gradually leaving Botticelli without commissions.

- **1502** Botticelli's financial situation is desperate, and he turns to Isabella d'Este, duchess of Mantua, to request her patronage.

- **1510** Passes away in Florence on May 17. Buried in the Church of All Saints, Florence.

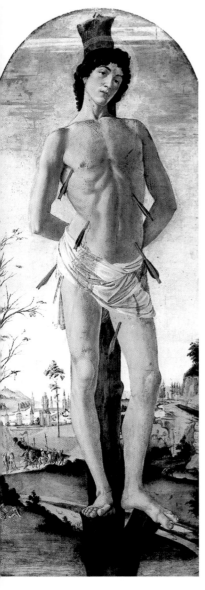

Saint Sebastian

(1473)
tempera on wood
77 x 29.5 in (195 x 75 cm)
Staatliche Museen,
Gemäldegalerie, Berlin

This nude was hung in the nave of the Church of Santa Maria Maggiore in Florence on the occasion of the saint's day. Although Botticelli is influenced by his teacher, Fra Filippo Lippi, his stroke is lighter and subtler, and the figure is modeled in greater depth. Nevertheless, the treatment is still somewhat rigid, far removed from the pictorial lyricism that the artist would later achieve.

Boticelli painted the saint in contrapposto, a pose that originated in classical Greek sculpture, giving the illusion of potential movement to a static figure through the contrast of contraction and relaxation. His search for beauty leads him to paint increasingly stylized figures, eventually making them an entrenched part of his style. The languor that characterizes both his male and female nudes evokes the art of the Pollaiuolos.

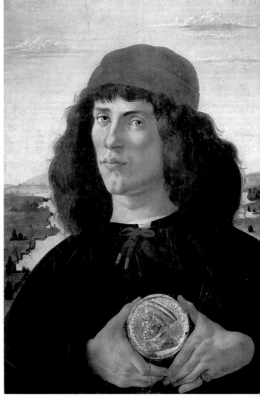

Portrait of a Man with the Medal of Cosimo the Elder

(1474-1475)
tempera on wood
23 x 17 in (57.5 x 44 cm)
Uffizi Gallery, Florence

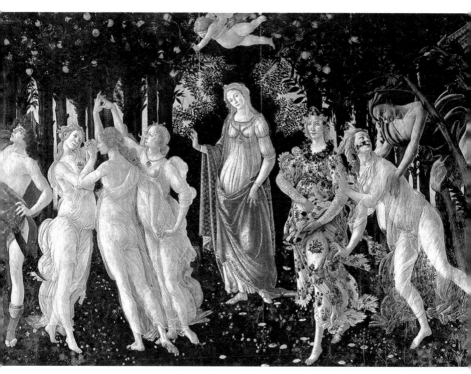

Commissioned by Lorenzo de' Medici, Botticelli's patron, for the Villa Medici di Castello, this is a key Renaissance work. Here the artist faithfully reflects the Humanistic thought prevalent in the Medici circle. It is an unusually large format for a secular theme, as such dimensions were normally reserved for religious art. Tapestries were often the only other secular art made to such a scale, but their exhorbitant prices frequently led buyers to opt for mural paintings.

Primavera

(~1481)
tempera on wood
80 x 123.5 in (203 x 314 cm)
Uffizi Gallery, Florence

The theme, inspired by a sonnet by Angelo Poliziano, is somewhat complex, combining many mythological figures, but without referring to a particular episode. The background is dense with orange trees behind whose column-like trunks an intense blue sky can be seen. On the right, Eolus, Greek god of the winds, embraces Briseis, the northeast wind, who is a lovely nude hardly covered by a transparent veil. Flora, the Roman goddess of flowers, pregnant and in a flowery dress, announces spring through the anemones and jonquils coming out of her mouth.

In the center, Venus, the goddess of beauty, presides over the scene in a long, transparent white dress and a red shawl dotted with flowers. Her son, Cupid, god of love, flies over her head while aiming an arrow toward the Three Graces, whose thin dresses allow their suggestive anatomies to show through as they dance in a slow, tranquil rhythm. At the extreme left, Mercury, the messenger of the gods, is represented in the guise of Giuliano de' Medici. Oblivious to what is going on in the rest of the scene, he reaches out his right arm in an attempt to pick fruit from a tree.

This work, with its suggestive nudes dressed in transparent fabrics, giving them an accentuated eroticism and air of myster, is an extraordinary evocation of ancient mythology. Far from the classical Renaissance view that lasted more than fifty years, which imagined a new humanity immersed in a world of harmonic order filled with classical architecture, Botticelli has let himself be captivated by nostalgia for the ancient world.

This early painting includes elements that are characteristic of Botticelli's later works. The face of the subject is the painting's focus, and it is particularly expressive for a portrait of the time. The entire figure, including the hair, hands, and clothing, is executed with great attention to detail and a strong stylistic manner. The draftsmanship, modeling, details, lighting—all the elements of this work—show the artist's great skill. This painting is also of interest as a double portrait. The medal in the young man's hands shows a posthumous portrait bust of Cosimo de' Medici, linking the subject to the Medici family.

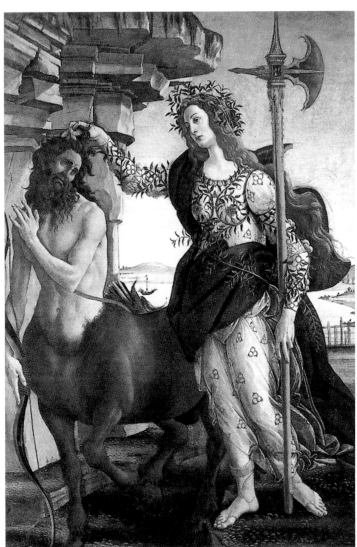

Pallas and the Centaur

(1482-1485)
tempera on canvas
81.5 x 58 in (207 x 148 cm)
Uffizi Gallery, Florence

This mythological work was painted in Florence for Lorenzo de' Medici after Botticelli returned from Rome, where he had been working on the Sistine chapel. It is one of his most important paintings because it combines aesthetic beauty with a political message.

Pallas Athena, the goddess of wisdom and war and daughter of Zeus and Metis, here holds a centaur by the hair, pinning him against a wall, his gaze expressing submission and pain. The centaurs, children of Ixion and Nephele, were savage, barbarous beasts with the bust and head of a man and the torso and legs of a horse. They lived in the mountains of Thessaly.

In this painting, Pallas is wearing a diaphanous transparent tunic adorned with three inter-twined rings, Lorenzo's coat of arms. Her head, bust, and arms are covered in olive branches and her windswept cloak evokes the flight she has taken to reach this place. The figure of Pallas is nimble yet idealized, holding a heavy halberd in her hand. The centaur has a face similar to the carvings found on ancient sarcophagii.

In the background, the sea of Tuscany is discernible. Both figures are perfectly constructed and have a sculptural quality emphasized by the treatment of the light falling on them. The work sym-bolizes the triumph of virtue (wisdom) over vice (instinct) and should be understood as an allegory of the Medici family, who were known for their culture and pursuit of knowledge. This painting was lost during the 18th century, and rediscovered in 1895 in an attic of the Uffizi Palace.

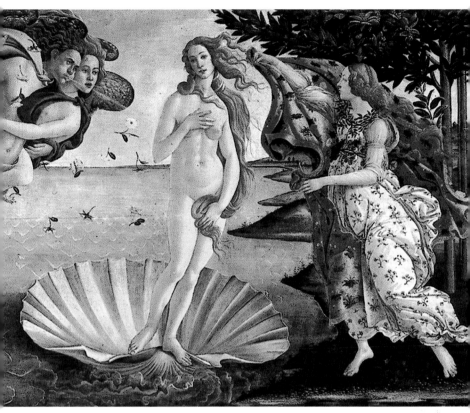

This was another work that Lorenzo de' Medici commissioned for one of his palaces. Botticelli's advocacy of the Neo-Platonic philosophy, which permeated the Medici court in Florence, was instrumental in the creation of his artwork. Neo-Platonism held that all artistic inspiration arose from the same source, whether from classical mythology or Christianity.

Just as in *Pallas and the Centaur,* this painting incorporates symbolic references that reflect the artist's cultural relations with the Italian humanist and philosopher Marsilio Ficino.

The Birth of Venus

(~1489)
tempera on canvas
69 x 109.5 in (175 x 278 cm)
Uffizi Gallery, Florence

Here Venus recalls Christianity's Virgin Mary. Venus is born when Uranus' seed, in the form of a rain of roses, fertilizes the sea spray. She emerges on a scallop shell and is pushed to her sacred island of Cyprus by the breath of the winds, Zephyr and Chloë. On the right is the Roman goddess of Spring and flowers, Flora, who approaches to cover Venus' nudity with her shawl. Venus covers her pubis with her long hair and modestly conceals her breasts with her right hand. She appears fragile and refined, with a mystical, somewhat sensual air accentuated by the use of a finely sinuous pictorial line.

The striking contrasts and harsh modeling lend the figures an appearance akin to classical sculpture, though formally recalling the female nudes of the Gothic period. Venus' tranquil attitude contrasts with the dynamism of her long hair. It is probable that Simonetta Vespucci, a woman of extraordinary beauty and the lover of Giuliano de' Medici, was the sitter, as Botticelli painted her several times.

The landscape is merely hinted at with a sparse, undulating coastline. Botticelli did not adhere strictly to Renaissance developments in perspective, instead using a decorative, stylized method to accentuate the allegory in the painting. As in other works, he has crafted an even balance between the figures and the objects, and the vivid colors and variety of tones. Curves and movement predominate, as can be seen in the curves in the sinuous figure of Venus, the rippling edge and curved lines of the scallop shell, and the movement in the windswept raiment of Flora and the winds.

Giuliano de' Medici

(~1478)
oil and tempera on wood
30 x 21 in (75.5 x 52.5 cm)
National Gallery of Art,
Washington, DC (Kress Collection)

Along with his brother Lorenzo, Giuliano de' Medici (Florence, 1453-1478) succeeded his father Pietro. He was the lover of Simonetta Vespucci, a woman of great beauty painted by Botticelli a number of times. She possibly posed as Venus in *The Birth of Venus*. His life was cut short when he was assassinated in the Cathedral of Santa Maria in Florence.

He is portrayed in the manner characteristic of the period, with the attire and attitude typical of the Medici. The colors of the clothing and background are designed to focus the viewer's attention on the face, with its solemn, serene expression. The figure conveys great dignity and nobility, certainly more in accordance with the family's reputation than with his own, as the dissolute youth had many love affairs, to which the turtledove in the lower left corner probably alludes.

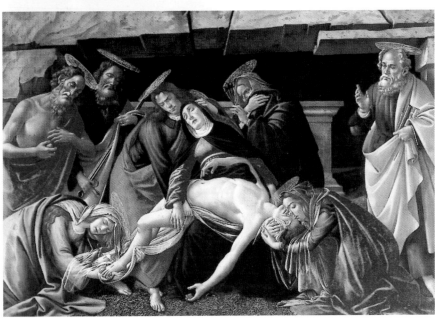

Lamentation Over the Dead Body of Christ

(~1495)
tempera on wood
55 x 81.5 in (140 x 207 cm)
Alte Pinakothek, Munich

This very dramatic scene portrays Christ's entombment. His arched body is held by his mother, who is overwhelmed with grief. The magnificent nude breaks slightly with the immobility of the figures in earlier works, its movement accentuated with sinuous lines. The Christ figure is shown as a healthy and athletic young man. Although the body is flooded in light, the muscles are modeled with near photographic precision. Botticelli, whose expressive capacity had already reached its zenith in *The Birth of Venus*, could hardly have surpassed this work. It is one of a series of religious paintings executed toward the end of his life.

HIERONYMUS BOSCH

Portrait of Hieronymus Bosch, which forms part of the Lampsonius collection published in Antwerp in 1572.

Hieronymous Bosch was a master of the grotesque and phantasmagoric. His works, basically aimed at the common people, are characterized by tragic, desperate representations with figures of all types and conditions, struggling to escape the powers of evil that ceaselessly beset them, in scenes of terror and punishment beyond imagination. A significant number of the elements in these visions refer to popular lore and legends of the Netherlands that were well known in his time. During that period, his works were fully comprehensible, but they are now difficult to decipher and have led Bosch to be erroneously considered a visionary or dreamer.

Bosch lived in a turbulent period of wars and plagues amid deep ideological and religious crises, as well as innumerous sectarian movements with apocalyptic preachers and propagandists of all sorts proclaiming to represent true Christianity. They spoke out against the scandals and abuses of a Church embracing power and immersed in an opulent world of pleasures. His artwork, sarcastic, cruel, and moralizing, is a mirror of his times.

Hieronymus Bosch represents popular art in a pure state, hardly influenced by contemporary movements. He is considered the precursor to Pieter Brueghel and all of the expressionists, from Lucas Cranach to James Ensor. In addition to laying the foundations for Surrealism, he can be considered the instigator of the movement that led Flemish painting from mysticism to popular realism.

- **~1450** Born Jeroen van Aken into a family of painters in 'sHertogenbosch, near Antwerp.

- **1475** At approximately this time, he produces his earliest known work, *Tabletop of the Seven Deadly Sins and the Last Four Things* (see p. 70), in which the resurrected Jesus is surrounded by representations of the seven deadly sins.

- **1480** After his father's death, in accordance with tradition, his older brother inherits the family studio as well as the exclusive right to the family name. This obliges Jeroen to invent a name by which to sign his works and establish himself, at a time when he must have had many commissions, judging from the large taxes he was levied. Why he chose Hieronymus as a first name remains a mystery. His last name is simply an abbreviated form of his place of birth. He marries Aleyt van den Meervenne, who contributes a significant dowry.

- **1482** Obtains the title of master, allowing him to gain full independence.

- **1486** Enters the Brotherhood of Our Lady, a group devoted to the worship of the Virgin, which commissioned works of art, including a representation of the Holy Mysteries by Bosch.

- **1493** Creates various drawings for several stained glass windows in the Cathedral of St. John in 'sHertogenbosch.

- **1504** Receives one of his most important commissions from Philip the Fair, who entrusts him to paint the triptych on wood, *The Last Judgment* (Künsthistorisches Museum, Vienna), for which he gains fame in the court of Burgundy.

- **1505** Henceforth, his works become more sober and monumental, such as *Triptych of the Epiphany* (Prado, Spain) and *Christ Mocked* (see p. 72).

- **1516** Dies in 'sHertogenbosch.

Tabletop of the Seven Deadly Sins and the Last Four Things

(1475-1480)
oil on wood
47 x 59 in (120 x 150 cm)
Prado, Madrid

Hieronymus Bosch only painted religious themes, which he treated with extreme radicalism, representing a dark world invaded by sin and moving toward perdition. This is one of his most important works.

Originally designed to serve as a tabletop, it was actually hung on the wall in the king's chamber as a decorative and devotional piece. The symbolism is complex. The circle in the center refers to God's ever-watchful eye, with Jesus in the center. Distributed in a circle around him, each of the seven deadly sins is represented by the corresponding legend traditionally associated with it.

Beginning at the base and continuing in a clockwise direction, the scenes are: Anger (a fight between two drunken farmers), Envy (from behind the counter of his establishment, a merchant tries to seduce another man's wife), Avarice (in plain view, a judge receives bribes from both litigating parties), Gluttony (a sumptuous family feast), Sloth (an ecclesiastic sleeps before the hearth, without heeding the nun at his side, who is reminding him of his duties), Lust (a couple in their tent, accompanied by two buffoons), and Pride (a bourgeois woman at her toilette). In the four corners, meticulously represented, are Death, Judgment, Heaven, and Hell.

The moralizing objective of this work is clear. The various scenes represent all of the weaknesses of Man, who falls easy prey to deception and temptations. Popular culture is one of Bosch's principal sources of inspiration, and he causes the sinners to suffer terrible and exemplary punishment. The representation of the figures is inventive and certainly anecdotal, but there is no doubt that the artist fully succeeds in making his catechizing message perfectly comprehensible through the language employed.

The Operation for the Stone (The Cure of Folly)

(1475-1480)
oil on wood
19 x 14 in (48 x 35 cm)
Prado, Madrid

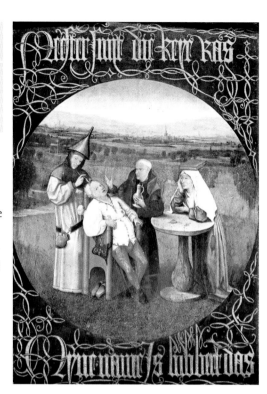

Quack doctors were common in both depressed rural areas and the filthy streets of many cities in the dark ages of Bosch's time. There was a popular belief that a so-called "stone of madness" caused idiocy or dementia. To cure this, it was believed necessary to remove a section of the skull surgically, which, considering the total absence of medical knowledge and hygiene, caused the death of the unfortunate victim in the majority of cases. To mitigate the patients' fear and reduce their pain, they were usually inebriated before the operation.

The frequency of this subject and other similar ones in Flemish painting demonstrates that this was a common practice. It serves as a testimony to people's ignorance, and to the cruelty and lack of scruples of the pseudo-doctors who, conveniently advised by procurers, emptied their patients' pockets.

The inscription in the upper area of the round frame reads: "Meester snyt die keye ras" (Master, extract the stone of madness); and the one in the lower frame: "Myne name is lubbert das" ("My name is Castrated Hound," which can be interpreted as a euphemism for stupid).

Saint John the Baptist in the Wilderness

(1504)
oil on wood
19 x 16 in (48.5 x 40 cm)
Museo Lázaro Galdiano, Madrid

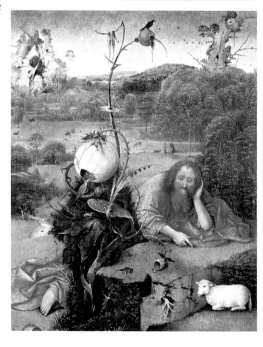

This panel appears to be missing the upper and lower sections, probably cut off to adapt it to the specific locations where it was hung. This mutilation is thought to have eliminated some 5 inches, causing serious damage, considering the work's dimensions. It represents the saint in a scene of profoundly dramatic overtones.

Simple observation of the landscape reveals a phantasmagoric world in decay, approaching putrefaction and destruction. Note the open fruit in the foreground being avidly devoured by a bird, which could be interpreted as temptations of the senses attempting to disturb the saint's meditation. The aesthetic is extremely detailed. In the foreground is a lamb, probably alluding to the martyrdom of the saint.

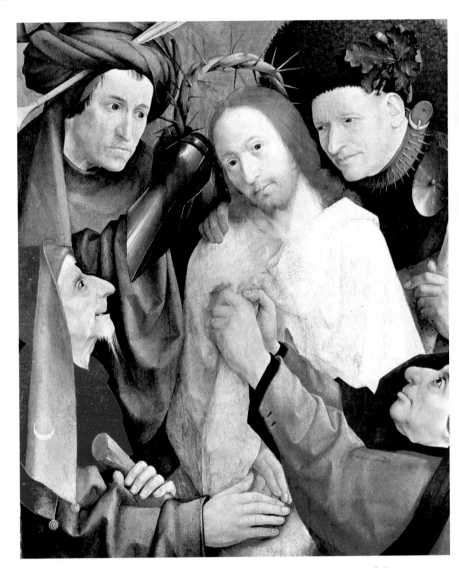

Christ Mocked (The Crowning with Thorns)

(~1490-1500)
oil on wood
29 x 23 in (74 x 59 cm)
National Gallery, London

This work, as many others by Bosch, exhibits *horror vacui,* the compulsion to make marks in every space, resulting in a crowded design. Thus, the five figures occupy the entire picture plane. The meaning of certain elements (the headless arrow in the turban of the figure on the left, the astrakhan hat adorned with holm oak leaves on the soldier, who expresses pain and mercy as he embraces Jesus, or the crescent on the headdress of the old man to the left, with a perverse expression and a toothless grimace) eludes us today, although it must have been clear at the time. The same is true of the collar studded with spikes on the soldier's neck, which was normally worn by sheep dogs to protect them from attack by wolves.

All of these elements may seem secondary, but, in reality, they are not gratuitous. Far from the visionary world which has so often been ascribed to this artist, his style reflects with dazzling clarity the mindset during the late Middle Ages, a period in which the majority of people, fearful of the terrible catastrophes, perils, and punishments that preachers ceaselessly foretold, lived with the single obsession of saving their souls after death and avoiding the horrors of hell at all costs.

The figures around Christ in this panel are dignified, with meticulous facial features and fine garments. They belong to the upper social classes and are wealthy. Could they be a reference to ecclesiastics, military officials, and the bourgeoisie? The vivid, intense colors in varied tones nearly eclipse the frail central figure, which is nevertheless much more humble and discreet in all respects. This enigmatic work allows a variety of interpretations.

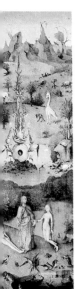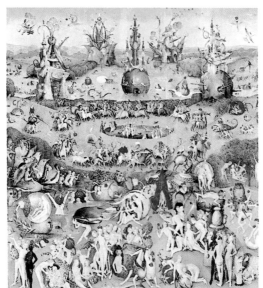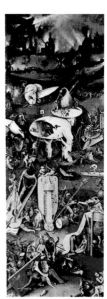

Bosch is so original that he can be considered timeless. His iconography, an elegant testimony of a certain mentality of the period, is a mixture of surrealism run wild and symbolism. The artist exaggerates the scene to the extreme to make his message clear and effective. This polyptych refers to the beginning and end of the world. When the leaves are closed, it shows a scene from the Book of Genesis, the creation of the plant world. Open, the left leaf portrays the creation of the world, the central panel displays life on earth, and the right leaf depicts hell.

The painting is filled with figures from all walks of life, in an infinity of poses and undertaking various actions, combined with an endless variety of flora and fauna, including fantastic creatures, imaginary monsters, and anthropomorphic plants. In the central panel, a multitude of human beings is represented as maggots riddling an enormous fruit that is the world. With its constant allusions to lust, this panel is a tribute to life, joy, and love, to pleasure and freedom. This explosion of unbridled euphoria and vitality inevitably leads to the dark underworld represented on the right, where sinners are tortured by demons and organic machines to unimaginable levels of cruelty and deviousness.

At a singular historical crossroad, this work can be ascribed to the phenomenon of conflicting ideas and sensibilities of the time, and it is open to myriad interpretations. Its symbolism could be explained in the simplest reading: God created a pure, clean, utopian world (left panel); human beings, letting themselves be tempted by the powers of evil, have converted it into a universe of hedonism, dissipation, and perdition (central panel); which inevitably leads to the punishment of hell (right panel). This fatalist and cruel vision seems highly exaggerated by today's standards, considering that the lower classes did not even approach the dissipation represented here, and therefore need not feel responsible for sins they had not committed. But the messages of the preachers at the time were apocalyptic and all-encompassing. In this context, it is clear that the common people, accustomed to a very hard life and a repressive social situation dominated by fear of established authority and calamities of all sorts, could only understand messages with a language as strong as this.

The Garden of Delights

(~1510)
oil on wood
Wings, 87 x 38 in each
(220 x 97 cm)
Central panel, 87 x 76.5 in
(220 x 195 cm)
Prado, Madrid

The Carrying of the Cross

(~1515-1516)
oil on wood
30 x 32 in (76.5 x 83.5 cm)
Musée des Beaux-Arts, Ghent

The point of view is the most interesting feature of this panel. As opposed to the usual representation of this subject from a distance and in an open landscape, Bosch opts for a close-range view, wholly involving the observer in the scene. The intention is evident: he sought to represent one of the Stations of the Cross in a way that it would have a profound impact on the believer and stimulate devotion. The quantity of faces inundating the scene and the variety of their expressions are remarkable.

Except for the faces of Christ and Veronica, who is on the lower left holding the cloth on which Jesus' face has been imprinted, all the figures are grotesque caricatures, exhibiting a rich sampling of the physical defects with which human ugliness can be expressed. The complexions of these toothless, wrinkled, and contorted faces with deformed noses, ranging from violets to grays and greens, is peculiar and adds a significant degree of surrealism. This type of caricature was common in Flanders, and was even adopted in Italy by Leonardo da Vinci himself. It therefore does not reflect extreme originality on the part of the artist, but was most likely the demand of the client, who may have liked certain details he had seen in works by other painters. These extravagant faces could also represent the personification of evil and sin.

LEONARDO DA VINCI

Self-portrait, red chalk, 13 x 9 in (33 x 21.6 cm), 1512-1513, Royal Library, Turin.

Multifaceted, erudite, and always inquisitive, Leonardo changed the course of the history of art.

He was a precocious artist soon in demand by important art patrons, for whom he painted all sorts of works, especially religious scenes and portraits. Many aspects of his art have hitherto never been surpassed.

Leonardo had a global concept of art and culture. Indeed, he was an architect, mathematician, physicist, inventor, musician, and painter! And though it was forbidden, he did not hesitate to dissect corpses in his eagerness to study the human body and its anatomy in depth. In addition, he wanted to change the prevailing concepts on painting. His works are singular and innovative because they seek compositional balance, life, and movement in the figures, and perspective through the interplay of lights and colors. He integrated elements in the setting through a peculiar technique called *sfumato* (from the Italian *fumo*, or smoke), using it to soften transitions from darkest shadow to brightest highlight. Especially important was his attempt to capture the character, sentiments, and expression of his figures, prioritizing psychology over aesthetics, though not to the detriment of the latter.

Leonardo was a perfect connoisseur of classical and medieval authors, a living compendium of all the knowledge concerning the western world accumulated until then. He could be considered the greatest humanist of all times.

- **1452** Born in Vinci, Tuscany, on April 15, the illegitimate son of the notary Ser Piero and Caterina, a young maidservant of the family.

- **1469** Enters the studio of Andrea del Verrocchio to learn draftsmanship, painting, and sculpture. Before long, he excels and paints very important works, including *The Annunciation* (see p. 76), which exhibits his first use of chiaroscuro as a means of improving tonal harmony.

- **1478** Executes the altarpiece for the Palazzo della Signoria of Florence as well as various portraits, including that of Ginevra de' Benci.

- **1482** Settles in Milan to enter the service of Duke Ludovico Sforza, taking up several commissions, including a large statue of Francesco Sforza.

- **1492** Designs the clothing for the wedding of Ludovico Sforza and Beatriz d'Este.

- **1495** Begins the *Last Supper* (see p. 78) for the refectory of the Santa Maria delle Grazie convent in Milan, and various decorative pieces for the palace of the Sforzas.

- **1499** Leaves Milan and moves to Vaprio, near Mantua, where he executes two portraits of Isabella d'Este.

- **1502** Appointed architect and engineer at the service of Cesare Borgia, whom he accompanies on his military campaigns in Romagna.

- **1503** Begins painting the so-called *Mona Lisa* (see p. 78) in Florence. The Republic commissions the painting *Battle of Anjou* for the Palazzo Vecchio.

- **1508** Studies geology and anatomy in Milan.

- **1513** Moves to Rome, where he remains for three years, studying mathematics and science by appointment of Leo X, the newly elected Medici pope.

- **1517** François I of France, who has recently conquered Milan, invites him to his court at the Château de Cloux, near Amboise.

- **1518** Collaborates on the staging of the wedding of Lorenzo de' Medici with the King of France's niece, and participates in the baptismal celebrations of the dauphin.

- **1519** Extremely ill, he makes his will on April 23, appointing his friend, the painter Francesco Melzi, as executor. On May 2, he dies at the Château de Cloux.

The Annunciation

(1472-1475)
tempera on wood
38.5 x 85.5 in (98 x 217 cm)
Uffizi Gallery, Florence

This is the first independent work by Leonardo, a commission for the convent of San Bartolomeo in Monteoliveto, where it hung until it was transferred to the Uffizi Gallery in 1867. It can be dated to the period before the artist reached the age of 20 because it was apparently inspired by Verrocchio's works for the tomb of Piero de' Medici. Further evidence is found in the decorative elements, as well as certain influences of the Pollaiuolo brothers, his teachers.

The panel represents the episode of the Gospel according to Luke in which the Archangel Gabriel appears before Mary to announce that, despite her virginity, she would give birth to a child whose name would be Jesus. Leonardo composed the scene in such a way that the volumes balance the whole, distributing the space in a regular fashion throughout the different zones, focusing on the areas around the two figures, each set in a pyramidal scheme. They are meticulously executed with a wealth of details, while the landscape and architectural structures are treated more schematically.

Leonardo expresses the figures' attitudes through their gestures. Gabriel, arm uplifted, confers divine blessing upon Mary, who, with a surprised expression, makes a gesture of submissive acceptance of the will of God. Leonardo uses the theme to introduce details that enrich its iconography: the Madonna lily that the Archangel is holding is the traditional symbol of Mary's purity and chastity; the beautifully flowered rug in the center indicates that the scene occurs in spring; and the book in front of Mary is the Book of Isaiah, which prophesies that the Messiah will be born of a virgin. This is one of Leonardo's best works.

Adoration of the Magi

(1481-1482) (unfinished)
tempera and oil on wood
96 x 97 in (244 x 246 cm)
Uffizi Gallery, Florence

In 1481, the monks of San Donato in Scopeto commissioned an altarpiece on the adoration of the magi for their high altar. Thirty months later, when Leonardo was summoned to Milan by Duke Ludovico Sforza and the work was still in the early stages, the monks commissioned another altarpiece of Fra Filippo Lippi. This is Leonardo's unfinished panel. The scene is based on the episode of the Gospel according to Matthew in which three wise men, upon seeing a strange star shining in the firmament, follow it until it leads them to Jesus, whom they worship as the Messiah.

In this work, Leonardo undertakes new artistic directions in both composition and technique. He makes extraordinary use of drawing to enter a richer realm, lending great splendor to the scene. The unfinished state of the work, along with the extant preliminary sketches, allows us to discover Leonardo's technique. He began the drawing in greenish umber. He then added color to the background and returned to the preliminary drawing, intensifying the outlines of the figures in darker colors and modeling the various elements in light and dark tones. Finally, he worked on the contrasts, applying a tenuous white where necessary.

The work, whose composition is highly balanced, emphasizes the Florentine influence of the artist, whose conception and style denote a clear interest in achieving greater dramatization through the gestures and movement of the figures. Also evident is his interest in the effects of light and color, as well as a tendency toward Nordic fantasy through a technique that he invented and that would later characterize many of his works: *sfumato*, that is, the fusion of areas of light and shadow through diffuse tones to blur the contours of a form.

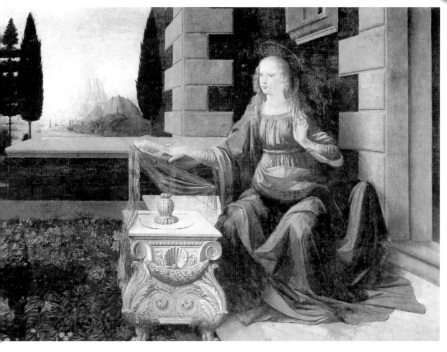

The Last Supper

(1495-1498)
fresco
181 x 346.5 in (460 x 880 cm)
Santa Maria delle Grazie, Milan

This work was commissioned by Ludovico Sforza to decorate one of the walls of the refectory. It was supposed to complement the decoration of a crucifixion scene on the opposite wall. Always resourceful and given to experimentation, Leonardo used an inadequate medium which caused the work to seriously deteriorate. It has recently been painstakingly restored, with remarkable results.

The scene shows Jesus and his disciples celebrating the Jewish Passover for the last time, on the eve of his Passion and death. The painter is more interested in the reaction of those witnessing Jesus' prophecy that one of them would betray him, than in the event itself. Jesus is majestic and immobile, with a grave expression. On the left at some distance is Judas, somewhat perplexed at having been discovered. The others show their preoccupation, disturbed and intrigued by what they have just heard, and making conjectures as to who it could be.

The work is a lesson in physiognomy, an attentive and meticulous study of the gestures and expressions of each of the figures according to their personality and temperament. The artist distributes the figures in groups of three, such that, without negating the concept of a group, he forces the viewer to contemplate the painting in detail and consider the sentiments of each figure. The manner in which Leonardo represents the food on the table is also remarkable. It comprises a collection of skillfully combined still life. Continuing his aesthetic investigations, he organizes the whole in a structure of perspectives achieved through an excellent treatment of light, adding much depth.

Leonardo had only recently returned to Florence when he began this panel, on which he worked almost to the end of his days, despite the date inscribed on it. He took it with him on his trips to Milan, Rome, and France, where Antonio di Beatis was able to view it at Le Clos-Lucé in 1517. Radiological examination shows that the execution was long and complex, with many layers of paint. When the artist died, the painting passed through many hands before Napoleon acquired it for the Louvre in 1805, from where it was robbed in 1811 and taken back to Italy. Before being returned to the Louvre, it was exhibited in Florence, Rome, and Milan.

This is one of the most famous works in the history of art. It is not certain whether it is the portrait of Mona Lisa, the wife of the Florentine banker, Francesco del Giocondo, or of a courtesan who was Giuliano de' Medici's favorite. The woman's strong character, her enigmatic smile not exempt of cynicism, her singular gaze, her impenetrable personality with a certain air of malice, and her aura of self-sufficiency constitute elements that give the painting a unique character. The landscape behind her is also fascinating—bucolic and evocative, dreamy and evanescent, with some sharp peaks in the far distance that seem to emerge from an imaginary sea.

Though the work has been the object of many studies, many of its aspects remain a mystery to this day. It is executed with perfect draftsmanship, and the brushstroke is concealed through many layers of paint and transparencies. A specific type of perspective is achieved in the landscape through the refraction of light in the atmosphere. Through a progressive reduction in definition as the distance increases, depth is created toward the hazy horizon where the mountains meet the sea.

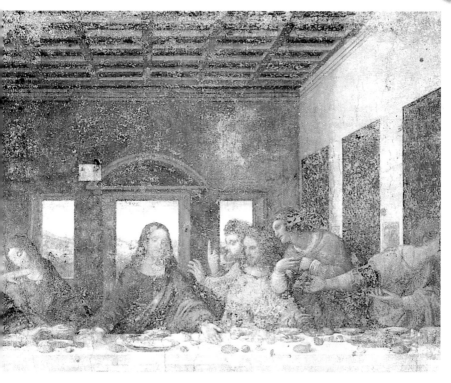

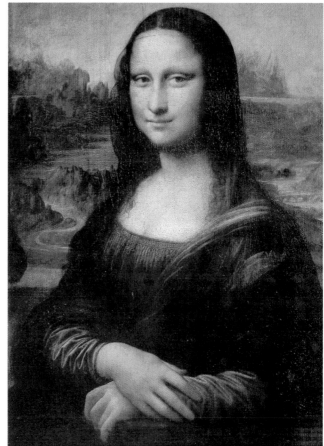

**Mona Lisa
(La Gioconda)**

(1503-1506)
oil on wood
30 x 21 in (77 x 53 cm)
Louvre, Paris

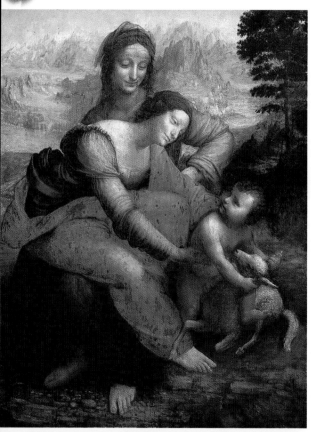

The Virgin and Child with Saint Anne

(~1510-1513)
oil on wood
66 x 51 in (168 x 130 cm)
Louvre, Paris

This panel portrays a familiar scene of Mary and her child in the presence of Jesus' grandmother, St. Anne. It is a common theme in Northern Europe that Leonardo adopts in a manner that is innovative in both content and compositional structure. The three figures are grouped in a pyramid with the clear intention of achieving aesthetic and psychological unity, while retaining movement in the work.

Some remarkable features are St. Anne's indulgent expression, Jesus' affectionate relationship with the lamb, the symbol of his future Passion and death, and Mary's protective gesture. On the artist's death, this painting was in his possession. Francesco Melzi then brought it to Italy and, in 1629, it was acquired by Cardinal Richelieu, who gave it to Louis XIII. In 1801 it entered the Louvre.

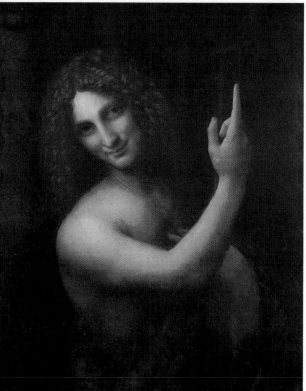

Saint John the Baptist

(1513-1516)
oil and tempera on wood
22.5 x 27 in (57 x 69 cm)
Louvre, Paris

This beautiful nude, which presages Caravaggio's chiaroscuro technique, is possibly the last work executed by Leonardo. The ambiguous face could very well have been painted from the same model as the Mona Lisa, executed years earlier. The figure seems to emerge from the shadows through a delicate sfumato that blurs the contours and makes it truly beautiful. The complexion, modeled with extreme sensibility, imbues the figure with great tenderness and sensuality. The anatomy is not very defined. Indeed, anatomical interest is relegated to the background and spirituality comes to the fore.

ALBRECHT DÜRER

Self-Portrait, *tempera on wood, 22.4 x 17.6 in (56 x 44 cm), 1493, Louvre, Paris.*

Dürer's art is characterized by insistent representation of the human figure, studies of perspective in space, harmony, the search for beauty, and precision.

His contact with painters during long sojourns in Venice and Bologna, along with his education and inquiring nature, paved the way for his great contribution to the history of painting: transplanting the Italian Renaissance ideology (a return to Greco-Roman classicism, humanism, formal aspects, luminous Mediterranean colors, and so forth) to German Gothic painting (serious, permeated with sensibility and fantasy, and highly detailed), without allowing it to lose its German roots. Dürer's artwork is hence a perfect and unique synthesis of the most characteristic aspects of two different and powerful neighboring cultures.

Dürer's work, executed in a period of great social upheaval associated with the Reformation, is a turning point for the German Gothic. The artist's creativity, forcefulness, sensibility, wise perception of reality, and constant inquiry produce an intellectual and definitive art with profound sentiment. He opens a fluid dialogue between two complementary European cultures that had been enclosed in their own worlds.

- **1471** Born in Nuremberg, the third of ten children of the goldsmith Albrecht Dürer and his wife, Barbara Holper.
- **1486** Against his father's wishes, he leaves the goldsmith's studio to enter the studio of the engraver and painter, Michael Wohlgemuth.
- **1490** Influenced by his father, he undertakes a study trip to different European cities.
- **1494** In July, marries Agnes Frey in Nuremberg. To widen his knowledge, he travels to Italy in autumn for the first time, where he sees Mantegna and Bellini's works.
- **1495** On his return trip to Nuremberg, he executes an excellent series of detailed, naturalistic watercolors.
- **1505** Travels to Italy again, this time to Venice and Bologna, where he comes into contact with Renaissance artists. Paints various works commissioned by German merchants residing there.
- **1511** Completes various engravings, including a *Passion* in large format (20 drawings with green paper, Albertina Museum, Vienne; 37 engravings, Uffizi, Florence) and *Life of the Virgin* (16 prints, Art Gallery of Greater Victoria Collection).
- **1512** Thanks to an introduction by the humanist Pirckheimer, executes many engravings and other works for Maximilian I, the Holy Roman Emperor, who grants him a stipend.
- **1519** Executes a portrait of the Emperor Maximilian in Augsburg.
- **1520** After Maximilian's death, to gain the favor of Charles V and a renewal of his stipend, he visits the Empress in the Netherlands. There he meets Patinir, Q. Metsys, and Lucas van Leyden. Meets with Erasmus of Rotterdam in Brussels. During these years, Dürer is immersed in a profound Lutheran sentiment.
- **1521** Returns to Nuremberg, ill with malaria, and nearly dies.
- **1525** Publishes *Instruction on the Art of Measurement.*
- **1527** Writes *Treatise on Fortification,* deeply influenced by the bloody peasant uprising of the previous year.
- **1528** Dies in Nuremberg and is buried in the Church of St. John.

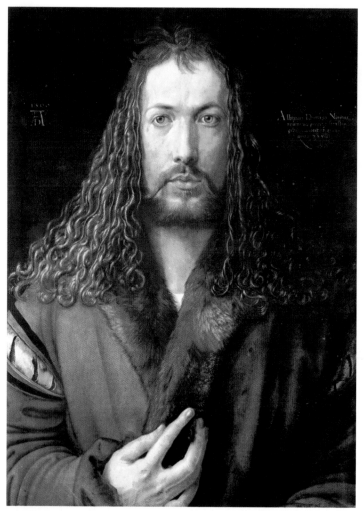

Self-Portrait

(1500)
oil on wood
26 x 19 in (67 x 49 cm)
Alte Pinakothek, Munich

Three self-portraits by this painter are extant in addition to this: one executed in 1493 when he was 22 years old, now in the Louvre (Paris); another, executed in 1498 when he was 27, now in the Prado (Madrid); and the third one from 1499, now in the Alte Pinakothek in Munich. All of them are masterpieces and reflect the artist's personality.

This self-portrait was done when the artist was 29 years old. The profound psychological study demonstrates that Dürer had reached artistic maturity. Although he had not yet taken his second trip to Italy, it is clear that the painter was seeking a humanist concept of art and an in-depth study of both physical and spiritual characteristics. An excellent connoisseur of anatomy, proportion, and psychology, and working in the Germanic style, he executes a meticulously precise study of the facial features and expression, as well as the hair and clothing. He depicts himself in a solemn frontal view recalling certain representations of Christ, an idea supported by his long, curly hair.

The dark background brings out the face, whose expression is mysterious, even disconcerting. The figure is captivating and constitutes a vivid reflection of the artist's true self: an educated humanist and an accomplished artist. The painting can also be viewed as an homage to Renaissance classicism and a manifestation of the artist's genius. In any case, it is an unconventional representation. Only he was capable of synthesizing the quintessence of two different cultures, the Germanic and Italian Renaissance, to produce a painting like this one.

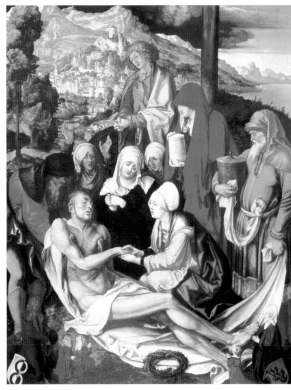

Lamentation for Christ

(~1500)
oil on wood
59.5 x 48 in (151 x 121 cm)
Alte Pinakothek, Munich

This significant work reveals a synthesis of two different but complementary movements: the persistent German Gothic conception and the contribution of the new Renaissance ideology. This painting closes the painter's glorious early period. Its austerity and a certain archaic approach reflecting the influence of Wohlgemuth are splendidly counteracted by the anatomical study of Christ's body, the pyramidal distribution of the figures, and the excellent landscape in the background, resulting in a lively, colorful, orderly, and perfectly balanced whole.

This watercolor, painted after Dürer's first trip to Venice, shows an evident naturalism arising from the influence of Italy's Renaissance spirit. The meticulous study of the fur, the general anatomy, and the daring foreshort-

A Young Hare

(1502)
watercolor and
gouache on paper
8.6 x 9 in
(21.5 x 22.6 cm)
Graphische Sammlung
Albertina, Vienna

ening demonstrate great realism. Before applying the watercolor, Dürer executed an elaborate drawing onto which he added a transparent wash serving as the background for the deeper tones. The tone of the wash can be observed in the inner ear and cheeks. Once the first wash was dry, he applied the darker colors before detailing the fur. After painting the principal tones, he began applying the details of the fur with a fine brush. The lighter areas of fur consist of a layer of tempera and whites. The artist executed various precious paintings of animals from nature.

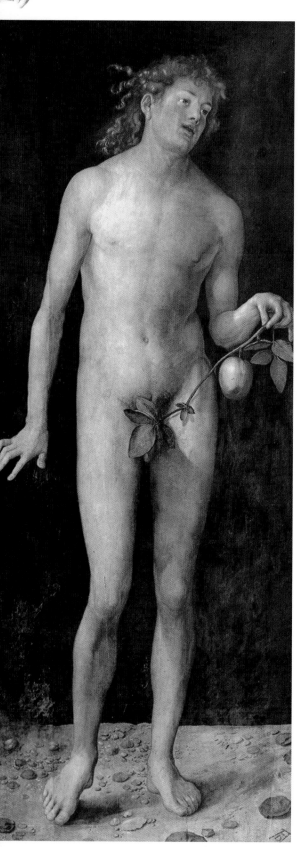

Adam

(1507)
oil on wood
82 x 32 in (209 x 81 cm)
Prado, Madrid

Dürer was the prime exponent of the Renaissance on German soil. He was a humanist par excellence who perfectly assimilated the ideals and characteristics of the art being executed in Italy without losing sight of his own cultural roots.

This painting and that of Eve form a diptych in which each panel is subtly different in conception, yet complementary. These two panels constitute eloquent examples of Dürer's work. When he painted this figure, his contemporaries immediately began copying it for obvious reasons: he had achieved a realistic, nonallegorical nude, with unidealized yet beautiful proportions, with a volume approaching that of sculptures by David or Michelangelo. In fact, both the volume and modeling of this figure are Italian in influence. The body is Apollonian, Mediterranean, and classical. The figure's serenity provides a harmonic counterpoint to the rhythmic forms of its delicate contrapposto.

Although this work was conceived as a diptych and is closely related to Eve, each figure was conceived as a separate entity with its own personality, the anatomy not ascribed to a rigid canon. This young Adam has a smooth, bronze complexion and a body which, though muscular and fibrous, is far removed from classical heroic ideals. The naturalism of this nude reflects the serenity of ancient Greek sculptures, though with a filter that lends the forms an intellectual air, making the figure wholly human. It is the manifestation of the Renaissance ideology adopted by the artist.

Eve

(1507)
oil on wood
82 x 31.5 in (209 x 80 cm)
Prado, Madrid

This panel forms a diptych with that of Adam. The beauty of this Eve lies between the Italian humanist spirit and certain Gothic canons, such as the pronounced slope of the shoulders and the round abdomen. Her anatomy no longer represents the archetype of the German Gothic, but rather the intellectualization of one of the principal cultural aspects that had defined the manner of interpreting female anatomy until then. Though vestiges of traditional iconography are present, Dürer creates a new woman, with realistic proportions, modeling, and anatomical study.

Yet the concept differs from that of Adam: whereas his nude displays significant references to the Italian Renaissance, in Eve, the German artistic concept prevails. The female forms, though delicate, are unidealized, slim, and sinuously sensual. Dürer, obsessed with one of the artistic concerns of the period, spent a great deal of time studying the mathematical canon of ideal proportions to be applied to the human figure to yield a perfect result according to Euclid and Vitruvius.

In both panels of this diptych, the artist establishes his synthesis of his ideal of beauty within abstract harmony. Eve's movement is remarkable, evoking a classical sculpture as in the figure of Adam. There is a fragile balance in this figure brought about by the inclination of the body. The treatment of the complexion, in pale, luminous tones, contrasts with the tanned skin of Eve's companion, demonstrating another aspect of the aesthetic tastes of the period.

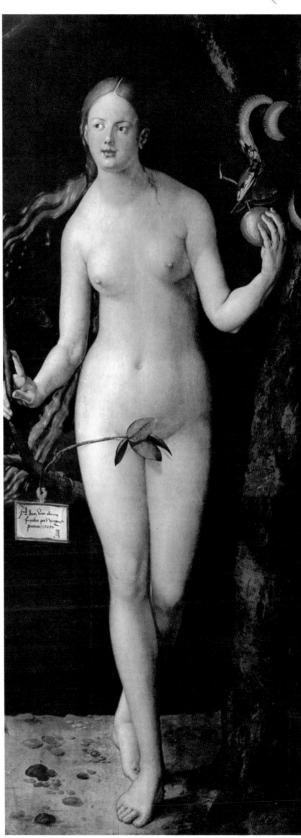

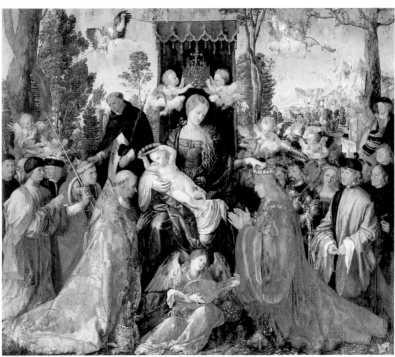

Feast of the Rose Garlands

(1506)
oil on wood
63.5 x 77 in (161.5 x 195 cm)
National Gallery (Národní Galerie), Prague

This work was commissioned by the guild of German steel manufacturers in Venice for the church of the German colony residing there shortly after Dürer had arrived. It is the synthesis of his entire artistic trajectory to this point, and constitutes one of his most important works. A pyramidal composition governs the general scene and each element within it. The background landscape provides a counterpoint to the crowd of people in the foreground. The leading role played by the general structure is complemented by the color treatment, with dynamic and balanced modeling in various luminous tones. The work combines Venetian splendor with the studied harmony typical of 15th-century Rhineland painters. The whole is imbued with lyricism and solemnity.

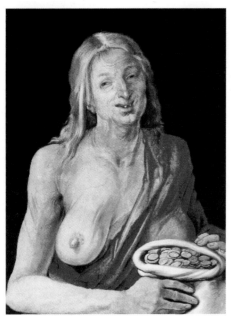

Avarice

(~1520)
tempera on wood
14 x 11.5 in (35 x 29 cm)
Kunsthistorisches Museum, Vienna

In this work, the artist expresses his moral sentiment, the result of his profound Lutheran convictions. Avarice is represented as a partially nude, grotesque woman, whose aspect and pictorial treatment reflect the baseness of this deadly sin. Throughout art history, with the exception of Brueghel, Cranach, and Hieronymus Bosch, artists have rarely indulged to such a degree in creating physical ugliness. To the old woman's grotesque facial features, Dürer adds skin as wrinkled as a raisin. The breast, formerly large and turgid, is now fallen and limp like a cow's udder. This is an allegory with a moralizing message.

LUCAS CRANACH, THE ELDER

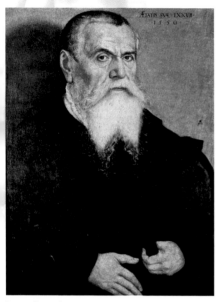

Lucas Cranach, *tempera on canvas, 25 x 19 in (64 x 49 cm), 1550, Uffizi, Florence. The artist at the age of 77 painted by his son.*

Cranach's oeuvre is one of the most remarkable of the Protestant Reformation for its expressiveness, elegance, delicacy, and innocent eroticism. His themes, varied and at times contradictory, constitute an excellent chronicle of Wittenberg court life. In addition to interesting portraits of important people, he created numerous religious and mythological works in which women were often featured (Eve, Venus, Judith, Lucretia, etc.). At first, his female nudes had a distinctly Italian imprint, progressing toward more personal characteristics, especially after his *Venus and Cupid* (see p. 89). Indeed, his nudes were so popular that he had constant commissions with the sole condition that the painting contain a female nude.

His first works reflect a sensibility akin to that of the Danube School. The paintings he executed in Saxony show the influence of Flemish Romanesque art, the consequence of his contacts with contemporary Dutch painters on a trip to the Netherlands. When these works attained overwhelming success, he began to create delicate works with a clear erotic intent.

Cranach was rediscovered by the Modern artists of the early 20th century, who held him in high esteem because the sinuous figures and the surrealist landscapes he often used as a background were wholly in keeping with their concepts.

• **1472** Born in Kronach, Franconia, the son of an engraver. His family name may have been Müller (Cranach is derived from his place of birth).

• **1501** Lives in Austria and frequents a group of Viennese humanists under the protection of Maximilian I, the Holy Roman Emperor. Paints his first known works, two crucifixions and *Rest on the Flight to Egypt* (Staatliche Museen, Gemäldegalerie, Berlin).

• **1504** Towards the end of the year, Frederich the Wise, Elector of Saxony, is impressed by his paintings and appoints him official court painter. Henceforth, he spends long periods at Wittenberg, where he will later serve as burgomaster. He begins what is to develop into a close relationship with Martin Luther, with whom he collaborates by executing the graphic propaganda for the Reformation, facilitating different works for the illustration of the Bible, and faithfully interpreting Lutheran iconography. Nonetheless, he was not necessarily committed to the cause.

• **1506** Executes three famous boxwood engravings: *Venus and Cupid, St. Christopher*, and *St. George Slaying the Dragon*. Paints the large triptych of *The Martyrdom of St. Catherine* (Gemäldegalerie, Dresden).

• **1508** Travels to the Netherlands and comes into contact with contemporary Flemish painting, which is to influence his later work. Paints several versions of Venus and Cupid.

• **1513** His studio executes a series of canvases on *The Hunt in Honor of Charles V at Torgau Castle.*

• **1520** Paints the *Portrait of Cardinal Albrecht of Brandenburg* (The Hermitage, St. Petersburg), indicating that, his relations with the Protestants notwithstanding, he is on good terms with the Catholics.

• **1526** Executes an altarpiece modeled after Dürer's masterful engraving, *Cardinal Albrecht of Brandenburg as St. Jerome in his study* (Ringling Museum of Art, Sarasota, Florida). Hereafter, he produces a great deal of mythological works in which the female nude plays the leading role.

• **1540** At this point, his artistic phase draws to a close and he becomes active in politics and commerce.

• **1550** At the Battle of Mühlberg, he is taken prisoner and brought to Augsburg, where he is imprisoned with John Frederich I, nephew and successor of Frederich the Wise.

• **1553** Accompanies John Frederich I to Weimar, where he dies.

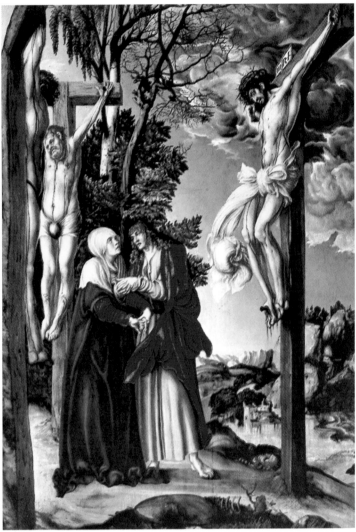

Crucifixion

(1503)
oil on wood
53.5 x 39 in
(136 x 99 cm)
Alte Pinakothek, Munich

Whereas other painters attempt to show realistic anatomies, Cranach depicts the victims in this scene as wretched creatures, with unusual expressionism and brutality. Cranach represents the bleak, cruel aspect of their torture, the bodies hanging like meat in a slaughterhouse. The originality of this work lies in the artist's intent to show the human body from different angles. The figures' muscles are extended, their chests expanded. Each is crucified in a slightly different position, Christ with his feet nailed and his arms spread wide.

Although the three figures have similar complexions, Christ's appears brighter due to the dark clouds behind him. A remarkable detail is the loincloth on Jesus, whose flying end, like a regal dignitary's sash, lends him an elegance and dynamism that are nearly surreal. Carried away by his emotions, the painter focuses on the theatricality of the scene, strategically placing the crosses such that they are integrated into a landscape that emphasizes the tragedy. The stormy, threatening sky is a vivid reflection of the drama represented, a method typically used by German masters in the early Renaissance.

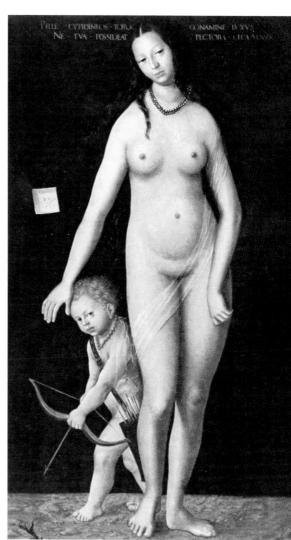

Venus and Cupid

(1509)
oil on canvas
84 x 40 in
(213 x 102 cm)
The Hermitage, Saint
Petersburg

This painting is the first female nude known to the German mythological genre. It is a singular work because it has nothing to do with the typical Italian Renaissance representations, nor with Cranach's subsequent works. It has a distich in Latin above it attributed to Scheurl or Sibutus, erudite humanists residing in Wittenberg whom Cranach had met on a trip to Nuremberg in 1508 and who had become close friends. The text reads: "Flee from Cupid and all of his pleasures, lest Venus capture your heart." The painting is thus moralizing, warning the observer of the dangers inherent to Venus, the Roman goddess of love, and Cupid or Amor, her son, who shoots his arrows to inflame the hearts of unwary lovers with desire. Yet, contrary to the apparent intention, and in contrast to the usual representations in such cases, the painter creates an erotic vision that causes a commotion in his conservative society. The goddess exhibits a slender, sensual body lightly covered by a transparent veil which, instead of concealing her pubic area from indiscrete glances, increases its fine voluptuousness. The goddess is impassive and self-assured, the epitome of the woman who cannot be conquered. Cupid, under Venus' protection, is attentively waiting to fire his arrows at the slightest indication from his mother. Nothing disturbs the vision—the background is completely dark. This work was so innovative and its subtle eroticism so acclaimed that immediately, and for many years to come, Cranach was flooded with commissions, all with the condition that the female nude be the protagonist of the painting.

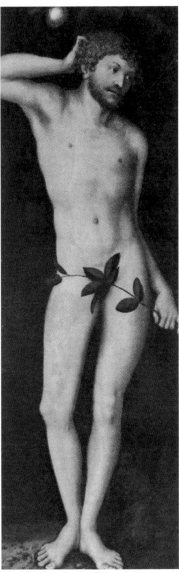

Adam

(1528)
oil on wood
68 x 25 in (172 x 63 cm)
Uffizi Gallery, Florence

This painting can be ascribed to one of the painter's many religious or mythological representations within the Flemish School. The dark background and distinct profile evoke Dürer, but the conception of the nude follows Italian Renaissance canons. The body is attractive and erotic. This work was done in a period when the artist enjoyed great popularity because of his nudes. He received so many commissions that a substantial part of his production consisted of nudes from 1509 onwards.

This canvas illustrates Cranach's complex nature. While he was a friend of Luther and sympathizer of the conservative Protestant cause, he nevertheless painted many religious or mythological paintings clearly inspired by the Renaissance and incorporating a significant degree of refined eroticism with an ambiguous pictorial language. Apart from the commercial aspect of this type of work, Cranach broke both aesthetic and moral standards and introduced a treatment of the nude that was revolutionary to German art.

Eve

(1528)
oil on wood
66.8 x 24.4 in
(167 x 61 cm)
Uffizi Gallery, Florence

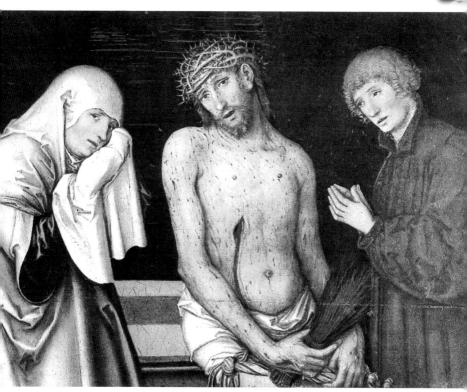

Cranach is a paradigm of the German transition from the Gothic to the Renaissance. His friendship with Luther led him to become one of the painters who best served the Protestant cause. One of its greatest interpreters, he created and proclaimed its iconography. Although there are evident signs of a Renaissance concept of the figure on this canvas, the painter is still significantly rooted in the Gothic tradition.

Pietà

oil on canvas
21.5 x 29.5 in (54 x 74 cm)
Vatican Gallery,
Vatican City

The modeling of the male forms is executed with a certain degree of naturalism, but the bone structure, along with the figures' poses and attitudes toward the viewer, associate the work with the traditional German School. The muscles are hardly visible, and the anatomical forms are conceived as a set of masses, held together by the joints.

Cranach shows quality draftsmanship with outlines tending toward clean definition, a characteristic that the German School would adopt for a long time. The figure of Christ has the expressive force characteristic of the early German Renaissance painters. Although this figure is far removed from Cranach's usual iconography, it has all of his stylistic values. To intensify the sentiment of devotion, the artist uses a dark, saturated background that focuses the observer's attention on the three figures, as static as statues. The expressions on their faces are not of pain but rather questioning. They establish a dialogue with the viewer, eliciting a reaction to their tragic situation.

The Adoring Husband

(1530)
oil on wood
15 x 10 in (38 x 25 cm)
National Gallery (Národní
Galerie), Prague

Just as in 1509 with Venus and Cupid, Cranach presents a moralizing work. An old man, believing himself still physically attractive, embraces a young woman to obtain her favors. The scene is a warning, illustrating the way people often fool themselves when they believe that the things they imagine are real. At the same time, it is a mischievous wink at the viewer, for the old man may be a fool, but, despite his age, ugliness, and ailments, he manages to enjoy the young woman's body, if only for a moment. The painter shows his sagacity and mastery in the art of ambiguity. Although these works with contradictory interpretations were transgressive, they were widely accepted among both Catholics and Protestants, since each group interpreted them as best suited it.

Martin Luther

(1529)
oil on canvas
14.5 x 9 in (37 x 23 cm)
Uffizi Gallery, Florence

One of Cranach's most important artistic facets was his portraiture, which he produced throughout his entire career with singular success. A friend of Luther, and a sympathizer of the Protestant cause, as well as a notable propagandist for it, he executed this portrait along with another of Luther's wife.

The eyes and facial features are meticulously executed to reflect the personality of the figure. They become the focus of attention due to the plain background and dark attire. The uniform treatment of light is curious, with tenuous shadows modeling the face. Cranach doubtless had two objectives: to faithfully reflect Luther's character; and to maintain total harmony with the Protestant aesthetic. Transformed into an institutional image, this portrait was copied and widely distributed.

MICHELANGELO

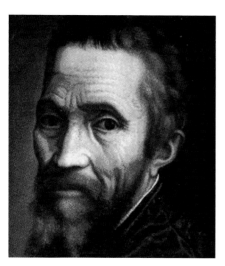

Marcelo Venusti, Portrait of Michelangelo *(detail), oil on canvas, 1535, Casa Buonarrotti, Florence.*

Michaelangelo (Michaelangelo Buonarroti) was a versatile artist whose talents extended to painting, sculpture, architecture, and poetry.

His paintings are characterized by the use of monumental space and a series of elements to achieve magnificence. In his time, his artwork was already considered the culmination of the Renaissance, and was even thought to close the period.

An exceptional artist with a strong character, he was the object of heated debate. Whereas some considered his artwork to be greatly superior to ancient classical art due to its refinement and profound intellectual content, others disliked his departure from realism and exaggerated forms, and considered him too elitist and inaccessible.

A man of deep sentiments, he was preoccupied throughout his life with both the physical aspects of the human body—compelling him to constantly investigate anatomy in search of a prototype of ideal beauty—and its spiritual aspects, the symbolic manifestation of human virtues and transcendental values. His work in the Sistine Chapel led him to read the Bible time and again. He became so deeply immersed in it that the humanist and Neo-Platonic aestheticism of his youth was replaced with a profound spirituality. He began using a grandiose language to express a transcendent reality.

Although he always considered himself a sculptor, Michelangelo was an essential figure in the history of painting.

- **1475** Born in Caprese, near La Verna, in Tuscany, the son of Ludovico Buonarroti, chief magistrate of Florence.

- **1488** After studying under the tutelage of the humanist Francesco d'Urbino, enters the studio of the Florentine painter Domenico Ghirlandaio, who recommends him to the great patron of the arts, Lorenzo de' Medici, the Magnificent. At Lorenzo's country home in Careggi, Michelangelo meets and spends time with the great intellectuals and famous people of the time, including the Italian humanist and philosopher Marsilio Ficino.

- **1489** Lorenzo de' Medici admits him to the free school in the Medici gardens. There, Michelangelo studies classical sculpture. In a dispute with another pupil he fractures his nose and is permanently disfigured.

- **1492** After the death of Lorenzo de' Medici, he sculpts and paints in Florence, Venice, and Bologna.

- **1496** When Florence is thrown into confusion by disturbances and by Girolamo Savonarola's sermons, he moves to Rome to study classical art.

- **1501** Returns to Florence and executes a series of works—the *Bruges Madonna, Taddei Tondo* (Church of Notre Dame, Bruges, and The Royal Academy of Fine Arts, London, respectively), and *The Holy Family,* or *Doni Tondo* (see p. 95)—which already show his style and personality. During these years, he executes the sculpture of *David* (Accademia, Florence).

- **1504** Commissioned to paint a mural in the council chamber of the Palazzo Vecchio in Florence.

- **1505** Summoned to Rome by Julius II, who commissions him to execute his funeral mausoleum. The long, laborious nature of the work and the Pope's neglect induces the artist to abandon the project temporarily.

- **1508** Commissioned by Pope Clement VII (see p. 98) to decorate the vault of the Sistine Chapel, a monumental work which he does not finish until October of 1513, working nearly alone and, at least in the beginning, with little enthusiasm.

- **1534** Pope Paul III commissions him to decorate the great wall behind the altar of the Sistine Chapel with a rendition of the *Last Judgment,* which he does not complete until 1541.

- **1542** Begins two frescos for the Pope's private chapel in the Vatican.

- **1564** Dies in Rome.

Nude from the Back

(~1504-1505)
pen and pencil
16 x 11 in (41 x 28.5 cm)
Casa Buonarroti, Florence

Michelangelo left us some 500 drawings, the majority of them preliminary figure studies for murals and other paintings. Some are only sketches, others are more finished. The nature of his paintings and typology of the figures in them can be ascribed to his predilection for sculpture.

This nude is a study for a painting he began in the autumn of 1504, *The Battle of Cascina*, for the council chamber of the Palazzo Vecchio in Florence. It constitutes an eloquent example of the artist's style and demonstrates his thorough knowledge of the male anatomy, which he always executed with particular care.

This body, the equivalent of ten heads, is stylized to the extreme. It adopts an idealized pose that transforms it into that of a hero free of all defects. It is perfection embodied. Muscle is everywhere and all elements are profoundly studied and well placed. The forms and volume are the work of an indisputable master, imbued with the ideas of the Renaissance, who takes his art to the limits of the canons of beauty, balance, and harmony. Although it would be difficult to find such a slender body in real life, Michelangelo creates a model that defines the ideal perfection sought after by other artists. Particularly interesting is the technique of modeling through cross-hatching, using a close-knit network of lines as in a drypoint engraving.

The Holy Family (Doni Tondo)

(~1504–1506)
tempera on wood
47 in diameter
(120 cm)
Uffizi Gallery,
Florence

This panel was commissioned to commemorate the matrimony of the patrician Agnolo Doni with Magdalena Strozzi toward the end of 1503 or the beginning of 1504, though the painting was executed somewhat later. It is a significant work, since, in addition to following an approach very close to that used by Leonardo in his St. Anne, it shares the grandiosity of many compositions used in the first phase of his Sistine Chapel decoration. The three protagonists are Herculean, with solemn, idealized poses, gestures, and expressions exuding a classical rather than intimate or familiar air, accentuated by the group of people in the background strategically displaying their athletic anatomies.

The Entombment

(~1500)
oil on wood
64 x 59 in (162 x 150 cm)
National Gallery, London

This work contains numerous corrections and superimposed layers of paint. The poses are static, affected, and unreal. Michelangelo dispenses with naturalism and gives free rein to his imagination. The figures display the artist's characteristic touch of monumentality, and the composition, recalling Mantegna, with an intense light and profusion of colors flooding the scene, prevents dramatization and tension. The figure of Christ is delicate and sensual, his form outlined and his legs slightly foreshortened. The proportions are idealized and the forms are treated in light, tenuous tones with the absence of black, evoking marble sculptures with their smooth transitions from light to shadow.

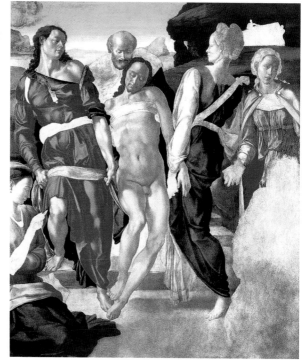

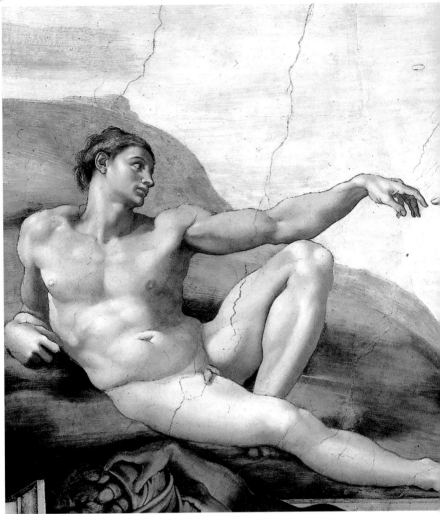

The Creation of Adam

(~1508-1512)
fresco
Sistine Chapel, Vatican City (detail)

This monumental fresco is one of the most renowned pictorial works by Michelangelo. It constitutes a historical landmark upon which all subsequent artists have reflected in order to comprehend the meaning of the nude in painting. It represents the pure poetry of the human relationship with the Divine Creator, and the exaltation of the figure to the point of the sublime.

According to the Bible, after God created the elements and creatures on Earth, he decided to create a being in his likeness, thus modeling the figure of Adam from clay and breathing life into him. Adam, with his left elbow on his knee, extends his hand toward God, the light contact with God's finger bringing him to life. This is one of the most beautiful nudes existing in art, its pose enhancing its
heroic character. The light entering from the left generates an excellent interplay of light and shadows which provides definition, models the figure, and determines its details. The light is subtle and the shadows minimal yet perfectly placed; the anatomy reflects Michelangelo's interest in the human body. The proportions that he establishes here have defined the canon of male beauty to the present. The various foreshortenings, such as that of the right arm or hip, gently twisted to join with the upright torso, are astonishingly realistic and dramatize the figure. The artist, who felt that he was a sculptor above all, executes an excellent drawing which, in its composition and volume, evokes a statue.

Michelangelo

The Book of Genesis explains that, after the flood, Noah became a farmer and planted a vineyard. He drank the wine he had made and became drunk, falling asleep in the open, and lay there nude until his children saw him and covered him. The scene refers to this episode, in which the artist introduces some small variations.

Noah is lying before a barrel, sleeping off his drunkenness after drinking copiously of his new wine. The people rushing to cover him are not just his two sons, Shem and Japeth, as recounted in the Bible, but also a woman. The scene is curious because they are all nude and display their anatomies without the slightest preoccupation. Their attitude toward Noah's state should not be interpreted as a desire to cover his nude body but rather as an intent to conceal his drunkenness and hence save his honor, another aspect not mentioned in the biblical text.

The classical beauty of the bodies is one of their principal characteristics, though the artist, in his peculiar style, seeks to establish a human standard reaching far beyond any natural anatomy. The figures are sexually ambiguous: whereas the men are primarily Apollonian, the woman is essentially Herculean. The bodies in these biblical scenes are spectacular, with a sculptural treatment exhibiting powerful muscles and daring foreshortenings that defy the capacity of the human eye to discern the two-dimensionality of the image. Contributing to the spectacular effect of the work is the static nature of the figures and their affected poses. The whole is permeated with the solemnity and grandeur typical of Michelangelo's magnificent representations.

Drunkenness of Noah

(~1508-1512)
fresco
68 x 104 in (170 x 260 cm)
Sistine Chapel, Vatican City

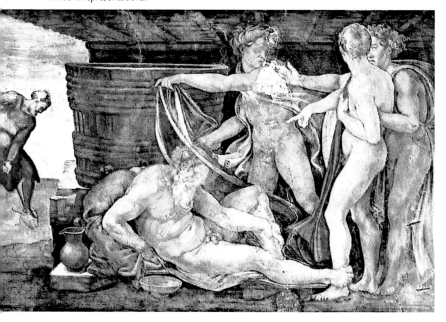

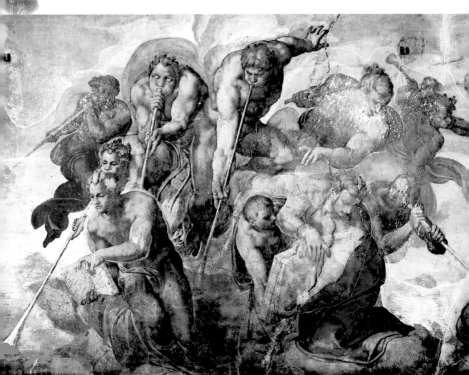

Angels with Trumpets and Books
(The Last Judgment)

(1534-1541)
fresco
Sistine Chapel, Vatican City (detail)

Many years after his early attempt to decorate the Sistine Chapel on commission from Pope Clement VII, Michelangelo was summoned to Rome by Pope Paul III to continue the great wall behind the altar. The preparation of the wall lasted several months, the actual painting beginning in the spring of 1536. As opposed to other representations by the artist, this fresco contains no architectural elements to regulate it. It is conceived as a tragic drama.

The dead arise as skeletons to the call of the angels' trumpets, take up their human form again, and slowly ascend to heaven to appear before God. On high, the chosen are distributed around Christ, who is presented as a severe judge. In the lower right corner, the damned are beaten and pushed toward Charon's boat and the bowels of Hades. The angels sounding the trumpets act as a complement to the scene, enhancing the concepts of Divine Justice and Glory. Their anatomy is heroic and of a highly spectacular nature due to the employment of superb draftsmanship and the profound study of the light values on the figures.

In developing the anatomy, Michelangelo lends great importance to half-light. The denser colors are tempered, creating a flat effect, which is combined with a bright blue background from which the figures appear to emerge. The brightest areas of the nudes act as white highlights on a drawing in a sanguine tone, lending the bodies incredible realism. This and a flowing compositional rhythm produce a dynamic effect.

The visual effect created by the size and elevated position of the frescos in general, filling the entire Sistine Chapel with nudes, is overwhelming. The Divine Forces convey triumph and splendor through their humanized forms, though they are not depicted as normal humans but as extraordinary beings with generous and grandiose bodies capable of predominating over the other figures in the scene. The painter choreographs the universe through human forms. The colors are dull and uniform, with a predominance of tanned complexions standing out against the blue sky and giving rise to an air of mystery. This work was completed on November 18, 1541.

GIORGIONE

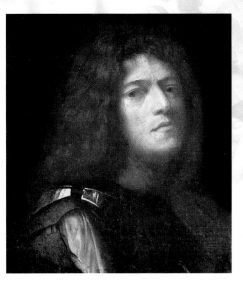

Self-portrait as David with Goliath, (detail), *oil on canvas, 20.5 x 17 in (52 x 43 cm), 1509-1510, Herzog Anton Ulrich Museum, Braunschweig.*

Giorgione's (Giorgione da Castelfranco) work is widely recognized as a turning point in Venetian painting, in which he championed the naturalism initiated by Giovanni Bellini. His style is characterized by a harmonious blending of the figure and landscape, and his influence was felt by 16th-century painters as eminent as Titian, his fellow student, Sebastiano del Piombo, and Palma Vecchio.

The main source of information concerning Giorgione is Vasari, who classifies Giorgione's short artistic trajectory into three periods: the autodidactic years, his training under Bellini, and his admiration for the work of Leonardo da Vinci.

His close ties with the Venetian aristocracy led him to assimilate the Neo-Averroist ideas (the concept, formulated by Averroes, of the divine origin of the Universe) that were fostered by the University of Padua, and that led the artist to combine what for him were two fundamental values: the human figure and nature. These he depicted within a meticulous composition whose color treatment and intricate modeling is based on tones, highlights, and shadows, giving rise to scenes of bucolic poetry and mystery.

Giorgione's works are controversial owing to the paucity of authentication and to his death at the age of 32.

Furthermore, Titian's invaluable collaboration as a pupil in the artist's studio has brought into question the authorship of certain works. It is possible that following Giorgione's premature death, Titian completed several unfinished works. But there is no doubt that the conception, composition, treatment, and a substantial part of their execution can be attributed to this ill-fated artist, to whom the success of his distinguished student is indebted.

- **1478** Born in Castelfranco, Veneto, of humble origin. According to Vasari, Giorgione is educated in Venice. He is a sensitive person with a love for music, especially for strumming the lute and singing; indeed, he receives frequent invitations to play at the soirées held at some of the palaces. He enters the studio Giovanni Bellini.

- **1504** Probably receives the commission to paint the Castelfranco altarpiece (Castelfranco Duomo, Veneto), whose dominant landscape broke with the pictorial criteria of his Venetian predecessors.

- **1506** Paints *Laura* (Kunsthistorisches, Vienna); the canvas bears an inscription on the back stating that it was painted on June 1 of the same year.

- **1507** On August 14 the Council of the Ten—a council of peers that solved disputes concerning the prices of paintings—issues an order to pay Giorgione ten ducats for a canvas.

- **1508** An order to pay by the Council of the Ten is issued on January 24 of the same year for an unfinished painting for the Palazzo Ducale of Venice. In November, Giorgione finishes the frescos of the Fondaco dei Tedeschi (now the main post office in Venice), and files a lawsuit due to his disagreement with the sum of money he has received; a settlement is reached December 11 by a commission appointed by Giovanni Bellini.

- **1510** Hearing of Giorgione's death, the Marquise of Mantua, Isabel d' Este, sends a letter, dated October 25, asking Taddeo Albano to procure for her a Nativity by the painter. In November Taddeo confirms Giorgione's death from the plague, adding that, despite having been in contact with the painter's friends, he has not found any of the artist's paintings for sale and was therefore unable to carry out her request.

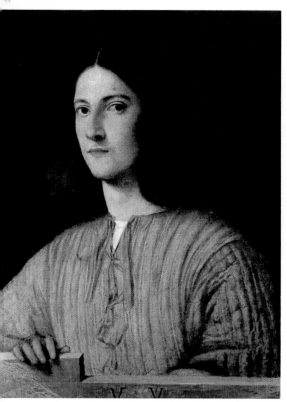

Portrait of a Young Man

(~1504–1506)
oil on canvas
22 x 18 in (56 x 46 cm)
Gemäldegalerie, Berlín

In this panel, one of his best-known works, Giorgione adopts two characteristics: the three-quarter pose to give the figure more presence (probably inspired by Antonello da Messina); and the parapet on which the subject is resting his hand with which the artist obtains an element of depth and gives the work a degree of context (a trait of Bellini). He would repeat these in many of his later portraits.

The dark and saturated background makes the figure stand out; the colors of the face, hair, and robes are well defined, thereby affording the subject a chromatic softness and distinction.

Reading Virgin

(~1507)
tempera on wood
76 x 60 cm
Ashmolean Museum, Oxford

The artist based this work on a pyramidal composition, whose colorfulness and intensity provides a contrast to the Virgin's composure and innocent expression. The landscape in the top left-hand corner shows the Riva degli Schiavoni with the Palazzo Ducale and the campanile of Venice. In an attempt to represent atmospheric depth, the artist sets off the hazy undefined landscape with the chromatic sharpness of the Virgin and the wall.

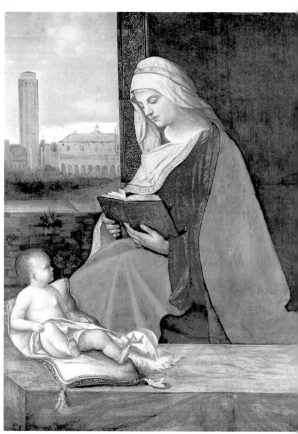

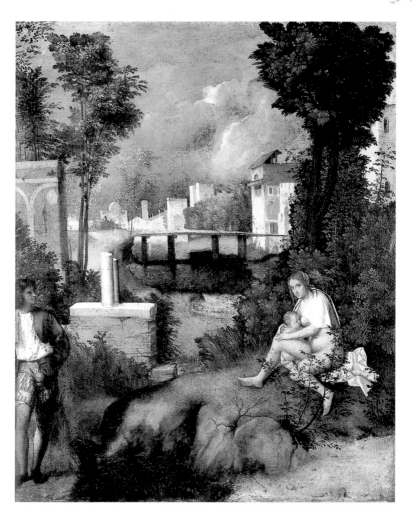

This painting was given a name after Giorgione's death. The scene has been interpreted in a number of ways: as an allegory of nature, a representation of Paris' childhood, an allusion to the origins of the artist, Adam and Eve after the Fall, and so forth. This is a symbolic and mysterious work and many of its details are difficult to interpret.

The Tempest

(~1505-1510)
oil on canvas
32 x 29 in (82 x 73 cm)
Galleria dell'Accademia, Venice

The title of the work alludes to the dense, leaden gray clouds of the storm gathering in the background. The unreal colors, together with the trees, lend an air of mystery to the landscape. The group of elements appears to compose a strange encrypted code. Some say that these elements can be linked to cabalist and magical movements that were so common in the Venice of the time.

On the right is a young mother seated on a blanket that partially covers the baby she is suckling, while she stares directly at the viewer in a relaxed manner, as if in a reality different from the rest of the work. The realism of the nude, heightened by elements in the foreground situated between the spectator and the woman, help to establish the different planes in depth. One unusual feature is the podium with two truncated columns. On the left-hand side of the work, a nobleman stares longingly at the woman. With this work, the artist takes Venetian painting one step further by giving heightened importance to the landscape, whose atmospheric treatment draws the viewer's attention.

Regardless of meaning or symbolism, the painter's interest clearly lies in combining the human figure and a landscape within a unitary whole. The two genres mutually complement each other. The color, the light, and the atmosphere lend unity to the work. X-rays show another naked woman where the shepherd now stands.

Three Philosophers

(~1508)
oil on canvas
48.5 x 57 in (123 x 144.5 cm)
Kunsthistorisches Museum,
Vienna

There are various interpretations regarding the meaning of this work. Given the painter's education and the intellectual circles in which he moved, especially at the University of Padua, it should be understood as the representation of the three ages of man: youth, maturity, and elderliness. This idea is echoed by the trees behind the three stately looking subjects, who are situated within a landscape on a natural staircase of rocks dressed in carefully chosen attire. Their serious and reflective expressions transmit mystery, as if they were searching for the solution to a profoundly troubling problem.

The scene is possibly linked to a transcendent reality. Throughout his life, Man never stops asking: Where do we come from? Who are we? and Where are we going? During Giorgione's day, these fundamental religious and profane questions provided the basis of the concept of cosmic globalization, which was widely supported by Neo-Platonic humanism. The painter presents three personages united by the common goal of solving the great problem. Their location in nature enhances the unitary cosmic concept that so interested the painter. The main areas of light, the foreground with the figures and the background with the landscape, are separated by the cave and trees. In the manner of a backdrop, they constitute two different worlds within a single scene.

Despite its intriguing symbolism, the scene abounds with optimism, in the intense illumination, the subtle modeling of the figures, the warm and enveloping color scheme, and the calmness of both the landscape setting and the philosophers. The artist appears to say that, despite everything, life should be viewed positively and faced with hope.

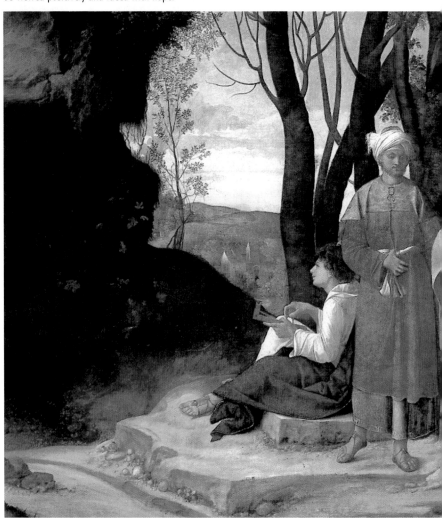

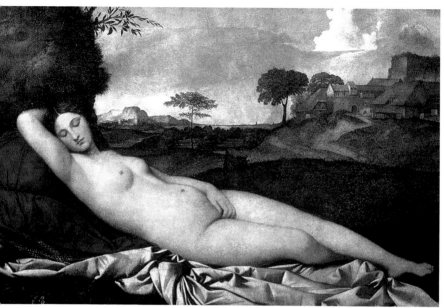

Set within an enigmatic landscape this venus shares certain similarities with Titian's *Venus of Urbino*. Giorgione painted the goddess and the rocks on the right, whereas the foreground and the landscape on the left are attributed to Titian, who probably finished it following the death of Giorgione. Furthermore, Titian appears to have altered Giorgione's initial design by painting Cupid

Sleeping Venus

(~1510)
oil on canvas
43 x 69 in (108.5 x 175 cm)
Gemäldegalerie, Dresden

(not shown in this image) with a little bird in his hand. This figure, concealed at one time, was discovered during restoration work on the painting in 1843. Nonetheless, it was so seriously deteriorated that the area was covered over again.

In his endeavor to attain a relation between landscape and the figure, Giorgione based the work exclusively on these two elements, for which reason Cupid and the patch are attributed to Titian. This nude body has elongated proportions of exquisite beauty, a clear representation of the Renaissance ideal of female beauty. In addition to the harmonious poetry of her form, she constitutes an embodiment of sensuality and eroticism. The woman's forms are rounded, with sinuous curves, constituting an invitation for the viewer's gaze to linger on them.

A series of details make this pose truly erotic. The right arm behind the head shows her underarm and makes her breast rise, firmly erect, while the woman's attitude is nonchalant and uninhibited. The head is slightly inclined, the face expressing pleasant sleep and her left hand playing with her pubis while she crosses her legs and keeps her thighs together. These are elements that the artist included in order to create a suggestive image. Giorgione succeeded in integrating the figure into the open landscape with great intelligence, placing the nude in a darker area to emphasize her luminosity. X-rays taken of this work reveal the numerous rectifcations carried out by the artist, for content reasons, rather for than compositional reasons.

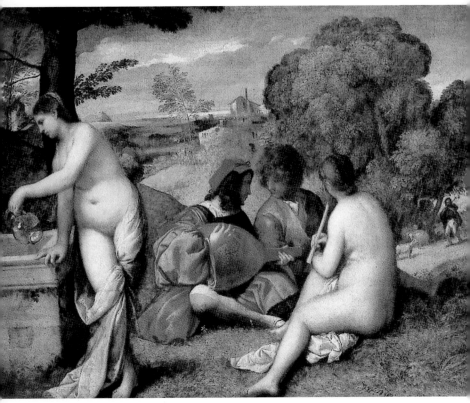

Fête Champêtre, or Pastoral Symphony

(~1510)
oil on canvas
43 x 54 in (110 x 138 cm)
Louvre, Paris

During the time Titian was studying with Giorgione, the two artists collaborated so closely that many of Giorgione's works have been erroneously attributed to Titian (exacerbated by the scarce biography concerning the former as well as the few paintings he left). This is one such work, which centuries later was to inspire Manet for his *Le Déjeuner sur l'Herbe* (see p. 343). Once again the artist strives for a perfect combination between landscape and the figure. The focus of attention is on the two voluptuous and suggestive women and the idyllic natural setting with its abundant vegetation. This combination of elements is set against a bucolic landscape (the green of nature, the luxuriance of the trees, the shepherd with his flock, the tiny village in the background, and so forth). The warm colors and poetic atmosphere that envelops the work and unifies the whole.

This is a work of immense sensuality and eroticism, with the representation of two women, unconcerned with their nudity, shown with several musicians who are discussing the piece they are about to play. The woman sitting on the grass partakes in the conversation, while the woman standing up, languid and distracted, pours water from a glass into a well.

Giorgione was aware that a nude for nude's sake was meaningless; it had to transmit something: mystery, candidness, sensuality, poetry, evil. These nudes, in addition to poetry, breathe freedom, delighting in nature. They are the reflection of the human being in its purest state and in its natural environment. They are treated with notable elegance, as much in the interpretation of the figure as in the flesh, and their skin reflects part of the golden light that envelops the atmosphere. This natural enclosure also doubles as a room, thus lending greater intimacy to the scene. Indeed, the dark background makes the women's bodies give off light, imbuing the scene with an atmosphere of tranquility and desire. This is an outstanding example of the painter's use of color and his pictorial concept, given that it displays a heightened Venetian color scheme, as opposed to the sfumato of Leonardo da Vinci, while at the same time achieving a relationship between figure and landscape that only the Impressionists were able to surpass.

RAPHAEL

Self-portrait *(detail), oil on wood, 18 x 13 in (45 x 33 cm), 1506, Uffizi Gallery, Florence.*

Raphael's (Raffaelo Sanzio or Santi) artwork can be divided into three artistic periods: The first (1500-1504) corresponds to his time in Perugia, with works that denote fidelity to the teachings of Perugino and respect for the tradition of the Umbrian School, as seen by a balanced composition, great formal simplicity, brilliant treatment of light, and the use of clean colors, invigorated by a sensitive lyricism.

The second period (1504-1508), during his time in Florence, is defined by his association with and rapid assimilation of Neo-Platonic ideology, adopting Leonardo da Vinci's interest in studying the human body, and Michelangelo's grandiose pictorial language.

The third period (1508-1520) coincides with his time in Rome, where he became the painter of preference among the Popes. The church leaders were obsessed with making Rome the center of contemporary Italian culture, which until then had been located in Florence. Raphael established the standards of official art, which represented the culmination of the universal and globalist concepts of Renaissance Rome, and consolidated a new style, Mannerism, which was to change the direction of the whole of European art.

Raphael was a superb artist whose works were personal in style and aesthetic, and who was able to capture the delicate beauty of his models. His works in general, as well as the details, were magnificent, with a meticulous application of transparencies using clean and vivid colors.

His stature is imposing, considering that he died at the age of 37, having achieved everything.

- **1483** Born in Urbino on March 28, son of the painter Giovanni Santi.
- **1494** Following the death of his father, he enters the studio of Pier della Pieve in Perugia.
- **1500** Works in the studio of Perugino, in Perugia.
- **1504** Paints *The Nuptials of the Virgin* (see p. 106), perhaps his most important work in this period. During a brief stay in Sienna, he paints *The Three Graces, An Allegory* (or *Vision of a Knight*) (Condé Museum, Chantilly and National Gallery, London, respectively), and *St. George and the Dragon* (see p. 108). With a recommendation from the Duke of Urbino's sister, he establishes himself in Florence. The art he creates during this period shows the influence of Leonardo and Fra Bartolomeo. He primarily concentrates on painting Madonnas, such as *The Coronation of the Virgin* (Vatican Gallery, Vatican City) and *Madonna with the Fish* (Prado, Madrid), but he also executes other themes: *The Pregnant Woman (La Donna Gravida)* and *Maddalena Doni* (both in the Palatine Gallery, Palazzo Pitti, Florence).
- **1508** Moves to Rome, summoned by Pope Julius II, who commissions the fresco decoration of two rooms in the Vatican, the Stanza della Segnatura (*The School of Athens, Parnassus,* and *Justice.*), which he completes in 1513, and the Stanza di Eliodoro, in which he paints *Miracolo di Boisano,* completed in 1415.
- **1513** When Julius II dies, his successor, Leo X, continues to confide in Raphael. He is one of the architects involved in the construction of St. Peter's Basilica. Paints the Sistine Madonna and draws up the plans for the Chigi Chapel in the Church of Santa Maria del Popolo, Rome.
- **1514** Succeeds Bramante as supervisor of various pontifical construction sites.
- **1517** Executes the sketches for 7 cartoons, to be used for the tapestry series on *The Apostles' Deeds,* manufactured in Brussels by P. Van Aelst.
- **1518** Begins painting *The Transfiguration* (see p. 110), which he nearly finishes in the same year. Its symbolism and structural complexity inspire a change, not only in Italian art, but also in European art in general.
- **1520** On April 6, he dies in Rome of the pneumonia which he catches when inspecting a construction site. His illness was probably compounded by his exhaustion due to his constant and enormous workload and the excesses of his passionate affair with his model and lover, Margarita, la Fornarina. He is buried in the Pantheon.

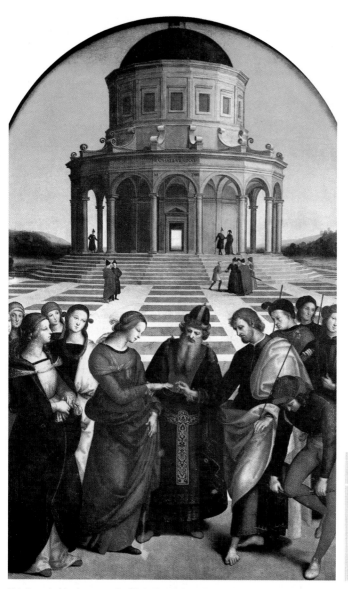

The Nuptials of the Virgin

(1504)
oil on wood
47 x 67.5 in
(118 x 170 cm)
Pinacoteca di Brera,
Milan

This is probably the most significant work from Raphael's early period in Perugia. It shows the influence of his teacher, Perugino (Pietro Vanucci), and a deep respect for the Umbria School. Despite the many figures and architectural elements represented, the painting is impeccably structured, with an ordered, symmetrical, and highly balanced composition, doubtless arising from both the intellectual rigor that the young painter had always demonstrated and his architectural skill. The latter is clearly shown by the depth of perspective and by the shrine presiding in the background—a perfectly designed architectural draft that reflects the influence of Bramante (it resembles the latter's Shrine of San Pietro di Montoro).

The painting is profoundly solemn and wisely uses a varied color range, the density of which gives rise to a rich and balanced color scheme. Raphael plays with light to animate the entire scene. There are three sources of light: one from the upper right, illuminating the figures in the foreground; another from the upper right as well, but entering diagonally and falling on the façade of the shrine, the staircase at its base, and the richly patterned flagstones leading up to it; and a third behind the shrine, lighting the blue sky. The tender, candid expressions of the faces are remarkable, as are the figures' gestures and poses. At the age of 20, Raphael was already revealing his great talent.

The Crucified Christ with the Virgin Mary, Saints, and Angels

(1503)
oil on wood
111.5 x 65 in (281 x 165 cm)
National Gallery, London

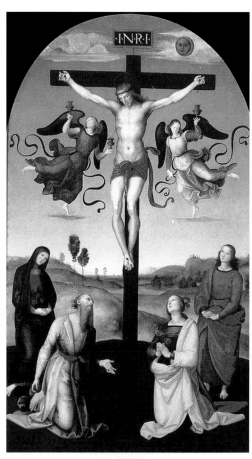

This is one of a group of three altarpieces from Raphael's early period, created for the church in Città di Castello. It shows the influence of Perugino, and has certain compositional aspects characteristic of Piero della Francesca.

The panel contains all of the pictorial elements that the artist used to captivate the viewer: a highly balanced and harmonious composition and a bright palette of varied tones, such that the compositional and chromatic rhythms combine perfectly. In the center, Christ crucified stands out against an intense blue sky. The simultaneous color contrasts eliminate the need to create an aura to light the figure, as the complexion itself is resplendent and energizes the painting.

During his Florence period, the artist's production centered on a series of portraits and Madonnas, conceived according to the same criteria. Along with *The Virgin of the Goldfinch* and *The Virgin of the Meadow*, this work can be considered one of the most representative of the period.

The pyramidal composition is very simple, with the Virgin centered in the scene, Jesus to one side, and John the Baptist to the other. Raphael avoids any accessories or elements that could distract the viewer's attention from the protagonists, who are normal, wholly unidealized people, without so much as a halo around the Virgin's head commonly found in other representations.

The landscape in the background is a reproduction of a real view, with the detail of the church reflecting the artist's interest in architecture. In addition to establishing a unique style through these Madonnas, Raphael introduced a highly delicate woman and child that were easily comprehensible to the devout of his time.

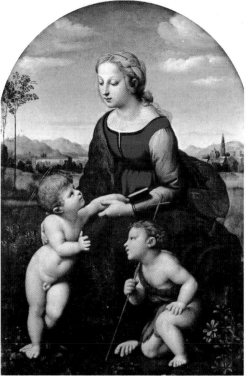

La Belle Jardinière

(1507)
oil on wood
52 x 32 in (132 x 80 cm)
Louvre, Paris

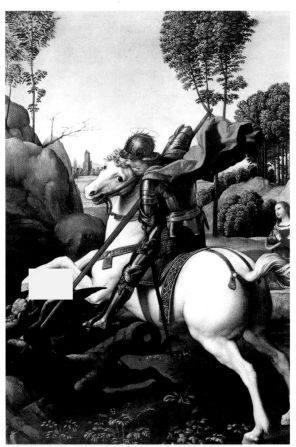

Saint George and the Dragon

(1504-1506)
oil on wood
11 x 8 in (28 x 21 cm)
National Gallery of Art,
Washington, DC

This work was painted during the artist's period in Florence, where he was immersed in the full effervescence of Renaissance ideology. Aside from the numerous Madonnas Raphael painted at this time, he also executed other themes, such as this one, following the same artistic concept.

The composition is well structured, with a general balance of masses and chromatic harmony prevailing. Attention focuses on the saint, represented in elegant, delicate lines and dense colors, with the whiteness of the horse illuminating the entire scene. Despite its precocious nature, the classicism of the scene shows Raphael's grandeur in his sure brushstroke and refined taste.

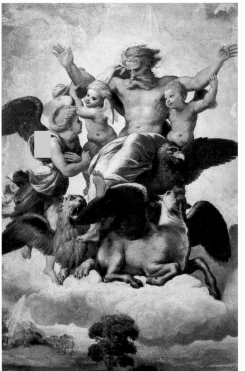

Ezekiel's Vision

(1518)
oil on panel
16 x 12 in (40 x 30 cm)
Palatine Gallery, Palazzo Pitti,
Florence

In accordance with the biblical episode, the painter represents God accompanied by the symbols of the evangelists: the eagle (John), lion (Mark), angel (Matthew), and bull (Luke). The miraculous vision is enhanced by a golden atmosphere pervading the whole, tingeing the sky and impregnating all elements represented. The striking circular composition, in addition to uniting the protagonists, increases the sense of solemnity and transcendence evoked by each figure in this successful dramatization. In the distant landscape of the lower background, the prophet appears as a miniscule figure illuminated by a beam of light.

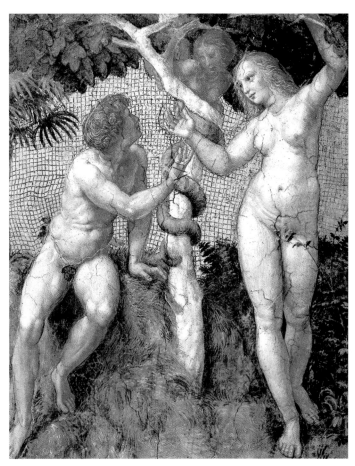

Adam and Eve

(1508-1511)
fresco
47.6 x 41.6 in (120 x 105 cm)
Cupola of the Stanza della
Segnatura, Vatican City

This scene is a detail of the first series of frescos executed by Raphael in several rooms of the Vatican. The figures are placed symmetrically, flanking the Tree of Good and Evil, which acts as the centerpiece. In keeping with his style, Raphael treats these powerful nudes with great subtlety and perfection.

Adam exhibits a beautiful anatomy, with a muscular, well-proportioned body. His pose is technically challenging, with complex foreshortening, an extreme torsion of the trunk, and a frontal view of his bent legs. Eve, full-bodied and voluptuous, is standing in a harmonious contrapposto that enhances her charm. The slanting hips and powerful thighs accentuate the curvature of her figure. As in the figure of Adam, her trunk is also twisted and her left leg foreshortened as well, capturing the movement as if in a snapshot.

The painter includes interesting details in Eve's body: a slender, well-proportioned torso with large breasts, combined with a somewhat rounded abdomen, with evident folds along the lower area as a consequence of her maternity. Another significant aspect is the treatment of light on the two nudes, lending them a highly realistic volume. The shadows are softer in the areas of contact with light, such that the modeling is gentle and a soft tone predominates in the complexions, although Adam has elaborate muscles. The scene breathes serene tranquility, balance, and harmony. The general conception recalls Dürer's work on the same theme, whereas the anatomical structure and gestures of the figures evoke Michelangelo.

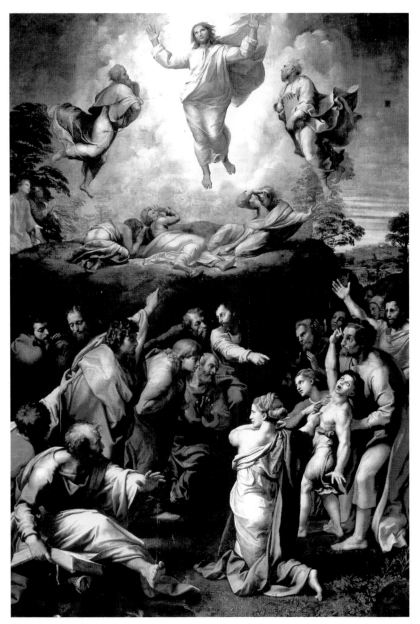

The Transfiguration

(1518-1520)
oil on wood
161 x 110 in (405 x 278 cm)
Vatican Gallery, Vatican City

The artist was finishing this work when he noticed the first symptoms of an illness that led to his death in only ten days. This canvas was exhibited on his catafalque. It is an important work reflecting the progression in Raphael's artwork, which was gradually growing more expressive, with a variety of vibrant colors and intense, vivid colors juxtaposed with dense, dark tones.

The scene is spectacular, with the figure of Christ emerging from an illuminated area of clouds and levitating between Moses and Elijah. Lying on a small mound at his feet are the apostles Peter, John, and James, overcome by what they are seeing. In the foreground are the remaining apostles, relatives, and followers of Christ, with profoundly expressive faces showing astonishment and alarm. The general composition, the distribution of figures, their poses and gestures, the treatment of light and color, and the symbolism reflected therein constitute a milestone, not only in the artist's career, but also in European art. It presages Caravaggio's chiaroscuro, and represents the consolidation of Mannerism and the beginning of the Baroque period.

TITIAN

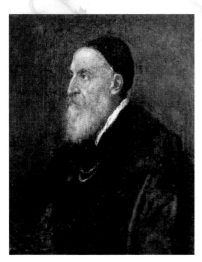

Self-portrait, *oil on canvas, 34 x 26 in (86 x 65 cm), 1567-1568, Prado, Madrid.*

Titian (Tiziano Vecellio) is the representative of the last classicist period, although, due to his longevity, his work illustrates the aesthetic and stylistic evolution of Renaissance painting from the Quattrocento to Mannerism.

In his first period, naturalistic in character, he was interested in the force of color, which he used with formal, volumetric, and spatial objectives, and in compositional audacity. Titian applied large chromatic areas of intense contrasts, and his works had a natural atmosphere, with the use of the landscape as a backdrop. His portraits were dark.

His second period, from 1520 to 1530, was characterized by the influence of light on volume and atmosphere, depth, an increased dynamism in his figures, and the use of warm colors with contrasting cool tones.

Beginning with his paintings for the Dukes of Mantua and Urbino, under the pressure of court demands, his art became more aristocratic and evolved toward Mannerism, a movement being consolidated in Venice. He executed many portraits and mythological themes, incorporating a powerful air of eroticism, with opulent female nudes in pearly or golden tones, as well as strong male bodies. His work in this period was classical in conception, with a certain Baroque atmosphere especially evident in facial expressions, stormy atmospheres, and loose brushstrokes, with dark tones predominating.

- **1488** Born in Pieve di Cadore, Veneto.

- **1500** Begins working in the studio of Sebastian Zuccaro, master of the Venetian mosaic, and later in Gentile and Giovanni Bellini's studio.

- **1508** Collaborates with Giorgione in the decoration of the secondary façades of the Fondaco dei Tedeschi in Venice.

- **1511** Executes frescos in the Scuola del Santo in Padua, and a Holy Spirit altarpiece.

- **1516** Succeeds Giovanni Bellini as the official painter of Charles V. Alfonso I d'Este, Duke of Ferrara, summons him and commissions a series of works for his palace.

- **1518** Completes *The Assumption of Mary* for the Church of Santa Maria Gloriosa dei Frari in Venice. Between 1518 and 1523, he executes several pieces for Alfonso d'Este: *Offering to the Gods of Love* and *Bacchanal* (both in the Prado, Madrid), and *Bacchus and Ariadne* (National Gallery, London).

- **1520** He is commissioned to paint the altarpiece of the Church of San Francesco in Ancona.

- **1522** Paints the Polyptych of Brescia.

- **1523** Enters into contact with Federico de Gonzaga, Marquis of Mantua, for whom he executes two portraits.

- **1526** Paints the altarpiece of *The Virgin of Pesaro* for the Santa Maria Gloriosa dei Frari.

- **1528** Paints *The Death of the Martyr St. Peter,* for the Church of Santi Giovanni e Paolo, in Venice.

- **1530** Begins to frequent the courts of Ferrara, Mantua, and Urbino, where he comes into contact with the Mannerist movement. Paints a portrait of Charles V in Bologna (see p. 115).

- **1533** Charles V appoints him Palatine Count.

- **1543** Paints the portrait of Pope Paul III (see p. 115).

- **1551** Travels twice to Augsburg, where he executes an equestrian portrait of Charles V, as well as the portraits of Isabel of Portugal and Philip II (all three in the Prado, Madrid).

- **~1553** Settles definitively in Venice. His works in this period are more informal, with spectacular light effects and dramatic expressiveness.

- **1576** Dies in Venice along with his son Orazio, victims of the bubonic plague. Buried with great pomp in the Santa Maria Gloriosa dei Frari.

Venus and Cupid with an Organist

(~1548)
oil on canvas
59 x 86 in (148 x 217 cm)
Prado, Madrid

Hardly any works with nudes in a landscape before Titian's have survived to our times. Giorgione was probably the first to paint such a theme, in his *Sleeping Venus,* whose characteristics indicate that Titian, his disciple and collaborator, may also have contributed to the work.

This painting is one of the most beautiful allegories of eroticism, a theme which Titian painted several times. The scene combines a courtly atmosphere with the evocation of a mythological figure. It portrays a voluptuous woman, a stunning Venus reclining on a bed, listening to the whispers of her child Cupid, the symbol of love, accompanied by the music of a young organ-player. Distracted from his instrument, he takes in the view of the naked woman, fixing his gaze on her pubis, thus accentuating the eroticism of the scene.

The nude Venus is powerful, elegant, and insinuating. Her attitude is particularly provocative, subtle and disconcertingly ambiguous, somewhat nonchalant, and somewhat premeditated. The accentuated curvature of her torso harmonizes with the position of her arms and legs, resembling Rubens' female divinities. In contrast to other goddesses, this figure is human, with the proportions of a real woman and not an idealized heroine. Nonetheless, she exhibits vestiges of the Nordic canon of beauty. Her head is somewhat small, the shoulders narrow, the breasts small. The influence of Rubens is evident in the treatment of the complexion and in the wide hips. Clearly, the mythological title is only an excuse to paint a theme with strong erotic connotations. The woman's attitude, the warm palette, the luxurious foreground, the involvement of the child, and the splendid and extremely ordered landscape in the background can all be interpreted as attributes used by the artist to create an appropriate atmosphere for a scene of lubricity.

This canvas represents various structurally divided scenes comprising a sort of composition in parts. Each group of elements (the celestial image of the Virgin with angels, St. Nicholas surrounded by other figures, and St. Sebastian) could be organized as a complete iconographic program and an independent work, yet together they form a coherent and well-structured whole. This type of composition, though not entirely original, is not common in art, except in cases of a sequential narrative.

Madonna of Frari

(1533-1535)
oil on canvas
154 x 107 in
(388 x 270 cm)
Vatican Gallery, Vatican City

It partially complicates, yet at the same time enriches the narrative, which is appropriate here since it suited the client (the painting was designed for the Church of Santa Maria Gloriosa dei Frari, in Venice). The glorification of Mary, seated on a bed of clouds, is evoked simply and without ostentation. She is represented as a simple, meek woman, unidealized despite her location on high. The lower frieze represents several saints, including Francis, Anthony of Padua, Peter Nicholas and Catherine, each wearing garments that make them easy to identify.

St. Sebastian stands out on the right, with a very young, nearly adolescent aspect, forming an interesting compositional diagonal with the Virgin Mary, allowing a harmonic interpretation based on the figures' gazes, which form a triangle. St. Sebastian is not looking toward the heavens as in most representations, but rather at the ground, making him a sacred icon. This nude, although in strong contrapposto, is not as sensual as other representations of this saint, perhaps because he is an accessory to the scene and not its protagonist. The figure of St. Sebastian is effeminate and naturalist, exempt of any idealization.

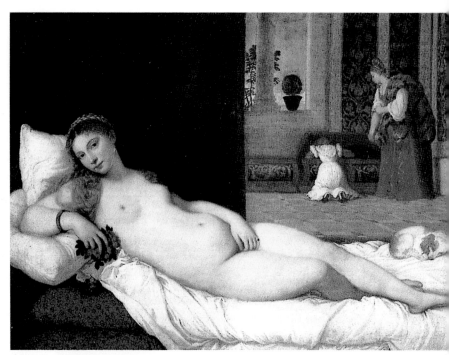

Venus of Urbino

(1538)
oil on canvas
47 x 65 in (119 x 165 cm)
Uffizi Gallery, Florence

This is one of Titian's most renowned works, executed at the court of Urbino at a time when the artist was in high demand by various families of the Italian nobility. It was commissioned by Guidobaldo della Rovere, the Duke of Urbino's son, a fact which has lead to speculation as to the identity of the model. Some believe she was Guidobaldo's wife, whereas others maintain that the model was a courtesan with whom he was deeply in love.

Although the title evokes a mythological figure, it is clear that the artist was simply using this excuse in order to paint a female nude with the freedom necessary to lend her a great deal of eroticism. The woman's sensual pose and attitude are accentuated by the sober yet stately setting and her luminous body. The painting is natural, refined, and sumptuous. A young woman with a splendid body reclines on a bed, whose white sheets radiate light, illuminating the entire room. Her attitude is ambiguous, somewhere between coquettish and insinuating, ingenuous and lascivious, and innocent and provocative, subliminally accentuated through her uninhibited demeanor. Despite her nudity, she is wholly unconcerned and self-assured. She gazes at the viewer nonchalantly, while playing with her pubic hair in a clearly defiant and inviting gesture.

Another erotic feature of this nude is her hair, which falls purposefully over her shoulder, a detail which in Titian's time was considered highly erotic, as it was customary for women to let their hair loose only in the intimacy of the bedroom. The representation seems natural but is really very studied. The two figures in the background, with their garments and attitude, provide a perfect complement to the nude.

Portrait of Pope Paul III

(1543)
oil on canvas
42 x 34 in (106 x 85 cm)
Museo Capodimonte, Naples

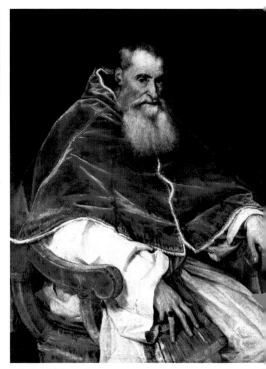

Titian was in Ferrara when he was summoned by Pope Paul III to paint this portrait. It was executed in Bologna, where the Pope was meeting with Charles V. The Pope exhibits a meticulous, expressive face, which is an excellent personality study. He is portrayed in red and white against a dark background. The artist demonstrates great skill in reproducing textures, whether anatomical (such as in the beard and hair), or in the garments. The pope must have been deeply satisfied with this portrait, as he requested another two years later, this time in the company of Cardinal Farnese and Duke Octavius, a relative of the Pope.

Portrait of Emperor Charles V

(1548)
oil on canvas
81 x 48.5 in (205 x 122 cm)
Alte Pinakothek, Munich

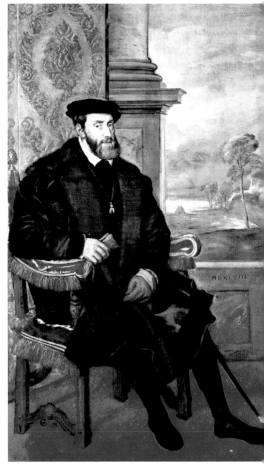

Charles V admired Titian, appointing him royal painter and, later, Palatine Count. The artist had already executed an excellent equestrian portrait of the monarch (Prado, Madrid), which had deeply impressed him. This one is very different.

The emperor is represented in the intimacy of a room in his palace, with a placid, kind attitude and an expressive face. In contrast to many of his paintings, Titian creates a background consisting of a rich fabric lining the wall on the left and a tapestry depicting a bright landscape on the right. This provides an excellent backdrop for the two intense, contrasting tones predominating in the foreground: the red of the rug and the various, intense dark tones of the garments. The artist successfully renders three important aspects: the personality of the sitter, elements and details which dignify him and provide context, and a composition with highly attractive and chromatic qualities.

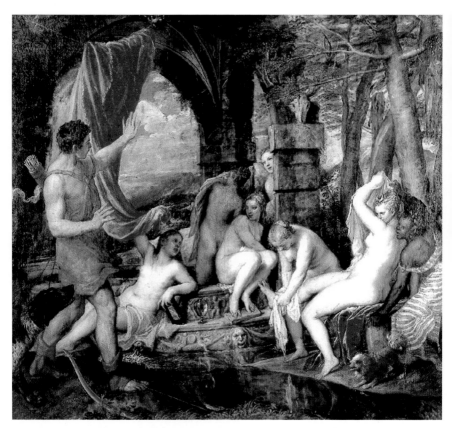

Diana and Actaeon

(1556-1559)
oil on canvas
75 x 81.5 in (190 x 207 cm)
National Gallery of Scotland,
Edinburgh

This scene is set among ruins with a lighting that resembles an interior. Titian revises the classical theme and represents a series of beautiful nymphs bathing after a hard day. They are presided over by Diana, the goddess of forests, nature, and the hunt, portrayed on the right being attended by a servant who dries her feet. On the left, the hunter Actaeon breaks into the scene and is spellbound, contemplating Diana's nudity. Realizing his presence, she makes a gesture of surprise, about to cover her body. This incident leads the misfortunate hunter to be turned into a deer and then be devoured by the goddess' fifty hounds.

The nudes are monumental, adopting varied and complex postures that constitute a rich sample of classic academic poses, skillfully combined within the composition, which is harmonic, balanced, and artistically attractive. The female bodies, slender and natural, are executed in loose and vibrant brushstrokes. The treatment of light is excellent and theatrical, with the colors typical of the Venetian School. The light adds depth and lends the figures relief and volume, brilliantly illuminating the goddess. The artist uses it to lead the eye to the protagonists.

The scene is highly sensual, with a great deal of movement and sinuous curves, uninhibited poses, and general freshness and spontaneity. The complexions, delicate and milky, were very much in vogue at the time. The dark contrasts accentuate the pallid complexions and define the outlines of these opulent female forms. This is an informal and dramatic work.

HANS HOLBEIN, THE YOUNGER

Self-portrait, *colored pastels on paper, 12.5 x 10 in (32 x 26 cm), 1542-1543, Uffizi Gallery, Florence.*

Holbein's artistic inheritance from his father was a prodigious one, as the elder's work was a chronicle of the entire southern German pictorial tradition as well as that of Flanders. This led the younger Holbein to develop a penetrating style, focused on the person.

Holbein, fully identifying with humanist ideals, was an extraordinary portraitist. Through precise and meticulous draftsmanship, he captured the psychology and personality of the sitter to extraordinary depths. At the same time, he did not concentrate on internal aspects alone, but also developed the external ones. He showed the person's inner as well as outer world and social position.

In his continual travels throughout Europe, he gained vast cultural knowledge and came into contact with the different ideological movements of Italy, France, England, and Switzerland, as well as the humanist vanguards of the time.

His skill in portraiture led him to render his figures with a deep inner dimension, demonstrating a singular, intense, and sober style. As compensation for his profound search for reality, Holbein borrowed the monumentality and architectural settings of Italian art.

His long periods in Britain decisively contributed to the pictorial evolution of that country. His extraordinary gift as an observer, his sense of aesthetics, and the great formal balance of his works constitute a benchmark, especially in the genre of portraiture, for later generations of painters.

- **1497** Born in Augsburg to the painter and engraver, Hans Holbein, the Elder, who becomes his teacher.
- **1515** Moves to Basel, Switzerland, where he executes his first painting, a centerpiece for a table with scenes of medieval traditions and customs.
- **1516** Illustrates a copy of *Encomium Morae*, or *The Praise of Folly*, by Erasmus, and paints an altarpiece with the Virgin, the burgomaster Jakob Meyer, and the burgomaster's wife.
- **1517** In collaboration with his father, he executes book illustrations and the façade decoration of Mayor Jakob von Hertenstein's house in Lucerne, where he demonstrates his knowledge of perspective and the Paduan Renaissance style.
- **1519** Joins the guild Zum Himmel in Basel.
- **1520** Works in Germany until 1526, concentrating particularly on portraits in which he already reveals his skill in distant, penetrating, and objective observation. He paints the portrait of the humanist, B. Amerbach, various panels with scenes from the Passion for the Oberiel Altar of the Freiburg cathedral, and *The Body of the Dead Christ in the Tomb* (see p. 118), possibly influenced by Grünewald.
- **1523** He befriends Erasmus of Rotterdam.
- **1525** Executes frescos in the High Council Hall of the Basel town hall and on the façade of the Zum Tranz House, with beautiful architectural motifs.
- **1526** Due to the Reformation, he moves to Britain, with a letter recommendation from Erasmus of Rotterdam to Thomas More. He resides there for two years, executing various commissions, including many portraits of important people (Thomas More, Nikolaus Kratzer, Thomas Godsalver), which were acclaimed by the public.
- **1528** Returns to Basel, but is profoundly disturbed by the religious upheaval there. Executes a portrait of Erasmus of Rotterdam.
- **1532** Returns to London. As his benefactor, Thomas More, has fallen into disgrace, he begins working for German merchants established in the city.
- **1533** He is constantly in contact with the English court, for whom he executes various works, primarily portraits.
- **1538** Returns to Basel, but three years later is living in London again.
- **1543** Dies in London from the bubonic plague on November 28.

The Body of the Dead Christ in the Tomb

(1521-1522)
oil on wood
12 x 79 in (30.5 x 200 cm)
Öffentliche Kunstsammlung,
Kunstmuseum, Basel

This image is realism taken to the extreme. As opposed to other representations, where Christ is portrayed tenderly or simply as if sleeping, this is the representation of a real corpse, with all of the signs of the traumatic death that it has undergone, and the recent rigor mortis evident in the position of the mouth and the progressive contraction of the fingers.

Holbein shows not only death, but also the signs of suffering of a man who was cruelly tortured. The purplish hands and feet are like extensions of the delicate yet powerful and well-proportioned body. Jesus' height and extreme slenderness lend his anatomy great spirituality. His face is the epitome of the image of death. The sense of helplessness that this vision evokes in the viewer leads to meditation and elicits reverence and devotion. The ashen complexion, the open eyes gazing upward, and the mouth ajar with the tongue protruding contribute to the underlying, silent drama.

To increase the dramatic effect, the corpse is not presented in an open space but rather boxed into the reduced space of a cemetery niche, emphasizing the extreme humiliation of Christ's human condition. Originally, the niche was curved along its upper edge, but it was retouched a year later and made straight. Rather then fear, the reaction elicited is an impulse toward profound meditation, humanizing the divinity of Jesus to the point of representing his total powerlessness and desolation. This work is an eloquent example of German Expressionism, inherited from the late Gothic through Grünewald, whose influence here is indisputable.

Erasmus of Rotterdam

(1523)
oil on wood
16.5 x 12.5 in (43 x 33 cm)
Louvre, Paris

Hans Holbein was very close to Erasmus, who had become his protector. When the Reformation began, he encouraged Holbein to move to London and wrote him a letter of recommendation to Thomas More, at that time a very influential figure in England. In this portrait, Holbein executes an introspective study of Erasmus, portrayed in profile and with a compositional harmony of nearly Raphaelesque perfection. Nonetheless, it is not a flat painting. There is a great deal of volume and a special relation between the background and the figure, the former providing context for the figure, which in turn gives meaning to the background.

Erasmus is represented as an intelligent, serene, and peaceful person. His concentration recalls the image of a tolerant person with a sense of humor, far from the grave serenity of other portraits of the same period. Originally, this work belonged to the royal English collections, but later it was given to Louis XIII of France in exchange for Leonardo's *Saint John the Baptist*. This portrait is believed to have been a gift from Erasmus to his friend Thomas More, as there is a letter from the latter thanking him for the painting, although the letter may have referred to another of the several portraits of Erasmus executed by Holbein.

After Holbein, introspection became one of the most important premises for artists to follow in the portrait genre. The model was no longer the object of solely physical representation, but of a true psychological study. Although Leonardo da Vinci had previously enriched the genre by incorporating the figure's inner world, Holbein made it a dominant characteristic.

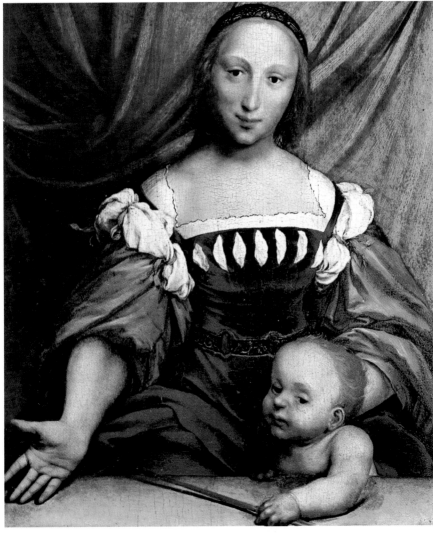

Venus and Cupid

(~1526)
tempera on wood
13.5 x 10 in (34.5 x 26 cm)
Öffentliche Kunstsammlung,
Kunstmuseum, Basel

This painting may have formed a diptych with that of Lais of Corinth as an allegory of pure love and profane love, although this is a somewhat disputed theory. Some even consider the possibility that the figure of Cupid was added later.

The goddess is represented as a courtesan. Some identify her with Dorothea Offenburg, the wife of the nobleman Joachim von Sultz. She was famous for the resounding scandals of her libertine lifestyle and constant love affairs, which she had carried on from a young age, as revealed by a court case brought against her in 1539. When this painting was executed, Dorothea was only 18 years of age, such that some consider it to be her mother, Magdalena, as licentious and scandalous as her daughter. At the time of this painting, she was 44 years of age. In any case, the identity and symbolism of this woman dressed as a courtesan lends the work a certain sultry and mysterious air, as it is well-known that courtesans led a luxurious life in exchange for their amorous favors to members of the court. This would justify the inclusion of Cupid, the subject of carnal love becoming idealized through the mythological interpretation.

The stylistic resemblance of the woman's face with the ideal of beauty inherited from Leonardo is curious, as is the position of the hand in a gesture of offering that closely recalls that of Christ in Leonardo's *Last Supper*. The idealization of beauty allows Holbein to convey a series of covert messages that were easily decipherable at the time, but which have become obscure over the years.

The Artist's Wife and Two Children

(1528-1529)
tempera on paper glued
onto wood
31 x 25 in (77 x 64 cm)
Öffentliche Kunstsammlung,
Kunstmuseum, Basel

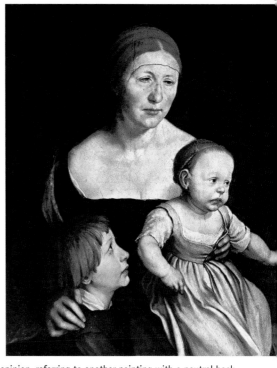

The treatment of this work is curious. The figures were first painted on paper, and then cut out and pasted onto a panel by Hans Asper, a student of the painter. This may have been due to some damage that the painting might have suffered.

The woman is Elsbeth Binsenstock, whom the painter married in 1519, represented with their son Philipp and the young Katharina. Studies attempt to ascertain the possible lost background. Some maintain that the family was originally in an interior, as there is a copy of the painting in an interior with a Renaissance atmosphere. Others maintain a very different opinion, referring to another painting with a neutral background. In any case, the influence of Leonardo's *Virgin with Child and John the Baptist* is indisputable.

The Merchant George Gisze

(1532)
oil on wood
38 x 34 in (96.3 x 85.7 cm)
Staatliche Museen,
Gemäldegalerie, Berlin

There is profound depth in this painting. It offers a great deal of information revealing Holbein's interest in portraiture and his desire to express the true personality of the sitter. On the wall on the left, the sitter's name appears under the inscription "Nulla sine merore voluptas" (There is no joy without sorrow).

Many objects appear as in a still life, such as the note written on white paper reading, "The image that you are observing shows the facial features of George Gisze, whose eyes are as lively as his cheeks." Another note states the sitter's address. The remaining elements provide additional information on the figure.

This was one of his first works for the German merchants residing in London, so Holbein put a great deal of effort into the details, as he wanted to impress them and receive more commissions. It was a successful endeavor.

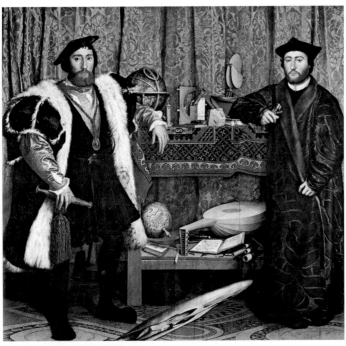

The Ambassadors

(1533)
oil on wood
82 x 83 in (207 x 209.5 cm)
National Gallery, London

This work was considered "the most beautiful painting in France," although it was sold to England in 1792. Jean de Dinteville appears on the left, with the blazon of the Order of St. Michael. To his right is Georges de Selve, with one elbow on a book, who in 1526 had been appointed bishop of Lavour and later interlocutor between the Pope and the king. The mosaic on the floor has been identified as that of the shrine of Westminster Abbey, from the early 14th century. A relevant detail is the allusion to death made by the anamorphic representation of a skull, which can be seen perfectly when the painting is viewed from an angle. Other allusions to death are the broach on Jean de Dinteville's hat and the broken string on the lute.

Henry VIII at Age 49

(1540)
tempera on wood
35 x 30 in (88 x 75 cm)
Galleria Nazionale, Rome

During his time working in the court of Henry VIII, beginning in 1533, Holbein painted various portraits of the monarch. This painting, which was a diptych with that of Anne of Cleves, his fourth wife, now in the Louvre, is highly impressive. The king's profound gaze is reinforced by his defiant pose, enriched by his ostentatious garments which, according to documentary descriptions, are the same he wore at his wedding with Anne of Cleves. This portrait idealizes the king's attitude more than his features, which clearly reflect a pretentious, overindulged, and violent character, attracted to pomp and magnificence.

CORREGGIO

Antonio Allegri, Il Correggio, in a contemporary engraving.

Although Correggio (Antonio Allegri), the standard-bearer of the pictorial school of Parma, did not produce such intellectually profound art as the Renaissance artists, he was a highly skilled draftsman, his works had great force and psychological depth, and his use of color was pleasant and vigorous, meticulously studied to achieve the atmosphere most appropriate to the sentiments he wanted to elicit from the viewer. His fluid, highly attractive art shows his expertise in creating harmonic compositions, his mastery of foreshortening, and his excellent integration of figures within background landscapes.

Correggio's works demonstrate sensibility and tenderness in his treatment of figures. The women in his art are delicate, sensual, and attractive, with suggestive forms and persistent youthfulness, their expressions affable and optimistic. In scenes in which they appear, the atmosphere, their poses, and the warmth of the chromatic range lend them a profound eroticism that is always measured and respectful, yet sultry and incisive. In his period, perhaps no one treated the female figure with such dignity and tenderness.

His paintings are formally elaborate, filled with vivid colors and a chiaroscuro which, combined with sfumato, softens forms and chromatic tones.

The work of this artist heralds Mannerism and constitutes an important precedent to the Baroque, on which it exercised a conclusive influence.

- **~1489** Born in Correggio, in northern Italy.

- **1511** Paints various medallions in the atrium of the Church of San Andrea in Mantua, which show the influence of Mantegna.

- **1518** Settles in Rome, where he studies the works of Raphael and Michelangelo, changing his art to a more expressive and complex style.

- **1519** Marries a 15-year-old woman, the daughter of the Duke of Mantua's squire, who is to serve as the model for many of his works, including *The Gypsy Madonna* (Museo Capodimonte, Naples).

- **1522** Begins the decoration of the large central cupola of the Parma cathedral, which portrays *The Assumption of the Virgin* (see p. 126). It represents the zenith of Correggio's artistic maturity. He had just finished several very important works: *Rest on the Flight to Egypt* (Uffizi Gallery, Florence), *Noli Me Tangere* (see p. 125), *Madonna della Scala* (Galleria Nazionale, Parma), *Madonna del Latte* (Szepmuveseti, Budapest), and *The Mystic Marriage of St. Catherine* (National Gallery, Washington, DC). He receives the commission of painting *The Adoration of the Child* (Uffizi Gallery, Florence).

- **1523** Paints the *Madonna of St. Jerome* (Galleria, Parma).

- **1524** The decoration of the Parma Cathedral, in which Correggio collaborates, receives heavy criticism, accompanied by the threat to relieve him of the commission and whitewash the walls. Thanks to the intervention of Titian, whose opinion of the frescos is wholly positive, Correggio is able to keep the contract and receive the payments that had been retained.

- **1528** His wife dies at 25 years of age.

- **1530** He retires to his home in Correggio. Paints the *Madonna of St. George* (Gemäldegalerie, Dresden) for the Church of San Pietro Martire in Modena. The Duke of Mantua commissions an important series of paintings on Jupiter's amorous adventures, including *Danaë* (see p. 127), *Leda and the Swan* (see p. 128), and *Zeus and Io* (Kunsthistorisches Museum, Vienna), to be given as gifts to Charles V at his coronation ceremony in Bologna. They are aesthetically refined and the atmospheres are highly erotic.

- **1534** He is commissioned to paint an altarpiece for the Church of San Agostíno, but dies at the beginning of the year in Correggio, leaving it unfinished.

The Adoration of the Magi

(1516-1518)
oil on canvas
33 x 43 in (84 x 108 cm)
Pinacoteca di Brera, Milan

This painting reflects the artist's evolution toward Mannerism and combines the style of the pre-Mannerist group of Emilia (Aspertini, Pirri, Dossi, Mazzolino, Garofalo, etc.) with Leombruno's decoration in the palace of the Dukes of Mantua. The painter is overcome by religious sentiment, creating a composition in which the figures show their faith through affected poses. The colors suggest his inclination toward Venetian chromaticism, although the use of chiaroscuro to dramatize the scene is evident. The painter's interest in the landscape is also patent, not only serving as a setting, but actually playing a significant role in the scene.

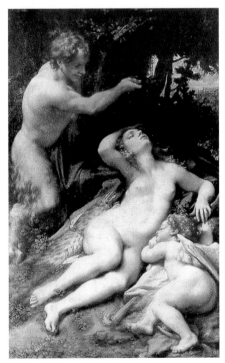

Venus, Satyr, and Cupid

(1525)
oil on canvas
75 x 49 in (190 x 124 cm)
Louvre, Paris

This graceful nude shows the influence of Leonardo da Vinci, although the pictorial treatment approaches the Venetian School: the sensuality impregnating the feminine forms is intensified by the insinuating modeling of the illumination, which lends the body a light, provocative air. The whole consists of a panoply of elements that contrast the contemplation of beauty by Cupid, partially ingenious for his childlike body, partially mischievous for the direction in which he is looking, with the more libertine instincts of the Satyr, though there is a clear complicity between the two. Venus, self-absorbed, abandons herself to her dream, apparently unconcerned by the nudity of her body but aware of the fact that it is the object of her two companions' desire.

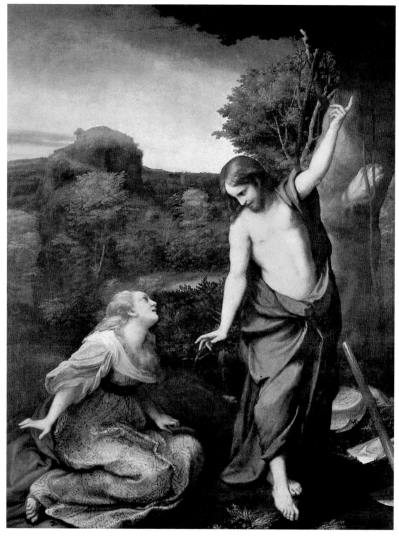

Correggio attains such expressiveness in his nudes that his paintings can be considered the most sensual beginnings of Baroque art. A deep rhythm of lines and forms, intense, well-balanced colors, and the expression of profound sentiment through pose, gesture, and facial expressions constitute the distinctive features. These characteristics are evident to such a degree in this work that it is regarded as Correggio's most representative piece.

Noli Me Tangere

(1522-1523)
oil on canvas
51.5 x 41 in (130 x 103 cm)
Prado, Madrid

A trembling and tense Mary Magdalene kneels before Jesus. Her attitude is not just of respect and admiration toward the man before her, but, in a highly expressive gesture, she surrenders her entire being, overcome by love. Jesus is very stylized, both in his Apollonian physique, with a delicate, sensual beauty, and in his extremely sensitive attitude toward the woman. This interpretation creates a sentiment of understanding and complicity between the two that goes beyond purely religious fervor, something which reliable studies have shown to be historical reality.

The dramatic aspect of the figures perfectly describes their inner sentiments, with Christ's affected pose being particularly explicit, exaggerating his fleeing stance through the diagonal formed by his arms. The dark tunic accentuates the nudity of his body, covering him to just above the pubic area with a precision that is somewhat extreme, but necessary for the development of the composition. Against the dark, velvety landscape, the whiteness of his skin becomes even more resplendent, with a soft modeling in which the shadows sculpt the male volumes without detracting from the importance of the light.

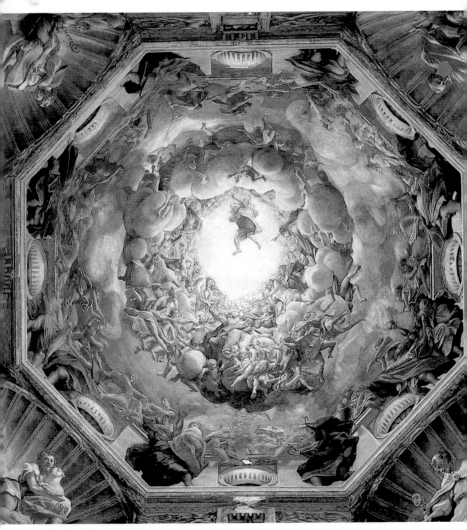

The Assumption of the Virgin

(~1525)
fresco
434 x 474 in (1093 x 1195 cm)
(diameter of base of dome)
Cathedral, Parma

After finishing the decoration of the Church of San Giovanni Evangelista in Parma, Correggio received the commission to paint the choir, cupola, and adjacent arches of the Parma Cathedral. The cupola frescos portray *The Assumption of the Virgin*, and constitute the apogee of maturity for the artist, who surpasses the works he had done in the chamber of the San Paolo Monastery and in the Church of San Giovanni.

The cupola is enormous, and therefore difficult to paint, calling for unity, depth, and light, despite the eight oculi letting in natural light. Through a composition of concentric circles in tones that becomes progressively brighter toward the apex, the most luminous area, a sensation of depth is created. The majestic figures of apostles, in wide, flowing garments, flank the circular apertures along the drum, gazing upwards.

Each circle forms a stratum in which the dense clouds mingle with countless nude bodies which, with their anatomies and robes, lend consistency to a highly dynamic, spectacular composition. In the lower stratum, the burial of Mary is depicted. The stratum just above it shows a multitude of angels carrying Mary to the heavens. In the following stratum, the saints await the Virgin's arrival and, above them all, the Archangel Michael descends to receive the Mother of God. With this composition, Correggio perfectly describes the overwhelming immensity of heaven and achieves a grand and sumptuous scene, as befits the theme. The myriad of figures and clouds in varied, rounded forms provides excellent dynamism, a clear prelude to the magnificent and graceful representations of the Baroque.

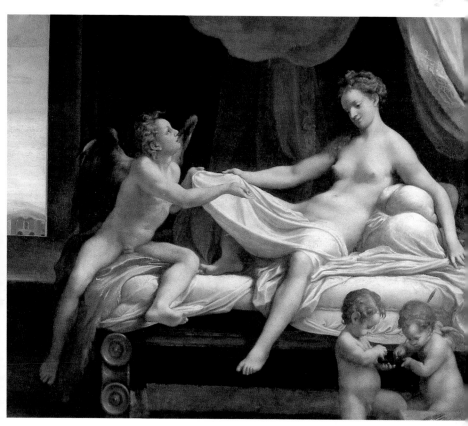

This painting was part of the series on the god Jupiter's love affairs given to Charles V by the Duke of Mantua at his coronation ceremony in Bologna. Danaë was the daughter of Acrisius, King of Argos. Jupiter fell in love with her and desired her. As the oracle had told Acrisius that one of his grandchildren would overthrow and kill him, he locked his daughter in a tower to prevent her from having children. Undaunted, Jupiter transformed himself into a golden rain and was able to possess her, begetting Perseus, who, in accordance with the oracle, accidentally overthrew and killed Acrisius.

Danaë

(1530-1532)
oil on canvas
64 x 76.5 in (161 x 193 cm)
Galleria Borghese, Rome

The scene represents the moment when the god enters the room. The image is highly erotic, all elements leading up to the consummation of the sexual act. Young Danaë, with her legs slightly apart, shows her complicity and willingness to receive the seed of her lover. Cupid, at the foot of the bed, attentively follows Jupiter's instructions and moves the sheet covering Danaë's body aside to facilitate the consummation of the act.

Jupiter is represented as the cloud in the upper central area of the canvas. The nude of Danaë, young, fragile, and sensual, gently modeled in tenuous shadows, is exquisite in all aspects. The light falls on her anatomy and emphasizes her adolescent breasts with a realism that enhances her beauty. Revealing her feelings, she gazes indulgently at her pubis, which she offers to her lover in a gesture of invitation. Cupid is a well proportioned young man with an athletic body, sitting with his legs apart and uninhibitedly showing his genitals in accordance with the typical representations of this god.

The pictorial treatment recalls Leonardo da Vinci in certain details, such as the sfumato, and develops an intense chiaroscuro in which the shadows are blended and the contours undefined. With this technique and the psychological study of Danaë's sentiments, the painter achieves a highly erotic work which is at once elegant and full of sensibility, a characteristic that fascinated numerous artists, among them, Guido Reni himself.

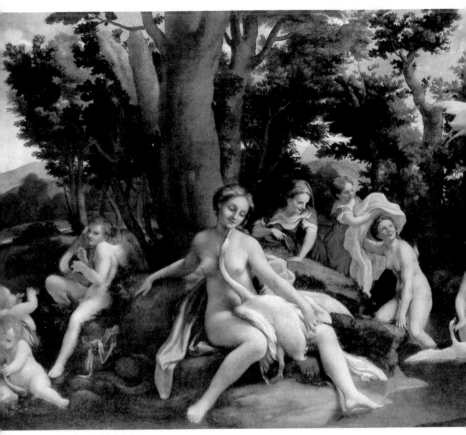

Leda and the Swan

(1530-1532)
oil on canvas
60 x 76 in (152 x 191 cm)
Staatliche Museen, Berlin

This work is part of the series that Correggio executed on the love affairs of Jupiter, commissioned by the Duke of Mantua as a gift for Charles V. Leda was the wife of Tyndareus, King of Sparta. Jupiter became enamoured of her and took the form of a swan to possess her. The beautiful Leda, fascinated by the bird's elegance and the pleasant texture of its feathers, and unaware of the spell it was under, began playing with it so that Jupiter was able to seduce her. Through this union, Leda produced four eggs, from which hatched two males, Castor and Pollux, and two females, Helen of Troy and Clytemnestra.

This is an exquisite mythological representation. Correggio creates a composition and uses a technique highly appropriate for the scene. Leda appears in an idyllic forest accompanied by other beautiful nudes, immersed in a magical and sensual atmosphere. The swan's long neck curves up between Leda's breasts and gently brushes against her torso, its beak reaching the cheek of the heroine, who slightly bows her head in a mystical gesture of submission similar to that of the Virgin Mary in certain representations of the Annunciation.

The forest serves as a backdrop, but is wholly integrated into the scene, as its dark colors enhance the luminosity of the nudes, whose warm complexions lie somewhere between golden and pearly hues. Although every aspect of this painting exudes eroticism, it is most patent in the two protagonists. Leda, her legs apart in a relaxed demeanor, is highly receptive to the swan's playful caresses, while he takes advantage of his position against her body to possess her. The strong eroticism of this work is neither grotesque nor coarse. On the contrary, it is refined, stately, and gentle, making it more subtle and thus more incisive. The extreme formal aspects of the work are combined with vivid colors. The light is wisely treated, helping Correggio to achieve highly realistic foreshortenings and a type of chiaroscuro that softens both forms and tones, in the manner of Leonardo da Vinci. This luminous treatment lends the figures an appearance of extraordinary smoothness and softness, a feature which 18th century critics called "morbidezza."

TINTORETTO

Self-portrait, *24 x 20 in (61 x 51 cm), 1588, Louvre, Paris.*

Tintoretto (Jacopo Robusti Tintoretto), a student of Bonifacio di' Pitati, Pordenone, Parmigianino, and Titian, spent almost his entire life in Venice, although his style clearly contrasts with that of the Venetian School. Instead he contributed the non-naturalistic and anti-classical Mannerist style to that school.

He was captivated by Michelangelo's draftsmanship and Titian's use of color, and his works are characterized by the volumetric forms of his figures, in daring foreshortenings, with theatrical conceptions. He lends prominence to black and white, using them to create contrasts, and adopts the wide and varied chromatic range of the Venetian School, dynamic and vigorous.

His works are highly studied and meticulously executed. Their conception is more powerful than works by Titian, and the figures are surpassed only by Michelangelo's. Opposed to classicism, he is drawn by exaggeration, tenebrism, and affected, though highly emotive, compositions, in a search for spectacularly dramatic scenes. His depiction of movement, mastery of foreshortening, and use of perspective heralds the Baroque.

Despite the fact that in his time and city, his work was eclipsed by Titian's, and thus neither received the attention it deserved nor awakened great interest, his influence is evident in the works of eminent painters such as Peter Paul Rubens and Anthony van Dyck. El Greco adopted his disconcerting stylization, Velázquez his suggestive sobriety of colors, and Tiepolo the difficult technique of technical planning and drawing.

Over time, the greatness of his artistic production has been reevaluated.

- **1518** Born in Venice to Giambattista, a dyer, or *tintore*, from Lucca, from which Tintoretto receives his sobriquet.

- **1542** Paints *Jesus in the Temple* (Duomo Museum, Milan), with a certain influence from the region of Emilia.

- **1544** Commissioned to paint two compositions (*Adam and Eve* and *Cain Slaying Abel*) for the Holy Trinity Church in Venice.

- **1546** Executes frescos in the choir of Santa Maria dell' Orto in Venice.

- **1548** Begins a series of paintings for the Brotherhood of San Marco (*The Miracle of St. Mark*, see p.130).

- **1554** The recognition he receives for his paintings for the Brotherhood of San Marco lead him to participate in a competition called by the Brotherhood of San Rocco, a rival to that of San Marco, in which he is chosen over Veronese, Schiavone, and Salviari for his work *The Glorification of St. Mark*. He receives a contract for 62 canvases, to which he devotes a large part of the remainder of his life.

- **1560** Begins decorating the Scuola di San Rocco, with scenes such as *Christ Before Pilate, Holy Mary of Egypt, The Trail to the Calvary, The Crucifixion*, and various others.

- **1572** The Venetian Senate commissions various works for the Palazzo Ducale *(The Victory at Lepanto, The Excommunication of Emperor Barbarossa*, and *Glorification of Venice).*

- **1574** During Henry III's stay in Venice, he executes various paintings and a portrait for the monarch.

- **1579** Executes a series of works for Guillermo Gonzaga, Duke of Mantua.

- **1590** Paints *The Glory of Paradise* in the Great Council Hall of the Palazzo Ducale, the largest painting in existence, in which he shows great energy and monumentality, recalling both Michelangelo, whose work he had studied in Rome, and the last artistic period of Titian, in whose studio he had worked early in his career and with whom he maintained a difficult relationship.

- **1594** Dies in Venice of bubonic plague, and is buried in the parish church that he had decorated, Santa Maria dell' Orto.

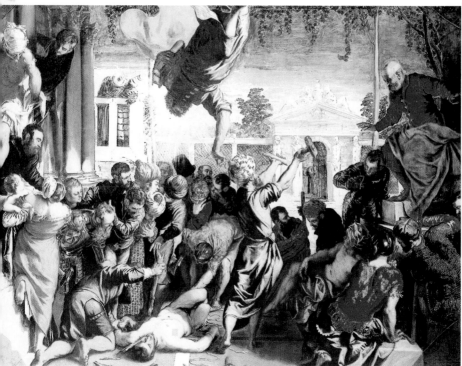

The Miracle of Saint Mark

(1548)
oil on canvas
164.6 x 214.6 in (415 x 541 cm)
Galleria dell' Accademia, Venice

Mark was the disciple of the Apostle Peter, who baptized him. He moved to Alexandria to establish a Christian community and wrote his gospel there at the request of the Christians. It was there that he was detained while he held mass. His feet were bound and he was dragged through the streets by the mob in order to kill him. When the pagans saw that he would not die, he was thrown into the sea with a large stone tied to his neck.

In this work of great movement, painted in the high and bright colors that the artist contributed to the Venetian School, a great knowledge of rhythm is evident and the composition is spectacular. Despite the large crowd gathering around the bruised body of the apostle, Tintoretto manages to focus attention on the figure of the evangelist, completely nude and lying helplessly on the ground. The fact that not all of the figures in the scene are looking at the body heightens the theatricality of the drama. Some figures are looking at one another, while others seek an explanation for the miracle that has just occurred, in which the saint's body is still intact despite having been dragged throughout the city. This interplay of gazes and the different directions of the heads increase the dramatic tension.

The reclining body is rendered in a pronounced foreshortening, so well executed that the viewer tends to forget the technique and wholly concentrate on the incident represented in the scene. A strong shaft of light illuminates the torso, making it stand out among the multitude of people and against the ground. The unity of the studied composition is remarkable, as is the varied range of colors, surprising for their vibrant richness.

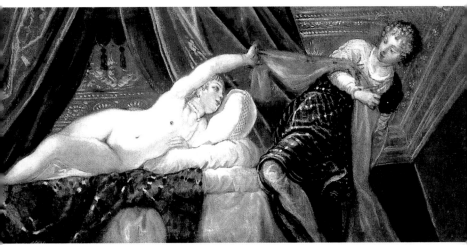

This painting is one of a series of eight commissioned by Philip II of Spain through his ambassador in Venice. Joseph was one of the twelve sons of Jacob. Angry at the favoritism their father showed for him, his brothers sold him to Ishmaelite merchants, from whom he was acquired by Potiphar, Minister of the Pharaoh and Chief of the Egyptian Guard. Joseph's intelligence and kindheartedness led his master to appoint him butler, a position that endowed him with great prestige and power throughout Egypt.

Joseph and Potiphar's Wife

(1553-1555)
oil on canvas
21.4 x 46.4 in (54 x 117 cm)
Prado, Madrid

Potiphar's wife, who was in love with the young Joseph, constantly harassed him, demanding that he sleep with her, but he always refused in loyalty to his master. Upset because Joseph had not acceded to her desires, she told her husband that he had tried to rape her and Joseph was imprisoned. This scene presents one of the many tricks the woman used to attempt to seduce him. As befits the episode, the nude is insinuating, not only for its pose and attitude, but also for the color treatment, with a cool palette that accentuates the foreshortening of the areas in shadow. The woman's attributes are emphasized through the tones of her complexion. The ample curtains, in addition to regulating the composition, lend the scene context and a luxurious, intimate atmosphere.

Purification of the Median Virgins

(1553-1555)
oil on canvas
117 x 72 in (295 x 181 cm)
Prado, Madrid

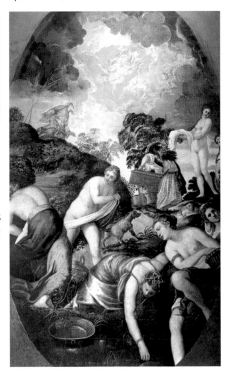

This scene refers to an episode from the Book of Numbers, chapter 31, in the Bible. Following the orders of Jahweh, Moses declared war on the Medians and killed all the men, taking the women and children prisoners, and the livestock and other possessions as booty. When they returned, Jahweh ordered all the children to be slaughtered, as well as all women who were not virgins. The virgins were to purify themselves before being handed over to the Israelite soldiers, who would possess them. The composition is triangular, and the perspective has a vanishing point near the upper right corner, lending the scene depth. The nudes are full of vitality, due to the pictorial treatment as well as the skillful use of foreshortening, creating a dynamic and sensual interplay and a spectacular scene. Under an impressively stormy sky, Moses stands to the left, as if keeping watch over the ablution of the virgins.

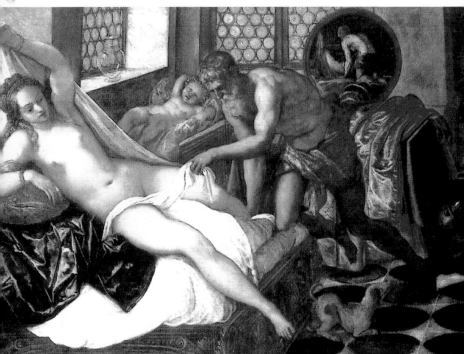

Vulcan Surprises Venus and Mars

(~1555)
oil on canvas
53.5 x 78.5 in (135 x 198 cm)
Alte Pinakothek, Munich

Vulcan, warned by the Sun of the adulterous love affair between Venus, his wife, and Mars, the god of war, fashioned an unbreakable metallic mesh in order to catch the lovers and bring them before the gods on Mount Olympus. In this scene, the Sun exposes the love affair as it does every day, and Vulcan enters the bedroom, catching the couple in flagrante delicto. Venus' son Cupid sleeps in the background. Mars attempts to hide under the sheets, as he cannot escape, prevented by Vulcan's metallic trap. All of the gods mocked the lovers, who were ashamed and stopped their affair.

This representation of Venus is one of the most beautiful nudes painted by Tintoretto. She attempts to conceal her consternation, and pulls at the sheet with her left hand to cover her nudity. In reality, she is still sexually united with Mars, as their union was so strong they could not separate.

Venus' beautiful body is young, graceful, velvety, and attractive. The light coming from the left highlights her small, firm, and nearly adolescent breasts, as well as one of her perfect, long legs, which is foreshortened. The nude is highly provocative, with its diagonal, partially reclining pose, exhibiting the woman's entire anatomy and with her legs apart. Her pubis, slightly revealed as Vulcan begins to pull back the sheet, accentuates the eroticism of the scene. There are many interesting compositional details in this work. It is rich in foreshortening and shows a sound mastery of perspective, lending the scene great dynamism. The colors are dense and the illumination creates contrasts that give rise to chiaroscuro in some areas. The light is meticulously studied to focus all attention on the figure of Venus.

The Book of Judith explains that Holofernes was the general commanding the troops belonging to Nebuchadnezzar, the King of Assyria. He was so cruel, violent, and implacable with his enemies, and was furthermore constantly threatening imminent attack, that the Jews feared falling into his hands. Hence, they devised a trick by which to kill him. Judith was an attractive young woman who had just been widowed, a devout follower of the commandments of God, and true to her people. She was sent to Holofernes' camp to seduce him with her charm and then kill him. When he saw this attractive and glamorously dressed woman, the general was taken by her beauty and invited her to his tent to sleep with her, at which point she cut off his head and fled with it, along with her servant. The next morning, when the general's army saw that the Jews had hung the general's head above their city, they fled in panic, and thus the threat was removed.

In this scene, Judith has just cut off the general's head and is handing it to her servant for her to place in a bag. Despite the gravity of the situation, the painting barely expresses any horror. Both Judith and her assistant are cool, collected, and self-assured, the former with her skirts slightly lifted and showing her breasts through a transparent bra, a clear sign of the amorous pursuits with which she tricked the unfortunate general, whose nude body lies on the bed.

His body is remarkable for its beauty and brilliance. Its slight foreshortening and diagonal position lend depth to the scene, although the general's proportions seem smaller than that of his murderess, a rather unusual feature, unless Tintoretto wanted to symbolize Judith's greatness. Holofernes' body, intensely illuminated, exhibits a subtly modeled complexion and reflects the profound anatomical study that the painter executed of a muscular and well-proportioned man. The dense background color and the curtains that act as a stage set both heighten the drama of the scene and make it more realistic and solemn by lending it a luxurious air.

Through the effects of light and the drama inherent in the scene, reinforced here by the cruel coldness of the women, the artist exhibits his skill in achieving a stunning effect, a factor which was to influence the second generation of Mannerists such as El Greco, and the subsequent Baroque period.

The Death of Holofernes

(~1570)
oil on canvas
39 x 129 in (98 x 325 cm)
Prado, Madrid

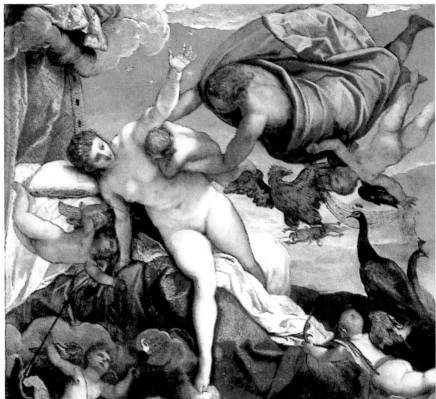

The Origin of the Milky Way

(~1570)
oil on canvas
59 x 65 in (148 x 165 cm)
National Gallery, London

Tintoretto studied with the circle of artists who introduced Mannerism of an Italian, Tuscan, and Emilian tendency to Venice. There, he carried out the majority of his artistic activity. In this example of this style, the female figure in the center of the scene has an affected pose arising from the painter's attempt to favor the overall composition and the postures of the figures around her. Her body falls within the classical tendencies of the time, with a significant amount of idealization and an evident intent toward monumentality. The male figure in the upper right corner recalls figures by Michelangelo for its drawing, corpulence, and way in which it is represented.

The woman, although she is in the center of the scene and exhibits an attractive anatomy, is somewhat overwhelmed by the figures and elements around her. She seems more like someone forced to breastfeed than like a loving mother offering her breast to her child for its sustenance. The children appearing as angels or cherubs and the exotic animals flanking the woman's body incorporate a certain symbolism and fantasy typical of allegorical representations. This work has all of the characteristics of Venetian painting with regard to sensuality, color, and light.

The black profile that outlines the figures is interesting, as is the treatment of light, which, although coming from the right, does not leave the left side of the woman in shadow. The painter combines a series of intense, vivid, and clean colors such that the painting as a whole is exuberant, with a wide and varied color range, characteristic features of Tintoretto's works. This, together with the forms given to the clothing, makes the painting grand and spectacular. It is clear why Tintoretto exercised so great an influence on the painters of the last Mannerist period such as El Greco, and the subsequent Baroque period.

PIETER BRUEGHEL, THE ELDER

Pieter Brueghel, the Elder, in a contemporary engraving.

Brueghel's work, the most evident reaction to the Raphaelite movement arriving in Flanders from Italy with force, constituted the bridge between the Flemish Gothic and Baroque. Although his work has some Renaissance characteristics, it focuses on subjects that aroused great popular interest, in which nature, scenes from everyday life, and the peasantry in general played a major role. These characteristics would become insignias of Flemish painting.

He is interested in multitudes much more than in the individual. In his works, he represents people as they are, with their idealism, customs, miseries, and roguishness. He often incorporates caustic satire and the most jeering irony, and is not particularly affected by the ideal of beauty. Many of his scenes, generally set in the countryside, in sweeping, open landscapes, could be qualified as pessimistic.

One of the most important geniuses of the 16th-century, he is often placed on a level with Hieronymus Bosch, who influenced him and with whom he shares a moralizing objective in some of his works.

The facts of his training are practically unknown, although, curiously, the earliest recorded criticism of him is from 1609. It refers to him as a poor ignoramus who liked comic art, a description that is wholly ruled out today. Indeed, he was actually an educated artist and maintained good relations with the intellectuals of his country. He was also interested in culture, traveling to Italy and executing a series of drawings that were rapidly disseminated throughout Europe.

- **~1525** Born in Breda, Brabant, the son of Maria Bessemers, one of the most important painters of her time. It was probably his mother who introduced him to the world of painting, although he was later a student of Pieter Coecke van Aelst.

- **1551** Registered as a painter in the Guild of St. Luke in Antwerp.

- **1552** From this year to 1554, he travels en route to Italy, during which he executes numerous drawings, *Martinswand Mountain* (Kupferstichkabinett, Berlin) and *View of Waltersburg* (Bowdoin College Museum of Fine Arts, Brunswick, Maine).

- **1554** Collaborates with Hieronymus Cock on a series of large landscapes.

- **1555** Executes a series of preliminary drawings for engravings based on works by Hieronymus Bosch.

- **1560** From this year on, he fully dedicates himself to painting, executing the majority of his works.

- **1563** Marries van Aelst's daughter, Mayken Coecke, 18 years old, in Brussels.

- **1564** His son Pieter is born, later known as the "Brueghel of the Infernos," for his themes with fire.

- **1565** Executes a series of paintings on the months of the year, including *Hunters in the Snow* (see p. 138), *The Gloomy Day* (Kunsthistorisches Museum, Vienna), and *The Harvesters* (see p. 137).

- **1566** Incorporates biblical scenes into his repertoire, *The Triumph of Death* (Prado, Madrid), *The Adoration of the Kings* (National Gallery, London), and *The Procession to Calvary*, (Kunsthistorisches Museum, Vienna).

- **1568** His second son, Jan, is born, later known as "Brueghel de Velours" (the Velvet Brueghel) or "Brueghel of the Flowers." In this period, paints genre scenes clearly influenced by Hieronymus Bosch, including *Peasant Wedding* (see p. 140), *Peasant Dance* (see p. 140), and *The Land of Plenty* (Alte Pinakothek, Munich).

- **1569** Dies in Brussels.

The Temptation of Saint Anthony

(~1558)
oil on wood
23 x 33.75 in (58.5 x 85.7 cm)
National Gallery of Art,
Washington, DC
(Kress Collection)

In all of his artwork, Brueghel demonstrated exceptional liberty and originality. His pictorial work represents sweeping panoramas in a flat style, with the rich chromaticism typical of a theatrical backdrop. This work combines the primitivism that the artist exhibited throughout his career and his great interest in nature, with bold foreshortenings, a masterful composition, and, above all, an extraordinary dynamism in his narrative scenes.

The influence of Hieronymus Bosch is evident, and like Bosch the rich symbolism of the scene defies clear interpretation in our time. Although it portrays the temptations of the saint, as the title indicates, this episode seems a mere anecdote, fading in importance in comparison with the richness of colors and profusion of themes that predominate. The battles between good and evil occurring in the sky pit demoniacal and fantastic beings against one another in a setting that is otherwise natural. In the foreground is a whole sequence of the most diverse scenes, with battles and peasants gathering around a giant, dark fish covered with a stole marked with an X. In the forest to the right, there are other scenes in twilight, making it difficult to discern the figures among the vegetation.

Brueghel loved nature, and tended to place minuscule figures within landscapes in a way that the latter became the principal protagonist of the scene. This work is one of a series of diverse genre scenes referring to the months of the year, which the artist carried out in this period.

The artist represents nature as something familiar, presaging the pantheist conception (the notion that all things have a common divine origin) of the landscape. Brueghel is considered the founder of the Flemish concept of nature, far removed from German or Italian interpretations, and especially from the Venetian concept, which represented nature as something fantastic, immense, and nearly devoid of figures.

As the painting reveals, Brueghel understood nature as a familiar and beloved environment, and he incorporated figures spontaneously. There is great attention to detail. The landscape is a vast panorama with a horizon far in the distance, lost in an atmospheric haze that invades the entire bay in the background and enhances the warmth of the foreground. The structure of the landscape shows great mastery and sensitivity.

Upon examination, the painting appears to contain a series of independent compositions (a group of people eating, reapers working in the fields, landscapes in the middle ground—one on the left and one on the right, the background landscape, etc.), which the artist skillfully combined as if in a puzzle, to produce this fresh and natural scene of everyday life.

The Harvesters

(1565)
oil on wood
45.8 x 62.8. in (116.5 x 159.5 cm)
Metropolitan Museum of Art,
New York

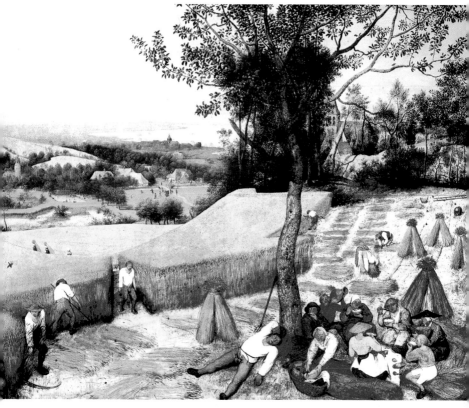

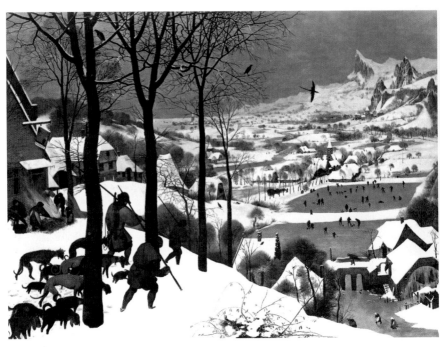

Hunters in the Snow

(1565)
oil on wood
46.5 x 64 in (117 x 162 cm)
Kunsthistorisches Museum,
Vienna

Brueghel's works must be viewed in their historical and geographical context. At that time, a new social class was appearing in cities that was making its power felt—the bourgeoisie. This middle class public was interested in themes related to life in their social situation. Landscapes were also well received, which is not surprising considering that a large part of people's lives occurred outside of the city. Hence, art in this period frequently portrayed landscapes and figures, often combining them. This is surely what inspired Brueghel to execute this work, blending urban aspects with nature in its purest state. The painting is rich and meticulous, with an attractive thematic content. It forms a homogeneous whole comprised of many sections constituting themes in their own right, with a plethora of ingredients. The accessory details are highly defined, and this snapshot of reality has great depth.

The Beggars

(~1568)
oil on wood
7 x 8 in (18 x 21 cm)
Louvre, Paris

Oin oaf or Werrelt is for cngeru
Daer oin oba ic inorn ru

This apparently simple painting contains a significant collection of anecdotal references to the picaresque mischief and local color typical of the time, through which the painter presents a moralizing scene. The panel originally belonged to Count Masi of Parma, but in 1611, the Farnese confiscated it.

Brueghel creates a satirical representation. The Flemish text at the bottom refers to the hermit and affirms that the reason he lives in seclusion is because of the indignity of society.

The Misanthrope

(1568)
oil on canvas
35 in diameter (88 cm)
Museo Capodimonte, Naples

Nevertheless, paradoxically, there is an evident relation between the hermit and the world in which he lives, despite himself. Furthermore, he is an exponent of the contradictions in which humans often find themselves. If the hermit feels removed from society, then it would logically follow that he would not carry money, as he would not need it. But indeed, he is carrying money, and, curiously, it is a member of the disgraceful society that he is fleeing which helps him to part with something which, according to his principles, he does not need at all.

The thief represents a doer of evil, a lesser evil, although no less criminal, manifesting a social reality of the time, in which roguishness was often an essential practice to guarantee survival for many people. In any case, the chromatic treatment of both figures is important, with the misanthrope transmitting seriousness and pessimism through his grave, austere, and ascetic aspect, whereas the thief, glad for the trophy he has just won at the expense of his victim, appears as an optimistic and jovial character. The paint was applied directly on an unprimed surface, such that a great deal of paint was absorbed, with the effect of a matte finish.

In Brueghel's day, people spent half of their time in the city and half in the country, and there were many health problems. Calamities such as the plague, leprosy, and deformations, whether congenital or produced by an accident, were frequent. Lack of hygiene and medical deficiencies of all sorts brought misery and marginalization to a large part of the lower-class population, which constitutes the subject matter of the painting.

The figures are represented in a circle, as if about to begin a dance, with the evident movement that the painter lends to many of his works. The expression on each face reflects the pathos and natural character of the scene. The richness of details in the clothing is astonishing. The meaning of the foxtails on each of them is difficult to interpret today, but must have been evident at the time, and probably referred to the type of illness as a warning for the rest of the population.

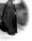

Peasant Wedding

(1568)
oil on wood
45 x 65 in (114 x 164 cm)
Kunsthistorisches Museum, Vienna

This work is one of the most renowned by Brueghel. Its genre aspect is certainly important, as it constitutes an entire narrative chronicle displaying various aspects of documentary interest. The character of each figure is evident, enhanced by his or her surroundings, constituting a possible prelude to the group portraiture that Frans Hals would later develop with great success in Flanders. There is a great economy of resources, especially in the details, on which the painter does not waste his energy. The scene is conceived with a compositional opulence that few artists have been able to match.

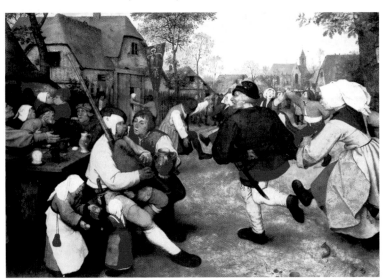

Peasant Dance

(1568)
oil on wood
45 x 65 in (114 x 164 cm)
Kunsthistorisches Museum, Vienna

Brueghel's trip to Italy was very beneficial for him, although it is not reflected in his works, which remained removed from the Italian Renaissance aesthetic. He did imbue himself with the compositional sense and pictorial technique of the Italians. A good sample of thematic influence is his propensity for abrupt terrain, sharp mountain peaks, and rugged ranges, quite in contrast to the Flemish plains. Nonetheless, his interest focused on fields, peasants, and everything related to them. He represented highly natural scenes of country life, work in the fields, and popular festivals and dances, showing the daily life of the simple people. The artist often attended such events in the company of Hans Franckert, a merchant friend of his and a painter by hobby, with whom he drew sketches of what he saw.

VERONESE

Presumed self-portrait dressed as a hunter, fresco, 1560-61, Villa de' Maser, Treviso.

The fact that Veronese (Paolo Caliari) was educated in his native city of Verona, a great artistic center where different schools were represented (the Venetian School, the Lombard School of Moretto, and the Mannerist movements of Parma and the Mantuan court, with Giulio Romano at its head), explains the solid artistic base of his works.

His painting, severe and independent, is the unique fruit of his idiosyncrasies. This artist developed a specific kind of Mannerism, devoid of all formal intellectualism and characterized by a free and splendorous chromatic language in the classic manner, possibly influenced by his friend and collaborator, Palladio, an exquisite Neoclassical architect.

His works are generally grandiose and solemn, with festive scenes of both a profane and religious nature incorporating architectural elements. Veronese is very interested in color, using dominant tones that affect the atmosphere and the figures. At the same time, his composition gains consistency through a balance of colors, which constitutes the originality of his style. This treatment of color would later be highly appreciated by artists such as Cézanne and Renoir, whose Impressionist ideas found a worthy precursor in Veronese. Also remarkable is his mastery of perspective and foreshortening.

- **1528** Born in Verona on April 18 to the sculptor Gabriele. He takes his pseudonym from his native city, where he studies under Antonio Badile.
- **1548** Paints the altarpiece for the Bevilacqua-Lazise altar in San Fermo.
- **1551** Summoned by the architect Sanmicheli to decorate Villa Soranzo near Castelfranco, in the region of Veneto, and to execute the frescos for the sacristy of San Liberale.
- **1552** Commissioned by Cardinal Ercole Gonzaga to collaborate on some paintings for the Cathedral of Mantua, for which he paints the *Temptation of St. Anthony* (Musée des Beaux-Arts, Caen).
- **1553** Introduced into the artistic circle of Venice, where he participates in the decoration of the Palazzo Ducale.
- **1556** Along with Tintoretto, he becomes a principal painter for the Palazzo Ducale, executing canvases for the halls of Consiglio dei Dieci and dei Tre Capi, as well as for the Biblioteca Marciana (three allegories: *Music* (see p. 144), *Geometry*, and *Arithmetic*), for which he receives an award.
- **1560** Travels to Rome, where he spends a brief period admiring the works of Michelangelo and Raphael.
- **1561** Decorates the Villa Barbaro built by Palladio in Maser.
- **1562** Executes *The Wedding at Cana* (Louvre, Paris) for the refectory that Palladio built on the island of San Giorgio Maggiore.
- **1566** Paints *The Martyrdom of St. George* for the Church of San Giorgio in Verona.
- **1570** Paints *The Last Supper at the House of St. Simon* for his friend, Father Torlioni, who had been his first patron, to be placed in the convent of the San Sebastiano church, Versailles.
- **1571** Paints *The Feast in the House of Levi* (Accademia, Venice) for the convent of SS. Giovanni e Paolo, where *The Last Supper* painted by Titian was destroyed in a fire earlier in the year. Is brought before the Inquisition for introducing unseemly secular elements in this work.
- **1575** In collaboration with his brother, paints *The Martyrdom of St. Justine* (Uffizi Gallery, Florence) for the high altar of the church by the same name in Padua.
- **1576** Works on the Palazzo Ducale in Venice. Philip II invites him to work in Spain, but he refuses.
- **1588** Dies in Venice on April 18.

Age and Youth

(1553)
oil on canvas
114.5 x 59.5 in (286 x 150 cm)
Palazzo Ducale, Venice
(reception hall)

As of 1553, Veronese participated actively in the decoration of the ceilings in the Palazzo Ducale of Venice. His work was admired for its daring perspective and its nudes in complicated poses occupying a large area of the composition, along with other decorative elements. The sensuality of his figures is one of the most powerful attributes of his style.

This allegorical work reveals a certain tendency in Veronese to combine themes, uniting compositional harmony with contrasts between the bodies. Here, he presents Old Age seen from below, personified by a strong, sculptural, and battle-hardened man approaching the monumentality of Michelangelo. A delicate, somewhat reserved young woman represents Youth. The interplay of gazes is significant, as Old Age looks toward the heavens in a contemplative mood, whereas Youth, somewhat timidly, gazes down at the Earth, displaying her innate desire to live. With the exception of a tranquil sky and a small architectural feature serving as a podium for Old Age, the artist has dispensed with all elements that could distract the viewer's attention or detract from the striking presence of the figures.

The Coronation of Mary

(~1555)
oil on canvas
80 x 68 in (200 x 170 cm)
Church of San Sebastiano, Venice

Through the work he carried out in the Biblioteca Marciana, Veronese acquired such fame and prestige that he was soon overwhelmed with commissions, such as this one, painted for the sacristy of the Church of San Sebastian. His style, based on Mannerism, is enhanced through a powerful treatment of the figures, which dramatize the scene in this lofty representation. The point of view and extreme yet natural foreshortenings influenced many artists thereafter. Dynamism is expressed through the supernatural golden atmosphere permeating the scene rather than by the figures themselves. The Trinity, accompanied by two angels who push back the clouds as if drawing back the curtains from a stage, is very human. God the Father is represented as an elderly man with a long beard, far from the almighty idealization he exhibits in other works. The delicate nature of the work is captured in Mary's tender and candid expression.

This work forms part of a series at the same museum, with Atalanta and Meleager, Olympus, and Venus and Mercury before Jupiter. Despite their small dimensions, the artist has managed to imbue these works with the character, composition, light, and color of masterpieces. Here the hunter Actaeon delights in his discovery of Diana and her nymphs bathing in the forest. Realizing the presence of the intruder, the women gather together, forming a beautiful and rhythmic set of nudes whose figures maintain their individuality due to the pictorial treatment of light and shadows. The composition is divided into two differentiated zones: the area on the left, in dense, dark colors, where Actaeon is reclining, and the area on the right, where the magnificent female anatomies seem to radiate light, with lithe, dynamic, yet forceful forms.

Actaeon Contemplating Diana at her Bath

(1560)
oil on canvas
10 x 43.2 in (25 x 108 cm)
Museum of Fine Arts, Boston

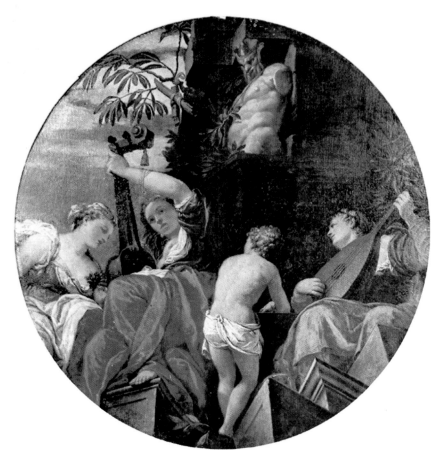

Allegory of Music

(1556-1557)
oil on canvas
92 in diameter (230 cm)
Biblioteca Marciana, Venice

The architect Sansovino was commissioned to design the Biblioteca Marciana in Venice. Veronese was chosen by competition to decorate it, and was awarded a medal by Titian. His work for the Biblioteca Marciana made him famous and consecrated him as one of the principal painters of the Venetian School.

The allegory, described by Vasari, presents Cupid with his back turned and without wings in an unusual but necessary representation. The painter shows how music is born of love, which, without wings, cannot fly. The figure of Cupid is delicate and demonstrates the skill of the artist in developing anatomy, although neither the attitude nor the pose reflects his usual sensuality. The luxurious fabrics of the women's clothes are striking. Here, Venetian Mannerism and use of light come together in a composition as brilliant as it is suggestive. The interaction between the hard architectural forms and the delicate sensibility of the bodies significantly enhances the sensuality of the scene. Although the figures are dressed, the work is imbued with a voluptuous atmosphere that titillates the senses. The point of view is quite unusual as well: Veronese creates a tromp l'oeil, such that the figures appear to be seen from below.

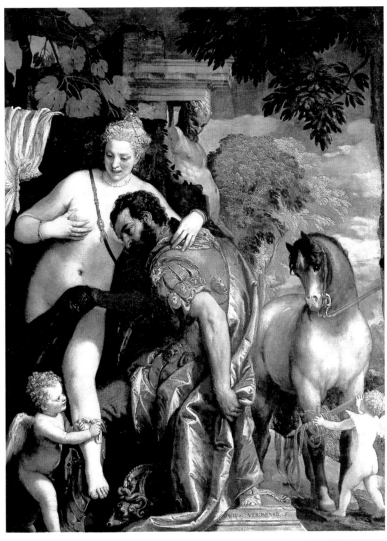

Here, the composition is diagonal, with the figures grouped to reinforce the idea of sexual union and intimacy. Veronese uses the landscape and architecture as complementary elements providing a background for the figures. The yellow leaves on the fig tree indicate that the scene takes place in autumn. The sky exhibits a varied range of colors, from blue in the upper area to a greenish tone, with a series of gray clouds. The delicate figure of Venus, with a milky, illuminated body, contrasts with the dark blue robe.

Mars and Venus United by Love

(~1580)
oil on canvas
80.4 x 64.4 in (201 x 161 cm)
Metropolitan Museum of Art, New York

The goddess has a robust anatomy and smooth forms, with the attractiveness and sensuality appropriate to her. Mars is dressed as a Roman soldier. Veronese probably based them on people who were known in society. Cupid, tying a pink ribbon to his mother's leg, unites Venus and Mars. He is not the mischievous figure of other representations, but an innocent, candid child, emphasizing the tenderness that is the principal subject of the painting. On the right against a luminous background is a steed controlled by a cherub armed with Mars' sword.

The painting exhibits a great variety of colors that provide atmosphere, chromatic coherence, and harmony. The various elements involved give rise to a perfect combination of light and shadows. This work is highly meticulous, with a series of details that illustrate Veronese's scrupulousness: the tunic draped over the dark wall, Venus' jewelry, Mars' spectacular garments, and the helmet at his feet, for instance.

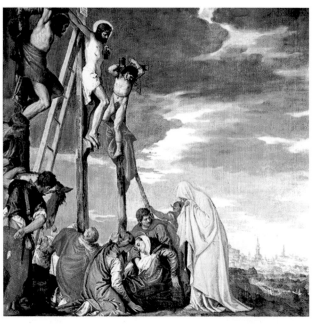

Calvary

(~1575)
oil on canvas
40.8 x 40.8 in (102 x
102 cm)
Louvre, Paris

In this composition, all of the figures are gathered to the left and distributed within a triangular area. The conception of the three crucified men is remarkable, and the dramatic scene is accentuated by the sky. The nudes are executed with depth in a daring side view, breaking with the traditional frontal view of the theme. The thief on the right is striking for the torsion of his limbs and the modeling of his muscles. The entire scene is intensified and made all the more theatrical by a spectacular interaction of light and shadows, with a stormy sky in intense tones against which the vivid clothes of the figures at the foot of the cross contrast strongly.

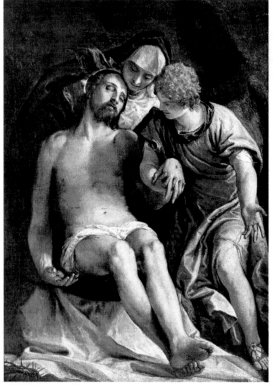

Pietà

(1576-1582)
oil on canvas
58.8 x 44.6 in (147 x 111.5 cm)
The Hermitage, Saint Petersburg

This scene does not correspond to a biblical episode. The inanimate body of Christ is represented in the company of his mother and assisted by an angel after being deposed from the cross. The work is profoundly austere and perfectly conveys the gravity and solemnity of the moment. The dark background focuses the viewer's attention solely on the three figures. The artist used a range of unusually tenuous, dark colors, most likely to enhance the impact of the light and the contrast, which lend the scene its relief. The heightened drama centers on Christ's face. His naked body is a faithful reflection of the humiliation and defeat of his human condition in the face of death. The statuesque figures form a harmonious compositional unit with a balanced color scheme.

EL GRECO

The Burial of the Count of Orgaz *(detail)*,
oil on canvas, 194.8 x 144 in (487 x 360 cm),
1586, Church of Santo Tomé, Toledo.
A self-portrait of artist appears on the right.

El Greco (Domenikos Theotokópoulos) is the most eminent representative of the last period of Mannerism and, although he studied in Italy, was possibly the artist who best interpreted the religious passion and transcendental inclination of the Spanish spirit.

He dispensed with the established norms and conventional canons, allowing himself to be inspired solely by his own sentiments. His idiosyncratic style and technique constituted an important innovation in painting, although it received severe criticism, and even censure, during the Inquisition. Nonetheless, he also had enthusiastic admirers, especially from among the distinguished and cultivated circles of the time.

A cultivated man of exquisite taste who assimilated the education he received in his youth, his deeply spiritual and mystically intense religious paintings made a profound impact on the devout. His very human portraits of studied psychology, a faithful reflection of the sitter, made him one of the greatest portraitists of all times.

El Greco is an important figure in the history of painting. His work transcends Mannerism in many aspects, wholly surpassing the limits of this school. Singular, severe, and passionate, with intense and unusual colors, strong contrasts, and daring foreshortenings, his work has a forceful, effervescent, and eminently Mediterranean character.

- **1541** Born in Candia, Crete.

- **1560** Perhaps in this year, attracted by the artistic ebullience in Italy, he moves to Venice (at the time, Crete was part of the Venetian Republic), where he becomes a disciple of Titian and especially of Tintoretto, whose interest in religious themes he shares wholeheartedly. His style, hitherto following the rigid formulas of Byzantine art, changes substantially.

- **1570** Moves to Rome, where the miniaturist, Giulio Clovio, becomes his patron, and introduces him to Cardinal Alessandro Farnese and his circle.

- **1576** Not satisfied with his reception in Rome and possibly rejected because of certain unfortunate comments he makes on Michelangelo's art and his paintings in the Sistine Chapel, he moves to Madrid, where there is the possibility of working in the Escorial along with many other Italian painters. Because of problems with adapting to the requirements of the court, he later moves to Toledo, an important Castillian cultural center.

- **1577** Executes three altarpieces for the Church of Santo Domingo el Antiguo, which reveal Michaelangelo's influence. Begins *The Disrobing of Christ (El Espolio)* (see p. 148) for the Toledo Cathedral, which he completes two years later. This piece is the first to reveal the artist's unique style and personality.

- **1579** Philip II summons him to Madrid, commissioning several works: *Adoration of the Holy Name of Jesus* (National Gallery, London), *The Dream of Philip II, The Martyrdom of St. Maurice,* and *The Theban Legion* (the last three at the Escorial, Madrid). The king rejects the last piece, perhaps because of the excess of yellows and blues, or for compositional problems, and has it substituted by another on the same subject matter by Rómulo Cincinati. Upset, the painter ceases his work at court and establishes himself definitively in Toledo, where he lives with his wife, Jerónima de las Cuevas, and his son, Jorge Manuel, also an artist.

- **1586** Commissioned by the parish priest of the small Church of Santo Tomé in Toledo, he paints *The Burial of the Count of Orgaz* (see p. 149), possibly his masterpiece. The success of this work is so great that he is inundated with commissions for paintings on religious themes.

- **1596** Begins a copious series of portraits.

- **1614** Dies in Toledo on April 7.

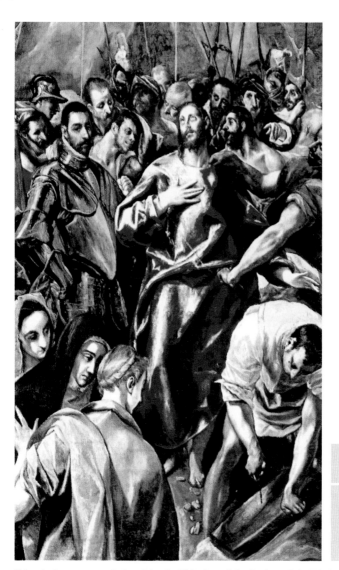

The Disrobing of Christ (El Espolio)

(1579)
oil on canvas
66 x 39.6 in (165 x 99 cm)
Alte Pinakothek, Munich

This painting was commissioned for the high altar of the Sacristy of the Toledo Cathedral, and completed in 1579 after two years of work. It is one of El Greco's most original paintings. The number of figures in the scene, detail, and finish appear to be the work of a miniaturist rather than that of a regular painter. Great emotional force is provided by the application of certain Renaissance formulas acquired by the artist in Italy, the placement of the figures in a Byzantine iconographic scheme, and the intensity of colors, from which the vibrant red of Christ's tunic stands out.

In the lower left corner is the figure of Mary, possibly a rendering of the woman who was often his model and later became his wife, Jerónima de las Cuevas. She has a lost gaze, large eyes, and a profoundly sorrowful expression, which the painter would repeat in many of his works.

The work illustrates the idea of the world exacerbated by religious pathos. The effects of light dominate the formal aspects and the lack of a defined space obliges the artist to apply solutions approaching Expressionism.

It is not surprising that this painting disconcerted many people, especially those who judged a work for its compliance with the norms established by the Italian schools. It was certainly difficult for people with closed minds to accept such freedom of both style and composition. El Greco was forced to make certain changes. The painting in Munich is a replica of the one in the Toledo Cathedral (1577-1579), with slight variations.

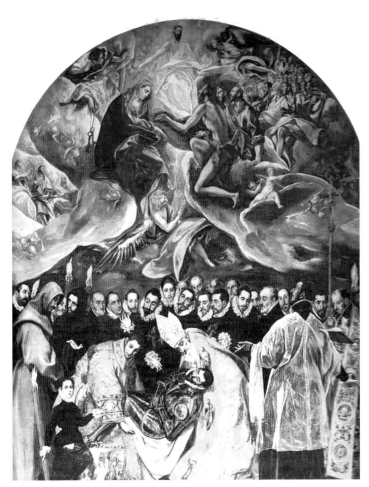

This work was commissioned by the priest of the small Church of Santo Tomé in Toledo, El Greco's parish church, duly authorized by Cardinal Quiroga. Accordingly, the painting represents the miracle that occurred at the burial of Gonzalo Ruiz de Toledo, the Count of Orgaz. According to local legend, God sent the Saints Stephen and Augustine to bury the count with their own hands in the chapel.

The Burial of the Count of Orgaz

(1586)
oil on canvas
194.8 x 144 in (487 x 360 cm)
Church of Santo Tomé, Toledo

This work is absolutely exceptional, possibly El Greco's masterpiece, for its excellent composition and distribution of the many figures, for its detail and the meticulous execution of many elements (for example, the cloak of the priest holding the ceremony, with highly realistic, detailed embroidery), as well as for the vibrant, striking colors. In the foreground, the saints Stephen and Augustine, the latter wearing a miter, dressed in liturgical attire, are transporting the body of the dead man. The three figures are surrounded by a group of religious figures, with their corresponding habits or liturgical attire, and behind them, dressed in black, civilians of the high nobility, perfectly portrayed and characterized (among whom is a self-portrait of the painter, just above the head of St. Stephen, with his right hand reaching out toward the viewer). With grave and devout expressions, they contemplate the scene and pay tribute to the deceased.

On high, celestial glory is represented by the figure of Christ resurrected presiding over the scene, surrounded by light and angels and, on a lower level, Mary on his left and John the Baptist on his right, at the head of a cohort of saints. In this funerary representation, conceived in the manner of a stained glass window, two worlds are associated: the celestial world, represented with a certain acrimony and even violence, and the earthly world, which radiates tranquillity, respect, and pious meditation, separated by a dense curtain of clouds filled with angels. The painting is highly mystical, with a solemn and austere spirituality. Curiously, the artist dispenses with the background, placing everything in the foreground. The painting is a beautiful symphony, full of rhythm, color, and chiaroscuro. It is a great display of chromatic expressiveness, with a variety of different tones and vibrant colors contrasting with black, as well as a varied range of grays.

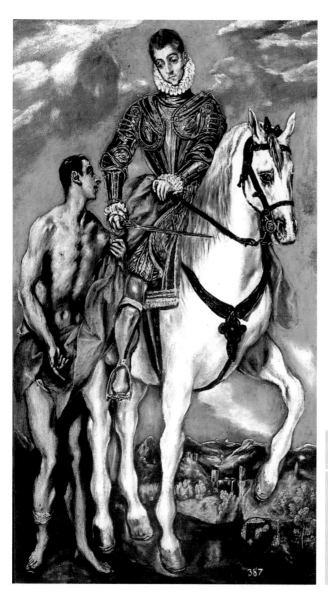

Saint Martin and the Beggar

(1599)
oil on canvas
77.2 x 41.2 in
(193 x103 cm)
National Gallery of Art, Washington
(Widener Collection)

This painting is from the Chapel of St. Joseph in Toledo. The scene represents an episode from the life of St. Martin. The saint, dressed in spectacular, Toledo-style armor and riding a white Spanish charger, offers his cape to a poor naked man whom he encounters along the way. In this painting, El Greco uses two different principles: one governing that of the saint, a well-balanced and proportionate figure, and one governing that of the beggar and the horse, with slender, elongated proportions. The body of the beggar is striking for the treatment of light on the skin, which almost seems to refract off it.

The drafting of the anatomy is not a mere formal study—each curve is interpreted with a significant rhythmic sense, creating a dynamic muscle structure and a deep expressiveness, which must have surprised his contemporaries. As is characteristic in works by this artist, vertical lines are exaggerated to the limit. Contrary to what some believe, the artist did not deform his images because he suffered astigmatism. He did it intentionally, for aesthetic reasons, and in this case, with a religious intent as well. It is only necessary to compare the clearly distorted figure of the beggar with that of the horse, treated with much more realism, to understand that this procedure was used by the artist to surprise the viewer, with the objective of calling forth a feeling of admiration and devotion. As in other works, El Greco used a variety of vibrant colors, which he juxtaposes to achieve great dynamism and impact. The armor of the saint is striking for its detail.

The Resurrection

(~1600)
oil on canvas
110 x 50.8 in (275 x 127 cm)
Prado, Madrid

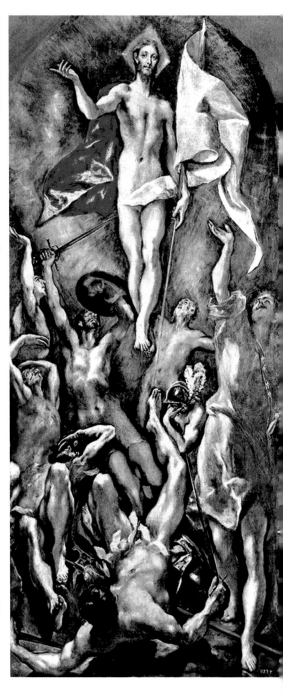

The extremely elongated format of the painting makes room for a composition with equally elongated figures, revealing the deep spiritual capacity of El Greco in his artistic maturity. The scene has a violent and somewhat anxious air, enhanced by the complex poses and contortions of the figures, with exaggerated and unsettling bodies, juxtaposed with the serene figure of the resurrected Christ. The figures form a semicircle about Christ as he triumphantly rises above the living, radiantly holding a great white flag. The light mysteriously emanating from him strikes each figure forcefully, giving rise to a singular modeling in each. The extreme foreshortening of the figure in the foreground gives rise to strongly contrasting areas of light and shadows, whereas the figures in the background seem like the dead rising from the grave.

Among them, the glorious and radiant figure of Jesus emerges weightlessly, displaying a perfectly modeled, Apollonian nude bursting with vitality and irradiating sensuality in both his gesture and the cadence of his movement. Nevertheless, it is not sensuality that the artist intends to portray, but rather the triumph of beauty as a platonic concept, synonymous with virtue and perfection, over the ugliness of sin and the poverty of the human spirit. The exaltation of the guard joining in the homage to Jesus can be understood as a gesture of recognition: he is announcing with simultaneous joy and fear the greatest mystery of the Christians—the resurrection of Christ.

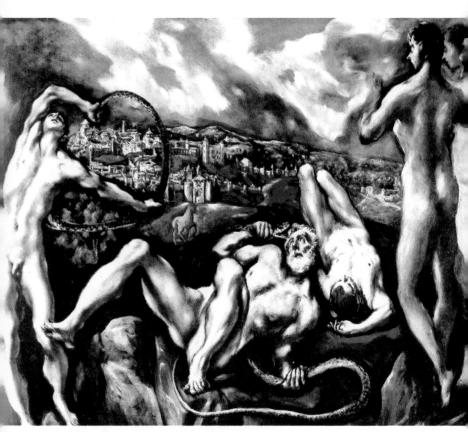

Laocoön

(1608-1614)
oil on canvas
54.8 x 68.8 in (137 x 172 cm)
National Gallery of Art,
Washington (Kress Collection)

According to the Aeneid, Laocoön was a high priest of Apollo who, during the Trojan War, was tenaciously opposed to the Trojans letting into their city the wooden horse that the Greeks had abandoned before their apparent retreat after years of siege. Laocoön took a pike and struck the belly of the wooden horse. At that moment, two enormous marine serpents from the Isle of Tenedos issued from the sea and wrapped themselves around the bodies of Laocoön and his sons until they were asphyxiated.

The Trojans interpreted the incident as the wrath of the Gods for Laocoön's action against the horse, so they took the wooden structure into the city and were finally overthrown by the Greeks. In reality, Apollo was punishing Laocoön because he had married Antiope and had children with her.

The scene represented here is delicate and immaterial. All of the nudes in the foreground are bathed in an eerie and contrasting light that makes them nearly phantasmagoric, with a whitish complexion rich in gray tones. The limbs of these nudes are stylized to the extreme, to the point of acquiring a tubular appearance, emphasizing the spectacularity of the episode. Although the work is unfinished, it displays the freedom and expressiveness typical of El Greco's art. The figures, in static and affected poses governed by compositional criteria, exhibit tortuous anatomies with significant deformations and elongation. This is more than the artist displaying his idiosyncratic style. He is accentuating the drama to make a greater impact on the viewer, aided by the effect of the threatening sky. Curiously, the city in the background, which should be Troy, is in reality Toledo, where the painter spent the majority of his life.

CARAVAGGIO

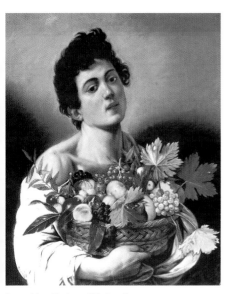

Boy with a Basket of Fruit, *oil on canvas, 175 x 26.8 in (70 x 67 cm), 1594, Galleria Borghese, Rome. Presumed self-portrait.*

Caravaggio (Michelangelo Merisi) was a rash adventurer. Vehement and foolish, he was constantly provoking people. He played with his luck, with those around him, and with his life, and he eventually lost. But his short life did not prevent him from having a significant influence on 17th-century Baroque painting.

In his early works, he shows deep interest in strict realism (the antithesis of the Carracci, leading artists from Bologna), in the interplay between light and shadow, and in the delicate effects of color, which he uses in its pure state in the Venetian manner. Later, his works are characterized by their objectivity, expressive manipulation of light, and realistic treatment of figures, combined with objects and natural elements. He then becomes immersed in hyperrealism, with a focus on figures and their environment.

Caravaggio achieves highly dramatic scenes through the use of the chiaroscuro technique, that is, the creation of pronounced contrasts between light and shadow, which was his principal contribution to the history of art. Through an intense source of lateral lighting, the colors of the figures are intensified and the composition is unified.

Light, drawing, and color, as well as dramatic realism with frequent reference to death, constitute the fundamental elements of Caravaggio's art, which represents an important milestone in the history of painting.

- **1573** Named after his birthplace, Caravaggio, a town near Milan, son of an architect.

- **1584** His brother Battista sends him to Milan as an apprentice to the Mannerist painter, Simone Peterzano.

- **1592** Probably fleeing because of a brawl, moves to Rome.

- **1593** Seriously injured after being kicked by a horse, he is hospitalized at the Consolation Hospital.

- **1594** Paints *Boy with a Basket of Fruit* (same page, Galleria Borghese, Rome) and *Rest on the Flight to Egypt,* (see p. 154).

- **1595** Paints *Cupid Triumphant* (see p. 155).

- **1596** Monsignor Fantin Petrignani introduces him to Cardinal Francesco María del Monte, who becomes his patron.

- **1600** Paints *Conversion of Saint Paul* (see p. 158).

- **1602** Paints *The Deposition* (Pinacoteca Vaticana, Rome).

- **1603** Enjoys wandering about the city provoking fights with passersby. In a dispute, he wounds the sergeant of Castel Sant' Angelo with his sword. He is detained and freed thanks to the intervention of the French Ambassador.

- **1606** He is wounded in a fight, but kills his opponent. He goes into hiding at the Colonno family's castle, where he paints several works. Paints *Emmaus Supper* (Pinacoteca di Brera, Milan), and *Flagellation of Christ* (see p. 158).

- **1607** A fight obliges him to flee to Malta.

- **1608** A grave offense against a knight of the Maltese Order damages his reputation and causes him to be demoted and imprisoned. He manages to escape to Syracuse, in Sicily.

- **1609** After painting works in Messina, he moves to Naples, where he is seriously injured by friends of the Maltese knight whom he had offended. Paints *Saint John the Baptist* (Galleria Borghese, Rome).

- **1610** He is pardoned by the Roman government. Before fully recovering from the injuries received the year before, he travels to Port' Ercole, on the coast of Tuscany, where he is detained as a suspect. When he is freed, he finds that his boat has been robbed along with all of his belongings. Desperate and alone, he dies of a malignant fever on July 18.

Rest on the Flight to Egypt

(1594-1596)
oil on canvas
52 x 64 in (130 x 160 cm)
Galleria Doria Pamphili, Rome

While living in Rome, Caravaggio worked for a time in Pandolfo Pucci's studio, and later with Cavaliere d'Arpino. In spite of this, he was struggling to earn a living with his paintings, and, for a time, he practically subsisted on charity, since he was able to sell only a few small works. Fortunately, Cardinal Francesco María del Monte became interested in his art and became his patron; Caravaggio was then able to earn steady income and was given credit.

From then on, he began to receive commissions such as this one, from Monsignor Petrignani, in which he demonstrates his solid grounding in draftsmanship and painting. This scene refers to a biblical moment, albeit an imaginary one, yet it appears profane due to the remoteness of the protagonists. The bucolic setting has no other purpose than to serve as a pictorial backdrop in which to develop the composition.

This work introduces a novelty in the treatment of landscape: the Venetian concept of nature as sacred combined with a poetic vision. Sexual ambiguity characterizes many of Caravaggio's figures, such as this angel, playing the violin while St. Joseph holds the score, whose aspect and treatment recall the body of a woman. This nude, conceived with profound delicacy, heralds the artist's preoccupation with the dramatic use of light. The position of the feet evokes both weightlessness and femininity, as does the falling hip, in a contrapposto more appropriate to a Venus than a man. Such unclear sexual attributes will become a constant in his works, though some of his figures remain wholly masculine.

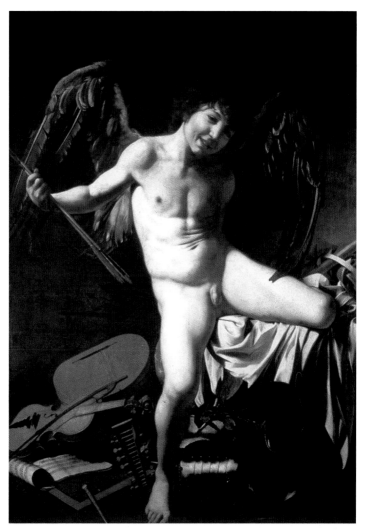

This canvas was commissioned by the Marquis Giustiniani, a man of great cultivation, who requested a painting of a profane Cupid capable of rivaling a painting of the same theme selected by Baglione, a rival and later the biographer of Caravaggio.

Caravaggio's Cupid is a street urchin, who exhibits his sensual anatomy with no reserve whatsoever and with a mischievous, teasing air. The boy has a natural, unidealized, and sultry body. He does not only represent profane love, but also contains enough sensuality to incite the onlooker, a vivid testimony of the high esteem in which ephebes were held by certain social strata of the time.

Cupid Triumphant

(~1595)
oil on canvas
61.6 x 44 in (154 x 110 cm)
Gemäldegalerie Dahlem, Berlin

Cupid thus shows himself triumphant on Earth, innocently trampling the mundane glories of science, war, riches, and art. His wings are that of a sparrow, a common bird in the city. The work is a parody of Michelangelo's piece of the same title, and ridicules the traditional, idealized representation of this figure. The boy is not slipping off the mattress by accident, but rather descends from the bed of love in a delightfully cheeky pose, appropriate to his triumph as Love over all things human.

The nude is a masterpiece in every aspect. The anatomy, perfectly studied, exhibits a body full of vitality, with a hard modeling of light, revealing what is to become the principal characteristic of his art: the chiaroscuro technique. An intense beam of light entering from the side provides the figure with relief and defines many details, although it does not reach the extreme of some chiaroscuro by this artist. At the same time, it submerges a large area of the painting in darkness, which dramatizes the figure. Caravaggio's tenebrist art, with its chiaroscuro, in addition to culminating the series of artistic transformations of 16th century Italy, constitutes the gateway to Baroque realism.

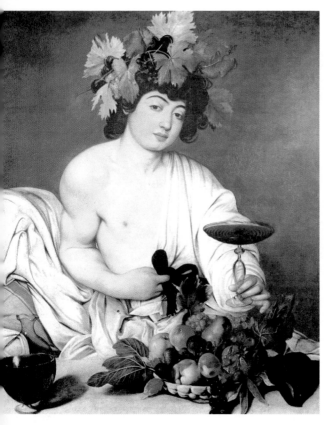

Bacchus

(1590-1593)
oil on canvas
37.2 x 34 in (93 x 85 cm)
Uffizi Gallery, Florence

Caravaggio was only 20 years old when he painted this work. He had not been in Rome for long and was struggling to become established. The youth in this work is in a static pose, probably due to the influence of the artist's master, Simone Peterzano, an exponent of Roman Mannerism. The painter compensates for the lack of movement with the splendid still life of fruit and leaves in the foreground and the grape clusters crowning Bacchus' head. The work is permeated with profound realism and enlivened by a varied range of colors that recall the Venetian School. Despite his youth, Caravaggio was beginning to show his superb artistic abilities.

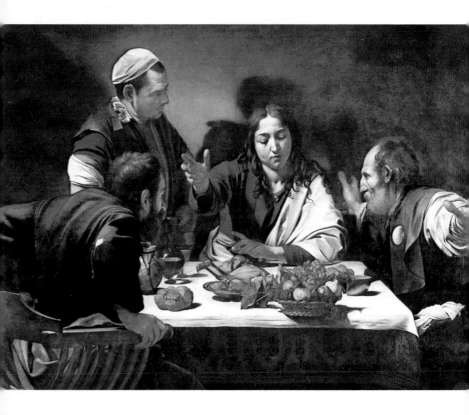

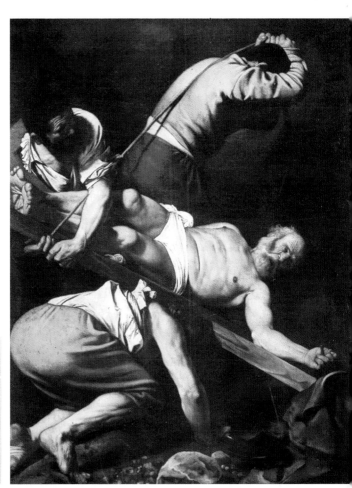

Crucifixion of Saint Peter

(1600-1601)
oil on canvas
92 x 70 in
(230 x 175 cm)
Church of Santa
Maria del Popolo,
Rome

Far from the peaceful existence of other artists, Caravaggio led a dissolute life of gambling and sword fights. Thus he would paint for a time and then stop working to spend a month or two making trouble. After the Contarelli Chapel commission, Caravaggio experienced one of the most brilliant and prosperous periods of his career. Beginning in the year 1600, he carried out numerous private and public works. This piece was executed for the Cerasi Chapel, along with *Conversion of St. Paul* (see p. 158).

This is one of the best paintings produced by Caravaggio. All of its aspects are magnificent, from the composition to the treatment of the figure in chiaroscuro. It portrays a specific episode and focuses the viewer's attention on the whole, guiding the eye with a single, powerful shaft of light. Although the influence of Venetian chromaticism is evident, the artist leaves the majority of the scene in darkness to bring out the figures. The nude of St. Peter is brutally realistic. As if in a snapshot, the artist has captured the frozen movement of the tormentors as well as the saint. Considering the figure's complexion and strong muscles, the model was probably a tanned farmer. It was common practice to use the same models for several works.

The Supper at Emmaus

(1601)
oil and egg tempera on canvas
56.4 x 78.48 in (141 x 196.2 cm)
National Gallery, London

The artist displays his mastery of color in this canvas, with a varied, lively, and balanced palette creating a chromatically attractive scene. The figures are expressive, and the still life of the food on the table adds a cheerful note and contributes to the predominant realism. To this the painter adds chiaroscuro, with a single shaft of intense light falling on the figures in a way that their features are exaggerated, their volumes enhanced, and the details sharpened. Thus the scene becomes highly theatrical. The Mannerism of the figures lends them the appearance of a group of sculptures.

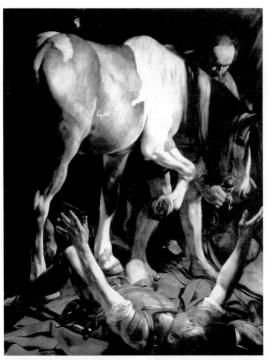

Conversion of Saint Paul

(1600-1601)
oil on canvas
94.8 x 75.6 in (237 x 189 cm)
Church of Santa Maria del Popolo,
Rome

This painting forms a diptych with *Crucifixion of St. Peter*. True to his principles, the painter eliminates all traces of idealism. He selects an episode, frames it such that he achieves the best possible scenographic result, and presents it in crude realism. He meticulously applies color, light, and shadow to lend the scene more drama and impact. Despite the religious theme, the painter is exclusively interested in the freer reality of transcendental myths or messages. The extreme foreshortening of the saint contributes to the sensational nature of this work.

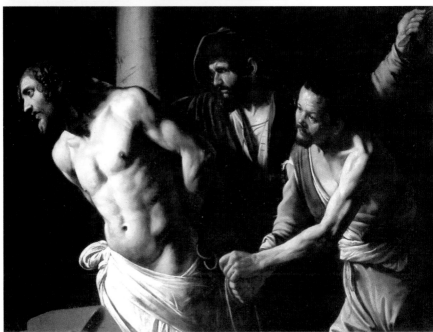

Flagellation of Christ

(1606-1607)
oil on canvas
53.8 x 69.8 in (134.5 x 174.5 cm)
Musée des Beaux-Arts, Rouen

This realist scene depicts three normal people, on whom Caravaggio centers all of his interest. The figures are adapted to the format of the painting. The chiaroscuro contributes to the precise definition of details. Jesus has a sensual, Apollonian anatomy. The painter lets the loincloth fall slightly to reveal part of the figure's pubic area, in half-light. The light models the figures and their garments, and the accentuated contrast of light and shadow heightens the drama. The figures, with the complicity of the areas in darkness, attains an exaggeration and an intensity that would be difficult to achieve with a natural light and color scheme.

PETER PAUL RUBENS

Self-Portrait without a Hat, *oil on canvas, ~1639, Uffizi Gallery, Florence.*

Rubens culminates the stylistic evolution begun by Titian and expresses that which, according to Wölfflin, constitutes the quintessence of Baroque art. Rubens' artwork can be considered from three points of view: the formal (the painter achieved compositional perfection through the interrelation of colors, forms, and light), the aesthetic (his works are a clear confrontation with the aesthetic models of the time, with voluptuous and fleshy female figures, horror vacui, and a rationalist concept), and the ideological (his art was at the service of the totalitarian power of the Church, although the greater liberty existing in Flanders spared him the obscurantism of other regions).

His works are characterized by dynamism and color, with extroverted scenes full of idealism and vitality that display the influence of the Venetian School, particularly of Titian. They are imbued with a solemn, monumental, and grandiose air that evokes Michelangelo.

He uses a varied chromatic range of intense, warm colors on a studied compositional scheme, filling the entire surface area of the painting.

It has been said that Baroque art rests on the laurels of Velázquez, as a paradigm of the expression of reality; Rembrandt, as a master of psychological introspection; and Rubens, as an exponent of the most extroverted Baroque. He can thus be considered the most important, famous, and predominant painter of his time, because his art is more personal and independent, more informed, and greatly influenced contemporary painters.

- **1577** Born in Siegen, Westphalia, the son of a lawyer from Antwerp who was forced into exile due to his Calvinist beliefs.
- **1591** Enters the studio of the landscape artist Tobias Verhaecht as a servant. Learns the technique of painting under Adam von Noort.
- **1594** Admitted as a student of Otto van Veen, one of the most famous painters of Antwerp.
- **1598** Admitted to the painters' guild of Antwerp.
- **1600** Visits Italy, where he is fascinated by the art of Titian, Mantegna, Carracci, Michelangelo, and Caravaggio. He soon begins working for Vincenzo Gonzaga, Duke of Mantua, for whom he executes many portraits and copies of famous works. From there, he travels to Rome (1601-1603 and 1606-1608), Geneva (1605), and Madrid (1603).
- **1608** His mother's serious illness brings him back to Antwerp, where he establishes an important studio, with Frans Snyders and Peter de Vos collaborating on still lifes, Wildens and Van Uden on landscapes, and Van Dyck on compositions with figures. He gains the favor of Nicolas Rockos and the Archduke Albert, governor of the Netherlands.
- **1610** Executes various works for the Antwerp Town Council, including *The Adoration of the Magi* (Koninklijk Royal Museum, Antwerp), as well as the triptych of *The Elevation of the Holy Cross* for the Chapel of St. Walpurgis in the Cathedral in Antwerp.
- **1622** Marie de' Medici commissions a panegyric cycle of 21 paintings.
- **1625** Through his relations with the daughter of Philip II of Spain, Isabel Clara Eugenia, he receives a commission for a series of tapestries on the Eucharist for the Convent of the Order of St. Clare in Madrid.
- **1627** As counselor of Isabel Clara Eugenia, he meets Velázquez.
- **1629** Travels to London to negotiate a peace treaty between Spain and England. The English court commissions him to decorate the ceiling of the banqueting hall in Whitehall in London, which he leaves incomplete until 1635.
- **1632** The Town Council of Antwerp commissions some works to celebrate the return of Cardinal-Infante Fernando, the new Regent of the Netherlands.
- **1633** Philip IV of Spain commissions the decoration of a new hunting pavilion at the Torre de la Parada Estate with various mythological scenes from Ovid's *Metamorphosis*.
- **1638** Goiter entirely prevents him from working.
- **1639** Dies in Antwerp.

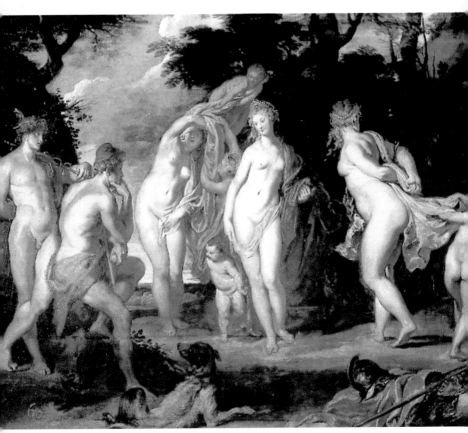

The Judgment of Paris

(1607-1609)
oil on canvas
36.4 x 45.6 in (91 x 114 cm)
Prado, Madrid

All the gods were invited to Peleus' wedding except for Eris, the goddess of discord. She gave vent to her anger for being left out by throwing a golden apple bearing the inscription "For the most beautiful" at the goddesses. This gave rise to a heated discussion to decide who would be the recipient of such a valuable gift.

To solve the problem, Zeus delegated the duty of judging to Paris, a young mortal famous for his beauty. Hera, Athena, and Aphrodite each attempted to bribe the unwary mortal. Aphrodite won by promising Paris that he could sleep with the most beautiful mortal woman, that is, Helen, Queen of Sparta. She kept her promise and Paris' abduction of Helen brought about the Trojan War.

This work represents Paris on the left, with Hermes behind him sent by Zeus, attentively contemplating the goddesses, who exhibit their extraordinary anatomies, with opulent, rounded forms illuminated by a golden atmosphere. The setting of a forest clearing makes the nudes appear more powerful and lends the work an air of romanticism and sensuality. The artist meticulously describes the character of each goddess with a wealth of details. Thus, while Hera and Athena are still getting undressed, Aphrodite, much more diligent, has beaten them to it and is already generously exhibiting her nudity before the young judge in an insinuating pose.

Only Rubens was capable of introducing this type of mischievous detail that lends the women's complexions so translucent a quality, combining the most vibrant Baroque style with the serenity appropriate to divinities. The modeling of the forms executed in a nervous brushstroke accompanies the well-choreographed rhythm of the three nudes, who while separate complement one another. There is also a striking juxtaposition of three differentiated anatomical types that the painter represents in glorious splendor: that of the male figures, that of the goddesses, and that of the cherubs accompanying them. Characteristics such as the sober chromatic treatment and the figures' dynamic and somewhat affected poses, with their statuesque and elongated forms, more than contributing to the episode, seem an homage to Aphrodite, whose illuminated figure magnificently centers the composition.

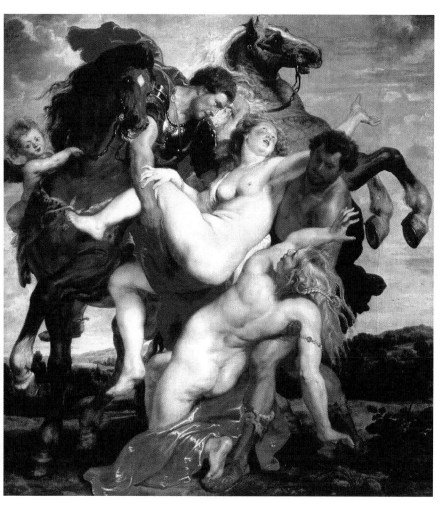

The story of the abduction of the daughters of Leucippus originates from various legends of classical literature that were combined to create a new one: Castor and Pollux were the twin sons of Leda and Jupiter, who attended the wedding banquet of the Leucippides, Phoebe, and Hilaira, names referring to light because their father was identified with Apollo. They were to be wed to Idas and Linceus, shepherds who were enemies of the twins. During the banquet, Castor and Pollux abducted the two women in

The Rape of the Daughters of Leucippus

(1616-1618)
oil on canvas
88.8 x 83.6 in (222 x 209 cm)
Alte Pinakothek, Munich

revenge, quickly galloping off with them on their horses. This caused a fight in which Castor slew Linceus and was in turn killed by Idas, who was slain by Pollux. The latter implored Jupiter to bestow upon his bother the same gift of immortality that he had been granted.

In this scene, with the vitality that Rubens confers on his figures, Castor and Pollux are taking Leucippus' daughters by force, although the drama of the episode is attenuated by its nearly choreographic rhythm. The two women have rounded, generous forms and are strong, yet agile. Despite the fullness of their bodies, they are light in the arms of their abductors. The complex foreshortenings suit the elaborate composition, increasing the movement. To represent these two women, Rubens used the same model in two different poses. The sensuality of the scene is enhanced by the rich fabrics falling away from the voluptuous bodies of the two women, revealing their splendid, corpulent, and supple anatomies, which are frequent characteristics of the artist's female nudes and comprise one of the distinctive features of his art. The work displays one of the artist's principal facets: compositional perfection achieved through the interrelation of forms, colors, and light. His facility for making corpulent bodies ethereally light constitutes an identifying characteristic of the Baroque.

Perseus and Andromeda

(1620-1621)
oil on canvas
39.8 x 55.6 in (99.5 x 139 cm)
The Hermitage, Saint Petersburg

This is one of Rubens' most famous works. The subject matter is taken from mythology. Andromeda was the daughter of Cassiopeia and Cepheus, King of Ethiopia. As her mother boasted that she was the most beautiful of the Nereids, Neptune was offended, flooding the country and sending a sea monster, or Gorgon, to devastate it. The oracle foretold that the only way to placate the monster was to deliver Andromeda to it. Cepheus was obliged to follow the oracle, chaining his daughter to a rock near the sea. The young woman was saved by Perseus, a hero who had just cut off the Gorgon's head. As he had promised, Cepheus gave his daughter's hand to Perseus, who first had to defeat Phineus, Andromeda's betrothed, in a heated struggle.

The scene represents the moment when Perseus arrives to rescue the princess. The hero is dressed as a 16th-century knight and stands before the chained heroine. Several cherubs are freeing her from her chains and attempting to cover her naked body while she covers her intimate parts. Another cherub is holding Perseus' shield, depicting the head of the Gorgon surrounded by serpents that he has just severed, and yet another holds his winged steed, Pegasus. A celestial figure rewards the youth's heroic deeds by placing a crown on his head.

The painter composed the figures and placed them in exaggerated poses in order to achieve balance and a more dramatic effect. The painting is expressive, with meticulous details defining the figures: Andromeda resembling a young Flemish woman; the childlike, candid expressions of the cherubs; the highlights on Perseus' armor; and so on. Movement is suggested by Pegasus' wings, the billowing garments, and the flight of the figure crowning the hero. The composition focuses the viewer's attention on the illuminated figure of Andromeda. The treatment of color is superb, with warm, intense, and vibrant tones.

This work was painted during Rubens' last decade of life, when his interest in mythological subjects increased. These allowed him to dispense with classical nude canons and introduce the voluptuous, opulent, and pearly forms that he so admired in his model and wife, Hélène Fourment, and who probably represented the ideal of beauty of the time.

The Three Graces

(~1635)
oil on canvas
88.4 x 72.4 in (221 x 181 cm)
Prado, Madrid

The Three Graces (Aglaia, Euphrosyne, and Thalia), daughters of Zeus and Eurynome, personified beauty and harmony and brought joy to nature through pleasant artistic manifestations. Here, in the foreground, they are intertwined as if about to begin a dance in an imaginary, bucolic landscape that stretches into the background. The scene is devoid of action, and a tranquil atmosphere predominates. Rubens attains formal compositional perfection through his interrelation of forms, colors, and light. The model on the right has been identified as Isabelle Brandt, Rubens' first wife, while the one on the left is Hélène Fourment, his second wife.

These nudes are highly sensual for the alternation of convex and concave curves in the modeling. The painter considered the folds and corpulence of these bodies very appropriate, suffused with a golden and silvery light. Devoid of all idealization, they symbolized the joy of life. They came to represent the Rubensian canon of beauty. Although they served the artist's purposes perfectly, the exuberant sensuality of the nudes, with their powerful and abundant flesh, was very daring for the time. It is not surprising, therefore, that after Rubens' death, Hélène Fourment wanted to burn the painting with the excuse that she found it indecent. Perhaps her vanity made her feel uncomfortable exhibiting the anatomy that her husband had painted without the least modification.

The Fur Coat

(1638)
oil on wood
70.4 x 33.2 in (176 x 83 cm)
Kunsthistorisches Museum,
Vienna

Rubens married his first wife, Isabelle Brandt, in 1609, but was widowed in 1626. Four years after, in 1630, he married Hélène Fourment, who was the sitter for the majority of his nudes thereafter. She was only 16 when she posed for this painting, already exhibiting a plump body. This painting reveals the close psychological bond of affection existing between model and painter, an emotional vibration that penetrates the viewer.

The voluptuousness with which Rubens treats his female nudes permeates this work, one of the last he painted, with a brilliant display of sensuality. The body of this woman not only displays eroticism, but also expresses sentiments of tenderness, meekness, complicity, and complete trust in the artist. An anecdote illustrating Rubens' vitality is the fact that, when he painted this work, he was seriously ill with a goiter that had begun to cause him intense pain three years earlier. The arthrosis that arose from the illness forced him to stop painting entirely shortly after completing this work, eventually paralyzing his hands. His pain and illness did not prevent him from imbuing this image with extraordinary eroticism, with the same exuberance he displayed in his youth.

The model provocatively looks the observer in the eye. Yet the elements of seduction in this work do not lie solely in the woman's gaze. The false modesty with which she attempts to cover her breast is also unsettling. It is propped up casually on one arm while the other holds the fur coat against her. The contrast between the brilliant figure and the dark background favors the coquettish exhibitionism of the woman, who was much more than a simple nude body to the painter.

FRANS HALS

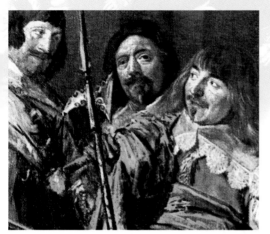

Officers and Sergeants of the Haarlem Militia of St. George *(detail), oil on canvas, 87.2 x 168.4 in (218 x 421 cm), 1639, Frans Halsmuseum, Haarlem. Self-portrait of the painter (center).*

Frans Hals is one of the foremost 17th-century European portrait artists.

He trained as a painter in the studio of Karl van Mander, but when he became independent in 1610, he began to develop a style for which he is recognized today. His first steps as a genre painter led him toward the portrait, in which he quickly excelled, creating an extensive oeuvre (some 240 works), the majority individual portraits, as well as some group portraits, a common practice in the Dutch Baroque.

In addition to specific poses and the movement with which Hals imbues his group portraits, certain characteristics of his paintings stand out for their excellence, such as their freshness, the immediacy and expressiveness of the figures, and his technique of quick, loose, and apparently unstudied brushstrokes, making him a unique painter in his genre and his time. His fame in his lifetime is demonstrated by the numerous commissions he received, especially between 1616 and 1639.

He was a diligent person of great vitality but his propensity for a dissolute lifestyle led him to paint all sorts of people (soldiers, countrywomen, street people, bohemians, drunkards, etc.), almost always depicting the joyful facets of life, with jovial figures who are invariably smiling.

He had many followers, including five of his children, Adriaen Brouwer, and Judith Leyster and her husband J. Miense Molenaer, yet they were never able to match the contribution of Frans Hals' art: the impact of pure colors applied directly onto the canvas. That which his disciples were unable to emulate was achieved two centuries later by Courbet and Manet. Frans Hals is considered one of the most brilliant portraitists of all times.

- **1580** Born in Antwerp to a weaver.
- **1585** Following the occupation of Antwerp by the Spanish, his family moves to Haarlem, in the Netherlands, where he is educated as an artist.
- **1603** He completes his studies under Karl van Mander.
- **1610** Registered as a painter of the St. Luke Guild of Haarlem.
- **1616** His first wife, Annetje Harmansdochter, who had borne him two children, dies. She is buried in a common grave for the poor. He executes the group portrait, *Banquet of the Officers of the St. George Civilian Militia* (see p. 166).
- **1617** Marries Lysbeth Reyniers, with whom he has no fewer than eight children.
- **1622** Joins the St. George Civilian Militia.
- **1627** Paints *Banquet of the Officers of the St. Hadrian Civilian Militia* (Frans Halsmuseum, Haarlem).
- **1628** Paints *The Gypsy Girl* (see p. 167), one of his most famous portraits.
- **1633** Paints the large group portrait, *The Meager Company* (Rijksmuseum, Amsterdam).
- **1635** Declares himself unable to pay the fees for the St. Lucas Guild of Haarlem.
- **1640** Reduces the number of his commissions.
- **1644** Taken to court for not paying his debts.
- **1661** A lawsuit is brought against him for failure to pay for several paintings he had acquired.
- **1664** Granted a subsidy. Paints *Regents of the Old Men's Home* (see p. 170) and *Administrators* (Frans Halsmuseum, Haarlem).
- **1666** On August 29, dies in an elderly home in Haarlem, which has now been converted into the Frans Halsmuseum. Buried in the choir of the Church of St. Bavo in the same city.

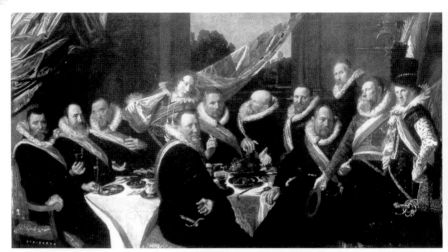

Banquet of the Officers of the Saint George Civilian Militia

(1616)
oil on canvas
70 x 129.6 in (175 x 324 cm)
Frans Halsmuseum, Haarlem

When he executed this portrait in 1616 (the date is inscribed on the armrest of the chair on the left), Hals wanted to create a more vivid and attractive piece than his previous work. He was therefore not satisfied with simply representing a group of well-placed, static figures seated around a table, but chose an especially important moment of the evening and rendered it like a snapshot. That moment was the entrance of the standard-bearer into the hall where the group of Dutch officers, with a jovial air, have just sat down around the table to eat.

In addition to adding meaning to the scene, the standard is used as a compositional element, comprising a striking diagonal above the lively congregation. The painting thus conceived is fresh and spontaneous, making it especially attractive. In addition to creating a daring yet successful composition, the artist fully satisfies the requirements of the commission, creating a faithful, individualized portrait of each member of the group. The painting was executed for the headquarters of the Civilian Militia. The sitters are, from left to right: Colonel Hendrick van Barchennode, Captain Jacob Laurensz, Second Lieutenant Jacob Cornelisz Schout, Nicolaes Woutensz, Captains Van der Meer and Vechter Jansz van Teffelen, Lieutenants Cornelis Jacobsz, Schout, Hugo Mattheusz, Steyn, and Pieter Adriaensz Verbeek, an unidentified individual, and the Second Lieutenants Gerrit Cornelisz, Vlasman and Boudewijn van Offenberg. When it was cleaned in 1920, it was discovered that the gray curtain on the left had been painted over in brown.

This is probably the portrait of a prostitute, with her provocative low-cut neckline (laser examination has revealed that the artist corrected the neckline to make it higher), rather than a bohemian, a term which at that period suggested a soothsayer. The painting can be ascribed to the brightly colored Caravaggiesque movement of Utrecht (with interposing vivid colors, light, and shade). Hals' contribution lies in the energy of his brushwork, which changes in the different areas, agile and soft in the face, with a more animated and brusque touch in the garments. This figure is one of the genre portraits executed by Hals. The background consists of a sort of cloudy sky or rocky landscape, somewhat abstract, crossed by a diagonal strip of lighter color. It accentuates the dynamism of the panel, and is quite exceptional for this artist.

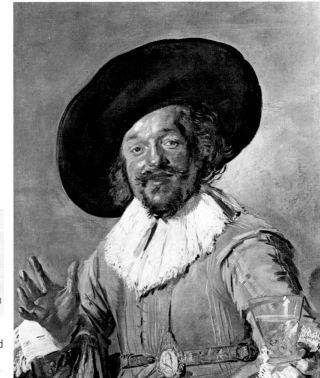

The Merry Drinker

(1628-1630)
oil on canvas
32.4 x 26.6 in
(81 x 66.6 cm)
Rijksmuseum, Amsterdam

Hals interprets extraordinarily well the vivacity and joy of the self-assured Dutchman, who feels content with the world around him. The technique he uses in this portrait is free and daring. For its freshness and gesture, for the loose, decisive brushstrokes, it has even been considered a precursor to Impressionism. His style, as represented in this portrait, gave rise to a pictorial genre typical of the Netherlands. His treatment of this figure is the same as in his group portraits, through which he achieves an expression of a group through its individuals. This portrait establishes a relationship with the viewer through the man's gesture and the vivacious, mirthful gaze that conveys his joy. This person has been identified with Prince Mauritius of Orange.

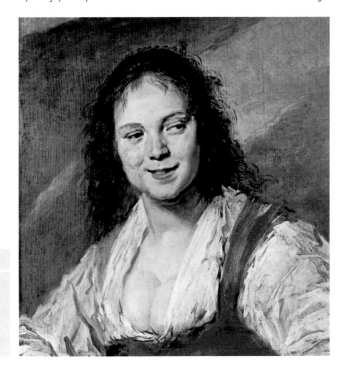

The Gypsy Girl

(1628-1630)
oil on wood
23.2 x 20.8 in
(58 x 52 cm)
Louvre, Paris

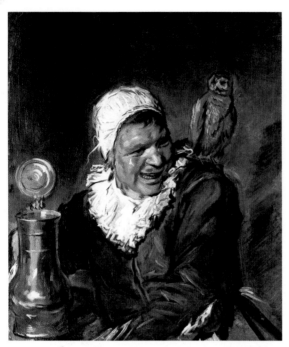

Malle Babbe

(1633-1635)
oil on canvas
30 x 25.4 in (75 x 63.5) cm
Staatliche Museen, Berlin

In portraits such as this one, Hals managed to capture moments of great spontaneity. The title is taken from an inscription on the canvas stretcher. Malle Babbe is supposed to have been a well-known figure in the bohemian world. In the northern Netherlands, baba or babbe meant an old gossip. The mug of beer helps define this woman's personality, as does the owl on her shoulder, an animal usually symbolizing madness or irrationality.

Hals' style here is clearly free and spontaneous, and reveals a great mastery of line. The woman's expression is so well depicted that the image seems as if it were created in no time at all and on first sight. His great skill as a draftsman, along with his style and subject matter, led some to consider him a precursor of Toulouse-Lautrec.

Portrait of an Elderly Woman with Gloves

(1643)
oil on canvas
49.2 x 39.2 in (123 x 98 cm)
Yale University Art Gallery, New Haven

Hals had no trouble finding patronage and support among the merchants and economically powerful families of his society. Group portraits were often commissioned to hang in rooms of official institutions of Haarlem or to decorate the homes of middle-class families who could afford the luxury of having a portrait of all of their family members.

Family Group in a Landscape

(~1647-1650)
oil on canvas
59.4 x 100.4 in (148.5x 251 cm)
National Gallery, London

He gained such fame and importance that the city granted him a stipend, which he received periodically. Although this painting may seem improvised at first sight with its sponta-neous, unplanned appearance, nothing could be further from the truth. His technique is precise and the composition and distribution of the figures are meticulous. The personality of these ten individu-als is evident in each figure.

The painter shows great skill in reflecting their characters and representing each in a different pose without destroying the unity of the group, which is placed in an informal and wholly natural distribu-tion. Each figure is portrayed as if alone, yet all of them fit together as as whole, united by a bal-anced treatment of color and lines. As a detail illustrating the importance that the painter grants the composition, observe how the cows in the background create a diagonal to balance the group of fig-ures in the foreground. According to the National Gallery, the background was painted by another artist, perhaps Pieter de Molijn. A common practice of highly specialized dutch and flemish artists of the 17th century. This may be the M. Everswijn family, although their identity is not certain.

f Hals f

In portraiture, Hals not only sought to satisfy the patron, but had a particular interest in achieving a very modern objective: art for art's sake. Hence, the portrait, in addition to reflecting the per-son's inner self, is an aim in and of itself. His copious oeuvre, stylistically homogeneous, is charac-terized by vivid, spontaneous representations, in rapid and irregular brushstrokes.

In this magnificent portrait, the gesture is intuitive. The corner of the wall is incorporated into the background in order to prevent an excessively centered composition. A remarkable feature is the way in which the atmospheric light affects the complexion. The color harmony is based on a limited palette, applied in a highly effective manner onto the canvas.

Stephanus Geraerdts

(1650-1652)
oil on canvas
46.2 x 35 in (115.5 x 87.5 cm)
Koninklijk Museum voor
Schone Kunsten, Antwerp

This portrait reveals the joyful mood of one of
the artist's first works (*The Laughing Cavalier*,
1624, Wallace Collection, London), which insin-
uates a slight smile and depicts the man in an
apparently spontaneous pose. Here, Hals' skill
comes through again in representing a snapshot
image through a technique based on rapid and
spontaneous brushstrokes. As in the rest of his
portraits, the brushstroke is wide and direct,
lending his works vigor and liveliness, though
after 1640, they become more sober.

Nonetheless, the artist seems to return to his
joyful and vivid beginnings from time to time,
as in this work. He uses two important tech-
niques to achieve this sensation: the illumina-
tion of the figure with direct light, and the mix-
ture of pure colors directly on the canvas.

Regents of the Old Men's Home

(1664)
oil on canvas
69 x 102.4 in (172.5 x 256 cm)
Frans Halsmuseum, Haarlem

This is Hals' last group portrait. He uses an extremely limited
palette, the result of his progressive evolution. As his colors
became more austere and his brushstroke more synthetic, his
palette gained dark, black, and gray tones. His brushstrokes
also changed, from audacious and short to wider and more
vigorous, increasing the effect of light and tonal values.

This canvas is considered his most important work, as he
achieved great complexity with few elements through his
original work method. Although the composition is simple,
the entire group is integrated into a harmonious structure. There is a significant difference
between this work and his early paintings. The figures are very dignified and expressive, which does
not detract from the characteristic that made the artist famous: the creation of spontaneity
through superb brushwork.

ARTEMISIA GENTILESCHI

Self-portrait *(detail), oil on canvas,* 37 x 30 in
*(93 x 74.5 cm), 1630?, National Gallery of Ancient
Art, Palazzo Barberini, Rome.*

Although she was treated unjustly, both as a person and as an artist, Artemisia was one of the first women to gain recognition in the post-Renaissance world of art. Problems in her private life, together with the fact that she was a liberal and self-assured woman, earned her an unjust and undeserved reputation.

Like many other female artists of her time, she was not allowed to study under famous artists. It was her father who opened the door for her in art and introduced her to bohemian artistic circles. Her work was highly esteemed by certain important families of the time, such as the Medici, thanks to which she was able to forge her way as an artist and develop her art. Her iron will helped her to overcome her illiteracy, although she did not learn to read until she was an adult. All of these difficulties heightened her spirit of protest, which constitutes the message of the majority of her works.

She was one of the few female artists of her time who was actually able to work and live as an artist. Her work was all but ignored until the late 20th-century. There are 34 paintings extant by her, some attributed to contemporary male painters by certain critics.

Elaborate compositions and excellent draftsmanship characterize her high-quality artwork, with well-modeled, extremely expressive, and generally female figures animated by mannerism. It is filled with highly compelling and original elements and details. Her formal classicist style in the Tuscan tradition was both esteemed and despised.

- **1593** Born in Rome to the painter Orazio Lomi Gentileschi, under whom she begins studying Caravaggesque art.

- **1611** Artemisia's father asks the landscape and seascape artist, Agostino Tassi, to teach his daughter the rules of perspective. During the lessons, Tassi sexually abuses his student repeatedly and over a long period. She paints *Judith Slaying Holofernes* (Museo Capodimonte, Naples).

- **1612** Tired of constantly being raped by her teacher Tassi, she takes him to court. During the trial, she is subjected to various absurd and humiliating "tests" with the excuse of proving the veracity of her accusations. Although Tassi is condemned and sent to prison, the experience of the trial marks Artemisia profoundly for the rest of her life. Furthermore, she becomes the focus of cruel criticism and earns the reputation of being a whore and a cunning manipulator. She marries the Florentine artist, Pierantonio di Vicenzo Stiattesi.

- **1613** She moves to Florence with her husband, where she begins to gain recognition. The fact that she is a woman brings her great sympathy among some artistic circles.

- **1616** Becomes a member of the Academy of Design of Florence, the first woman to achieve this.

- **1621** Executes a series of frescos for the Galleria Buonarroti, in Florence. Throughout this period, she begins to develop a singular style. She becomes interested in biblical scenes, especially the subject of Judith and Holofernes, which she treats with profound severity and violence, doubtless influenced by the traumas she has undergone. Returns to Rome and lives with her sister, an indication that she may have separated from her husband.

- **1622** Meets Van Dyck.

- **1626** Returns to Naples, where she receives many commissions. She begins a period in which chiaroscuro predominates in her work.

- **1631** In a style radically different from her usual one, she paints several religious works, among which is *The Annunciation* (Prado, Madrid).

- **1636** Paints *The Adoration of the Magi* (Cathedral of Pozzuoli).

- **1638** Moves to England with her father, where she primarily paints portraits in the court of Charles I.

- **1652** Dies in Naples. Various injurious epitaphs are inscribed on her tomb.

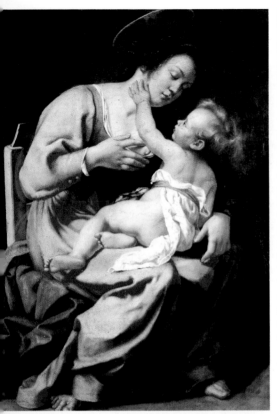

Virgin and Child

(1609)
oil on canvas
46.6 x 34.6 in (116.5 x 86.5 cm)
Spada Gallery, Rome

This composition is pictorially impeccable, with an excellent treatment of light in the tenebrist style invented by Caravaggio. Throughout her career, women were the protagonists of her paintings, and she represented them in a highly original manner, far removed from the stereotypes common until then. Mary's way of breastfeeding her child is especially interesting, since the artist shows the femininity and tenderness of the woman directly, without artistic conventions, breaking with an unspoken tradition in which the Virgin's nipple is rarely seen, always strategically covered by her son's head. Artemisia emphasizes the quality of maternity as the origin of life and women as the progenitors of divinity, and introduces a fresh and tender note of human realism. According to the contract of the commission, the painter used a neighbor and her child as models.

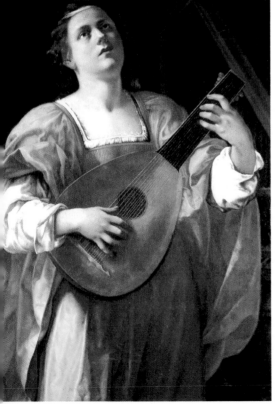

Woman Playing the Lute

(1609-1612)
oil on canvas
43.2 x 31.4 in (108 x 78.5 cm)
Spada Gallery, Rome

The naturalism adopted by the artist, under the influence of Caravaggio, not only reflected the physical characteristics of her figures, but also delved into their inner world. The subject of music is common in Baroque art. The lute was always present at concerts and other events in the courts and palaces of the nobility. Like Caravaggio and Georges de la Tour, Artemisia incorporated this element here as a symbol of such musical events, but it was no coincidence that she chose to portray a female musician. It can be interpreted as an assertion of the female aesthetic in the face of male exclusionism. The painter imbued the canvas with a golden-yellow aura that permeates the whole in a clear intent to idealize the figure. It shows her perfect draftsmanship, modeling, and meticulous details (the woman's expression, her hands, the folds in the sleeves, etc.).

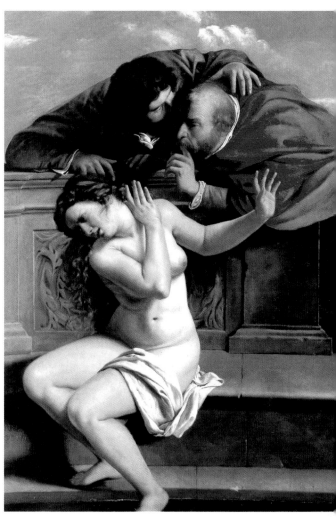

**Susanna
and the Elders**

(1610)
oil on canvas
68 x 47.6 in (170 x 119 cm)
Graf von Schönborn
Kunstsammlungen,
Pommersfelden

Many of Artemisia's works reflect her own life, such as this one, representing a biblical episode common in art. She was repeatedly raped by her drawing teacher and, when she finally took him to court, was subject to numerous embarrassing and humiliating "tests" by midwives to demonstrate the veracity of her accusations. The trial gave Artemisia the lifelong reputation of being a libertine and prostitute, reinforced by the fact that she frequented bohemian and marginal circles, including those of Caravaggio himself.

This painting portrays the moment when the two elderly judges suddenly appear before a surprised Susanna, who is naked, and attempt to sexually abuse her. According to the Bible, when they were unable to achieve their aims, they accused her of inciting them and she was sentenced to death. She was saved by Divine intervention, her innocence was proven, and the judges were sentenced to death instead.

The painter must have identified deeply with the figure of Susanna. The woman has a dignified, noble attitude—she is a symbol of purity and rectitude. Her body is attractive and corpulent, well-modeled and sensual, yet does not evoke lust. The nude in general and its pose has profound force, through which the painter reveals her point of view and her sentiments as a woman, probably reflecting her own reaction to humiliation and abuse. Susanna expresses her frustration and impotence before the elders, heightened by the contrast between her corpulence and her inner fragility and powerlessness to prevent what is happening.

The expression of the elder with the red cape wholly defines his intentions and moral level. This work was painted when the artist was only 19 and had not yet finished her studies. Despite this, it shows the quality of a consolidated artist. Due to its high artistic level, it was thought to be the work of her father, despite the fact that it was signed and dated by her.

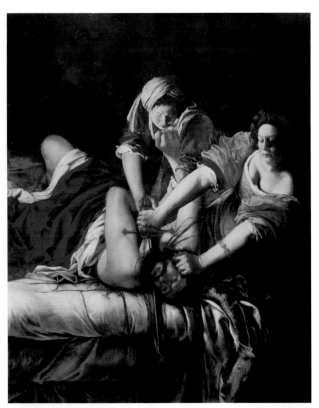

Judith Decapitating Holofernes

(~1620)
oil on canvas
(200 x 163 cm)
Uffizi Gallery, Florence

Artemisia had a particular propensity for this biblical scene, possibly because it allowed her to express certain sentiments that were deeply rooted in her spirit. This work is one of her most interesting for its character studies and tenebrist treatment.

According to the Bible, in an attempt to save the people of Israel from the imminent attack and cruelty of the Assyrian general, Holofernes, Judith went to his camp, where she seduced and murdered him by severing his head. The scene represents the moment immediately after the assassination. Judith places the severed head in a basket and prepares to escape with her servant to the Israeli camp.

This work represents the woman as a hero, defender of her own ideals and of her people. Above all, beyond the biblical episode and other interpretations, the expressions on the women's faces are eloquent, evoking strength, character, and conviction. They are an homage to all women and a declaration of the importance of women's role in society. Their coolness and self-assurance after having completed their mission despite the difficulties could not be matched by any man. This message is reinforced by the treatment of light in intense chiaroscuro, the vivid, contrasting colors, and the dramatic, static, and forceful pose.

The cruelty and violence of the action could also be interpreted as the artist's reaction against men in general, arrogant and domineering like Holofernes, against whom the heroine rebels in response to his abuse. It should also be kept in mind that Artemisia was working in Florence, where Judith was a symbol of the Florentine Republic heroically struggling to free itself of tyranny. Despite all of these interpretations, this portrayal of Judith was not always well received. Even in the 20th century, the historian De Longhi affirmed: "This Judith is certainly terrible. Was it a woman who painted her? Let us beg for mercy."

The Penitent Magdalene

(1617-1620)
oil on canvas
58.6 x 43.2 in (146.5 x 108 cm)
Palatine Gallery, Palazzo Pitti,
Florence

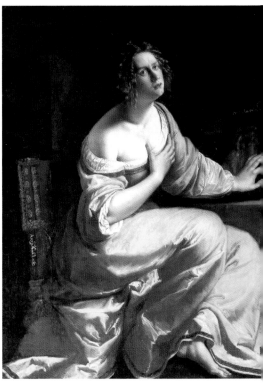

On the chair is the signature used by the artist during her period in Florence—Artemisia Lomi. The most remarkable aspect of this painting is the color of the dress, recalling certain works by Guido Reni. A wide range of brilliant golden-yellows is applied, achieving a burst of light in the darkness of the room. The predominance of this tone throughout the work and its reflection in different areas, such as the hair and chair, lend it great personality. The harmonious color range creates an atmosphere and integrates all elements of the scene.

Once more, the painter represents a normal, very human woman, with her own thoughts, inner world, and strong character. This woman is prepared for everything—she is ready to suffer, struggle, and live fully. The expression on her face, the anatomical forms of her powerful body, and her pose denote a profoundly noble air. She exhibits all of those qualities that women claim to have as human beings and which society repeatedly denies that they do.

Allegory of Inclination

(1616)
oil on canvas
60.8 x 24.4 in (152 x 61 cm)
Casa Buonarroti, Florence

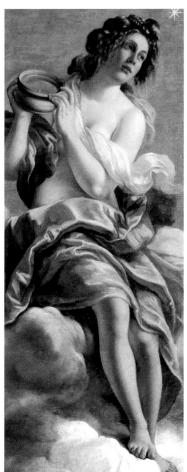

The Medici, who were the Florentine patrons of Michelangelo, became acquainted with Artemisia's work thanks to her friendship with Michelangelo's nephew. They commissioned her to paint several frescos. This work is part of a series designed as a homage to Michelangelo, representing his eight virtues (inspiration, study, tolerance, patriotism, piety, moderation, honor, and inclination).

Originally, this work was to be commissioned to artists from the city, but Leonardo Buonarroti's power of persuasion convinced the Medici to choose Artemisia. The protagonist has the aspect of a lively woman of strong character, with a delicate complexion but a powerful body. The static pose is typical of allegories, and appropriate here. The work is meticulous, with the body modeled in soft shadows through a measured treatment of light. The artist painted this woman fully nude, but Michelangelo's heir contracted Il Volterrano to paint the robe that partially covers her.

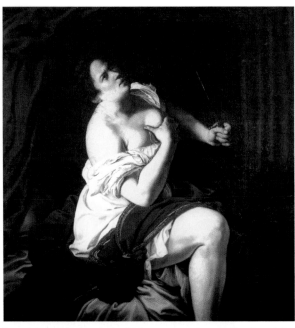

Lucretia

(1621)
oil on canvas
54 x 51 in (100 x 77 cm)
Palazzo Cattaneo-Adorno, Genoa

The artist was fond of the tenebrism apparent in this work. She learned it from her father and directly from Caravaggio himself. The scene represents Lucretia about to commit suicide after having been raped by her brother-in-law, Tarquin, the last Roman emperor. This dishonor, which the woman cleansed by taking her life, caused the Romans to revolt against the tyranny of their emperor and establish the Republic.

Lucretia's pose is theatrical, with her garments in turmoil and partially revealing a strong, voluptuous body. She is remarkably expressive: her gaze and pose, and the gesture of gripping her breast with force perfectly define the feeling of impotence and rage of a woman highly conscious of her moral values and her condition, whose dignity has been violated. The woman's willingness to die to defend her honor is a message appearing again and again in Artemisia's art.

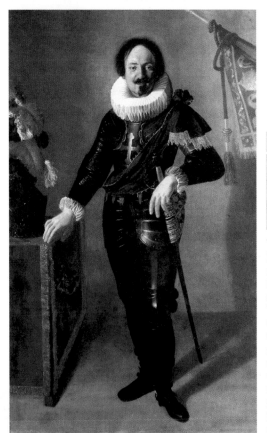

Portrait of a Gonfaloniere

(1622)
oil on canvas
82 x 50 in (208 x 128 cm)
Palazzo d'Accursio, Bologna

This is one of the few portraits extant by Artemisia, although she executed many during her sojourn in England beginning in 1638. Her superb skill as a portraitist is perfectly evident here. The identity of the sitter is not certain, but some believe it is Pietro Gentile. The study of the face is remarkable, reflecting deep introspection, as is the elaborate execution of the armor and the accessory elements. On the other hand, there are several imperfections, such as the difference in the proportions of the body in general with relation to the arms.

NICOLAS POUSSIN

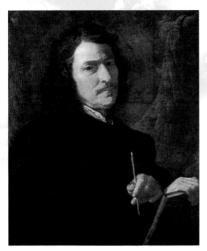

Self-portrait, *oil on canvas, 31 x 26 in (78 x 65 cm), 1650, Staatliche Museen, Gemäldegalerie, Berlin.*

Born in France, Nicolas Poussin was active in Rome where he studied classical artists, for whom he felt deep admiration. Poussin is considered one of the foremost initiators of French Neoclassicism.

Opposed to the naturalistic art of Caravaggio and the gentler art of Guido Reni, he represented mythological and religious subjects indiscriminately, using identical parameters and combining agnosticism with Christian ideology. His figures have superbly modeled, athletic bodies treated in accordance with his training as a sculptor.

His art provided important contributions to atmosphere and landscape, which played a larger role, instead of serving as a mere backdrop. His work reflects a profound study of Titian's palette and of Raphael's works. It incorporated the Renaissance spirit into the aesthetic and cultural sensibility of his time, showing the mark of classical Greek and Roman art.

The artistic conception of his works reveals his origin and the tastes of the upper classes of the time. His representations created an important school in subsequent centuries, especially among painters from his country like Jean-Antoine Watteau, François Boucher, and Jean-Honoré Fragonard.

- **1594** Born in Villers, near Les Andelys, in Normandy.
- **1612** Persuaded by Quentin Varin, moves to Paris, where he works in the studios of Georges Lallemand, Ferdinand Elle, and Alexandre Courtois.
- **1620** Travels to Florence, where he enters into contact with the engraver Stella and meets Callot.
- **1621** Settles in Paris, where he collaborates with Philippe de Champaige on the decoration of the Palais de Luxembourg.
- **1624** Moves to Rome, where he begins painting important works, the majority of which are commissioned by Cassiano dal Pozzo, the secretary to Cardinal Francesco Barberini, the nephew of the Pope in office, Urban VIII. Becomes acquainted with the sculptors Duquesnoy and Algardi.
- **1629** He wins the commision for two paintings, *The Martyrdom of Saint Erasmus* (see p. 178) and *Et in Arcadia Ego* (see p. 178) over his rival, Pietro da Cortona.
- **1636** Gains fame throughout France and begins to receive important commissions from patrons in that country, including a series of bacchanals for Cardinal Richelieu.
- **1639** On Richelieu's advice, he is appointed painter to King Louis XIII and director of artistic works in the royal house. Poussin enjoys his work in Rome at this time, immersed in an atmosphere that he finds magnificent. He leaves the Eternal City only grudgingly to establish himself in Paris at the insistence of the king and Richelieu.
- **1640** Lodging at Les Tuileries, he paints various works for the French court, but the servitude of working for the palace, the obligation of painting religious subject matter, with which he does not feel particularly comfortable, the intransigence of artists well established at the court, such as the architect Lemercier or the landscape artist Fouquières, and especially his rivalry with Simon Vouet, cause him to abandon the post after two years.
- **1642** Keeping his title and the honoraria, he returns to Rome, where he again immerses himself in the atmosphere and painting he most enjoys, based on classicism.
- **1644** Begins to execute series of paintings on specific subjects. One of the most important is the *Seven Sacraments,* commissioned by Chantelou (National Gallery of Scotland, Edinburgh).
- **1664** Victim of a serious illness that had been progressively destroying his health, he stops painting. He is highly admired in Rome, both by the general public and his students.
- **1665** Dies in Rome.

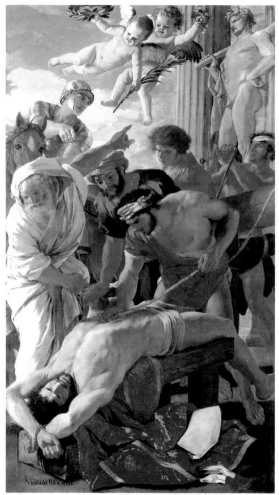

The Martyrdom of Saint Erasmus

(1628)
oil on canvas
128 x 74.4 in (320 x 186 cm)
Vatican Gallery, Vatican City

Poussin always maintained good relations with influential people of Rome, who admired his painting style. Thus, he attained prestige there as a creator of large religious works and was inundated with commissions from all of the churches of the city.

This is one of his most important works, executed for the Chapel of St. Erasmus in St. Peter's Cathedral, the Vatican. Political intrigue and influence were the order of the day and greatly affected the kind of art commissioned, giving rise to constant fights and all sorts of animosity and dirty play among artists.

This work was supposed to be entrusted to Pietro da Cortona, but thanks to the intervention of Cassiano dal Pozzo, the secretary of Cardinal Francesco Barberini, Poussin was entrusted with the work. Both dal Pozzo and Barberini were clients and protectors of Poussin. Perhaps this is why the painting was received with such indifference by a certain sector of Roman society.

The scene refers to the story of Erasmus, Bishop of Formia, who was taken prisoner by Diocletian. Refusing to renounce his Christianity, he was submerged in a cauldron of boiling oil but remained unscathed through Divine intervention. Imprisoned and shackled, he was freed by an angel. Finally, hot irons were applied to his body. Other legends also recount that his entrails were removed.

Although Poussin always felt removed from Caravaggio's style as well as Guido Reni's gentler touch, the treatment of light and the hardness of the actions recall the former. The saint's body is in an extremely foreshortened position that gave rise to some criticism. The painting, though Baroque in the main, manifests an accentuated interest in classicism, both in the treatment of the figure and in the work in general, not surprising for an artist who was one of the foremost precursors of French pictorial Neoclassicism.

When he executed this painting, Poussin was in Rome, where he maintained contact with Cardinal Francesco Barberini and his secretary, Cassiano dal Pozzo, an enthusiast of ancient classical art who wanted it reinterpreted in the light of contemporary European culture. Poussin, who shared their ideas, was the ideal artist to materialize their objective. This work suggests the bucolic world of Virgil. Conceived in the classical manner, it has the solemnity and dignity called for in an allegorical representation, with distinguished, meticulously executed figures in affected poses. The painting is a clear precursor to what was to become the predominant style and subject matter of Poussin's works.

Et in Arcadia Ego

(1629-1639)
oil on canvas
34 x 48.4 in (85 x 121 cm)
Louvre, Paris

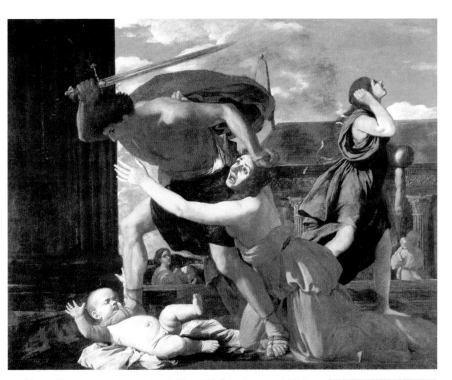

This painting corresponds to the period in which Poussin was establishing himself in Rome, where he executed works in a medium format for individuals, including Cassiano dal Pozzo, his best client. It depicts a subject represented various times by the artist. Among his commissions, religious subject matter predominated, as in this work, in which the painter devised a very dramatic scene through the use of few elements, highly contrasting light effects, and a highly theatrical mise-en-scène. The figures are posed like statues, with an intense source of light and an architectural background in dark colors. The artist carefully portrays the feelings of each figure. The cruelty of the soldier, the desperation of the mother attempting to stop him from murdering her child, and the despair of the mothers who have already lost their children, with their terrified gestures, lend the work its extreme expressive force.

The Massacre of the Innocents

(1628-1630)
oil on canvas
58.8 x 68.4 in
(147 x 171 cm)
Musée Condé, Chantilly

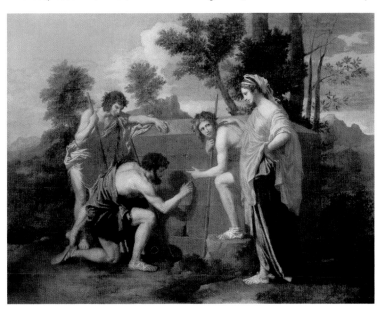

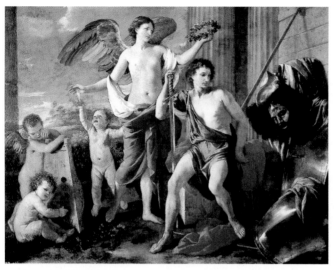

The Triumph of David

(~1630)
oil on canvas
40 x 52 in
(100 x 130 cm)
Prado, Madrid

This work, executed for a private collection, reflects the artist's evolution in various ways. This is not a pure biblical story, but rather a combination of mythological and classical elements. The small angels recall certain reliefs by Duquesnoy and the figure of Victory is classical in style. Young David contemplates the giant Goliath's head, which he has just severed, while he is crowned by the allegory of Victory in the purest classical style. The sexually ambiguous nude of Victory recalls certain Roman friezes. That of David corresponds to a hero in a somewhat rigid stance if compared with the great expressiveness of the children, executed with highly dynamic, naturalistic drafts-manship. He represents light in the manner of Caravaggio, though less dramatically.

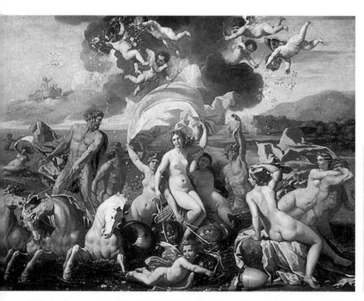

The Triumph of Neptune and Amphitrite

(1634)
oil on canvas
45.8 x 58.6 in
(114.5 x 146.6 cm)
Philadelphia Museum of Art, Philadelphia

This work was painted for Cardinal Richelieu, the prime minister of Louis XIII, who commissioned a series of bacchanals for his palace in Poitou. Executed within the classicist aesthetic, it reveals the influence of Titian and Raphael. The scene is set in an idealized environment presided over by Amphitrite, queen of the seas, surrounded by a cortege of nymphs, tritons, and cherubs, as well as by Neptune, god of the waters, riding his marine steeds. All of the figures are nude, in varied poses with great movement, in a warm atmosphere where lust predominates. In accordance with his Italian influence, the nudes recall the greatest figures of Renaissance art. They are vigorous and sensual, in daring, elegant poses, with heroic proportions and an air of monumentality.

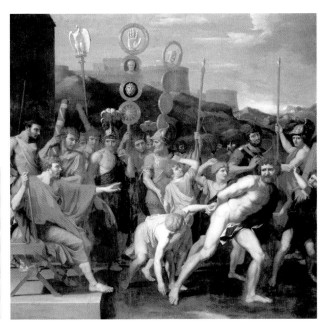

Camille Delivers the Teacher of the School of Faléries to his Pupils

(1637)
oil on canvas
100 x 107 in
(252 x 268 cm)
Louvre, Paris

This work was painted at a time when Poussin's fame had spread throughout France. It was commissioned by Louis Phélypeaux de la Vrillière for his residence in Paris, where it hung until it was confiscated in 1794 during the French Revolution. The scene represents the teacher, naked and with his hands tied behind his back, at the mercy of his students, who take revenge for the cruel punishment he had previously inflicted upon them. Camille, seated and wearing a red mantel, condemns their actions. The painter demonstrates excellent knowledge of human anatomy and great mastery in evoking eroticism in any sitclassicism, which so interested the artist and which was the most distinctive characteristic of his works.

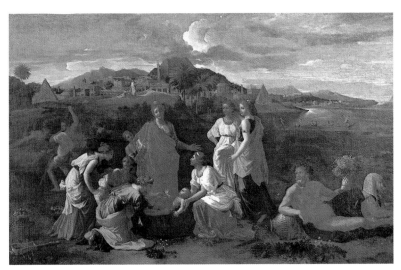

This canvas represents the biblical episode in which Moses is rescued from the river by the servants of the pharaoh's daughter, who show him to the princess. The composition is dominated by the princess, accompanied by her servants. On the right is the River Nile, represented as a reclining, elderly man accompanied by a sphinx. His athletic body recalls certain aspects of Neptune. The combination of figures and landscape is remarkable, whereby the latter, beautiful, varied, and with presence, surpasses the jaded function of a simple stage set. This lends the work a natural, fresh air, leaving the scene devoid of solemnity and idealization.

Moses Rescued from the Waters

(1647)
oil on canvas
48.4 x 78 in (121 x 195 cm)
Louvre, Paris

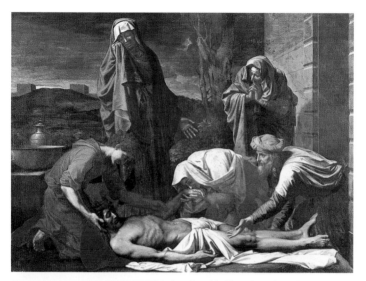

Lamentation of Christ

(1656-1657)
oil on canvas
37.6 x 52 in (94 x 130 cm)
National Gallery of Ireland, Dublin

In spite of its Venetian color scheme, this work is more sober than those of the artist's early years, which reflected the Italian fashions of the time. The figures have an interesting chiaroscuro, but it is the application of light on Christ's body which is the most engaging. The way it shines on the shroud is uncommon in this period of compositional sobriety. Shadows lend the figure a mysterious quality. They nearly cover his face, which is hardly defined, consisting of only the lighter protrusions of the cheeks, forehead, and nose. The scene, solemn and theatrical, comprises a group of static figures resembling statues, some in affected poses.

Winter, *or* The Deluge

(1660-1664)
oil on canvas
47 x 64 in (118 x 160 cm)
Louvre, Paris

This painting is part of a series on the four seasons commissioned by the Duke of Richelieu. It is a synthesis of his artwork in his last period. The landscape represented is magnificently mysterious and the narrative refers to some literary works from the Middle Ages and to classical mythology as well. The title makes it clear that it represents both the tragic biblical story and a profane subject, giving rise to something which was a constant in Poussin's work: a skillful synthesis of pagan humanism and Christian doctrine. The painting is spectacular and once again shows the mastery of this artist, especially in those subjects that he enjoyed.

Francisco de Zurbarán

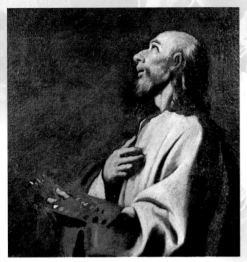

St. Luke before Christ on the Cross *(detail), oil on canvas, 42 x 33.6 in (105 x 84 cm), 1635-1640, Prado, Madrid. Many consider the figure of the evangelist to be the artist's self-portrait.*

Zurbarán's art belongs to the School of Seville, which was already consolidated in the early 17th century, based on the Baroque style of Ribera.

In his unique manner, Zurbarán combines the Venetian style of Juan de Roela, the realistic, direct style of Herrera the Elder, a turbulent and inconsistent painter, and the Romanist principles of Francisco Pacheco.

His artwork is characterized by the following features: unintegrated compositions, as if the elements had been conceived and executed independently; tenebrism, using light to define profiles; the use of light colors to create sculptural and sober modeling; masterful draftsmanship, although somewhat bold at first; and an ability to construct volumes and distribute them throughout the canvas. His crucifixions are solemn, his representations of the Virgin and female saints present an idyllic image of femininity, and his still lifes possess.

Although he tried to assimilate the sensibility of the new generation of painters led by Murillo, he could not conceal the fact that his severe and static style was the product of a bygone era. Its splendor shines through an energetic execution and great chromatic richness, in which whites stand out through contrasts between blues and reds, greens, and browns.

A profoundly religious man, he is considered by many as the founder of 17th- and 18th-century Latin American painting, since many artists from countries such as Mexico, Peru, Bolivia, and the Antilles were inspired by his work.

- **1598** Born on November 7 in Fuente de Cantos, Badajoz, to Luis, probably from the Basque country, and Isabel Márquez, from a family of modest merchants.

- **1614** Enters the workshop of the Sevillan religious painter, Pedro Díaz de Villanueva, as an apprentice.

- **1616** Paints an Immaculate Conception, in which he, despite his youth, reveals his great skill.

- **1617** Marries María Páez in Llerena, where he resides and paints various altarpieces for churches in the area.

- **1625** Widowed the previous year, he marries Beatriz de Morales.

- **1628** The Dominicans of Seville commission 22 paintings, 14 of which are on the life of St. Peter Nolasco.

- **1629** To comply with the many commissions he receives from Seville, he moves to that city, where the town council appoints him official painter.

- **1631** Paints *The Triumph of St. Thomas,* (Museo de Bellas Artes, Seville), in which the tenebrism that would become characteristic of his works appears for the first time.

- **1634** On the recommendation of Velázquez, he is called to the court of Madrid to paint *The Defense of Cádiz* and 10 emblematic *Labors of Hercules* for the Buen Retiro Palace (all at the Prado, Madrid).

- **1638** Executes an altarpiece for the charterhouse of Jerez, representing various male saints and a good deal of sibyls and female saints resembling elegantly dressed Andalusian women. From this year, he executes various commissions for the Monastery of the Order of St. Jerome of Guadalupe, in Cáceres, including eight large canvases for the sacristy.

- **1639** His second wife dies.

- **1644** Marries Leonor de Tordera.

- **1645** With the arrival of a new generation of artists headed by Murillo, appreciation of his painting begins to decline. In collaboration with his students, he paints various series of apostles and patriarchs, many of these works exported to Latin America.

- **1664** On August 27, dies in Madrid, where he had lived since 1658.

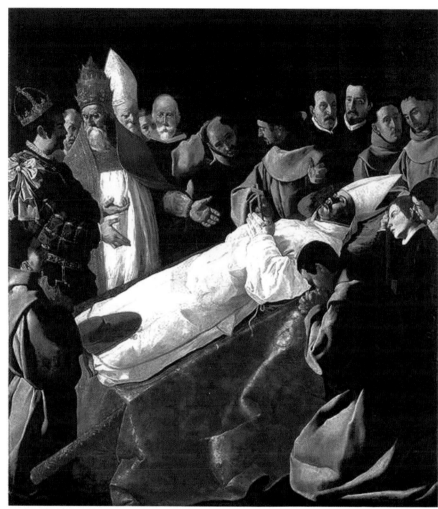

Saint Bonaventure on his Deathbed

(1629)
oil on canvas
98 x 90 in (245 x 225 cm)
Louvre, Paris

When he painted this work, Zurbarán had attained such renown that the city council of Seville summoned him to settle in the city and work there, an offer which he accepted. He was commissioned to continue the series on St. Bonaventure that Francisco Herrera the Elder had left unfinished.

This canvas portrays the body of the dead saint on a diagonal, wearing his liturgical attire (alb, chasuble, stole, and miter) and reclining on a catafalque covered by a richly brocaded fabric and with the cardinal's hat resting on his feet. The saint's white attire centers the viewer's attention and cuts the composition into two. The figures surrounding him consist of ecclesiastics, other religious figures, and noblemen. The background is absolutely dark so as not to interfere with the prominence of the figures. Through intense chiaroscuro, arising from a single source of light from the left that leaves the other side in total darkness, Zurbarán presents a rich collection of expressive and natural faces, with very studied features and theatrical gestures that perfectly describe the solemnity of the moment.

Reverence, absorption, and devotion are the principal sentiments reflected here. The work is highly theatrical. A beautiful example of post-Renaissance art, it seeks to exalt the death of those whose existence is based on piety and contemplation. In a fully appropriate language, he achieves the double objective of glorifying the saint and evoking devotion among believers. It is not surprising that Zurbarán was inundated with commissions.

FRANCISCVS.DZVRBARAI

Saint Agatha

(1630-1633)
oil on canvas
50.8 x 24 in (127 x 60 cm)
Musée Fabre, Montpellier

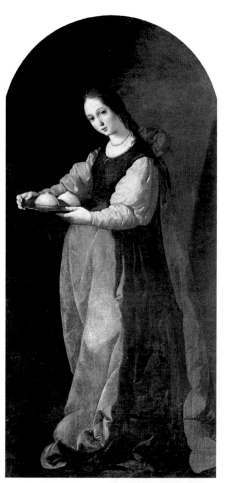

According to legend, Agatha was a young woman from a noble Sicilian family who underwent martyrdom during the persecution called by Emperor Decius. Familiar with the chastity and beauty of the girl, Quintian, the praetor of Sicily attempted to win her favor by offering her all sorts of gifts, which she refused, remaining true to her Christian faith. Angry at this, the praetor subjected her to torture, first applying incandescent iron plates to her body and then cutting off her breasts. That night, St. Peter miraculously appeared and cured her. Upon seeing the miracle the next day, Quintian placed her in a dungeon, and her body ascended to heaven while she was praying.

This saint was highly venerated in the 5th century. She is represented in this work standing against a dark background with the aspect of an attractive young woman from Seville, with long hair and an oval face. The dark, dense background contrasts with her bright garments, each piece in a different color. The saint is holding a platter with her breasts. The work is imbued with candor and tenderness, the fruit of a sentimental and devout painter.

Immaculate Conception

(1632)
oil on canvas
100.8 x 67.2 in (252 x 168 cm)
National Museum of Art
of Catalunya, Barcelona

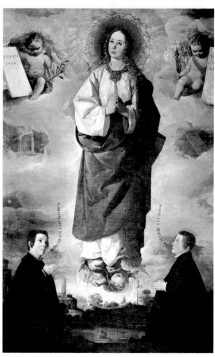

Zurbarán's paintings reveal his devoutness, for they convey highly spiritual sentiments. In this work, Mary is standing on a crystal ball whose upper part is covered with the heads of angels. The Virgin is a young woman with an attractive, delicate face, an innocent expression, and a humble pose, who is glorified in the painting.

Otherwise, she is a person of normal appearance, wearing a wide pink tunic covered by a dark green cape in the same color as the halo around her head. In each of the upper corners, an angel holds a panel with an inscription in one hand, and in the other hand, a bouquet of roses and of irises, respectively. Below, two young clergymen kneel before Mary and venerate her. From their mouths issue the following words: monstra te esse matrem (Show us that you are our mother) and mites fac et castos (Make us sweet and chaste).

Still life

(~1633)
oil on canvas
18.4 x 33.6 in (46 x 84 cm)
Prado, Madrid

Among Zurbarán's still life works, this is considered his masterpiece. As in many of his paintings, the background is entirely dark. The four objects represented on a table are independent, such that each could form a separate painting. They are highly realistic and sharply defined by a clearly chiaroscuro technique, executed with a single source of pale light. They are juxtaposed in a horizontal composition, with well-balanced masses and colors and a studied sense of improvisation. For the period, this concept of still life is absolutely singular.

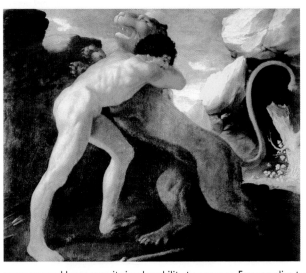

Hercules Fighting with the Lion of Nemea

(1634)
oil on canvas
60.4 x 66.4 in (151 x 166 cm)
Prado, Madrid

The first of the twelve tasks that King Eurystheus imposed upon Hercules was to slay and skin the lion that threatened Nemea, as no one could overcome its invulnerability to weapons. From an olive tree that he had uprooted, Hercules fashioned an enormous club and went to the beast's lair. When he saw that his arrows were rebounding, he struck the lion a deadly blow with the club, and while it was staggering, grabbed it by the neck, strangled it, and skinned it with its own claws. When the hero attempted to bring the skin to the king, the latter barred him from the city because he feared an uprising.

Zurbarán's art is characterized by static figures and somewhat disjoined compositions, as if each element had a life of its own. Here, the hero is shown strangling the lion. The nude, one of the few by this artist, is a splendid academic study of a muscular man. Whereas the figure of Hercules is perfectly studied and modeled, with certain influences of tenebrist realism, the lion is pure invention. Despite the requirements of the scene, there is no movement, as evident in the analysis of the figure, a typically static studio pose.

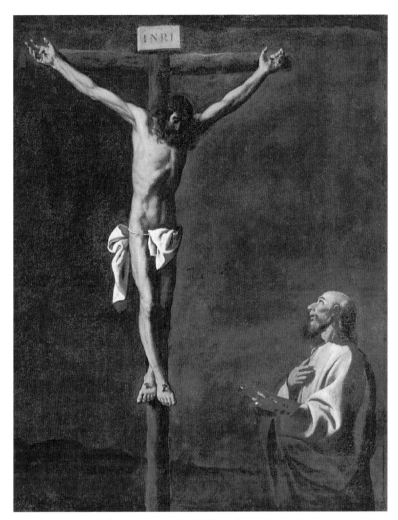

This painting is rather small in format compared to the dimensions commonly used for these types of works in order to enhance their monumentality. Perhaps the artist painted it for personal use. The sobriety of color and lateral illumination striking Christ's nude body are very theatrical elements, which invite meditation. The body of Christ crucified is generally not presented with such tension. It is portrayed against a dense, dark background devoid of elements except for a tenuous horizon that can be made out near the bottom.

Saint Luke before Christ on the Cross

(1635-1640)
oil on canvas
42 x 33.6 in (105 x 84 cm)
Prado, Madrid

On the other hand, the image of Christ is highly realistic and natural. Hence, the structure of the arms is based on a thorough analysis of what has just happened: death has just overcome him. The weight of the body stretches both arms and makes the thorax rise, causing death by asphyxia. The gesture of the hands is very expressive, although in reality, the nail could not be placed in the center of the palm because the hand would not withstand the weight of the body and would tear. In such a static image with such elongated lines, the movement of the loincloth is surprising, with its forms and folds.

As it is a work designed for devotion and meditation, the painter concentrates on the pose, lines, light, and color, but avoids all signs of blood. This may be the most important difference with regard to traditional iconography, although other elements of this nude are also highly original, particularly the modeling of light and the contrast created by the shadows, which lend the work great drama. St. Luke, in ecstasy before the figure of Christ, has forgotten the task of painting in which he was involved. Perhaps this contemplative figure reveals Zurbarán's own devotion, which is visible in all his religious works.

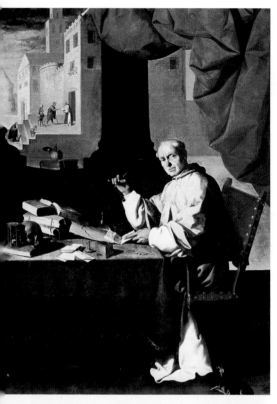

Fra Gonzalo de Illescas

(1639)
oil on canvas
116 x 88.8 in (290 x 222 cm)
Monasterio de Guadalupe, Cáceres

This painting is part of a series of commissions made in 1638 by the Monastery of the Order of St. Jerome of Guadalupe. Zurbarán takes the opportunity of portraying the friar to execute a painting of high compositional and technical complexity. It comprises a series of elements that are combined with singular skill: the full-body portrait of the friar, the still life on the desk, a foreground with substantial tenebrist elements, bounded by a dark background, the highly realistic drapes hanging in the upper right corner resembling a drop curtain, the small still life on the windowsill on the left, and a well-illuminated scene viewed through the window of a cityscape under a brooding sky. The work is an ingenious and highly spectacular mise-en-scène.

Saint Francis

(1645)
oil on canvas
78.8 x 42.4 in (197 x 106 cm)
Musée des Beaux-Arts, Lyon

Painted in a period when Zurbarán's fame was beginning to fade, eclipsed by a new generation of emerging artists, this canvas portrays a monk, one of the most common subjects of his artwork. This highly theatrical representation is significantly tenebrist, with the source of light from the left creating great contrasts, defining profiles and forms and submerging the remainder of the work in total darkness. The image is stylized, austere, and deeply spiritual, with a balanced treatment of color. Above and beyond the representation of the saint, the painting is an exaltation of the contemplative life of monks, filled with spirituality and mysticism.

ANTHONY VAN DYCK

Self-portrait, *oil on canvas, 46 x 37 in (116.5 x 93.5 cm), 1620-1621, The Hermitage, Saint Petersburg.*

One of the greatest Flemish painters, Sir Anthony Van Dyck concentrated on mythological and religious painting early in his career and never abandoned it completely. However, toward the year 1627 he began specializing in portraiture, in a style similar to that of Rubens, but imbued with a more lyrical, personal touch and a gentler chromatic range, representing full body portraits of stylized, elegant figures with languid gazes and magnificent attire, set among abundant drapes or architectural elements. He created many double portraits as well.

This artist, accustomed to courtly life, executed aristocratic portraits designed for high society, whose condition and colonial mentality—Holland had many overseas possessions at the time—they vividly reflect. In his works, dynamic compositions and figures with robust and meticulously executed anatomies predominate. He often uses red in the background or the setting to make the chromatic impact stronger.

Curiously, there is a significant difference between his mythological and religious works, which recall Rubensian magnificence, and his portraits, always severe, with a certain degree of melancholy and invariably distant. His style directly influenced English portraitists, giving rise to the English School, very important during the 18th century (Gainsborough, Reynolds, etc.) and well into the 19th century.

- **1599** Born in Antwerp to a rich textile merchant.

- **1609** Enters the studio of Hendrik van Balen.

- **1615** Establishes his own studio.

- **1616** Paints his earliest extant works, a series of busts of the apostles (Gemäldegalerie, Dresden), *Head of a Man* (Musée de Aix-en-Provence), and *Study of a Head* (Louvre, Paris). Begins his first period, characterized by great expressiveness, a spontaneous brushstroke, and figures with vehement gestures.

- **1618** Admitted as master painter into the Guild of St. Luke in Antwerp, which allows him to work independently. Works in Rubens' workshop as an associate, where he basically concentrates on religious paintings.

- **1620** Moves to the English court of James I.

- **1621** After his father's death, he travels to Italy, where he remains some 6 years, visiting different cities. He remains in Genoa for a long time, decorating several palaces with portraits of their owners, and then studies Titian in Venice, adopting his colors and poses. He also travels to Padua, Mantua, Turin, Florence, Rome, and Palermo. During this period, his elegantly drafted, chiaroscuro works are characterized by a contained and expressive chromaticism, and he paints his oils on canvas. His frequent contact with the aristocracy leads him to dedicate himself to portraiture, primarily executing portraits of Genovese families such as Brignole-Sale, Cardinal Bentivoglio, etc., which reveal the influence of the Venetian and Bolognese Schools.

- **1627** Returns to Flanders (Antwerp), where he paints various religious works: *Christ on the Cross* (Sint-Jacobskerk, Antwerp), *Rest on the Flight to Egypt* (Alte Pinakothek, Munich), *Samson and Delilah* (Dulwich, London). He also paints portraits reflecting the different social classes of his country.

- **1632** Summoned to Britain by Charles I, where he is appointed official court painter and knighted. He resides there until his death. Paints many portraits of royal family members, as well as court figures and the nobility.

- **1633** Temporarily moves to the Netherlands.

- **1639** Marries Lady Mary Ruthven, of a noble Scottish family.

- **1641** Dies in his home at Blackfriar in London. Buried in St. Paul's Cathedral.

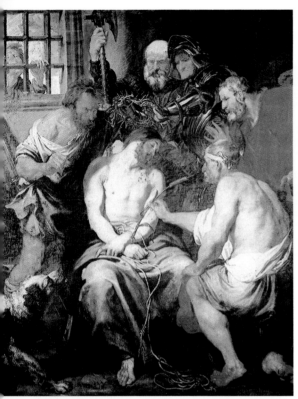

The Crowning with Thorns

(1620)
oil on canvas
89 x 78.4 in (223 x 196 cm)
Prado, Madrid

Despite Van Dyck's strong personality, the influence of Rubens is especially evident in the painter's early works. This canvas, inspired by the one by Titian, reveals compositional schemes that Van Dyck would repeat in the future. His style is more classical than Rubens' and demonstrates an interest in the study of light on anatomy. The body of Christ, treated with majestic dignity, has a herculean anatomy recalling the tritons of Rubens. But here the human aspect of Jesus comes to the fore. He is exhausted and devoid of tension, his arms falling limply on his lap. The dark setting allows the body to radiate light, accentuating the divine quality of the figure. The modeling of the volumes, approaching Caravaggio's, represents lights and shadows in a photographic chiaroscuro where the half-light is enriched through the reflections of surrounding colors.

Susanna and the Elders

(1621-1622)
oil on canvas
77.6 x 57.6 in (194 x 144 cm)
Alte Pinakothek, Munich

Susanna is represented as a normal woman who, while washing her feet, is suddenly accosted by two elderly men. One of them places his hand on her shoulder. The other threatens her with a raised arm while he pulls the cloth that covers her with the other. Susanna, timid and frightened, is shocked and defenseless against them. In accordance with the tastes of the period, she exhibits a rotund body, appropriately well illuminated in order to draw the viewer's attention. This work reflects excellent compositional skill, great mastery of draftsmanship, a sound treatment of light and color, and his resolution of volumes and detail on the folds of the garments. All denote the influence of Venetian and Bolognese artists, especially of Titian, whose painting was being studied at the time in Venice.

When Van Dyck painted this work, he had already begun to decrease his mythological and religious production to dedicate himself more to portraiture. According to mythology, Endymion was a young shepherd of extraordinary beauty who slept in a cave on Mount Latmos every night. His beauty was so great that Selene, the Moon (associated with Artemis or Diana), fell hopelessly in love at first sight. Every night she visited him in his cave but, true to her virginity, would only lie down next to him, caressing him and kissing his eyelids as he slept. Endymion, happy with Diana's company and caresses, asked Zeus to sleep eternally, so that he could remain young forever and enjoy the goddess' attentions.

Diana and Endymion

(~1630)
oil on canvas
57.6 x 65 in (144 x 163 cm)
Prado, Madrid

Despite her divine condition, Selene is represented as a normal woman, in the Rubensian style. She exhibits the charm of her naked body, unaware of the presence of the satyr who has furtively entered the scene, contributing to its eroticism. To the same degree that his body is Herculean, tanned, and toughened by nature and combat, Diana's has a white, delicate complexion and is corpulent. She is somewhat heroic in aspect, as well as suggestively voluptuous.

Young Endymion, dressed in a green tunic, is sleeping deeply at her side, totally unaware of what is happening. Although the chromaticism is more contained than in Titian's work, this painting is conceived in a manner similar to his, with Diana forming the focal point through the bright illumination of her naked body and the dash of intense red in the fabric that covers part of her anatomy, a technique often used by the painter to direct the observer's attention to a specific area.

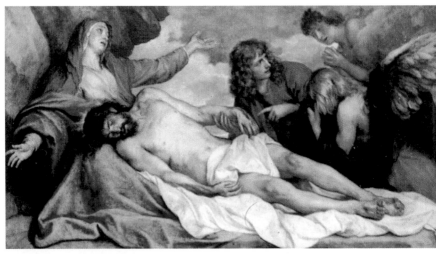

Pietà

(~1630)
oil on canvas
54 x 83 in (135 x 208 cm)
Koninklijk Museum voor Schone
Kunsten, Antwerp

This work was executed when Van Dyck had just returned to Flanders from a long sojourn in Italy, where he had received many commissions for different churches throughout the country. Elegance, delicacy, and sentimental richness are reflected in the dead body of Christ. As he sought to move the viewer and prompt devotion, the painter focused on the general aesthetic of the work, in both the composition and color scheme, and left out details such as blood, the crown of thorns, and the wound in his side, whose gruesomeness could distract the spectator.

Without those ingredients, Christ's body reveals a detailed treatment and, despite the tragedy of the moment, the figures around him display calm expressions of respect and devotion.

Silenus Drunk

(1621)
oil on canvas
42.8 x 36.6 in (107 x 91.5 cm)
Staatliche Kunstsammlungen,
Dresden

The sileni were mythological beings familiar with the occult sciences and possessing magical powers that, along with the satyrs, personified libertine and dissolute life, fond as they were of everything having to do with the "base passions." Van Dyck represented them as mature men with beards and a grotesque aspect, despite which their relentless sexual harassment of the nymphs was often met with success. In a very saturated surface area, the central zone is occupied by the enormous anatomy of a silenus, with a copious head of hair and an abundant, curly beard. As he is inebriated, two figures steady him while another continues the pleasures of drinking. The silenus gropes at the lower regions of the nymph, who attempts to remove his hand. A scene appropriate to a bacchanal, forms and aesthetic of the best Rubensian images.

Cornelius van der Geest

(~1620)
oil on wood
15 x 13 in (37.5 x 32.5 cm)
National Gallery, London

This figure was an important collector and merchant from Antwerp, well known among Flemish painters of the time. Van Dyck painted this portrait a year before leaving for England.

The head emerges from a white collar with a multitude of folds that, in addition to creating a contrast with the totally black background, help to focus attention on the person's face. The draftsmanship is excellent, the details extremely meticulous, the complexion and features overwhelmingly realistic. The painter succeeds in conveying the figure's nobility through the perfect execution of all elements without eliminating the slightest detail.

Equestrian Portrait of Charles I

(~1637)
oil on canvas
146.8 x 116.8 in (367 x 292.1 cm)
National Gallery, London

At the end of the English Civil Wars, Charles I was convicted under the mandate of Cromwell and beheaded at Whitehall, London, in late January of 1649. He had been an enthusiast of Van Dyck as well as his principal patron beginning in 1632, when he summoned the artist to his court in Britain. This painting, one of many that the artist executed of the king, is a beautiful combination of figure and landscape, with the addition of the horse, which acts as a unifying element in the composition. As befits a work of this nature, the king's face stands out, highly illuminated. It is enhanced by the contrast with the shining black armor, just as the light color of the horse serves as a counterpoint to the colors of the landscape. This representation, with a solid dose of romanticism and fantasy, places the king in an imaginary world, substantiated by a Flemish-style landscape.

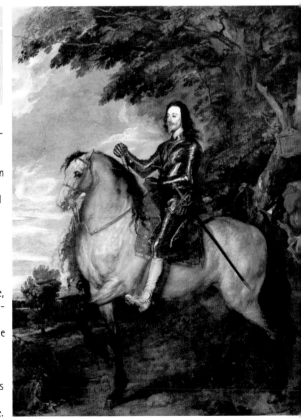

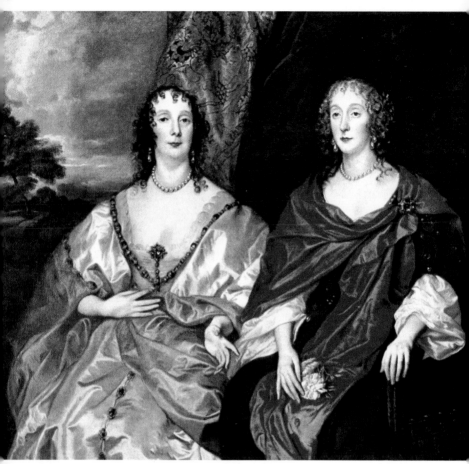

Ladies-in-Waiting to Queen Henrietta Maria

(~1637)
oil on canvas
52.6 x 60 in (131.5 x 150.6 cm)
The Hermitage, Saint Petersburg

Beginning in 1632, when he was summoned to Britain by Charles I, Van Dyck focused his painting on the genre of portraiture, usually executing portraits of figures from the court or nobility, with whom he maintained constant contact. The painter did not limit himself to the cold reality of the figure's appearance, but often inserted wholly realistic context and details that provided subtle, burlesque criticism of the sitter. This seems to be the case here.

The two ladies are part of the court: Anne Kirke on the right, sister of the poets and dramatists Thomas and William Calligrew; on the left, probably Anne Dalkieth, Countess Morton, one of the most intimate confidantes of the queen. It would seem that the two ladies were not to the liking of the painter or that they were disagreeable people, as they are represented in a devastatingly critical sense.

Under their curly hair, these faces appear cold, distant, unpleasant, and, whereas the woman on the right seems indifferent, detached and with a certain air of stupidity, the one on the left is vain, haughty, and rather ridiculous. Nonetheless, they are represented in magnificently sumptuous attire, one with silvery and pinkish white tones predominating, the other in black, white, and red, probably what they were actually wearing at the time. As he often did, the painter covered a large area of the background in dense black, bordered by finely brocaded drapes in gold and black. On the upper left is a striking landscape with a threatening evening sky and a large, leaning tree. Its aspect and colors match the overall color scheme, while acting as a counterpoint to the principal subject matter of the work.

DIEGO VELÁZQUEZ

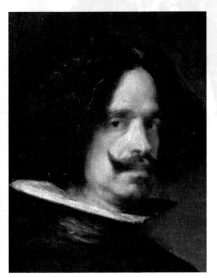

Self-portrait, *oil on canvas, 18 x 15 in (45 x 38 cm), ~1630, Museum of Fine Arts, Valencia.*

Diego Rodríguez de Silva Veláquez had a long and prolific career. His art, considered the greatest example of the Spanish Baroque, contributes a series of innovations that make him one of the most important artists in the history of art.

He concentrated principally on three genres: still lifes with figures—*Christ in the House of Mary and Martha* (National Gallery, London) and *Woman Cooking* (National Gallery of Scotland, Edinburgh); portraits—*Philip IV in Brown and Silver* (National Gallery, London), *Innocent X* (Galleria Doria Pamphili, Rome), and *Las Meninas* (Museo del Prado, Madrid); and religious subjects—*Christ on the Cross* and *Coronation of the Virgin* (both at Museo del Prado, Madrid). The use of an extremely varied palette, along with the protagonism he lends to secondary elements, scrupulousness with which he treats interior settings, very free brushstrokes, and an innovative concept of perspective, consisting of enhancing the depth of the composition through an elaborate atmospheric treatment, constitute the principal characteristics of his art.

His works are realistic and devoid of idealization, although he is always true to his concepts of truth and beauty, as well as to his sense of tolerance in choice of subject, a significant aspect in the close-minded and Manichaean epoch in which he lived.

- **1599** Born in Seville to Joao Rodriguez de Sylva and Gerónima Velázquez, from a modest Sevillan family of Portuguese origin.

- **1610** Begins his apprenticeship under Francisco Pacheco.

- **1617** Obtains a painter's license and joins the Sevillan Guild of St. Luke.

- **1618** Marries Juana Pacheco, the daughter of his professor.

- **1623** The Count of Peñaranda introduces him to the court, where he paints a portrait of Philip IV of Spain, who, impressed by his work, appoints him court painter. Begins a period in which he paints many portraits of royalty.

- **1627** After winning a competition for all of the court painters, he is appointed Chamberlain of the Private Chambers of Philip IV.

- **1628** Befriends Rubens during the latter's stay in Madrid.

- **1629** In August, moves to Italy, where he remains until the end of the following year, visiting the principal cities. During his stay, he paints *Vulcan's Forge* (see p. 196).

- **1634** Among other works, he paints *The Surrender of Breda* (see p. 197) for the Salón de los Reinos in the Buen Retiro Palace of Madrid.

- **1636** He is appointed "Assistant to the Wardrobe" at the Madrid royal court.

- **1644** Accompanies Philip IV on a trip through Aragón lasting several months.

- **1648** Travels to Italy as part of the Duke of Nájera's delegation, in charge of acquiring various paintings and sculptures for the new Alcázar gallery, to the Academy of Fine Arts, about to be inaugurated, and to collect the Archduchess Mariana de Austria, the future wife of the king, in Trent. Visits various Italian cities. During his stay in Rome, paints a portrait of Pope Innocent X.

- **1650** Enters the Academy of San Luca, in Rome.

- **1652** Appointed Supreme Court Marshal.

- **1658** Receives the Order of the Knights of Santiago.

- **1660** In April takes charge of preparing the Faisanes Royal Residence for the marriage of Infanta, María Teresa, daughter of the king of Spain, to Louis XIV of France. Having successfully completed his assignment, exhausted and ill, he returns to Madrid, where he dies on August 6.

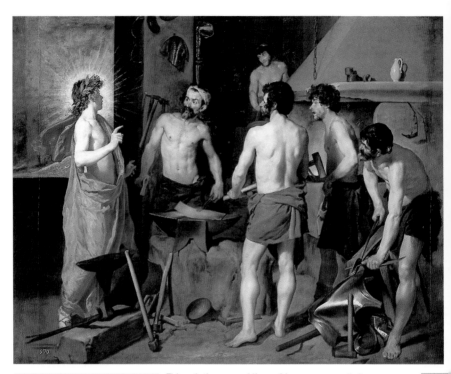

Vulcan's Forge

(1630)
oil on canvas
89 x 116 in (223 x 290 cm)
Prado, Madrid

This painting, resembling a frieze, was executed on the artist's own initiative, without a commission, possibly during his first stay in Rome, in the home of Manuel de Fonseca, the Count of Monterrey, Ambassador to Philip IV in the Pontifical States. Some of the figures in the scene are probably the ambassador's servants. Its frieze-like composition recalls Guido Reni, as well as ancient statues. The color scheme, on the other hand, evokes Guercino.

Apollo appears as a young, sensual person of ambiguous gender, with smooth skin and delicate forms, his head crowned with a laurel wreath and a radiant halo that appears to illuminate all of the figures. Vulcan, the husband of Venus, is holding a strip of incandescent iron on his anvil before his colleagues. He is attentively listening to Apollo, who notifies him of his wife's infidelity with Mars, the god of war, for whom it so happens that the blacksmiths are fashioning a sword.

The painting deviates from the mythological version, allowing Velázquez the opportunity to represent a scene of great compositional beauty. The manner in which each blacksmith is presented is very interesting: the one seen from behind seems to be modeled on ancient statues, although somewhat cold and academic; the one on the right is a vibrant nude with a great deal of movement; and the one in profile is theatrical, with tousled hair and a vivid, attentive expression. Velázquez, who designed the painting with two brilliant points of light (Apollo's bust and the sword that the blacksmith in the middle is holding), animated the composition with several details: the god's luminous halo against a blue sky, the incandescent iron, the fire in the chimney, and the small ceramic vase.

This canvas, Velázquez's largest, was executed for the hall called Salón de Reinos in the Buen Retiro Palace. This scene portrays the surrender of the Dutch city on June 2, 1625 to General Ambrosio de Spinola, commander of the Spanish forces. The Dutch governor, Justin von Nassau, is handing the keys of the city to the general. Although based on history, with the exception of Spinola, whom the painter had met on a ship voyage to Italy in 1629, the scene is invented.

At the center of the composition, the two military leaders are set off against a luminous background landscape. Behind Spinola are Albert of Arenbergh, the Prince of Neuburg, Carlos Colomo, Gonzalo de Córdoba, and, on the far right, according to some, the artist himself. The infantry soldiers have long sideburns and moustaches. Above their hats is a forest of lances forming a sort of fence, acting as a barrier that distances and filters the background, giving rise to a slight trompe l'oeil and evoking the idea of order and discipline for which the regiment was so renowned.

Several lances are slightly inclined to provide a more natural appearance. The Dutch army is smaller and less orderly, with lances and short halberds, among strong contrasts of light, exaggerated by the figure in a white shirt, whose color provides a counterpoint to the horse behind him. By alternating light and dark areas and gradating tones and shadows, the artist heightens the sensation of depth and the impression of being outdoors. Curiously enough, in this painting, the artist did not use a uniform technique throughout, but modified it with total liberty according to each element's aesthetic needs, so as to make them stand out or to represent specific textures. Hence, the paint is thick in the suede hat, watery in the Flemish figure wearing a white shirt, sparkling in the armor and Spinola's sash, and homogenous and smooth in the horse on the right. In this highly balanced and chromatically harmonious composition, Velázquez was inspired by artists such as Alciato, Bernard Salomon, Veronese, El Greco, and Rubens.

The Surrender of Breda, or Las Lanzas

(1635)
oil on canvas
123 x 145 in (307 x 367 cm)
Prado, Madrid

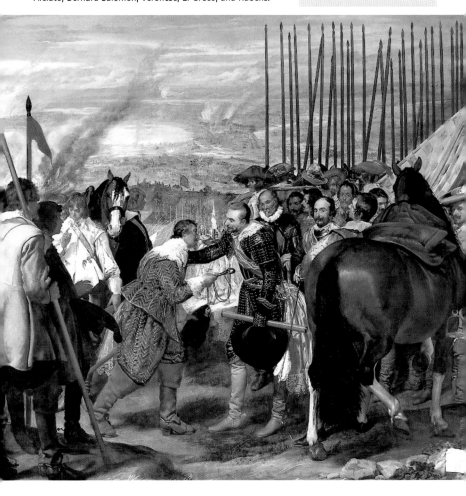

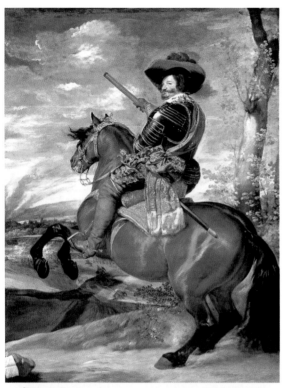

The Count-Duke of Olivares

(~1634)
oil on canvas
125 x 95.6 in (313 x 239 cm)
Prado, Madrid

The figure is Gaspar de Guzmán, son of the Count of Olivares, who was appointed prime minister and granted the title of duke when Philip IV acceded to the throne of Spain in 1621. Gaspar summoned Velázquez to Madrid and became his patron. In 1643, the Count-Duke fell into disgrace, withdrew from the court and died two years later in Toro.

The painting is spectacular, and the artist manages to convey the great power held by Guzmán at the time. The portrait shows the Count-Duke as partially euphoric and partially depressed, in all his glory, but almost turning his back in a timid gesture, Velázquez's way of describing his complex personality. Through several rapid, loose brushstrokes in various colors (purple, gold, black, brown, etc.) he achieves relief and volume, defines elements and details, and creates an interplay of light and shadows that is peculiar to this artist. Some details even seem to reveal a burlesque criticism of the sitter (the large sash, the somewhat comical hat, the affected insignia), as these give the feeling that the sitter is wearing a costume and detract from his naturalness.

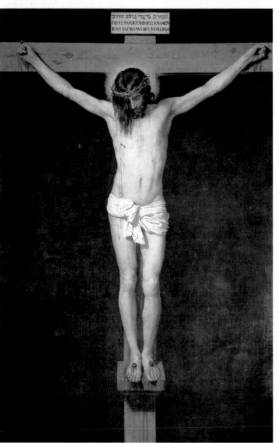

Christ Crucified

(1638)
oil on canvas
99 x 67.6 in (248 x 169 cm)
Prado, Madrid

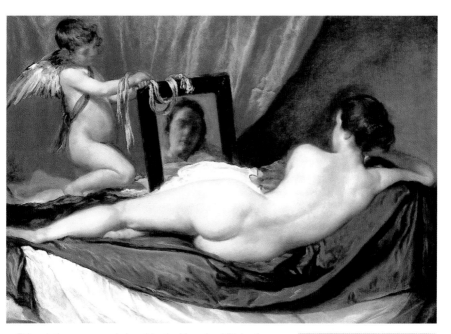

This painting was commissioned by the Marquis of Eliche, famous for his parties and libertine lifestyle. Velázquez painted it in Rome. An attractive, sensual nude woman (Venus), reclining on a bed, contemplates her face in a small mirror held by a winged boy (Cupid). The numerous works of nudes that the painter saw in Italy probably inspired him to paint this work, although some believe it is a homage to the unknown young woman with whom Velázquez was in love and who bore a child by him.

The Toilet of Venus

(1650)
oil on canvas
49 x 70.8 in (122.5 x 177 cm)
The National Gallery, London

Although Velázquez had already consolidated his own style when he painted this work, he may have taken the pose from other works, especially *Venus at her Toilet* by Titian and *Venus* by Rubens, of which it seems to be a combination. As is habitual for Velázquez, the scene is both naturalistic and innovative, at once ordinary and surprising, suggestive yet unidealized. This Venus is demystified, although the gray silk sheets, carmine drapes, and general atmosphere radiate a certain luxury and sensuality, as well as evident dignity. The smooth body, excellently modeled and with a superb treatment of the complexion, contributes to this. The woman is cold and distant, nonchalantly turning her back to the viewer, showing not the slightest interest for her child, and concentrating exclusively on her beauty.

Mirrors have always been considered a symbol of both truth and vanity, here contributing to demythologize the goddess, since the face reflected in it is not in the least attractive and is even somewhat vulgar. Cupid is attentively serving his mother, upon whom he is wholly dependent, conveying the subliminal message that love is always a slave to beauty. The gray and red tones enhance the complexions of both figures. In March of 1914, a woman slashed the painting seven times. Thanks to excellent restoration work, the damage is hardly visible.

This may be the most important religious painting executed by Velázquez, not only for its technique, aesthetic level, and emotive force, but also for the legends to which it gave rise. The most famous alleges that this work was commissioned by Philip IV in atonement for his affair with a young nun from the Benedictine Convent of San Plácido in Madrid, with whom he would sleep at the home of Jerónimo de Villanueva, notary-in-chief of Aragon. In 1790, he was incarcerated in Toledo by the Inquisition, accused of concealing the affair.

Emerging from a nearly black background, Christ is portrayed with great dignity despite the fact that he is naked. The nailed feet rest on a pedestal. The shaft of clear light from the upper left gives rise to a gently modeled body with tenuous shadows, such that the concepts of spirituality and devotion take precedence over those of dramatization and spectacularity. The sagging head is remarkable for its solemn majesty, expressiveness, and dramatic force, with the crown of thorns and loose hair concealing part of the face. The discretion with which the blood has been painted is interesting, doubtless intended to avoid excessive realism that could detract from the spiritual objective of the work.

Las Meninas

(1656)
oil on canvas
124 x 110.4 in
(310 x 276 cm)
Prado, Madrid

This painting was executed for the summer office at the Alcazar in Madrid. It is certainly his most complex and famous work. The scene is set in the painter's studio in the Alcazar. In the background, a small door opens onto an illuminated staircase, where there is a figure dressed in black, José Nieto Velázquez, head of tapestries for the queen, who was unrelated to the artist. Next to the door, a wide framed mirror reflects the blurry but perfectly recognizable figures of Philip IV and Queen Mariana, the upper half of their bodies visible under a red drape or baldachin. On the other side of the mirror is another door, similar to the first but closed. Above this, two large paintings hang on the wall, copies executed by his pupil and son-in-law, Juan Bautista del Mazo, of Rubens' *Minerva and Arachne* and Jordaens' *Apollo and Pan*. In the foreground on the left is part of an enormous canvas in front of which Velázquez is standing, gazing at the viewer with a palette, brushes, and maulstick in one hand, and a paintbrush in the other. He wears the Cross of Santiago on his chest, added later.

In the center is the 5-year-old Infanta Margarita, the daughter of the king, between two ladies-in-waiting called *meninas,* a word taken from the Portuguese. One of them, María Agustina Sarmiento, offers the Infanta a silver platter. The other is Isabel de Velasco, on whose right is Mariabárbara, a macrocephalous midget of German origin, and a child, perhaps Nicolás de Portosano, born in Italy. The woman in the white dress in the background is Marcela de Ulloa, the assistant guardian of the ladies as of 1643. Next to her is the guardian.

The composition, which distributes the figures in two groups, is certainly ingenious, with realistic draftsmanship, excellent treatment of light and color and two superbly combined perspectives, linear and aerial. The illumination of the dog and the figures in the foreground lend the partially dark room depth. The somewhat faded tones are profoundly harmonious, with juxtapositions and gradations. Despite the complexity of the scene, it is highly natural and so realistic that the viewer is transported into it. The meticulous background constitutes an attractive and transcendent element, something that would have impressed Leonardo da Vinci himself. The painting is a combination of intentions and meanings, of appearance and reality, a display of technique and creativity.

CLAUDE LORRAINE

The artist in a contemporary engraving.

Claude Lorraine (né Gelée) was the greatest landscape artist of the 17th century. He represented different times of the day, suffusing his landscapes with the color and light of sunrises and sunsets, using figures merely to show perspective and scale.

In his early period, Claude reveals a passion for the beauty of distance: distant horizons, atmospheric vibrations, surrounding light, details in the middle and background, and so forth. His works during this period are characterized by their expressive force and meticulous detail.

In his mature period, his compositions become simplified: atmosphere becomes the subject and light invades the darker areas. He begins painting tranquil seascapes combined with monumental architecture and landscapes with tree groves that give rise to strong contrasts and various light and shadow effects.

In his last stage, he also shows a propensity toward a vigorous and forceful style, using impasto—the application of large quantities of paint—much more energetically.

During his long stay in Rome, he becomes profoundly familiar with the outlying countryside and ancient ruins, which he frequently represents in his paintings, harmoniously combined in a poetic and classical style, although his contrast of colors shows the influence of lesser Dutch masters, such as Elsheimer and Paul Brill.

Held in high esteem in his time, especially among high ecclesiastical dignitaries, kings, and the nobility, he can be considered the precursor to the great British landscapists. The technique he used to create atmospheric effects had many followers and persisted until the arrival of Impressionism in the 19th century.

- **1600** Born in the province of Lorraine.

- **1612** After he is orphaned, he moves to Freiburg am Breisgau, in Germany, with his brother, who is a wood sculptor.

- **1613** Moves to Rome with a relative. Enters the workshop of Agostino Tassi as assistant.

- **1619** Studies painting in Naples for two years along with Goffredo Wals, also an assistant to Tassi.

- **1625** Returns to Lorraine and remains for some time in Nancy, where he collaborates with Claude Deruet on the fresco decoration of the Carmelite Church.

- **1627** Settles in Rome again, where he remains until his death, living on Margutta Street, along with other painters. Maintains close relations with Nicolas Poussin.

- **1629** Works with Joachim von Sandrart, with whom he paints directly from nature.

- **1633** Enters the Accademia di San Luca. Takes Gian Domenico Desiderii as an apprentice.

- **1641** In the middle of his seascape period, paints *The Embarkation of St. Ursula* (National Gallery, London).

- **1643** Joins the Congregazione dei Virtuosi, an artist's guild.

- **1647** In this period, he paints mythological and biblical scenes, including *Ulysses Returns Chryseis to Her Father* (Louvre, Paris), *The Marriage of Isaac and Rebekah* (National Gallery, London).

- **1653** His daughter Inés is born out of wedlock to his servant.

- **1656** Begins a period in which his paintings gain a more vigorous execution through impasto.

- **1658** Desiderii leaves Claude's workshop, taking his daughter Inés with him.

- **1663** Becomes seriously ill with gout.

- **1682** Dies in Rome on November 23. Buried in Trinità dei Monti Church.

Morning in the Harbor

(1635)
oil on canvas
39 x 48 in (97.5 x 120.5 cm)
The Hermitage, Saint Petersburg

Claude's works are characterized by a magical atmosphere created through a specific treatment of light according to the time of day, usually dawn or dusk, as these times allowed greater chromatic possibilities. His scenes are thus immersed in a diaphanous atmosphere that permeates the whole and determines the color balance.

In addition to landscapes, he executed numerous seascapes where the minute figures are dwarfed by the water, boats, and spectacularly monumental architectural elements. Here the sunrise, which the painter audaciously represents full on in the background, tinges the sky with a golden hue and lights the tranquil waters, modeling the slight waves and lending them soft colors. This presaged the style that Turner would develop many years later, which was then followed by the Impressionists.

As Claude's works were so successful, forgery soon arose. To prevent this, he compiled a register, called *Liber Veritatis,* or Book of Truth (British Museum, London) in which he wrote the date and the name of the client, often including a drawing of the work. The register indicates that this painting, of which there is an engraving executed in 1635, was painted for the archbishop of Le Mans. On the frame is the inscription SPQR TITO (*Senatus Populusque Romanus, Tito*), and on a boat is a coat of arms, probably that of the Beaumanoir, the ecclesiastic's family. The archbishop held his post from 1601 to 1637, traveling to Rome in early 1635 as part of a French delegation led by Cardinal Alphonse Louis du Plessis, the brother of Cardinal Richelieu. This painting may have been acquired then.

This painting, executed in the vicinity of Rome, represents a view of the Tiber from Monte Mario. Claude painted many works in wash. The apparent technical simplicity does not conceal his great skill in achieving a descriptive and fresh work with great depth. The artist is so certain of his technique and uses the chromatic range of a single color so well that he attains an apparently multicolored visual effect. These wash paintings were generally preliminary sketches for oil paintings, but were high-quality works in themselves. It is not surprising that Constable stated of Claude: "It is said that he is the most perfect landscape artist that the world has ever known, and he deserves this compliment ... his principal quality consists in knowing how to unite splendor with tranquility, color with freshness, shadow with light."

View of a Lake near Rome

wash on paper
7.4 x 10.7 in (18.5 x 26.8 cm)
British Museum, London

Embarkation of St. Paula Romana at Ostia

(~1639)
oil on canvas
84 x 58 in (211 x 145 cm)
Prado, Madrid

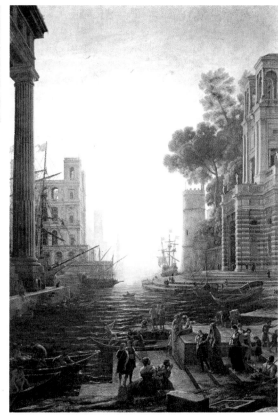

The subject of this painting is indicated on a stone in the lower right, where an inscription reads "IMBARCO Sta PAVLA ROMANA PER TERRA Sta" (Embarkation of Saint Paula Romana for the Holy Land), and on the rock in front of it, "PORTVS OSTIENSIS A(VGVSTI) ET TRA(IAN)" (Port of Ostia built by Augustus and Trajan). According to the legend, St. Paula left her four children, Paulina, Eustoquio, Rufina, and Toxotius, in Rome and traveled to the Holy Land to meet with St. Jerome.

This subject suited Claude Lorraine well, as it allowed him to represent three elements that attracted him: a landscape, in this case the sea; architecture, here classical and magnificently spectacular; and natural light, represented at dawn in this work. The painting is monumental, especially due to the buildings that flank the scene and the treatment of light, with the buildings nearly in silhouette and a golden hue permeating the entire scene and unifying the colors. The figures involved in the embarkation are mere accessories.

Landscape with Satyrs and Nymphs Dancing

(1646)
oil on canvas
38 x 48 in (95 x 120 cm)
Private Collection, Switzerland

Unlike the rest of Claude Lorraine's landscapes, the figures in this painting play the leading role, though they are small within a vast landscape that is, as always with Claude, meticulously executed. In this sense, the work can be compared to similar paintings by Rubens or Poussin.

The artist's style is clear in the composition, draftsmanship, and treatment of light. The majority of the painting is in shadow, and partially backlit with some tenuous rays of sun filtering through the tree branches, creating a dark setting in warm light in which a series of figures is moving. This darkness is enhanced by the illuminated portion of landscape under a blue sky to the upper left.

Among the figures are Faunus, Marica, Pan, here curiously young and callow, and a nymph, perhaps Echo, Euphemia, or Selene. The seated nymph recalls Raphael's Juno. The painting includes a series of formally classicist elements—panoramic nature scenes, groups of naked figures, a festive air, and studied illumination of certain figures—habitually used by artists of bacchanals and feast scenes or mythological dances in the wild. Claude's departure here from his usual themes could be attributed to the requirements of the client.

CLAUDE CI LOV

In this canvas, Claude uses a shortcut common in his works—he incorporates figures or elements from previous paintings. In this case, the setting already appeared in his *Breakfast in the Country* (1637), the figures in *Landscape with Dancing Farmers* (1637, Louvre, Paris), and the trees in *Landscape with the Discovery of Moses* (1639, Prado, Madrid). He uses these elements in later works as well, such as *Landscape with Dancing Figures* and *The Marriage of Isaac and Rebekah* (both 1648, National Gallery, London). This leads to the conclusion that, faced with a high demand, the artist created several standard elements, which he repeatedly incorporated into his works with some variations, as he knew that these elements were successful and well accepted among his clients.

Nonetheless, they gave rise to natural scenes that were very balanced in composition, with excellent draftsmanship and meticulous detail, evident in a simple analysis of the thoroughness with which the treetops are executed. The superb treatment of light in these scenes was used not only to model all elements involved, but also to create the necessary atmosphere, here in warm, golden tones in accordance with the twilight hour in which the scene is set, as well as to chromatically unify the entire painting. The style is conservative, elegant, and meticulous, pleasant to the eye and well received by the high society of the time.

Landscape with Dancing Farmers

(1648)
oil on canvas
47 x 59 in (118 x 148.5 cm)
Woburn Abbey, Duke of Bedford

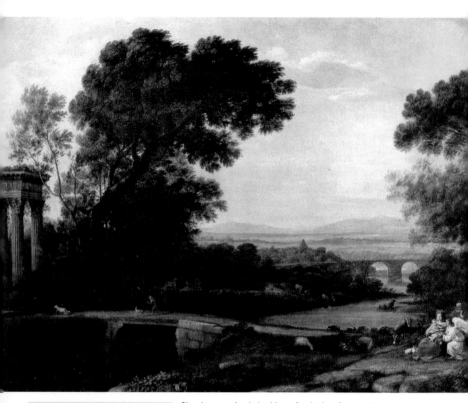

Noon, *or* Rest on the Flight to Egypt

(1663)
oil on canvas
46. 4 x 63.6 in (116 x 159 cm)
The Hermitage, Saint Petersburg

Claude conceived the idea of painting four works as a series corresponding to the different times of day: dawn, noon, afternoon, and evening, which he executed in different years and for very different clients. This painting is the second in the series, representing noon. The work was painted for Hälmale, the bishop of Antwerp, and although the landscape and ruins appearing in it were actually executed by Claude Lorraine, the figures represented in the lower right corner were executed by the Italian painter, Philippo Lauri.

Claude depicts a landscape with diverse natural elements (the sky, the vegetation, and the river), architectural elements (the remains of a classical building and a bridge) and figures (the Holy Family and an angel, accompanied by a donkey). In accordance with his style, he submerges the scene in twilight, creating the desired atmosphere. In the middle ground are backlit elements with cleanly defined profiles set against a yellowish sky, which serves as a background and provides a setting for the figures. The latter radiate light despite their small size. Equal importance is given to the magnificent and theatrical landscape, and to the luminous figures, toward which the viewer's eye is inevitably led. This is how Claude was able to satisfy his clients, who wanted to have a painting as a decorative object, and incorporate a feature that made it singular. This popular scene of the Holy Family shows them during a short rest on their flight from Egypt, which they have undertaken to prevent Herod from killing their child Jesus.

REMBRANDT

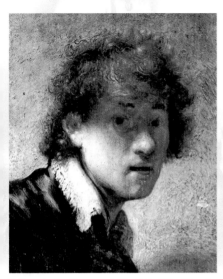

Self-portrait, *oil on wood, 37 x 27 in (93 x 68 cm),* ~*1629, Alte Pinakothek, Munich.*

Rembrandt Harmensz van Rijn, the genius of Flemish art, belonged to the upper middle class, a powerful group generally interested in art. His works have an underlying Italian classicist tone and are influenced by Caravaggio.

In his first period (1625-1641), his art consists primarily of portraits and religious works revealing an incipient naturalism that uses chiaroscuro as an instrument rather than an objective. Light and color are treated softly and applied with a view to enhancing the overall beauty. Despite his strong personal style, Rembrandt is greatly limited by the demands of his clients.

Beginning in 1641, Rembrandt enters a difficult, turbulent second period. Facing a financial crisis and the death of his wife Saskia, he begins painting in a style that, though highly esteemed today, was far from appreciated by Flemish society of his time. His subject matter becomes melancholy and his art stagnates, although it is precisely at this time that he produces very important works that are practically compendiums of all of his aesthetic values and of the various contributions he made to the art of painting.

Brilliant and prolific, Rembrandt can be considered to be the greatest Flemish painter. Far above the affectedness and penchant for grandeur of the Flemish School, and of the ideological force of the 17th-century aristocratic Catholic movement, he demonstrates complete mastery of technique resulting in perfect execution.

- **1606** Born in Leiden to a prosperous family. His father, Harmen Gorits van Rijn, was a miller, and his mother, the daughter of a baker.
- **1620** Attends the studio of Jacob van Swanenburgh and Jacob Symonszoon Pynas in Leiden, both local artists trained in Italy.
- **1624** Works in Amsterdam for six months in the studio of Pieter Lastman, who is familiar with Caravaggio's art.
- **1626** Returns to Leiden. Inaugurates his own studio in his parent's home.
- **1631** Moves to Amsterdam, where he remains until his death. Begins producing a good deal of portraits, adopting a style similar to that of Thomas de Keyser. In his period pieces, light is treated so as to achieve different chromatic effects.
- **1634** Marries Saskia van Uylenburgh, from a well-off Friesian family, whose dowry allows the couple to live in financial ease. That same year, he paints a portrait of her (Gemäldegalerie, Dresden).
- **1642** His wife dies of tuberculosis. They had had four children, but only Titus, born in 1641, survived. Paints *The Night Watch* (see p. 211) , which does not please his clients. Economic hardship leads him to move to a simpler house on Rosengracht Street.
- **1643** He becomes sentimentally attached to Geerge Dirck, his son Titus' nursemaid, which brings him severe criticism.
- **1649** Using various cunning arguments and tricks, he ends his relationship with Geerge, whom he had promised to marry, to live with Hendrickje Stoffels, his housekeeper, later his model, and ultimately his emotional support. As of this date, he begins to paint his most famous works.
- **1654** Cornelia is born to Rembrandt and Hendrickje. During this period, his artwork becomes concentrated, his brushstroke freer, and he executes a series of portraits. The couple's cohabitation out of wedlock brings a serious threat of excommunication from the Protestant Church.
- **1656** Declares himself bankrupt. His works are auctioned to pay off his debts.
- **1658** Paints one of his best self-portraits (Frick Collection, New York), highly expressive. It shows his state of mind—his disappointment in people and confidence in God. His house is placed on the market.
- **1668** Paints the mysterious *Jewish Bride* (Rijksmuseum, Amsterdam).
- **1669** Dies in Amsterdam.

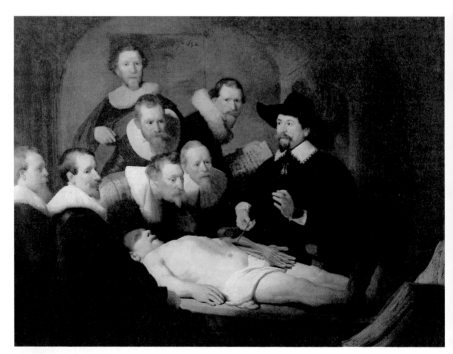

Dr. Tulp's Anatomy Lesson

(1632)
oil on canvas
668 x 86.6 in
(169.5 x 216.6 cm)
Mauritshuis, The Hague

The dissection of corpses had ceased to be a crime shortly before Dr. Nicolaes Tulp, the head anatomist of the surgeon's guild of Amsterdam, gave an anatomy lesson in January of 1632, using the corpse of an executed convict. The guild decided to immortalize the event and commissioned Rembrandt to paint it. With the characteristics of Rembrandt's early period, this is one of the best pictorial representations of a corpse. The luminosity of this nude, shown in an extremely foreshortened position so as not to detract from the group, makes it the focal point. The ghastly, yellowish, and opaque complexion is superb, lacking any chromatic warmth. This provides a great deal of information: how long the person had been dead, the state of conservation of corpses in the morgue, and the way in which these lessons were conducted.

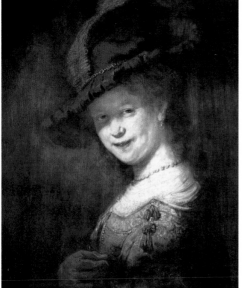

Saskia van Uylenburgh

(~1634)
oil on canvas
21 x 17.8 in (52.5 x 44.5 cm)
Staatliche Kunstsammlungen, Dresden

Painted shortly after their wedding, this is one of several portraits executed by Rembrandt of his wife. In dense colors with an abstract background, the entire painting is immersed in darkness so that the face of the young woman emerges, radiant and splendorous.

Her face is meticulously executed and highly expressive, exuberant with youth and joy. In addition to her physique and state of mind, the artist also describes the woman's social and financial status through the spectacular hat covering her abundant red hair and the rich garment of finely brocaded fabric she is wearing, with embroidery, braids, and transparent tulles along her neckline. Judging from the painting, the artist was profoundly in love with his wife.

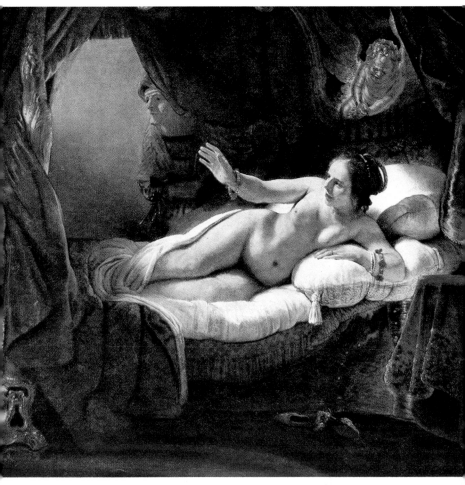

This painting was executed in Rembrandt's successful early period in the prosperous city of Antwerp. His style is based on tenebrism, but without Caravaggio's brusque contrasts. According to Greek mythology, Danaë was the only child of Acrisius, king of Argos, and Eurydice. Her father locked her in a bronze tower to prevent the oracle's prophesy from coming true, according to which one of Danaë's children would take the king's throne and life. Zeus, in love with the young woman, took the form of a golden rain and united with her. She conceived a child, Perseus, who was to fulfill the prophecy years later.

Danaë

(~1636)
oil on canvas
74 x 81 in (185 x 203 cm)
The Hermitage,
Saint Petersburg

Rembrandt substitutes the mythological golden rain with an intense light that illuminates the bed and the body of the protagonist, from which a golden atmosphere emanates, while a servant draws the heavy curtains. The painter reflected as no one else had before him Danaë's eagerness as she awaits Zeus. With an attitude halfway between reservation and complacency, the woman does not appear as young as the models that the painter usually selected. Contrary to the models most artists chose for their mythological representations, Rembrandt selects an attractive yet normal woman who was not especially beautiful. He portrays an eager woman impatiently awaiting her lover, exhibiting her femininity and with an expressive hand gesture.

The setting is sumptuous and the details clean: the drapery, golden cherub, bracelets, brocaded slippers, sheets—everything is permeated with a sumptuous Baroque rhythm, at that time at its apogee of Italian influence in the Netherlands. Many consider this Rembrandt's most delicate work from the period around 1630. It has been debated whether the title traditionally given to this work is correct. Some identify the figure with Venus, whereas others affirm that it is Messalina, the wife of Emperor Claudius, while yet a third more recently associates her with a biblical figure (Sarah, the daughter of Raquel, Raquel herself, or Leah), yet this is wholly unfounded speculation, since in the list of Rembrandt's paintings auctioned in 1656, it is clearly referred to as Danaë.

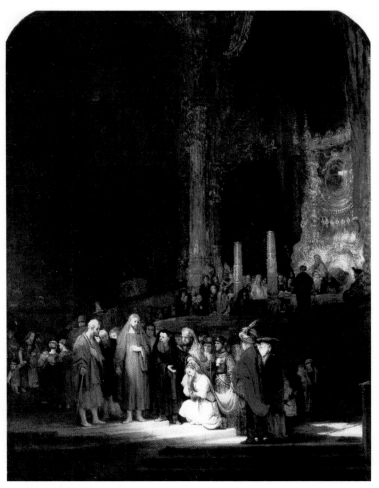

The Adulterous Woman

(1644)
oil on canvas
33 x 26 in (83.8 x 65.4 cm)
National Gallery, London

Religious works are significant among Rembrandt's copious oeuvre. The Gospel according to John (8, 1-11) recounts that the scribes and Pharisees, in order to test Jesus, brought before him a woman who had been caught committing adultery, for him to declare the punishment she deserved. According to the laws of Moses, she should be stoned to death. At their insistence that he condemn her, Jesus responded: "Whomsoever is free of sin amongst you, let him throw the first stone." One after another, they gradually left until the woman was alone with Jesus. He lifted his head and asked, "Where are they? Has no one condemned you?" "No one, Lord", she stated, whereupon Jesus replied, "Nor do I condemn you. Go in peace."

This painting portrays the beginning of the episode. In a dark setting, the central area is illuminated to draw the viewer's attention to the protagonists: the woman, the Pharisees, and Jesus. Rembrandt creates a highly theatrical scene. The effect he achieves through chiaroscuro is evident—he eliminates everything that is unimportant and, through many strong contrasts, synthesizes the elements necessary to lend protagonism to those figures that are truly important, rendering the rest as simple accessories.

The gradation of light intensity on each figure is directly proportional to his or her importance, as can be seen in the woman, who is dressed in a white tunic and receives the direct impact of the strongest light. The principal scene is complemented by a secondary one in the upper right quadrant, where the interior of the church appears with the high priest saying mass before an altar lined in gold, in a majestic and richly spectacular setting. The artist also treats this secondary scene with an appropriate gradation of light, so that it lacks the strong focal illumination of the principal scene. In the two scenes, the artist juxtaposes two different ways of interpreting religion: the often hypocritical and ostentatious maintenance of form, and the good faith of those who believe in the integrity of the individual. For this work, Rembrandt used as models Jews from Spain and Portugal who lived on his street, with whom he maintained good relations and used in other paintings as well.

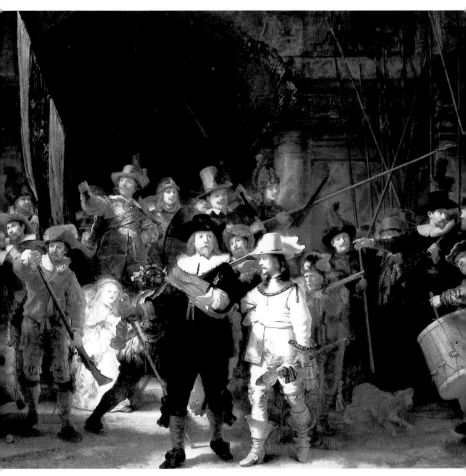

It had not yet been a year since the death of his wife Saskia when Rembrandt received the commission to paint the members of the Company of Harquebusiers under Captain Frans Banning Cocq. Each member paid 100 florins and they all expected to be represented in a manner that would make them perfectly recognizable, as in a group portrait. However, Rembrandt conceived the painting in an entirely different manner, with the group on their way to a shooting contest. Whereas Captain Banning and his Lieutenant are instantly recognizable, leading the group in the center of the scene, the remaining members are either in the shadows or appear as smaller, distant figures due to the requirements of perspective, so that they are either unidentifiable or occupy a secondary place.

The Night Watch

(1642)
oil on canvas
143.6 x 175 in (359 x 438 cm)
Rijksmuseum, Amsterdam

It is clear that the artist's interest, far from his client's wishes, focused primarily on an imaginative composition and a careful treatment of light. As could be expected, those who had commissioned the painting were highly unsatisfied with the results. In any case, this work can be considered one of Rembrandt's most important, and marks a turning point in his art. He conceives an attractive composition in which the distribution of figures provides excellent balance of masses, despite their asymmetrical placement. With the excuse of representing a specific event, he achieves an overall work that conveys a festive air, full of movement, and far removed from the traditional static nature of group portraits.

The artist displays great skill in characterizing the figures through their poses, expressions, gestures, and even clothes. The treatment of light is also remarkable, with a concentrated intensity in the center that fades toward the edges and as the figures appear further in the distance. Through this light, he describes, contrasts, and unites all elements. Without detracting from the importance of the foreground, the background is lit enough to reveal a neoclassical building. The color scheme is rich and varied, with balanced colors and studied tonal ranges. This does not prevent the artist from remaining faithful to his style and creating a peaceful, intimate painting.

Bathsheba at Her Bath

(1654)
oil on canvas
56.8 x 56.8 in (142 x 142 cm)
Louvre, Paris

With the excuse of painting a biblical scene, Rembrandt painted this portrait of his lover, Hendrickje Stoffels, of whom there is another portrait extant from 1650. Hendrickje began working as Rembrandt's maid in 1646, four years after he had been widowed and while he was having an affair with Geerge Dirck, his son Titus' nursemaid. Rembrandt soon began using her as a model, and in 1649, ended his relationship with Geerge to begin living with Hendrickje. Together, they had a daughter, Cornelie, in 1654, the year in which this painting was executed.

This nude, one of the most important of his mature period, lacks idealizing concessions and is true to reality as far as possible, revealing both the positive aspects as well as the physical defects of the model. The anatomy in this rich work is natural, painted in chiaroscuro. The tones lie within a restricted chromatic range, in which umber and other browns predominate, treated with many nuances. The chiaroscuro technique allows the figure to stand out against a mysterious background, yet without sharply defined outlines, as the shadows softly integrate into the illuminated area. The transitions between the areas of light and shadows on the body are interesting as well. These small impastos give a sculptural quality to the woman's physique, serving the same purpose as the highlights in the draftsmanship.

For Rembrandt, rather than an erotic element in and of itself, the nude is above all an ideal element for capturing and radiating light, whose effect lends the figure its voluptuousness. The pose and treatment of light and color provide the figure with a heroic appearance comparable to the mythological figures common in art, and the predominant golden overtones provide great splendor.

VERMEER

The Procuress *(detail), oil on canvas, 57 x 52 in (143 x 130 cm), 1656, Gemäldegalerie, Dresden. Self-portrait within the painting.*

Jan Vermeer was the greatest painter of the last generation of the Golden Age of Dutch art. His small body of work shows that he was influenced by Caravaggio and the Italian Baroque in general, while he differed from Rembrandt in conceptions of light and color and in that he painted canvases of limited scope.

In his early works, he represents spacious interiors. Later, he begins to focus on the figure, framing the upper body in an almost photographic fashion. The majority of Vermeer's oeuvre, consisting of 40 or so extant works, revolves around scenes of everyday life, serene and quiet, with a particular luminosity and a certain air of timelessness.

Many of his works were painted in the same room. It is believed that the artist used a large camera obscura constructed at one end of a room, which projected images onto a surface, from which he traced outlines. He painted scenes with objects such as maps, pearls, and musical instruments that imbue the atmosphere with magic and mystery. His figures, primarily women, radiate strong personalities, whereas the few male figures he painted could be self-portraits. His blues are unique, with a palette that no other painter has managed to duplicate.

Vermeer's influence on Dutch landscape art was significant, though he executed very few works in this genre. He is said to have carried out optical experiments with mirrors, frames, and the camera obscura. Rediscovered in 1886 by Bürger-Thoré, he was greatly admired by the French realists and by avant-garde artists such as Dalí.

- **1632** Recorded in the baptismal register of the New Church in Delft as the son of Reynier and Dympha Vos. His father ran an inn with a tavern. Hardly anything is known about his childhood and youth, although he is believed to have been the student of Carel Fabritius.

- **1653** Marries Catharina Bolnes, who belongs to a well-off family, and they settle in "Mechelen," the name of his father's inn. Admitted as a painter to the Guild of St. Luke, which he directed on several occasions.

- **1654** The explosion of the munitions magazine in Delft destroys or seriously damages Mechelen.

- **1655** After his father's death, he inherits a portion of the family house and business. He is believed to have gone into the business of selling other artist's paintings. Takes out a large loan to pay off his many debts.

- **1656** Paints *At the Matchmakers' House* (Staatliche Kunstsammlungen, Dresden)

- **1662** Moves to Amsterdam and is appointed vice-deacon of the Guild of St. Luke.

- **1663** The advisor of the French monarchy, Balthasar de Monconys, visits the artist's studio and is deeply disappointed at the near absence of paintings there, meaning that Vermeer either had no commissions or had already finished them all, which is hard to believe.

- **1665** Paints *Allegory of the Art of Painting* (see p.216) and *The Lacemaker* (see p. 217).

- **1668** Paints *The Astronomer* (see p.217).

- **1670** His mother dies, and he inherits her portion of Mechelen.

- **1671** Receives two inheritances, one from his older sister, which help him restore his ailing finances.

- **1672** Rents Mechelen out for six years. His home is sacked by French troops.

- **1673** Takes out a loan for 1,000 florins.

- **1675** Dies in Delft on December 13 at the age of 43.

The Milkmaid (detail)

(1658-1660)
oil on canvas
18 x 16 in (45.5 x 41 cm)
Rijksmuseum, Amsterdam

This work fools the viewer. It appears to be a canvas of large dimensions, but it is actually very small. Vermeer conveys the simplicity of domestic life here, with a humble setting, judging from the plain background and total absence of elements except for the lamp, in keeping with the figure's humble profession. The illumination of the work, inherited from Caravaggio, gives rise to a composition regulated by the source of light, an effect present in many of Vermeer's paintings. The artist dignifies the scarcity of elements in the room, converting each object into an essential element. The woman is wholly engrossed in her work and absolutely unaware of the viewer's presence, which increases the intimacy of the scene, enhanced by the framing of the figure.

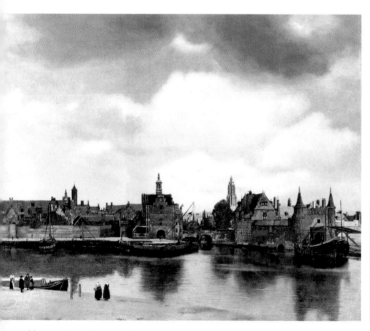

View of Delft

(1658-1660)
oil on canvas
39.4 x 47.4 in
(98.5 x 118.5 cm)
Mauritshuis,
The Hague

Vermeer lent this view of his city the same serenity as his interiors. As in the latter, he builds an interesting composition based on different intensities of light. The clouds form a backdrop under which the city can be seen in the background, illuminated by the light of the sun. This strong contrast saturates the colors and lends the water and atmosphere grayish tones. This type of atmosphere was not an invention of the artist, as it was characteristic of landscape painting in the Netherlands for quite some time. The reason for this pictorial phenomenon is that there was a succession of storms that occurred then. It was what the painter saw with his own eyes. He used a camera obscura to capture the image more perfectly, in a manner similar to a photographic camera. Consisting of a box with a pinhole, the camera obscura projected the image onto a surface like a modern-day projector, and the artist traced the outlines. That is how Vermeer painted this view of the city, reorganizing the buildings until he obtained the desired composition.

A Street in Delft

(1658-1660)
oil on canvas
22 x 17.5 in (54.3 x 44 cm)
Rijksmuseum, Amsterdam

Although Vermeer is only known to have created three landscapes, among them this cityscape, his influence on Dutch landscape art was significant. This painting has a great affinity with works by Vermeer's contemporary and competitor, Pieter van Hooch, although the latter had a propensity for warm, golden light, whereas Vermeer preferred fresh, silvery clarity. He conveyed the calm serenity of his interiors in his landscapes. Resembling a snapshot, the work is meticulously executed and reveals the beginnings of an important conceptual innovation, Pointillism, which he would develop later. His brush technique was based on his analysis of light and objects.The innovation in his canvases would be taken to an extreme by Seurat.

The pregnant woman in this work appears to be Vermeer's wife, Catharina. There is a great deal of symbolism in the painting. Holding a goldsmith's scales, the woman has just weighed some gold coins, now on the table. To the side is a small box with a string of pearls. The light enters from above and falls on the woman's hand and body, towards which the eye is led. The line of her body converges in the center of the painting with the line formed by her hand and the light striking it. The painting in the background represents the Last Judgement. Thus, it is not difficult to establish a direct relation between the woman's action and the weighing of souls occurring in the biblical scene to determine whether they will be destined to heaven or hell for infinity. The pregnant woman suggests life and hope, as well as death, comprising a sort of reflection on the vanity, or ephemeral quality, of life on earth.

Woman Weighing Pearls

(1662-1663)
oil on canvas
17 x 15 in (42.5 x 38 cm)
National Gallery of Art,
Washington, DC

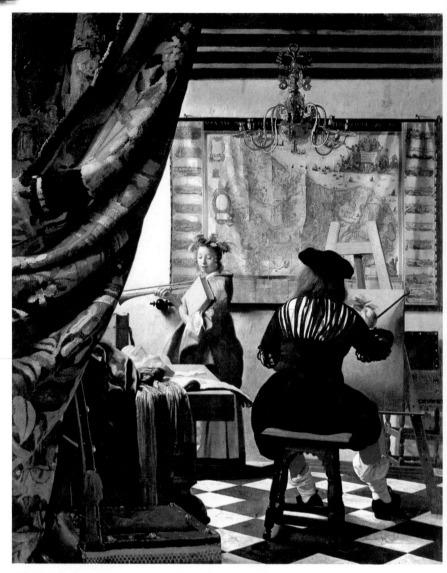

Allegory of the Art of Painting

(1665)
oil on canvas
48 x 40 in (120 x 100 cm)
Kunsthistorisches Museum, Vienna

The subject of pictorial creation acquires particular importance in this work. The artist represents himself in his studio, beginning a painting of a model. The various elements in this scene can be interpreted symbolically. Hence, the map shows the autonomy of the Netherlands from Spain. The model, wearing a laurel wreath and holding a trombone and book, symbolizes victory and fame. The painter, with his back turned, is not wearing work clothes but rather his finest attire, through which Vermeer seeks to dignify painting and the freedom of creation.

There is a series of features that also appear in works by other artists, such as the curtain in the foreground, surprising in this artist. The light entering from behind the curtain, probably through a window, gives rise to strong contrasts. Together with the intense palette, they create a highly spectacular interplay of colors. Vermeer's skill of observation and his attention to details are remarkable. Simply observe the realism of the map in the background.

The Lacemaker

(1665)
oil on canvas
9.6 x 8.4 in (24 x 21 cm)
Louvre, Paris

This intimate, detailed scene of everyday life is a highly modern work with a composition more like that of a photograph than that of a painting, an aspect that the painter developed over the course of his career.

Vermeer paints the young woman in close-up, well defined against a plain background harmonious in a tone with the general color scheme. This was the first time a figure was represented this way, with only the upper part of the body visible. Engrossed in her work, she is wholly unconcerned with the viewer.

Light becomes the principal protagonist, a feature that caught the attention of the avant-garde artists of the 19th-century. Renoir considered this work one of the most beautiful paintings ever created. The treatment of light evolved from the Baroque tradition of Caravaggio and Ribera. Tenebrism was essential in the Dutch Baroque, since this manner of capturing the reality of a moment frozen in time could only be conceived through light. Vermeer's unique treatment of color is also important, seen in his use of flat, pure colors, with few variations.

The Astronomer

(~1668)
oil on canvas
20 x 18. 5 in (50.8 x 46.3 cm)
Louvre, Paris
(Rothschild Collection)

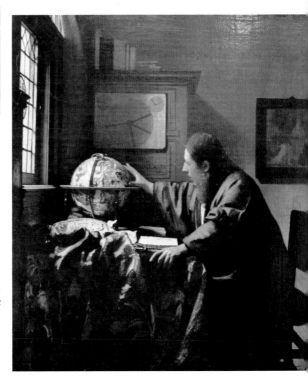

This work forms a pair with another, similar one, *The Geographer* (see next page). The figure is probably the painter himself. The scene does not conclusively reveal the figure's profession, although he has been identified as an astronomer because he is observing a globe and has a book on the table next to him. The globe in this work is the same as the one appearing in *The Geographer*. This unifying factor provides clues to the allegory of the pair, which could consist of two representations of a single philosopher, and not of two sciences. With a predominance of green, the painting is illuminated by the light entering from a window, which creates shadows and volumes.

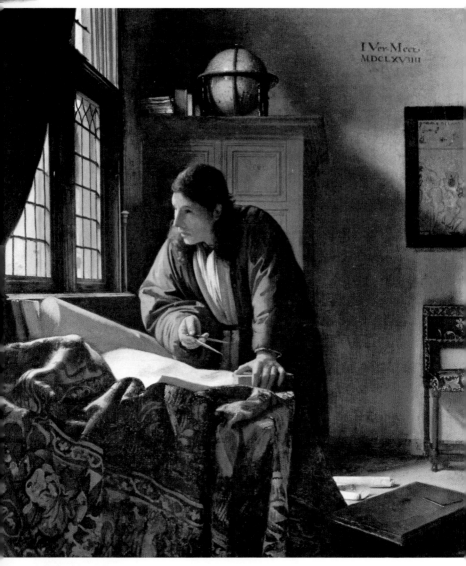

The Geographer

(~1668)
oil on canvas
21 x 18.6 in (53 x 46.5 cm)
Städelsches Kunstinstitut,
Frankfurt

This painting, along with The Astronomer, is one of the most representative of Vermeer's artwork. In an oeuvre in which women nearly always appear as the protagonists, here, it is a man who plays the leading role. The instruments, precisely distributed throughout the painting, refer to the man's scholarly pursuits. The figure seems superior to the level that would logically correspond to a scientist, as the man seems to be belong to a certain social class and is wearing clothing of high quality.

The light permeating the room enters from the same window as in *The Astronomer* (see previous page), flooding all objects and giving them a feeling of sobriety. These objects are particularly important, transcending the ordinary, despite their subtle depiction.

The rich fabrics in the foreground are probably Syrian, highly appreciated by the refined upper classes of the period. Vermeer painted these fabrics in cool colors and fine, short brushstrokes, for which he can practically be considered a precursor to the Pointillist technique and palette. Vermeer placed such importance in the faithful reproduction of all details that he even painted part of the camera obscura that he used in one of his works (*The Music Lesson,* 1660, Frick Collection, New York), in which it is reflected in a mirror. The blue used by the artist is also remarkable, and can be considered unique to him, as no one has ever been capable of reproducing it. The intimacy of the scene is typical of his works, with a certain air of mystery permeating everything.

JEAN-ANTOINE WATTEAU

Period engraving of Watteau.

The works of Jean-Antoine Watteau describe the mentality and customs of French high society, always associated with the nobility, civil and military authorities, and the rich. His painting is characterized by the use of many different styles (Baroque, Rococo, Neoclassicism, and Romanticism).

In his mature period, festive subject matter abounds, with dance and musical theater scenes usually featuring members of the nobility. They are often set in the wilderness, among trees and classical sculptures. His figures are fragile, elegant, and "Versaillesque," the women evanescent and the men sexually ambiguous.

In his renderings of pastoral scenes and country dances, his most popular works, he enriches the figures with fanciful elements recreating the pastimes of the period. The frivolity of these games has a bittersweet undertone, as it is often combined with an air of melancholy created through dusky landscapes in the background, with golden, sorrowful atmospheres.

His art is vivid due to the luminosity of his palette and the pureness of his tones. He often contrasts dark edges with splendid brilliance in the central area of his works. The beauty and grace of lines and the delicacy of the composition are remarkable.

In keeping with the interest that the French felt at that time for Italian theater, Watteau incorporates many figures from the commedia dell'arte in his works. His artwork exercised a significant influence on European painting from the 18th-century until the advent of Symbolism and including Renoir.

• **1684** Born in the Flemish town of Valenciennes.

• **1702** After working in the studio of the local artist, Albert Guérin, he moves to Paris and paints under Abraham Métayer. Begins working for the engraving business of the Mariettes, for whom he executes many classical Baroque copies.

• **1703** Enters the studio of the set painter, Claude Guillot, who introduces him to theatrical painting and to the airs and graces that gradually lend consistency to his style.

• **1707** Enters the workshop of Claude Audran, fashion decorator for the high aristocracy, who entrusts him to decorate the Castle of La Muette and the Hôtel de Nointel in chinoiserie, and brings him to the Medici Hall of the Palais Luxembourg so that he can become directly familiar with Rubens' artwork.

• **1709** Paints several soldier scenes in his village.

• **1715** Lives in the home of the collector, Pierre Crozat, where he is able to study works in his important collection by Veronese and Titian, and enters the high society of Paris, which was to provide a source of inspiration for many of his works.

• **1717** Leaves Crozat's home to become more independent. Allowed to join the Académie Royal de Peinture et de Sculpture through the influence of its director, De la Fosse. Upon entering the academy, he presents the painting *A Pilgrimage to Cythera* (see p. 221), a work of obscure meaning for which he receives the official title of "painter of *fêtes galants* (elegant entertainments)."

• **1719** Having suffered tuberculosis for some time, he is forced to move to London to be attended by Dr. Mead. His works are highly appreciated there but the climate does not suit him.

• **1720** Returns to Paris, living with the antiquarian Gersaint, for whom he paints *Gersaint's Shop* (see p. 224).

• **1721** Seriously ill, he moves to the house that his friend Gersaint has in Nogent-sur-Marne, Île-de-France, where he dies after burning all paintings of nudes in his possession.

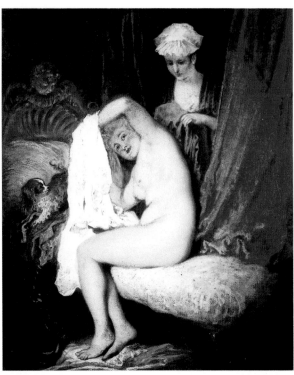

Woman at her Toilette

(~1705)
oil on canvas
Wallace Collection, London

Watteau's pleasant, delicate art, characterized by gallant subjects full of coquetry and sensuality, developed a tendency toward sultriness and eroticism, giving rise to a style that was much to the liking of the Parisian nobility and court. This work induces the viewer to observe the intimacy of the protagonist, whose singular pose, with arm uplifted and exhibiting her anatomy, constitutes an invitation. The dark, dense background brings the woman's body to the fore, making it the focal point of the work. The artist accompanies this intimate, everyday scene with all of the elements necessary to make it suggestive.

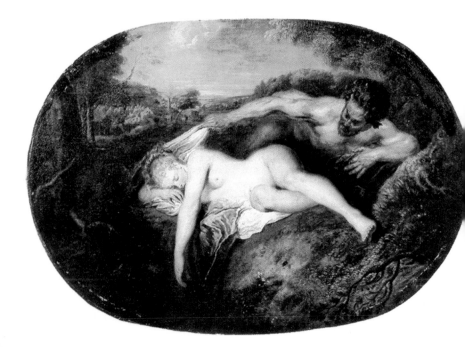

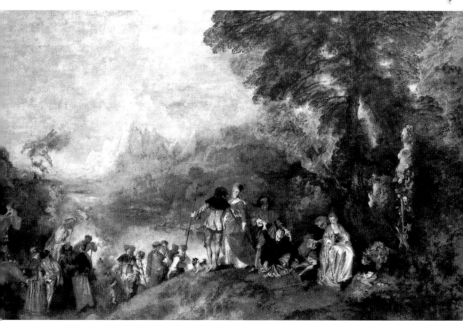

Although Watteau became an honorary member of the Académie in 1712 through the influence of its director, De la Fosse, it was not until 1717 that he was able to become a full member. He painted this work for the occasion, and it was well received, consecrating him as the champion of a new category of paintings, the *fête galante*, or elegant entertainment.

A Pilgrimage to Cythera

(1717)
oil on canvas
51 x 77 in (128 x 193 cm)
Louvre, Paris

According to mythology, Cythera is the Mediterranean island where Venus arrived on a shell, after her birth from the union of the sea spray with the rain of roses that was the seed of Uranus. The title, composition, and color scheme of the painting lead to the conclusion that, despite the courtly attire of the figures, it is an allegory combined with elements of *fêtes galantes*.

The scene is set in the wilderness, with a warm light and the colors of some of the leaves indicating autumn, a period of decline. The figures are conversing in static poses, distributed in small groups, and the scene looks more like a pilgrimage to a local shrine than a festival. Realism and spontaneity are reflected in the varied collection of poses, with some even turning their back to the viewer, an unusual feature, or to the bust of Venus above a small rosebush on the right. The forest is superb, luxurious, in a varied range of colors and tones. It covers the middle ground, serving as a background for the figures and as a frame for the illuminated area of sky in the upper left. Considering his usual melancholy tone, and the fact that he knew that the turberculosis he suffered from would eventually lead to his death, this work can be understood as an allegory of nostalgia for lost youth and love.

Jupiter and Antiope, *or* The Nymph and the Satyr

(1715-1716)
oil on canvas
29.4 x 43 in (73.5 x 107.5 cm)
Louvre, Paris

Antiope was the daughter of Nycteus, King of Boeotia, who disowned her after Zeus had seduced her in the form of a satyr. After leaving her father's home, Antiope took refuge at the court of Epopeus, King of Sicyon, who took her as his wife. Nycteus committed suicide but his brother Lycus fought against Epopeus and killed him, then locked Antiope in a dungeon, where she gave birth to the twins, Amphion and Zethus. They avenged their mother, killing Lycus and his wife Dirce. The scene represents the moment when Zeus, having taken the form of a satyr, discovers young Antiope, whose nude body is brilliantly lit, accentuated by the dark tones around her. The skillfully distributed highlights on the skin model the body and enhance its volume. The satyr observes her lustfully, sullying her sensual innocence and making the scene profoundly erotic.

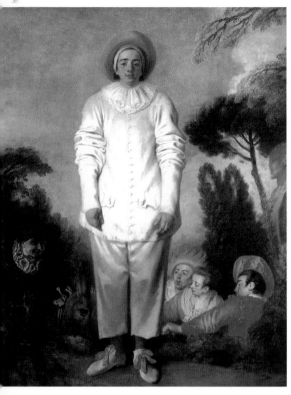

Gilles

(1717-1719)
oil on canvas
73.6 x 59.6 in (184 x 149 cm)
Louvre, Paris

Because of his profession and education, Watteau was always in contact with the world of theater, and he was interested no only in the plays themselves, but also in the design and mounting of stage sets as well as in the traditional characters and the reality they represented. This is a beau tiful and illustrative example of how the artist interpreted a figure from the Italian commedia dell'arte. Although because of its inherent criticism and ridicularization of the dominating classes of society, the commedia dell'arte was banned in France from 1697 to 1716, it always retained great popularity among ordinary people.

This Pierrot, with his highly expressive face and an outfit that does not fit him well, comes across as a human being, not a caricature. He is accompanied by an abundance of elements complementing th world in which he is immersed, full of fantasy, light, and vivid colors. It is a tragi-comic representation that gives prominence to an absurd and solitary figure, while making a poignant commentary on fatuous, ridiculous, and outlandish world.

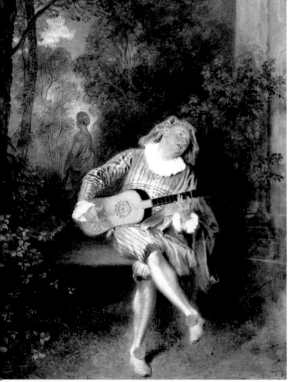

Mezzetin

(~1718)
oil on canvas
22 x 19 in (55.2 x 48.2 cm)
Metropolitan Museum of Art,
New York

True to his experience, Watteau represents a figure related to the world of theater, a buffoon, Mezzetin—a stock character of the commedia dell'arte. He is dressed in varied yet soft, subdued colors, the warm tone of his complexion standing out. The figure is brightly lit against a fanciful background, with severe shadows on the right sleeve. As if it were a stage set, the background is evanescent, its darkness invading nearly everything with the exception of a misty light filtering in from the upper left that adds an air of mystery and allows the luxuriant forest to be seen, along with a female silhouette recalling certain Roman sculptures.

This scene is an homage to the actors who spent their lives traveling from town to town, entertaining people with their plays. The darkness envelops the figures in the center, illuminated only by the light of lanterns and torches, their faces expressive and well modeled. The work expresses the greatness of these people, lovers of art as much as the crude reality of a life of sacrifices and privations. The artist plays with contrasting values to provide a bittersweet view of existence.

The Italian Comedy

(~1717)
oil on canvas
15 x 19 in (37 x 48 cm)
Staatliche Museen,
Gemäldegalerie, Berlin

The scene is simple: some children have gone to the country to picnic. Afterwards, one of them plays the flute while a girl seems about to begin a dance. It is a bucolic vision that could be considered superficial, yet is full of charm and poetry. The artist meticulously applies a varied range of intensely vivid tones in the clothing, especially that of the dancing girl, contrasting with the background and a superbly realistic sky. The details are also painstakingly executed: the hat, dog, basket of apples, flock of sheep, and village in the background.

The Dance

(~1717)
oil on canvas
39 x 46.4 in (97 x 116 cm)
Staatliche Museen,
Gemäldegalerie, Berlin

Gersaint's Shop

(1720)
oil on canvas
65 x 123 in (163 x 308 cm)
Staatliche Museen,
Gemäldegalerie, Berlin

A year before executing this painting, Watteau had spent a period in London, seeing Dr. Mead in the hope of finding remedy for his tuberculosis. The London climate did not suit him and he had to return to Paris. He settled in the home of the antiquarian, Gersaint, for whom he painted this work, considered by many as his masterpiece. It represents a radical change from his many festive, brilliant, and colorful outdoor scenes. In addition to a significant change in subject matter, the composition and color scheme also vary substantially.

The scene is a panoramic view painted on two juxtaposed canvases, representing the interior of Gersaint's busy shop. It is rendered as if it were a stage, with a sharp vanishing point. The walls are entirely covered with paintings and there are two groups of people in the foreground, each slightly off to one side, representing the sales clerks, other employees, and clients. The poses are highly natural and transmit spontaneity in what is a chronicle of a moment.

The color scheme is well studied and harmonious, with the predominance of a single tone that balances and unifies the colors. A source of light from the left illuminates the figures, modeling their bodies and, through highlights on white, establishing a clever interplay that lends the painting dynamism and relief. The perfection of the two long dresses, one pink and the other white, is spectacular, their modeling giving rise to a highly effective realism full of varied tones. With an excellent treatment of light, this meticulous work resembles a genre scene from the Romantic period. Despite the theme, it is imbued with poetry and is aesthetically attractive.

GIOVANNI BATTISTA TIEPOLO

Tiepolo in an engraving executed during his lifetime.

The artwork of Giovanni Battista Tiepolo, the last of the great Venetian painters, culminates and closes the formal Baroque. Its subject matter, dominated by sensuality and joie de vivre, marks the transition toward 19th-century painting.

The influence of Piazzetta can be seen in the intense passion, solid forms, and dense masses of his earlier works. Later, his colors become lighter and tend toward a brightness that will gradually become characteristic of his art.

Tiepolo painted many large-scale works on ceilings of palaces and churches, representing allegorical, religious, and historical scenes with spacious skies and an interesting interplay of perspectives and trompe-l'oeil, giving rise to compositions that recall Veronese, ethereal and magnificent, with extremely luminous colors.

His skill has been compared with Rubens'. His monumental works are considered decorative and complementary to the architecture of the corresponding building rather than artistic per se. Nonetheless, his idea of art clearly goes beyond the matter of dimensions, and is based on the conception and execution of the subject represented.

Tiepolo's art reflects the tastes and painting style of the 18th century, both in its colors (in the Venetian tradition but with a lighter color range) and in the way it reflected the customs and attire of Venetian society of the time.

Although he is primarily known for his large mural decorations, Tiepolo's easel pieces are among the most brilliant of the 18th century.

- **1696** Born in Venice.

- **~1710** Studies under Gregorio Lazzarini.

- **1715** Decorates the Ospedaletto Church in Venice.

- **1717** Registered as a member of the painters' guild.

- **1719** Marries Cecilia Guardi, the sister of the painters Giovanni Antonio and Francesco.

- **1725** On the ceiling of the Palazzo Sandi in Venice, he begins a series of large frescos that he completes the following year with the decoration of the Chapel of the Holy Sacrament in the Cathedral of Udine and the Archbishop's Palace in the same city, considered his most important early work.

- **1740** Decorates the Palazzo Clerici in Milan.

- **1743** Finishes a ceiling fresco for the Carmine Brotherhood in Venice. Begins a ceiling fresco for the Carmelite Church, destroyed in 1915. Decorates the church of Villa Cordellina, near Vicenza.

- **1747** Paints the Palazzo Labia in Venice with scenes from the story of Anthony and Cleopatra.

- **1750** Prince Charles Philip of Greiffennlau commissions him to decorate his residential palace in Wurzburg with scenes from the life of Frederick Barbarossa, assisted by his sons, Giovanni Domenico and Lorenzo.

- **1753** Returns to Venice.

- **1757** Assisted by his son Giovanni Domenico, decorates Villa Valmarana, near Vicenza, with frescos.

- **1759** Paints the altarpiece of the cathedral of Este and an Assumption fresco in the Purity Church of Udine.

- **1761** Paints the ceiling of the ballroom in the Palazzo de Canossa, Verona.

- **1762** Summoned by King Charles III, he moves to Madrid with his sons to decorate the throne room of the new Palacio Real and to execute various easel paintings.

- **1770** Dies in Madrid, after some difficult years due to disputes with the painter Anton Raffael Mengs, a distinguished Neoclassicist.

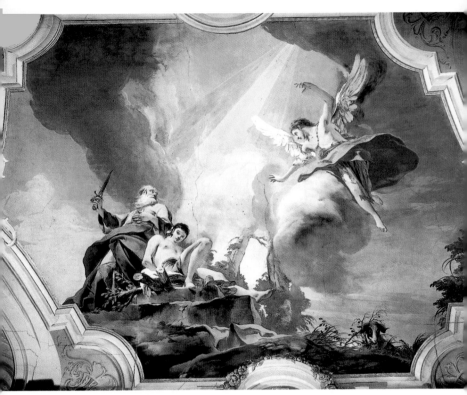

The Sacrifice of Isaac

(1726-1728)
fresco
160 x 200 in (400 x 500 cm)
Archbishop's Palace, Udine

Tiepolo was finishing a series of large frescos for the Palazzo Sandi in Venice when he received the commission to paint the Chapel of the Holy Sacrament in the Cathedral of Udine, as well as the Archbishop's Palace. This fresco is from the latter building, and is considered the masterpiece of Tiepolo's early period.

It consists of a series of biblical stories that reveal the influence of the Venetian tradition, though the artist lightens the colors in accordance with 18th-century tastes. According to the biblical episode, although Jehovah had promised Abraham many offspring, the patriarch was already quite old and still had no children. The couple was overjoyed when, finally, his wife Sarah, also elderly, gave birth to Isaac, considered a blessing from God in the Jewish tradition. In order to test Abraham's faith, Jehovah asked him to sacrifice Isaac when he had grown into a fine youth. The patriarch acceded, trusting in God. His faith proven, Jehovah stopped Abraham's arm just before the sacrifice was consummated.

The fresco represents the moment when the angel arrives to stop Abraham from killing his son. The work is one of the many large frescos that Tiepolo executed to decorate palaces and churches. Spectacular and grandiose, with an ample sky, the sensibility and luminosity of the colors are remarkable, as is the skillful interplay of perspectives, preventing the painting from appearing deformed despite the shape of the ceiling.

Nude, with his hands tied, Isaac gazes fearlessly at the viewer. His anatomy is beautiful, with generous proportions and a complex foreshortening, considering the artist's viewpoint. The youth's body, carefully protected by Jehovah, receives the direct impact of a shaft of light emerging from the heavens, lending his complexion great luminosity. The modeling of the shadows and the boy are natural, the trompe-l'oeil producing the sensation that the scene takes place in the very hall. The works executed in Udine mark a turning point in Tiepolo's style: the poses gain audacity, and the composition becomes daring, the forms and details dynamic, the skies particularly luminous and rich in color, and the nudes extremely sensual.

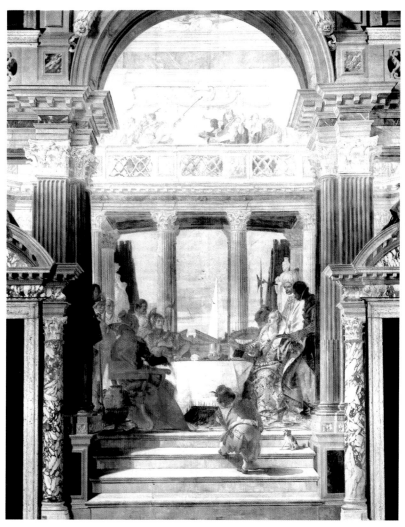

This work was painted at a time when the artist had associated with Mengozzi-Colonna, a specialist in decorating important buildings, who was in charge of painting the edges that framed the large representations created by Tiepolo. The Palazzo Labia was a Neoclassical building of large dimensions, with an abundance of columns, pilasters, and majestic imposts. The family who commissioned the decoration wanted it to depict the story of Anthony and Cleopatra, using their facial features for the main protagonists.

The Banquet of Anthony and Cleopatra

(1747-1750)
fresco
Palazzo Labia, Venice

Tiepolo conceived a work in which the style, composition, and scenic elements combine perfectly with the architecture of the building, a subject in which he specialized. Hence, the architectural style of the gallery in the background, with its columns, is the same as that of the building, as are the cornices that demarcate the ceiling.

In a luxurious and sumptuous framework, the artist represents a banquet with richly dressed figures distributed symmetrically on each side of the scene to achieve a balance of masses. He leaves the center clear to exhibit a bright landscape, visible between the columns of the gallery, that creates a contrast and enhances the prominence of the figures. The trompe-l'oeil effect, a frequent feature in Tiepolo's art, is superb here. The scene is static and the figures adopt effective theatrical poses. The balanced composition, exquisite symphony of colors, and poses of the figures in luxurious attire surpass the best operas and exalt the patrons. There is a preliminary sketch at the University of Stockholm for this work, considered the best product of the collaboration between Tiepolo and Mengozzi-Colonna.

Olympus

(~1750)
oil on canvas
34.4 x 24.8 in (86 x 62 cm)
Prado, Madrid

This solemn, grandiose painting has a spatial composition in which a series of nude gods is distributed in a luminous blue sky. The atmosphere acts as a sort of filter, with Mercury standing out in the upper foreground. Somewhat more distant and lower in the painting is Athena. Farther off and to the left are Venus and her son Cupid. The three remaining figures in the background are blurry due to the effect of the intervening atmosphere.

These nudes have complex foreshortenings, revealing the artist's great drafting abilities. The variety of poses created and colors applied, excellently combined, show Tiepolo's superb savoir-faire. His rich imagination succeeds in mixing myth with reality, a pagan vision with a transcendence reaching far beyond the allegorical meaning of the scene.

Neptune Offers Gifts to Venice

(1750)
oil on canvas
54 x 110 in (135 x 275 cm)
Palazzo Ducale, Venice

This work is an allegory of the gifts received by Venice, represented as a queen in lovely clothing with her arm resting on the head of a lion, the symbol of St. Mark, patron saint of the city. Neptune, offering Venice various gifts, which pour forth from the cornucopia he is holding, is a battle-hardened old man with a white beard, recalling figures by Rubens. Nonetheless, Neptune is portrayed as a normal man with the trace of the years evident in his skin and muscles. He evokes certain paintings by José de Ribera, though his realism is not as strict, since the anatomical features are softened by the dense, warm atmosphere. The colors are warm and the palette harmonious. The light entering from the left models Neptune's nude torso and Venice's garments, leaving the background in half-light so that the two main figures appear to emerge, capturing the viewer's attention.

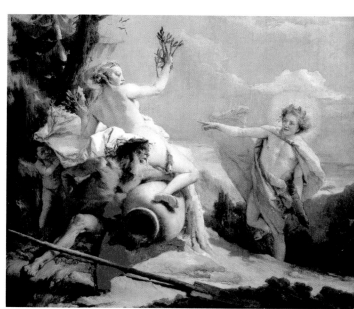

Apollo Pursuing Daphne

(1755-1760)
oil on canvas
27 x 34.8 in
(68.8 x 87.2 cm)
National Gallery of Art,
Washington

After killing the python with arrows, Apollo mocked Cupid for being so small and carrying arrows. Cupid took revenge by letting fly one of his arrows and making Apollo fall in love with the nymph, Daphne. He also shot an arrow at her to cause her to reject love, especially Apollo's love. The latter, on the right, is running toward Daphne, who reclines next to her father, the river god, Peneus. Nearly concealed on the left, Cupid symbolizes the spark of love. Daphne asks her father to transform her into a laurel so that Apollo can never possess her. Tiepolo is a great master of the nude, permeating his works with a combination of sensuality and romantic realism. The work emanates a certain tension, softened through the explicit sensuality of the figures, which attenuates the drama of the metamorphosis.

Ruggero Delivers Angelica from the Sea Monster

(1757)
fresco
100 x 70 in (250 x 175 cm)
Villa Valmarana, Vicenza

The luminosity and colors that Tiepolo uses for his mural decorations approach the Rococo, in fashion at the time. The artist's palette incorporates gray, yellow, and golden tones, creating a splendorous and lively universe. Tiepolo was a great draftsman, and on some occasions, such as here, he may have done without a model, causing slight distortion in some of the nude's lines and a tendency toward stiffness. As appropriate to a subject taken from classical literature, and in his peculiar style, Tiepolo conceives a magnificent work that evokes the epic tales of antiquity, for which he always demonstrated great skill. The appropriate use of light creates a clear, transparent background, allowing the figures to emerge and contrast against it as if in relief.

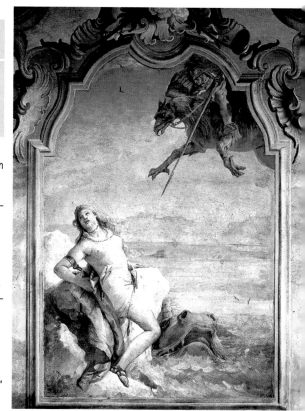

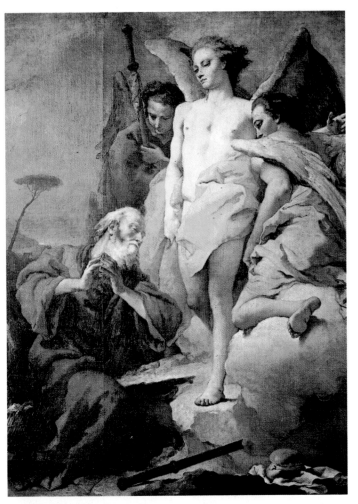

Abraham and the Three Angels

(~1768)
oil on canvas
79 x 60. 4 in (197 x 151 cm)
Prado, Madrid

Tiepolo was considered the most famous painter among the masters in 1739. Although he became famous for his large fresco decorations for churches and palaces, his canvases are also of great artistic merit. Though some believe this work was painted before Tiepolo traveled to Spain in 1761, the fact that the models and technique used are practically identical to those in the works he executed for the Convent of San Pascual in Aranjuez (1767-1769) would indicate a later date.

The subject represents an episode from the Book of Genesis: Abraham, very old and sitting at the door of his shop, is upset because his wife Sarah, becoming elderly as well, has had no children. For the Hebrews, this was not only a misfortune, but a punishment from God. Suddenly, three angels appear in the guise of young men, whom the patriarch invites into his home. They show concern for his wife, and one of them promises to return the next year, asserting that Sarah, despite her age, will have a child by then, fulfilling the divine promise. As the angel said, a child was born to the couple.

The angels, contrary to classical representations of cherubs or beings of justice, are rendered as young people walking among dense clouds, with perfectly defined, androgynous features. The central figure, with a slender silhouette barely covered by a cloth, has the face of woman, a feature that Tiepolo often incorporated into his works. Sexual ambiguity is the most notable element of this nude of beautiful proportions, yet far removed from the classical ideal of beauty. The treatment of the skin is superb, strongly illuminated with a gentle modeling of volumes through minimal, tenuous shadows. The slight contrapposto and the position of the hand evoke David, and the beauty of Michelangelo's nudes in general.

JEAN-BAPTISTE-SIMÉON CHARDIN

Self-portrait, *pastel, 16 x 13 in (40.5 x 32.5 cm), 1778-1779, Louvre, Paris.*

Chardin was renowned for his genre works and still lifes. His domestic interiors and family scenes, approaching the Flemish style, significantly contrast with the romantic scenes of his contemporaries in France.

Fascinated by painting material, he applies a great deal of pigment, making the simplest objects acquire great importance. In his genre works, basically comprising scenes of everyday life in bourgeois society, with women and children as subjects, the human being is represented with a dignity unusual in French painting until then.

Chardin paints what he sees, in settings that he is deeply familiar with. He captures the essence of domestic life in such a realistic manner that his paintings, in addition to being psychological studies, accurately document the way of life and of a specific sector of society.

Technically, his works include superimposed colors in a singular impasto, which he juxtaposes with measure in order to achieve sfumatos that soften the contrasts between light and shadow.

For his peculiar conception of the still life, influenced by the Enlightenment, which saw nature from an aesthetic and intellectual point of view, he is considered to have revived the genre, and for his poetry and singular manner of portraying intimacy, he is considered one of the greatest French realists of the 18th-century.

- **1699** Born in Paris on November 2 to a humble cabinetmaker.

- **1724** Having studied under Pierre Jacques Cazes and then Noël-Nicolas Coypel, he is admitted as a master to the Académie de St.-Luc.

- **1728** His 12 works displayed at the annual exhibit for novice painters at Place Dauphine, and especially *The Skate* (see p. 232), are a great success. Enters the Académie Royale de Peinture et de Sculpture thanks to Nicolas de Largillière's support, a famous painter of still lifes at the time.

- **1731** After his marriage to Marguerite Saintard, his works show scenes of bourgeois family life.

- **1733** As of this year, he makes the human figure the subject of his paintings.

- **1735** Executes the first scenes of the series *Boys Blowing Soap Bubbles* (Metropolitan Museum of Art, New York), in which he uses his son, Pierre-Jean, as a model. His wife and daughter Marguerite die.

- **1737** Begins exhibiting regularly at the Paris Salon. This year he exhibits eight paintings.

- **1740** By this time, many collectors and famous people have become interested in his art: the Count of Tessin and even Louis XV, who purchases *Saying Grace* (see p. 233) and *The Industrious Mother* (both at the Louvre, Paris).

- **1744** Marries Françoise Margherite Pouget, the widow of a musketeer called Charles de Malnoé.

- **1749** His artistic production declines. Participates in the Salon with two works: *The Morning Toilette* (Nationalmuseum, Stockholm) and *Monsieur Lenoir's Son Building a House of Cards* (The Hermitage, Saint Petersburg).

- **1757** Actively painting, with a special emphasis on portraiture and still life. In March of this year, the king allows him to lodge in the Louvre, where other artists are living (De La Tour, Lépicie, Cochin, Lemoine, Tocqué, Duvivier, etc.).

- **1770** Serious sight problems lead him to substitute pastel for oil painting, in which he paints a portrait of his wife and three self-portraits.

- **1774** Due to grave financial problems, he is obliged to sell a house. Resigns from the post of Treasurer of the Académie because he feels disrespected by the new artists favored by Louis XVI.

- **1779** Dies in Paris on December 6.

The Skate

(~1727)
oil on canvas
45.6 x 58.4 in (114 x 146 cm)
Louvre, Paris

Thanks to its success at the exhibit for novice artists held annually at Place Dauphine in Paris, this painting opened the door for Chardin. This still life was conceived in a manner very different from the works painted at the time. The scene, drawn within a triangle, maintains a noteworthy balance of elements (table, tablecloth, kitchen utensils, jug, fish, cat, etc.), colors (a varied, excellently compensated range), and light (from the most intense illumination to the darkest areas, dense and with great tonal variation). Though this balance could have given rise to a static, stilted painting, the work actually displays a great deal of dynamism and depth, a successful combination of lines and volumes, and a spectacular treatment of light. Despite the subject matter, the painting radiates freshness.

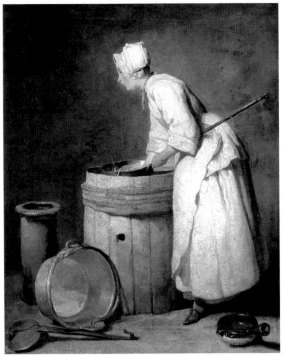

Woman in the Pantry

(1738)
oil on canvas
18 x 14.8 in (45.4 x 37 cm)
Hunterian Art Gallery,
University of Glasgow, Glasgow

This painting represents the type of domestic scene with the human figure as protagonist for which the artist had a true weakness. A young woman is shown busy at her housework; more precisely, she is readying the ingredients necessary to prepare a meal. The artist applies a plain background in a dark tone that makes the woman and objects in the foreground stand out, thereby facilitating the treatment of light. The light falling on the figure is intense, and, in addition to the bright color of the clothing, makes the woman the focus of attention. The interplay of light and shadows defines the volumes and perspectives.

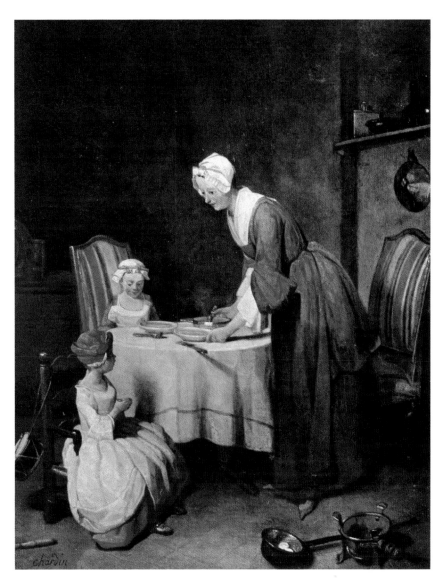

The artist was clearly interested in subjects related to domestic scenes, nearly always with women and children, possibly to laud the concept of the family and the values it stands for. This scene represents a young woman serving a meal for her two daughters. The composition is meticulously executed to achieve greater expression, with the table as the work's focal point, around which the three figures are gathered, treated with evident sympathy. Their poses, and attitudes, along with the treatment of light, favors the idea of unity and communion among them, less through the drafts-manship than through the atmosphere rendered.

Saying Grace

(1744)
oil on canvas
20 x 15.3 in (49.5 x 38.4 cm)
The Hermitage,
Saint Petersburg

Although there are various household objects in the painting, the light avoids them and obliges the viewer to concentrate on the three protagonists. Despite the sobriety of the setting and the overall simplicity of both the clothing and the atmosphere, the cleanliness of the room, the well-groomed appearance of the people and their clothing, and the diligence and kindness of the woman come to the fore.

The artist executed several versions of this subject in this period, which he presented at different editions of the Paris Salon. As it is signed and dated, we know this is not the first version, but it may be the most complete one. It differs from the others in certain details, such as the greater contrast and visibility of the figures against the background and the improved draftsmanship in the garments, tablecloth, and utensils in the foreground, as well as in the pattern of the floor tiles.

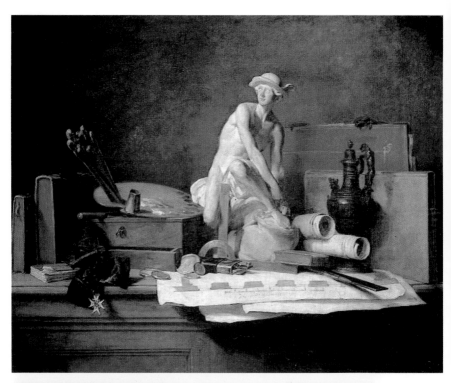

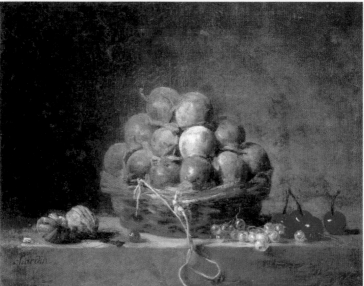

Still Life with Plums and Nuts

(~1765)
oil on canvas
13 x 17 in (32 x 42 cm)
The Chrysler Museum, Norfolk, Virginia

This still life reveals the artist's expertise in rendering reality and in the treatment of light and color. Despite the varied range and intensities of colors used, Chardin achieves a chromatically harmonious and unified work. The composition takes the form of a pyramid with a wide base, in whose interior all of the masses are balanced in order that the whole not be disjointed. The background is plain but a gradation of light expressly contributes to creating a contrast. This makes the various fruit appear to emerge from the surface toward the viewer. The illumination is tenuous, with the maximum point of intensity on the plums in the center, defining and modeling them, and providing a perfect description of volume. The depth, perspective, and general atmospheric treatment make this a masterpiece.

The Attributes of the Arts

(1766)
oil on canvas
44.8 x 56 in (112 x 140.5 cm)
The Hermitage, Saint Petersburg

This still life represents a table with various objects related to art. In the center of the composition, the small plaster statue of Pigalle evokes sculpture, the dark amphora on the left represents ceramics, the palette, brushes, and box of paints clearly refer to painting, the sketchbook and portfolio allude to drawing, and the scrolls, plans, and geometrical instruments suggest architecture. On the far right is the Cross of the Order of St. Michael, which was awarded to artists.

Despite the overwhelming number and variety of objects on the crowded table, Chardin creates a whole in which the principal protagonist is light, treated such that it lends the agglomeration of objects order. The light entering from the left illuminates a series of objects (statue, plans, etc.) that stand out among the others, creating a sense of depth and giving rise to a gradation of light and color intensities. Whether or not they are important, all of the objects are drawn meticulously, lending them realism and a singularly attractive quality. The generally pale colors are perfectly adapted to the modest condition of these mundane objects, none of which has value or distinction.

It has been stated, and not without reason, that Chardin executed still lifes in a manner that they allow the viewer to easily imagine the personality of the owner of the objects. This painting was commissioned by the Empress Catherine II of Russia. Although it was intended for the Academy of Art of St. Petersburg, it was installed in the imperial palace of the Hermitage. There are other versions of this painting, one of which is in the Louvre in Paris.

chardin

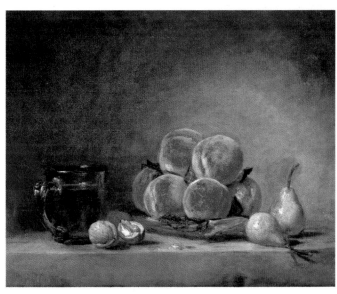

Jug and Peaches

(~1769)
oil on canvas
15 x 18 in
(37 x 45 cm)
Newhouse Galleries,
New York

Chardin stood out among his contemporaries in the still life genre. Through his compositions and treatment of light and color, Chardin had the ability to turn the most mundane objects into something spectacular. This painting is a good example of this talent. The composition is very simple, with the objects grouped horizontally, leaving an ample surface area free consisting of a dense, plain background against which the fruit emerges. Executed in vivid colors, they are highlighted in a gradated and all-encompassing illumination. The artist demonstrates how, with a few simple objects, a true work of art can be achieved.

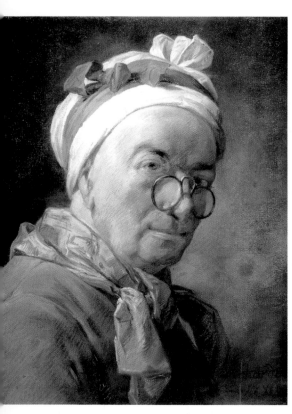

Self-portrait

(1771)
pastel
18.4 x 15 in (46 x 37.5 cm)
Louvre, Paris

Toward 1770, the painter began to have serious problems with his eyesight, along with a general physical degeneration due to old age. This led him to take up pastel, a medium that was more convenient and would allow him to execute his paintings more easily. Accustomed to painting in oil, he used pastel in an innovative technique of his own, with short, parallel strokes, in a style similar to what the Impressionists would use a century later. He superimposed thin layers of pigment in order to construct forms in a precise manner. He would break the stick of pastel and crush it against the paper, obtaining a series of colored areas that, when the painting was observed from a distance, revealed a thousand details and dramatic textures. This work is an eloquent example of the artist's polished technique.

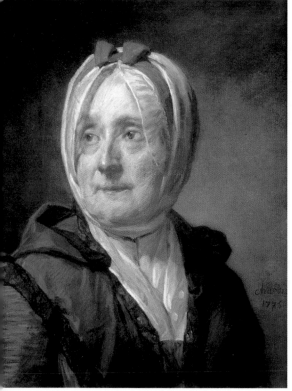

The Artist's Wife

(1775)
pastel
18.4 x 15.4 in (46 x 38.5 cm)
Louvre, Paris

This painting forms a diptych with the self-portrait above painted four years earlier. Both the concept and style are closely related to the intimate representations so typical of Chardin. The woman, dressed in the style of the period, is represented in a highly realistic manner. Although the pastel medium lends itself to fresh, spontaneous results, the artist opts for meticulous detail work, painting in a manner similar to his style in oil. The draftsmanship is excellent, the light well studied, and the whole natural. The result is a highly expressive portrait.

FRANÇOIS BOUCHER

The Painter in his Studio, *oil on canvas, 11 x 9 in (27 x 22 cm), 1753, Louvre, Paris. According to some, the painter is Boucher himself.*

The leading artist of French Rococo, Boucher had important friendships among the nobility and French court. He painted the fashionable themes of day (mythological, allegorical, religious, and pastoral). But he gained recognition through works in which the female nude takes center stage, permeated with sensuality and eroticism. Together with Watteau, Boucher is regarded as the creator of a category of art called *fêtes galantes,* or elegant entertainments, which explore the most significant subjects of the Rococo.

His style is never as refined as Watteau's, nor does his palette contain the wealth of tones of Fragonard's, but the liveliness of his drawing, the freshness of his color, and the subtle wit of his rendering made his works popular among the nobility and court.

Boucher's painting should be regarded as a homage to women. Executed in a novel manner, the work is devised to meet the demands of Parisian society. His work is not conceived to move the spectator, for which reason he leaves aside tenderness or wild and passionate eroticism in order to focus on an image that is above all delicate and beautiful, if not piquant and provocative. The mythological scenes that characterize his oeuvre convey joy and are set within a heavenly and seductive world, which caught the essence of the spirit of the late 18th-century, having a profound effect on artists, from Fragonard to David.

- **1703** Born in Paris, son of Nicolas, an embroidery designer.
- **1723** Pupil of François Lemoyne and Jean-Antoine Watteau; wins the prize of Rome with the work *Evilmerodach Frees Joaquin, Prisoner of Nabucodonosor,* currently lost.
- **1727** Moves to Rome, where he lives for four years and works with Tiepolo.
- **1732** Marries Marie-Jeanne Busean, who poses for many of his paintings. Paints *Venus Demanding Arms from Vulcan for Aeneas* (Louvre, Paris).
- **1734** Paints *Rinaldo and Armida* (Louvre, Paris). Joins the Académie Royal de Peinture et de Sculpture. He devotes his time to drawing, copying, and etching, techniques that prepare him for the landscapes he would paint later in his career.
- **1735** Paints the "Royal Virtues" for the queen's chamber, at the Palais Versailles.
- **1736** Begins a series of pastorales on 14 cards.
- **1737** Nominated teacher of the Académie Royale.
- **1739** Begins a series on the history of the psyche, in which he combines fiction and imagination, fantasy with intimism, and sensuality with eroticism. His works of this time are highly original, with an off-centered composition, curves and countercurves, and meticulously calculated perspectives, with lively and impacting colors.
- **1743** Until 1746 undertakes a number of different works for the Bibliothèque Royal, Paris, for Choisy, and for the Delfín residence, at Versailles.
- **1747** Madame de Pompadour entrusts him with various tasks (decoration of the dining room of the Château Fointainebleau in 1768, a commission in the Louvre in 1752, the mural painting of the Cabinet du Conseil in 1753, and various tapestry designs for La Muette.
- **1755** Becomes Director of the Gobelins tapestry factory.
- **1764** Paints *Adoration of the Shepherds* for the Cathedral of Versailles.
- **1765** Made *Premier Peintre* to the king, succeeding Carle van Loo, and Director of the Académie Royale.
- **1766** Travels to Flanders with Boisset.
- **1769** Decorates the town hall of Marcilly. Named associate member of the Academy of St. Petersburg.
- **1770** Dies in Paris.

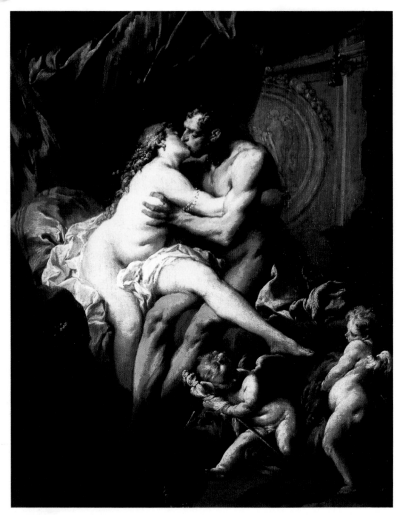

Hercules and Omphale

(1724)
oil on canvas
36 x 29.6 in (90 x 74 cm)
Pushkin Museum, Moscow

According to legend, Hercules killed Iphitus, the son of Eurytus, and asked Apollo what he should do to make amends. Apollo replied that he could only gain his peace of mind by allowing himself to be sold into slavery, the proceeds from which would be given to Eurytus. Hermes sold Hercules to Omphale, queen of Lydia, a vicious and perverse woman, renowned for her libertine lifestyle and wild orgies.

According to Alexandrian poets, Omphale kept Hercules as her slave for three years, forcing him to perform domestic duties with the other servants, and she used him as an instrument to satisfy her every whim and insatiable sexual appetite.

Here, the queen's palace chamber provides a luxurious setting for the two lovers in one of their many amorous encounters. They are oblivious to the spectator. This is one of Boucher's most erotic works and probably one of the most provocative paintings of the entire 18th century. Whereas in other works Boucher merely insinuates, here he gives full vent to the passion of the moment.

The embrace between the two figures is underscored by Omphale's sensuality. She is portrayed with a voluptuous figure, her legs apart, one resting on those of her lover. Hercules, with his powerful and tanned body, is shown as strong but submissive, predisposed to fulfill her every desire. The figure of Omphale, drawn according to Baroque canons, shows a magnificent anatomy, and her uninhibited pose allows the artist to draft beautifully foreshortened legs and reflect on canvas the body's torsion, which lends it notable dynamism. The artist used the dark background to bring the two lovers to the fore and lend them greater impact. The inclusion of putti as extras heightens the sensuality of the scene and adds a further erotic touch.

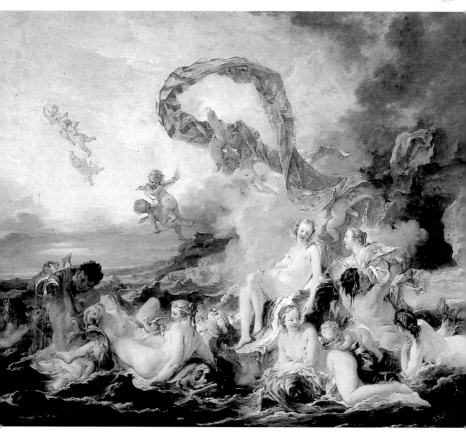

Boucher's female nudes made the artist famous during his lifetime, especially among the nobility and French court. His compositional schemes, flawless, dynamic poses, resourceful combination of curves and countercurves, and ability to render immense beauty and sensuality from unsophisticated bodies earned him the admiration of both the critics and a public in tune with the court's enthusiasm for his intrepid Rococo mythology.

The Triumph of Venus

(1740)
oil on canvas
52 x 64.8 in (130 x 162 cm)
Nationalmuseum, Estocolmo

The subject matter of this work does not correspond to a specific mythological legend. With the excuse of evoking Venus' grandeur, the painter composed this magnificent and sensual scene, generously populated with nudes, who exhibit a variety of poses. It goes without saying that Boucher displays a remarkable skill for the female anatomy and uses his knowledge to render it in all its splendor. Depicted in a poetic setting, imaginative and idyllic, the group of woman appear to float on the waves as if they were on a bed, thereby heightening the dreamlike and mysterious milieu. The clouds and spray that envelop the goddess, together with the great veil that crowns her figure in the manner of a baldachin, imbue the work with great splendour. The work is a perfect combination of elegance and the sensation of pleasure, aesthetics with chromatism, the poses of the figures with subtle provocation.

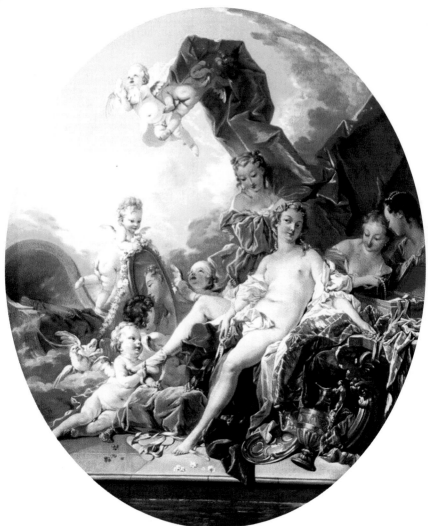

The Toilet of Venus

(1742)
oil on canvas
40.4 x 34.6 in (101 x 86.7 cm)
Hermitage Museum,
Saint Petersburg

If there is one thing that characterizes Boucher, it is the sensual treatment with which he renders the female nude. His Baroque style is apparent in the emotional and intensely erotic subject matter of his oeuvre, whose scenes are filled with color and characters in the most diverse poses.

Among his mythological representations, Venus is a subject that frequently crops up in his work. Owing to its piquant nature and with the pretext of painting a nude, *The Toilet of Venus* was a popular motif among 18th-century painters. The canvas shows a frivolous, nonchalant scene full of erotic details. It constitutes part of a diptych along with The *Triumph of Venus* (see previous page), combining a series of highly interesting visual details.

The nude of Venus, placed in a mysterious environment, is represented in the company of cherubs waiting on her. She is reclining on a luxurious couch covered with drapery, against a sensual fantasy background, far removed in its erotic connotations from earlier mythological representations.

Here, the goddess, her cheeks red with rouge, haughtily gazes at the viewer with her legs provocatively apart. Boucher has gently modeled her skin, so that her anatomy is portrayed in all its magnificence. The Baroque canon, with its search for the grandeur of the flesh, is no longer used here, although certain aspects such as small breasts continued to be attractive until the 20th century. With this type of painting Boucher, along with Watteau, becomes one of the leading exponents of the suggestive *fêtes galantes* painting of the Rococo period.

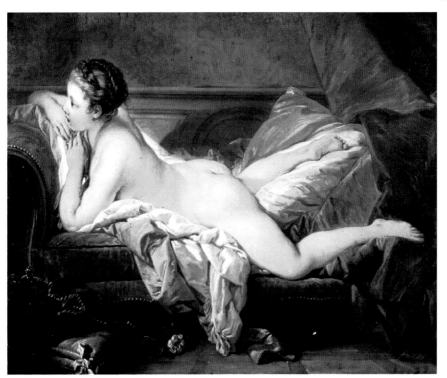

This is no classical Venus; rather Boucher painted a por-
trait of Louise O'Murphy, a young Irish woman who
worked as a model for the artist and in 1753 became
Louis XVth's lover. The woman is posing in an obviously
libidinous position, with her legs apart and her abdomen
pressed against the luxurious white pillow. The painter
plays with a certain ambiguity here in order to heighten
the eroticism by making the young woman's pose appear
to be innocent relaxation.

Resting Girl

(1752)
oil on canvas
23.6 x 29 in (59 x 73 cm)
Alte Pinakothek, Munich

On the one hand, the young woman is innocent and naive, her skin smooth and delicate; she
appears relaxed and happy. On the other hand, everything has been studied down to the last detail:
each gesture, area of her body, and curve are calculated to seek out the best way of highlighting
the sensuality of this attractive and suggestive nude.

The woman's body, modeled with subtle shadows, reflects a great deal of light and in some
areas her skin glows like mother-of-pearl. These flesh colors recall some of the nudes by Rubens,
with a multitude of tones and hues and greater translucency.

The woman's posture is slightly diagonal, and her gaze suggests that someone has just stepped
into the room. This type of subject matter marks the artist's departure from the usual female
nudes, which are tender and delicate, by artists of his time. He seeks instead to create a high-
intensity eroticism accompanied by subtly piquant undertones. The overt sexuality of this painting
could have received public censure, but instead this painter's artwork had a large following in the
high society of Paris.

The Naiads and Triton

(~1763)
Black and red chalk on paper
11.6 x 18.7 in (29.1 x 46.9 cm)
Louvre, Paris
(Cabinet des Dessins)

Boucher left 10,000 drawings, all of them pictorial, as opposed to decorative, which provide a lively testimony of the artistic spirit of Louis XV. The naiads, daughters of Zeus, were water nymphs who presided over bodies of water. Triton, son of Poseidon and Amphitrite, also lived in the water and participated in the expedition of the Argonauts. The artist includes him in the composition to contrast with the smooth curves of the naiads. Their abundant flesh has been meticulously modeled, over which a soft and caressing light is cast. The style is reminiscent of Correggio. For the main figure, it would seem that the artist drew from a live model in a classical pose, while the two figures on the right were added to provide context. The masterful composition forms a rectangular triangle.

Pan and Selene

(1759)
oil on canvas
13 x 16.6 in
(32.5 x 41.5 cm)
National Gallery,
London

The nymph Selene gave off a magical light that illuminated objects in shadow, for which reason the Romans associated her with the Moon. This work recounts the story of how Pan, in the guise of a lamb, charmed Selene and persuaded her to mount him and to go for a run around the meadow. In exchange the lamb asked her to grant him one wish, which the nymph had to fulfill at the end of the run. Pan then possessed Selene. In this work, Selene does not appear in the least startled by Pan's sudden appearance. Faithful to the mythological account, Boucher represents a radiant Selene, whose light illuminates her surroundings. She is depicted at play with one of the river nymphs, while a corpulent Pan emerges from the undergrowth. Both nymphs are reminiscent of Rubens, although these women are more restrained and authentic. They both convey great sensuality.

Jean-Honoré Fragonard

Self Portrait, *oil on canvas, 24 x 18 in (60 x 45 cm), not dated ;18th century, Louvre Museum Deposit, Paris.*

A student of Jean-Siméon Chardin, Carle van Loo, and François Boucher, this artist began painting primarily historical subjects, but then moved on to so-called *fêtes galantes* in 1767. Along with Watteau and Boucher, he is considered one of the most important French painters in this genre, although Fragonard was more openly concerned with frivolous and highly erotic subjects. These are the works that made him famous —works with which he felt comfortable and that reveal his great skill as an artist. They are full of charm and poetry, varied and expressive, with a loose, vibrant brushstroke announcing the Impressionist movement, which was to develop in the second half of the 19th-century.

Fragonard is spiritual and imaginative, a master at unveiling the female body just as far as necessary (through the pose, point of view, situation, atmosphere, profile, and imagination) to show its most charming aspect. His female figures are delicate, attractive, and captivating. The caressing light he creates and the velveteen brushstrokes he applies provide a standard for later generations of painters, particularly Renoir.

His principal clients were bourgeois families, although there were also some famous people from the upper classes, such as Madame de Pompadour and Madame du Barry.

Fragonard, highly influential in the 19th-century, is the last artist of the French *fêtes galantes* painting movement. As stated, his work provided an important basis for the future development of Impressionism.

- **1732** Born in Grasse, Provence, on April 5.

- **1748** His father goes bankrupt and he becomes employed as a clerk to a notary, who convinces the young man's father to let him follow his heart and become a painter. He is introduced to François Boucher, then at the height of his fame, who directs him to Chardin's studio. However, Boucher leaves an lasting impression on his future work.

- **1752** Not yet a member of the Académie Royale, he receives the Rome Award for his *Jeroboam Sacrificing to the Idols* (École des Beaux-Arts, Paris).

- **1756** After being taught by Carle van Loo at the Academy school, he is admitted as a student to the Académie Royale. He is fascinated by the artwork of Rubens, Rembrandt, and Frans Hals. Moves to Rome and enters the Villa Mancini (an art school owned by the Académie Royale). There he is under the tutelage of the painter Natoire, and meets Hubert Robert, with whom he works on landscapes, and the abbot, Jean-Claude de St.-Non, who becomes his patron.

- **1761** After returning to Paris, travels to Naples, Bologna, and Venice.

- **1765** Paints *Corésus and Callirhoé* (Louvre, Paris), which is a great success.

- **1767** Participates in the Paris Salon with two paintings. Tired of working for the government, which is lax in paying, he leaves behind historical subjects and dedicates himself to scenes of gallantry and love, more to the liking of certain primarily bourgeois clients, who are much better at paying.

- **1769** Marries his student Marie-Anne Gérard, to whom two children are born. Their relationship enters a difficult period due to his reputed affair with his sister-in-law, whom he finds more beautiful and spiritual.

- **1773** Travels to Italy, accompanying the financier Bergeret de Grandcourt.

- **1793** Despite the protection of Jacques-Louis David, the French Revolution interrupts his work and he has to flee Paris to take refuge in Grasse, where he remains until the beginning of the next century. Several years later, the Assemblée Nationale appoints him curator of the Louvre.

- **1806** Dies in Paris on August 2, in obscurity.

The Bathers

(~1756)
oil on canvas
25.6 x 32.4 in (64 x 81 cm)
Louvre, Paris

This is a festive, sensual scene, permeated by a warm, lush atmosphere. On first sight, it appears to represent a mythological scene with nymphs, but it actually depicts a sensual game among young women. Although Boucher's influence is evident, certain characteristics and details of this composition recall works by Rubens: the fullness of the bodies, the vibration of the nudes in movement, and, above all, the integration of the colors of the environment with those of the subjects. Fragonard's thick, spontaneous brushtrokes allow the dense surroundings to intermingle harmoniously with the gradations of flesh, so that the nudity of the figures is more suggestive. He creates a sculptural volume through the contrasts between lights and shadows. In half-light, the volumes are generous, whereas in more-illuminated areas, the skin appears nearly flat.

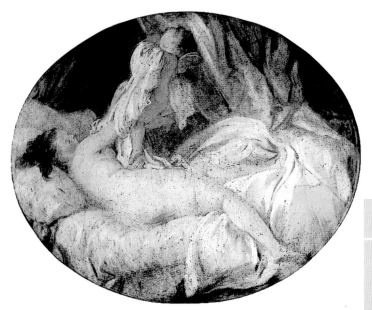

The Stolen Nightgown

(1767-1772)
oil on canvas
14 x 17 in
(35 x 42.5 cm)
Louvre, Paris

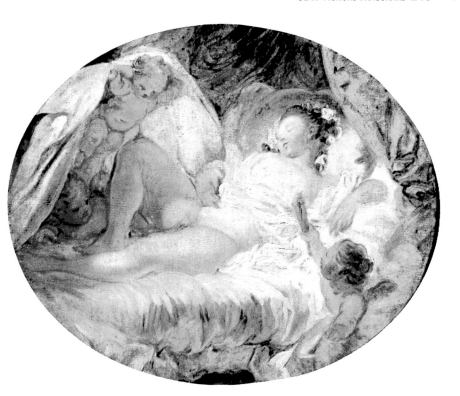

Fragonard consolidated the genre of *fêtes galantes* begun by Watteau and Boucher. After spending some time painting landscapes and sketches of Roman villas, he turned his attention to historical themes, which brought him fame but not money, as the commissions were mostly for government institutions that were always reluctant to pay. He therefore gradually stopped painting in that genre and, especially after 1767, began representing erotic, decorative scenes very much to the liking of the society at the time, who proved to be loyal, paying clients.

Dream of Love

(1768)
oil on canvas
Louvre, Paris

With the onset of the French Revolution, he went bankrupt and, though he was granted a post as curator of the Louvre through the intercession of Jacques-Louis David, he eventually fell into total obscurity. Nevertheless, a great deal of his work survives and is considered the epitome of sensuality, eroticism, and good taste.

This canvas represents several nude cherubs flanking a beautiful young woman who is in a deep slumber on her bed, legs apart, and female attributes uncovered. The woman's body is in acute foreshortening, and the luminous, vibrant brushstroke causes her forms to nearly integrate with the warm surroundings. The light, color, and treatment are highly refined. It lies somewhere between sensuality and poetry, suggestion and realism, and desire and provocation. In any case, a series of elements is superbly combined: the woman's nude body and apparent lack of concern, her abandon, the suggestive and provocative pose, the duality of the cherubs, who embody both innocence and mischief, and the atmosphere of dreamy fantasy. Its ambiguity and sultriness make it a refined yet incisive example of sensuality and lubricity, much to the liking of certain sectors of French society of that time.

This painting has been interpreted as an intimate scene between Venus and Cupid, playing a game that reveals the nude figure of a beautiful woman whose nightgown has just been removed, though others simply see a cherub mischievously undressing a young woman to reveal her anatomy. The brushstroke is loose and daring, and the drawing almost completely disappears, giving way to a misty atmosphere that moves the viewer to become a voyeur. The figure is so brightly lit that it is hardly modeled, with slightly ruddy tones on the cheeks and buttocks. The scene is permeated by the sensuality with which Fragonard's predecessors treated the nude, and is centered on almost purely decorative aspects, though the anatomy is treated so subtly that it nearly integrates with the sheets on the bed.

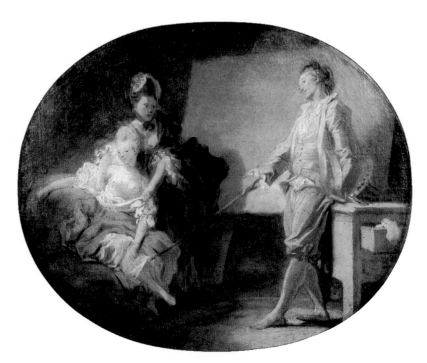

The Model's Debut

oil on canvas
20 x 25 in (50 x 63 cm)
Institut de France, Musée
Jacquemart-André, Paris

One of the most witty subjects in painting is the representation of a model who is embarrassed to be seen, making the viewer a voyeur. In this composition, the situation is brought to the height of refinement, with a young model revealing her body for the first time before the artist. The transgression of her modesty makes the scene more erotic than if the figure were simply entirely nude. Rococo is evident here in details such as the oval shape of the painting and the sumptuous attire. The young woman has a whitish complexion with flushed cheeks. Her firm, round breasts form a diagonal that intersects the line created by the artist's arm in the center of the composition, enhancing the visual importance of the nude within the whole.

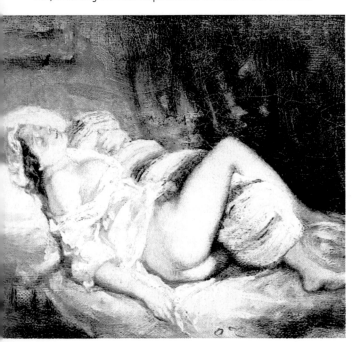

Dream of Love

(1768)
oil on canvas
Louvre, Paris

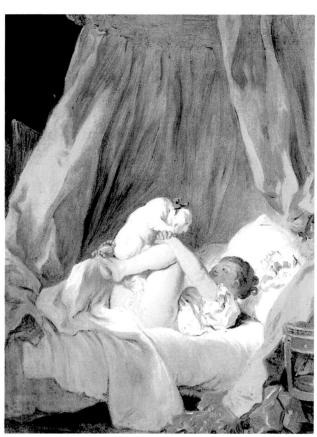

Curling Up

(1770)
oil on canvas
Louvre, Paris

Eroticism becomes more incisive the more meticulously the subject is executed, more disturbing and suggestive the more ambiguous the rendering, and more provocative the more apparently innocent the scene. For this reason, erotic scenes often mix sensuality with other, everyday ingredients, full of candor and innocence. They combine superficial appearance with an underlying reality to create a contrast and increase the intensity of the effect sought.

In this composition, the brushstroke is not as energetic as in other works by the artist, and the treatment approaches Boucher's, in both the execution of shadows and definition of the figure, helping to create the appropriate atmosphere. The young woman is apparently innocent, yet wholly uninhibited in her nudity, accentuated by the fact that the nightgown casually reveals one of her firm breasts. She absentmindedly lifts up her legs, revealing her pubic area and showing a delicate body with a luminous complexion and striking highlights on her tender, terse skin. She is holding an inoffensive, playful lap dog on her legs that, as it wags its tail, unconsciously caresses the young woman's pubic area in a lewd motion. She is not irritated in the least, but, on the contrary, seems to enjoy it.

These details are full of charm and poetry, and comprise intentional erotic insinuations through which the artist increases the sultriness of the scene and incites the viewer in a mischievous yet subtle manner. The treatment of the light and color contributes to this, with a myriad of details regarding the light, color, and general atmosphere. Although the scene may represent a real, everyday episode, it is more like a dream, an erotic fantasy imagined a thousand times and clearly represented here.

Unconcerned by the fact that someone might see her, a young woman reclining on her bed abandons herself to her dreams and gives free rein to her passion. As if it were her lover, she strongly embraces a pillow, with one end tucked between her legs. Her body is firm, with modeled, rounded, and voluptuous forms. Fragonard's style changes throughout the work, with a vibrant brushstroke that blurs forms in some places, and a deliberate style in others, meticulously defining each detail. Here the artist opted for a pictorial treatment approaching Rembrandt's, accentuating the presence of the figure through the dark background. The outlines become blurred and the nude nearly fuses with the golden surroundings, filtered by light in an attempt to place greater emphasis on the dreamlike quality of the episode.

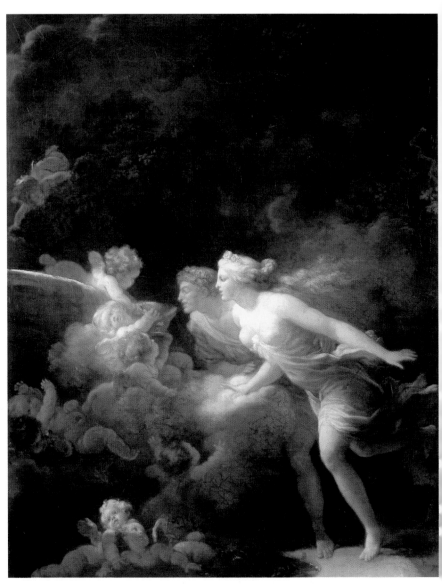

The Fountain of Love

(~1785)
oil on canvas
25.6 x 22.4 in (64 x 56 cm)
Wallace Collection, London

A man and woman avidly present themselves before several cherubs on a bed of clouds, who offer them the elixir of love. The young, slender figures, sensual and dynamic, are surrounded by an ethereal atmosphere suffused in a warm, golden light that unifies the scene and provides chromatic harmony. The representation lies somewhere between a mythological vision and dream, clearly conveying charm and poetry, as well as refined and elegant sensuality.

The technique used, though decisive and masterful, is strict and contained, lacking the freedom and looseness of other works that the Impressionists would find so interesting years later. In some aspects, this work is like a synthesis of Fragonard's artistic trajectory. Certain elements and the treatment recall the mythological or allegorical representations esteemed by Roman artists of the time, but combined with the sensibility, poetry, and refined eroticism of the French taste that was so admired by the public. However, Fragonard expresses them here in a much more subtle fashion, as composition and movement take precedence over suggestiveness and provocation, and formal aspects over psychological content. This is a symbolic vision rather than an erotic scene. Perhaps with a certain degree of exaggeration, some consider Fragonard's oeuvre a poetic expression of the entire Western cultural tradition.

FRANCISCO DE GOYA

Self-portrait with Backlighting *(detail)*, oil on canvas, 17 x 11 in (42 x 28 cm), 1775-1780, Royal Academy of San Fernando, Madrid *(Conde de Villagonzalo Collection)*.

Francisco de Goya y Lucientes was a painter with an extraordinary personality, a strong character, and an enormous range in subject matter (he produced religious and historical works, portraits, genre scenes, and his "black paintings"; (see p. 253), techniques, and media (oil, engraving, and etching), demonstrating great mastery and originality in everything he did.

His personal style was characterized by so loose a brushstroke, demonstrating a freedom the duty of accurate description had never before seen. Along with a superb treatment of color and highly expressive realism,this made it difficult to classify him among the stylistic movements of his time. Indeed, his artwork was a prelude to modern European art, namely, to future trends as wide and varied as Romanticism, Realism, Impressionism, Expressionism, and Surrealism. Goya, whose art always reflected the people close to him and the environments in which he lived, can justly be considered one of the most significant figures in the entire history of art.

At one time, he was the official painter par excellence, but this did not prevent him from being admired by the general population because of his mastery at portraying people, adversity, and everyday life.

His artwork did not give rise to a school, but he did have many followers: Eugenio Lucas, Leonardo Alenza, Felipe Abas Aranda, Antonio Pérez Rubio, Agustí Esteve, Ascensi Juliá, and so on.

- **1746** Born on March 13 in Fuendetodos to the gilder, José Goya.
- **1759** Studies under José Luzán and then in Madrid.
- **1771** Travels to Italy, painting in Rome and Parma. On his return, settles in Saragossa, where he paints a fresco in the Virgen del Pilar Church.
- **1771** Paints a mural with scenes from the life of the Virgin in the Aula Dei Charterhouse.
- **1776** Begins painting a large series of cartoons for the royal tapestry factory.
- **1780** Elected member of the Academy of Bellas Artes for his *Crucifixion* (Prado, Madrid).
- **1784** Appointed director of painting at the Academy.
- **1786** Appointed painter to Charles III. Paints *The Marquesa de Pontejos* (see p. 250).
- **1788** Executes various paintings for the Church of Santa Ana in Valladolid.
- **1789** Shortly after his coronation, Charles IV appoints him Court Painter.
- **1790** Executes various drawings and prints for the Alameda Estate belonging to the Dukes of Osuna.
- **1791** Paints several portraits of members of the royal family, among them, *Charles IV in Hunting Dress* (Palacio Real, Madrid). Paints *Sebastián Martínez* (Metropolitan Museum of Art, New York), one of his best portraits. A nervous affliction causes him to become almost deaf. Moves to Madrid.
- **1797** After he is widowed, Goya lives with the Duchess of Alba in her estate in Sanlúcar de Barrameda. Executes *Los Caprichos,* a collection of 80 etchings on the incongruity of human conduct.
- **1798** Decorates the Chapel of San Antonio de la Florida in Madrid in tempera and fresco.
- **1800** Paints *The Countess of Chinchón, Wife of Godoy* (Duquesa de Sueca Collection) and *The Family of Charles IV* (Prado, Madrid).
- **1803** Paints *The Nude Maja* (see p. 251) and *The Clothed Maja* (Prado, Madrid).
- **1810** Begins the series of etchings called *The Disasters of War.*
- **1814** Paints various works on episodes of the war: *The Second of May, 1808* (Prado, Madrid), and *The Third of May, 1808* (see next page).
- **1814** Paints the series of etchings *Tauromaquia.*
- **1819** Acquires the estate, La Quinta del Sordo, whose walls he decorates with scenes from the period of his "black paintings" (see p. 253).
- **1828** Dies of an attack of apoplexy in Bordeaux, where he had gone into exile in 1824.

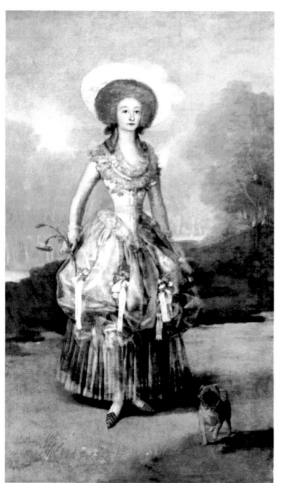

The Marquesa de Pontejos

(1786)
oil on canvas
84 x 50 in (210 x 127 cm)
Mellon Collection,
National Gallery of Art,
Washington, DC

Goya had a preference for the genre of portraits, and this is one of the most famous from his early period. Until his style was fully consolidated, Goya's art was eclectic, adopting different features as needed, which suited his approach to art.

In this portrait, the artist portrays the slender, young, and attractive figure of the marquise as well as her social condition, for which he spares no detail. The hazy landscape in the background and the chromaticism comprise a delicate, romantic setting, very much in a Neoclassical line. The woman exhibits her splendidly smooth skin and an elegant, luxurious, and complex dress, treated with such meticulousness that the woman seems a Rococo courtesan. Goya was highly appreciated for this type of portraiture among the high society of Madrid.

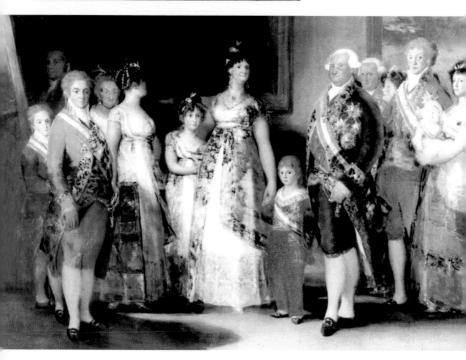

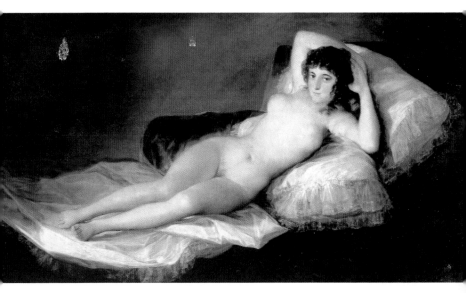

This painting was executed during Goya's second artistic period (1793-1808), along with *The Clothed Maja* (Prado, Madrid). It is believed that the two Maja paintings, showing the woman nude and clothed, were originally hung in the same place, one above the other, with a secret mechanism for switching them, in the mansion of the Duchess of Alba, Goya's friend and lover, in La Moncloa, Madrid. Speculation apart, they appeared in the inventory of the queen's favorite, Chief Minister Godoy, during the confiscation of his property in January of 1808. These canvases led the Inquisition, which had been zealously watching the painter for some time, to open a case against him in 1814, during which he was pronounced innocent.

The Nude Maja

(1803-1806)
oil on canvas
38 x 75 in (95 x 188 cm)
Prado, Madrid

The woman is reclining on a divan with pillows, her hands behind her head to better exhibit her charms. The body is attractive, well modeled, and realistic. The painter chose a posture that would convey the woman's nudity as generous and suggestive without being obscene. He accentuated her position and, above all, her attitude, defiant and provocative. Her nudity is neither innocent nor sublime, as in mythological or allegorical works. Goya was portraying a real woman, not a goddess.

Certain of the attractive qualities of her body, she displays her sensual and seductive potential, with an anatomy of delicate volumes, tempting curves, and smooth skin. The light is cool, and the scene is devoid of poetic attributes appearing in previous nudes, such as silk, flowers, and other details reflecting pleasure as a blessing from heaven. The woman's gaze constitutes a challenge, and the insinuated smile is that of an arrogant, defiant, and lascivious woman, certain of her charms and inviting the viewer.

Through this work, Goya establishes a new concept of the female nude and of male-female relationships. Some consider this to be the first, truly modern nude in the history of art. The model may have been the Duchess of Alba, with whom Goya was deeply in love. Although the artist executed several paintings of her, the identity of the model for this work remains uncertain.

Charles IV and His Family

(1800)
oil on canvas
112 x 134.4 in (280 x 336 cm)
Prado, Madrid

This group portrait was painted in the Palace of Aranjuez. The psychological characterization of each figure is so sharp that it approaches satire. For this same reason, in many of his portraits, the royal family resembles the bourgeoisie, since personality of the family prevails over the demands of protocol common to these types of works. The self-assured technique used by the artist is remarkable, especially in the color scheme, with a wide range of vivid, transparent, and luminous colors fluidly mirroring the tones of his festive genre paintings set in the countryside.

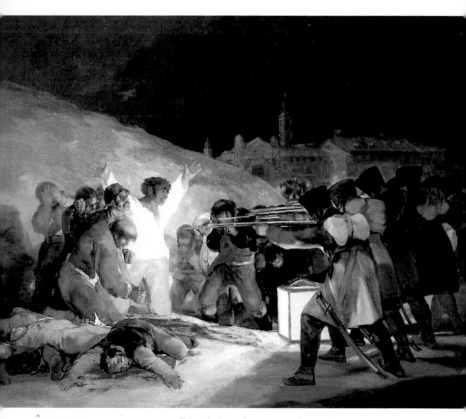

The Third of May, 1808

(1814)
oil on canvas
107 x 139 in (268 x 347 cm)
Prado, Madrid

This painting refers to a popular revolt occurring in Madrid in 1808 against French occupation, which sparked the war against Napoleon. The revolt was a desperate attempt to prevent the Spanish royal family from being taken to France. To control the situation, the French army intensified its activity and reacted with extreme brutality, establishing a military commission in the post office building that sentenced all of those who had been taken prisoner during the revolt to death with no trial and no information whatsoever. The prisoners were executed by firing squads on the nights of May 2 and 3 on Príncipe Pío Mountain and at other locations in Madrid.

During the French occupation, Goya's attitude was somewhat ambiguous. At first, he seemed to side with the French, that is, to collaborate, and he even painted a portrait of Joseph I, but later he clearly sided with the Spanish cause, as is revealed in this painting. He represents the night in a dense, very dark, yet warm tone evoking the heat of war, with buildings visible in the background. Before the firing squad, well drawn in dark tones, though in a schematic manner, several prisoners passionately cry out patriotic slogans in the tense moments before they are shot to death.

The treatment of light clearly illustrates the artist's political views. The eye is directed toward the prisoners, whose illumination, radiant in the figure in a white shirt and yellow pants about to be shot, transforms them into heroes, despite the tragedy of the scene. Their highly expressive gestures and postures vividly display the group's unity and common fate awaiting them. Their last act for the cause and refuge in prayer contribute to their heroic aspect. In order to represent the episode as well as the situation of the figures, Goya uses a loose brushstroke with a studied application of color to define the volumes. The forceful romanticism of this passionate scene increases the drama of the intense action represented.

Goya

**Saturn Devouring
One of His Sons**

(~1819)
oil on canvas
58.4 x 33 in
(146 x 83 cm)
Prado, Madrid

The so-called "black paintings" were painted by Goya on the walls of the house he acquired in 1819 on the outskirts of Madrid, known as La Quinta del Sordo. By 1820 or so, he had already painted the walls of the principal rooms with phantasmagoric scenes, representations of tormented, cruel and horrific figures. At this time, the painter was aging, completely deaf and bitter, most likely affected by the war that had wracked the country for several years.

The paintings of this period, with a strong Expressionist character, were executed in a dark palette, with whites, blacks, and an abundance of brown tones, reflecting his profound pessimism and critical view of life. This scene, representing the myth of Saturn, is one of the most appalling of his black paintings. Saturn, an ancient Roman divinity identified with the nocturnal sun, is avidly devouring one of his sons. Saturn symbolizes time, which consumes all that it creates.

The nudes are executed quickly and loosely, with a strong Expressionism (simply observe Saturn's terrifying face), far advanced for his time and presaging what would develop into one of the principal pictorial movements in Europe after World War II. The deformation of Saturn's body is executed through strong contrasts, in which only the points of light allow his anatomy to be perceived.

Two Old Men Eating

(~1825)
oil on canvas
21 x 34 in (53 x 85 cm)
Prado, Madrid

Goya pictorial register was great, and he never stopped developing it even in his final years, the period to which this work belongs. With extreme economy of means, the artist achieves a singularly fascinating work focused on the faces of these two marginalized, destitute, elderly figures that seek relief from hunger. The background is wholly black, the brushstrokes aggressive and thick throughout, defining the facial features and hands as well. In keeping with the condition of both figures, dark tones predominate, which, combined with the pose, framing, and attitude of the figures, lend the work a great drama. In this outstanding eclectic work, the Impressionist technique—the use of light and color to emphasize the brushstroke—is superbly combined with an Expressionist conception—the use of whatever resources can illustrate the internal state and environment of the person represented.

Juan Bautista de Muguiro

(1827)
oil on canvas
41 x 33.6 in (103 x 84 cm)
Prado, Madrid

In the year 1823, Spain became an absolutist state, giving rise to a series of repressive actions that brought about a hostile, uneasy social situation. This moved Goya to exile himself to France in 1824, using the safe-conduct he obtained. After a brief period in Paris, he settled in Bordeaux, where he painted this portrait of his friend, who had voluntarily gone into exile there as well. Despite his 82 years of age and his many ailments, this portrait, one of his last works, demonstrates the degree to which Goya had polished his technique and the fluidity with which he portrayed the figure. Serenely seated before his desk in a distinguished pose, he is painted against a dark, greenish background. The dark tones of the painting focus attention on the sitter's well-drawn, expressive face.

JACQUES-LOUIS DAVID

Self-portrait, *oil on canvas, 32.4 x 25.6 in (81 x 64 cm), 1794, Louvre, Paris.*

David lived in a time of great political upheaval in France that directly affected him and in which he was fully involved, determining the subject matter of many of his works, as well as their meaning and objective. Nonetheless, he managed to adapt himself to the constantly changing circumstances. Hence, under the monarchy, he painted members of the royal family; during the Republic, he painted revolutionaries; and, during the Empire, he executed portraits of Napoleon.

According to the artist himself, his works attempt to reflect the most attractive and perfect forms of nature, with an underlying moralizing message.

Despite the solemnity and thoroughness with which he previously studied his works, he avoids theatricality, seeking meticulousness in everything and the ideal canon of beauty for his figures, which he borrows from the classical art of antiquity that had always attracted him. His work is formally punctilious, with a measured treatment of light and color. The results are conceptually flawless paintings, both in the manner of combining elements and resources, and in achieving a myriad of effects through a characteristic sobriety.

David's art gave rise to the French Neoclassical School, of which he was the ultimate exponent. His works were a prelude to romanticism as well, evident in his interpretation of the figures and the delicate color scheme he applies.

- **1748** Born in Paris to a lower middle-class family. He is maternally related to the painter, François Boucher, thanks to whom he studies under the classicist painter, Joseph-Marie Vien.

- **1774** Obtains the Prix de Rome and lives in Rome until 1780, executing various drawings. He is influenced by Bolognese artists and later, following archaeological excavations of Pompeii and Herculaneum, becomes interested in classical Greek and Roman art.

- **1781** Returns to Paris and participates in the Salon with his work, *The Funeral of Patroclus* (Louvre, Paris), depicting over 300 figures.

- **1784** Appointed as painter of the Académie Royal.

- **1785** Participates in the Paris Salon with *The Oath of the Horatii* (Louvre, Paris), presented in Rome the previous year as well, with a tendency toward Poussin's style, achieving great success. Paints *The Death of Socrates* (Metropolitan Museum of Art, New York), for which he receives acclamation at the Salon of 1787.

- **1789** His painting *Brutus and His Children* (see next page), a clearly Neoclassical work, is interpreted by the revolutionaries as a commitment to their cause. Under the new regime, he gets involved in the Revolution, becoming the President of the National Convention and the Public Health Committee, a member of the Jacobin Club, and General Inspector of Fine Arts, and votes in favor of the execution of Louis XVI.

- **1790** The National Assembly commissions *The Tennis Court Oath* (Musée National du Château de Versailles), an episode that was considered to be the origin of the new regime. He is unable to finish it, since many of the figures portrayed are later persecuted and guillotined for their political ideas.

- **1793** Paints several works in homage of victims of the Revolution, such as *The Death of Marat* (see p. 257) and *The Death of Joseph Bara* (Musée Calvet, Avignon), painted the following year.

- **1799** Completes *Intervention of the Sabine Women* (see p. 258), his masterpiece.

- **1801** An admirer of Napoleon Bonaparte, he paints the romantic work *Bonaparte Crossing the Alps at Mont St. Bernard* (Musée National du Château de Versailles).

- **1804** Appointed painter to the First Consul, Napoleon, who, the following year, commissions *Sacré, or Coronation of the Empress Josephine* (Louvre, Paris), and appointed him Knight of the Legion of Honor.

- **1815** With the fall of Napoleon goes into exile in Brussels, never returning to France.

- **1825** Dies in Brussels.

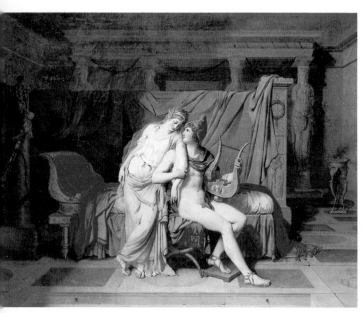

Paris and Helen

(1789)
oil on canvas
57.6 x 69.6 in
(144 x 174 cm)
Musée des Arts
Décoratifs, Paris

Paris awarded Venus the Apple of Discord for her beauty, in exchange for which she promised him the love of Helen of Troy. Paris thus abducted Helen and took her to Troy, upon which her husband Menelaus declared war on that city. Following the same criteria as in other works, David represents a static scene with only the necessary figures, well drawn and defined, in a classical humanist style. David's nudes have the stylized, ideal proportions of the ancient classical canons of beauty. This work reveals the characteristics of the incipient Neoclassical school and was a success at the 1789 Paris Salon.

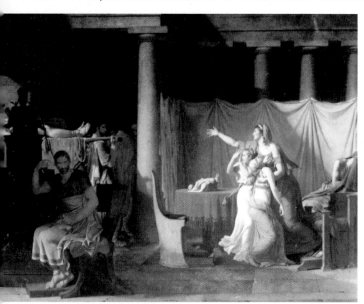

Brutus and His Children

(1789)
oil on canvas
129 x 169 in
(323 x 422 cm)
Louvre, Paris

David lived in an era of profound social and political upheaval in France. The execution of this painting coincided with the advent of the new regime. The subject matter and its warm reception at the Paris Salon that year made it a rallying cry for the Revolution. The scene represents an interior, with Lucius Junius Brutus, founder of the Roman Republic, and his wife, embracing two of their children while the corpse of a third is brought in, having suffered capital punishment for conspiring to overthrow his father and establish a monarchy. Despite the overall meticulousness, the great care in the figures' anatomy, the treatment of light, and the expression of the spouses (the gesture of desperation of the woman, brilliantly illuminated, in juxtaposition to the unconcerned attitude of Brutus, in the half-light), the painting is somber and contained.

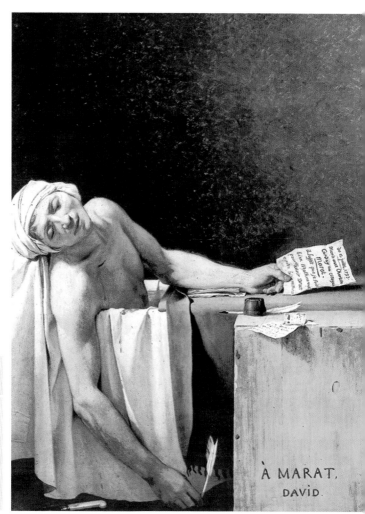

The Death of Marat

(1793)
oil on canvas
66 x 51 in
(165 x 128 cm)
Musées Royaux
des Beaux-Arts,
Brussels

A legendary figure of the French Revolution at his death, Jean-Paul Marat, a friend of David's, had been a fervent champion of radical republican patriotism and an inspiring orator. He was a member of the Committee on Public Safety in the Parisian Commune, one of those responsible for the massacres of August 10 and September of 1792.

A skin disease forced him to spend long hours in therapeutic baths. He even worked and received visitors in this improvised office. Marie Charlotte Corday stabbed him in 1793 while visiting him at his bath. She was a monarchist and fervent follower of the Gironde Party, against which Marat had fought until it had been disbanded in June. Represented here just after his assassination, the politician's arm falls heavily to the ground while still gripping a quill. In the other hand he holds the letter that the assassin had used as an excuse to see him. It reads: "July 13, 1793. From Marie Anne Charlotte Corday to citizen Marat. In view of my terrible misfortunes, I would request your kindness...."

David was wholeheartedly involved in politics for a time, upholding the ideals of the French Revolution. At first, he held several positions and was responsible for many of the events of that time, but later he was imprisoned. When he was set free, he dedicated himself exclusively to art. He painted various canvases related to episodes of the Revolution, at times heroic, other times tragic, such as the assassination of Marat.

This work, with a nearly sacred air, exhibits a dramatic nude with severe modeling arising from the intense source of light from the left. The entire upper half of the painting is empty and dark, creating a dense atmosphere of silence very appropriate to the austere solemnity called for by the subject. The illuminated body of the figure stands out against the background, and the precise definition of his profile makes the scene more realistic. This tragic-heroic work exalts the figure of the revolutionary, imbued with profound sentiment, measured simplicity, and evocative asceticism. One of David's most important paintings, it was considered the leading exponent of the revolutionary cause in its time.

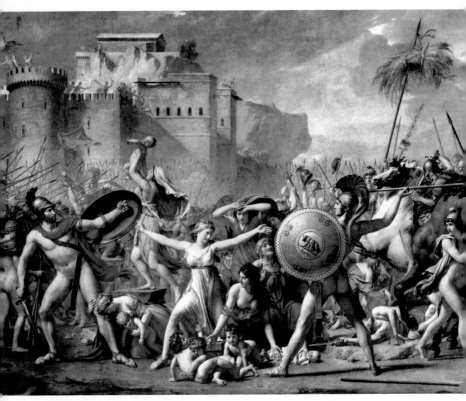

Intervention of the Sabine Women

(1799)
oil on canvas
154 x 209 in
(385 x 522 cm)
Louvre, Paris

This classical subject was an ambitious project, which led David to the height of fame and made him the undisputed leader of the French School. After founding Rome, with the intention of populating the new city, Romulus sent messengers to the king of the Sabines, asking for women as wives for his people and proposing to establish an alliance between the two cities. When the king rejected his proposal, Romulus came up with a ruse to achieve his objective.

During the festival of the Corsican god, attended by a multitude of people from neighboring cities, his men abducted the many Sabine women there and granted them to his subjects to be possessed and bear children. Naturally, this gave rise to a war between the cities. Tatius, King of Cures, attacked the Romans and entered the city to inflict a terrible punishment, but the Sabine women who had been abducted came out to stop them, as they were now the wives of the Romans, with whom they had had children. Thanks to them, peace was made.

The painting, which caused an enormous sensation at the time, represents the heat of the battle before the ramparts of Rome, with the Sabine women between the two parties attempting to separate the combatants and exhibiting their children, which are of the blood of both peoples. The painting is spectacular and well constructed, with dramatic poses and gestures, and an excellent treatment of light and color. Curiously, despite the force and intensity of the action, the artist is cool and distant, lending the painting a journalistic air of crude reality. The sensual nude anatomies, well-proportioned and modeled, enhance the force of this stylistically perfect scene, recalling certain bas-reliefs of classical antiquity.

This painting was executed in Brussels, where David had gone into self-imposed exile in 1815 after Napoleon's downfall, in order to avoid having to beg Louis XVIII's pardon for his political past. There, he began painting scenes inspired by classical mythology and literature, as in this work, representing Venus and her husband, with Cupid tying one of his legs, in the presence of the Three Graces. The painting combines architecture with the human figure in its purest expression, that is, nude. David attempts to approximate Greek classical art, on which he bases the aesthetic, rhythm, and color balance. Above and beyond the sensuality he attains through the colors, ethereal atmosphere, clouds, and the attractive physique of the nudes, the artist sought an ideological objective, consisting of expressing a spiritual conviction or proclaiming the excellence of specific artistic criteria.

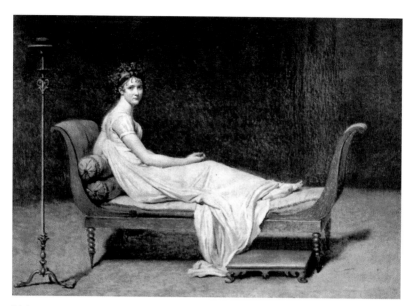

Of the many classical portraits executed by David, perhaps this is the most renowned. Juliette Récamier was a lady whose attractive physique, elegance, good taste, and glamour made her so famous that her unique style became a model that all women of Parisian high society strove to imitate. In this portrait, she is 23 years old. The coldness of David's historical paintings wholly disappears in his portraiture, in which he renders the sitters carefully and meticulously. In addition to the excellent treatment of the face, the general sobriety, the young woman's natural air, bereft of arrogance, the elegance of the pose, and the graceful dress in masterful modeling of grays, make the painting a lovely example of delicacy, elegance, and distinction.

Madame Récamier

(1800)
oil on canvas
68 x 96 in
(170 x 240 cm)
Louvre, Paris

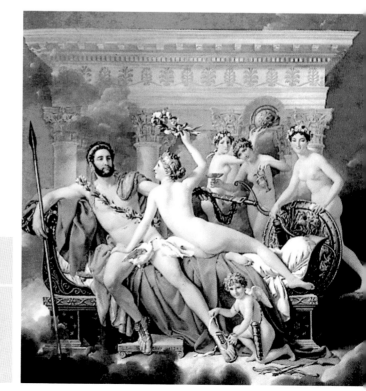

Mars Disarmed by Venus Before the Three Graces

(1824)
oil on canvas
123 x 104.8 in
(308 x 262 cm)
Musées Royaux des Beaux-Arts, Brussels

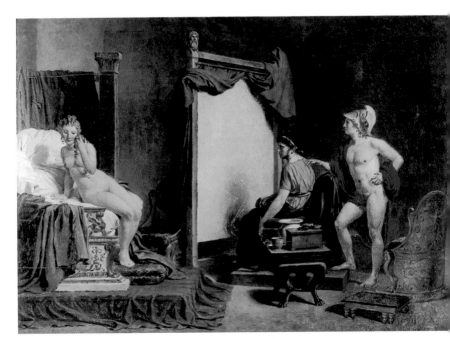

Apelles Painting Campaspe Before Alexander

(1812-1813)
oil on wood
38.4 x 54.4 in (96 x 136 cm)
Musées Royaux des Beaux-Arts, Brussels

One of the first texts referring to the presence of Campaspe in Apelles' studio were the chronicles of the Roman historian Pliny, in which he recounts that Alexander the Great, to demonstrate his esteem and admiration for his personal painter Apelles, offered him his wife Campaspe as a nude model. Captivated by her beauty, the artist fell in love with her. Alexander eventually realized his error in placing his wife in the painter's hands without considering their human condition.

This subject, lying somewhere between history and legend, allows the artist to paint two magnificent nudes and to create an emotive and sensual scene. For this reason, it is a relatively common theme in painting. Here, the sentiments of each person are portrayed, as well as the curious relationship existing between them. Campaspe, aware that her charm and power of seduction have affected the artist, blushes and poses in embarrassment, thrilled at being desired yet reserved. The artist absently sits before a large canvas, engrossed by the disturbing beauty of the woman and forgetting the work at hand. Alexander, still unaware of what is happening, attentively gazes at his wife.

In keeping with his characteristic style, David creates a classicist scene of great sobriety in the figures (only the essential figures are portrayed), the stage set (the furniture, curtains, and remaining objects are minimal), and the skillful use of the elements in general. Against a background of predominantly dark tones, the three figures reveal perfect, sculptural, and well-proportioned anatomies with exquisite draftsmanship and modeling, a faithful reflection of the artist's interest in Greek and Roman classical art. The extreme sensuality of the nudes is heightened by the treatment of light and color. These qualities and the sultriness inherent to the subject matter make the work highly erotic despite its sobriety. This type of painting found a warm reception among a large sector of French high society.

DAVID

ÉLISABETH VIGÉE-LEBRUN

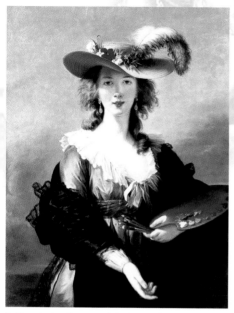

Self-portrait, *oil on panel, 25.6 x 17.4 in (64 x 43.5 cm), 1782, Private Collection.*

Marie-Louise-Élisabeth Vigée-Lebrun was an important portraitist of the French Rococo period. From her work, we can see the style of the *ancien régime*, and the spirit and taste of the late 18th century, which sought a return to antiquity.

Vigée-Lebrun's finest portraits exhibited her great skill in capturing the inner world of the sitter in a warm, candid treatment. This brought her many commissions from the nobility, including Queen Marie-Antoinette herself, whom she painted on a multitude of occasions and at whose side she remained during the difficult times of the Revolution.

Her connections with the nobility and her opposition to the revolutionary cause led to her exile in 1789, and brought her the disdain of the reformists, who accused her of painting bourgeois art and trying to gain favor with those in power.

In exile, she continued to paint portraits of European aristocracy and always had more commissions than she could fill. Abroad she gained the recognition that the French public denied her, though she returned to her country after the fall of Napoleon.

Vigée-Lebrun's natural and candid works are imbued with an expressiveness and sensibility that goes far beyond social conventions toward a characteristically personal atmosphere that lies at the heart of the French Rococo.

- **1755** Born in Paris on April 16 to the portraitist Louis Vigée and the hairdresser Jeanne Maissin.

- **1760** Enters the boarding school of the Trinity Convent, where she demonstrates a talent for the arts, especially drawing.

- **1767** Takes drawing classes from her father at his studio after definitively leaving boarding school and returning home.

- **1770** Establishes herself as a professional portraitist.

- **1774** Because she has no title as an artist, Chatenet officials order her to close her studio. She decides to become a member of the Academy of St. Luke. In September, she exhibits her first works as a member of the Academy.

- **1776** Marries Jean Baptiste Pierre Lebrun, a painter and art collector. Commissioned to paint several portraits of Louis XVI's brother.

- **1781** Exhibits for three years at the Salon de la Correspondance. Travels to Flanders and the Netherlands with her husband.

- **1783** Exhibits for the first time at the Royal Academy Salon.

- **1789** Leaves France due to the revolutionary events occurring in Paris and travels to Italy. Frequents antirevolutionary, aristocratic circles in Rome.

- **1794** Leaves Rome and returns to Paris. Having been blacklisted, she loses all of her rights as a citizen. The revolutionary government confiscates her property. She gets divorced.

- **1800** Appointed member of the Academy of Fine Arts of St. Petersburg.

- **1802** Returns to Paris and resides in the hotel she owns.

- **1807** Executes a portrait of Napoleon's sister. Visits Switzerland.

- **1820** Her sister Caroline moves in with her.

- **1842** Dies in Paris, probably from arteriosclerosis. Buried at the Louveciennes Cemetery.

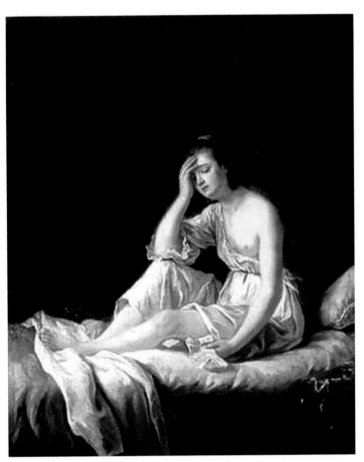

Irresolute Virtue

(1775)
oil on canvas
19 x 15 in (48.3 x 38 cm)
Private collection,
Hôtel Drouot, Paris

Vigée-Lebrun painted this work when she was only 20 years old. The partially nude young woman seated on the bed in a pensive pose could refer to youth or virginity, or both at once. In any case, sensuality and delicacy imbue both the figure, which exudes charm and candor, and the relaxed, sober atmosphere. The style is typical of the *ancien régime*, with its realism, meticulousness, as well as the details.

Although the painting is neither signed nor dated, there is no doubt as to its authorship, as the style and general character of the work are typical of Vigée-Lebrun. As she did throughout her career, the artist uses a short, meticulous brushstroke, applies her great powers of observation, and finishes each area, small though it may be, with exquisite attention to detail. The warmth of the colors, the intimacy of the figure and the pose give the impression of a young, inexperienced woman waiting for the man who will love her. The falling shoulder of the dress revealing one breast recalls mythological representations, tending to idealize the figure, which suits this interpretation. The painting is a paragon of naturalism, candidness, and refined eroticism. Despite her youth, the artist allows a glimpse of her future style and manner of treating the human figure. She never strayed from this line.

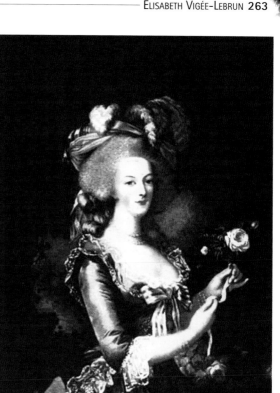

Marie-Antoinette of Austria was the wife of Louis XVI of France. A woman of strong political influence, she was accused of making the interests of Austria prevail over those of France. Her reputation of spending recklessly and her opposition to anything that sounded like reform made her deeply unpopular among the populace.

Marie-Antoinette

(1783)
oil on canvas
45.8 x 35.2 in (114.5 x 88 cm)
Musée National de Versailles et des Trianons

During the Revolution, she opposed the demands for sweeping institutional and social changes, which led to the deposition of the king, her imprisonment in 1792, and her execution a year later. Because Vigée-Lebrun had painted 30 or so portraits of the queen, she was granted various privileges from the royal family, for which she was accused of taking the side of the monarchy and turning her back on the revolutionary cause.

In this portrait, the queen is represented as a young, attractive, and elegant woman with a great deal of class. Although the image is dignified and delicate both in conception and treatment, the figure is not distant and inaccessible. The portrait has an air of intimacy. Adorned as befits a queen, her human qualities nonetheless come to the fore. This proximity is enhanced by the rose she is holding, a dignified symbol that, in the hands of the queen, becomes an expression of her humanity, of her condition as a woman despite her stately position. The painting has all of the qualities characteristic of Vigée-Lebrun.

Peace Leads to Abundance

(1780)
oil on canvas
41 x 53 in
(102.5 x 132.5 cm)
Louvre, Paris

This work was painted at a time when Vigée-Lebrun longed to become a member of the Royal Academy, but her membership was opposed by its director, Jean-Baptiste-Marie Pierre. Nevertheless, she was received into the Academy in 1783 thanks to the personal intervention of Queen Marie-Antoinette. Probably to gain acceptance, the artist began a series of mythological and allegorical works such as this one, in which she used an unusual format. Given the situation of the country, the artist emits a clear political message: where peace reigns, abundance prospers. The iconography is typical and the artist gave it the treatment that she usually employed in her portraits, especially those with allegorical or mythological connotations.

Julie Lebrun as Flora

(~1799)
oil on canvas
52 x 39 in (130.5 x 98 cm)
Museum of Fine Arts,
St. Petersburg, Florida

This is a portrait of the artist's daughter at age 19. It was painted in St. Petersburg, Russia, shortly before Julie got married to Gaetan Bernard Nigris. Vigée-Lebrun based this work on another she had painted earlier for Princess Eudocia Ivanova Galitzia (*Eudocia Ivanova Galitzia as Flora,* Hirschl and Adler Gallery, New York).

The sitter is portrayed as the goddess Flora as an allegory of youth and everything that it entails. Evoking a figure from classical mythology—Flora was the Roman goddess of flowers and was usually represented with a wreath of flowers on her head—the painting combines the figure with a landscape in a representation that is somewhat romantic and highly Neoclassical.

The goddess is wearing a softly modeled white dress with delicate folds that is brightly illuminated to focus the viewer's attention and make the figure stand out against the landscape, which, in addition to providing context, lends it a new interpretation. Clearly, the expression on her face, the woman's attitude and her natural air, the symbolism of the attire, and the scarf flapping in the wind contribute to the vitality, dynamism, and hopes of this person, so appropriate to her age. The portrait is an expression of the love and admiration that a mother feels for her children. The remaining elements (facial features, complexion, and technique) demonstrate the fact that Elizabeth was a great master of portraiture.

Princess Luisa Dorothea Filipina Radzwill was born in 1770 and was married at a young age to Prince Anton Heinrich Radzwill. A Russian princess, she was the niece of Frederick the Great and the cousin of Frederick William II.

The Princess Luisa Radzwill Hohenzollern

(1801)
pastel
23.6 x 17 in (59 x 42 cm)
Private collection

This is a beautiful portrait in pastel, which Vigée-Lebrun finished in Berlin. She painted another version in oil the following year. In her works, the artist showed her excellent command of psychology and her great capacity to grasp the character of the people she was representing. The young woman in this pastel portrait reveals her personality, candid and sensual.

Vigée-Lebrun's polished technique, delicate brushwork, and attention to detail were enhanced by the texture of the pastel and the manner in which she applied it. In addition to being a great observer, the artist was meticulous to the extreme and never ignored a single element, insignificant though it might seem. The complexion, hair, gauze around neck, and the texture of the dress; absolutely everything is treated with extreme care, leaving no room for interpretation. The pose is natural and the portrait realistic. Without making the figure sublime, it presents her benevolently, concealing imperfections and avoiding less favorable angles. With these criteria, it is not surprising that the artist was in high demand among the aristocracy. It would be difficult to find someone who could better interpret the wishes of the sitter.

Alpine Festival in Unspunnen

(1808)
oil on canvas
33.6 x 45.6 in (84 x 114 cm)
Kunstmuseum, Bern

For Vigée-Lebrun, who specialized in portraiture, this landscape is a curious, singular work. She creates a scene with three elements—landscape, figure, and genre painting—and manages to combine them perfectly. The landscape is magnificent, with grandiose mountains crowned by a sky full of clouds that enhance the spectacular atmosphere. In this setting, a multitude of minute figures is celebrating a traditional festival.

In the center is a circle of people. Around it and distributed throughout a wide area, people stroll, converse, and enjoy the festival. This homogeneous work combines the beauty of the setting with the festive air of the gathering. The colors employed are warm and the treatment is characteristic of the artist in its great naturalism and attention to detail.

As with various Flemish works from previous centuries, this painting could be divided into various fragments, each of which would constitute an independent work, interesting in and of itself. Although this is a genre she did not normally work with, she would clearly have obtained the same success with landscapes as she did with portraits.

WILLIAM BLAKE

William Blake.

William Blake was a poet, printmaker, and painter, whose pictorial work is characterized by an exuberant imagination and a magnificent capacity to capture a timeless, dreamlike world.

He rebelled against the rationality and material values of the Enlightenment, which made him the first Romantic poet of Britain. Many of his contemporaries considered him crazy, and they even called him Mad Blake because he claimed to have direct contact with the dead and to take astral voyages in a waking state. His work was largely forgotten until the Pre-Raphaelites recognized its value after his death.

Blake developed a pictorial style approaching mysticism and intended to proclaim the supremacy of the spirit, influenced as he was by the Bible, especially by the Old Testament and the Book of Revelation. Evil is a constant element throughout his works and his horrific, disturbing images and phantasmagoric iconography reveal his inner world.

The majority of his engravings were monotypes that were treated with watercolor once printed, making them unique pieces.

He was truly in the vanguard and influenced later generations of artists, including the Art Nouveau and Symbolist movements.

- **1757** Born in London on November 28 to a textile artisan. He went to drawing school at the age of 10.

- **1768** Begins writing poetry.

- **1770** Works as an apprentice to James Basire, an engraver at the Antiquarian School, with the intention of becoming a painter.

- **1773** Studies for a short time at the Royal Academy, but rebels against the aesthetic doctrines of its director.

- **1778** Holds his first exhibit at the Royal Academy.

- **1783** Publishes his first book, called *Poetical Sketches*, in which he reveals the influence of Shakespeare, Chatterton, and popular ballads.

- **1784** Opens a print shop and, although he goes bankrupt after a few years, he continues to earn a living from engraving and illustrating. His wife, Catherine Boucher, helps him to print his illustrated poems.

- **1789** The death of his brother leads him into a profound mystical crisis. He joins the Christian sect of Swedenborg.

- **1790** Publishes one of his most important works, a strange treatise entitled *Marriage of Heaven and Hell*, the first of his prophetic books, with pantheist and sensual overtones.

- **1791-1794** Writes poems about the single idea of liberty, such as *French Revolution, Urizen*, and *Visions of the Daughters of Albion*, works that become a manifesto for the liberty of peoples and individuals.

- **1794** His faith in the possibility of human perfection lost, he publishes *Songs of Experience*, with poems in the same lyric style as previously.

- **1800** Moves to the coastal city of Felpham, where he lives and works for three years under the patronage of William Hayley. Executes profound spiritual explorations that prepare him for his mature works, the great visionary epics he writes and illustrates between 1804 and 1820.

- **1804** Returns to London, where he publishes his *Prophetic Books*, handwritten and hand-illustrated out of necessity, since no publisher would accept it.

- **1805** A retrospective is held on his oeuvre, which is a failure.

- **1827** Dies in London on August 21.

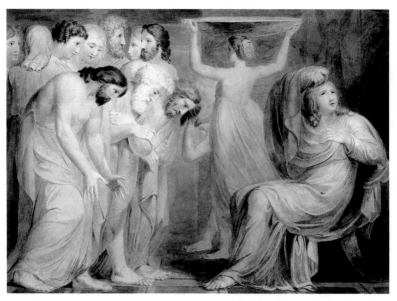

Story of Joseph: Joseph's Brothers Prostrate Themselves Before Him

(~1785)
graphite pencil, nib and black ink,
and watercolor on vitela paper
16 x 22.5 in (40.3 x 56.2 cm)
The Fitzwilliam Museum, Cambridge

The iconography of this painting diverges greatly from the usual Christian interpretation. Blake imposes his own ideas and images, which he held had been revealed to him in dreams. The biblical scene is represented symbolically. Although the artist bases the work on the Holy Scriptures, there is a clear attempt to establish a dynamic uniting aesthetics with mysticism. The palette here is still far from the caustic colors of his most eclectic, intimate works that accompany his poetry. Classical influence is evident; the forms are distributed according to compositional and harmonious criteria that he will soon abandon. Another remarkable aspect is the treatment of the figures, which still show a classical modeling. Gradually, the line becomes subordinate to color.

Songs of Innocence: The Lost Child

(1789)
etching printed in relief in green ink
and painted in watercolor
4.6 x 2.8 in (11.5 x 7.1 cm)
Complete format with text: 7.5 x 5.4 in (18.8 x 13.5 cm)
National Gallery of Victoria, Melbourne

According to Blake, "The work depends on the form and the line—errors are made when color is added." This artist's work is directly influenced by Mannerism and the Middle Ages. He learned Mannerism from his friend, the painter Fuseli. The line is from medieval miniatures, and the application of color is based on Italian painting. With the union of these elements he attained what medieval art could not: a perfect union between text and illustration. Technique was never very important to him. The printing methodology that he followed is unknown, although it is believed that he first wrote the text, and then executed the illustrations of each poem on a copper plate, using a reserve liquid impermeable to acid, such as varnish or resin, which created a relief when applied. Then he would apply a layer of colored ink, print, and touch up the printed piece in watercolor.

Marriage of Heaven and Hell (Print 10: Proverbs from Hell)

(1790-1794)
etching printed in relief in brownish
green ink and painted in watercolor
6 x 4 in (14.9 x 10.2 cm)
Complete format with text: 10.7 x 7.7 in
(26.7 x 19.4 cm)
The Fitzwilliam Museum, Cambridge

Marriage of Heaven and Hell depicts Blake's idea that "without opposites there is no progress." This work includes the *Proverbs of Hell*, one of which states: "The tigers of anger are wiser than the horses of instruction." For Blake, this was the way of the world. Thus the indestructible purity of the human spirit recovers its original innocence. According to the artist, the Bible divides the human into the body and soul, the body associated with energy and perversion, and the soul with reason and goodness. Hell is the damnation for those who followed energy, the opposite of truth. Blake does not distinguish between the soul and body in his art, as the body is part of the soul perceived through the senses. He values the line in his artwork, and it tends toward caustic colors, not so much for aesthetic reasons, but to better define the type of image that he wanted to produce and lend it a psychosymbolic character in the manner of Florentine painters. This characteristic would be adopted later by the Symbolist painters.

Europe: A Prophecy (Print 1: Frontispiece)

(1794)
etching printed in relief in brown, blue, and green ink and painted in watercolor
9.3 x 6.7 in (23.3 x 16.8 cm)
Glasgow University Library, Glasgow

Blake was a visionary, a precursor to the British Pre-Raphaelites. His obsession with literature led him to publish different works that he illustrated himself, and even works written with the assistance of his brother. His work is characterized by a powerful imagination and he is a pre-romantic in his themes, showing a rejection of Neoclassicism. His graphic art defies the artistic conventions of the 18th-century. Blake placed imagination above reason, which can be observed in this work, in which the ideal forms are not constructed through the observation of reality but rather through inner visions. He thus achieves a peculiar interpretation of his iconography. His remarkable linear style is based on rhythmic repetitions at odds with the academic style of the time. His figures can be compared to the statues of medieval tombs, which he had copied time and again in his youth.

Visions of the Daughters of Albion (Print 1: Frontispiece)

(1795-1796)
etching printed in relief
in brown ink and painted in
watercolor with touches
of nib and black ink
6.8 x 4.8 in (17 x 12 cm)
Tate Gallery, London

In his *Prophetic Books*, Blake created a personal mythology and invented his own symbolic characters. Blake interprets the figure and theme in a way that is innovative for both the concept and the manner of representing it. He was a nonconformist and a radical, along the lines of other artists. He would confess: "Either I create a system or I will remain enslaved by those of others." In this work, he reveals a marked interest in the line that was to prevail in the rest of his works. The contrasts between the masses of the bodies and background are strong. The sculptural and grandiose influence of Michelangelo is evident in the torsions and foreshortenings.

Whether poetic or visually artistic, Blake's works are unequivocally immersed in a symbolic world that was incomprehensible in his day and during the remainder of the 19th century, which meant that he was neither recognized nor appreciated as an artist during his lifetime. Fuseli and Flaxman said: "The day will come when Blake's drawings will be more sought after and valuable... than Michelangelo's are now."

In his visionary and pantheistic artwork, everything was part of a whole: heaven and earth, eternal life and the present. Heaven was a space in which all existing desires were fulfilled, where forgiveness was the only law. Hell, as can be observed here, unmasks the crudeness of autocracy. The anatomical forms of the devils are powerful, impious, and spectacular. Blake never went to church because he hated organizations. His mysticism was submerged in an imaginative world. Through his works he reflected the indestructible purity of the human spirit, although with the presence of evil as in this work, it is not so apparent. Blake believed in the idea of the forgiveness of sins and in the conciliation of good and evil. According to him, "Every living being is sacred."

The Number of the Beast is 666

(~1805)
graphite pencil, black ink, and watercolor
16.4 x 13.4 in (41.2 x 33.5 cm)
The Rosenbach Museum and Library, Philadelphia

Newton

(1795)
monotype illuminated with watercolor and touches of nib and black ink
18.4 x 24 in (46 x 60 cm)
Tate Gallery, London

Newton is represented as a rational man. He illustrates the concept that the work of reason leads inevitably to truth. His physics is based on experimentation and the knowledge of the laws of nature are used in order to formulate general principles that allow natural phenomena to be controlled. This makes the work a vision of Newton's physics, certainly far from mysticism. Blake found the idea of atoms and particles of light amusing and treated the influence of physics on humanity as satanic. Nonetheless, this image is an homage to the science of Newton, who exhibits a body approaching the classical ideal of beauty. Another important reference in this work is the use of the compass, with the same angle as in the "The Ancient of Days," the frontispiece to *Europe: a Prophecy*.

**Illustrations for the *Divine Comedy*
(The Circle of the Lustful:
Paolo and Francesca da Rimini)**

(1824-1827)
pencil, graphite, ink, and watercolor.
14.8 x 20.8 in (37.2 x 52.2 cm)
Birmingham Museum and Art Gallery,
Birmingham

This work illustrates an episode from Dante's *Divine Comedy*. Blake lived in a period in which, despite his attempts, he was unable to appeal to the general public. It was not until the Pre-Raphaelites posthumously recognized the importance of his work that the fantastic world of this artist was discovered.

In his obsession with illustrating his own and others' works, he published throughout his life, until he began publishing the *Divine Comedy*. Today, his illustrations for the Bible and the *Divine Comedy* are considered an important precedent of Surrealism. This scene shows the lovers imprisoned in the second of the infernal circles. The story is tragic. Francesca da Rimini married Gianciotto Malatesta to further her own interest. Giancotto's brother, Paolo, in love with his sister-in-law, visits her every evening with the excuse of reading the story of the adulterous love between Lancelot and Queen Guinevere. Paolo and Francesca voice their love for one another in the precise moment when Gianciotto arrives. He discovers them and kills them.

WILLIAM TURNER

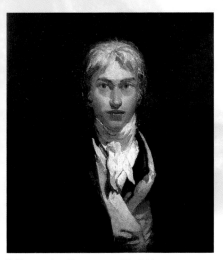

Self-portrait, *oil on canvas, 27 x 21 in (67.6 x 53.2 cm), 1799, Tate Gallery, London.*

Along with Constable, Joseph Mallord William Turner is considered the most important landscapist of his time. His work contains disparate treatments, some clearly academicist, others in which dreams, passion, and nature portray his personality, deeply rooted in romanticism. This artist painted in oil and watercolor, with an appreciation of the intrinsic beauty of the latter medium that did not prevent him from reaching great heights of lyricism and splendor.

Watercolor allowed him to reproduce the subtle patterns of light and a subjective perception of reality, to the point where he created nearly abstract works. Solitary, taciturn, and difficult, Turner did not have many friends. Immersed in the solitude of his apartment, he executed curious experiments: staying indoors with the shutters closed and in the dark for days on end, he would suddenly open the shutters wide to become temporarily blinded by the force of the light. He even installed a walkway from his room to the roof of the house to better contemplate the effects of light on the Thames. He would go into ecstasy admiring the sky at dawn or dusk. Turner was a sort of visionary. His palette and his studies of light and color in some of his works are precursors to Impressionism. The Expressionists admired his emotion. For the formalists, he announced nonfigurative art. In fact, one of his most important contributions to painting was his symbolic vision and the strong romanticism with which he imbued his works. Hardly anyone is indifferent to his work.

- **1775** Born in London to a humble family (his father was a barber).

- **1784** At only nine years of age, he begins coloring in engravings on commission. His success brings him fame and prestige despite his age.

- **1787** Executes his first watercolor.

- **1793** Attends courses at the Royal Academy and begins painting watercolors with the topographer, Thomas Malton.

- **1794** The art collector, T. Munro, becomes his patron, and at his house, Turner meets the landscapist, T. Gurtin. Begins copying John Cozens.

- **1795** He is considered a master in drawing and the watercolor technique.

- **1799** At the height of his fame, he is appointed a member of the Royal Academy.

- **1802** Travels abroad for the first time; contemplates the grandeur of the Alps and admires various works in collections formed by Napoleon in Paris.

- **1805** Inaugurates his own gallery. Attempts to emulate the atmospheric landscapes of Claude Lorraine, whom he deeply admires.

- **1819** His first trip to Italy opens a new period in his art, characterized by intense luminosity and brilliant colors, seeking light in itself and dispensing with contrasts created by shadows.

- **1829** The death of his father, to whom he was very close, makes him retreat even more into himself.

- **1834** The fire at the Parliament building offers him an opportunity to study the effects of a violent fire on light and color.

- **1835** A visit to Venice marks his third period, characterized by his study of light and color and the representation of dreamy and mysterious visions. He shows a preference for subjects in which the elements of nature allow him to express the vibrations of light and movement.

- **1845** Begins suffering mental disorders.

- **1851** On December 19, he dies under an assumed name in a Chiswick lodging house, where he was living in poverty. He leaves a significant fortune and a legacy of more than 20,000 works, the majority of them drawings and watercolors. He is buried in St. Paul's Cathedral.

The Pantheon

(1792)
watercolor
20.6 x 25.6 in
(51.6 x 64 cm)
Tate Gallery,
London

This watercolor, painted when Turner was only 17 years old, constitutes a good example of the possibilities of combining two techniques, drawing and watercolor, which he mastered with singular skill despite his youth. The image is a lovely study of perspective (in 1807, Turner was appointed professor in this subject at the Royal Academy), combining theoretical or academic skill with an unusual treatment of light, through which he already previews his typical concern for atmosphere, which was to become one of the principal characteristics of his later work.

The Battle of Fort Rock

(1796)
watercolor
27.8 x 40.6 in (69.6 x 101.5 cm)
Tate Gallery, London

This large-format watercolor reveals the artist's preoccupation with representing the forces of nature, far above the vicissitudes and insignificance of humanity. The landscape is the true protagonist and cancels out the principal subject matter, which, according to the title, is supposedly the battle that takes place in the midst of this immense wilderness. The episode does not make sense unless related to the forces of nature. Turner's genius allowed him to combine various subjects within a single work.

In this early work, his solid academic training is evident and his romantic feeling for nature can be discerned, duly combined with the best qualities of classical art. The technique makes the work resemble a colored drawing, a characteristic abounding in his works from this period.

Venice: The Campanile and Doge's Palace

(1819)
watercolor
Tate Gallery,
London

Turner made various trips to Italy (Naples, Rome, and Venice) that led to significant changes in his artwork, which adopted the intense luminosity of the Italian landscape, not surprising in a painter obsessed by light. The treatment of light and the atmosphere play the leading roles in this painting, to the detriment of greater detail in the architecture. The buildings are imbued with the soft tones of a changing light. The transparency and purity of watercolor led Turner to execute thousands of sketches in this medium, which he used to investigate light in more depth, achieving fresh and highly spectacular results.

To render unusual views of river landscapes, Turner painted several works from boats, such as this one. Led by his desire to capture emotions, dispensing with anything resembling a detail or anecdote, the artist conveys only the essential elements that allow the viewer to gain a chromatic view of reality. This is precisely the objective of artists, since they are attempting to communicate their subjective view.

The Thames Near Walton Bridge

(1806-1807)
oil on canvas
14.8 x 29 in (37 x 73 cm)
Tate Gallery, London

In a display of skill he synthesizes light and shadows by simply applying a series of color to different areas. Turner selected a landscape that was not unusually attractive in and of itself: a sky with a spontaneous suggestion of clouds; the land along the riverbanks, with color masses that represent the ground, the trees, and some houses; and the water, reflecting the overhead elements. The painting is nearly Expressionist and, despite the fact that this is from his early period, illustrates how advanced this artist's work was in comparison with his contemporaries.

Snow Storm in Val d'Aosta

(~1842)
watercolor
36.6 x 49 in (91.5 x 122.6 cm)
Art Institute of Chicago, Chicago

Although Turner was certainly enamoured of landscapes, what most interested him were the atmospheric effects, the grandiosity and spectacularity of nature when it reveals its power. Landscapes such as this one are so magnificent that the human is often represented as a small and powerless creature, reduced to its minimum expression, as in this work.

Resembling stage sets for Wagner's operas, Turner's paintings of this sort represent a spectacular exercise in light and color. The chromaticism, atmospheric effect, vibration, and force are evident, and the painter demonstrates that one need not represent reality as one sees it, but rather as one feels it, resulting in a much more powerful image. The impact is not created by the eyes but in the mind of the viewer. For this reason, the artist attempts to synthesize and select those elements that will shake the viewer's imagination. Turner achieves this in his works through his loose, spontaneous treatment, with a great mastery of technique, focusing on the basic objective of the painting, and reducing the details and the anecdotal elements to a minimum in order to make the painting even more forceful. The astonishing results achieved by Turner through his atmospheric treatment comprised one of the characteristics that most inspired the Impressionists.

Yacht Approaching the Coast

(~1838-1840)
oil on canvas
40.8 x 56.8 in
(102 x 142 cm)
Tate Gallery, London

Turner's art is permeated by a preoccupation with light. Although his paintings deal with nature and he is regarded as one of the greatest British landscapists, as his career progressed, light gradually became the true protagonist of his paintings. This is just one of many eloquent examples. The essential aspect of the work is the treatment of light, which Turner approaches by perfectly combining a variety of tones, achieving a vibrant, varied, theatrical, and evocative work. The dense atmosphere envelops everything. The atmosphere reveals the painter's thorough study of light and color. Everything else is a simple accessory, including the title of the work.

The Lake of Lucerne

(~1844)
watercolor
Tate Gallery, London

This watercolor demonstrates Turner's preoccupation with and taste for surface textures and the effects of areas and strokes of color. He was daring in his experimentations and sought a manner of representing a landscape so that it reflected his subjective perception of nature. He used color ranges that were progressively more transparent, and invented new techniques. At times, color daubs are applied with the fingertips or dripped. Pale or violent colors are applied. The brushstrokes are loose and white tempera is mixed in with his watercolors. The result of these techniques, often combined into one work, is a study of light and color that was to thrill the Impressionists, a dreamy, mysterious, symbolic, and nearly abstract, yet wholly theatrical, vision.

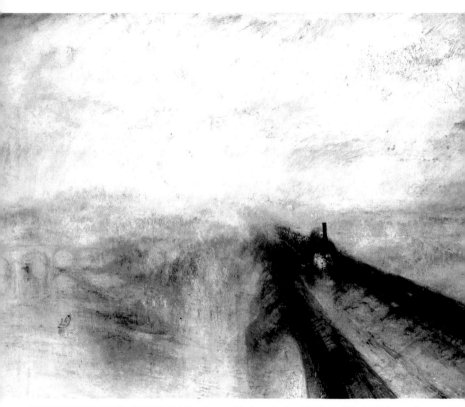

Rain, Steam, and Speed, or The Great Western Railway

(1844)
oil on canvas
36.4 x 48.8 in (91 x 122 cm)
National Gallery, London

Along with the painting, *The Sun of Venice Going to Sea* (1845, Tate Gallery, London), this one shows how Turner's can be considered a precursor of Impressionism. With his loose technique and interplay of brushstrokes, the artist combines different chromatic tones and various intensities of light to produce a nearly abstract, yet wholly evocative and stunning work.

Despite the density of the atmosphere, the paint is clear and transparent and the tones are applied subtly to represent a certain reality – his reality. The result is an evanescent image, a dreamy and unreal vision with a certain air of mystery. The artist not only reflects the sensations produced by a landscape, an image of nature, but also succeeds in immersing the viewer in a festival of light, in a spectacular setting that makes one feel small before the grandiosity of nature.

Turner's art is a profound, philosophical, transcendent view of nature, deeply rooted in romanticism. But his obsessive interest in far-reaching experimentation lead to spectacular representations of the phenomenon of light, as well as a formidable display of chromatic combinations. Here the light filtering through the mist gives rise to a nearly abstract painting, with swirling colors that evoke rather than describe the scene. Although there were many detractors of this type of painting at the time, it clearly shows the artist's irrepressibly inquiring nature, which created a new style and more modern technique of representation.

JEAN-AUGUSTE-DOMINIQUE INGRES

Self-portrait, *oil on canvas, 25.6 x 21.2 in (64 x 53 cm), Koninklijk Museum voor Schone Kunsten, Antwerp.*

Although he painted a variety of subject matter, Ingres' skill is exhibited most fully in the figure genre (nude and portrait), for which he won universal recognition. In his work, the artist displays a mastery for capturing reality, rather than his imagination and creativity. His portraits reflect both the subjects' physical and psychological attributes through a meticulous technique and extreme attention to detail. His nudes, which convey serenity and balance, reveal his preoccupation with drafting, shapes, and modeling, with less attention to color, probably due to the influence of Raphael's works.

His work finds its highest expression in its stylistic coherence, with which he achieves great expressiveness and formal pureness.

A prestigious member of the French Academy and exponent of official French art, he decisively influenced the moderate romanticism of European art. He was regarded by the art establishment as a model of perfectionism.

Ingres' work has always been admired for its fidelity to the Greco-Roman canons of art, and criticized for its lack of modernity and innovation. He was recognized as the leader of the Neoclassical school that was diametrically opposed to the new romantic movement led by Eugene Delacroix. His style, conception of art, and methodology remain obligatory subject teaching matter in classic figure drawing.

- **1780** Born in Montauban in southern France, the son of painter and sculptor Joseph Ingres.
- **1791** Enters the workshop of Roques, in Toulouse.
- **1797** In Paris, becomes a student in the studio of Jacques-Louis David.
- **1801** Wins the Rome Prize with the painting *Ambassadors of Agamemnon* (École des Beaux-Arts, Paris)
- **1806** Presents different portraits in the 1806 Paris Salon, which were negatively received. Moves to Rome, to Villa Medici, where he studies Italian painters, especially Raphael.
- **1813** Marries Madeleine Chapelle, a couturier from Guéret.
- **1814** Paints *Pope Pius VII in the Sistine Chapel* (National Gallery, Washington), and *Grande Odalisque* (see p. 281), and begins *The Source* (Musée d'Orsay, Paris).
- **1820** Travels to Florence, where he resides for four years with his friend, the sculptor Lorenzo Bartolini.
- **1824** Exhibits his *Vow of Louis XIII* (Cathedral of Montauban) in the Paris Salon, and receives wide acclaim in contrast to Delacroix's *Massacre at Chios* (Louvre, Paris).
- **1827** Paints the *Apotheosis of Homer* for a ceiling in the Louvre, which is severely criticized.
- **1828** Takes up residence in Paris, where he takes up position as director of a studio at the Academy of Fine Arts.
- **1832** Nominated vice-president of the École des Beaux-Arts.
- **1834** Paints *The Martyrdom of St. Symphorian* for the Cathedral of Autun, a work that marks his stylistic departure from David.
- **1835** Named Director of the French Academy in Rome, where he remains for seven years.
- **1841** Reconciled with the French public for the favorable reception of the works presented in Paris during this period, he returns to the city.
- **1843** At the request of the Duke of Luynes, moves to the Château de Dampierre, where he paints two decorative frescoes, *The Age of Gold* and *The Age of Iron*, neither of which he finishes after 10 years work on them.
- **1855** Wins the medal of honor and is named Grand Officer of the Legion of Honor.
- **1862** Napoleon III makes him a senator, a position that establishes him as the undisputed master of official French art.
- **1867** Dies in Paris.

Virgil Reads *The Aeneid* to Octavia and Augustus

(~1812-1819)
oil on canvas
55 x 57 in (138 x 142 cm)
Musées Royaux des Beaux-Arts, Brussels

This canvas was painted for Villa Aldobrandini, the governor of Rome's official residence. It refers to something that happened when Virgil, author of *The Aeneid*, paid a visit to Augustus in order to read the adventures of Aeneas, from which the title derives. Having reached the part where Aeneas descends to the kingdom of death and foresees the death of Octavia's son, she passes out and falls into the emperor's lap.

The nude Augustus is somewhat ambiguous, partly deliberately and partly induced by the models that were then used in Italy. The classicist style with which this nude has been treated recalls the Roman sculptures of the emperor, although, in this case, it is afforded a dramatic gesture of the hand as if to prevent the tragic fate of Octavia's son. The modeling of the flesh tones is smooth and integrates the highlights of the skin in the darkest areas with noteworthy elegance and draftsmanship.

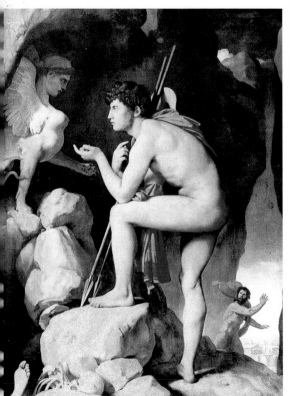

Oedipus and the Sphinx

(1808)
oil on canvas
75.6 x 57.6 in (189 x 144 cm)
Louvre, Paris

As it was prophesied at his birth, Oedipus would kill his father and marry his mother. In order to avoid this fate, his parents abandoned him. This work shows Oedipus' encounter with the Sphinx, from whom he learns of his destiny.

Oedipus is represented as a nude that recalls classical sculpture. The modeling of the forms is exquisite. Its subtle flesh tones help the figure to stand out against a dark background. The forms appear to convey a cold sensuality, but still achieve a classical perfection. In 1808, Ingres, who was living in Rome, sent this canvas to the Paris Salon, where it was harshly criticized for its conventional beauty and for the excessive realism of the subject matter.

Three versions exist of this painting, the only difference from the earlier versions being the bearded man in the background. This could be an older Oedipus, trying to escape his destiny.

Madame de Senonnes

(1814-1816)
oil on canvas
42.4 x 33.6 in (106 x 84 cm)
Musée des Beaux-Arts, Nantes

The work, which was painted on Ingres' return to Rome following a stay in Naples, provides a fine example of his portraiture. In addition to capturing the subject's physical features, Ingres, in his own particular meticulous style, renders all the elements with careful detail, lending each and every one of the small sections of the surface as much importance as the face itself.

The portrait reveals the painter's mastery of four elements: characterization, expressiveness, detail, and color. With this work, Ingres begins to show his interest for surroundings (draperies, cushions, the mirror, and so on) that he would incorporate in his orientalist works.

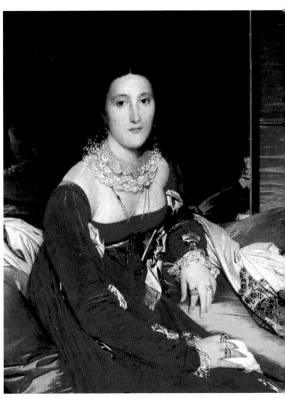

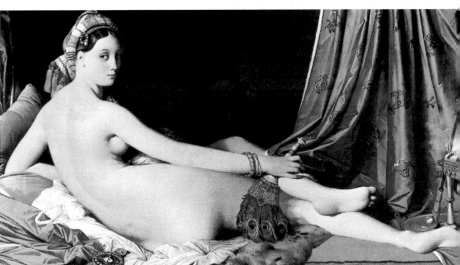

Ingres often used oriental themes as a source of inspiration. This type of subject matter allowed him to work freely with nudes and imbue them with sensuality. Their anatomies deviate from realistic anatomy, and often recall Raphael. The effect of his anatomical interpretation is evident in this odalisque, whose spinal column is elongated for reasons of harmony and aesthetics. The woman's curves set in beautiful surroundings exemplify how harmony can prevail over realism. Rich colors and bright illumination enhance the idea of the harem.

This majestic nude is captured in an everyday situation, staring straight at the spectator. In a natural though static pose, she appears calm and indifferent, even defiant, an attitude that heightens the sensuality of the image. Manet's *Olympia* was inspired by this work.

Grande Odalisque

(~1817)
oil on canvas
36.4 x 64.8 in (91 x 162 cm)
Louvre, Paris

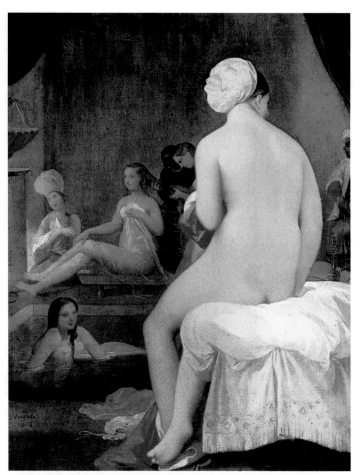

The Small Bather

(1828)
oil on canvas
14 x 11 in (35 x 27 cm)
Louvre, Paris

In 1808, when Ingres was in Rome, he sent the *Valpinçon Bather* (Louvre, Paris) to the Paris Salon, where it was well received for its delicate modeling and lighting, achieved with the use of a reflective screen, a piece of white linen placed in front of the light source in order to enhance the light and attenuate shadows. Twenty years later, Ingres returned to this theme, changing certain details in the main subject and adding substantial variations to the rest, especially the figures in the background. This work forms part of a series, in which the characteristic refinement, luxury, and sensuality of the Near East form the setting for a harem scene.

The numerous nudes painted by the artist demonstrate his firm grounding in female anatomy and mastery of multiple techniques to achieve his classical interpretations. The main subject of this work is the bather with her back to the spectator. Her body emanates luminosity in keeping with the intimate atmosphere of this room. The pale skin and softness of the figure lend the work sensuality.

In the middle ground, a barely sketched young and natural-looking woman is shown bathing, allowing her shapely waist and breasts to be seen; her pose exhudes voluptuousness and eroticism. Against the smooth, dark background, the bathers and attendants, in static poses and with unexpressive faces, serve the purpose as extras.

Every one of the subject's curves convey a refined sensuality; observation of the line of the neck and its effect on the shoulder reveals a subtlety that breaks with formalism, perspective, composition, lines, etc., in favor of the general aesthetics.

It seems as if Ingres left everything else aside in order to focus his attention on painting a female nude in a traditional academic pose, with a meticulous gesture and clean line, favoring a balanced and flawless drawing over color to render a harmonious figure. While avoiding any kind of musculature, which would detract from the woman's sensuality, the artist has based everything on the purity of the line.

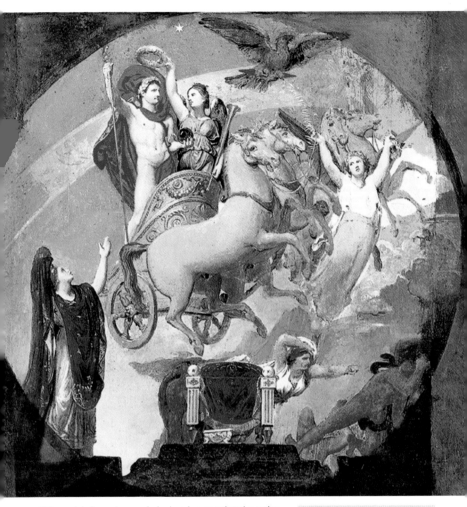

This work belongs to a period when Ingres painted a series of portraits that idealized the subject and that became the object of extremely negative criticism and even mockery. The purpose of this kind of official art was to disseminate and glorify the magnificence of the emperor's political, personal, and moral power. Such paintings were a propaganda tool for imposing authority and respect over all social classes.

Apotheosis of Napoleon I

(1853)
oil on canvas
19 x 19 in (48 x 48 cm)
Louvre, Paris

This is an allegory on the power of Napoleon, riding a golden chariot drawn by two golden chargers. He crosses the firmament like Aeoulus, Greek divinity and custodian of the winds. Victory places a crown on the emperor's head, emulating the triumphant entrance into Rome of a victorious commander and his army following their return from battle.

Napoleon is shown nude and idealized as a hero; he has the face of a Roman emperor while his body is that of a Greek hero, with studied proportions and athletic form, although the portrait does resemble the real person to a certain degree. The artist's attempts to idealize Napoleon were in vain, producing an image that would be ridiculed, since Napoleon had nothing like the attractive body portrayed here.

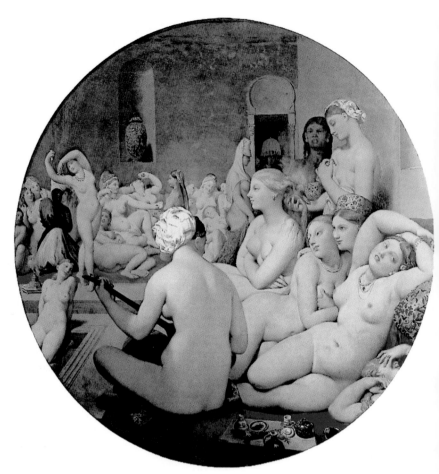

Turkish Bath

(1862)
oil on canvas
43 in (108 cm) in diameter
Louvre, Paris

This canvas, completed in 1863 and regarded as the finest work to come out of his last period, was painted when Ingres was 82. Once again he takes up an oriental theme. The Turkish bath is populated by young bathers and odalisques, in a variety of poses. These nudes are highly sensual in attitude. Their voluptuous anatomies are an ode to female beauty.

The forms are idealized nearly to the point of extreme softness, in which lines are deformed and made to fade for purely aesthetic reasons. The woman with her back to the spectator is reminiscent of the nude of the *Valpinçon Bather* (Louvre, Paris) here greater eroticism is conveyed. The dense atmosphere of the room makes the nudes in the background progressively less defined, until they practically merge with the background. While conserving to a great extent the curves and forms of the latter, the main nude of this work is more explicit in that the position of the arm supporting the instrument reveals one of her breasts.

The scene, somewhere between reality and fantasy, is an enticement of the senses, of lust and joy, always with a meticulous style and soft contours. The painting is a beautiful example of Ingres' classicist and academic style. In general, his works were a model of perfection, balance in drawing, and supremacy of the latter over color.

This work shows the ease and mastery with which he painted the human anatomy. Ingres decisively influenced many of the European romanticists, although he did not lack detractors due to his close-minded attitude toward the latest artistic tendencies of his time.

THÉODORE GÉRICAULT

Self-portrait, *oil on canvas, 8.4 x 5.6 in (21 x 14 cm), Private Collection.*

Théodore Géricault style is characterized by direct observation of reality and a palette of finely varied tones, breaking with the Neoclassical concepts of the day and paving the way for French Romanticism.

His art has been said to combine the creativity of Michelangelo with the socialist realism of Honoré Daumier, and it constitutes a bridge between Caravaggio's chiaroscuro and Courbet's realism. His interest in Michelangelo led him to exchange his initial classicism for a Mannerism of conclusive draftsmanship, aggressive brushstroke, great movement, and antiacademic vitality.

Obsessed with representing the darker side of life with extreme realism, he conveys profound and unsettling pessimism in many of his works. Psychologically forceful, tragic, and striking, the works include sketches on the murder of Judge Fualdès, portraits of mad people at the Salpêtrière Hospital in Paris, and drawings of corpses executed at the Beaujon Hospital.

Despite his premature death, he is considered the undisputed leader of the French Romantic School. He exercised a great deal of influence on artists of his time, especially on Delacroix, and some of his works laid the groundwork for new artistic trends, among them Impressionism.

- **1791** Born in Rouen to a well-to-do family.

- **1800** Moves to Paris.

- **1808** Becomes a student of Carle Vernet, famous for his horse studies.

- **1810** Studies under Pierre-Narcisse Guérin, a Neoclassicist painter and follower of David.

- **1812** Exhibits his painting *Charging Chasseur* (see p. 286) at the Paris Salon, introducing a horse motif that will remain in his painting for the rest of his life.

- **1814** Presents the *Wounded Cuirassier Leaving the Battle* (Louvre, Paris) at the Paris Salon.

- **1815** Enlists in a mounted regiment that is disbanded the following year. Moves to Italy, where he visits Florence and Rome, admiring works by Michelangelo and Caravaggio. In Rome, he meets Ingres, whose drawings captivate him, and he executes various classicist drawings in the style of 17th-century sketches, some typically French erotic scenes and scenes of horse races.

- **1817** Disappointed in the French Academy in Rome, he returns to Paris, where he executes paintings in a variety of subject matter (dogs and cats, animals at the Jardin des Plantes, the children of his friends), at times in the company of Delacroix and Barye. Begins work on *Raft of the Medusa* (see p. 289), which he shows at the 1818 Paris Salon.

- **1818** Upset at the criticism of *Raft of the Medusa*, retires for a time to Feticy, near Fontainebleau, where several contacts (the sociologist Brunet, the psychiatrist Georget, and the doctor of the Salpêtrière Hospital) lead him to a turning point in his artistic career, after which he adopts a more aggressive form of Romanticism.

- **1820** In the spring, he moves to Britain, exhibiting *Raft of the Medusa* at the Egyptian Hall in London, and then in Dublin, Ireland as well. It is so well received, and praised so effusively by Constable, that he remains in England for a year and a half. Paints three versions of *Epsom Downs Race* (see p. 290).

- **1822** In the autumn, he returns to Paris. Complications arising from a riding accident, aggravated by his venereal disease, eventually lead to his death.

- **1824** After a few agonizing months, he dies in Paris.

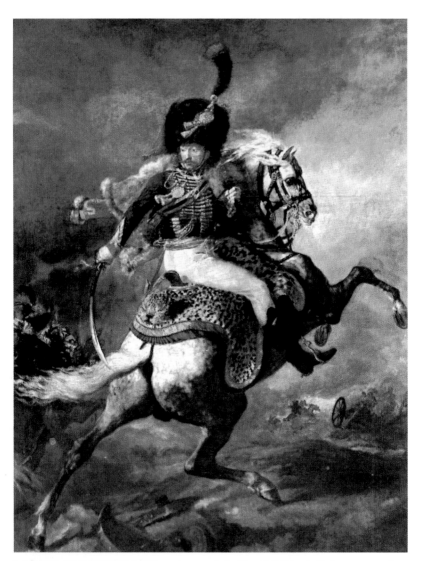

Charging Chasseur

(1812)
oil on canvas
20.8 x 15.2 in (52 x 38 cm)
Louvre, Paris

This work, presented at the 1812 Salon in Paris, was not well received by the public because it did not fit the classicist mentality predominating in official art of the time. Pierre-Narcisse Guérin called it a "foolish painting." However, it appealed to a few, including Jacques-Louis David.

Although the subject is an anonymous soldier and the painting does not have the pretensions of a portrait, it is a monumental work with remarkable force and movement. The conception, movement, rhythm, and lines recall certain works by Rubens, whom Géricault profoundly admired in this early period of his artistic career. Considering the static and affected nature typical of Renaissance art, it is evident that Géricault was interested in achieving a very different style.

A great enthusiast of horses since his youth, the artist renders a well-drafted animal here, from a point of view that would be difficult for someone not as thoroughly familiar as he was with horses. The head, mane, tail, legs, and body, in a complex position, are perfectly combined with the soldier's action, and reflect his skill and savoir-faire. The bulky horse becomes the real protagonist, while the rider, rigid in his tight uniform, is relegated to a secondary position. The color scheme successfully creates an abundance of contrasts, with illuminated areas and points of vivid color that enhance the movement in this wartime setting.

Nude Torso

(~1815)
black pencil and watercolor
22.3 x 18 in (55.7 x 45.1 cm)
Musée Ingres, Montauban

This work illustrates Géricault's classicist period, when he was deeply influenced by Michelangelo, and described the human body with meticulously executed volume and forms and an idealizing treatment that renders it as the supreme element of nature.

Using mixed media, Géricault achieves a powerful, chromatically balanced, and expressive torso, and an excellent interplay of light and shadow in the muscles. The details of the anatomy and complexion are defined with singular thoroughness. Although it is an unfinished work, it is evident that Géricault intended to show the human body in a spectacular and grandiose manner, along the lines of Michelangelo.

Géricault's artwork paved the way for French Romanticism, which he took to the extreme in his wholly unconventional representations. His *Raft of the Medusa* (see p. 289) led him to become obsessed with the individual and even more so with life, often representing its most bitter aspect.

Heads of the Executed

(~1820)
oil on canvas
23.6 x 24 in (59 x 60 cm)
Nationalmuseum, Stockholm

His frequent visits to the Beaujon Hospital, where he observed the corpses of patients who had recently died and, above all, the faces of prisoners who had been executed, allowed him to study the signs of suffering and death. This led him to execute paintings of hideous, wholly devastating realism, such as this one. The artist renders it as if it were a still life of two heads, giving it a macabre treatment in keeping with his dark, tragic, and cruel vision. His skill of observation, the detail, and the romanticism of the work make the feelings it evokes even more intense and distressing.

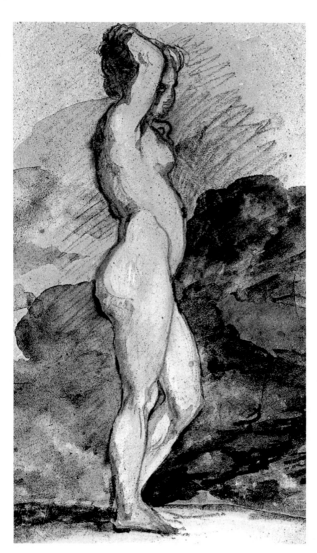

Nude Woman Standing

(~1819)
wash, indigo, and pencil
8 x 5 in (19.8 x 13 cm)
Musée des Beaux-Arts, Rouen

Géricault is the leading exponent of French Romanticism. He was only 21 years old when he first exhibited in the Paris Salon. The classicist ideas he had on his arrival in Rome in 1816 soon yielded to the influence of Michelangelo and the Mannerists. This inspiration led him to execute forceful and dramatic works, far from academic criteria and with a growing tendency to reveal the darker side of life and the least attractive facets of the individual, for which he often studied human corpses in morgues.

This sketch of a nude woman, in profile and in a typical academic pose, should be viewed in that context. Despite the powerful body and well-drawn muscles and other details, the treatment makes this figure intriguing. Géricault lends it a certain horrific quality and a significant degree of pessimism, through both the texture of the body and its forms and the background. The palette consists of only neutral colors, with a background of dark tones against which the drawing is executed in hard, thick, and sometimes violent lines, imbuing the work with drama and severity. The draftsmanship is perfect and the artist demonstrates a profound knowledge of the female anatomy.

The loose, aggressive strokes in the upper background convey profound anxiety; the drawing of the figure, outlined in thick lines, with powerful muscles and intense shadows, provides a dark, disturbing view of this woman. Far from portraying the sensuality of the female body, the painter represents this woman facing life, her very existence, and her future, full of uncertainties. The artist's premature death lends a sense of fatalism to the tragic view of life that can be observed in many of his works.

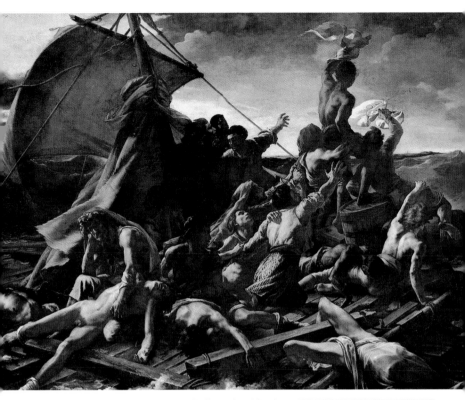

The artist spent a long period in Italy, until, disappointed by the French Academy in Rome, he decided to return to Paris. The sketches he executed on the notorious assassination of Fualdès in Rodez and the subsequent trial encouraged him to paint this work, one of his most important, which deeply impressed Delacroix.

Raft of the Medusa

(1819)
oil on canvas
196.4 x 286.4 in (491 x 716 cm)
Louvre, Paris

The scene refers to the tragic shipwreck of the frigate *Medusa* in 1816, in which 149 people initially survived, many of whom eventually died after indescribable suffering on a raft, which drifted for many days before being rescued. The incident caused great commotion in society.

The artist began this work in the autumn of 1817. In order to render the shipwrecked individuals in this work of documentary interest, he made frequent visits to the Beaujon Hospital, near his studio in the suburb of Roule, to observe the mentally retarded, handicapped, and dying, as well as the corpses of those who had recently died. They included patients, executed criminals, or homeless. The majority of them were marginalized, victims of misery and neglect, and familiar with the most tragic aspects of life. The painter studied and sketched their faces, expressions, gestures of pain, and squalid anatomies, using them as the basis of his work. Hence, the results are not surprising: bodies with hyperrealistic gestures, muscular tension, expressions of horror that could only be rendered by an artist who had seen them first-hand.

The painting is a vivid image of desperation and tragedy, the horror of death, the helplessness and terror of the damned before their fate. When the work was exhibited at the 1819 Paris Salon, its realism gave rise to heated debate. On the one hand, it was appreciated for its classical conception and the influences it revealed, especially of ancient sculpture, Michelangelo's figures, Caravaggio's tenebrism, and the palette of the Bolognese School. On the other hand the ambiguity of the draftsmanship and the theatricality of the work produced consternation. Furthermore, it was interpreted as an acid critique by the liberal opposition of the ruling party, which was leading France to its ruin.

From an artistic point of view, the work represents a significant deviation from academic tradition. The nudes are statuesque, evoking Michelangelo's art, although the whole recalls ancient bas-reliefs. The Baroque dynamism of the composition combines with the rich treatment of light on the bodies, borrowed from tenebrism, heightening the sense of drama and spectacularity.

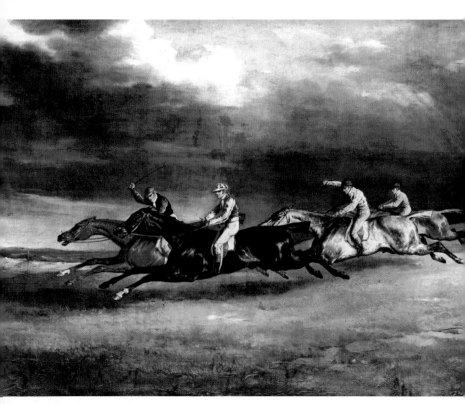

Epsom Downs Race

(1821)
oil on canvas
35.2 x 48 in (88 x 120 cm)
Louvre, Paris

Géricault executed this painting in London, where he had moved to exhibit *Raft of the Medusa* (see previous page). Its favorable reception moved him to remain there for a year and a half.

A horse enthusiast, he attended many races, suggesting the subject for this painting. The work illustrates the exertion of horses during a competition. The artist, who was a good rider, imbued the animals with rhythm, rendering their extremely stylized, dynamic forms in a single take as if in a snapshot, with an aesthetic recalling the bas-reliefs of classical Greek antiquity.

The horses are the sole protagonists, the remaining elements relegated to secondary importance. Even the riders have less expressive, less dynamic poses, appearing to be simple accessories. Each of the four horses is a different color, such that they are individualized and stand out from each other. Though integrated within the work, the horses stand out against the foreground, whose only ornament is the texture of the grass, executed in a range of green tones.

The silhouette of the group of horses and riders is defined against the background, consisting of a sky of heavy, well-modeled clouds threatening rain. In addition to demonstrating his mastery of drawing and deep knowledge of the subject matter, Géricault achieves a fresh, spontaneous, and loose work, anticipating both the technique and one of the favorite subjects of the Impressionists. This scene is a modern, realistic representation that deeply impressed Degas, who painted several works on the same subject.

CAMILLE COROT

Self-portrait when Corot was approximately 25 years old.

Jean-Baptiste-Camille Corot's work, belonging to the Barbizon School, gradually evolved from the type of landscapes he began painting in Italy to his later employment of a short, nervous brushstroke with pointed, specific applications of paint, presaging Impressionism.

In his early period, he was interested in landscapes with Roman ruins, but after 1850, his style began to move toward Romanticism, with grayish greens and silvery tones, hazy atmospheres, ethereal foliage, and softly filtered light in poetic forests, in subdued colors with wide tonal ranges. His apparently traditional technique created an atmosphere of light and clarity.

His landscapes are intimate, luminous, and poetic, and his representations of women far from the idealism that had been predominant signify a new conception of art and nature, a singular contribution to painting at that time. His compositional purity and the classical simplicity of his first works are remarkable, as is the monumental concept of form that predominates in his later period.

Corot was a teacher of Berthe Morissot and Camille Pissarro, and was admired by Claude Monet and Auguste Renoir. One of the great landscape artists of the 19th century, he was highly acclaimed by the Impressionists.

- **1796** Born in Paris to a hairdresser who later became a prosperous draper, Louis Jacob, and a couturier from Freiburg, Switzerland, Marie Françoise Oberson.

- **1807** Begins studying at the Institut de Rouen.

- **1922** Thanks to a stipend from his father, he begins studying art under the landscapist, Etna Michallon, who instills in him a meticulous technique and an ingenious naturalism.

- **1825** Travels to Italy, where he paints landscapes. In Rome, he meets E. Bertin, L. Robert, Schnetz, Bodimier, Reinhart, Lapito, and Carnelle d'Aligny.

- **1827** Paints *The Bridge at Narni* (National Gallery, Ottawa).

- **1828** Returns to Paris and begins painting outdoors, in the forests of Fontainebleau, the valleys of Normandy, and the foliage of Ville-d'Avray.

- **1834** Travels to Italy to paint the landscapes of Tuscany, Florence, Venice, and the lakes region.

- **1838** The duke of Orleans acquires one of his paintings.

- **1843** Travels to Italy again to paint outdoors.

- **1844** Appointed Knight of the Legion of Honor.

- **1849** Paints *Christ in the Garden of Olives* (Musée de Langres), which reveals his mastery of composition.

- **1855** The World Exposition launches his career as an artist. In his last period, his friendship with Daubigny, whom he had met in Switzerland, and with young French painters, lends his style greater flexibility.

- **1865** He is forced to rest for a time due to his poor health. During this time, he executes a series of female studies.

- **1874** A few months before his death, he paints *The Cathedral of Sens* (Louvre, Paris). Receives a medal minted by Geoffroy Dechaume from his friends and admirers.

- **1875** Dies in Paris on February 22.

Avignon from the West

(1836)
oil on canvas
13.6 x 29.2 in (34 x 73 cm)
National Gallery, London

Corot's art followed a trajectory that allows the period in which each painting was executed to be clearly identified. He attended several exhibits by Constable and Bonington, which convinced him to concentrate on working outdoors. He developed a spontaneous and decisive style dominated by the effects of light and a subtle colorism that excluded dark, muddy colors.

Corot painted this work during a trip to Auvergne, Avignon, and Montpellier. Deeply influenced by the landscape art he had executed in Italy, this painting is a lovely example of spontaneity and freshness. Because of its lack of detail, it resembles a sketch *alla prima*, a method of painting without the use of preliminary studies. A magnificent contrast is established between the soft, clean blue of the sky, and the landscape, abounding in neutral colors, which surprisingly lends the work great brightness, in a synthesis that delighted the Impressionists.

The Galette Windmill

(1840)
oil on paper pasted on canvas
10.4 x 13.6 in (26 x 34 cm)
Musée d'Art et d'Histoire,
Geneva

This building was a former flourmill located on the outskirts of Paris, on the hill of Montmartre. As the milling business was not running very well, the mill was converted into a center for recreation and dance, frequented by simple folk, bohemian artists, and young women in search of a better future. In this beautiful image, the artist not only shows the location of the building and the state of the terrain, but also describes the effect of light and the shadows cast. Under a light blue sky, the artist applies a predominantly gray tonal range. Although the sunlight is intense, the shadows are not absolutely black. The neglected buildings and barren natural surroundings are treated with profound respect and delicacy, in a limited color range.

This work is an example of Corot's Italian landscape style. Rather than representing the landscape itself, it seems that the artist is more interested in conveying the effects of light and color. He focuses on a blue-and-green color range, and plays with the scale of grays to define masses, establish volumes, create perspective, and represent the atmosphere. The light is hazy, the scene diaphanous, giving the impression of a dream rather than a real landscape. The figures can be interpreted as elements introduced to provide a counterpoint, or as mere reference points.

Mornex. Morning Effect

(~1845)
oil on canvas
16 x 24.4 in (40 x 61 cm)
Mellon Collection, Upperville, Virginia

Rather than depicting a real scene or getting involved in details, Corot creates a general work playing with light and color in order to evoke a sensation through atmosphere. The painting is conceived with the idea of a series of dark, dense color masses: a gray sky, a dense grove of trees forming a large mass, and a swampy foreground. It is a gray autumn day, judging from the color of the leaves. The cow, with its warm color and the small star on its head, constitutes a note of contrast among the dense colors, in which silvery gray plays a leading role. The strokes are light and the color thinned to achieve transparencies similar to watercolors, especially in the sky.

Landscape with Willow Trees and a Cow

(1855-1860)
oil on canvas
10.2 x 15.2 in (25.5 x 38 cm)
The Hermitage, Saint Petersburg

Recollection of Mortefontaine

(1864)
oil on canvas
26 x 35.6 in (65 x 89 cm)
Louvre, Paris

This painting was executed during Corot's mature period. He often applied a formula to his landscapes: in the foreground, intense, often dark colors, as in this painting, provide a frame for the scene through which a luminous landscape can be seen in the distance. Light filters through the foliage of the trees in the foreground. The artist never left out the effects of light, which constitute the basis of his work, evoking a range of emotions. This canvas perfectly fits the described formula. It conveys tranquility. The draftsmanship is superb, the composition perfect and theatrical. The intense light and trees reflected on the water in varied, subdued tones of gray are evidence of Corot's skill.

The Peasant Woman and Her Cow

(1865-1870)
oil on canvas
19 x 14 in (47.5 x 35 cm)
The Hermitage, Saint Petersburg

This work is a study in color, using the possibilities of the chromatic range to the maximum. The vegetation is treated in dark colors, with which Corot perfectly describes its volume. Tenuous light is reflected in the tips of the boughs. The leafless tree whose trunk stands out against the silvery gray sky and the shaft of light illuminating the treetops in the upper left corner are striking. In the foreground, a peasant woman is rendered in a natural pose. Her actions are part of her everyday routine: before returning home, she gazes one last time at the cow in the river. The colors of her clothing (a white blouse, black vest, large dark skirt, and pale blue apron) are a display of daring, considering the background. Despite its multiple tones, it is a dense, tenebrous landscape.

The Studio

(1866)
oil on canvas
22.4 x 18.4 in (56 x 46 cm)
Louvre, Paris

In both his landscapes and figure paintings, Corot was always involved in transforming reality through a specific treatment of light and color, evoking sentiments in accordance with Impressionist ideology.

This painting represents solitude and nostalgia. Although she is holding a musical instrument and sitting before a painting, the woman is absent, lost in her thoughts. Vivid and intense colors are used in both the woman's complexion and her clothing, with a passage of light entering from the upper right. In addition to creating a contrast, it makes the image stand out against the dark background and heightens the sensation of the viewer.

The Woman with the Pearl

(1869)
oil on canvas
22 x 28 in (55 x 70 cm)
Musée d'Orsay, Paris

Although the artist primarily painted landscapes, he also executed some figures in a very natural style. This work is considered Corot's best figure painting. He renders a normal woman, simple and candid, in unsophisticated attire. Far from idealizing her, he represents her in a natural state with a sound dose of realism, in a pose recalling the *Mona Lisa*. This conception imbues the painting with a sense of poetry. Although painted in an interior, Corot applies colors and a technique close to those he employed in his landscapes. They lend the figure the same tranquil quality of his outdoor scenes.

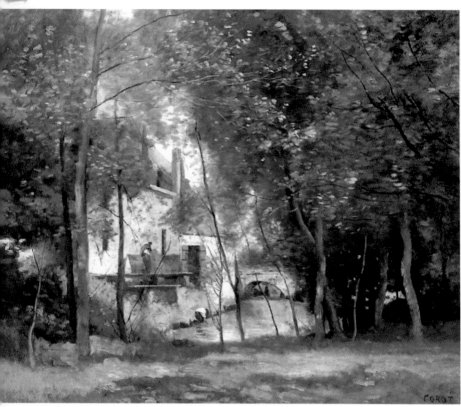

The Mill at Saint-Nicolas-les-Arras

(1874)
oil on canvas
26.2 x 32.4 in (65.5 x 81 cm)
Musée d'Orsay, Paris

After an entire career dedicated to landscapes, Corot achieved a spontaneity and a mastery of technique that fascinated Monet, who claimed, "There is only one master, and that is Corot; compared to him, we are nothing."

Here Corot renders his pattern of trees in the foreground in dense, dark colors that act as a frame, through which a luminous background can be seen. The results here are a masterpiece. In the foreground, light enters and illuminates the ground and some leaves, and dapples the trees in glints, animating the vegetation and filling it with rhythm.

Beyond them is a mill, not an especially attractive building but one that becomes fascinating in the hands of this artist. Corot extracts from each element all its suggestive and poetic facets: the water, the bridge, the whitewashed walls, the contrasts, the warm light, the two figures and the blue sky. As in many of his works, the painting radiates tranquility and reveals the artist's great esteem of the landscape and his sharp observational skills. He demonstrates how an ordinary view can be converted into something spectacular.

The artist's ability to use a limited color range, as in the trees, is remarkable. The green in them appears in a variety of tones, hues, and intensities, describing the elements and creating depth. Through the use of varied tones and the absence of black, he achieves a delicate painting of chromatic richness and makes the landscape beautiful and relaxing, a sort of refuge where one can withdraw and relax in the outdoors.

COROT

EUGÈNE DELACROIX

Self-portrait, *oil on canvas, 26 x 22 in (65 x 54.5 cm), 1837, Louvre, Paris.*

Following Géricault's untimely death, Delacroix became the leading exponent of French Romanticism and a staunch champion to free painters from inflexible academicist canons. Many of his paintings reflect this ideology, and his historical scenes are represented with force, dynamism, and a Baroque touch.

Delacroix even rejected the use of models. He sought a chromatic balance in his works based on complementary colors, ceaselessly experimenting with them. He enlivened his paintings by juxtaposing hues, leaving them to be mixed by the viewer's eye. This opened the door for the work of Impressionists and Neo-Impressionists.

An educated, passionate person, his work reveals the existence of an internal struggle, a constant spiritual crisis, and an innate nonconformity that led him to discover new artistic ideas.

Delacroix's work is highly unified and demonstrates how values as diverse as romanticism and classicism, graphic arts and oil painting, mural decoration and easel painting, and personal inspiration and commercial or social demands can coexist peacefully if the artist is highly talented.

- **1798** Born on April 26 to a well-off family. He is the bastard son of Talleyrand.

- **1816** With a sound classical education and on the advice of his uncle, the painter Henri Riesener, he enters the studio of Guérin.

- **1822** Exhibits *The Barque of Dante* (Louvre, Paris) at the Paris Salon, where it is acquired by the State.

- **1824** Exhibits *The Massacre at Chios* (see p. 298) at the Paris Salon, revealing a new conception of painting that unintentionally makes him the standard-bearer of a new school.

- **1825** Stays in England from March to August, where he is acquainted with the art of Constable, Turner, and Bonington, and the English watercolor tradition. Attends plays by Shakespeare and sees the opera Faust, based on Goethe's work, all of which he finds magnificent.

- **1827** Participates in the Paris Salon with *The Death of Sardanapalus* (see p. 299), which gives rise to a variety of contrasting reviews and criticism. Fond of social and intellectual gatherings at Parisian establishments, he maintains friendships with Stendhal, Mallarmé, Dumas, and George Sand, among others.

- **1831** Receives the Legion of Honor.

- **1832** Travels to Morocco as part of a delegation headed by the duke of Morray. The Sultan Muley-abd-al-Rahman receives them. This trip changes his life and his artistic style.

- **1836** The government, presided over by Adolphe Thiers, founder and first president of the Third Republic, gives him important commissions.

- **1842** Spends several days at Nohant, at George Sand's house. There he meets Chopin, whom he had first met in 1836.

- **1854** Due to the riots related to the Paris Commune, his paintings in the Hall of Peace at the city hall are destroyed.

- **1855** Afflicted with tuberculous and laryngitis, he nevertheless enjoys great success at the World Exposition, where he exhibits 42 canvases.

- **1858** Decorates the Chapel of the Angels in the Church of St.-Sulpice.

- **1863** On August 13, dies at his home at 6 place de Furstenberg, near the Church of St.-Sulpice. He is buried at Père Lachaise Cemetery.

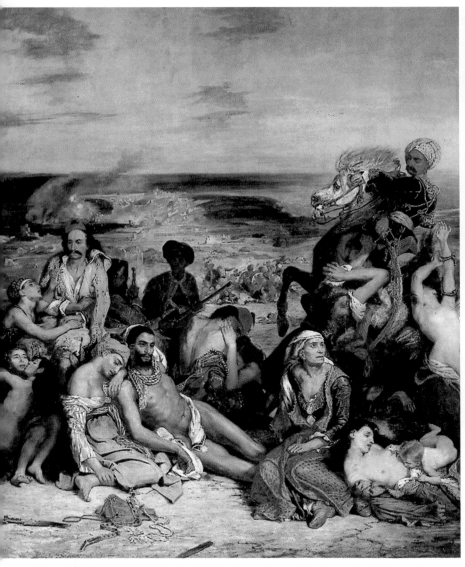

The Massacre at Chios

(1824)
oil on canvas
166.8 x 141.6 in (417 x 354 cm)
Louvre, Paris

In 1822, the inhabitants of the Greek island Chios revolted against Turkish rule. The Turks cruelly put down the uprising, massacring 22,000 people. The painting, exhibited at the 1824 Salon, represents this incident, which aroused great interest throughout Europe because the Greeks were fighting for their liberty. In fact, the work is interesting for its condemnation of Turkish domination over the Greeks and for its contribution to the Romantic movement.

Delacroix was classified among the Romantic painters who were initiating a new style, as opposed to the group of classicists, followers of Ingres, and, though he did not intend it, he became the champion of the Romantic movement. Though the artist grouped the figures as if they were a classical relief, the modeling and rich palette of dense colors evoke the Rubensian Baroque.

The figures of this scene portray all of the calamities inherent in war: death, misery, desperation, and helplessness. Each nude comprises a specific, highly sensitive, individual anatomical study with perfect yet unpresuming foreshortening. The palette of the complexions is remarkably rich: the man with an athletic build has tanned skin of Asian appearance, whereas the women's complexions are much lighter and more luminous. In addition to the thorough study of the figures and the rich nuances of their expressions, the painter also placed a great deal of effort in the background and the bright sky, which act as a backdrop in which the influence of Constable is evident.

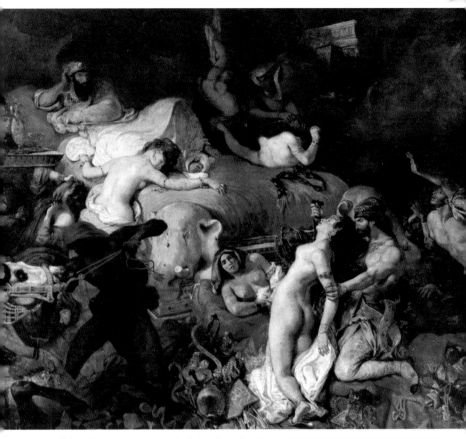

In 1825, Delacroix spent several months in London, where he was able to admire the works of Romantic English painters. The subject of this work, clearly Romantic, is taken from Lord Byron's tragedy, and it constitutes one of his most renowned and frenetic works.

On his return to Paris, he exhibited it at the 1828 Paris Salon. This large work, whose audacity sparked conflicting responses, is an unequivocal attack on the intransigent academicism represented by the classicist followers of David.

The Death of Sardanapalus

(1827-1828)
oil on canvas
158 x 199 in (395 x 498 cm)
Louvre, Paris

The scene represents the time when the Assyrian king, Ashurbanipal (Sardanapalus in Greek), the grandson of Sennacherrib and a sumptuous monarch fond of all sorts of luxuries and pleasures, finding himself in Nineveh, was besieged by the Medes for two years. Seeing that the city could hold out no longer, and in order to avoid surrender and defeat, the king ordered his entire court to be killed, including his concubines, slaves, and even the horses, and his palace to be torched, where he himself perished in the flames.

The work is strikingly Baroque in composition and its abundance of elements. Despite the tragedy occurring, the decor and atmosphere reveal the luxury and voluptuousness in which the king indulged. The highly sensual female nudes are treated with a nervous, direct brushstroke over a studied drawing from nature, with realistic proportions far from the subjective interpretations of Ingres, Delacroix' artistic rival. The painting shows the influence of Rubens, especially in the movement and composition, as well as of Rembrandt, in the treatment of the shadows through direct blending and impasto, and in details such as the horse's head in the lower left.

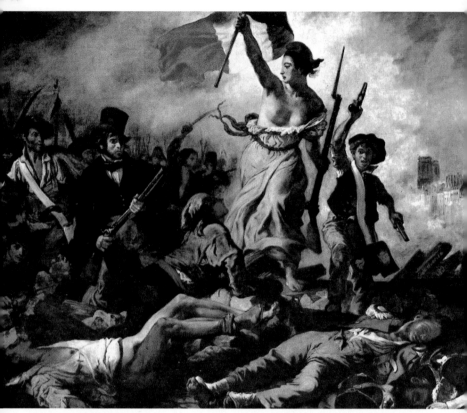

Liberty Leading the People

(1831)
oil on canvas
104 x 130 in (260 x 325 cm)
Louvre, Paris

After meeting Géricault, Delacroix enrolled in the School of Fine Arts where he began copying historical and mythological works as was traditional. He intended to create his own historical works employing the contributions of technique and subject matter of Géricault, who died before fully developing them.

This romantic spirit led him to execute this work, which he exhibited at the 1831 Paris Salon. The painting is an idealized allegory of the rebellion of July 28, 1830, which brought about political change and placed Louis-Philippe on the throne of France. This is one of Delacroix's most important works, and elevates the historic event to an epic level. It closes his early romantic period.

Liberty, represented by the woman with one breast uncovered and holding up a flag, is shown as an intrepid leader who controls and inspires the masses. In the heat of battle, her nude torso reveals a powerful body that recalls certain sculptures by Michelangelo. She is the embodiment of the passion and courage of those whose profound convictions lead them to defend a cause.

The nude is not sensual, but rather serves to reinforce the epic nature of the work, though the falling shoulders of the dress leave turgid breasts in view that are not exempt from certain eroticism accentuated by their contrast with the rest of the dramatic scene. The illumination modeling the torso is harsh, making the bust more forceful, the firm, round breasts revealing Delacroix's interest in idealizing the figure. The fact that the artist rendered himself in the work (he is the figure on the left in a top hat) underscores his personal support of the popular cause that led to the uprising.

Aspasia *or* The Mulatto Aline

(1824-1826)
oil on canvas
32 x 26 in (80 x 65 cm)
Musée Fabre, Montpellier

This nude, one of Delacroix' most beautiful, is far removed from the criteria of the French Academy, for both the figure's lack of idealization and the loose and independent pictorial treatment, in direct brushstrokes with impasto. These were the result of his continual experimentation and his romantic spirit.

The brushstroke and synthetic manner of executing the forms recall Velázquez. The dress is executed in numerous brushstrokes with no direct blending, a characteristic which the Impressionists would imitate.

After his trip to Morocco in 1832, Delacroix's style, previously inclined toward romanticism and epic art, undergoes a change. The country, people, customs, and lifestyle impressed him deeply—he discovered a more relaxed, serene world, reflected in this painting, which he exhibited at the 1834 Paris Salon. The room shows the tranquility, luxury, pleasure, refinement, and sensuality that were never lacking in the homes of the rich. Though everything is perfectly visible, the setting is darkened to allow the illuminated figures to stand out and become the focus of attention. Their placement and attitudes portray the same emotions that Delacroix wants to communicate.

Women of Algiers in Their Apartment

(1834)
oil on canvas
72 x 91.6 in (180 x 229 cm)
Louvre, Paris

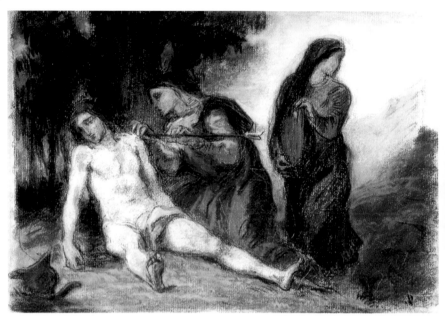

Saint Sebastian Attended by the Holy Women

(1850-1854)
pastel
7 x 10.6 in (18.2 x 26.5 cm)
Private Collection

According to legend, Sebastian was a Roman military leader who converted to Christianity and underwent martyrdom for refusing to renounce his faith. After suffering the punishment that would lead to his death, he was attended by Irene, a rich and pious woman, who removed the arrows from his body and cured his wounds. This is the subject of this canvas, a replica of a previous one (1836, oil on canvas, Church of St. Michael, Nantua, Ain). The lovely nude is realistically foreshortened, in a way approaching those of the Renaissance and the Baroque. The brilliance of the figure, surrounded by dark tones, is striking. The luminous areas of the saint's body are combined with other, slightly grayer hues, creating tonal differences that define the anatomy. The background and the figure of the women, less defined, in dark tones and in the shadows, increase the suggestive, mysterious effect of the scene.

The Struggle of Jacob with the Angel

(1861)
oil and wax on wall
312.4 x 194 in (781 x 485 cm)
Church of Saint-Sulpice, Paris

This work can be considered the artist's spiritual testament. It represents the biblical story in which Jacob struggles with an angel under the guise of a man. Before the angel leaves, Jacob requests his blessing. The angel reveals himself to Jacob and tells him that God sent him, and that, henceforth, Jacob's name would be Israel.

The painting is filled with rich vegetation. The tough, warriorlike figures are in the middle of hard combat in a grandiose, highly dramatic setting that would do justice to the best of traditional operas. The fact that the format is so large makes it even more remarkable, as there are neither errors nor any signs of hesitation whatsoever.

HONORÉ DAUMIER

The Print Collector, *oil on canvas, 16 x 13 in (40 x 32 cm,) 1860, Musée du Petit Palais, Paris.*

A lithographer famous for the caricatures he published in various republican newspapers, Daumier began painting as well as sculpting in 1852. His artwork focused on everyday scenes in which he dispensed with academic canons and concentrated on the gloomy side of life, the most prosaic atmospheres, and the most sordid places, with humble people as the principal protagonists.

Accustomed to painting from memory, he never painted his works from nature. At a time when drawing was profoundly respected by artists, Daumier was admired for his great mastery of the line, developed through his experience in lithography. He tended toward an exaggeration approaching caricature in his pictorial works, though the elements of his paintings were always well distributed.

Although he touched on religious, mythological, and literary subjects, his works were distinguished for their social commentary. His artwork did not give rise to a school, nor did he have followers, but for his style, he deserves a place among the famous painters of his time. His paintings are characterized by a long, sketchlike brushstroke that clearly recalls Goya.

Creator of a new social caricature in painting, he was a master of the satirical-realist style. His distorted forms led him to be considered a precursor to Impressionism, and the force and aggressiveness of his images an exponent of Expressionism.

- **1808** Born in Marseilles to a glass artisan with literary aspirations.

- **1814** Moves to Paris with his family.

- **1829** Publishes his first lithographs, executed in his spare time.

- **1830** Begins his career as a caricaturist-lithographer for the magazine *La Silhouette.*

- **1831** Under the pseudonym of Rogelin, he collaborates on the magazine, *La Caricature,* owned by Charles Philippon, with caricatures harshly criticizing the dominant social classes.

- **1832** His satirical works against King Louis-Philippe, whom he had previously held in high esteem but who now disappointed him, and especially the caricature *Gargantua,* land him in prison for six months beginning in August. The publicity he receives from his imprisonment turns him into the most famous political caricaturist of the day. He does not stop drawing in prison.

- **1834** He executes a series of lithographs on the *Repression of April* (Galerie des Illustrations de la Bourgeoisie Parlementaire, Paris). His lithograph *La Rue Transnonain* (Boston Public Library Collection), depicting the execution by firing squad of a group of unarmed men in a working class house, becomes the symbol of repression of all times.

- **1835** *La Caricature* is banned. As a substitute, Philippon creates *Charivari,* on which Daumier collaborates until 1872, with caricatures criticizing the new French bourgeoisie. Strict censorship laws make it difficult to disseminate his republican ideology.

- **1848** With Napoleon III's coup d'état, two new characters appear in Daumier's repertoire: Ratapoil, a person living at the expense of others, and Monsieur Prudhomme, a politician of false ideals and a self-interested patriot. Paints *The Republic* (Musée d'Orsay, Paris), his first work as a painter.

- **1852** In addition to lithography, he now focuses on genre paintings and theater and courtroom scenes.

- **1870** True to his ideals, he refuses the Legion of Honor.

- **1875** Becomes blind and is assisted by Camille Corot, who gives him a house and a stipend.

- **1878** His only individual exhibit is held at the Durand-Ruel Gallery in Paris.

- **1879** Dies in Valmondois.

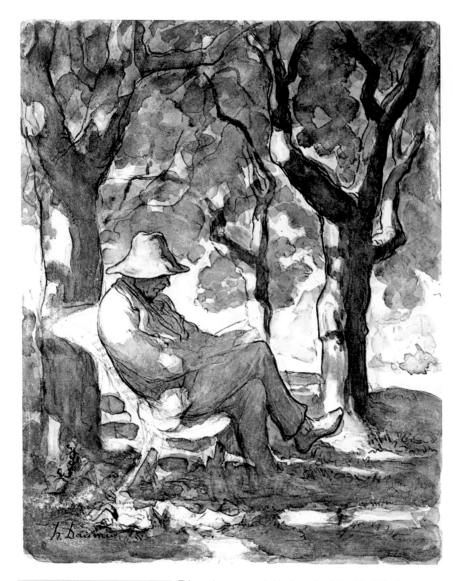

The Reader

(~1832)
watercolor and black pencil
13.5 x 10.8 in (33.8 x 27 cm)
The Metropolitan Museum of Art,
New York

This work was executed by Daumier during his difficult years, when he published caricatures in *La Caricature* criticizing the working class and especially King Louis Philippe of Orléans, whom he had supported as a candidate to the throne but whose policies had disappointed many of his supporters.

This painting is imbued with a romanticism enhanced by the placement of the figure among the luxuriant vegetation of a park. It is a humble, relaxed figure placidly involved in reading. In this setting, the scene might seem poetic, were it not for certain details that reveal Daumier's intention, with elements characterizing his later works: harsh strokes, in some areas even aggressive, thick lines outlining everything, and strong contrasts between light and shadows.

Upon closer observation, the state of the protagonist is actually quite ambiguous. It is difficult to tell whether his attitude is one of relaxation or depression, tranquility or exhaustion. Considering the artist's personality, his ideology and the general subjects of his works, it would be appropriate to interpret this work as a social statement: despite being in a pleasant place, a park, the humble person, often feeling alone, tired, and disillusioned, never manages to free himself from the weight of life, from the difficulties of getting ahead.

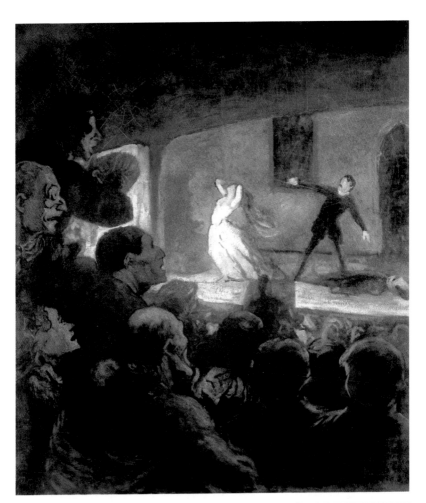

The world of theatre was one of Daumier's favorite subjects, possibly because it allowed him to combine reality with fiction, mix pantomime with satire, and play with contrasts between light and shadows, which can be interpreted in a dual manner.

In this work, the artist uses a style similar to many of his lithographs. The audience members have deeply expressive

Drama

(~1859)
oil on canvas
Neue Pinakothek, Munich

faces showing surprise and even horror. Fascinated by what is occurring on stage, they are submerged in a darkness that lends them a dramatic air. The scene is violent, with a man lying dead, a woman in a long white dress, her long hair flowing, in utter desperation, and a third character in the center who makes a commanding, threatening gesture. Just in front of the stage is the orchestra, with the director before it.

In a homogeneous chromatic range, the work shows an interesting interplay of light and shadow, with the audience in darkness, their caricaturized faces resembling masks, forming a dark mass that contrasts strongly with the illuminated stage. This gives rise to a suggestive chiaroscuro that juxtaposes volumes in two settings: one sordid, dark, nearly dismal (the audience) and the other brilliant and spectacular, yet fictitious, artificial (the stage). It is evident that, above and beyond the pictorial interest, Daumier was attempting to create a parable juxtaposing two worlds, two very different realities of society.

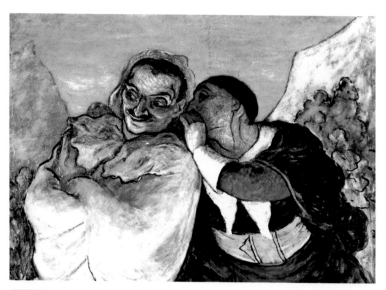

Crispin and Scapin

(~1860)
oil on canvas
24.2 x 32.8 in (60.5 x 82 cm)
Louvre, Paris

Daumier was always a staunch, critical observer of reality. He became a caricaturist because this genre allowed him to reveal and satirize the defects, corruption, and abuse of those in power. This work represents two figures that the French theater had borrowed from Italian theater. One of them whispers in the ear of the other, who is attentively observing something occurring before his eyes. His sardonic gaze clearly demonstrates the painting's satirical intentions. Although these are two theater characters, and therefore fictitious, they describe perfectly the reality surrounding them. The expressiveness, the touch of romanticism, and a certain lyricism do not prevent a critical view of the scene.

The Good Bottle

(~1860)
oil on canvas
8.8 x 11.6 in (22 x 29 cm)
Nationalmuseum, Stockholm

In this painting, Daumier represents a scene very similar to a lithograph, for both its subject and the technique employed, characteristic of his work. It depicts a meeting, rather than a social gathering, doubtless similar to those that Daumier frequented with his politically like-minded companions. The group sits around a table in a room at night while one of them returns from fetching a bottle of wine. The caricaturized treatment of the figures is quite interesting, as is the light that strikes the center of the painting like a flash and determines the appearance of the figures and the atmosphere in the room. The scene has great force, with dense, saturated chromatism.

As he felt deeply rooted with and politically dedicated to the humble classes and their milieu, Daumier showed a propensity for using common folk as his subjects. He always represented members of this social level with a great deal of respect. Although he does not ignore their humility nor the privations of their social condition, Daumier often seeks a certain lyricism and color treatment that enhances the figure itself, similar to Millet's works.

The Laundress

(~1863)
oil on canvas
19.6 x 13.2 in (49 x 33 cm)
Musée d'Orsay, Paris

This painting represents a humble woman holding her child's hand as they walk up a set of stairs after having washed the clothes she is carrying under her left arm in the Parisian waters of the Seine. The figures are like blended shadows. The artist is concerned less with representing specific people than with depicting anonymous figures of everyday life. The figures convey their social condition, their humbleness, and a certain amount of fatigue. They are backlit and undefined, though all the basic elements are visible.

The artist tends toward abstraction, since it helps him to call forth certain emotions and create an allegory of a specific reality. And he truly achieves his aims. The strong contrast between the foreground and the radiant sun striking the houses on the other side of the river under a dark sky enhances the unreal and somewhat visionary quality of the scene. The image offered, loose, passionate, and suggestive, is part of a world that would appear repeatedly in the works of the Expressionists.

The Third-Class Carriage

(1863-65)
oil on canvas
25.8 x 35.5 in
(65.4 x 90.2 cm)
The Metropolitan
Museum of Art,
New York

This is one of Daumier's most characteristic works. Once more, he represents several figures crowded into an enclosed space (here, a train car). The scene clearly juxtaposes two worlds, two social classes. In the background is a group of people, mostly men in top hats tranquilly conversing; in the foreground, and clearly separated, is a group of humble folk. This is a faithful reflection on the poverty of a wide sector of society that is marginalized and must confront the difficulties of life in solitude and disillusionment. It is certainly a romantic vision, yet it is also a cruel one. To prevent any doubts concerning the social meaning of this work, the principal and almost exclusive protagonist is the human being.

Two Heads

(~1870)
oil on canvas
9.2 x 12 in (23 x 30 cm)
Museu de Arte, São Paulo

Daumier certainly had a somber, pessimistic view of life. This is natural since he lived in times of great political upheaval. Consequently, he defended the cause of the lower classes, among whom there was no end of problems, and became personally acquainted with the harsher side of life. The subjects of his artwork and his manner of treating them reflect this. In its composition and message, this works recalls Géricault's *Heads of the Executed* (see p. 287). In this case, these are not two severed heads but the busts of two people immersed in a dark world. One of them, with back turned, is nearly completely in black silhouette. The expression of the other leaves no room for doubt—they are desperate. The density and darkness of the colors support this fact. The romanticism of this work is realist in its description of the figures and profoundly dramatic in its exaggerated postures and use of color.

JEAN-FRANÇOIS MILLET

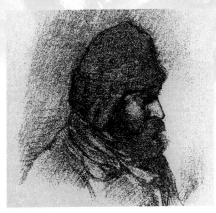

Millet in a contemporary engraving.

The fact that Jean-François Millet was born into a peasant family and grew up in the country affected both his subject matter and its conception. He mostly painted scenes of rural life, which he interpreted with mastery.

Realistic, static, somber, and austere, as well as somewhat cold, his oeuvre is an ode to nature and a homage to humble country folk. He represents them as they are, with no idealization or romanticism. His country scenes are often permeated with emotion and melancholy.

Although his works generally represent outdoor scenes and belong to the Barbizon School, a fervent champion of painting in the open air, Millet executed his works in his studio. He would go out, observe, sketch, and then create his compositions at home.

His painting focuses on draftsmanship, and is devoid of any unnecessary accessories. The figures are often represented in silhouette, with the illumination taken to an extreme. He defines the forms of the figures using basic colors with little elaboration. Although he was politically conservative, the great simplicity of his works led to the widespread belief that he promoted a socialist view. In reality, he was a fatalist. The peasants he portrays do not demand change, but rather appear resigned to their miserable situation. His careful compositions, in which perfect balance is sought between the background and the figure, and his study of light, executed in a theatrical manner, influenced painters such as Boudin, Bazille, Sisley, and Van Gogh, who executed several personal versions of Millet's works.

Millet was a singular, ingenious painter, whose style differed completely from Constable's vision of rural themes. He is justly considered one of the most eminent French landscape artists and a predecessor of Impressionism.

- **1814** Born in Gruchy, near Cherbourg, Normandy.

- **1835** Studies under the portraitist Mouchel, a follower of David, in Cherbourg.

- **1837** Moves to Paris, where he enters the studio of Delaroche.

- **1840** After quitting his official art studies, he participates in the Paris Salon.

- **1845** Paints *Madame Lecourtois* (Louvre, Paris), one of his most remarkable portraits. Meets Troyon and becomes acquainted with Durand-Ruel, a merchant who would become famous for his close relations with the Impressionists.

- **1848** Concentrates on portraits and religious scenes. Meeting with no success, he turns to rural scenes. Paints *The Winnower* (National Gallery, London), which was presented in the Paris Salon the same year, where Alexandre Ledru Rollin, Minister of the Interior, saw it and commissioned a painting, *Le Semeur* (Provident National Bank, Philadelphia).

- **1849** Fleeing a cholera epidemic, he settles with his family in Barbizon, a village in the forest of Fontainebleau, where he meets Théodore Rousseau. They become good friends and join the local group of painters, known as the Barbizon School.

- **1854** Thanks to the merchant Sensier and several friends, he sells a series of paintings.

- **1855** Participates in the World Exposition of Paris with the painting *A Peasant Grafting a Tree* (Private collection), obtaining great success.

- **1859** Consolidates himself with the painting *The Angelus* (see p. 313).

- **1862** Paints *The Man with the Mattock* (Hillsborough, California).

- **1866** Begins painting watercolor landscapes of Barbizon.

- **1867** The French government grants him the first class medal, a decoration that was given from time to time to persons who had distinguished themselves in the world of the arts and culture.

- **1868** Appointed Knight of the Legion of Honor.

- **1875** On January 20, he dies in Barbizon, highly respected yet in financial difficulties. Buried next to his friend, Rousseau, who died nine years earlier (1876).

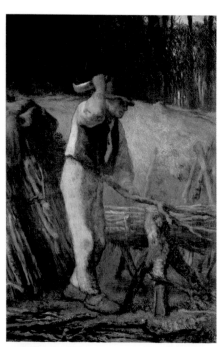

The Log Splitter

oil on canvas
15.2 x 11.8 in (38 x 29.5 cm)
Louvre, Paris

In keeping with Millet's characteristic subject matter, this painting offers a vision of rural life. It portrays a peasant splitting firewood to prepare for the imminent winter. Far from representing a tough and idealized figure, the artist tends toward a simple, humble image. The dark tones seem to emphasize the difficulty of life. Executed with academic draftsmanship and modeling, the image is expressive and the message perfectly conveyed.

The subject matter, which Millet frequently represented, caused great excitement among the bourgeois French society, since, in addition to being a novelty, it focused on a social stratum that had previously elicited little interest among the so-called "privileged class."

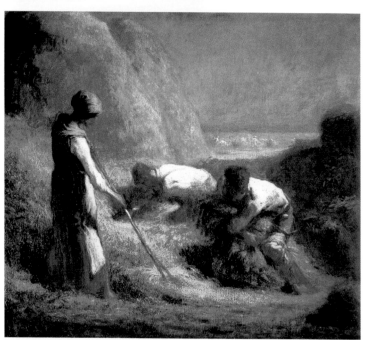

The Sheafmakers

(~1850)
oil on canvas
21.8 x 26 in (54.5 x 65 cm)
Musée d'Orsay, Paris

As a member of the Barbizon School, Millet was always interested in landscapes. But his origins and constant preoccupation with the humble country folk led him to closely combine landscape and figure painting, creating images of profound documentary interest. Here, Millet illustrates the work of forming the sheaves in preparation for threshing. Through a strategic use of light and shadowS, he produces a theatrical and expressive image. Rather than seeking to show the pleasant side of the everyday life of peasants, the artist attempts to represent the reality of an entire sector of society that is forced to work hard in order to eke out a living.

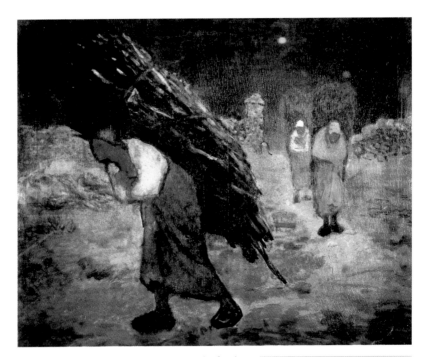

Winter: The Wood Gatherers

oil on canvas
31.2 x 38.8 in (78 x 97 cm)
The National Museum of Wales,
Cardiff

Some consider Millet to be a conformist, an artist who fought little to change things. Clearly, he knew the countryside and the people who worked the land so well that he successfully reflected what he saw in his canvases, that is, the crueler side of nature and the difficulty of the peasant's life. Although his works reveal this world, they do not condemn it, since the figures are represented as inevitably bound to their slavish situation. This painting is an eloquent display of his fateful view: in the middle of the night, in the harshness of winter, several women are weighed down by the huge bundles of firewood, their gestures expressing exhaustion and pain. The draftsmanship, the thick lines, the economy of detail in the figures, which are more akin to specters or masses of color, the color of the night, against which the women are silhouetted, and their poses lend the scene its profound drama and vividly capture the harshness and suffering that is the condition of these wood carriers.

The Seamstress

oil on canvas
13.2 x 10 in (33 x 25 cm)
Musée d'Orsay, Paris

Although the figure is the subject, Millet has not painted a personal portrait. This is an image of the everyday life of a humble seamstress, alone, against a plain background with nothing to distract from her.

The composition is well conceived, and the artist reveals a thorough grounding in draftsmanship, as he describes everything in a few strokes and a successful interplay of light and shadows. Although the scene is set in an interior, unrelated to the usual farming world, and the colors used are bright and varied, ranging from blues to yellows and greens, and even red, the work inevitably conveys the melancholy air typical of Millet's works, raising a feeling of unease in the viewer.

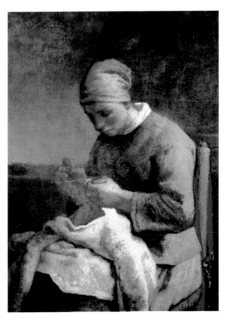

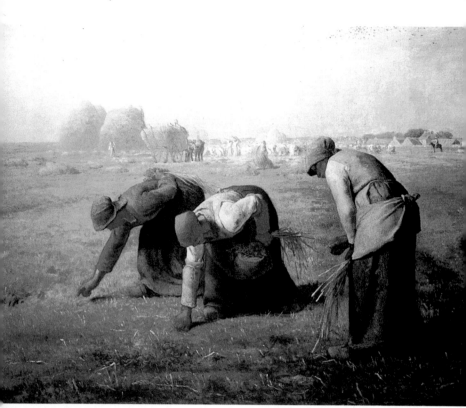

The Gleaners

(1857)
oil on canvas
33.4 x 44.4 in
(83.5 x 111 cm)
Musée d'Orsay, Paris

This is another view of country life. After the reaping and once the sheaves have been formed, women walk through the fields gathering the wheat that has been left behind. This painting once again reveals the reality of a social class that, immersed in poverty, struggles indefatigably to earn a living, working a devastated land. This is a representation of the misery of the peasantry in the year of 1848.

Just as Courbet's work was associated with a new social naturalism, strongly contrasting with the classicism and romanticism reigning at the time, Millet's work must also be understood in this context. However, the message is not typically socialist, since it does not condemn the fate of these peasants. Rather, it is fatalistic. The paintings of this artist provide documentary evidence of the reality of the time.

Millet was a nature lover and enjoyed painting outdoors. Obsessed by peasants and their problems, he converts nature into yet another element to illustrate the reality of rural life. Hence, he does not portray bucolic, springtime scenes full of poetry, but rather crude, harsh nature and arid, rough land. It is not an attractive and gratifying setting in which to lose oneself, but a daily battlefield of sweat and toil with little, and sometimes even no, reward. From his own childhood, Millet had been so influenced by this reality and felt such a need to communicate this message that all elements in his artwork serve this purpose. To gather some meager handfuls of wheat, these women are working in a treeless landscape, under the summer sun. As in many of his works, the inclined posture of the figures seems to indicate their situation of inferiority and helplessness.

J.F. Millet

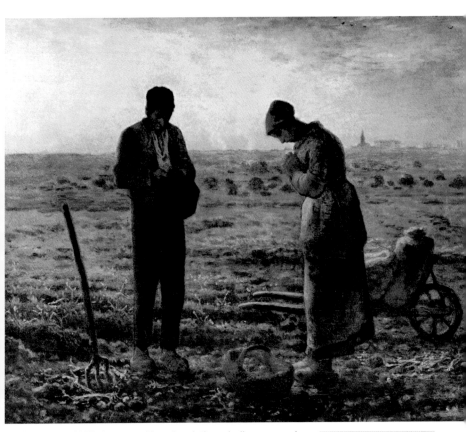

This is one of Millet's most emblematic paintings, dealing once again with rural life. At precisely twelve o'clock noon, the church bells were rung to inform the people in the area that it was time for the angelus. This meant that the faithful had to interrupt their work and recite the Hail Mary, recalling the evangelical episode of the Annunciation of the Archangel Gabriel to Mary, informing her that, despite her virginity, she would conceive a son who was to be the Messiah.

Millet combines a series of elements (composition, draftsmanship, landscape, light, romanticism, and aesthetics) to create a profoundly expressive painting, as always, with a subliminal message. The horizon is very high, generating a sentiment of pessimism due to the overbearing weight of the land. Only the profile of the village church and a few trees can be discerned on the horizon. The rest is an immense plain with some bushes and hay.

Although the scene takes place at noon, the painting is illuminated with a subdued, tenuous light, so that the static figures are in half-light, though the woman is more brightly lit. Absorbed, the two peasants put their hands together to pray in silence. The unrewarding nature of the work foretold by the infertile ground, the sorrow of life alluded to by the melancholy colors, the impoverished clothing, and the sense of neglect and loneliness in a solitary, treeless landscape characterize the existence of these poor people, who take refuge in prayer, as they can hardly satisfy their physical hunger.

The Angelus

(1859)
oil on canvas
22.2 x 25.4 in
(55.5 x 66 cm)
Musée d'Orsay, Paris

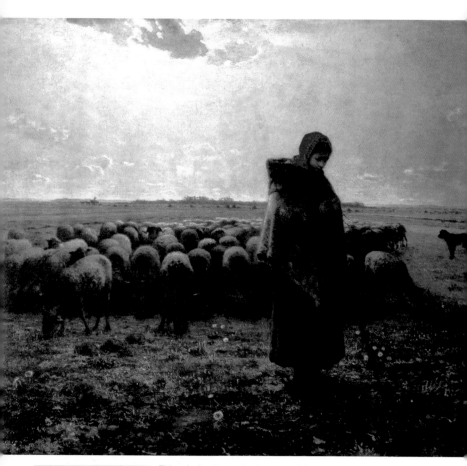

The Shepherdess

(1863-1864)
oil on canvas
32.4 x 40.4 in
(81 x 101 cm)
Musée d'Orsay, Paris

This painting has a simple composition, regulated by a completely flat horizon line that divides the painting in two. The sky is executed in variable tones, with the sun hidden behind the clouds and immersing the absolutely flat, desolate landscape in twilight. Only in the far distance can several trees be seen, along with a cart pulled by two horses on which sheaves are being piled, and some low hills. The remainder is a flat, nearly barren land, with only sparse grass to feed the flock of sheep that the young shepherdess is grazing.

The entire scene is flooded in twilight, emanating from a dim sun that backlights the shepherdess and sheep. Both the group of animals and their shepherdess are well drawn. The artist successfully employs a technique that avoids the monotony inherent to the scene, creating rhythm and movement through the treatment of light, perspective, and distribution of the sheep.

The image would be romantic if it weren't for the feeling expressed by the shepherdess. Warmly yet humbly dressed and withdrawn, she turns her back to the flock, leaving the flock under the watchful eye of her dog, seemingly to pray. As well as representing an everyday moment, Millet conveys a subtle but cruelly sober message: the only solace the poor woman has is in prayer. This message is emphasized by the general chromaticism of the painting, whose brightest areas reflect a subdued light, while the remainder is immersed in a twilight that barely illuminates the woman's headscarf.

GUSTAVE COURBET

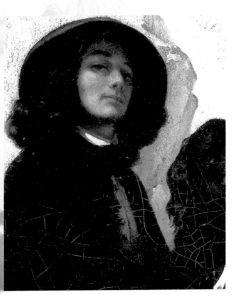

Self-portrait with Black Spaniel *(detail), oil on canvas, 1844, Petit Palais, Paris. The artist is 23 years old here.*

Courbet's art deals with harsh reality. For this, he was the leader of Realism. Furthermore, it reveals his socialist ideology and constitutes an excellent account of society in the mid-nineteenth century.

For him, the medium of painting was a reality in itself, and the artist's role was to use it to denounce social problems. This revolutionary message made him famous and enthralled the younger generations. But it was absolutely unacceptable to one sector of society—the rich and powerful and certain critics who, accustomed to academic ideology and the established order, found his subject matter lacking in artistic value and the conception and treatment of his works vulgar. He was even accused of being sexually obsessed and a provoker for his works on the female nude. This was a crass error in judgment, since his works represent commonplace reality and both the figures and their treatment are imbued with dignity.

This artist's talent, his skillful draftsmanship and compositions, his sure lines and firmness, and his unusual treatment of light and color to create atmosphere make him a great artist, certainly far from vulgar. He changed people's ideas, paved the way for Impressionism, and provided a source of inspiration.

In the end, history determined his rightful place in art. The acceptance that he failed to gain in France was given him abroad with great enthusiasm, and his works are now to be found in the best museums in the world.

- **1819** Born in Ornans, near Besançon, to a family of vine-growers. His grandfather was a revolutionary who influenced him ideologically.

- **1839** Quits his law studies at university and moves to Paris to become a painter. He becomes interested in Veronese, Velázquez, and Zurbarán.

- **1844** Exhibits his first work at the Parisian Salon, *Self-portrait with Black Spaniel* (left).

- **1846** He and Bouchon draw up a manifesto against the Romantic and Neoclassical movements of the time. Travels to the Netherlands, where he admires paintings by Hals and Rembrandt.

- **1848** Paints *Burial at Ornans* (see p. 317), which establishes him as the leading exponent of the Realist School.

- **1851** After Louis Bonaparte's coup d'état, his group of likeminded painters is disbanded.

- **1852** Becomes friends with the socialist theorist, Pierre-Joseph Proudhon.

- **1854** Visits his friend, Alfred Bruyas, in the Midi, the south of France. Begins *The Painter's Studio: A Real Allegory* (see p. 316), which is not admitted to the Paris Salon because it did not adhere to the norms of the Academy.

- **1855** At odds with the organizers of the Paris Salon, he organizes a parallel exhibit funded by Bruyas, in whose catalogue he publishes his Realist manifesto.

- **1856** His artwork begins to focus on the female nude, which he paints with great liberty and total candor.

- **1870** In the midst of the Franco-Prussian War, he is appointed president of the commission for the protection of artistic heritage, which saves the Louvre from burning down in a fire. He refuses the Legion of Honor. Once the war is over, he sympathizes with the Paris Commune and is incarcerated for allegedly destroying the Vendôme Column.

- **1873** With the change of regime, he is condemned to pay for the reconstruction of the Vendôme Column, which forces him to flee to Switzerland. His goods are confiscated and he becomes seriously indebted.

- **1877** Dies in La Tour de Peilz, Switzerland.

The Painter's Studio: A Real Allegory

(1856)
oil on canvas
144 x 239 in (360 x 598 cm)
Musée d'Orsay, Paris

The artist executed this work, curiously subtitled *A Real Allegory*, with the aim of participating in the World Exposition of 1855. The scene, set in the artist's own studio, can be broken down into three perfectly differentiated areas. On the right, the artist's friends—regular people, yet well dressed and placed in a harmonious composition—gaze with interest at his work.

On the opposite side, the weary faces of the figures, both poor and rich, constitute a clear social criticism. Their placement is disorderly, with objects dispersed about the floor. The impression that each one is isolated without the possibility of conversation adds to the message.

In the center, the artist is painting a landscape before the innocent gaze of a child while, behind him, a woman (Truth) has just undressed, revealing her anatomy. She is one of the most beautiful female nudes of French art, this muse who inspires his art. This nude, executed with the mastery characteristic of Courbet, has a powerful yet slender anatomy far removed from any romantic idealism, with a smooth, luminous complexion bathed in the atmosphere of the studio.

The woman occupies the most illuminated area and constitutes the focus of attention. The painting of this nude is especially delicate, evoking the artist's dedication to his work and to the viewer. The painter's passionate language and his force and expressiveness are undeniable. By painting figures from real life, the artist is proclaiming his social and political ideology, with his preferences and desires, his dreams and dislikes, attempting to combine his sentiments as a human being with those as an artist.

The painting combines various elements: portraits, still lifes, a mysterious landscape, an interior, and a well-illuminated, intimate area. The message, compositional conception, and treatment have nothing to do with academic canons, and hence did not interest the official stratum of society. The work was refused for the World Exposition in Paris.

Burial at Ornans

(1849-1850)
oil on canvas
126 x 267 in
(315 x 668 cm)
Musée d'Orsay, Paris

Courbet exhibited this work at the Paris Salon of 1850. Considering the mindset of the French Academy and the traditional, stagnant criteria of a sector of society accustomed to grandiose historical subject matter in the romantic tradition, it did not go unnoticed. Many considered it an inappropriate subject for a painting. They found the extremely realist and abrupt style uninteresting, even vulgar, and therefore unacceptable.

But Courbet was clearly attempting to represent reality as is, with its own implicit message that the painter must communicate to the viewer. Proudhon was one of the foremost defenders of this type of art, an exponent of a clearly socialist view. The subject, a common sight in the painter's native village, is a burial with well-known people from the area. It includes the habitual protagonists in such ceremonies and the usual details, such as the men standing separately from the women, the priest accompanied by altar boys, the undertakers in charge of carrying the coffin, with sheets hanging from their necks, and a dog wandering among the people, all as real as life itself.

The spontaneous and truthful nature of the scene, the garments, and the people's expressions is wholly realistic. The merit of the work lies precisely in having elevated an everyday scene to the category of something historical or even monumental through a meticulous study of each figure; of the illumination, colors, and atmosphere; and, indeed, of all details, making the work forceful. His detractors would not have been so outraged had the work been of low quality. Underlying this adverse criticism was an implicit recognition of its value.

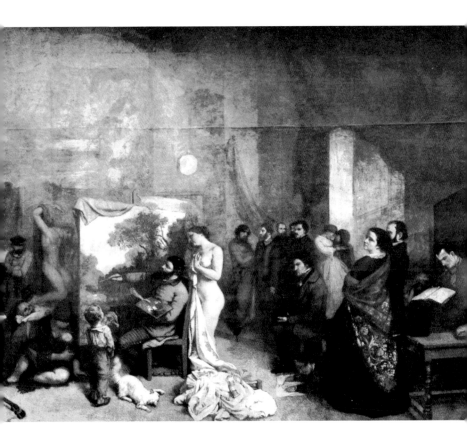

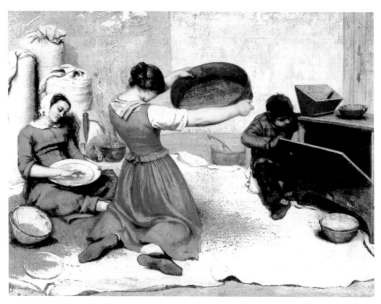

The Wheat Sifters

(1854)
oil on canvas
52.4 x 66.8 in (131 x 167 cm)
Musée des Beaux-Arts, Nantes

Courbet represents some humble figures carrying out a habitual task in their home. In addition to its documentary value and evident aesthetic qualities (composition, characterization, chromaticism, and dynamism), the painting represents the painter's vision of a normal scene and demonstrates the great expressiveness he is capable of extracting from it, full of sentiment and poetry. Nonetheless, the subliminal message contained herein is evident to attract attention to the social reality of the lower classes. These are the interests and sentiments that moved the painter, who was, after all, a person with his own ideas. In the year 1855, this work was exhibited at the World Exposition in Paris.

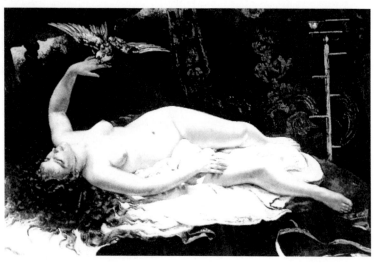

Woman with Parrot

(1866)
oil on canvas
51 x 77 in (129.5 x 195.6 cm)
Museum of Modern Art,
New York

This painting is an eloquent example of Courbet's work. The dark setting enhances the force of this nude and the colors contribute to creating a suitable atmosphere. In his realist style, the artist is technically very free and spontaneous, resulting in a vibrant, fresh, well-conceived idea of singular beauty and not exempt of poetry and emotion. It is precisely these values that strengthen the erotic force of the painting, based on the daring pose, the woman's candor and lack of modesty, and the disturbing fascination that she awakens in the viewer.

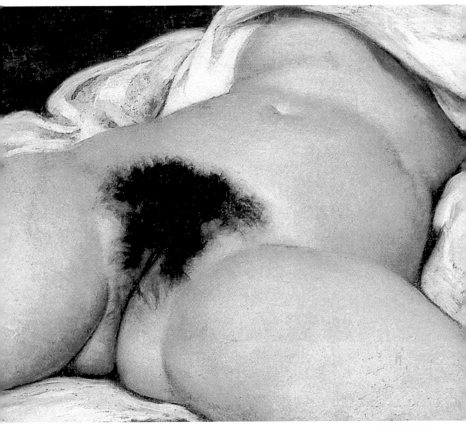

This painting passed through many hands before reaching the Musée d'Orsay. Bought from the artist in 1866 by Jalil-Bey, ambassador of Turkey, in 1868 it became the property of Jean-Baptiste Faure, baritone of the Paris Opera, in whose house it was admired by Gautier, who dedicated some verses to it, and by Edmond de Goncourt, who stated that "it is an abdomen as beautiful as the flesh of a Correggio." The baritone's wife did not rest until he got rid of it.

The Origins of the World

(1855-1856)
oil on canvas
22 x 18.4 in (55 x 46 cm)
Musée d'Orsay, Paris

After changing hands through various owners, a gallery bought it in 1912 from Madame Vial, a private collector. Acquired by François de Hatvany, a collector in Budapest, in March of 1944, it was stolen by the Nazis and recovered by the Soviet Red army. In 1955, Sylvia Lacan, the protagonist of Jean Renoir's *The Rules of the Game*, asked her husband, a psychoanalyst, to give it to her. In 1988, it was exhibited for the first time in a museum, The Brooklyn Museum of Art. In 1995, it became part of the national collections of France and is now exhibited at the Musée d'Orsay.

This long trajectory can be explained by the subject of the painting. In a society with double standards, externally puritan with regard to sex and its representation, it is comprehensible that this work became an utterly polemic piece, at once desired and rejected, admired and anathematized. Courbet was a painter with an open mind, a liberal without conditions, for whom sex was not so much in what was represented in his paintings as what was in the mind of each individual.

In his works, he often dealt with subjects such as this one, in which sex and eroticism are represented decisively and explicitly, without heeding convention, masking reality, or hiding behind appearance and ambiguity, something which he profoundly despised. Courbet was a person who felt and lived intensely. The extremely expressive and incisive nature of his paintings brought him enthusiastic admirers as well as passionate criticism and the resounding rejection of people who saw the artist as an obsessed individual and a libertine who only enjoyed himself when he was transgressing and provoking.

The painting, disturbingly realistic, is perfect in its composition, point of view, and technical execution. It does not leave the viewer indifferent. The subject matter is daring and profoundly interesting, as it constitutes an homage to the intimate sanctuary of the woman in its dual symbolism as a nest of pleasure and fountain of life. Courbet used his red-haired lover, Joanna Hiffierman, as a model.

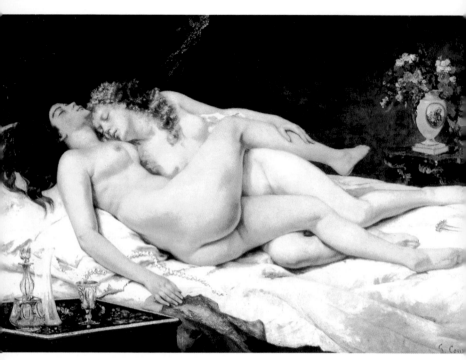

The Sleepers

(1866)
53.2 x 78.8 in (135 x 200 cm)
oil on canvas
Musée du Petit Palais, Paris

Courbet was very sensitive to realism and his scenes, formally perfect and exquisitely meticulous, in both forms and details, were hardly conventional. For their singularity, subject matter, and, often, their message of protest, his paintings made certain sectors of society uncomfortable, caused scandal and controversy, and gave rise to serious problems, even among his friends.

Among the subjects that most interested him, especially after 1855, was the female nude, which he represented often, exhibiting it with total generosity and candidness, no matter what the motive or circumstance. This painting represents two women making love. It was a subject that other artists had previously painted, often using prostitutes who would pose in erotic scenes or lesbian love scenes for little money.

Courbet demonstrates perfect knowledge of the female anatomy, which he executes with exceptional talent to the smallest detail. Nothing remains undefined, everything is meticulously described. The well-studied pose, the expressive faces, the attitude of the models, the texture of their bodies, the setting—everything contributes to the significant charm of this attractive scene.

The figures are sensitive, with beautiful bodies and smooth, delicate skin. The sensuality of their soft, voluptuous forms is seductive, enhanced by the chromatic and rhythmic balance between lines and forms. Courbet has even gone into detail in such secondary elements as the vase of flowers and the objects on the tables. Such perfection makes the scene even more suggestive and incisive.

Gustave. Courbet

ROSA BONHEUR

Rosa Bonheur, with her palette and dog, *mixed media, 18 x 12 in (45 x 29 cm). Painted in 1896 by Consuela Fould, Marchioness of Grasse.*

Although Rosa Bonheur was not an exceptional artist, her personality was so singular that she deserves a place in the history of art.

From childhood, her father instilled in her a love of nature and especially animals, which led her to constantly go into the countryside. She also visited slaughterhouses and animal markets frequently and nearly set up her own farm at her house to observe the anatomy, movements, and habits of animals, which are practically the exclusive subject matter of her works.

Her style is conservative, showing an interest in naturalism, the depiction of reality as is, leaving the artist's own vision and interpretation far in the background.

In her personal life she was highly unconventional, moved by her defense of equal rights for women. Hence, from a young age, she defied the mentality of her time, like George Sand, whose works she admired deeply. She smoked in public, did not ride sidesaddle like other women, wore shorts, and obtained permission from the police to disguise herself as a man and thus enter all of the places where only men were allowed.

Despite her attitude and lifestyle, her art is rather traditional and unoriginal. Nevertheless, she did have a great capacity for work and the desire to represent nature just as she saw it, and she was extremely honest.

- **1822** Born in Bordeaux to Raymond Bonheur, a humble landscape painter, who encourages her to dedicate herself exclusively to painting animals. She studies under her father and Louis Cogniet.

- **1829** Her family moves to Paris, where she visits the Bois de Boulogne, an outlying woodland, to study nature and animals.

- **1835** In her works representing nature, she shows the influence of Constant Troyon and Brascassat, whose works she uses as a reference.

- **1841** Her reputation increases with her exhibition of animal paintings at the Paris Salon, an annual exhibit organized by the French Academy, consisting of works by painters selected by competition, and designed to promote classical and traditional art. She continues exhibiting there until 1853.

- **1845** Obtains third prize at the Paris Salon.

- **1848** Obtains a gold medal at the Salon.

- **1849** Official recognition comes in the form of a commission from the French government.

- **1852** In her struggle for equal rights, she obtains permission from the police to walk through the streets and frequent public establishments dressed as a man.

- **1853** Exhibits *The Horse Fair* (see p. 324) at the Paris Salon, for which she gains international renown.

- **1855** Beginning in this year, she practically stops exhibiting entirely.

- **1857** With two versions of *The Horse Fair*, she introduces herself to British society, where Queen Victoria, with whom she has a good relationship, acquires one for Windsor Castle.

- **1860** During this decade, she paints in both France and Britain.

- **1865** In June, she is awarded the Legion of Honor by the Empress Eugènie, her personal friend.

- **1870** During the Franco-Prussian War, the German government orders its army to leave the painter's studio untouched.

- **1899** She dies in By, near Fontainebleau.

Wagon Pulled by Horses

(1852)
oil on canvas
13.7 x 25 in (34.3 x 62.4 cm)
The Metropolitan Museum
of Art, New York

In many of her paintings, Bonheur combined animals and landscapes with singular skill, seeking different settings and contexts in which to represent animals in movement. She represented them in all sorts of positions and from different points of view.

This painting is very rich, for in addition to its documentary value and the romanticism inherent to the scene, with its tenuously lit landscape, it represents several horses in a variety of different poses. As in other works by the artist, a series of animal studies is combined in a single painting. Each one could have constituted an independent work. The anatomies are well studied and executed, the animals' poses and gestures are natural, and the moment chosen for the scene, when the driver stops to fix one of the horse's bridles, lends it a fresh, spontaneous air.

There are four different colors among the six horses—white, black, brown, and gray—as if Bonheur was attempting to display her ample knowledge of horses. The painting has local color, its evocative charm enhanced by the ancient, rudimentary aspect of the wagon, the general, somewhat warm color scheme, and the measured illumination that gives rise to a richness of tonal variations.

Bonheur represents a traditional scene in this work. During the hunt, hunters, hounds, and horses take a break. The hunters warm themselves around a small fire and prepare a meal.

In this horizontal composition, the combination of elements is excellent. The placement and poses of the hunters and animals are natural, and the artist has achieved a spontaneous scene that resembles a snapshot. The movement of their gestures and poses constitutes an element of strong contrast against the flat, misty landscape employed as a backdrop. Though each element is individually executed, the painting forms a harmonious whole.

As in many of her works, the artist's generous, confident hand renders a scene that could be divided into different parts forming independent works. This characteristic makes the composition much more difficult and lends it a great richness. Another remarkable aspect is the treatment of light, in the form of an intense passage that enters from the right and gives rise to an interplay of light and shadows through which the figures are modeled, relief is created, and intense contrasts are produced. This results in a very clean work, with the figures in dark, dense tones in clear profile against the light background, and with the relief of the landscape in high definition and contrasting tones. Through a studied technique applied with singular success and daring, the painting exudes a love of nature and animals, as well as of the people among them.

Study of Male Figure

Graphite and white chalk
on blue paper
19 x 12.4 in (47.7 x 31.1 cm)
Fine Arts Museum, San Francisco
(Donation of René A. May)

For Bonheur, who specialized in painting animals, this work was an exception. Though the subject matter is different, the style of the drawing is exactly the same as she employed in her portrayals of animals. Academicism, a profound respect for traditional canons, and a great effort to include all aspects that would produce a classical work is evident here. Considering Bonheur's personality, her quest for freedom and her feminist ideas, the conservative nature of her works is surprising—they seem to belong to a bygone age and have an outmoded style. The draftsmanship is excellent, as are the perspective, foreshortening of the right leg, and treatment of light and shadows. The attention to detail and excellent observational skills produce an work of great merit.

Meal During the Hunt

(1856)
oil on canvas
31 x 59.4 in (77.5 x 148.6 cm)
Pioneer Museum and Haggin
Galleries, Stockton, California

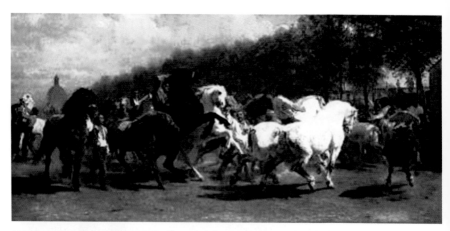

The Horse Fair

(1853)
oil on canvas
98 x 202.6 in (244.5 x 506.7 cm)
The Metropolitan Museum
of Art, New York (Donation of
Cornelius Vanderbilt)

The artist's interest in horses often led her to observe them grazing in meadows, sketch them at the slaughterhouse, and frequent the horse fairs that were held on the tree-lined Boulevard de l'Hôpital in Paris, near the Salpêtrière Home appearing in the background in this work.

Though the painting depicts a view of a horse fair, it is but an excuse to represent a series of horses in different poses from various points of view, such that the painting becomes a set of studies of horses duly combined to produce a whole. It goes without saying that the artist demonstrates a profound knowledge of horses in this work. Among the many horses, there is not the least indication of error or the slightest hesitation. The draftsmanship is excellent, the modeling rich and sculptural— Bonheur was also a sculptor—and the treatment of light and color is carefully studied so that the animals display relief and gain protagonism.

In a predominantly realist style, the painting is perfect. It was exhibited at the Paris Salon of 1853, where it was very successful and brought the artist international renown. Bonheur took up the subject again and later created two more versions, one of which was acquired by Queen Victoria for Windsor Castle in 1857.

The Palette

(1863)
oil on wood palette
20.6 x 18.8 in (51.5 x 47 cm)
The Minneapolis Institute of
Arts, Minneapolis (Donation
of Thomas Barlow Walker
Foundation)

This piece has the dual aspect
of being a painting and a docu-
ment showing the colors used
by Bonheur. The colors are
placed in perfect order along
the edge of the palette, begin-
ning with black and ending in
white, with reds and yellows in
between. The blues and greens
are in a separate area reserved
for mixtures. Warm tones are predominant. The tones of this palette and the colors applied in
Bonheur's pictorial works clearly match. Her great interest in animals is illustrated with the
inclusion of the deer in the middle.

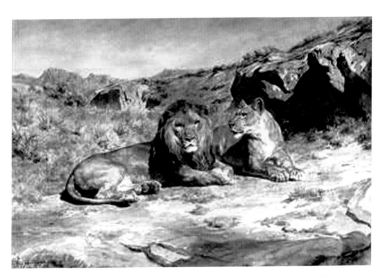

Although Bonheur was always interested in animals, she
rarely painted them alone or out of context, but rather
within a landscape, doubtless reflecting her love of nature
in general. This pair of lions is represented in a desert-like
landscape to enhance the sensation of austerity and
harshness and make the image more powerful. This solu-
tion allows the artist to harmoniously combine the tones
of the animals and the landscape. In addition to achieving
an aesthetic solution, the union between the animals and
their habitat is enhanced. The harshness of the landscape

Kings in their Territory

(1885)
watercolor on cream-colored paper
15.8 x 22.4 in (39.5 x 56 cm)
The Minneapolis Institute of Arts,
Minneapolis (Donation of Ziegler
Corporation)

and the aggressiveness traditionally associated with lions contrasts with the sensation of tranquili-
ty that the painting conveys. The majesty of these beasts and the respect they evoke is combined
with their calmness. Self-assured in the knowledge that they are on home territory, they are
expressively resting and watching. Behind this representation lie many hours of observation,
sketches, and psychological studies of felines.

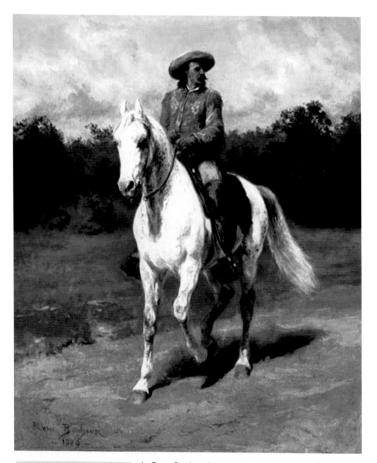

Buffalo Bill

(1889)
oil on canvas
19 x 15 in (47 x 38 cm)
William F. Cody Collection

In Rosa Bonheur's oeuvre, there is an abundance of paintings of horses. Although some affirm that she was influenced by the artwork of Théodore Géricault and Karl Bodmer, this opinion is difficult to uphold, as Bonheur's naturalism, with its light and colors, hardly resembles the style of the former two, which is much more dramatic and spectacular.

Bonheur always felt deep admiration for Buffalo Bill, since she found he personified the freedom and independence existing in the United States. The painting reflects Buffalo Bill's spirit very well. The natural surroundings and the horse he is riding are very natural in style. The animal is slender and elegant, and is represented in detail, with perfect modeling, well distributed volumes, and careful treatment of light and shadows. The movement is dynamic, evident in the action of the swishing tail. Although the horse is the clear protagonist, the artist took care to leave enough space for the rider and the surrounding landscape. The horse stands out against the other elements, which in turn enhance the horse's beauty. This vision is not exempt of romanticism—note the idyllic setting, the idealisation of the person through his elegant aspect, the perfect mount, etc.

JEAN-LÉON GÉRÔME

Self-portrait, *oil on canvas, 16 x 12 in (40.6 x 30.5 cm),*
Aberdeen Art Gallery, Aberdeen, Scotland.

Jean-Léon Gérôme primarily executed mythological
and genre works, but perhaps his most important
paintings were his oriental scenes. In his travels
through Turkey, Egypt, and Algeria, he obtained excel-
lent, firsthand information on a world whose land-
scapes, colors, and traditions fascinated him and gave
him a unique opportunity to develop those subjects at
will. The exoticism and sensuality inherent to such
orientalizing scenes were in fashion in France for a
time and were well received by the public.

Gérôme's artwork is highly realistic, classical in
scheme, and precise in execution. At times, his exces-
sively austere style lends the excellent draftsmanship
a barren appearance, while his highly academic fig-
ures suffer from a certain sculptural coolness, as if
they were made of marble. Gérôme has a cold tem-
perament and a restrained imagination. His works are
remarkable for their execution, always extremely
meticulous, and for their draftsmanship, ingenious
and spiritual, rather than for their originality. Within
a conservative framework, his works are always
imbued with sensuality.

A steadfast champion of official art, he always
took the side of painters who followed the norms of
the French Academy, and fought openly against the
ideas and initiatives of the Impressionists. Considered
one of the last great representatives of academic
French painting, his work is particularly appreciated
in the United States.

- **1824** Born in Vesoul.

- **1841** Enters the studio of Delaroche.

- **1844** Sojourns in Rome, accompanying his
teacher, Delaroche. In the studio, he is directed
by Charles Gleyre, teacher of many of the
important painters of the future Impressionist
movement (Renoir, Monet, Sisley, Whistler,
Bazille, etc.).

- **1846** Participates in the Paris Salon for the
first time, exhibiting the painting *Cockfight*
(see p. 328) with great success. In this work,
the artist touches on the nude, which will
become an important facet of his artistic pro-
duction.

- **1854** Visits Turkey and then Egypt, where
he is fascinated by the landscape, colors, cus-
toms, and lifestyle, especially the luxury and
sensuality of palace interiors.

- **1855** He is granted the Legion of Honor for
his large-format work, *The Legion of Augustus*
(Musée d'Amiens, Amiens), a rather cold
attempt at an allegorical scene.

- **1863** After five years of frequent voyages
and longer periods spent in various oriental
countries, he makes numerous voyages along
the Danube in Germany. Becomes professor at
the École des Beaux-Arts, where he is
renowned for his strictness. His long and fre-
quent diatribes with the Impressionists begin.

- **1865** Appointed to the French Academy.
Paints *The Death of Caesar* (W.A.G.,Baltimore).

- **1874** Paints *Police Verso* (Phoenix Art
Museum, Arizona).

- **1875** Begins to teach at the Academy.

- **1894** He vehemently opposes the donation
of works by Caillebotte to the French state,
making the following caustic affirmation, "If
the State is capable of accepting such non-
sense, then it is completely morally bankrupt."

- **1904** Dies in Paris.

Cockfight

(1846)
oil on canvas
57.2 x 81.6 in
(143 x 204 cm)
Musée d'Orsay, Paris

Gérôme, a student of Delaroche, whom he accompanied to Italy in 1844, had always shown an interest in antiquity, apparent in the subject matter of some of his works. His academic, elaborate, and high-quality execution recalls Ingres. He perfectly combines Greek elements with genuinely Pompeian characteristics, as in this work, which was exhibited at the 1847 Paris Salon with considerable success.

With the cockfight as an excuse, the painter represents a young Greek couple revealing highly attractive anatomies. The young man is Apollonian, with smooth, excellently modeled skin. This figure is an admirable study of light and shadows. His body is slender, delicate, and sensual, and somewhat ambiguous in keeping with the canons of beauty held by the ancient Greeks for young men.

His companion is semireclined, foreshortened, her torso twisted to the side. Slightly more distant, she contemplates the scene. She modestly covers her breasts with her arms, and her pubic area with a light, transparent cloth that allows her nudity to show through. She also has a sensual body, with strong hips and a rounded abdomen.

The landscape in the background, the architectural element against which the woman is resting, and the clean, vibrant colors of the garments she has removed contribute to creating the warm atmosphere suitable to the lovers' games. The poses of the young couple, the sensuality of their bodies, the modeling of their figures, and the meticulous execution of details illustrate a style to which the artist remained true throughout his entire career.

The painter was thoroughly familiar with the atmosphere of palaces, harems, and public baths in oriental countries through his prolonged travels, especially to Turkey, Egypt, and Algeria. This firsthand knowledge, combined with his classicist style, realism, and careful execution, gave rise to detailed works of academic perfection, in which an atmosphere of luxury and sensuality predominated.

The artist uses the setting of the baths to represent a highly attractive scene, where a series of slender, well-modeled, and sensual bodies are rendered in different poses and from various points of view. In addition to the tranquility it breathes, the scene has the freshness and spontaneity of a snapshot. The painter has introduced many details (the shoes, pipe, colored servants, and so forth), which, in addition to their documentary value, contribute to creating an appropriate atmosphere.

Large Pool at Brousse

(1885)
oil on canvas
28 x 38.6 in (70 x 96.5 cm)
Private collection

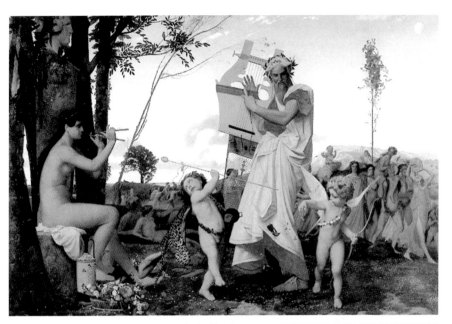

Anacreon was a Greek poet who was invited by the tyrant Polycrates to settle in his court, where he extolled love and life in verses that everyone admired. Exhibited in the 1848 Paris Salon, this work, characteristic of the painter's taste for classical subjects, is an homage to the poet. He appears in the center as a venerable elderly man dressed in a dignitary's tunic, with a laurel wreath on his head and playing the lyre, an instrument alluding to poetry. At

Anacreon, Bacchus, and Cupid

(1848)
oil on canvas
134 x 203 cm
Musée des Augustins, Toulouse

his side is Cupid with his bow, and on the left is Bacchus, represented as a smooth-skinned Apollonian youth. The work is conceived as an allegory, with classical and conventional criteria. The scene is a fantastic and evocative vision, with an imaginative color scheme that lends the nudes a mysterious air.

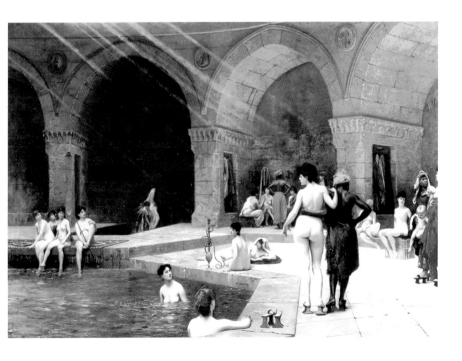

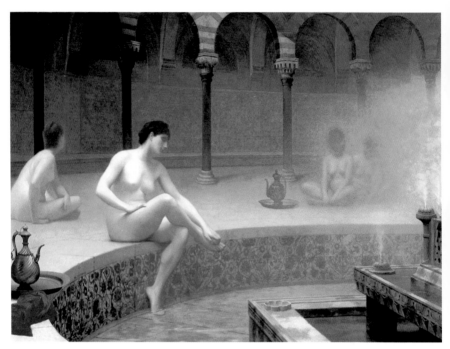

Steam Bath

(1889)
oil on canvas
29.2 x 40.4 in (73 x 101 cm)
Richard Green Galleries, London

On his various trips and prolonged stays in oriental countries, Gérôme was fascinated by the atmosphere and customs he discovered. He took note of what he saw and used it in his works. Here the artist enters the intimacy of a Turkish bath. The setting, the suffocating atmosphere of sulfurous vapor, the illumination, and the nude bodies are ideal ingredients to create an air of mystery. The women have delicate figures with soft modeling based on tenuous shadows, imbuing them with sensuality. The careful modeling lends them a porcelain texture, which does not preclude an air of exotic lubricity.

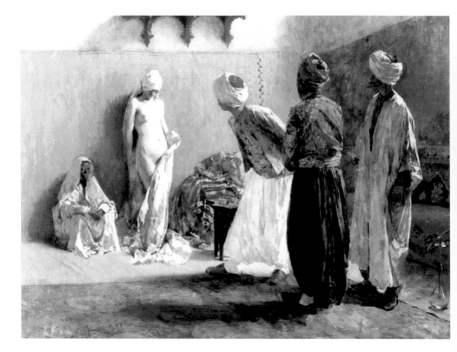

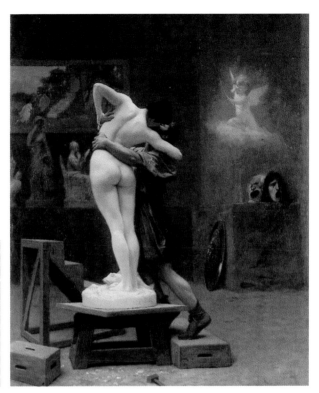

Pygmalion and Galatea

(1890)
oil on canvas
35 x 27 in
(88.9 x 68.6 cm)
The Metropolitan
Museum of Art,
New York

This subject is one of the most beautiful in classical mythology, the legend of Pygmalion, King of Cyprus, famous for his generosity. Oblivious to his matrimonial duties, he would spend all day and all night sculpting. He created a female figure out of ivory that was so perfect he fell hopelessly in love with it and asked Aphrodite to help him. The goddess had pity on Pygmalion and she herself became incarnate in the sculpture, thus bringing it to life, and requited the artist's passion, giving herself to him. From their union, Paphos was born, the mother of Cinyras.

This work represents a loose version of said legend: Aphrodite, feeling pity on Pygmalion, orders him to kiss the statue, called Galatea, at which point she comes to life. From a small, illuminated area in the background, Cupid or Eros lets fly an arrow to seal the love between the king and the living statue. The treatment is magnificent, with a pre-Raphaelite aesthetic in which the artist exhibits great virtuosity and skill. Appropriately, Galatea reveals a sculptural, slender anatomy, modeled with intense light and delicate shadows. The sensual nude becomes vibrant, soft flesh in a smooth transition from its pedestal of cold white marble. The complexion and treatment of the figure approach photographic perfection. Indeed, photography, recently invented, served as a support to the majority of painters of the time, including Gérôme.

There are many striking aspects in this figure, from the illumination, emphasizing the feminine forms, to the woman's gesture at the moment she comes alive. The king's embrace, at first timid, almost reluctant, becomes passionate when Galatea, certain of his love and desire, bends toward him to decisively pull his body closer. Amid the general darkness, the light striking Galatea's body lends it great brilliance and relief and makes it the true protagonist of the scene. This work has profound intensity and expressiveness.

The Examination of the Slave

(1890)
oil on canvas
21.6 x 30.9 in (54 x 77.3 cm)
Private Collection

Gérôme represents the moment when a young woman from Circassia or Georgia, which is where the majority of white slaves for Arabic countries came from, is being examined by her owners before being incorporated into the harem. The artist incorporates formal values: a beautiful composition, an excellent rendering of perspective, and skillful treatment of light and color. The scene contrasts two very distinct situations: that of the slave, reserved, fragile, young, and attractive, and that of the Arabs, who, in their own world, attentively contemplate the merchandise they have just bought. The painting thus combines helplessness with violence, humiliation with cruelty, sensuality with sultriness.

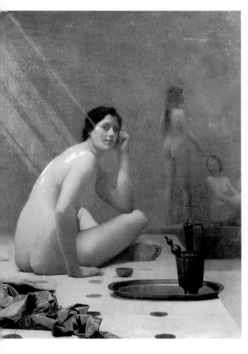

Women at the Bath

(~1895)
oil on canvas
Musée Georges Garret, Vesoul

The trips made by many artists to oriental countries led them to adopt certain subjects that gained widespread acceptance among the public for their exotic possibilities and erotic connotations. Gérôme was one of the most assiduous painters of orientalist art. This scene represents a Turkish bath, focusing attention on the woman in the foreground, who is relaxed and lost in thought. The artist uses a typically academic pose and caresses the figure with an excellent treatment of light, whose rays fall directly on its back, and a soft modeling that lends it volume and delicacy. The work includes a series of elements that provide context, heighten the sensuality, and describe the atmosphere in the room: the tenuous light, the diaphanous atmosphere, the nudes in the middle ground lost in the half-light, and the complexions.

J.L. GEROME

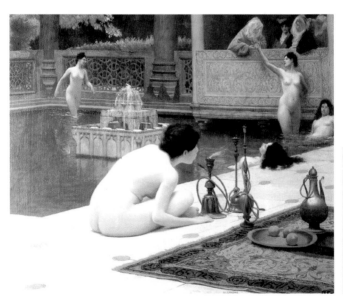

Nargil Lighter

(1898)
oil on canvas
22 x 26 in
(54.6 x 66 cm)
Gallery Keops, Geneva
(Ghassan Shaker Collection)

The scene is a harem in a palace. The young women, exhibiting beautiful anatomies, relax in a pool. The older ones enjoy themselves, observing from a balcony. The interesting interplay of perspectives, the series of marblelike female nudes in varied poses, all of them slender, well modeled, and sensual, and the luxury of the setting constitute the predominant features of this work. As a counterpoint, the artist introduces elements that lend the scene a subtle sultriness: the fruit in the foreground, the tranquility of the women in the water, the action of the woman in the foreground preparing to smoke a nargil lighter, the contrast between the sensuality of the young bodies and the women watching from the balcony, and so forth.

CAMILLE PISSARRO

Self-portrait, *oil on canvas, 22.4 x 18.7 in (56 x 46.7 cm), 1873, Musée d'Orsay, Paris.*

Pissarro is one of the leaders of the Impressionist movement. The few works remaining from his early period (the majority was destroyed in 1871, during the Franco-Prussian War) reveal the influence of the Barbizon School.

Obsessed by the effects of light, he ceaselessly experimented with different colors and techniques. He painted the same subject, from the same place and with the same framing, but at different times of day or seasons in order to study the variety of possibilities and effects of light and color that could be created using a single scene.

Perhaps it was his interest in light that led him to paint landscapes and cityscapes almost exclusively, since, for a painter, natural light has neither limits nor substitutes. In his palette, pure, light colors significantly prevail over earth colors, a characteristic typical of the Impressionists.

His superb artistic dexterity, fine character, and affability made him very popular. He shared his discoveries with his many friends and was always open to new ideas, be they from artists with many years of experience or young painters who were just starting out.

Pissarro, whose work is essential for understanding Impressionist theories, made a deep impression on his contemporaries, especially his friends. Painters as brilliant as Cézanne, Gauguin, and Matisse were inspired by him.

- **1830** Born on July 10 on St. Thomas, in the West Indies, to a French merchant of Jewish descent.
- **1842** Moves to Passy, near Paris, where he begins to draw.
- **1852** Moves to Venezuela to work as an assistant to the Danish painter, Fritz Melbyl, sent by his government to study the flora.
- **1855** His family moves to Paris and Pissarro moves in with them. There Corot and Courbet, the most important artists, influence him.
- **1859** Participates in the Paris Salon for the first time. Studies in the Académie Suisse until 1861, befriending Manet, Monet, Renoir, Sisley, and Guillaumin, all influenced by Courbet. Becomes sentimentally involved with Julie Vellay.
- **1863** Not admitted to the Salon, he exhibits at the Salon des Refusés.
- **1866** In Pontoise, he paints landscapes in which the realism of the Barbizon School develops into Impressionism. Frequents the social scene at the Café Guerbois in Paris.
- **1869** Moves to Louveciennes, a village located along the Prussian line of advance toward Paris.
- **1869** Goes into self-imposed exile in London, where he marries Julie. There he studies Turner's art. The Prussian army occupies his house in Louveciennes and destroys all of the paintings it finds there.
- **1872** After the war is over, returns to France and settles in Pontoise. Has contact with Vignon and Cézanne, with whom he sometimes paints. With Monet and others, he develops and improves Impressionist theories.
- **1874** Impressionist exhibits begin in this year, and Pissarro participates in all eight of them over the course of the years.
- **1879** Executes a painting in collaboration with Gauguin.
- **1884** Settles near Eragny-Razincourt, near the Epte River.
- **1886** Adopts the Pointillist technique for a time. Thanks to Durand-Ruel, he exhibits in New York.
- **1889** Participates in the World Exposition of Paris and in the Exposition des Vingt in Brussels.
- **1894** Flees to Belgium to escape the persecution of anarchists.
- **1896** Paints different views of Rouen.
- **1896** Paints views of Paris, Dieppe, and Le Havre.
- **1903** Dies in Paris on November 13.

The Road from Versailles to Louveciennes

(1870)
oil on canvas
40 x 32.4 in (100 x 81 cm)
Stiftung Sammlung E. G. Bührle, Zurich

This painting was executed when Pissarro lived in Louveciennes, during the Franco-Prussian War. It was a time of uncertainty, which would send him into self-imposed exile in London. This is an every-day scene of village life, with superb lighting and color.

A diagonal line divides the composition. The upper right side is permeated with sunlight. The predominantly bright, warm colors create a background against which the trees, especially those in the foreground, are defined with great contrast and precision. The remaining elements, executed in loose brushstrokes, are hinted at rather than defined. The lower right half, in shadow, is illuminated by the reflection from the sunlit area. Dense colors predominate, in both the women's dresses and luxurious plants forming the hedge, with flowers sparkling among them. The artist carefully defines elements such as the houses and trees.

Crystal Palace

(1871)
oil on canvas
19.2 x 29.4 in (48 x 73.5 cm)
Art Institute, Chicago

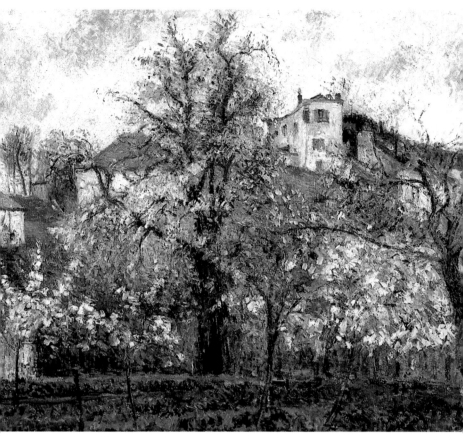

On the advice of Doctor Gachet, his mother's homeopathic doctor who later became close friends with the Impressionists and Van Gogh, Pissarro moved to Pontoise in early 1866, with his companion and his two children, Adèle and Georges.

Spring in Pontoise

(1877)
oil on canvas
26.2 x 32.4 in
(65.5 x 81 cm)
Musée d'Orsay, Paris

The long hours Pissarro spent painting outdoors attracted many of his artist friends to join him. The village became a hive of artistic activity and a meeting place for the Impressionists. This painting is a lovely representation of the artist's work during this period.

Preoccupied with the effects of light and color, Pissarro represents a dynamic landscape with great chromatic harmony. In the foreground are trees that partially conceal some buildings in the middle ground. The structure of the trees can be seen in their trunks and branches. They are set against a luminous and textured sky with an interplay of whites and blues. The sprinkling of white flowers in short brushstrokes provides contrast. Combined with the green tones of the background, and the rhythm of the central area, it creates a lively and colorful atmosphere. Green and black dominate the garden in the foreground, which Pissarro also paints with short brushstrokes.

These short, quick brushstrokes that can be observed when in proximity to the work become a superb blend of light and color at a distance. The painting is a masterpiece: a symphony of colors with an excellent interplay of light, a pure example of the Impressionist style.

During the Franco-Prussian War, Pissarro moved to London with his companion Julie Vellay and their two children. They were married there. He lived there from December of 1870 to June of 1871, executing 12 paintings of southeastern views of London near his home in Norwood. Represented here is the entrance to the palace that housed the World Exposition of 1851. The painter takes the opportunity to represent many elements in the foreground, in which the cityscape is combined with numerous figures, animated by small, precise, and multicolored brushstrokes. The density of the lower right area contrasts with the general illumination of the painting, executed in a palette of clean, light colors. The perspective leads the eye to the buildings in the background, whose colors are affected by the atmosphere. The sky is luminous and filled with clouds executed in delicate grays. The general lighting perfectly suits the tranquility of the strollers.

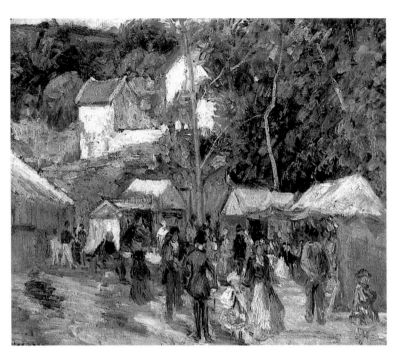

The Festival at the Hermitage

(~1878)
oil on canvas
18.4 x 22 in (46 x 55 cm)
Courtauld Institute Galleries, London
University, London

As soon as Pissarro settled in Pontoise in 1866, he felt a special attraction to the area. He painted it many times and in different seasons and hours of the day. In this painting, he represents an annual religious procession and festival in the countryside. The figures in the foreground are finely dressed and stroll among the stands. The artist superbly combines vivid, luminous colors to convey a feeling of joy and optimism appropriate to such an occasion. In a purely orthodox Impressionist style, Pissarro exhibits an appropriate treatment of light and color, and a confident loose brushstroke. The painting evokes an emotion, a state of mind, an impression. This is what gives the movement its name.

The Shepherdess, *or* Girl with a Stick

(1881)
oil on canvas
32.4 x 25.8 in (81 x 64.7 cm)
Musée d'Orsay, Paris

Here Pissarro depicts a simply dressed country girl, against a brilliant background consisting of an area densely covered in a myriad of varied green and yellow brushstrokes describing the natural colors of the ground. Both elements, the landscape and the figure, are harmoniously integrated to form a balanced whole. In contrast to the small, precise brushstrokes of the background, the figure is modeled in elongated brushstrokes with a smoother finish, giving rise to soft modeling and delicate volume. The contours are not defined and priority is given to the treatment of light. In addition to its chromatic expressiveness, the figure is well lit, thus conveying tranquility, and bringing it closer to the viewer, not only physically but also emotionally.

Harvesting Apples

(1886)
oil on canvas
51.2 x 51.2 in
(128 x 128 cm)
Ohara Museum
of Art, Okayama

Pissarro was constantly experimenting, and the emergence of the divisionist theories on the disintegration of color into small dots led him to investigate this field as well. Thus, he executed a series of pointillist paintings such as this one.

The miniscule brushstrokes give rise to a pattern creating great precision and increasing the intensity of the light. It is an everyday scene, inundated with light and filled with a variety of warm colors. The color scheme indicates that it is summer. The day is so sunny that the women, although they are in the shade, are represented in vivid colors. Pissarro must not have been pleased with the results of the pointillist technique, since he definitively abandoned it after several years, returning to his own peculiar style.

Bather in the Woods

(1895)
oil on canvas
24 x 29 in (60.3 x 73 cm)
Metropolitan Museum of Art,
New York

Pissarro was primarily painting urban landscapes in this period. In this work, though, he changes subjects, representing this nude in a study of light and color. The vegetation is executed in small, multicolored brushstrokes that define every detail and corner of the canvas in a technique approaching pointillism. The figure, bereft of any intent or function besides a strictly aesthetic one, is strategically located in the point of brightest light. Her complexion is treated in a limited tonal range that is brightest in the back in order to define its profile against the luminous green vegetation in the background. On the right, the shaded branches of a tree provide intense contrast and lend the work movement and depth—a very theatrical effect in keeping with the Impressionist taste.

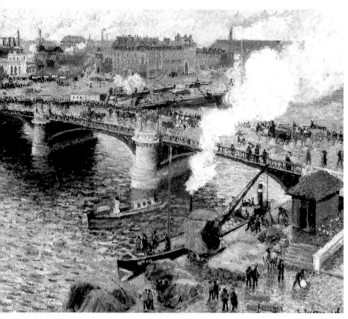

Boieldieu Bridge in Rouen

(1896)
oil on canvas
29 x 36.5 in
(73.3 x 91.4 cm)
Art Gallery of Ontario,
Toronto

Toward the end of his life, Pissarro began concentrating on cityscapes, continuing in the Impressionist style. His serious problems of sight forced him to stop his outings to the country and paint from a window in his home.

It goes without saying that this painting reflects the artist's many excellent qualities, as well as his experience and skill. The depth and interplay of perspectives are striking aspects of the composition. His technical excellence is revealed in the varied colors, including some vivid ones, which he attenuated for this gray and rainy setting. The touches of vivid colors do not adversely affect the general grayish tones of the work, enhanced by the smoke of the boats and the buildings in the background. All elements are precisely defined, with an attractive interplay of light and shadows that magnificently reflects the atmosphere of this part of the city. It is a true masterpiece.

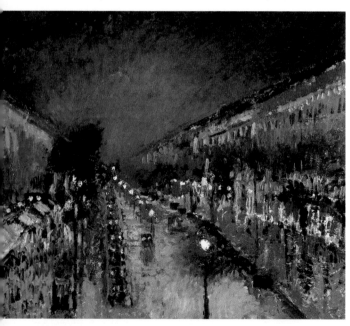

The Boulevard Montmartre at Night

(1897)
oil on canvas
21 x 26 in
(53.3 x 64.8 cm)
National Gallery,
London

Confined to the city for reasons of health, Pissarro rented apartments and hotel rooms from where he could paint his chosen subject without having to move around. This work, painted from the windows of the Hotel de Russie, is a good example of this. A fascinating night view is represented here, with a dense, dark background, against which the lights and their reflections acquire an intense brilliance. Pissarro uses vivid, aggressive colors to create a ground drenched by rain. In paintings such as this one, he demonstrates that it is not necessary to represent the most picturesque areas or emblematic buildings of the city to achieve a spectacular painting. A well-selected frame, an attractive perspective, the right lighting, and a specific ambiance are sufficient to achieve highly theatrical effects. It was not by chance that the Impressionists, under the influence of Japanese woodcuts that made use of strong color contrast between subject and background, adopted this type of subject for their works.

ÉDOUARD MANET

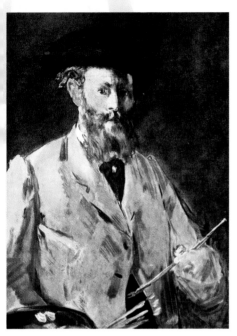

Self-portrait with Palette, *oil on canvas, 33.2 x 26.8 in (83 x 67 cm), 1879, Jacob Goldschmidt Collection, Zurich.*

Though his education was based on classical art, from the beginning Manet showed a great interest in new, freer forms of expression. Nevertheless, this did not prevent him from considering himself a classical painter and seeking official recognition.

His innovative theories and technique, often the cause of great scandal, represented a lively response to the academic establishment, which repeatedly rejected him. They also provided a strong impetus for younger generations of artists, who found many of the concepts they stoutly defended embodied in his works.

Manet was in constant contact with the Impressionists, even painting with many of them outdoors. Indeed, he was considered by them to be a leader of the movement, though Manet never formally joined the group and chose not to participate in their exhibits.

His work had a realist conception, devoid of idealization, possessing compositional audacity. He used light colors and black, defined profiles and dense tones. He breached the wall of traditional formalism, advocating a different manner of painting and contributing to the initiation of an important chapter in the history of painting in the latter 19th-century.

- **1832** Born in Paris on January 23, his father was the personnel division head of the Department of Justice and his mother the daughter of a diplomat and goddaughter of Marshal Bernardotte.
- **1850** Enters the studio of Thomas Couture to learn to paint and visits the Louvre to copy works by Titian, Hals, Velázquez, Goya, etc.
- **1858** Generally following Couture's style but beginning to distance himself, especially in the treatment of color, he paints various works that are severely criticized by his teacher but are applauded by Baudelaire.
- **1862** Paints *Le Déjeuner sur l'Herbe* (see p. 343), which is rejected by the Salon and causes a great commotion for its anti-academicism in the treatment of color and the model's brazen attitude.
- **1865** The exhibit of *Olympia* (see p. 342) at the Salon causes an enormous scandal. Both the subject matter and the technique receive highly favorable reviews from prestigious critics such as Zola and young artists such as Bazille, Monet, and Renoir, promoters of Impressionism. Travels to Spain, where he visits the Prado Museum and is enthralled by the works of Velázquez and Goya.
- **1867** Despite the many favorable reviews, his works are not admitted to the World Exposition in Paris.
- **1870** During the Franco-Prussian War, he joins the artillery unit of the National Guard as a deputy of the general staff.
- **1871** Once the war is over, the merchant Durand-Ruel purchases a number of paintings from Manet for a considerable sum.
- **1874** With Monet and Renoir, he spends the summer painting in Argenteuil.
- **1879** He begins to suffer serious health problems, with strong leg pains. He undergoes treatment but it is ineffective.
- **1881** Receives the medal of the Legion of Honor.
- **1882** The jury of the Salon is comprised of 17 of the artists who had voted in favor of him the previous year. He obtains a resounding success with his painting *A Bar at the Folies-Bergère* (see p. 344).
- **1883** On April 6, his leg is amputated due to gangrene. He dies on the 30th of the same month. He is buried at the Cemetery of Passy.

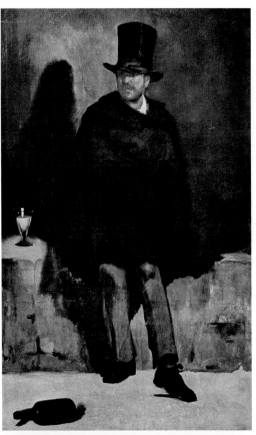

The Absinthe Drinker

(1858-1859)
oil on canvas
32.4 x 42.4 in (81 x 106 cm)
Ny Carlsberg Glyptotek,
Copenhagen

Manet used a renowned drunkard, Collardet, as the model, thereby lending the painting authenticity. A number of elements contribute to the striking, dramatic atmosphere: the hat and its shadow concealing the upper part of the face and the beard cloaking the lower part, the cape wrapped about his body, the shadow projected on a light area in the dark background, the bottle on the ground, and the dense, dark colors. A dark line delineates the forms and serves to define areas that are later covered in dense oil paint, increasing the contrasts. The painting was greatly appreciated by a sector of the public but rejected by the Salon of 1859. This and his rupture with Couture made many consider Manet to be difficult, while some saw him as a victim, and others even thought he was mad. From this time on, his name would no longer go unnoticed.

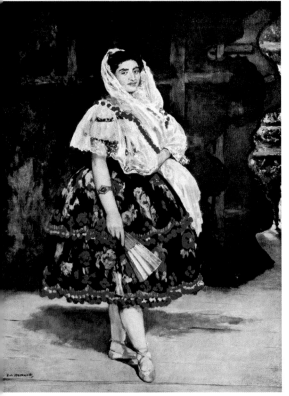

Lola of Valencia

(1861-1862)
oil on canvas
49.2 x 36.8 in (123 x 92 cm)
Louvre, Paris

This painting, to which Baudelaire dedicated a quatrain, is one of Manet's most famous works, revealing the characteristics typical of his art from this period. The wide, dark strokes that define the facial features make the modeling and creation of volume difficult. The ballerina's left leg is hidden in the shadows and she is resting on the other leg in a somewhat artificial manner that lacks liveliness. The red tassels of her dress resemble candy, while the stockings appear thick and rough, detracting from the figure's aesthetics and elegance. All of this indicates the rather amateur stage of the artist, which can be ascribed to his search for new approaches and his interest in simplification and evocation, leaving behind attention to detail and conventionalism and attempting to suggest rather than explain through his images, a concept that Impressionism would promote.

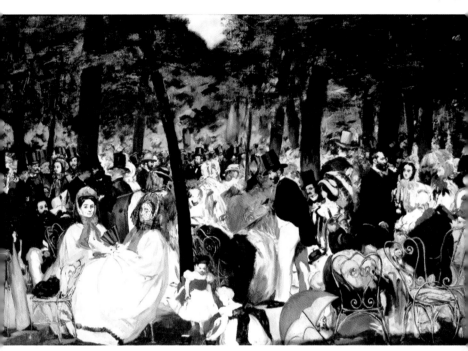

This is one of Manet's first paintings of street scenes. It represents the people that frequented the Tuileries Gardens to spend an agreeable time listening to music and chatting with friends and acquaintances.

Many well-known people are portrayed in the work: Manet himself (far left), Albert de Balleroy (at his side and almost frontally viewed), Zacharie Astruc (on the right behind the former two), Eugène, the artist's brother

Music at the Tuileries

(1860-1861)
oil on canvas
30 x 47 in (76.2 x 118.1 cm)
National Gallery, London

(in the middle towards the right), Offenbach (in the back, sitting next to a tree), Baudelaire (viewed from the side next to the large tree on the left, to the right of Astruc), Théophile Gautier (next to the former) and Fantin-Latour (viewed frontally, behind and to the left of Gautier), Madame Lejosme, wife of the commandant and a friend of Baudelaire (wearing a veil) and Madame Loubens (next to her), as well as Champfleury, Aurelien Scholl, and the painter Monginot.

This is a highly dynamic painting. According to Antolin Proust, the artist visited this place diligently, and sketched figures for the paintings he would later execute in the studio, as in this case. The work contains many important facets: the abandonment of classical academic criteria and the portrayal of everyday life, entirely free of idealization; the execution of a group portrait of over 50 different, fully identifiable people and their natural appearance in the scene, with no one figure predominating over the others; a dramatic study of light on the figures, which filters through the thick treetops under which they are gathered; and a fresh rendering of a festive and relaxed atmosphere.

Manet was innovative in his choice of subject and the manner of conceiving it (coupling reality with a vivid, sensitive imagination), and for the technique (employing a short, direct brushstroke), as well as the simple execution of forms. The painting heralded a new, modern concept of painting and influenced many Impressionist painters, especially Monet, recently arrived from Paris, who was deeply impressed by it, and Renoir, who took up the subject and technique of this painting in some of his later works.

éd. Manet

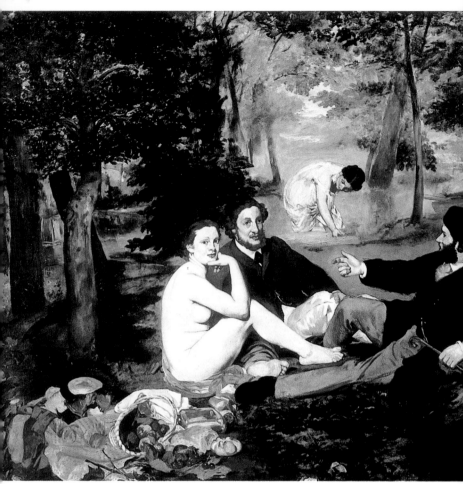

The theme of Olympia is a classic. Manet was inspired by previous works (Giorgione's *Venus Sleeping,* Titian's *Venus of Urbino,* and, for the pose, color, and modern nature, *The Nude Maja* by Goya). Just as Velázquez had done in his *Venus with the Mirror,* Manet eliminates all traces of idealization. He represents a nude young courtesan, Victorine Meurend, the same model as in *Le Déjeuner sur l'Herbe* (see opposite page), reclining on a bed and gazing proudly and nearly defiantly at the viewer, paying no attention to the servant who brings her a bouquet of flowers.

Olympia

(1863)
oil on canvas
52 x 76 in (130 x 190 cm)
Musée d'Orsay, Paris

The woman is realistic in style, with delicate forms and a strong, expressive character, rosy skin, and an illuminated body that gently contrasts with the white of the sheets. The figure stands out against the sheets, with a multitude of folds in different shades of gray, the intense black background, and other black areas (face and hand of the servant, the cat). The work is highly unified, all of the elements are executed with meticulous care and are perfectly combined, and the lighter colors are enhanced by strategically placed black tones. The artist studied the details thoroughly to make this natural nude of a normal woman dignified, sumptuous, and striking, yet he dispensed with everything resembling academicism. He sought authentic beauty, not an idealized, nonexistent concept.

The painting was exhibited at the 1865 Salon, where it caused a great scandal, both because it seemed to be mocking classical art, and because of its profound rupture with the established artistic canons. In addition, the fact that Olympia is exhibiting her anatomy with no reserves—even her gesture of covering her pubis with her hand was interpreted as malicious and provocative—and with an insolent, nonchalant air, injured the sensibility of Parisian society. The painting is an ode to the freedom and independence of expression of the artist and an exaltation of a revolutionary technique that broke with the past in search of a new concept of art.

Le Déjeuner sur l'Herbe, *or* Luncheon on the Grass

(1862-1863)
oil on canvas
83.2 x 105.8 in (208 x 264.5 cm)
Musée d'Orsay, Paris

Three elements can be distinguished in this painting. There is a dense, dark landscape with a clearing in the background where an undefined image of a young woman in a nightgown is visible. She is bathing her feet in a pond or stream. In the foreground on the lower left is a still life consisting of a blue dress, yellow hat, violet ribbon, basket of bread and fruit, and red fruit on green leaves. The central area is occupied by three people sitting on the grass: two artists (Eugène Manet, the artist's brother, and Ferdinand Leenhoff, a Dutch sculptor and the brother of Suzanne, Manet's wife) conversing with a nude woman (Victorine Meurend, the artist's model of choice).

It was considered an affront to morality and rejected by the 1863 Salon. The woman's nonchalant attitude, sitting naked before her companions with no inhibitions whatsoever, caused an uproar so that it had to be shown at the Salon des Refusés under the title *Le Bain*. Napoleon III viewed it there and also found it distasteful.

Manet was supposedly inspired by Giorgione's *Fête Champêtre* (see p. 104) and by a Raphaelesque engraving by Raimond from the 16th century. Despite the outdoor setting, the painting was executed in the artist's studio. Many of his contemporaries, anchored in their traditional criteria, rejected the antiacademic technique used in the painting. They could not understand why Manet employed flat colors and moved so brusquely from full illumination to dark areas without using the system of transitions through progressive, soft gradations to avoid such intense contrasts and such defined and aggressive outlines in the figures, which appeared as if they had been cut out and pasted onto a stage set. The most original aspect, however, was that Manet did not represent light in the traditional manner, but according to the colors. Hence, light is absorbed by the men's dark suits and reflected by the rosy whiteness of the nude woman. The landscape contains areas of blue-green shadows created by the reflection of the foliage against the water.

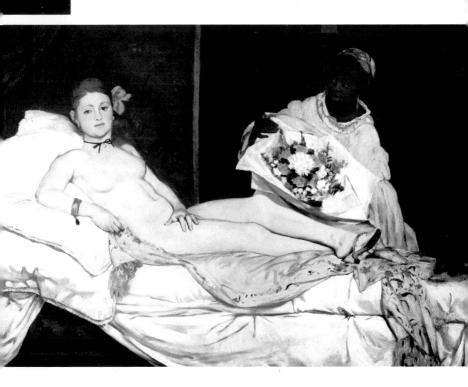

The Fife Player

(1865)
oil on canvas
64.4 x 38.8 in (161 x 97 cm)
Musée d'Orsay, Paris

This painting, influenced by Velázquez, reveals a sure hand and a rigid execution. The figure is placed against a plain background. Victorine Meurend may have been the model. Manet applied an economy of light and shadows, and the transitions between them are very rapid. He did not take great pains to correct errors here either—he simply covered them with a thick line through which the underlying layer can be seen. His manner of executing the pants is remarkable, with a dense red background against which soft grays model the fabric and lend it volume. Within the artist's oeuvre, this work shows the great technical evolution he underwent in a short time.

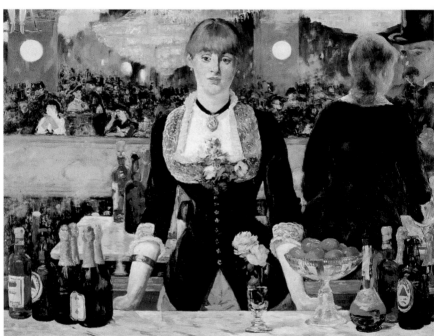

A Bar at the Folies-Bergère

(1881-1882)
oil on canvas
38.4 x 52 in (96 x 130 cm)
Courtauld Institute Galleries, London

This is one of the artist's last works, and it reaped great success at the 1882 Salon. Painted in his studio from various sketches executed in situ many years earlier, it portrays an aspect of the eventful life in the Parisian quarter of Montmartre. In the foreground, a countertop full of bottles, fruit, and flowers that comprise separate still lifes, behind which is a barmaid (the professional model, Souzon). The large mirror behind her reflects her back and reveals the boisterous atmosphere in the establishment, profusely lit with gas lamps. Considering the fact that this work was painted when Manet was seriously ill in Rueil and he was primarily executing images of his garden, it can be understood as a nostalgic recollection of an intense period of his life, a period that had passed, never to return. Manet died shortly after painting this canvas.

EDWARD BURNE-JONES

Edward Burne-Jones painting in his studio, *as portrayed by his son Philip, oil on canvas, 30 x 21.4 in (74.9 x 53.5 cm), 1898, The National Portrait Gallery, London.*

The English painter Edward Burne-Jones was trained by the Pre-Raphaelite painter Dante Gabriel Rossetti. As a result, he shared the movement's penchant for medieval and mythological subject matter, which he treated with stylistic unity and a degree of symbolism, influenced by the poetry of his friend William Morris. Sworn enemy of realism, he comes closest to Mantegna, Carpaccio, and Botticelli in style.

He was interested in painting serialized collections of works based on stories, which he called cycles. These included Pygmalion, Perseus, St. George, Phyllis, and Demophöon. He was an imaginative and sensitive draftsman, especially in his watercolors. His figures are svelte and excellently modeled, always thought provoking, intriguing and sensual, and executed with painstakingly studied poses, expressions, and chromatic tonalities, which arouse a bittersweet feeling, the result of nostalgia for the past.

Burne-Jones was a cultured artist of international renown who moved in the intellectual circles of the day. He is mainly recognized for his interest in new forms of Symbolism, his singular poetic vision, his particular manner of rendering his subjects, his unconventional sensuality, and his modern approach to painting.

- **1833** Born August 28 to Edward Richard-Jones and Elizabeth Coley, who dies one week after the artist was born.

- **1853** Studies at Exeter College in Oxford, where he makes friends with William Morris.

- **1855** Visits the cathedrals of northern France and the Louvre, in Paris.

- **1857** Makes designs for stained glass for James Powell and joins the mural paintings campaign organized by Rossetti at the Oxford Union.

- **1859** Teaches drawing at the Working Men's College.

- **1860** Marries Georgina Macdonald in Manchester. Undertakes a number of commissions inspired by Rossetti.

- **1864** Becomes an associate member of the Old Water-Colour Society.

- **1865** Finds two patrons: William Graham and Frederick Leyland.

- **1867** Strikes up an affair with Maria Zambaco, one of his models and later his *protegée*.

- **1869** Following an unproductive period, he breaks off his relationship with Maria Zambaco.

- **1873** Travels to Italy and puts up his nephew Rudyard Kipling at Christmas.

- **1877** Exhibits seven canvases in the inaugural exhibition of the Groswenor Gallery, which are received with acclaim.

- **1881** Receives the title of Doctor Honoris Causa from Oxford University. Becomes friends with the painter Lawrence Alma-Tadena.

- **1882** Together with Leighton, he is chosen to represent Great Britain at the World Exposition in Paris.

- **1885** Elected member of the Royal Academy of Arts and honorary president of the Royal Birmingham Society of Artists.

- **1891** Participates in the Pre-Raphaelite exhibition in Birmingham.

- **1898** Dies of a heart attack during the night of June 16/17. A funeral service is held for him at Westminster Abbey. He is buried in the churchyard at Rottingdean, Sussex, where he had a country home.

Maria Cassavetti (1845-1914) came from a family of merchants from the Greek community in London. In 1861, she married the Greek doctor Demetrius Zambaco, who was a resident of Paris. In 1865, she separated from him and returned with the two children she had had by him to London, where she frequented artistic and intellectual circles.

She met Edward Burne-Jones in 1866, when her mother Euphrosyne commissioned him to paint a watercolor. She became his model, student, teacher, and lover. Given that he could not bring himself to leave his wife Georgina, the painter decided to distance himself from Maria and, therefore, traveled abroad with his friend William Morris. His departure led Maria to arrange a meeting with her friends in Lord Holland Street, where she attempted suicide by taking an overdose of laudanum in public, an episode that caused a great scandal.

Painted as a gift for Euphrosyne, while the artist was alone in London, with his family away on holiday, this work is a heartfelt homage to Maria, a woman of stunning beauty, with a sensual face and a sad nostalgic expression. Despite the time that had passed since their separation, the painter could not avoid disclosing his still-strong feelings for his ex-lover. In this painting, Cupid expresses love and turns the protagonist into a Venus, with a white flower in her hands, symbol of clean passion, with a page of the book open at *Song to Love*. The artist communicates his passionate feelings through careful attention to detail, delicateness of the treatment, and subtle idealization.

This work is one of the artist's last commissions to be painted for one of his most loyal patrons, William Graham, whose daughter Frances, later Lady Horner, would visit the painter and bring him freshly picked flowers from her London garden.

This work depicts the wedding feast of Peleus, son of Aeacus, king of Egina, and the Nereid Thetis, future parent of Achilles, with god and goddess guests and centaurs waiting on them. On the left are Mars and Vulcan; on the right, Bacchus with Proserpina, goddess of the underworld, in a red tunic, and Ceres, goddess of agriculture, in a light blue dress. In the foreground, Apollo god of the sun, plays his harp. In the center, Cupid, god of love, makes the marriage bed, while the three Parcae, on the left, sew with thread the destiny of the mortal. On the far right, Eris, goddess of discord, emerges from the half shadow, with a fearful expression, bat's wings, and hair formed by snakes. Her presence astonishes the guests at the table, since she was not invited to the feast.

Also present is Mercury, god of commerce, shown with his back to the spectator wearing an electric blue winged helmet and boots; he holds an apple in one hand and a scroll in the other bearing the inscription DETUR PULCHERRIMA (FOR THE FAIREST), which has just been thrown to the ground by Eris, in order to a create a conflict between Aphrodite, Athena, and Juno, considered to be the fairest goddesses of the party. All three stand on the left, next to Zeus, the supreme god.

The outstanding composition, devised in the manner of a frieze, boasts a generous number of beautiful Apollonian nudes, whose subtly modeled anatomies are set in a wide variety of poses. Their flesh colors contrast with the darkness of Eris, indicative of her evil intent. Both the expressions on the faces and the attitude of the characters reflect the anticipation of the dreadful thing that is about to happen.

The Feast of Peleus

(1872-1881)
oil on canvas
15 x 43.7 in (37.5 x 109.2 cm)
Birmingham Museum and Art
Gallery, Birmingham

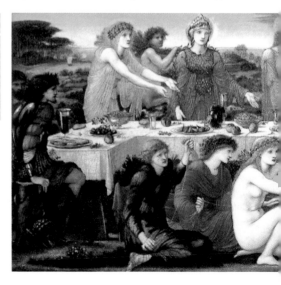

Maria Zambaco

(1870)
gouache
30.6 x 22 in
(76.5 x 55 cm)
Clemens-Sels-Museum,
Neuss, Massachusetts

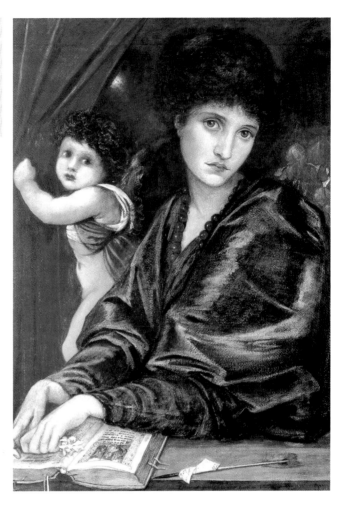

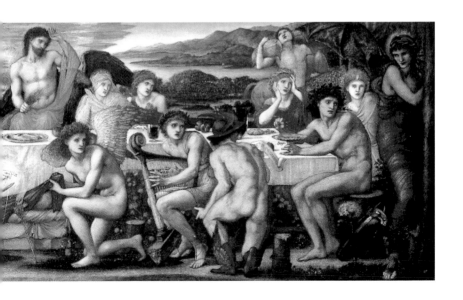

The Wheel of Fortune

(1875-1885)
oil on canvas
79.6 x 40 in (199 x 100 cm)
Musée d'Orsay, Paris

The scene shows the goddess Fortune spinning the great wheel to which various males figures are bound. Their nudity is almost complete with the exception of the tiny veils that cover their intimate parts. Fortune offers herself to the man she most desires. Excellently and imaginatively drawn, the mysterious and idealized figures evoke concepts and forms from the past, even though the modernist style of the work is a clear indication of the artist's search for new horizons.

The Golden Stairs

(1880)
oil on canvas
107.7 x 46.7 in (269.2 x 116.8 cm)
Tate Gallery, London

This work was painted during a period of great inactivity. Using a limited palette, the work exudes an academic classicism that brings to mind the work of Piero della Francesca. The artist used this composition without context to present a series of characters, for whose heads he used the models Antonia Calba and Bessie Keene, in addition to various young members of his family and friends (his daughter Margaret, top, in profile; May, the youngest daughter of William Morris, in the center facing forward; Frances Graham, daughter of his patron William Graham, bottom left, shown leaving; Mary Gladstone, friend of Frances, daughter of the Liberla Party leader; and so on). This highly original work is remarkable for the fine work on the tunics and the facial expressions. The way in which the characters are composed to form a semicircle is an original approach to rendering these slim figures of immense sobriety and distinction.

This work forms part of a series of paintings known as the Perseus Cycle, inspired by the poem *The Earthly Paradise* by his friend William Morris.

According to mythology, Cassiopeia proclaimed her daughter Andromeda to be the fairest of the Nereids, the sea nymphs protected by Poseidon. He was so infuriated by her claims that he sent a sea monster to lay waste the land. In order to avert this punishment, the oracle of Ammon commanded the people to chain Andromeda to a rock and leave her to be devoured by the monster. However, Andromeda was freed by Perseus, who slew the creature and, as a reward, took Andromeda as his wife.

The Doom Fulfilled

(1884-1885)
gouache
61.5 x 55.3 in (153.8 x 138.4 cm)
Southampton City Art Gallery, Southampton

Brave Perseus, who has just severed the head of Medusa, who of the three Gorgons was the only mortal one, is shown doing battle with the monster, represented here as a giant serpent with a modern structure and forms. The creature's metallic color is similar in texture and color to the hero's armor. The conception of the scene, with the heroine on one side and the warrior's colossal body occupying a significant part of the canvas, brings to mind certain representations of the legend of St. George rescuing the maiden from the jaws of the dragon. The sculptural rendering of Andromeda's naked body is sensual and flawlessly modeled; the contrapposto lends it rhythm and a hint of suggestiveness. The pale skin, combined with the prevailing bluish tendency of the scene, gives rise to a great contrast. The perfect lines of the nude, together with the adjacent scene of the fray between the hero and his foe, constitute a remarkable combination of sensuality and violence.

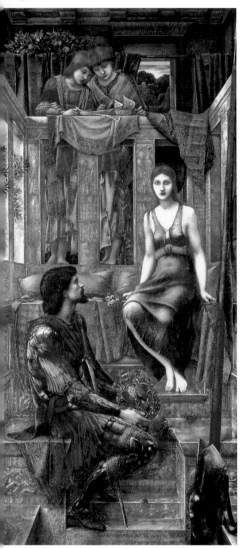

King Cophetua and the Beggar Maid

(1880-1884)
oil on canvas
116 x 54.4 in (290 x 136 cm)
Tate Gallery, London

This theme is inspired by the Elizabethan ballad *Reliques of the Ancient English Poetry* by Thomas Percy (1765). It is based on the Pygmalion myth in which the king falls in love with a beggar maiden whom he protects.

This work contains several details that recall Andrea Mantegna's *Madonna della Victoria* and Carlo Crivelli's *Annunciation*. The static and silent singers in the background evoke a sensitive and romantic timelessness. The beggar maiden holds a bunch of anemones, a symbol of unrequited love, heightening the emotional unease. Finally, the king, enraptured by the woman whom he loves, appears to be waiting for a favorable but impossible reply. This melancholy scene is based on the opposing feelings of the two subjects, which are highlighted by the color of the king's armour and the warm tone of the beggar woman, an unusual and unexpected contrast of tones.

The Challenge in the Wilderness

(1894-1898)
oil on canvas
51.8 x 38.6 in (129.5 x 96.5 cm)
Lord Lloyd-Webber collection

Despite the fact that the painting is unfinished, this work illustrates how the artist adopted a certain degree of abstraction to his art around the year 1895. The naturalism of the detailed folds of the garments, the gestures of the hands, and the serious expressions on the faces of the subjects unite to form a stylized outline, which gives rise to a singular work. As in most of this painter's works, the abundant tones of gray, green, and blue convey an atmosphere of mysterious solemnity; the desolation of the landscape is very unsettling.

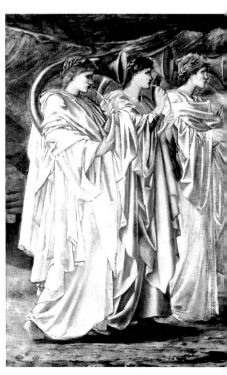

JAMES ABBOTT MCNEILL WHISTLER

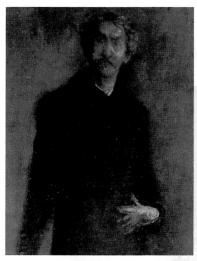

Brown and Gold: Self-portrait, (detail), oil on canvas, 38.3 x 20.6 in (95.8 x 51.5 cm), 1895-1900, Hunterian Art Gallery, University of Glasgow, Glasgow.

Whistler's artwork reflects the various artistic movements of the second half of the 19th-century. Through the influence of his first years in Paris, where he befriended Gustave Courbet and Henri Fantin-Latour, his art approached the worlds of Impressionism and realism. However, he sought to elicit the emotions of the viewer rather than to study the effects of light.

The influence of Japanese art is evident in his series of etchings on the Thames, as well as in his paintings. Scenes of life in this area of London are reproduced by Whistler in the style of the Japanese *ukiyo-e*, or paintings of the floating world. Just as Rossetti, Whistler incorporated oriental elements in his paintings, manifest in his compositional harmony and use of cool tones.

Whistler's strong personality made him very popular at the London social gatherings of the time, contrasting with his subtle and discrete style in art. The influence of oriental art and his admiration for Velázquez would remain with him for the rest of his life. Whistler believed in the idea of art for art's sake, free from moral connotations, religious messages, and other similar considerations. At his *Ten o'Clock Lecture* in 1885, he makes public his doctrine of free art in a caustic and highly ingenious and humorous manner.

- **1834** Born in Lowell, Massachusetts. Due to his father's work as a civil engineer, the family soon moves to Russia.
- **1845** Enters the Academy of St. Petersburg to receive drawing classes.
- **1849** His father dies and his family returns to the United States.
- **1855** He begins studying art in Paris.
- **1856** Enters the studio of Gleyre, where he meets Fantin-Latour and Courbet.
- **1859** His work is rejected by the Salon. He moves to London.
- **1860** Exhibits the work *At the Piano* (Taft Gallery, Cincinnati) at the Royal Academy.
- **1866** Visits Valparaiso, where he witnesses Chile's war of independence from Spain.
- **1876** Works as a decorator in the Peacock Room, the London establishment of the ship owner, Frederick Leyland, where he presages Art Nouveau with his decorative designs reminiscent of oriental art.
- **1877** Sues John Ruskin for accusing him of fraud in his *Nocturne in Black and Gold: The Falling Rocket* (see p. 356), exhibited at the Grosvenor Gallery in London.
- **1879** Although he wins the lawsuit against Ruskin, the expense of the trial brings him serious financial problems that oblige him to move to Venice, where he resides for a year, concentrating on etching.
- **1884** Exhibits at the Exposition des Vingt, in Brussels, and participates in the Salons of Paris, Dublin, and London.
- **1885** He explains his aesthetic theories at the *Ten o'Clock Lecture*, and they are translated into French by Mallarmé.
- **1886** Presides at the Society of British Arts, for which he obtains the support of the crown, transforming it into the Royal Society of British Arts. Resigns from the post two years later.
- **1891** The Corporation of Glasgow purchases his *Portrait of Thomas Carlyle* (Glasgow Museum), and, shortly thereafter, the French State acquires the portrait of his mother (see p. 354) and grants him the Legion of Honor.
- **1892** His individual exhibit at the Goupil Gallery in London is highly successful. Moves to Paris.
- **1898** Appointed President of the International Society of Sculptors, Painters, and Engravers.
- **1899** Exhibits at the first World of Art exhibit in St. Petersburg.
- **1901** Appointed honorary member of the Academy of Fine Arts in Paris.
- **1903** Granted the title of Doctor Honoris Causa by the University of Glasgow. Dies in London.

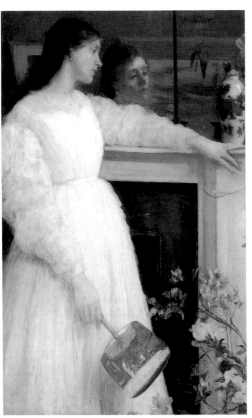

Symphony in White No. 2: The Little White Girl

(1864)
oil on canvas
30.6 x 20.4 in (76.5 x 51.1 cm)
Tate Gallery, London

The portraits that Whistler executed of his sentimental companion, Joanna Lifferman, attempt to combine the realism of Courbet with the introspectively languid artwork of his friend and neighbor, Dante Gabriel Rossetti, who led Whistler to approach the style of the Pre-Raphaelites, though without their symbolic message.

The resemblance of this portrait to Rossetti's work from the same period is remarkable. Although in Whistler's painting, the girl is lost in thought and idealized, there is no detail that makes the work transcendent. Everything remains within the framework of pure aesthetics. The first portrait of the woman in white, which would later become a series, was executed on a trip to Spain in 1862 to see Velázquez's work. The composition was rejected by the Paris Salon of 1863, just as his previous work, *At the Piano* (Taft Gallery, Cincinnati), had been rejected in 1859.

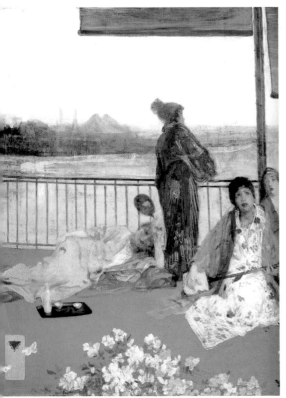

Variations in Flesh Color and Green: The Balcony

(1865)
oil on wood
24.4 x 19.6 in (61 x 49 cm)
Freer Gallery of Art, Smithsonian Institution, Washington, DC

Whistler manifests his admiration for Japanese art in this work, with a compositional style combining a clearly oriental subject and a conventional landscape. The representation in the foreground of a typically Japanese scene, rich in color details and full of light, in contrast with a landscape typical of previous works by the artist, places this painting at a crossroads of the various stylistic influences existing in his art.

The painter sought an art of sensations, using color freely in details, which he studied and placed carefully to achieve a strong visual impact through contrast. The artist's admiration for the oriental aesthetic is illustrated by his signature in the form of a butterfly, visible in the lower left corner of the painting.

Girl with an Almond Tree in Flower

(1868-1878)
oil on canvas
55.7 x 29.48 in
(139.3 x 73.7 cm)
Courtauld Institute of Art,
London (Private collection
on indefinite loan)

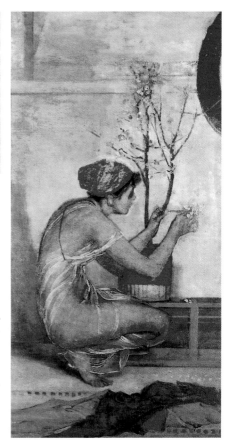

The influence of Japanese engravings was quickly assimilated by Whistler, who, instead of imitating the style, was able to interpret it and integrate it into his own style. In addition to painting and engraving, he soon felt attracted to the decorative arts that announced the future Art Nouveau.

In this work, Whistler reinterprets Japanese woodcuts. The woman is deeply involved in caring for an almond tree that is reproduced in the most genuine Japanese style. It is a delicate composition with highlights in the flowers and dress. The use of small sparks of light is a constant in oriental art that Whistler employs in his landscapes and portraits, in a search for subtle details and a touch of intensity and color.

The Port of Valparaiso

(1866)
oil on canvas
30.6 x 20.4 in (76.6 x 51.1 cm)
National Museum of American Art,
Smithsonian Institution,
Washington, DC
(Donated by John Gellaty)

In this work, the artist intuitively plays with forms and colors, representing a tranquil view of this port in Chile. The two ships act as a focus of visual interest, whereas the human figures on the dock are blurred by Whistler and thus diminish in importance. He developed his technique on his return to London, where he executed a series of engravings entitled Valparaiso, in which he blurred edges to reproduce the mystery of the fog on the Thames. After the series, this type of representation became an important characteristic in artwork by Whistler, who presented his works in golden frames decorated with cobalt blue waves. This is also the period when he created his butterfly-shaped signature, playing with his initials, JW.

Arrangement in Gray and Black, No. 1: The Artist's Mother

(1871)
oil on canvas
58 x 65.6 in (145 x 164 cm)
Musée d'Orsay, Paris

After several years in which various influences are reflected in his works, Whistler carried out a series of portraits during the 1870s in which he reveals a very distinct style of his own. He applied diluted paint in layers on the canvas, so that the brush-strokes fluidly criss-cross one another from one end of the canvas to the other.

In this portrait of his mother, the somber colors highlight the soft tones of the face, accentuating the effect of spontaneity that the artist often sought in his works. His idea of art as a simple aesthetic element with no moral ties led him to comment: "Observe the portrait of my mother that was exhibited at the Royal Academy, a composition in gray and black. Obviously, it is what it is. It can be interesting to me because it is a portrait of my mother, but what interest could the identity of the sitter possibly have for the general public?" After a cool reception at the Royal Academy exhibit in 1891, the painting was acquired by the French State thanks to admirers such as Clémenceau and Mallarmé. The popularity of this work, approaching the British realistic tradition, arises from the severe, precise composition. The balance between linearity and tonality in a search for pure harmony lends this work a very modern aspect for the period in which it was painted.

| 1865 | 1873 | 1883 | 1885 | 1889 | 1894 | 1898 |

Different marks with which the painter signed his works throughout his career.

Nocturne in Blue and Gold: Old Battersea Bridge

(1872-1875)
oil on canvas
27.3 x 20.4 in (68.3 x 51.2 cm)
Tate Gallery, London (Donated by the National Art Collections Fund)

This work is part of a second series of paintings inspired by the London neighborhood of Wapping, on the banks of the Thames, where the artist lived for a time. An interest in capturing an ephemeral moment, with no historical baggage, is a constant element in Whistler's art. He often used musical terms, such as nocturne or symphony, in the titles of his works, seeking an analogy to music, which he considered more abstract and free of moral connotations. In this work, the old Battersea Bridge is elongated, recalling Japanese prints. The delicate sparks of light in the background applied as dots seek to create an impression, to evoke the genuine London that Whistler admired.

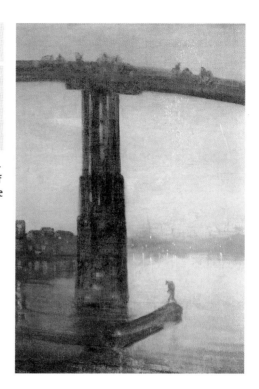

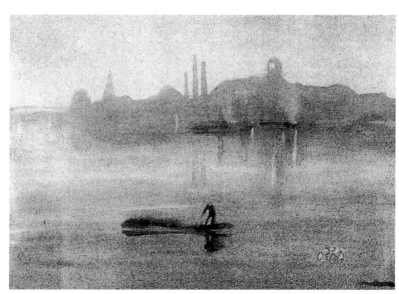

After spending some time in Venice, Whistler returned to London and exhibited a series of twelve engravings in different styles and several pastel drawings. The central piece of the series of engravings was this Nocturne, in which the Church of San Giorgio is insinuated in fine vertical lines and the boats are represented through a thin layer of ink. After his trip to Venice, the painter became more deeply involved in the creative process of his engravings. He began working directly with copperplates outdoors, dispensing with the habitual preliminary sketches. His work became

Nocturne

(1879)
lithograph
6.84 x 10.3 in (17.1 x 25.9 cm)
The Victoria and Albert Museum, London

more personal and the line became the basic reference point of the engraving. Even where there are no lines, the paper is tinged and modulated with color to avoid blank areas, just as Rembrandt had done in his works, which Whistler also studied for their composition based on the effects of light and shadow.

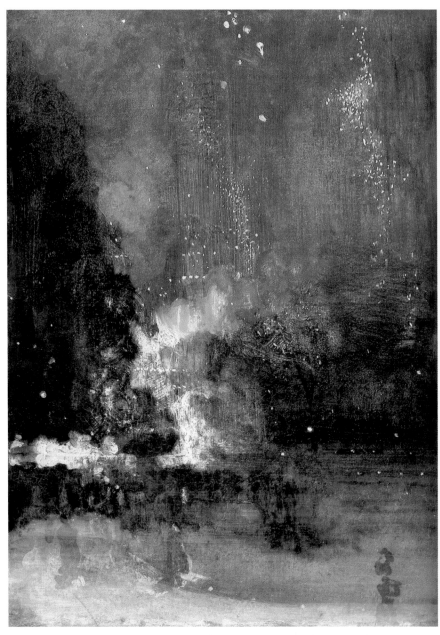

Nocturne in Black and Gold: The Falling Rocket

(1875)
oil on canvas
24 x 18.3 in (60.3 x 45.8 cm)
Detroit Institute of the Arts, Detroit

Whistler's nocturnes are works with a strong character that focus on representing the atmosphere of the city. In this work, the artist paints an ephemeral yet spectacular moment, during which fireworks make the London sky sparkle. Whistler plays with predominantly green, dark tones that cover the near entirety of the surface, creating a background against which light effects are represented in the form of minute sparks. It is an impressive and evocative composition that recreates in a very personal manner the concepts of light and color that so preoccupied Turner. The similarity of this work with those of symbolist movement artists such as E. Burne-Jones or D.G. Rosetti, with which the artist identified, caused the critic, John Ruskin, to comment: "I cannot understand how a second-rate painter would dare to charge 200 guineas for throwing a bucket of paint in the public's face". Whistler sued him for that comment. Although he won the case, the expense of the trial ruined him.

EDGAR DEGAS

Self-portrait, *(detail), oil on canvas, 32.4 x 33.6 in (81 x 84 cm), 1855, Musée d'Orsay, Paris.*

Nearly self-taught, Hilaire-Germain-Edgar Degas always showed great interest in scenes of everyday life. Extremely observant, he depicted reality with an immediacy that did not detract from the psychological study of the figures or the setting in the least. It did, however, help to describe attitudes and arouse profound emotions.

Despite their spontaneity, freshness, and rapid, sketchlike appearance, his works were all excellent, well studied and prepared to the last detail, with perfect draftsmanship, a carefully created atmosphere, and a treatment of light and color difficult to improve. Though he was close to the Impressionists and often exhibited with them, his artwork differs from theirs. Degas was more interested in new concepts of space and composition inspired by photography and Japanese prints than in problems of light and color. A great majority of his works are of interiors, and he did not embrace the Impressionist doctrine that painting should be done outdoors in natural settings.

In his enthusiasm to render everyday life, he frequented different venues: horse races, the circus, the opera, dance performances, cafés, and music halls, wherever he could observe people in action.

Degas' art demonstrates how everyday life offers not only a variety of subject matter for painting, but also the many different realities that can awaken all sorts of emotions.

- **1834** Born in Paris to a nobleman and banker.

- **1853** Learns pictorial technique under Félix Joseph Barrias.

- **1854** After studying for a brief time with Lamothe and Flandrin, and copying at the Louvre, Paris, he travels to Italy where he spends several seasons. In Florence he meets the Macchiaioli. From the beginning, he shows an interest in the classicism of Ingres, from whom he receives advice, and the romanticism of Delacroix.

- **1859** Paints his aunt, the Baroness Belleli's family from Florence, revealing an interest in spontaneity.

- **1860** His style takes shape progressively, influenced by his friendship with Bracquemond, the photographer Nadar, the critic Duranty, and the painter Manet.

- **1862** Frequently visits the Longchamps horse racetracks to paint the races.

- **1866** Frequents the artistic gatherings at the Café Guerbois in Paris with the future Impressionists, with whom he maintains good relations. His work, Impressionist in a visual rather than a conceptual sense, departs from the basic characteristics of that group.

- **1872** He settles in New Orleans, the city where his mother came from and where his brother lives. There he paints various works from everyday life.

- **1874** Once again in Paris, he participates in the first Impressionist exhibit, collaborating in its organization. Except for the year 1882, he participates in all of the group's exhibits.

- **1876** His financial situation leads him to turn to pastel to increase his production, executing female nudes that become characteristic of his oeuvre and make him famous.

- **1881** Executes various female nudes designed to be modeled in bronze.

- **1886** At the Durand-Ruel Gallery in Paris, he participates in a group exhibit with a series of female nudes at their toilette.

- **1893** He has his only individual exhibit at the Durand-Ruel Gallery in Paris. Due to an eye condition that began in 1870, during the Franco-Prussian War, he gradually loses his eyesight to the point where he finds it impossible to paint. He then begins sculpting female nudes and ballerinas.

- **1917** Dies in Paris.

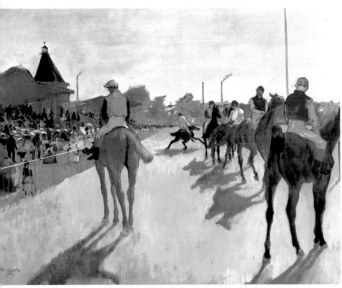

The Longchamps Racetrack

(1869-1872)
oil on canvas
18.4 x 24.4 in
(46 x 61 cm)
Musée d'Orsay, Paris

The characteristics of this informal composition, such as the head of the horse on the right cut off by the frame and the shadows cast by the horses, evoke Japanese prints and suggest a photograph. Such a composition clearly communicates the idea of movement. The sunlight is timidly represented by the gray shadows of the horses, and the jockeys' vests do not portray the vivacity that would be expected. Opposed to the application of thick layers of paint, Degas employed oil paints thinned with turpentine, lending his works a quality similar to watercolors. The draftsmanship in this work is extraordinary, which may explain why the artist chose to render the horses before the race, avoiding having to represent them at a gallop, a difficult and unrewarding task.

The Opera Orchestra

(~1870)
oil on canvas
22.8 x 18.4 in (57 x 46 cm)
Musée d'Orsay, Paris

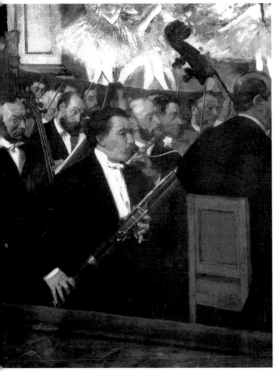

In order to render scenes of everyday life, Degas frequented many different places in order to capture ordinary people in their natural, habitual surroundings. He would observe his surroundings to obtain a spontaneous image.

The scene in this painting is viewed from a corner of the opera hall, and the artist takes the opportunity to portray several renowned musicians, many of them friends of his: the composer Chabrier, flutist Atlès, first violinist Lancen, violinist Gouffré, and double bassist Dihau, who takes up a significant amount of the picture plane. The static nature of the orchestra is balanced by the ballerinas on stage. The artist represents them partially, showing the dynamism off their legs and tutus but cutting of their heads to prevent them from drawing attention away from the musicians. The painting offers a feeling of immediacy and is greatly expressive.

Dance Class at the Opera

(1872)
oil on canvas
12.8 x 18.4 in
(32 x 46 cm)
Louvre, Paris

The subject of ballet dancers was a recurrent theme in Degas' work and was part of his effort to depict everyday scenes from different points of view. This scene is conceived as if it were a photograph. For the sake of spontaneity and freshness, the figures are distributed asymmetrically so that the space, instead of simply framing the figures, gains a more active role. To increase the sensation of realism, break the monotony of a large space, and lend the room depth, a chair is placed in the foreground. Although Degas did not share all of the same priorities as the Impressionists, he adopted some of their ideas. The color scheme is soft, delicate, and harmonious. The artist enlivens the scene with the light entering from the right, which hits the figures closest to the source, and highlights and defines the forms of the ballerinas and their tutus.

L'Absinthe

(1876)
oil on canvas
36.8 x 27.2 in (92 x 68 cm)
Louvre, Paris

The actress Ellen Andrée and the bohemian painter Marcellin Desboutin are portrayed at the Café de la Nouvelle-Athènes, where the Impressionists gathered instead of their previous meeting place, the Café Guerbois.

The foreground of the painting is occupied by areas of plain color while the figures are placed in the upper right. The figure's attitudes, their expressions, the serious atmosphere, and the austere decoration, with an abundance of dark, pallid, and neutral tones, convey exactly what the painter had in mind: an image of abandonment, loneliness, and tedium felt by characters with dissipated lives.

Exhibited in London in 1893, the painting was the object of severe criticism by those who championed Victorian morality, such as Sir William Blake Richmond and Walter Craine, who could not accept that amoral scenes and situations such as this could be the object of artistic representation.

Miss Lala at the Cirque Fernando

(1879)
oil on canvas
46.7 x 31 in (116.8 x 77.5 cm)
National Gallery, London

This scene represents the Cirque Fernando in Montmartre, later known as the Cirque Médrano, during a performance by Lala or Lola, a famous mulatto acrobat. The performer is raised in the air on a rope that she is holding in her teeth.

This circus was frequented by many of the artists living in that neighborhood of Paris, who would take advantage of the performance, ambiance, and audience to draw sketches for later works, as the movement and immediacy gave rise to interesting compositions.

The acrobat is viewed from below to increase the dramatic effect, and she is placed in the upper left corner to increase the sensation of depth. Just as the Impressionists did, Degas focuses on light, color, and the brushstroke, evident in certain details such as the clothing and shoes. In this work, the artist dispenses with the activity in the rest of the tent to concentrate on Lala's intrepid act.

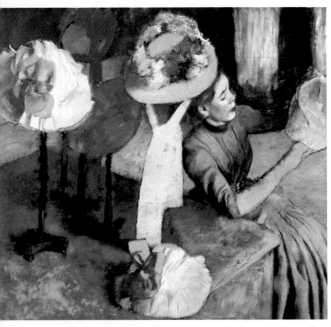

The Millinery Shop

(~1884-1890)
oil on canvas
40 x 44.2 in
(100 x 110.7 cm)
Art Institute of Chicago

As he did with the subjects of horse races, ballerinas, and women at their toilette, Degas also painted a series of works on hat shops. Each of these series demonstrates the artist's skill in depicting a single subject matter in many different ways by simply changing the colors, light, and composition.

This canvas, painted in a purely Impressionist style, shows how a work of art can be produced on a banal subject and with elements as simple as hats. In the interest of immediacy and spontaneity, the painter creates an asymmetrical, somewhat disorderly composition. Though logically the subject should be the shopkeeper, here it is the hats in the foreground that play the leading role, with their intense, striking colors. The artist gives priority to color in its own right, and his brushstroke is indefinite, only marking off areas and providing contour. The background is executed in warm, dark colors, with some areas of light, vivid tones reflecting the light that strikes them.

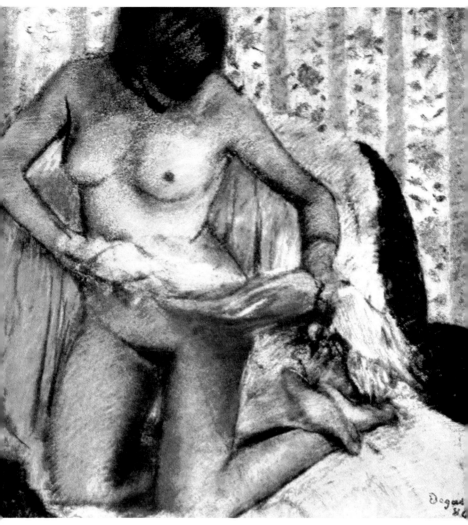

Degas went through various stages in his pictorial career, identifi-
able by their specific subject matter and treatment. Toward 1875,
he focused on painting women at their toilette. Of his many works
on this subject, he exhibited a significant number at the
Impressionist exhibition of 1886. In these works, Degas broke with
the tradition of idealizing the female body and presented it in its
everyday context, moved by a desire to study the female anatomy
and the artistic possibilities it offered in depth.

**Woman Kneeling
After a Bath**

(1884)
pastel on paper
20 x 20 in (50 x 50 cm)
The Hermitage,
Saint Petersburg

In these works, the women do not pose. They are represented as
if the painter had surprised them in the intimacy of their rooms,
like a voyeur. Employing ordinary women as models, he would study the pose, decor, setting, light,
and all the details so well that they resemble sultry snapshots of women in spontaneous, uninhib-
ited poses and gestures. This inherently voyeuristic approach was hardly known before and allowed
Degas many possibilities with regard to composition and the study of light on the skin.

In this painting, the artist plays with a tenuous light that gives rise to shadows integrating the
figure with its surroundings and creating an appropriately intimate atmosphere. The vertical lines
on the wallpaper balance the curves of the figure and the movement of the arms. The pastel medi-
um favors a great deal of technical aspects, its texture increasing the warmth and sensuality of the
work and lending it a certain air of mystery. The artist's effort to make academic poses seem nat-
ural by placing them in context is remarkable, demonstrating that everyday scenes can provide rich
material for painting, often with excellent results, as is the case here.

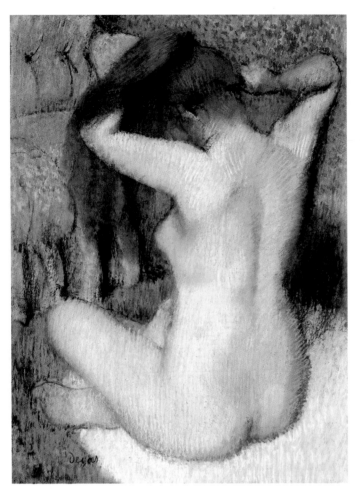

Woman Combing Her Hair

(~1888-1890)
pastel on light green wove paper
24 x 18 in (61.3 x 46 cm)
The Metropolitan Museum of Art, New York
(Gift of Mr. and Mrs. Nate B. Spingold)

Degas was one of the artists most successful at rendering the private world of women. He painted up to 280 works on this subject, many of them in pastel. They exhibit delicate textures, perfectly defined outlines, and beautiful, extremely expressive studies of light and color.

He painted ordinary women at their toilette, lending his paintings great realism and an intensity difficult to match. As he himself affirmed, he was not interested in painting perfect, idealized bodies in the classical manner, but rather normal women going about their private lives.

In these paintings, Degas based the classicism of the poses on Ingres' style, but he rediscovered drawing and the figure. Through the setting and pastel medium, which he mastered completely, he provided a more realistic vision of the female, though always sensual, with delicate skin and attractive forms. Here, his interest in the female nude is evident, as it occupies nearly the entire surface area of the painting, hardly leaving room for the abstract background. His technique was to apply the pastel in many layers. Thus, the woman's skin contains many details and textures. The result is a harmonious work in which Degas reveals his great mastery of drawing and compositional technique.

WINSLOW HOMER

Winslow Homer (left) and Albert Kelsey in Paris, *1867, Bowdoin College Museum of Art, Brunswick, Maine. Gift from the Homer Family.*

Trained as an illustrator, Winslow Homer's early works were influenced by the naturalistic romanticism of the Hudson River School, and provide a detailed description of nature. The specific use of light in his early landscapes, approaching the illumination of Fitz Hugh Lane and Martin J. Heade's artwork, was a dramatic means of expression that converted nature into an idealized element.

In 1867, Homer moved to France and his style evolved toward the Impressionism of Claude Monet and Eugène Boudin. But it was his stay in the coastal village of Tynemouth, England, in 1881 that most influenced his painting. Homer began to use watercolor in a more expressive manner, and his paintings, more fluid and varied than what he had produced in the United States, were enriched through a more pictorial technique.

In England, Homer painted landscapes that were a more personal interpretation of reality, and his painstaking realistic work gave way to a style characterized by the suppression of extraneous elements and details, strengthening the expressiveness of his paintings.

Homer began using oil when he moved to Prout's Neck, Maine, in 1883. In his seascapes, he sought the brilliant effect of light on water, which he combined with scenes of daily life in that small fishing village. Influenced by the Impressionists' images of rural life, he emotionally recreated scenes from the everyday life of the fishermen, rendering them as heroes facing the fury of the sea.

Homer is the greatest exponent of the realist tradition of American 19th-century painting.

- **1836** Born in Boston to a well-off New England family. His mother's experience as a watercolorist is a determining factor in his career.

- **1842** The Homer family moves to Cambridge.

- **1855** Begins his apprenticeship as an engraver in J.H. Bufford's lithography studio in Boston.

- **1857** Executes his first illustrations for *Ballou's Pictorial* and *Harper's Weekly*.

- **1859** Moves to New York, where he briefly studies with Frederic Rondel.

- **1861** Moves to Belmont, near Waverly Oaks.

- **1862** Begins painting scenes of the Civil War.

- **1864** Elected member of the National Academy of Design.

- **1866** Exhibits his work, *Prisoners from the Front* (Metropolitan Museum of Art, New York) in New York.

- **1867** Moves to France, where he adopts Degas' style and paints outdoors. Exhibits two paintings at the World Exposition.

- **1870** Travels to the Adirondack Mountains in the state of New York.

- **1881** Moves to the northeast coast of England to be close to the sea.

- **1882** Returns to the United States, where he exhibits the paintings he executed in England.

- **1884** Moves to Prout's Neck, Maine. Spends a secluded spring and summer in isolation.

- **1885** Travels to Nassau and Cuba, where he executes a series of paintings inspired by the brilliant light of the tropics.

- **1893** Receives the gold medal at the Colombina Exhibit in Chicago.

- **1910** Dies on September 29 in Prout's Neck.

Waverly Oaks

(1864)
oil on paper glued on wood
13.4 x 10.1 in (33.6 x 25.4 cm)
Thyssen-Bornemisza Collection,
Madrid

The first landscapes that Homer painted in Waverly Oaks show his interest in intimate scenes as opposed to the gigantic panoramas of the Hudson River School watercolorists. He focuses the light intentionally to create a certain atmosphere around the two central figures. The trees represented in chiaroscuro also play an important role in the scene. Indeed, among American watercolor landscapes, it is very rare to find paintings in which the atmosphere plays such an important role.

In this work, Homer interprets the new pictorial trends, which placed the subject matter in a spectacular and detailed setting, appearing in France and England to create a country scene in a magnificent, dense forest. With regard to composition, the artist tends toward the more decorative sense of painting, enclosing within it different tonal grounds that direct the viewer's eye toward the interior of the woods. The same is true of the realistic details—the trees in both the foreground and background, the atmosphere of the scene, and the stream of light that the artist employs to focus interest on the figures. Further into the distance, the details gradually lose importance and become vague, thus preventing any interference with the two female figures.

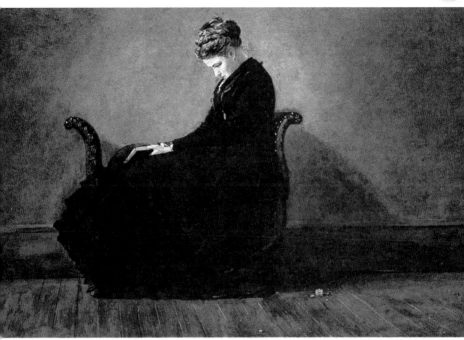

The resemblance between the art of Winslow Homer and James Whistler is evident in this portrait. Executed only two years after Whistler produced the portrait of his mother (see p. 354), it shows the artistic parallels between the two painters.

Homer executed a compositional exercise totally different from his previous works. The meticulous nature of his first landscapes is also reflected here. For example, the wooden floorboards and the texture of the wall were painted after executing minute preliminary studies.

Portrait of Helena de Kay

(1873)
oil on wood
12.4 x 18.8 in (31 x 47 cm)
Thyssen-Bornemisza Collection, Madrid

As in Whistler's work, the black of the dress plays an important role in the painting, directing the viewer's eye to the delicate tones of the face, which is illuminated with a brilliance that contrasts significantly with the predominating dark tones. Although the expressive aim of this lighting is clear, in Homer's art there is a nearly metaphysical depth in the illumination of the female figure. While the rest of the work is in shadows, the woman rests under an unreal light that appears to emanate from the figure itself.

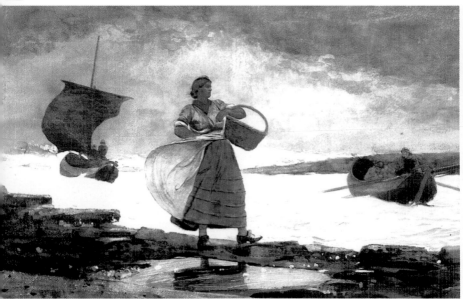

On the Sandbank

(1881)
watercolor and pencil on paper
15.6 x 28.8 in (39 x 72 cm)
The Metropolitan Museum
of Art, New York

When Winslow Homer moved to the English fishing village of Cullercoats in 1881, the previous panoramic landscapes appearing in his works became a search to reflect the anecdotal aspects of everyday life. Inspired by Turner's romanticism and Whistler's aesthetic theories, Homer's watercolor technique evolved in search of greater expression. The realist style, based on meticulous details and precise brushstrokes, gave way to more fluid brushstrokes and a more personal interpretation of reality.

In this work, the artist portrays the moment when two fragile fishing boats take to the open sea. Homer emphasizes the female figure in the central foreground. Her strength reflects not only the harsh struggle between humans and the sea, but the daily hardships of those who wait on land to share in and lighten the hard work.

The Milk Maid

(1878)
watercolor on paper
National Gallery of Art,
Washington

After his trip to France, where he came into contact with the group of Impressionists, Homer showed an interest in European painting in his choice of subject matter, for example, painting scenes from everyday life. Here, a woman is going to milk a cow. Homer reproduced scenes such as these in highly elaborate, studied compositions. The woman is placed slightly to the left, slightly inclined in a position of doubt or waiting. At her side, several roosters direct the viewer's gaze toward the grass, represented in great detail. Behind the roosters, a cow compensates for the visual weight of the woman's light dress. The entire scene is under a large tree whose lower part covers the background, yet the foreground is not tenuously illuminated under the shadow of the tree but lit from the front. The careful distribution of the visual elements reflects how Homer directed the viewer through his paintings.

Deer in the Lake: The Adirondacks

(1889)
watercolor on paper
13.2 x 19.2 in
(33 x 48.2 cm)
Thyssen-Bornemisza Collection, Madrid

When Homer returned from England, he moved to the Adirondack Mountains. There he painted a series of works under the influence of the Impressionist movement, which he had encountered in Europe. This work reveals a daring use of color distributed in horizontal planes. These large masses of color, in which the landscape is simply insinuated and the realistic details are totally dispensed with, contrast with the detail of the animal crossing the lake.

The interplay of contrasts in the work represents an evolution in the watercolor technique. Still interested in panoramic views of nature, Homer composes the painting according to the distribution of color, eliminating the profusion of excessively defined elements common to many American watercolorists. This use of color as an expressive element progressively acquires a more important role in Homer's art, and he begins to sacrifice realism for a tonal fluidness based on a constant interplay of light and shadow.

The Call for Help

(1892)
watercolor on paper
25 x 39 in
(62 x 98 cm)
Thyssen-Bornemisza Collection, Madrid

This work, begun in 1880, was retouched time and again by the artist, until in 1888, he repainted it completely. The creative process continued four years longer, and the artist deliberately manipulated the elements appearing in the painting. Details were suppressed and Homer took great pains to eliminate any superfluous elements that could distract the viewer. In this painting, although Homer represents various fishermen and sailors, he focuses on the two figures getting into the fragile rescue boat. The remaining figures observe them with respect, expressing the sense of everyday heroism that Homer reproduces in many of his works. Homer often used large waves and a threatening sky as an expressive resource. American genre painting was transformed by Homer, moving from the anecdotal to a complex study of the relations between humans and nature.

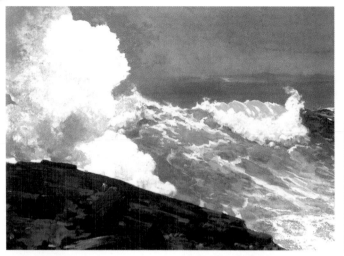

The Northeaster

(1895)
oil on canvas
34.8 x 50.8 in
(87 x 127 cm)
The Metropolitan
Museum of Art,
New York

This painting shows the force of the works Homer executed in Prout's Neck. In his last paintings, the artist used oil to create a more forceful texture for the sea. This work portrays the harshness of a storm striking the coast. The powerful breaker defines the compositional structure, forming a diagonal that divides the painting into two totally different planes. The expressiveness of the white foam that seems to want to swallow the rock is based on the brilliance of the white and its contrast with the dark tones of the rock. On the right, on the other hand, the painter portrays the wave breaking on itself and the vitality of the water surface through details in color that reveal the artist's completely free style. The sky is rendered in grays and ochres, balancing the composition by compensating for the weight of the brown in the rock.

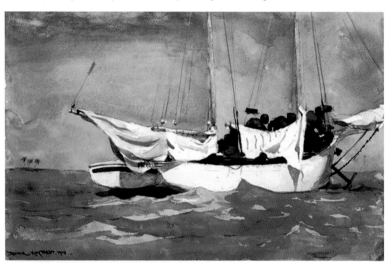

Key West, Hauling Anchor

(1903)
watercolor
14 x 21.8 in (35 x 55 cm)
National Gallery of Art,
Washington

This painting reveals Homer's interest in the effects of light as an expressive medium. The brushstrokes, more fluid here than in his previous works, create the waves of the sea through different tones of blue that are superimposed to obtain a dynamic effect. The boat, in a brilliant white that contrasts with the surrounding colors, increases the sensation of volume. It is executed with great realism. As in many of his works, Homer uses the technique of reproducing the principal element in greater detail, leaving the background as an expressive but less realistic element. The sky is a wash that ends in a fully defined horizon line. In his seascapes, Homer never leaves the line where the sea and the sky meet free of elements. Here, it is a small island with palm trees appearing on the left that breaks the horizon line. After his trip to the tropics in 1885, his paintings increased in luminosity. In this painting, the effect of light is treated in a manner that is totally new for the artist, producing a relaxed scene of life on the sea.

PAUL CÉZANNE

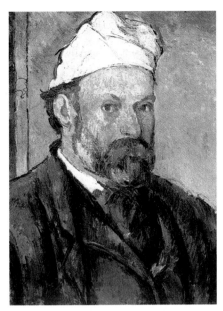

Self-portrait with White Turban, *oil on canvas, 21.6 x 17 in (55 x 43 cm), ~1880, Neue Pinakothek, Munich.*

Paul Cézanne's art goes one step beyond Impressionism. Whereas the members of the Impressionist movement were generally interested in the different ways of interpreting nature, Cézanne sought a naturalistic interpretation, investigating the pictorial element itself as the fundamental objective. For this artist, the subject was only an excuse to investigate the elements and areas composing it, an idea that would constitute the basis of Cubism.

Cézanne worked with all sorts of genres—still lifes, portraits, landscapes, and nudes—in which he displays a propensity to structure space architecturally. His authenticity and personal view of things constitute the end of naturalism and demonstrate that the painting is not a reproduction of reality but rather an interpretation of it.

Along with Gauguin and Van Gogh, Cézanne was one of the key figures in Post-Impressionism, a term that applies to painters of the 1880s and 1890s who had passed through an Impressionist phase and exceeded its limitations. Cézanne's art opened the door to Braque and Picasso's Cubism. With his interest in going beyond the relationship existing between natural reality and artistic rendering, this artist's work culminates the entire creative impulse of the latter 19th century.

- **1839** Born in Aix-en-Provence to a Piedmontese hatter who founded the Banque Cézanne et Cabasol.

- **1856** After studying at the Collège Bourbon at Aix-en-Provence, where he meets Émile Zola, he attends classes at the École des Beaux-Arts in the same city.

- **1861** Enrolls at the Académie Suisse in Paris, where he meets his classmate, Camille Pissarro, who introduces him to the circle of the future Impressionists who meet regularly at the Café Guerbois. He meets Monet, Bazille, Sisley, and Renoir, with whom he establishes close friendships.

- **1870** The Franco-Prussian War causes the group to disperse. Cézanne flees to l'Estaque on the Bay of Marseilles with the model, Hortense Fiquet, who would bear him a son in 1872.

- **1872** Once the war is over, the group of Impressionists comes together again and Cézanne begins his Impressionist period, influenced by Pissarro, with whom he paints at Pontoise.

- **1874** Participates in the first Impressionist exhibit with *The Hanged Man's House* (Musée d'Orsay, Paris). Although he maintains relations with the Impressionists, he is stylistically somewhat distant from the group.

- **1878** Begins a period of artistic maturity in Provence. Aix-en-Provence, l'Estaque, and Montbriand become the settings for many of his works.

- **1881** Resides in Paris for a time, where he meets Van Gogh, Émile Bernard, Paul Gauguin, and, shortly thereafter, Clemenceau and Rodin.

- **1886** Ends his friendship with Zola because he believes the writer has used him as a model for Claude Lantier, the main character of his novel, *L'Oeuvre,* who is an unsuccessful artist. On his father's death, he inherits the country house, Jas du Bouffan, and moves in.

- **1889** Sells Jas du Bouffan and settles in Aix-en-Provence. Despite his diabetes, he continues to go to the countryside to paint.

- **1895** The art dealer Vollard organizes an individual exhibit for him. He becomes a model for many young painters.

- **1904** The Salon d'Automne holds a retrospective on his works that is a great success.

- **1905** While painting in a field near the mountain of St. Victoria, a storm breaks out. He is struck by lightning and dies shortly thereafter.

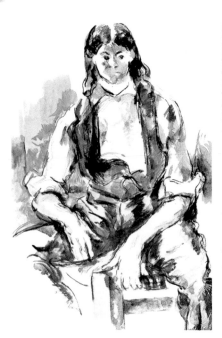

Boy in a Red Vest

(~1862)
watercolor on paper
Marianne Feilchenfeldt
Collection, Zurich

This work is very fresh, recalling an alla prima painting. The figure is drawn in a fine line in pencil, and then painted over in a rapid, loose brushstroke to reinforce the definitive structure. In areas and hollows created by the lines, the artist applies color very freely, suggesting volume, light, and shadows as well as other details, thanks to which the natural forms are consolidated. This watercolor shows an agile stroke and a fresh and direct rendering of reality, with no frivolous details. Despite its spontaneity, the work is clear, precise, and luminous.

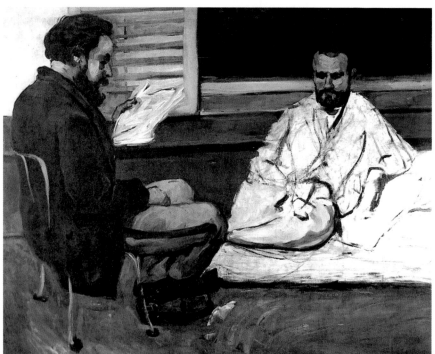

Paul Alexis Reading to Émile Zola

(1869-1870)
oil on canvas
52 x 64 in (130 x 160 cm)
Museu de Arte, São Paulo

Possibly on Cézanne's request, Alexis, who was a writer, became Émile Zola's secretary. This scene has an immediacy that makes it resemble a snapshot. Zola is seated on a mat on the ground in an oriental fashion, and his attitude is one of concentration and gravity, as if he were listening to something of great interest. Although the painting seems unfinished, it is quite possible that the artist intentionally left it thus. The loose brushstroke and the sketchlike nature of the figure of Zola, whose face is perfectly expressive, are very fresh elements typical of Cézanne's works. After Zola's wife's death, in 1927, this painting was found in the attic of her house.

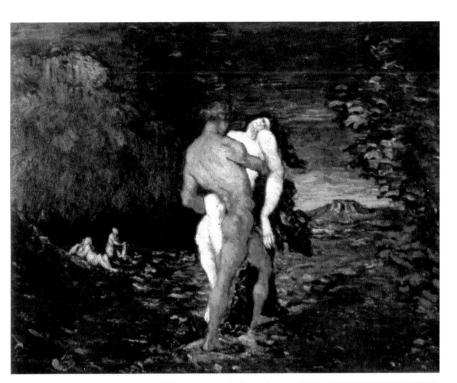

Cézanne was sexually repressed. He loved his paintings of nudes and felt the desire to caress their skin and embrace them, but he did not dare go beyond the painting. Several times he confessed to his friends, "I make love with all of the women I paint. Through the brush, I can follow their lines and caress their bodies time and again."

To conceal his repression, he often said terrible things about them. In his novel, *L'Oeuvre*, his friend Zola portrayed Cézanne's sentiments in all crudeness through the character, Claude Lantier, an unsuccessful painter who was the protagonist of the novel. It ended Zola and Cézanne's friendship.

This painting appears to represent Pluto, the god of death and lord of the underworld, abducting Persephone, a terrible goddess who presaged death and destruction, to make her his wife and the queen of Hades. However, the painter clearly gives free rein to his feelings on violence and sexuality in this passionate scene. Against a dark background, a man with tanned, leathery skin walks through a dismal landscape carrying an unconscious woman with a white complexion. In the middle ground, two nude people are bathing, indifferent to the scene. Despite the overall simplicity of the figures, the artist precisely defines their actions and represents them with force, juxtaposing the strength and cruelty of the man with the woman's weakness and sensual form. The force of the images increases the eroticism inherent in the subject, which Cézanne would take up again in later works, possibly attempting to compensate for his unsatisfied desires.

The Abduction

(1867)
oil on canvas
33 x 47 in (82.5 x 116.9 cm)
Provost and Scholars of King's College, Fitzwilliam Museum, Cambridge

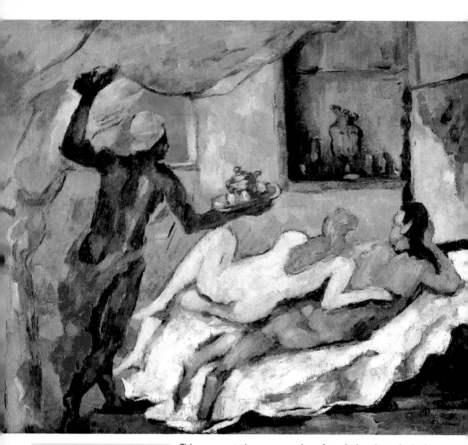

Afternoon in Naples

(~1876)
oil on canvas
14.8 x 18 in (37 x 45 cm)
National Gallery of Australia,
Canberra

This appears to be a new version of a painting the artist had executed in 1867. Cézanne represents a couple playing amorously on a bed while a colored servant attends them. This work was painted during a period of reprieve from the sexual repression that haunted him all of his life. In 1870, he moved to L'Estaque, on the Bay of Marseilles, with the model Hortense Fiquet. She was to bear them a son two years later, and the couple married in 1886.

The appearance of Hortense in his life seemed to mitigate the effects of his sexual tension. This is evident in the erotic paintings from the period, much more romantic, rich in color, and more positive than previous works, and lacking the violence and tension of *The Abduction* (see previous page).

Here, the two lovers are the protagonists of the scene. The black skin of the servant introduces a note of exoticism and constitutes an important element of balance in the composition and color scheme. The artist conceived the work such that the entire surface area is filled. The servant's pose, leaning forward and holding a tray in her outstretched arm while she lifts the curtain with the other, is an excellent example of the artist's skill in playing with elements to achieve a whole full of interest, movement, and theatricality. Though Cézanne was more interested in the structural elements of the painting than in the reality it represented, the sensuality he achieves through curves and colors is indisputable, and the eroticism he attains through the subject itself and the manner of interpreting it is remarkable.

Provence, with its fantastic landscapes, splendorous light and colors, and immense range of tones, doubtless moved the painter to combine the nude with landscapes in well-structured, bucolic visions. This work represents an idyllic natural setting with luxuriant, multicolored vegetation against a brilliant blue sky, framed by a large tree in intense colors on the left that provides a backdrop for a group of women who, like nymphs, are nude, some bathing in the river visible in the center. Its unfinished appearance lends the work great dynamism and freshness. The trees and sky are executed in loose brushstrokes, with a dramatic juxtaposition of tones. Yet the vegetation, though luxuriant, is not overwhelming. Even the inclined tree on the right contributes to the over-all movement and lightness.

The slender nudes in varied, spontaneous poses exude free-dom, joy, and relaxation, and their lines and forms help create a picturesque scene imbued with poetry and romanticism. With regard to the technique, the artist's manner of repre-senting the grounds is striking: he applies flat colors whose ordered arrangement is what produces the sensation of depth. Also striking are the thick, loose brushstrokes employed on the nudes, which show the Impressionist influence.

Bathers

(1899-1904)
oil on canvas
20.4 x 24.7 in (51 x 61.7 cm)
Art Institute of Chicago, Chicago
(Amy McCormick Collection)

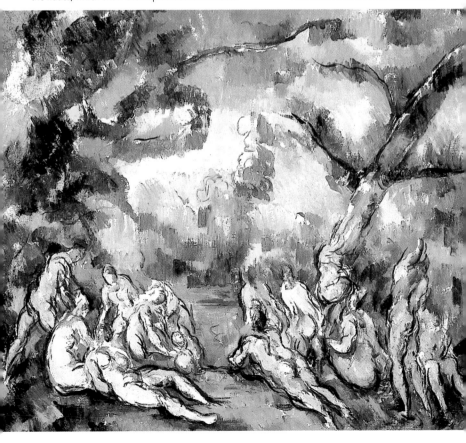

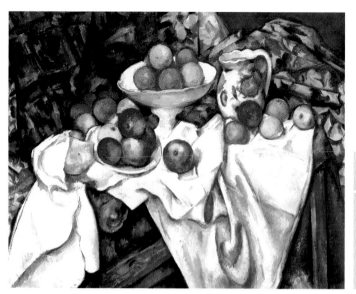

Apples and Oranges

(~1899)
oil on canvas
30 x 37 in
(74 x 93 cm)
Musée d'Orsay,
Paris

In this still life, Cézanne demonstrates that simple elements can become a work of art if they are well placed within an orderly whole and with sound treatment of light and color. Any object, humble though it may be, contains a myriad of possibilities that it is the artist's job to discover. The sense of space is perfectly rendered. The image is represented on an undefined plane in which the color of the apples and the white of the tablecloth are juxtaposed. The arrangement of the fabric in the background makes it an interesting constructive element. The volumes and compositional structure are the principle protagonists in this singular work. It is one of Cézanne's most renowned still lifes because, in 1911, five years after his death, its owner, Isaac Camondo, donated it to the state and it was immediately exhibited to the public.

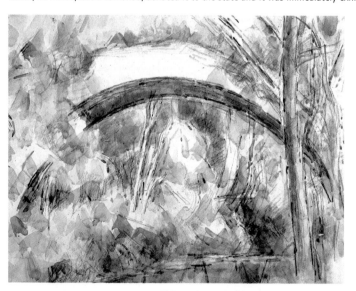

The Bridge of Trois Sautets

(~1906)
pencil and watercolor
on white paper
Art Museum, Cincinnati

This work reveals Cézanne's interest in working with paint independently of the subject matter, which is only an excuse for a structural study, the true objective of the painting being the pictorial element itself. The direction of the brushstroke follows the structural composition of the grounds, creating well-placed color zones. Colors are superimposed in strokes that do not seek to define form, but rather create an interplay between the different structural elements. The transparency of the watercolor is evident, as the greens applied on the underlying colors do not conceal them. This painting illustrates the new concept created by Cézanne: a great variety of lines and brushstrokes can be used to construct forms, dispensing with tonal evaluation and gradations.

CLAUDE MONET

Monet, in the early 1920s, working in his studio on the large canvases of the Nympheas series.

Claude Monet did not decide to become an artist until he met Eugène Boudin, with whom he went to the countryside to paint. In his first landscapes, Monet was drawn to ways of rendering light, which would become a determining factor throughout his artistic career.

After a stay in Normandy in search of new landscapes, he settled in Paris, where he met Renoir, Pissarro, and Sisley, with whom he shared his aesthetic experience in the outdoors. His works on the Forest of Fontainebleau and the town of La Grenouillère heralded a new style in painting, expressive and impulsive. The importance of atmosphere in the works of the new movement is manifested in *Impression: Sunrise* (1872, Marmottan, Paris), giving the new pictorial style its name, Impressionism. He incited new sensations in the viewer with his techniques of the brush and color.

The success of Impressionist painting encouraged Monet to continue experimenting with light. Thus he created series in which a single subject was rendered repeatedly in different intensities of light. He had a garden laid out at his country house in Giverny, where he could use the water lilies in his pond and the remaining vegetation to create the light effects he needed for his work.

One of the most eminent representatives of Impressionism, Monet created a new visual language based on the expressive force of light and color, allowing the artist to interpret reality instead of simply reproducing it.

- **1840** Born in Paris.
- **1856** Meets Eugène Boudin, who will become his teacher.
- **1859** Works at the Académie Suisse in Paris, where he meets Delacroix and Courbet.
- **1862** In Paris, he meets Sisley, Bazille, and Renoir.
- **1868** Leaves Paris because of his debts and moves to Étretat and Le Havre.
- **1869** Monet and Renoir move to St.-Michel, where they live together. The Salon rejects their participation.
- **1870** Marries Camille Doncieux, with whom he had a child in 1867, and moves to London during the Franco-Prussian War.
- **1872** Settles in Argenteuil with Renoir.
- **1879** His wife dies.
- **1881** The Impressionists disband and Monet moves to Fécamp, on the coast of Normandy.
- **1883** After an individual exhibit at the Durand-Ruel Gallery, he settles in Giverny.
- **1884** Participates in the third Internatonal Exposition organized by Georges Petit, titled *Sports in Art*. Returns to Étretat.
- **1888** Travels to Antibes and exhibits at two Parisian galleries thanks to the collaboration of Théo Van Gogh.
- **1889** Participates in the acquisition and posthumous donation of Manet's *Olympia* (see p. 342) to the French State.
- **1890** Purchases the house and property of Giverny, where he settles definitively.
- **1892** Marries Alice Hoschedé and begins his series on the Cathedral of Rouen.
- **1894** Meets Rodin, Geffroy, and Clémenceau.
- **1897** Stages an individual exhibit in Stockholm.
- **1899** Travels to London. When he returns to Giverny, he begins the series, *Water Lilies*.
- **1908** Travels to Venice, returning a year later, with very bad eyesight.
- **1911** His second wife, Alice, dies.
- **1914** His first son, Jean, dies.
- **1918** Moves to Le Havre, Pourville, Dieppe, Honfleur, and Étretat to work.
- **1923** Undergoes an operation on one eye.
- **1926** Diagnosed with a tumor. He dies on December 6.

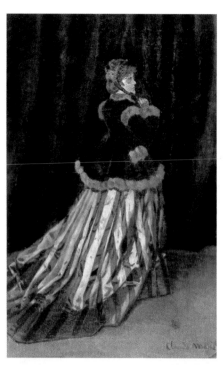

Camille Dressed in Green

(1866)
oil on canvas
92.4 x 100.4 in (231 x 251 cm)
Kunsthalle Bremen, Bremen

Monet executed this portrait of his lover in only four days in order to exhibit it at the Salon of 1866. His intention was to execute a monumental work, six meters by six meters in format, inspired by Manet's *Déjeuner sur l'Herbe* (see p. 343), and create the same scandal as the latter had in the Salon of 1863, to obtain the same publicity.

The canvas shows the elegant figure of Camille Doncieux, in a green dress that her close friend Bazille lent her. The structure of the work and its classical execution were admired by the members of the Salon and led to the sale of some of his paintings. The writer, Émile Zola, greatly liked this work and discovered in it the new preoccupations of a vital and energetic artistic movement.

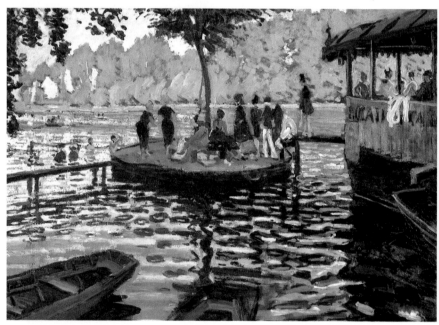

La Grenouillère

(1869)
oil on canvas
29.8 x 39.8 in (74.6 x 99.7 cm)
The Metropolitan Museum of Art, New York

This painting represents the jetty at La Grenouillère, a town near St.-Michel where Parisians gathered to spend the day in the countryside with friends, far from the bustle of the city. This modern subject matter was chosen by Renoir and Monet with the aim of perfecting their technique and finding a means of artistic expression with which to reproduce the atmosphere of the out-of-doors. In contrast to Renoir, Monet shows his interest in the effects of light, which he reproduces on canvas in rapid, thick brushstrokes. The light on the water is not treated as a simple backdrop—it becomes the principal element of the work and the focus of the scene. Here the Impressionist ideas were beginning to be felt.

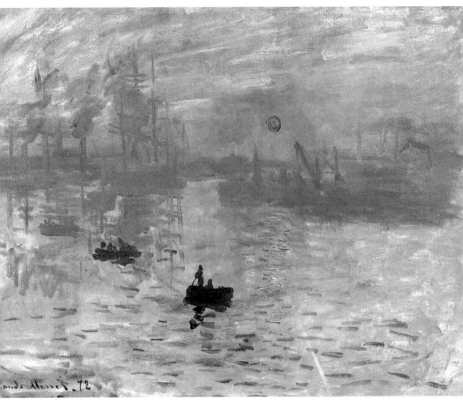

After the Franco-Prussian War, the Parisian Salon of 1872 was filled with works depicting military allegories and patriotic exaltations that disappointed the public. Hence, the inauguration of the "Salon des Impressionistes" at the photographic studio of Nadar was an important event announcing significant changes in the world of painting.

The exhibit of this work provided Monet with the opportunity to call attention to his works, which many qualified as "provocative."

Impression: Sunrise

(1872)
oil on canvas
19.2 x 25.2 in (48 x 63 cm)
Musée Marmottan, Paris

This painting contrasts with previous works by the artist for its dark tones and the simplistic nature of the composition. The predominant element in this view of Le Havre port at daybreak is the sun, a brilliant red sphere reflecting its rays on the tranquil waters, over the masts of the merchant marine in the background and on the three rowboats in the foreground. The atmosphere of the scene recalls Whistler's engravings of the Thames, which Monet had seen on a trip to London the previous year.

The interesting aspect of the painting is not the details, but the effects of the light on the elements of the seascape in an interplay of colors executed through a series of brushstrokes that evoke an emotion. This manner of seeing things by focusing on light and color, though already present in previous works, was innovative and sparked a movement that would mark an entire period—Impressionism. *Impression: Sunrise* was the essence of Impressionism, not only giving the movement its name, but providing a model for its nature and execution.

Claude Monet

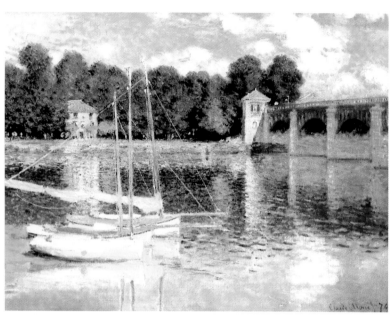

The Bridge at Argenteuil

(1874)
oil on canvas
24 x 32 in (60 x 80 cm)
Musée d'Orsay, Paris

Monet worked long on the compositional aspect of this canvas. It shows a meticulous study of depth on the movement of water and light. The water near the observer is calm whereas the ripples become more visible in the center. At the far shore, the water becomes tranquil again, mirroring the elements on the shore. In Argenteuil, Monet discovered and cultivated his passion for the interplay of light and color provided by bodies of water. To obtain a better point of view and facilitate certain perspectives from the water, he had a special boat built that he converted into his floating studio, where he often worked in the company of Renoir, and, at times, Manet. Monet eliminated certain elements that he considered unaesthetic and interfered with the feeling he wanted to convey. For example, the pollution of the Seine is wholly concealed here.

Rouen Cathedral: Façade and Saint-Romain Tower

(1893)
oil on canvas
42.4 x 29.2 in (106 x 73 cm)
Musée d'Orsay, Paris

Between 1892 and 1894, Monet painted fifty or so works on the Rouen Cathedral. The painter's obsession with the effects of light led him to execute a series on the principal façade at different times of day, from daybreak to dusk, representing a myriad of variations of light on stone. The portal and bell tower were rendered in meteorological and seasonal variations, but were naturally also subjectively interpreted by the artist, whose personal approach was constantly changing, evolving toward a more defined and experienced conception. The monumentality of the building was a pictorial challenge whose complexity attracted Monet. He played with the volume of the building and its different compositional possibilities according to the light.

Saint-Lazare Station

(1877)
oil on canvas
30 x 40 in
(75 x 100 cm).
Musée d'Orsay, Paris

For Monet, the railway represented technical progress and was a symbol of modern life. When he returned from Le Havre, the painter described the new constructions in iron and glass as "cathedrals of progress," and he began painting a series on the St.-Lazare Station in Paris at different times of day.

With the permission of the stationmaster, he placed the trains to his liking to achieve an elaborate composition. The painting consists of a network of lines moving in different directions and contrasts between different color areas, providing a great deal of vivacity. The importance for Monet of the smoking, phantasmagoric trains lay in the interplay of the steam, light, and movement, which imbues the scene with an atmospheric effect. The importance of the train to modern life was recognized by artists in other disciplines as well, such as the composer, Berlioz, who composed *Ode to the Railway*.

Houses of Parliament: Sun Breaking Through the Fog

(1904)
oil on canvas
32.4 x 36.8 in (81 x 92 cm)
Musée d'Orsay, Paris

During his stay in London, Monet suffered a condition that forced him to stay in the hotel or at St. Thomas' Hospital. In both places, he painted the views from the windows. From the hotel, he painted the bridges over the Thames and from the hospital, Parliament in the light of dusk.

In this work, the atmospheric architecture combines with the effects of light in an unusual manner. The contrast of color and light lends the work a dramatic air. J. M. W. Turner's influence on Monet's London works is evident, though the artist denied it time and time again. The English painter's manner of representing luminous effects is visible in Monet's work, though the latter used more intense and defined tones that lent his image a homogeneous appearance.

Pond with Water Lilies

(1899)
oil on canvas
35.6 x 36.8 in (89 x 92 cm)
Pushkin Museum, Moscow

Toward the end of 1890, Monet acquired the estate of Giverny where he was living. There he constructed an idealized garden where he could play with the vegetation and modify the light and color in his paintings. It became his passion. Shortly after purchasing the estate, he acquired a second lot where he had a pond put in, filled with water lilies and crossed by a wooden bridge in a Japanese garden style. In this painting, representing the bridge over the pond, the artist directs the viewer's gaze at the surface of the water, a subject matter that he would repeatedly take up in his old age. The depth and perspective evident through the water lilies floating on the water would soon give way to Monet's experiments on light in his series on the garden.

BERTHE MORISOT

Berthe Morisot toward 1877. The artist appears dressed in black, due to the recent death in 1876 of her mother.

Though in her lifetime she received much advice and was influenced by others, Berthe Morisot painted in her own manner, in a style that reflected her personality. Her teacher, Camille Corot, encouraged her to paint in the open air, an activity that found fertile terrain in the independent spirit of the artist. Later, her friend Édouard Manet, for whom she had modeled and who later became her brother-in-law, influenced her strongly, lending her a modern vision of painting. She immediately adopted the free, direct style characteristic of his works.

In 1874, she joined the Impressionist group, changing as they changed, and participating in many of their exhibits. As a result of her continual contact with them she lightened her palette and begain filling her paintings with light.

Her artwork is characterized by wide, vigorous brushstrokes executed with great freedom. It is always fresh, with luminous colors. Although after 1890 she is clearly influenced by Renoir, her friend and admirer, the great firmness of her draftsmanship continues.

She concentrated on outdoor scenes, portraits, and intimate family scenes, always incorporating women and children, basically her daughter, revealing a great tenderness and a fine sensibility.

- **1841** Born in Bourges on January 14. She is one of the three daughters of a high-ranking civil servant of the Department of Cher, a region of France, and the grand-niece of Fragonard.

- **1857** Begins studying drawing and painting under Cocharne, and later under Joseph-Benoît Guichard, an academic painter and friend of Ingres and Delacroix.

- **1859** Spends many hours copying paintings in the Louvre, where she becomes friends with Fantin-Latour and Bracquemond.

- **1861** Thanks to Fantin-Latour, she meets Camille Corot, becomes his student, and a long friendship begins.

- **1863** Paints in Pontoise, where she meets Daubigny, Daumier, and Guillemet.

- **1864** Participates for the first time in the Salon, exhibiting two landscapes.

- **1866** Paints in Pont-Aven, Bretagne.

- **1868** Fantin-Latour introduces her to Édouard Manet, who becomes a friend. She poses for him.

- **1870** During the Franco-Prussian War, she remains in Paris.

- **1871** Under the Paris Commune, she settles in St.-Germain on the advice of her admirer, Puvis de Chavannes.

- **1872** Travels to Spain and is enthralled by the works of Goya and Velázquez.

- **1874** Exhibits nine works at the Impressionist exhibit, participating in nearly all of their exhibits hereafter. Through her friendship with Édouard Manet, Berthe meets his brother Eugène, whom she marries.

- **1875** Her works are among those auctioned at the Hôtel Drouot. Travels to Britain and paints on the Isle of Wight.

- **1879** Gives birth to her daughter Julie.

- **1881-1883** She has a house built in Paris, on Rue Villejust, where artists and intellectuals gather every Thursday (Degas, Caillebotte, Manet, Pissarro, Whistler, Puvis de Chavannes, Duret, Renoir, Mallarmé, etc.).

- **1886** Exhibits on the island of Jersey. The dealer Durand-Ruel exhibits her works in the United States.

- **1887** Along with Monet, Renoir, Pissarro, and Sisley, she participates in the Georges Pétit International Exposition.

- **1892** Her first individual exhibit is held at Boussod and Valadon.

- **1894** The French State acquires for the first time a work by her, *Young Woman Dressed for a Ball* (Musée d'Orsay, Paris).

- **1895** She dies in Paris on March 2, at 54 years of age, from a disease she contracted while caring for her sick daughter.

The Harbor at Lorient

(1869)
oil on canvas
17.1 x 28.75 in (43.5 x 73 cm)
National Gallery of Art,
Washington, DC

This is a view of a city in Bretagne, the northwestern region of France, which was a naval port for many years. During the Second World War, German submarines were stationed there and it was heavily bombarded by the allied forces. Its bay is an estuary formed by the confluence of the rivers Scorf and Blavet.

The figure on the bridge is Morisot's sister, Edma, also a painter. The work was executed during a trip they had taken to this town. It is imbued with freshness, both for its soft, luminous, pastel colors, and its technique of careful brushstrokes, with great contrast between the pictorial textures of different areas. Simply compare the sky, very smooth, in a delicate, continuous brushstroke, the water, in visible brushstrokes of juxtaposing tones that lend it chromatic movement, and the side of the bridge where the woman is sitting, in aggressive, decisive brushstrokes resembling a sketch.

Though it was painted when the artist was 28, the canvas achieves the objectives of the Impressionists, and demonstrates her full support of the movement's idea of combining the landscape with the figure. The soft tones, the general finesse, and the attractive delicacy of this work caused a certain critic, Joris-Karl Huysmans, to call the style senseless. Nonetheless, Puvis de Chavannes, the leading French mural painter of the time, found the painting magnificent and Manet liked it so much that Morisot gave it to him.

Berthe Morisot

This painting represents Edma (Madame Pontillon), the artist's sister, watching her daughter Blanche, asleep in her cradle. This family scene is full of tenderness and candor, for which Morisot had a great weakness.

This painting reflects Morisot's observational skill and the care she dedicated to details. The woman's facial expression shows her full concentration on her daughter. Her gesture is delicate and her dress executed with great dignity. The diaphanous curtains imbue the scene with softness and make the woman stand out. Her dress and hair, in dark colors, frame a highly expressive face that is mirrored in the tranquil baby's face. The artist's mastery of technique is evident.

Paul Valéry, who knew Morisot well because she had married his nephew, said that she lived her paintings and painted as if it were something natural and necessary for her. In Morisot's artwork, the idealism of the artist is fused with the intimacy of the characters into an inseperable whole.

The Cradle

(1872)
oil on canvas
22.4 x 18.4 in (56 x 46 cm)
Musée d'Orsay, Paris

Chasing Butterflies

(1874)
oil on canvas
18.4 x 22.4 in (46 x 56 cm)
Musée d'Orsay, Paris

This painting combines two characteristics of Morisot's art: the outdoors and the combination of landscape with the figure. From the start, she was encouraged to work in the open air by Camille Corot, one of her teachers.

Morisot adds her feelings of tenderness toward people to the freshness and freedom of the landscape. Curiously, the women she paints, as in this scene, are always well dressed and have a dignified demeanor. They belong to the middle class.

This painting lies fully within Impressionist canons, not only because it is an open air scene in the countryside, but also because of the technique. With a limited but well-employed color range, Morisot juxtaposes a myriad of tonal variations to describe the grass, trees, leaves, and flowers. Faithful to the movement, the short, studied, visible brushstrokes magnificently suggest rather than describe the elements represented. Hence, she creates an excellent atmosphere and lends the painting depth through a successful study of color and light, which filters down through the trees. The setting conveys what the subjects are feeling. It is not surprising that Morisot was recognized as a distinguished Impressionist.

The subject of a woman surprised at her toilette was often painted by artists such as Degas, Renoir, or Toulouse-Lautrec. But, whereas they represented nude women with an obvious erotic air, Morisot approaches the subject with quite a different intention: the rendering of coquetry, a highly feminine characterisitc.

The young woman is getting dressed before the mirror, attentively examining how the dress fits her in a narcissist exercise of self-contemplation along the lines of some of Proust's works.

The title is also eloquent. Psyche is the personification of the human soul and she is represented as a beautiful young woman. Despite the delicate subject, the artist executed the work with great freedom, in a loose, vigorous, and nearly aggressive brushstroke that juxtaposes contrasting colors to define the setting, figure, and girl's expression. She uses an excellent treatment of light and color. The painting constitutes a modern, harmonic symphony that is full of life. It is a faithful reflection of the artist's singular character and her involvement in the Impressionist movement.

Psyche

(1876)
oil on canvas
26 x 21.6 in (65 x 54 cm)
Thyssen-Bornemisza Collection, Lugano

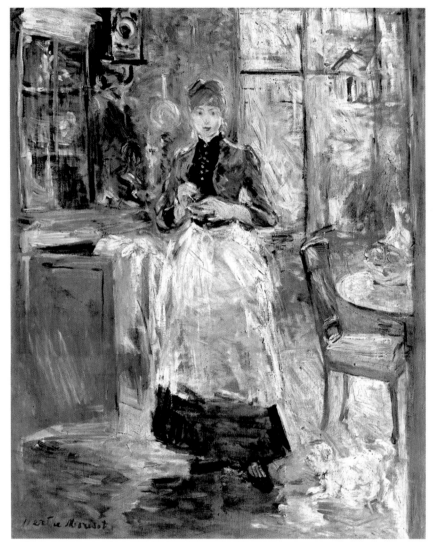

In the Dining Room

(1886)
oil on canvas
24.5 x 20 in (61.3 x 50 cm)
National Gallery of Art,
Washington, DC

When she painted this work, Morisot was 41 years old and artistically mature. At the previous Impressionist exhibit, she showed 14 paintings. In the same year, the dealer Durand-Ruel exhibited her works in New York and she received positive reviews from critics as famous as Paul Valéry.

Her enthusiasm for playing with light and the brushstroke follows Impressionist criteria, but her style is highly personal, for through the latter elements, she not only expresses a vision, but also a certain emotion.

In a display of liberty and audacity, she applies a decisive, loose brushstroke in all directions, attacking the areas of light, which are vibrant and rich in nuances. The intensity of the colors and the contrast she achieves by superimposing them lend the painting definition which is not actually there, since the brushstrokes are quite visible. Except for the upper half of the figure's body and her delicate, pleasant, and detailed face, the painting is nearly abstract. The forms and modeling are achieved through the application of numerous dabs of color, producing a work of great vivacity and impact.

Pierre-Auguste Renoir

Self-portrait, *oil on canvas, 17 x 13 in (42 x 33 cm), 1910, Durand-Ruel Collection, Paris, New York.*

Renoir's works fall into a number of periods. Around 1870 he painted in the Impressionist style, varying only in the practice of painting outdoor themes. Instead, he concentrated on the human figure, treating it not just as another element in the landscape but in and of itself. His outstanding portraits of women usually with their children made him famous.

Around 1883, after his travels through Italy elicited his interest in classical art, he began to abandon the Impressionist palette in order to dedicate himself to linear painting with citric colors and a dry technique. In this period the painter becomes more meticulous in the production of his works, addressing problems of volume, form, and value.

Around 1890 he began a new period, characterized by delicate images tinged in a sensual and innocent manner with soft, iridescent colors. Beginning in 1903, his pictures shine with a luxurious plenitude of colors. They are clearly influenced by Fragonard and the French School of the 18th century, a tradition he along with Rubens and Ingres upheld. He paints ample female nudes in warm and resplendent tones, their poses classic and unmistakably charged with eroticism.

Considered as a unitary whole, the style of Renoir is unique, personal, and cannot be ascribed to any other artistic school or current of that epoch. Nonetheless, Renoir should be considered a key figure in modern painting.

- **1846** Born in Limoges, the son of a tailor and a working mother.
- **1854** Works as an apprentice decorating china in the porcelain factory of the Levy brothers.
- **1862** Attends the courses of Gleyre in the School of Fine Arts in Paris. He meets Monet, Sisley, and Bazille.
- **1865** Paints outdoors in the Fontainebleau forest with Monet, Pissarro, and Sisley. He meets Courbet and takes up with Louise Trébot, his favorite model until 1872.
- **1867** Excluded from the Salon, he exhibits at the Salon des Refusés with Bazille, Pissarro, and Sisley. He regularly attends the artistic gatherings in the Cafe Guerbois. Here he and Manet help out future Impressionist painters.
- **1869** Paints with Monet on the island of Croissy, in the Seine, in the resort of La Grénouillère.
- **1872** Paints with Monet in Argenteuil, on the banks of the Seine.
- **1873** Becomes one of the founders of the "Société Anonyme" for artists, painters, sculptors, and printmakers.
- **1874** Participates in the first exhibition of the Société Anonyme, which takes place in the studio of the photographer, Nadar; among various works he shows *The Box Seat* (see p. 389).
- **1877** Takes part in the third Impressionist Exhibition with *Dancing at the Moulin de la Galette* (see p. 391).
- **1879** Takes part in the Salon with a *Portrait of the Actress Jeanne Samary* (Pushkin Museum, Moscow) and *Madame Georges Charpentier and Her Children* (Metropolitan Museum of Art, New York). He forms a sentimental relationship with Aline Charigot, a model for many of his canvases, whom he marries in 1890.
- **1881** Travels to Algeria and Italy, where the works of Raphael and the pictures of Pompeii impress him greatly.
- **1882** In Palermo he meets Richard Wagner and paints his portrait (Musée d'Orsay, Paris).
- **1886** With 28 paintings, he participates in the New York exhibition organized by the dealer Durand-Ruel.
- **1897** Travels to London, The Hague, Bayreuth, and Dresden.
- **1900** Awarded the Legion of Honor.
- **1912** Despite suffering rheumatic paralysis, he continues to paint.
- **1919** Dies on December 3 in Cagnes-sur-Mer, Côte d'Azur, where for health reasons he had moved some years before.

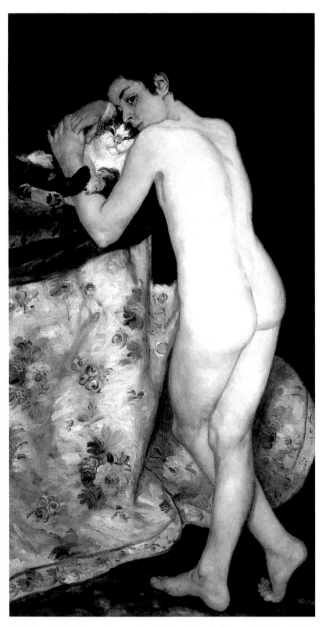

A Boy with a Cat

(1868)
oil on canvas
49.6 x 26.8 in
(124 x 67 cm)
Musée d'Orsay, Paris

Here the painter presents a recurrent theme in art: the nude. Although the pose is inspired by academic models, here with the props, atmosphere, and general concept, he takes the idealism from the subject in order to present a figure in an interior setting.

The skin, realized with a great delicacy and realism, stands out against a thick, dark color in the background. The positioning of the feet, with the right foot supporting all the weight and the left foot crossed over in front of it, gives a delicate rhythm to this fresh and spontaneous composition. The area occupied by the faces of the boy and cat is exceptional as much for its expressive nature as for the tenderness it conveys. The half-asleep cat leans against the face of the boy gently caressing it.

The boy's face presents many meticulously worked-out details: a large nose, a sensual mouth flanked by pallid red lips in harmony with the predominantly pale color of the body, and the sharp fixed glance of transparent and penetrating eyes. This naked body is doubtless that of a young man, though the artist seems to be playing with a certain sexual ambiguity, which makes it even more intriguing. Possibly Renoir utilized as a model one of the Italian boys willing to pose for four francs per five-hour session in the studios and academies of Montmartre and the Latin Quarter of Paris.

The Box Seat

(1874)
oil on canvas
32 x 25.6 in (80 x 64 cm)
Courtauld Institute
Galleries, London University,
London

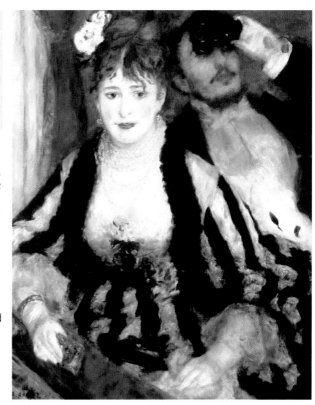

Aside from being a depiction of the fashions of the time, this painting is also a portrait. The gentleman is Edmond, the brother of the artist. The lady is Nini Gueule en Raie, a popular model in Montmartre.

Renoir sold this painting to Father Martin for 425 francs, the exact amount the artist owed him for the rent of his apartment.

The painting is dominated by these two personalities and Renoir's treatment of light. The working method—softer brushstrokes, realistic illumination and, delicate realization—is not Impressionist. Nor is his use of black. Nonetheless, he utilizes the color in the woman's dress and the man's binoculars to achieve a greater contrast and give the painting more impact. This allows the bright tones of the clothes and flowers to stand out even more. With its features well worked out, the delicate face of the woman is the center of attention.

The First Date

(1875-1876)
oil on canvas
26 x 20 in (65 x 50 cm)
Tate Gallery, London

Renoir painted various interiors that show the evolution of his style, first preoccupied by the drawing and progressively more attentive to the setting and atmosphere. Here he focuses the attention on a young lady who is obviously a pampered member of the privileged classes. Her well-coifed hairdo is elegantly capped. Her bouquet of flowers is the only counterpoint to her head and contrasts with the dark area of her frock. Renoir leaves the impression of a stolen glance. Everything is diffused. Only the most important details are captured: the forms of the box seats, the colors of the walls, and the hazy blend of the audience; in sum, the setting and atmosphere of the theater.

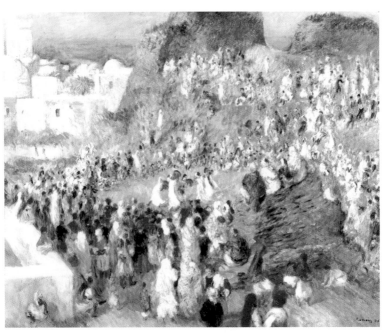

Muslim Festival in Algiers

(1881)
oil on canvas
29.4 x 36.8 in (73.5 x 92 cm)
Louvre, Paris

With funds received from his sold-out exhibition at the Salon of 1879, Renoir was able to travel to Algeria. During this trip he did this painting. The warmth and luminosity that dominate the picture are painted with an ample range of vivid orange colors that match the happiness of the crowd. Its participants are composed of the countless spots that become more abstract further in the distance. The festive atmosphere is captured with multicolored points forming the strongly contrasting turbans. There is a curious interplay of strokes on the rocks and boulders to the right. The whole scene, well-counterbalanced by bright colors, stands out even more with the blue sea and white houses in the upper area.

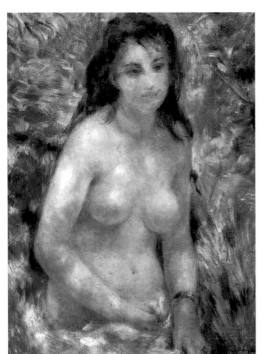

Torso in the Sun

(1875)
oil on canvas
32.4 x 26 in (81 x 65 cm)
Musée d'Orsay, Paris

This model shows off a body of diaphanous colors and full-figured, voluptuous forms. The white patches on her skin represent the effects of a recent sunburn. The vegetation of the forest, seen in multiple brushstrokes going in various directions, is abstract and only serves as a context and backdrop for the young girl. Though the warmth and innocence of her face seem somewhat blurred, Renoir realistically depicts her hair and the forward lean of her body. Modesty requires that she cover her pelvis with some garment, which she does in a dainty gesture. This combination of her nude body with the natural surroundings is perfection indeed .

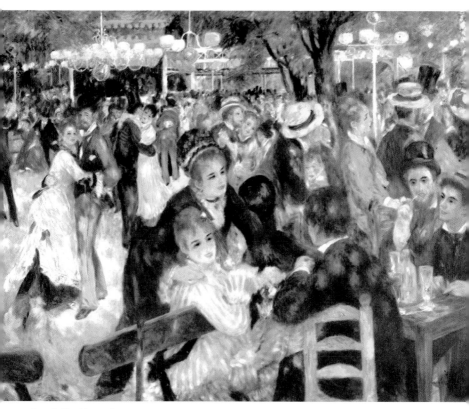

Renoir, like Monet, Degas, and other painters of the epoch, adored painting scenes dealing with the customs and manners of Paris at the time.

On a hill overlooking the working-class quarters and artist colony of the Montmartre district was the site of an old mill, or *moulin* in French. Originally it was a grain mill that over time had turned into a recreation center. There one could also buy its famously delicious sponge cakes, or *gallettes*.

Every Sunday afternoon in its ample patio a large crowd gathered—mainly consisting of working-class girls and their boyfriends—in order to drink, dance, chat, and in general have fun. Various artists also frequented the area for the same reasons. They could find young men and women willing to model for their paintings for very little money.

In this canvas, Renoir makes the same study of light that he would make in *Torso in the Sun* (see opposite page). In this work the rays of the sun penetrate through the branches of the acacia trees over the patio to fall over the happy crowd. This creates a speckling that is mirrored in the colors on the faces and the lights of the street lamps. Following the fashion of the time, Renoir takes advantage of the occasion to incorporate real people, his friends, in the scene. In the lower center is Estelle, the sister of Jeanne Samary, the artist's model. To the left, Margot, another of his models, is dancing with the Cuban painter, Cárdenas. On the lower right, sitting at a table are Frank Lamy, Norbert Goeneute, and Georges Rivière, friends of the artist and regulars at the Moulin de la Galette.

Other versions of this work exist: a little sketch in the Ordrupgard Museum outside Copenhagen and an even smaller picture in the John Hay Whitney Collection. This painting is a fine realization of the idea that was always the principal object of the Impressionists: the study of the effects of light and color.

Dancing at the Moulin de la Galette

(1876)
oil on canvas
52.4 x 70 in (131 x 175 cm)
Louvre, Paris

Renoir.

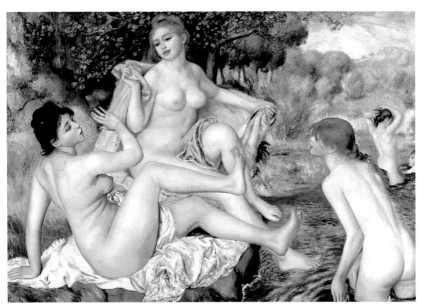

Bathers

(1887)
oil on canvas
47 x 68 in(118 x 170.5 cm)
Philadelphia Museum of Art,
Philadelphia

For this work, most certainly inspired by the relief *The Nymphs' Bath* by Girardon (Versailles Garden), the artist made a series of studies and red pencil sketches before painting it in his studio. Judging by the uniqueness of each body, it would appear the artist had painted each figure separately with the intention of inserting them into a common setting. There is a need to slightly reposition the figures. Also, the scene could be further unified to improve on the chilly indifference and frozen movement it exhibits.

Nonetheless, the figure study itself is perfect. Its two protagonists possess a voluptuousness that is taut and firm. Renoir has devised a harmonic balance of bright colors that unify the scene.

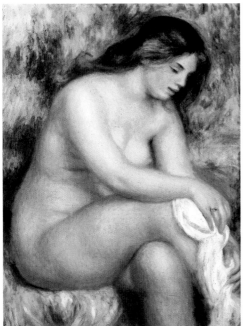

Bather Drying Her Foot

(1910-1911)
oil on canvas
33.6 x 26 in (84 x 65 cm)
Museu de Arte Moderna, São Paulo

The female nude gained such importance for Renoir that here the figure occupies almost the entire surface of the painting leaving hardly any space for a minimal backdrop. The anatomy of the young girl has been studied to the last detail and represented with a delicate and uniform chromatic range. In order to describe the skin, draw the forms, and place the shading, Renoir plays with tones that are weak or strong, bright or dark. The result is a delicate work made ever more so by the naive innocence in the facial expression. The mass of color that is the body is crowned by an abundant mane of dark chestnut hair. The background evokes more than represents nature. In his last years, everyone commissioned the artist to paint female nudes and many were the young girls of Cagnes and Essoyes who offered to model for the artist. As Guilleume Apollinaire affirmed in 1913, the nudes of Renoir's last period are the most beautiful, the freshest, the freest, and the most youthful.

PAUL GAUGUIN

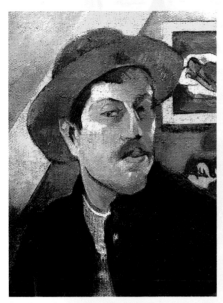

Self-Portrait with Hat, *oil on canvas, 18.4 x 15.2 in (46 x 38 cm), 1893-1894, Musée d'Orsay, Paris.*

Departing from Impressionism, to which the works of his first period should be attributed, Gauguin represents the so-called Synthetism (or Symbolism) of the Pont-Aven School, characterized by the simplification of forms and decorative features between great spaces of flat color, bordered by black lines. For him, the composition is more important than the unity. His paintings are typified by a series of almost dimensionless areas with dark contours, filled with vivid colors. The juxtaposition of these spaces create works of great color and intensity.

His stays in Tahiti, living with the natives and surrounded by the natural purity of an island awash with warm tropical colors, greatly influenced him. It was there he realized his most characteristic and interesting works. His direct contact with the local people and their simple life led him to a new approach to painting. In the primitive art that resulted, color and exoticism prevailed. Incorporating various native elements and symbolism, it addressed transcendental themes which human beings have pondered for eons.

Gauguin's theories about color, the juxtaposition of masses, and using lines to create profiles notably influenced modern painting and decorative drawing in the 20th century, especially for the German Expressionists and Picasso in his pre-Cubist phase.

- **1848** Born in Paris, the son of a French journalist from Orléans and a Peruvian Creole woman.
- **1849** His family moves to Peru and settles in Lima.
- **1855** Returns to France and studies in Orléans.
- **1865** Joins the Merchant Marine.
- **1868** Joins the Navy and serves during the Franco-Prussian War.
- **1871** Establishes himself in Paris and becomes a stockbroker.
- **1873** Marries a Danish girl, Mettre Sophie Gad, with whom he would have five children. Begins drawing at the Colarossi Academy.
- **1876** Takes part in the Salon with the work, *Landscape at Viroflay* (Tully Collection).
- **1879** Encouraged by Pissarro, he takes up painting and participates in Impressionist expositions.
- **1883** As a result of the stock market panic, he dedicates himself totally to painting. The beginning of hard times sees him living in poverty, separated from his wife and abandoning his children.
- **1886** With 18 pictures he takes part in the eighth exposition of Impressionists. In the Summer he moves to Pont-Aven, Brittany, where he paints landscapes and figure studies. Eventually he lives with Émile Bernard, Paul Sérusier, and other painters.
- **1887** With fellow artist Charles Laval, he sets off for America to work on the construction of the Panama Canal. From there he continues on to the island of Martinique.
- **1888** Returns to Brittany to paint. Here he also develops his theory of Synthetism, which incorporates a simplification of forms and unnaturalistic colors within dark contours that recall cloisonné enamels. In October he moves to Arles in order to live with Van Gogh. The association ends very badly.
- **1889** Paints in Pont-Aven and Pouldu, Brittany, where he lives with Sérusier.
- **1891** Sells various paintings at an auction and moves to Tahiti where he "goes native."
- **1893** Returns to Paris and has an unsuccessful show in the Durand-Ruel Gallery. He paints new landscapes in Brittany.
- **1895** Returns to Tahiti where he continues to paint pictures of the natives.
- **1901** Moves to Atuona, in the Marquesas Islands.
- **1903** Dies of syphilis in Atuona.

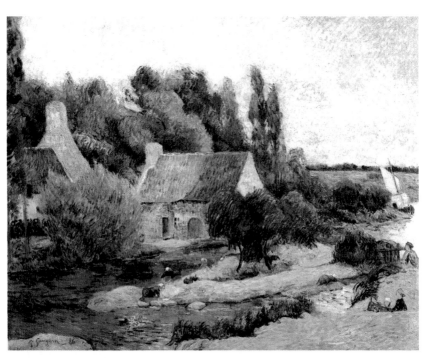

The Washerwomen of Pont-Aven

(1886)
oil on canvas
28.4 x 36 in (71 x 90 cm)
Musée d'Orsay, Paris

During this period, the artist was distressed by a series of personal problems, and decided to move to Brittany in search of peace and quiet. There he painted this picture. It is considered a perfect example of the Impressionist style, which at that time was at the fore of the artistic vanguard.

Gauguin painted this bucolic scene with loose brushstrokes and juxtaposed colors. The appearance in the painting of the washerwomen, though on a very small scale, shows how much he liked to include people in his scenes. He believed that portraying local inhabitants was indispensable to a landscape. During his stays in Tahiti later on, he would reinforce this notion by making the native women the major protagonists of his pictures.

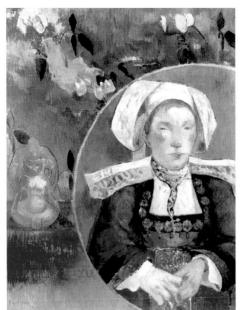

La Belle Angèle

(1889)
oil on canvas
36.8 x 29.2 in (92 x 73 cm)
Musée d'Orsay, Paris

This canvas was painted by the artist during his stay in Pont-Aven. Before moving on to live in the nearby town of Pouldu, he did this portrait of the mayor's wife, Marie-Angélique Satre. She obviously expected something very different and, seeing the result of her sitting, she was so horrified that she would not even accept it as a gift.

In fact, the artist did not really intend to portray her per se, but rather allowed himself to be carried off by the symbolism, using her personality to represent a specific idea.

Angèle appears inside an oval, clearly separated from the background. Her posture is rigid, and her expression deceptive, with her party dress hanging off-center.

The White Horse

(1896)
oil on canvas
16.4 x 36.4 in (41 x 91 cm)
Musée d'Orsay, Paris

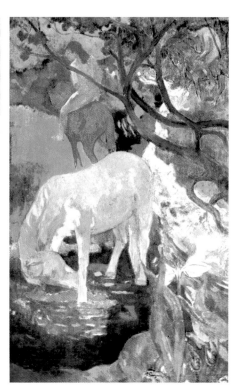

Gauguin did this painting in Tahiti, but even though the scene shows a local landscape almost as if it were a postage stamp, the artist cannot conceal his artistic origins.

Regardless of the motive, here he portrays a symphony of color, giving free reign to the Impressionist ideology that new sensations could be derived through color, which had influenced his early works. The luxuriant vegetation is an element that helps the artist create this symphony. From this an exotic work emerges, full of poetry, imagination, and chromatic rythm.

As for the human figures, whoever they are in real life, they have a symbolic role here. This painting is characteristic of his works during the years he spent in Polynesia.

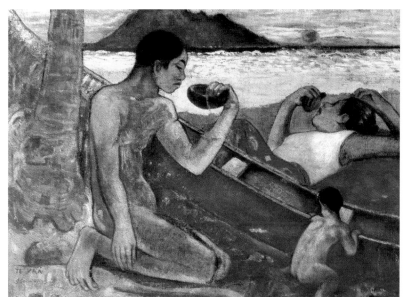

Judging by how often he employed it in his works, the family was one of the artist's predominant themes. Here the composition is lovely and carefully conceived. The lines of the boat's profile divide the painting diagonally.

In the upper part is the somber but dreamlike landscape of a golden sea and volcanic island. The woman, immersed in sleep, is pure poetry itself. In the lower part, the naked fisherman and his son go about their work, representing the hardness of reality, the double-faced nature of life. Curiously, the artist gives the male protagonist a strong body but shows him in a profile reminiscent of ancient Egyptian art.

Te Vaá (The Canoe)

(1896)
oil on canvas
38.4 x 52 in (96 x 130 cm)
Hermitage Museum,
Saint Petersburg

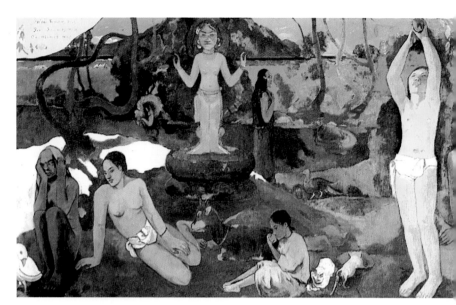

This work was painted while the artist underwent much grief and anxiety. In fact, times were so bad, as the painter confessed to his friend, Daniel de Monfreid, that he almost committed suicide but was saved by throwing himself into his work. This painting is his reflection on life. It is both monumental and symbolic.

On the right, a newborn baby represents the beginning of life, and on the left, an old lady represents the end. In the center, naked native girls symbolize naiveté, youth, and life. Their yellow coloring stands out against a background of blues and greens.

Other symbols populate the painting. Evolution is depicted as the animal with a monstrous appearance. Culture and religion appear in the idol. Daily life is conveyed through the people dressed in their normal attire and in the girl who is eating. Nature is represented by the animals and the landscape.

And yet, the whole remains a mystery. The artist leaves it open to interpretation, a feature that distinguishes the work of this painter. This is a work of great complexity. Its composition, chromatic treatment, and contents constitute a living testament to the painter. The large format augments the idea that this mural deals with life and mankind's contemplation of the finality of his existence.

For this painting, the artist made use of his usual resources. He draws the figures in profile and combines dark colors to create a mysterious milieu. With its curves and lines, the architecture forms the frame and decor of this scene.

In the foreground sit two women of differing colors with their naked and sensual bodies. Nearby is a Buddhist statue that incorporates multiple personages of a Far Eastern religion. In the background, Gauguin represents Christianity by portraying the last supper of Jesus and his disciples. In the middle distance, two women, one native in appearance, chat peacefully.

It is difficult to interpret this enigmatic work. What do the different colors of the skin, the two women talking, and the two religious representations mean? Is it an appeal for Christianity to respect other religions? To learn from them what it can? Is Gauguin asking whether societies mold their cultures, ideas, and belief systems so differently? Gauguin's works always pose multiple questions that are difficult to answer.

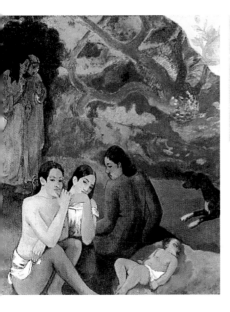

Where Do We Come From? What Are We? Where Are We Going?

(1897)
oil on canvas
54.7 x 147.5 in (139.1 x 374.6 cm)
Museum of Fine Arts, Boston
(Tompkins Collection)

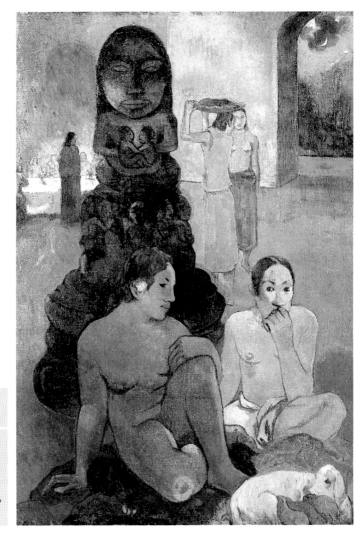

The Great Buddha

(1899)
oil on canvas
53.6 x 38 in
(134 x 95 cm)
Pushkin Museum,
Moscow

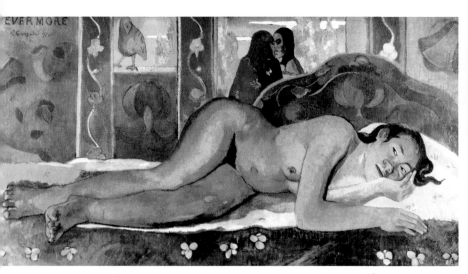

Nevermore

(1897)
oil on canvas
23.6 x 46.4 in (59 x 116 cm)
Courtauld Institute Galleries,
Cambridge University

At first, he painter was influenced by the ideas of Émile Bernard, Paul Sérusier, and Maurice Denis, with whom he lived at various times in Brittany. Later he was increasingly inclined toward a symbolism, especially after he arrived in Tahiti in 1891 and began to submerge himself in local beliefs.

Although this appears to be a simple study of a nude, such is not the case. In fact, the artist wished to reflect the defenselessness of the girl with no clothes, fear and doubt showing on her face. A threatening crow sits on the windowsill, women gossip in the background, and a sadness and weariness is evoked by the somber tones of the colors. All this, corroborated by the commentaries of the artist himself, shows that he meant to express more in this painting. The title itself is illustrative: nevermore means never again.

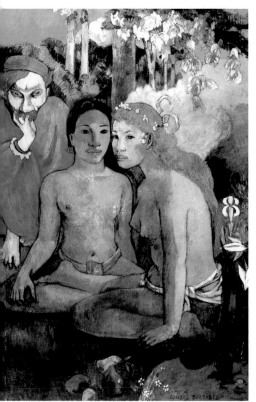

Barbarous Tales

(1902)
oil on canvas
12.6 x 36.2 in (31.5 x 90.5 cm)
Folkwang Museum, Essen

Painted shortly before his death, this canvas stresses a much-beloved theme of the painter: native girls, seated peacefully, with expressive faces and captivating glances, showing off their sensual nakedness. The eroticism of the scene, underlined by the look and characterization of the girls' bodies, brings great force and expressivity to the work. They are in vivid contrast with the landscape in the background, illuminated by clean, bright colors.

Gauguin was a lover of symbolism. Here the presence of the man lost in thought is intriguing. This painting may be the sum of the artist's experience.

A former stockbroker and painter, he fled the civilized world of high finance and high culture to live in a still-unspoiled so-called "primitive society." There he could feel at home with himself while trying to find the answers to those questions that had so long troubled his mind.

ODILON REDON

Odilon Redon in 1880.

According to the artist himself, "true art is art that is felt," and Redon's artwork shows a symbolic universe that maintains constant contact with reality. It is always imaginative, yet the ideas revolve around reality. In his artistic beginnings, the painter studied under a drawing tutor who taught him to appreciate English Romanticism. Black charcoal dominated his earliest drawings, which served to express his constant melancholy.

Redon executed his works through a detailed observation of nature, which he used as a basis to develop impressions and feelings. For this reason, he often executed several works on the same subject, but in different periods and with differing approaches. Redon worked without hesitation. His steady hand was decisive and rendered reality just as he saw it.

The Symbolist movement that originally arose in literature conquered painters who, headed by Redon, sought the inspiration for their creations in books. The literary symbolism of Baudelaire, for whom he illustrated *Les Fleurs du Mal*, determined Redon's style. The imagination of Redon, who had studied botany, was also fed by the natural sciences and mythology. He recreated mythological figures from ancient Greece, the Christian tradition, and Shakespeare's drama in his paintings. All of the elements of his works are metaphorical and follow an imaginative logic that he stretches to the limits of reality.

- **1840** Born on April 22 in Bordeaux to Bertrand-Jean Redon. Due to his delicate health, he spends his childhood at the family estate of Pèiralevada.

- **1855** First begins studying drawing under Stanislas Gorin. Studies architecture to enter the faculty at the École des Beaux-Arts in Paris, but fails the entrance exam.

- **1860** Exhibits his works for the first time at the Société des Amis de l'Art in Bordeaux. Meets Bresdin.

- **1864** Enters as a nonenrolled student in the studio of Gérôme at the Academy of Fine Arts in Paris, although his studies there, according to him, are pure torture.

- **1867** Exhibits an etching at the Parisian Salon.

- **1870** Executes part of the decoration of a chapel in Arras.

- **1872** After the Franco-Prussian War, in which he served as a draftee, returns to Paris and settles in the Montparnasse quarter.

- **1875** Paints in Barbizon and Bretagne.

- **1879** Publishes his first lithographic album, *Dans le Rêve*.

- **1880** Marries Camille Falte.

- **1881** His first individual exhibit is held.

- **1883** Meets Mallarmé, with whom he collaborates, illustrating one of his works. The book was never published due to Mallarmé's death in 1898.

- **1884** Presides over the first meeting where the foundations and rules of the Salon des Indépendants are established.

- **1886** Participates in the eighth Impressionist Exhibit in Paris and in the Salon des Vingt in Brussels. Meets Paul Gauguin.

- **1890** *Les Fleurs du Mal*, by Charles Baudelaire, is published, with nine illustrations by Redon.

- **1900** Exhibits three works at the World Exposition in Paris.

- **1904** Exhibits 72 works at the Salon d'Automne. The Musée de Luxembourg acquires his work *Closed Eyes* (Musée d'Orsay, Paris).

- **1913** Exhibits 40 works at the International Exhibit of Modern Art, known as the Armory Show, in New York.

- **1914** Participates in the International Exhibit of Modern Art in Berlin.

- **1916** Dies in Paris on July 6.

Fishing Boat

(1875-1880)
oil on canvas
2.5 x 8.7 in (6.2 x 21.8 cm)
Private collection

In his early years as a painter, Redon was influenced by Corot and exe-cuted various landscapes and seascapes in very small formats. In this one, a fishing boat is returning to shore. The sky is in the same tones as the water, and they unite on the horizon.

Redon enjoyed playing with the forms of the different elements in his works. Here, the coast arises as a fine line toward the right and gradually becomes thicker, increasingly separating the sky from the sea. On the sea, totally alone, a humble fishing boat appears.

Nonetheless, the serenity of the delicate boat conveys a romantic idea of solitude. Alone throughout his life, he learned to live with the solitude of his paintings and the freedom of art. His paintings from this period reflect this solitude.

Ophelia

(~1900)
oil on paper
23.4 x 19 in
(58.6 x 47.7 cm)
Ian Woodner
Collection

Redon was attracted by Shakespeare's dramatic universe and he recreated it in numerous works. Ophelia's face is framed by a series of undefined color planes. This disturbing use of color expresses the dramatic intensity of the moment. The woman is floating on water. The peaceful expression on her face is executed in fine strokes, with floral details in her hair and above her head that refer to an episode in the story in which she explains the symbolism of certain flowers and herbs.

Redon idealized the figure, placing it against a background of strong contrasts. In the last years of his life, he painted numerous portraits in profile, with the sitters surrounded by masses of luminous colors. Redon also executed a portrait of Ophelia in pastel (Woodner Collection), in which she is floating on intense blue water and surrounded by flowers with a greater richness of details. The expressiveness of this work lies in the absence of realistic details. Redon composes a metaphor around Ophelia's face. The portrait is immersed in a fantastic setting. It is at once a dream and a world full of romanticism.

The Mystical Boat

(1890-1900)
pastel on canvas
20.4 x 25.4 in (51 x 63.5 cm)
Ian Woodner Collection

This painting reflects the profound crisis that the artist underwent in the 1890s that gave rise to an artistic period that he himself would call mystical. The boat refers to a Christian legend from Provençal of a boat sailed by St. Peter, which represented the Church.

Redon's conception of art during this period evolved, introducing elements such as the use of pastel. The figures are merely an anecdotal addition. Their posture and the light expression of their bodies give a sense of fatigue arising from long and difficult voyages. Despite this, the artist presents a work in which the intense color gives the sail the leading role. After 1900, Redon often employed the distribution of elements found in this work, figures in a boat in a tense, airless atmosphere.

Bouquet of Flowers

(1902-1905)
oil on canvas
26 x 20 in (65.4 x 50.4 cm)
Ian Woodner Collection

Beginning in 1900, Redon painted a great many still lifes of flowers. His representations of flowers progressively acquired a more abstract character. The vases are an important part of the painting, and Redon, who often entitled his work according to the style of vase, indulged in the contrast between nearly abstract flowers and highly realistic vases. The painter himself admitted that this type of work represented an exercise for his imagination, which made his art constantly move from the details of the vegetation to the fantasy of color. For Redon, his compositions with flowers also constitute exercises in memory.

The Brown Vase

(1905-1910)
oil on canvas
29.4 x 40 in (73.6 x 99.8 cm)
Ian Woodner Collection

Redon's floral compositions were highly realistic, rich in details, with a sound compositional design. This brown vase reproduces the tones of the table it is sitting on and suggests the reddish color of the flowers. In Redon's painting, color smoothly changes through the different zones and, in this case, the homogeneous impression of the lower part of the composition emphasizes the meticulous nature of each small leaf and flower in the upper part. The background consists of a wall of undefined colors that provides a contrast against which the elements of the bouquet stand out. The bouquet seems to emanate its own atmosphere and light. The delicate use of color, consisting of a pyramidal structure of intense colors surrounded by complementary tones, insinuates the symbolic aspects of the plant life that Redon studied in the botanical garden of his friend, Armand Clavaud.

Thought

oil on paper
9 x 11 in
(22.4 x 27 cm)
Private collection

The representation of winged figures is a recurring motif throughout Redon's work. This work shows Prometheus chained. The painting is influenced by his black paintings, a series of engravings representing a deformed reality in dark colors. As in his other paintings on classical mythology, the expressiveness of this work lies in the colors of the sky. He uses red and black to represent the torment of Prometheus. This work, for which Redon executed a preliminary study, *Thought Under the Sunlight,* shows a figure who feels guilty and is resigned to his punishment. In the preliminary study, the chains are stronger and more visible, whereas in this painting, Redon preferred to show the figure as a prisoner of his own conscience.

Apollo's Chariot

(1909)
oil on cardboard
40 x 32 in (100 x 80 cm)
Musée des Beaux Arts, Bordeaux

Redon's visual language was composed of a symbolic vocabulary, complemented in the last years of his life by a symbolism based on colors as well. Strong contrasts such as blue and yellow accompanied mythological scenes of an abstract tendency, in which only elements playing the main role were represented figuratively.

In this painting, Redon focuses attention on the four horses of the god Apollo. The horses are more defined than the remainder of the painting, and the artist used white to render the effect of the sunlight, born of Apollo, striking them. The Symbolists represented Greek mythology in their own way, not at all in the classical manner of portraying characters as magnificent representatives of human virtues. For the Symbolists, Greece was romantic decadence.

The Birth of Venus

(1912)
oil on canvas
57.3 x 24.8 in (143.4 x 62.2 cm)
Private collection

According to Redon, to gain meaning, the female nude must be treated without conditions. The human body is beautiful in and of itself and should be portrayed as such. It should not be shown in the middle of an action, such as getting dressed. It should be exhibited without hesitation, for its sensuality, for the artist's expression, and for the viewer's aesthetic satisfaction.

Here the figure of Venus is rendered in a fine line that delicately outlines the body. It is framed by a conch shell that suggests a vulva and serves as a mystic aureole. The woman openly exhibits her nudity and allows the viewer to enjoy it.

The erotism of the image is immersed in a poetic atmosphere. Redon used elements that he had used in earlier works. His renderings of Eve and Pandora give the same impression of sensuality as this Venus.

Redon had a great attraction for the fantastic life inhabiting the depths of the seas. The seashell resembling a vulva refers to the world of erotic pleasure of which Venus is queen. Redon was so fascinated by the book *La Tentation de St. Antoine* by Gustave Flaubert, which contained descriptions of sea animals and monsters, that he executed a series of lithographs to illustrate it.

As a model for this figure, Odilon Redon used Alphonsine Zobé, who was recommended by the French painter Maurice Denis. Redon used her in many other works as well.

VINCENT VAN GOGH

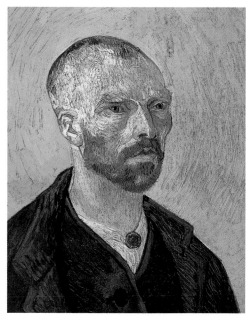

Self-portrait dedicated to Gauguin, *oil on canvas,
24 x 19.7 in (60.3 x 49.4 cm), 1888, The Fogg Art Museum,
Harvard University Art Museums, Cambridge.*

Few painters like Van Gogh have expressed what they thought, felt, and lived with such intensity and passion. However, during his lifetime, his oeuvre was completely overlooked. Some of his paintings were even used as roofing for the chicken coop of the lodging house where he spent his final days. Today his works fetch exorbitant sums at international auctions and are regarded as indispensable to understanding 20th-century Expressionist movements.

Van Gogh was a profoundly sensitive and artistic person. The tragedy of his life was his inability to adjust and his persistent failure in everything he attempted. While his close friendship with his brother Theo alleviated these failures, it did nothing to improve the mental illness he had suffered since childhood. Driven to the depths of madness, he cut off one of his ears following a bitter quarrel with Gauguin, admitted himself to an asylum, and finally committed suicide.

His paintings are categorized into various periods, styles and sensibilities:

- 1884-1886: Energetic Expressionism and dark tones, with themes of a social nature. Painted in Nuenen.
- 1886-1888: Luminosity and color inspired by Impressionism and Japanese prints. Painted in Paris.
- 1888-1890: Evasive and contorted forms of vertiginous rhythms and tortuous lines, with aggressive brushwork and intense colors. Painted in the south of France.

- **1853** Van Gogh was born in Groot Zunderet, The Netherlands, the son of a protestant pastor.
- **1866** He is employed by the Goupil Art Gallery, in The Hague.
- **1872** Begins to write letters to his brother Theo, who would become his lifelong friend and benefactor.
- **1875** Obtains employment as an art dealer in the Goupil Gallery, Paris, where he fails to succeed.
- **1876** Studies the bible, and works as a schoolteacher in Ramsgate. He also preaches there.
- **1877** Studies theology in Amsterdam.
- **1878** Seeks a post as preacher in Brussels but is rejected by the Evangelization Board. He works as lay preacher in the Belgian mining region of Borinage. His reclusive life irritates his superiors, who receive complaints and suspend his religious functions. He draws his first sketches of the coalmines and takes an interest in realist literature.
- **1880** Paints canvases, copying Millet, who had a decisive influence on Van Gogh's career.
- **1882** He moves to The Hague. The painter Mauve asks him to paint an oil and a watercolor.
- **1883** In a burst of activity, he paints numerous works in Nuenen, landscapes from nature, portraits, and themes of a social nature.
- **1886** He travels to Paris to join his brother Theo, who introduces him to the Impressionist circle of painters.
- **1887** He holds his first exhibition with Toulouse-Lautrec, Émile Bernard, and Gauguin.
- **1888** Attracted by the light and color there, he moves to Arles and tries to establish a cooperative of artists; Gauguin joins him, although their friendship is short-lived.
- **1889** Following a series of nervous breakdowns and depression, he admits himself to the asylum at St.-Rémy, although he continues to paint.
- **1890** He moves to Auvers-sur-Oise, Île-de-France. Shortly thereafter, he shoots himself in the chest and dies from his wounds two days later.

The Potato Eaters

(1885)
oil on canvas
32.2 x 45 in (82 x 114 .3 cm)
Van Gogh Museum, Amsterdam

This work comprises a Flemish technique and palette commonly employed by the painters of the day. In this work, Van Gogh displays his compassion for the plight and problems of the poor of Nuenen, represented here with remarkable poignancy. The distribution of the figures is curious and somewhat unusual, the result of the painter's lack of skill, which is also visible in the way elements in the background are arranged. The chromatic uniformity is broken by several details—the coffee cups, potatoes, and the lamp—which are brought out by the way in which the light falls. The work is also remarkable for the accurate portrayal of the faces.

Montmartre

(1886)
oil on canvas
176 x 13.2 in (44 x 33 cm)
The Art Institute of Chicago, Chicago

This was one of Van Gogh's first paintings in Paris, where he became acquainted with the Impressionists and their ideas concerning light and color. Their influence on Van Gogh is clear from his change of style. The painter plays with broad areas of gray filled with a wealth of hues, such as that of the sky, which tints many of the elements represented and against which he contrasts the motifs in the foreground, in this case lampposts, trees, and the observation platform. Also interesting are the energetic and rudimentary brushstrokes in the foreground and certain details applied to lend realism to the scene, such as the undulation of the handrail and leaning lamppost.

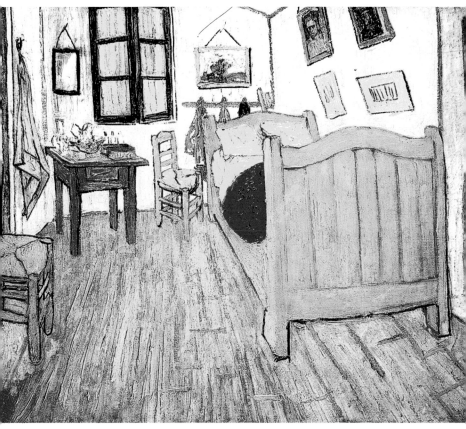

Van Gogh was a very meticulous painter. Each stroke has a justification. The composition, the drawing, and the interplay of highlights and shadows are consistent features in his paintings. Although Van Gogh was not a master of drawing, his works display great vitality, both thematically and technically.

This work shows the room that Van Gogh lived in at Arles, a small and humble lodging, decorated only by a few of his own paintings. There is a self-portrait and a portrait of the postman Roulin, painted in 1888, which belongs to a private collection. The pictures below them are probably two Japanese prints, a genre that excited Van Gogh and had a significant influence on the work of his later years. The picture hanging on the wall in the background is a landscape with olive trees.

> ## Van Gogh's Bedroom in Arles
>
> (1888)
> oil on wood
> 28.8 x 36 in (72 x 90 cm)
> Van Gogh Museum, Amsterdam

Van Gogh executed other versions of this work painted at different times of the day and with different colors. Curiously, the composition of the objects is identical, even in the version painted one year later, the only difference being the pictures on the right, which the artist probably changed occasionally; this suggests that he used a single study of the room for reference. This particular version of the work is supposedly the representation of the "complete repose"—Van Gogh attained a certain degree of relaxation when painting it—as he explained in a letter to his brother and intimate friend Theo. Notwithstanding, great tension permeates this work, thanks to the pronounced and erratic perspective between the different elements. This accentuated perspective is apparent, as the lines do not converge at a single vanishing point. Whatever the case, it seems clear that the painter was more preoccupied with the interplay of planes and colors than with precision of forms.

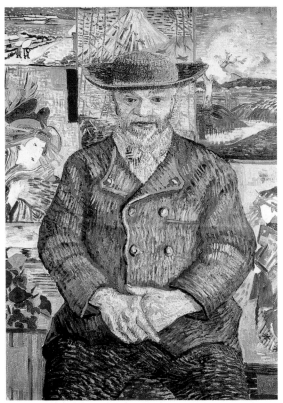

Le Père Tanguy

(1887)
oil on wood
37 x 29 in (92 x 73 cm)
Musée Rodin, Paris

Julien Tanguy was an art dealer, in whose tiny establishment the Impressionists and Post-Impressionists would meet for their debates. Here the artist captures perfectly his subject's personality, revealed by the expression on the face and position of the hands. The frontal position brings to mind medieval icons; the Japanese prints in the background indicate Tanguy's taste for exotic oriental art that had so significant an influence on Van Gogh. This work is outstanding for the bold stroke employed in the execution of the face. The colorful background, to which great attention has been given, provides a contrast with the treatment of the figure.

Sunflowers

(1888)
oil on canvas
38 x 29 in (95 x 73 cm)
Rijksmuseum, Amsterdam

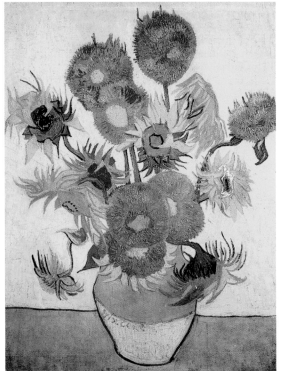

This composition of frenzied movement and color was painted to decorate Van Gogh's lodging at Arles. In the majority of his works, the artist carried out painstaking studies of light, for which reason he rose at daybreak. The color is direct, without intermediary phases other than the blue lines that outline the table and several strokes in the vase, applied to prevent the colors from staining one another and to outline certain forms. A far cry from the traditional rendering of a floral theme, this still life exhibits the artist's lyrical relationship with his work; rather than concerning himself with a flawless conception, Van Gogh was preoccupied by the interplay of colors and dynamic of the stroke.

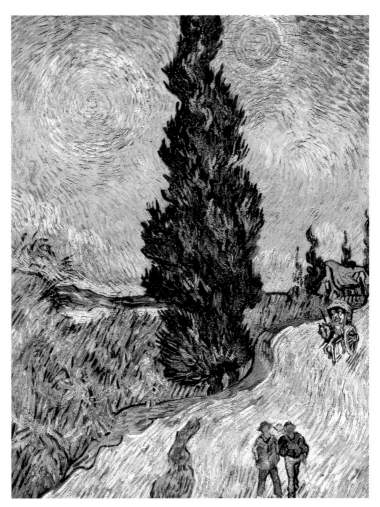

In this work, Van Gogh transforms a normal landscape into a transcendental motif, filled with symbolism. Indeed, it is significant in the sense that it was one of the last canvases to be painted by Van Gogh before he killed himself.

The main motif is the cypress, a tree that the artist much admired for its lines and form, akin to an obelisk, deeply rooted in the ground and flanked by the sun and moon.

Road with Cypress and Star

(1890)
oil on canvas
36.2 x 28.7 (92 x 73 cm)
Rijksmuseum, Kröller-Müller, Otterlo

The artist paints a svelte cypress tree, robust and erect but tortured and extremely disquieting, and a luminous sun and moon, executed with a vibrant color range. The anonymous people on the wide path add a touch of realism and spontaneity to the scene. Van Gogh creates contrasts between elements (cypress–sky, walkers–path), colors (vegetation–horizon, path–its edge), and between perspectives (foreground–righthand background).

Van Gogh's expressiveness can be seen in the broad, vigorous, and swirling brushwork, in the concentric strokes of the sun and moon, as well as those that describe the sky, vegetation, and cypress tree. He also uses a rich chromatic range. An examination of the sky and path reveals the wealth of colors and how they are combined to obtain the overall color sought. There is balance in the masses of color (the blue of the sky and blue of the path; the green of the path and green of the house; the warm colors of the sun and moon and warm colors of the countryside), as well as in the lines (the vertical line of the cypress tree and diagonal line of the path; the rotundity of the sun and moon and undulation of the path).

In short, this work has been executed with a masterly technique that highlights the artist's unbearable anguish and his delirious search for answers to unanswerable questions. A few weeks after this canvas was painted, Van Gogh wrote to his brother Theo: "In my work I have risked my own life and mind and have almost lost everything,... What more can I do?" It did not take long for him to find an answer: a few days later he shot himself in the chest with a revolver.

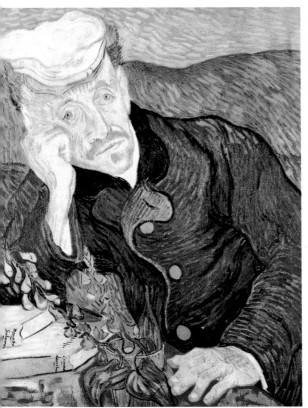

Portrait of Doctor Gachet

(1890)
oil on canvas
26.3 x 22 in (67 x 56 cm)
S. Kramarsky Collection,
New York

Doctor Gachet was an amateur painter and etcher. His friend, Theo, Van Gogh's brother, had asked him to take care of the artist. Gachet treated Van Gogh up to the end of his life, although he could do nothing to save him from his self-inflicted gunshot wound.

The doctor and Van Gogh struck up a good friendship. This work brings together two important features: the facial expression and the formal aspects of line, color, and composition. They define perfectly the subject's, as well as Van Gogh's, timid and depressed personality. Perhaps it was for this reason that they had such a good rapport.

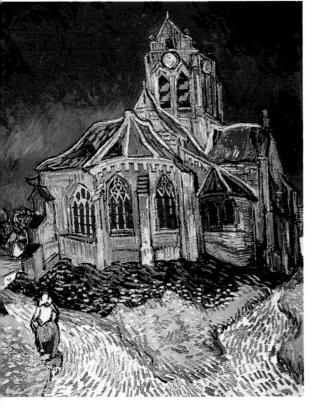

The Church at Auvers

(1890)
oil on canvas
37 x 29.2 (94 x 75 cm)
Musée d'Orsay, Paris

Van Gogh painted this work at Auvers just before his death. Plagued by mental illness, he had a burst of productivity—in a short period of time he painted 80 works. This is a singular work in the artist's oeuvre, given that he did not paint buildings. The artist has achieved an excellent unity between the church and landscape. The cobalt blue sky is reflected on the walls of the church, while the straight lines are related to the vertical lines of the building. The undulating forms, aggressive brushstroke, and intensity of the colors reflect the artist's inner torment and extent of his mental condition, which left him completely helpless and broken. His death was imminent.

GEORGES SEURAT

Georges Seurat.

Seurat's experimentation with color and Pointillism, or Divisionism (the term he preferred), arose from the ideas of Impressionism, which was nearing a close at that time. He also studied *The Grammar of Painting and Engraving,* by Charles Blanc, the former director of the Royal Academy. His decomposition of light into points of color corresponded to Blanc's theories on juxtaposing colors and leaving them to be mixed by the observer's eye.

Despite Seurat's study of newly discovered optical and color theories, the composition of his works follows an academic line. He studied the compositional balance of the Italian Quattrocento artists, as well as Poussin, Ingres, and Millet. The influence of the latter artist is clearly visible in his early outdoor works.

Seurat was a reserved person with a strong, proud character. He ceaselessly sought the public's recognition of his art. Although his work contained elements clearly derived from Impressionism, his work was more sophisticated and perfectionistic. He showed himself to be contrary to everything that Impressionism upheld, finally establishing a Neo-Impressionist group.

Seurat's work is antiintuitive. Meticulous and cold, it exercised a great deal of influence on Cubism, Futurism, and Abstraction.

In his constant search of an artistic formula that could combine logic and science with painting, he was a great admirer of Charles Henry, who in his book, *Scientific Aesthetics,* had formulated several theories on quality of strokes, proportions, and composition.

- **1859** Born in Paris to a modest family.

- **1875** Attends evening drawing courses until 1877 at the municipal school, directed by the sculptor, Justin Lequien.

- **1876** Studies *The Grammar of Painting and Engraving,* by the French critic Charles Blanc.

- **1878** Along with his friend, Edmon-Aman-Jean, he is admitted to the Academy of Fine Arts in Paris, where he studies painting under Henri Lehmann, a pupil of Ingres. He is a mediocre student, though he greatly enjoys copying masterpieces in the Louvre.

- **1879** Rents a studio in Paris with Edmond-Aman-Jean and Ernest Laurent.

- **1881** After visiting the fourth Impressionist Exposition, he quits the Academy of Fine Arts. Begins studying the electromagnetic theories of light and the perception of optical rays through the retina.

- **1883** Participates for the first and last time in the Salon with his *Portrait of Edmond-Aman-Jean* (Metropolitan Museum of Art, New York). Meets Puvis de Chavannes.

- **1884** The Salon rejects his painting, *Bathers at Asnières* (see p. 412), the first important Neo-Impressionist work. As a result, he and other artists found the Society of Independents, a platform of dissident artists opposed to Art Nouveau. Exhibits at its Salon des Indépendents. Meets Signac, with whom he establishes a lasting friendship.

- **1885** Paints with Charles Angland on the island of La Grande-Jatte in the Seine.

- **1886** Exhibits *A Sunday on La Grande Jatte* (see p. 413) at the eighth and last Impressionist exhibit. Meets the mathematician, Charles Henry. Durand-Ruel organizes an exhibit of Seurat and Signac's works in New York.

- **1887** On the initiative of Émile Verhaeren, he is invited to exhibit at the Exposition des Vingt in Brussels. With Signac, he founds the Neo-Impressionist group.

- **1888** With his Neo-Impressionist friends, he exhibits at the gallery of the Revue Indépendante. In the summer he moves to Port-en-Bessin, on the Channel, where he paints numerous seascapes. With *The Stand* (Stephen Clark Collection, New York), he becomes the precursor of the aesthetic theory of Charles Henry.

- **1889** Irritated by the conflicts among his friends, he moves away from the circle of the Neo-Impressionists.

- **1891** Exhibits his unfinished work, *The Circus* (Musée d'Orsay, Paris), at Les Vingt. On March 20, he dies suddenly in Paris.

Farmer Women at Work

(1882-1883)
oil on canvas
15.1 x 18.2 in
(38.5 x 46.2 cm)
Guggenheim, New York

For his early works, Seurat found his subjects in the outskirts of Paris. Here the abstraction and simplification of the subject recall Cézanne, although the composition is clearly influenced by Courbet. They are executed in a network of interlacing brushstrokes.

At this time, Seurat was studying the theories of Eugène Chevreul, an organic chemist who applied his discoveries to the understanding of color. In accordance with Chevreul, Seurat's figures are framed within a setting of slight contrasts. The technique he used in drawing was also applied to his first paintings, in which light and shadows provided the compositional framework. The brushstrokes of this painting are still Impressionist. For these early canvases with scenes of work in the countryside, the artist employed the small cards with religious and moralist images that his father collected, and many of them resemble some of Millets' works.

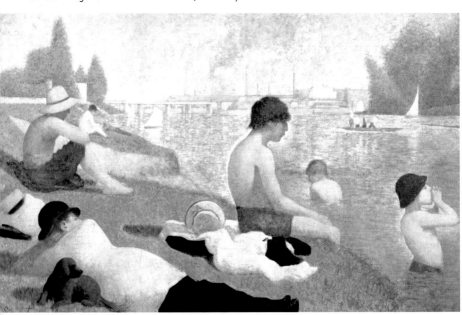

Bathers at Asnières

(1882-1884)
oil on canvas
80.4 x 120 in
(201 x 300 cm)
National Gallery, London

The painting, a scene at Asnières, a suburb of Paris, conveys a feeling of tranquility. The figures are formed by clean, smooth colors against the green background of the riverbank or the blue of the River Seine. The brushstroke seen here is a first step toward his later division of color into small dots, paving the way for Pointillism.

This work was exhibited at the first Salon des Indépendants (1884), and at the exposition entitled "Works in Oil and Pastel by the Impressionists of Paris," organized by Durand-Ruel and held at the National Academy of Design in New York (1886). At both exhibits, it received very negative reviews.

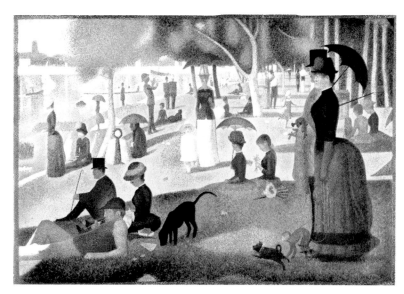

This painting, one of the most important works of Neo-Impressionism, is perhaps the cradle of Pointillism. Here Seurat divides color into small points. For the sake of compositional unity, he also adds an elaborate linear treatment, to the detriment of the Impressionist obsession with light, atmosphere, and movement. The artist was more interested in the figures, which are static, than the landscape.

Previously, he had executed several preliminary works that were distinctly Impressionist, though the final results were quite different. Each figure is placed to give the painting its perfect balance. Seurat has created a scene remarkable for its light, as it is for the care with which he rendered the farthest elements (rowers, people on shore). It is filled with charming details: the lady with the monkey, the dog running, the girl playing, and the reclining figure on the left.

A Sunday on La Grande Jatte

(1884-1886)
oil on canvas
83 x 123.2 in (207.5 x 308 cm)
Art Institute of Chicago, Chicago
(Helen Birch Bartlett Memorial Collection)

The Lighthouse at Honfleur

(1886)
oil on canvas
26 x 32 in (68 x 82 cm)
National Gallery of Art, Washington, DC
(Paul Mellon Collection)

The magnificent organization of all of the elements creates a compositional balance. The indispensable wooden structure in the foreground directs the eye toward the luminosity of the beach and the farthest details. The scene is bleached due to the strong sunlight, an optical trick that Seurat used to produce a clean and integrated landscape.

In his series on Port-en-Bessin, he works on another important aspect of his works, the frame. The golden frames in which works were habitually exhibited had already been a problem at the Exposition des Indépendants in 1886. On his return to Paris, he began painting the frames of his seascapes in the Pointillist technique as well.

The Port of Honfleur

(1886)
oil on canvas
32.4 x 26 in (81 x 65 cm)
Rijksmuseum Kröller-Müller,
Otterlo

As opposed to the Impressionists, who executed their works spontaneously, Seurat spent a great deal of time on preliminary studies. First he would prepare a detailed drawing in which he began applying the first tones in long brush-strokes, according to his earlier studies on the theory of optical contrasts. Here, the surface of the water consists of various layers of color including green, red, and turquoise. The same occurs with the boat, which was originally painted entirely in blue and then modeled with small dabs of red and light blue.

Due to the departure of the boats and the consequent change in the scene, Seurat never finished this work. Nevertheless, its careful distribution of masts and riggings combine the naturalism of a landscape with modern abstraction.

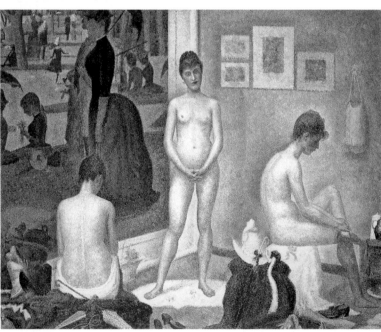

The Models

(1886-1888)
oil on canvas
80 x 100 in (200 x 250 cm)
The Barnes Foundation,
Merion, Pennsylvania

For this work, Seurat used the same model, whom he represented in three different positions. The painter was against the spontaneous art of the Impressionists and established a relationship of sizes that did not correspond to the laws of perspective. He placed elements in the work according to their overall effect.

On the wall is one of his most famous works, *A Sunday on La Grande Jatte* (see previous page), in which the same model appears. The artist was attempting to establish a connection between the formal modernity of the painting on the wall and the classical nudes in this painting, in which the public recognized the influence of Ingres and a reference to the Three Graces.

In August of 1888, the artist visited Port-en-Bessin, a village on the coast of Normandy, where he painted a total of six paintings that he exhibited at Les Vingt, in Brussels. This scene of the docks, in which the flat, luminous surface in the foreground directs the viewer's gaze toward the buildings and their stylized shadows, produces a sensation of artificiality caused by the static figures in the scene.

Port-en-Bessin

(1888)
oil on canvas
25.5 x 32.5 in (63.75 x 81.25 cm)
The Minneapolis Institute of Arts, Minneapolis

For these outdoor works, the artist jotted quick notes and created a series of preliminary sketches that served as a basis for his work in the studio. There he could be more scientific and precise. The scenes that he executed on the coast of Normandy continue the French tradition begun by Vernet in the 18th-century that attracted painters of all styles and periods to the northern coast of the country.

The Eiffel Tower

(1889)
oil on canvas
9.5 x 6 in (24.1 x 15.2 cm)
Fine Arts Museum, San Francisco

Seurat considered himself the precursor to a new, scientific type of painting based on fixed rules. This unfinished painting reveals the study of the image and the optical division of color on which the artist based the construction of his works. At that time, the tower was decorated with enamel in vivid, brilliant colors that he represented by surrounding the ascending diagonals of the architecture with a network of yellow and red points in an attempt to create a sensation of dynamic light. In his selection of subject matter, Seurat demonstrated his interest in technology and progress. This work, appropriately executed in a scientific method, is an homage to them.

Young Woman Powdering Her Face

(1888-1890)
oil on canvas
37.5 x 31.25 in
(95.5 x 79.5 cm)
Courtauld Institute Galleries,
London University, London

In this portrait of Madeleine Knobloch, the artist's lover by whom he had a child in 1890, the same meticulous and studied Pointillism is used as in *The Models* (see p. 414). Here, however the study of the overall composition prevails.

The woman is represented in an uncomfortable pose and a strange setting. The dress, with its skimpy corset, and the complex hairdo contribute to create a sensation of formal affectation that the artist reinforced when he decided to substitute the self-portrait that was to appear in the background with the small window and plant. The two spirals included in the painting convey a feeling of movement. This technique, which the artist learned from Charles Henry, is complemented by a color scheme that plays with contrasts and complementary colors.

Le Chahut (The Can-Can)

(1889-1890)
oil on canvas
67.7 x 55.6 in (169 x 139 cm)
Rijksmuseum Kröller-Müller,
Otterlo

The expressiveness of the vertical, horizontal, and diagonal lines matches the selection of colors. The yellow tones increase in brilliance through their contrast with blue, which Seurat used in the shadows. The painting was exhibited at the Salon des Indépendants of 1891, where it was well received for its dynamism and joyful nature. The critics, who had reacted rather coldly to Seurat's austere, rigid landscapes, now began to evaluate him positively. Interest in his Pointillist technique grew. His works from the early 1890s on were more festive and joyful, with scenes of cabarets and circuses like this one.

GUSTAV KLIMT

Gustav Klimt in the smock he often wore while painting (1913).

Gustav Klimt is the painter that best represents the Belle Époque Vienna, a city that had become internationally renowned as a cultural and artistic center thanks to Sigmund Freud, Otto Wagner, Gustav Mahler, and Arnold Schönberg.

Klimt's oeuvre is a combination of Symbolist and Byzantine features that typify the underground eclecticism of the Secession movement. They contain various elements: gold and silver tones, extremely vivid multicolor mosaics, mysterious, exotic subjects, fantastic animals, floral decorations, and so forth. Klimt creates a specific atmosphere and disrobes his figures, physically as well as spiritually, in such a brazen manner that they are nearly distressing. They represent the Freudian idea of the inevitable eroticism in everything having to do with the human being, and unveil the secrets of the subconscious, the most hidden and inaccessible zones of the human spirit.

This Freudian concept is a recurring motif in the artwork of the Expressionists and Surrealists. Klimt's style is two-dimensional, and he employs intense, vibrant colors in a constant interplay of juxtapositions that act as a decorative element and evoke sentiments. The human figure, treated with exquisite dignity, is often placed in a refined universe imbued with eroticism and, at times, tragedy. This artist's work reflects an obscure and disturbing vision that reaches its high point in the Expressionism of Oskar Kokoschka and Egon Schiele, who learned from Klimt.

- **1862** Born in Vienna to a goldsmith and engraver named Ernst.
- **1876** Studies at the School of Arts and Crafts of the Austrian Museum, and then studies painting under Laufberger.
- **1880** Together with Kunstlerkompanie, the group he founded with his brother Ernst and a schoolmate, Franz Matsch, he paints a ceiling in the Sturany Palace of Vienna and the ceiling of the Karlsbad Thermal Baths in Czechoslovakia. The group establishes a studio in Vienna and decorates various public buildings (Hermesvilla in Lainz, the theater of Reichenberg, Burgtheater in Vienna). In this decade, the artist begins painting individual works (*Fable, Idyll,* etc., Kunsthistorisches Museum, Vienna).
- **1890** Decorates the walls of the grand staircase in the Kunsthistorisches Museum of Vienna, where he reveals an interest in silhouettes and decorative motifs.
- **1897** Establishes the Viennese Secession, an avant-garde group equivalent to the Art Nouveau or Modernist movements, which confronts official academic ideas and bourgeois conservatism. The movement is influenced by various tendencies, from Impressionism to Japanese woodcuts.
- **1898** Elected president of the Viennese Secession. Paints *Portrait of Sonia Knips* (Österreichische Galerie, Vienna), an asymmetrical work influenced by Japanese prints. Collaborates on the magazine *Ver Sacrum,* the mouthpiece of the Secession movement, along with the principal representatives of symbolism (Beardsley, Burne-Jones, Puvis de Chavannes, etc.).
- **1902** Decorates the Secession building. He is commissioned to paint the Beethoven Frieze, a large mural in the palace, for the presentation of the statue of Beethoven sculpted by Max Klinger.
- **1903** Paints *The Golden Apple Tree,* destroyed in 1945, characterized by very small, compact decorative motifs, a characteristic that appears in many works by Klimt.
- **1907** After several modifications, he finishes three paintings (*Philosophy, Medicine,* and *Music*) for the auditorium of the University of Vienna. Their provocative eroticism and tragic air cause a great scandal and the artist is forced to remove them. In 1945, all three paintings, which were being stored in southern Austria because of the war, were destroyed in a fire.
- **1917** The Academy of Fine Arts of Vienna and the Academy of Munich grant him honorary membership.
- **1918** Shortly after returning from a trip to Romania, he has a stroke and is hospitalized in Vienna, where he dies on January 6.

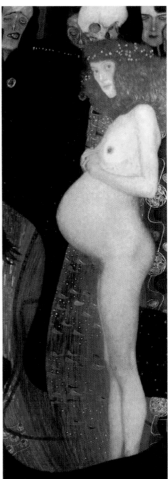

After the Rain

(1899)
oil on canvas
32 x 16 in (80 x 40 cm)
Österreichische Galerie, Vienna

Hope

(1903)
oil on canvas
75.6 x 26.8 in (189 x 67 cm)
National Gallery of Canada, Ottawa

This work was created at a time when Klimt had not yet developed his definitive style. The image is realistic and placid, with an asymmetrical composition. The trees and chickens contrast against a diaphanous, chromatically balanced surface with gray tones, especially in the background. In some areas, the paint is applied in the Pointillist technique, as in the leaves of the trees and the red flowers in the lower left corner, lending the painting relief and contained vitality. The white areas representing the chickens, in addition to introducing a note of contrast in the green mass of the meadow, increase the realism of the landscape and the sensation of tranquility.

The title of the work clearly denotes its allegorical intent. This woman's pregnancy is a stake in the future, an unknown trajectory that will bring innumerable incidents and new circumstances, represented here by masks, symbolic elements, and fantastic motifs, that may convert what is the hope-filled adventure of a new life into the most tragic of reckless decisions.

This woman's profile is exquisite, profoundly sensual and spiritual, and intensely dramatic, even more so when accompanied by a series of horrifying symbols. For example, the red of the woman's hair does not exactly symbolize purity. This juxtaposition of values makes the Expressionism of the image stronger.

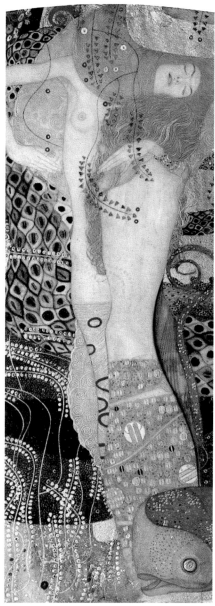

Water Snakes

(1904-1907)
gold and watercolor
on parchment
20 x 8 in (50 x 20 cm)
Österreichische Galerie, Vienna

This scene resembles some parts of the Beethoven Frieze, a mural the artist painted at the Secession Palace. On a luxuriously decorated fabric with its golden, mosaic-like patterns, two women with stylized bodies and smooth skin are reclining together. They are entwined in a dramatic, amorous embrace in a clear evocation of an unreal world permeated by hedonism, sensuality, and fantasy.

Although the public found this compromising subject difficult to accept at the time, the artist, true to his style, treats it exquisitely and with evident dignity. Far from concentrating on sultriness, the painting is pure poetry. The diaphanous complexions, the stylization of the anatomical lines, exaggerated in an attempt to evoke the intense spirituality of the protagonists' sentiments, the long hair, the intense expression on the visible face, and some of the details of the bodies, such as a small breast, are profoundly sensual elements. The pose, gesture, and facial expression are a reflection of passionate love and the most delicate tenderness, eliminating any pejorative connotations.

Beyond the eroticism of the image, an intense mysticism prevails. The work has great compositional merit, with soft lines and a balanced color scheme. Its delicacy conceals a daring and assertive message that the defenders of love would certainly appreciate.

The Three Ages of Woman

(1905)
oil on canvas
72 x 72 in (180 x 180 cm)
Galleria Nazionale d'Arte Moderna,
Rome

Klimt's artwork usually represents a refined and intriguing universe combining tragedy with eroticism, in accordance with the ideas of the Vienna Secession, a group that he presided over.

Here three women are represented against a generally abstract background with a wide horizontal strip of black occupying the upper area and a much larger lower area in the manner of a curtain with the texture of folded fabric.

There is a girl with a delicate, tender body sleeping placidly in her mother's arms, and the mother herself, a young woman with skin as smooth as her daughter's, whom she embraces tenderly, with a pleasant, expressive and well-made-up face and an abundant head of red hair sprinkled with flowers. In profile on the left is an elderly woman who, despite her considerable height, has a worn, hunched body with leathery skin, a bulging stomach, sagging breasts and a crestfallen pose, with her long hair concealing her face, which she covers with her hand in a gesture of shame or desperation.

The artist uses a compositional scheme common in his works. The figures, treated delicately, are placed against a colorful background of vivid, intense, and vibrant colors, giving rise to a juxtaposition that makes the message of this allegory more severe and radical. Despite the sensuality predominant in this work, the tragic sense of life that it conveys is evident: innocence, tenderness, youth, and beauty inevitably lead to degeneration and dejection. So much love, so much effort, so many hopes, and in the end, one is almost ashamed to have lived. The extremely negative sensation radiating from this work is hardly neutralized through the vivid colors accompanying each figure.

Danaë

(1907-1908)
oil on canvas
30.8 x 33.2 in (77 x 83 cm)
Private collection

In classical mythology, Acrisius, king of Argos, locked his daughter Danaë in a bronze tower to avoid the fulfillment of an oracle, according to which the king's grandson would take his throne and his life. By locking his daughter in the tower, Acrisius prevented her from having any contact with men and thus from becoming pregnant. But Jupiter, who was in love with Danaë, turned himself into a golden rain, entered the tower from above, and possessed the young woman, who became the mother of Perseus. Acrisius locked Danaë and her son into a coffer and threw them into the sea, but to no avail, for they survived and, years later, the oracle was fulfilled.

Here the artist creates an attractive composition. The figure of Danaë is blocked into a square space, occupying the entire canvas, nude, reclining on a bed with a transparent cloth. This is beautifully decorated with circular golden patterns, whose dark color provides a contrasting element that lends the woman's body, delicate, pink, sensual, and full protagonism. The heroine, with long red hair, exhibits a body that is perfectly outlined by a bluish contour. She reveals a small, yet firm and flushed adolescent breast, framed by her bent arm. Although she is asleep, she cannot conceal her expression of pleasure and complicity. Her powerful thigh is splendidly foreshortened. Danaë places her legs in a position to receive the golden rain, represented as a myriad of golden pearls that inundate her intimate area. The compositionally perfect and chromatically balanced work evokes tenderness, sensibility, delicacy, and an intense eroticism.

Lady with a Feathered Hat

(1910)
oil on canvas
31.6 x 25.2 in (79 x 63 cm)
Private collection

An important facet of Klimt's work was his portraiture, a rich and varied oeuvre generally consisting of female figures. This example combines the characteristics of a portrait with the sophistication that the Belle Époque style lent to its figures.

This woman, distant and self-absorbed, is in a static pose. The painting is nearly a sketch, with the background and attire only hinted at. The focal point is the face, treated meticulously and only revealing the most important features. Above it is a thick head of red hair, carefully coifed, crowned by a spectacular black hat adorned with enormous feathers. The artist does not limit himself to portraying the image of the figure, but has captured the essence of her character and interpreted it with singular mastery and a perfect sense of aesthetics.

The Friends

(1916-1917)
oil on canvas
39.6 x 39.6 in (99 x 99 cm)
Österreichische Galerie, Vienna

Klimt's paintings caused a great scandal in his time, for both their content and technique, which the upstanding society of the time found difficult to accept. Yet the innovative ideas of the Secession were important, and the artists of the movement valiantly defended them.

In this work, the painter plays with a symphony of vivid colors, flowers, exotic birds, and fantastic animals to provide atmosphere and evoke the feelings of this pair of friends/lovers before they make love. The sensuality of the nude woman, with the tenuous colors of her complexion, the delicate flesh of her body, and the tender expression on her face nearly clashes with the face of her companion, affable and contained, and her fiery dress, a vivid expression of the passion that siezes her. The work is insinuating and expressive, and the steady gazes of the protagonists toward the viewer can be understood as a challenge, or at least a declaration of principles in the face of a society of repressive and jaded ideas.

HENRI DE TOULOUSE-LAUTREC

Toulouse-Lautrec around 1890.

Henri de Toulouse-Lautrec, who lived an intense life, produced highly expressive work. He was born into an aristocratic family and received a sound education. Complications arising from two falls suffered during adolescence and the consanguinity of his parents, who were cousins, prevented his legs from developing properly. Hence he took up drawing and painting, but suffered from severe problems of self-esteem, feelings of self-destruction, and depression.

The artist came in close touch with the world of prostitution and music halls, such as the famed Moulin Rouge. He painted its atmosphere with sharp vivacity and its figures with a realism that was at times tender, at others cruel, ironic, or devastating, but always with great skill and an extraordinary sensibility.

In his works, drawing predominates over the painterly aspects. They have a photographic view of the world. To better convey sentiment, he exaggerates features, deforms elements, and intensifies light and color. He defines shapes and contours with line, and uses pure colors in loose, energetic brushstrokes. His painting is sheer emotion, bursting with energy and intense passion. Toulouse-Lautrec was an eminent heir to Impressionism, singular for the force and originality of his subject matter, and for his unique Expressionism. He occupies a distinguished place in the history of painting of the latter 19th-century.

- **1864** Born in Albi on the night of November 24, the son of Count Alphonse-Charles de Toulouse-Lautrec and his cousin, Adèle Marquette Tapié de Celeyran.
- **1882** Interested in drawing, he enters the studio of Léon Bonnat. They do not get along.
- **1883** Enters the studio of Fernand Cormon, more liberal than Bonnat, but he is not satisfied with the instruction he receives.
- **1885** Aristide Bruant inaugurates the cabaret Le Mirlonton, where Toulouse-Lautrec will exhibit his works. Enters a short-lived, stormy relationship with Suzanne Valadon. Meets Van Gogh.
- **1888** Participates with considerable success in the Exposition des Vingt in Brussels.
- **1889** The Moulin Rouge is inaugurated in Paris, and he exhibits some of his works in the foyer.
- **1890** Meets Jane Avril and he lives for a period at a luxurious brothel on Rue des Moulins, where he paints various works and has a relationship with a pupil, Blanche. Challenges Henri de Groux to a duel in defense of Van Gogh's artwork.
- **1893** Meets the singer Yvette Guilbert, whom he painted several times. Decorates the sitting room of a brothel on Rue d'Amboise.
- **1894** Meets Oscar Wilde and Whistler in London. Meets the owners of La Revue Blanche. Exhibits in various European galleries with singular success.
- **1895** Decorates the establishment that La Goulue, an outrageous dancer of the Moulin Rouge, has just acquired at La Foire du Trône.
- **1897** First spell of delirium tremens, caused by advanced alcoholism.
- **1898** Interned at the Madrid Clinic in Neuilly for treatment, which seems successful. He is entrusted to Paul Viaud, a distant relative, to ensure that he does not start drinking again.
- **1900** Member of the jury for the poster section of the World Exposition. He settles in Bordeaux. Suffers an attack of paralysis from which he manages to recover.
- **1901** Returns to Paris, then moves to Toussat, where a brain hemorrhage on August 15 leaves him paralyzed. He is brought to his mother's house in Malromé, where he dies on September 9.

Marie

(1884)
oil on canvas
31.6 x 25.6 in (79 x 64 cm)
Museum Von der Heydt, Wuppertal

This painting has been compared with a nude by Gauguin from 1889, *Woman Bathing, Life and Death* (Mahmoud Khalil Bey, Cairo Museum). The woman was one of the many prostitutes of Montmartre who joined the elderly, children, and others at Place Pigalle who offered themselves as models to artists for a modest price. This was probably the first time that the artist used a prostitute as a model.

Although it was executed when he was barely 20, this work, with its touch of sordidness and a good helping of realism, is important to his body of work. It represents a regular woman who is imperfect, and brings her powerful anatomy so close to the viewer that one could almost touch her. She is even cut off just below the knees to bring her even closer.

She is self-assured and nonchalantly exhibits her nudity, generously offering her abundant flesh with an insolent, nearly defiant attitude. Enhancing this feeling are the strong lines, her fixed gaze, her expression, the corpulent body, and the proximity of her hirsute pubis, strategically located in a focal point of the painting. The eroticism is hard, aggressive, fully lacking idealization, but certainly as real as life itself. The masks in the upper part of the painting have been interpreted in many different ways, yet their meaning remains an enigma.

The force of the painting is accentuated by the technique used, the loose, quick strokes executed with passion and vehemence. The well-studied pose gives rise to a curvature of the body that increases the woman's voluptuousness. The face is excellently rendered. In both intention and style, this painting is a preview of his later paintings.

Study of a Male Nude

(1882)
oil on canvas
26 x 31.6 in (65 x 79 cm)
Forbes Collection, New York

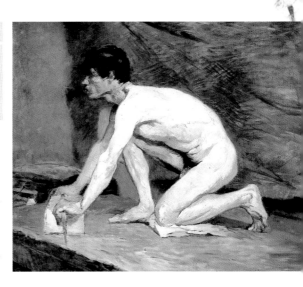

This work, painted when Toulouse-Lautrec was 17, is probably his first at the studio of Léon Bonnat, whose style was a synthesis of realism and academicism. The model affects a task that is merely an excuse for an academic pose.

The drawing is self-assured, but the style is still hesitant. The young artist may have felt uncomfortable, as he was still being directed by his teacher. The figure is powerful, but the volumes are not well executed, and the background colors are those of Bonnat's paintings. Once he finished, his teacher reproached him for the poor results, which incited him to improve.

Jane Avril Dancing

1892
oil on cardboard
33.6 x 17.6 in (84 x 44 cm)
Musée d'Orsay, Paris

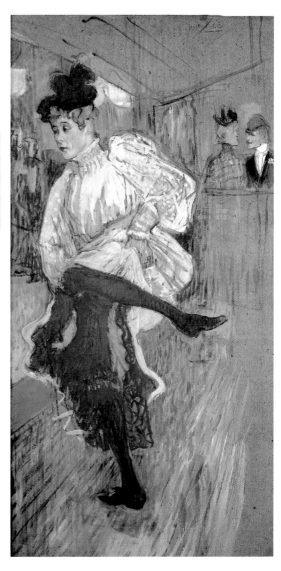

Jane Avril was the daughter of a courtesan and an Italian aristocrat who, in 1891, became the star dancer of a quadrille group at the Moulin Rouge. Her greatest success was in her individual performances.

Toulouse-Lautrec saw her for the first time in 1891 and soon an intimate but short-lived relationship developed. He was fascinated by her cultural level and her fiendish dancing. For her part, Henri was her "sick genius."

In this work, Jane, her hair died red and wearing a distinguished dress, is dancing alone and exhibiting her skill at moving her legs and keeping her balance. Seated at the table in the rear, in a bowler hat, is the English businessman, William Tom Warner, a frequent client of Parisian night life, avid to discover and employ music hall actresses.

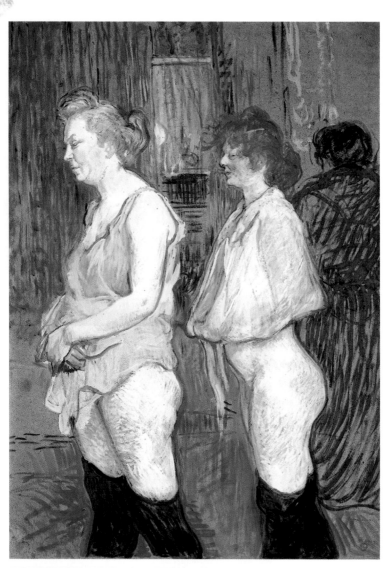

Rue des Moulin

(1894)
oil on cardboard
33.4 x 24.5 in (83.5 x 61.4 cm)
National Gallery of Art, Washington, DC
(Chester Dale Collection)

This scene was taken from real life. Toulouse-Lautrec was very familiar with the setting: a luxurious brothel at Rue des Moulins, where he had lived for a time and which he never stopped frequenting. At the time, prostitution was legal but the prostitutes had to be registered with the police and undergo a weekly medical examination to control the epidemic of venereal disease (15 percent of deaths were due to syphilis, a disease that the artist also contracted).

Here, two prostitutes lift their dresses and await their turn to be examined. A checkup was an extremely stressful experience for them as it could lead to the loss of their job (unless they wanted to run the risk of severe sanctions) and their entrance into the Hospital of the Sisters of St. Lazare.

The face of the blonde-haired woman says it all. It perfectly captures the feeling of anxiety. Her hunched posture and the expression are superb. These two women are unattractive, especially the one on the left, getting on in years, with powerful buttocks and a large abdomen. Far from idealizing them, the artist renders a disturbing reality, a sordid world and a depressing situation. On the right, with her back turned is the madame of the brothel. She is executed in large, vigorous brushstrokes, as is the room. Such brushstrokes, typical of the artist, enhance the scene. Together with the deep, intense colors, they create great contrast with the bodies of the two women, who are represented in light, luminous colors. The blonde woman is Gabrielle, La Danseuse, a prostitute who was a lover and patron of Toulouse-Lautrec. The redhead is a prostitute who appears in other paintings by the artist.

The Two Friends

(1895)
oil on cardboard
25.8 x 33.6 in (64.5 x 84 cm)
E. G. Brührle Foundation,
Zurich, Switzerland

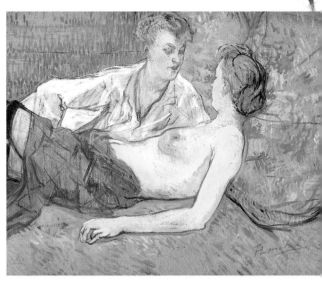

Some consider this painting, especially its subject matter, to have been inspired by Japanese woodcuts by Kitagawa Utamaro. Although Toulouse-Lautrec was familiar with them, he had no need to turn to them for inspiration, as lesbianism was something that he was not only personally acquainted with, but encountered as part of everyday life.

Here two young women, probably prostitutes, are lying in bed together. One of them passively opens her legs while she receives the intimate caresses of her companion. Despite the sultriness of the subject, the painting is very natural, and the figures are dignified and painted with respect. The aggressiveness of the brushstrokes are compensated for by chromatic softness and harmony. Only the red of one of the women's skirts stands out, probably added to break the monotony. Aside from a desire to provoke, the artist also wanted to enter into the intimate sanctuary of these two people to render their amorous relations.

Messalina Descending the Stairs

(1900-1901)
oil on canvas
40 x 29.2 in (100 x 73 cm)
County Museum of Art,
Los Angeles

The artist had seen the opera *Mésaline* in Bordeaux and liked it so much that he painted five works on it. Messalina, the third wife of the Roman Emperor Claudius, was a hedonist who was constantly having affairs. Her intense sex life was also a tool of her infinite ambition. It eventually led to her death. The artist had also lived a dissipate life, frequenting cabarets and music halls, surrounding himself with beautiful, famous women, and recklessly plunging into the world of sex and alcohol, which would also cause his death.

Toulouse-Lautrec's sagacity and his peculiar sense of humor often led him to laugh at himself and perhaps explains the great interest he showed in this subject toward the end of his life. There is a tragic parallel between the life and death of this protagonist and his own.

Dance in the Moulin Rouge

(1890)
oil on canvas
60 x 46.2 in (150 x 115.5 cm)
Philadelphia Museum of Art,
Philadelphia (Henry P. McIlhenny
Collection)

The Moulin Rouge was a cabaret inaugurated in 1889, and the owners' obsession was to surpass the nearby Élysée Montmartre. Hence, they invested large sums of money to offer performances and an atmosphere that would attract a numerous and select public. Closely linked to his life and works, the Moulin Rouge was like a second home to Toulouse-Lautrec, and he had a permanent table reserved for him there, which he used as a place to hold discussions with other artists and as an improvised studio for many of his paintings.

This work was commissioned by the owners and decorated the cabaret from 1890 to 1893. The painter rendered what he saw from his table: the public, the actors, and the atmosphere. He also took the opportunity to portray a series of regular clients who made the cabaret famous. In the middle left, Valentin-le-Désossé, "the Boneless," so named for his singular agility on the dance floor, is dancing with La Goulue, so called for her insatiable appetite. In the background on the right, with a white beard, is the artist's father. In the rear, behind La Goulue, are the artist Verney, Maurice Guilbert, a painter and photographer, representative of the champagne, Moët Chandon, Paul Sescau, a photographer and close friend of the artist, and François Gauzi, who studied with the artist under Fernand Cormon. In the background on the left, seen frontally and in a dark cape, is Jane Avril, a dancer and Henri's lover.

The painting juxtaposes the vivid pink of the woman's dress in the foreground with the movement of the two dancers. In the background, the walls and lamps act as a backdrop against which the clients, (dark, well-dressed figures in top hats) stand out. It is a lively atmosphere, condusive to socializing, and restricted to a wealthy public. It is a place for women to show off their jewelry and best evening gowns, which the artist paints using two different techniques: long, fine, and parallel strokes in the woman on the right, and parallel brushstrokes combined with more blended ones in the two on the left. The freshness and liberty of execution have not replaced careful details.

HENRI MATISSE

Self-portrait in a Striped T-Shirt, *oil on canvas, 22 x 18.4 in (55x 46 cm), 1906, Royal Museum of Fine Arts, Copenhagen.*

Henri Matisse's long artistic career evolved through different styles and tendencies, from Imprssionism to near Abstraction. In his early period, his color treatment, adopted from Impressionism, developed toward an unrestrained use of that concept in compositions that still retained a conventional formal structure.

The influence of Arabian art, which he encountered on several trips to Morocco and Algeria, introduced new elements to his work. The decorative sense of Arabian ceramics and detailed richness of their tapestries were incorporated into the artist's aesthetic and used in scenes where oriental luxury and opulence are the protagonists.

Matisse's second stage began with his painting, *Le Bonheur de Vivre* or *The Joy of Life* (The Barnes Fundation, Merion, Pennsylvania), in which he played with distinct outlines of a thickness that was extraordinary for the time. He freed his portraits and nudes of convention through the use of abstract lines and the contrast between the volume of the body and the flat background. Matisse sculpted occasionally and employed what he learned about volumes in his paintings.

He can be considered the initiator of modern art in the 20th-century. According to him, "Art must be luminous, a pleasure for the spirit."

- **1869** Born on December 31 in Le Cateau-Cambrésis, in northern France.
- **1889** Attends drawing classes at the École Quentin La Tour.
- **1893** Begins unofficially working at the École des Beaux Arts, in Moreau's studio.
- **1896** Exhibits four paintings at the Salon de la Société Nationale.
- **1898** Marries Amilié Parayre and travels to London, where he sees Turner's works.
- **1899** Studies with André Derain at the Académie Carrière.
- **1900** Decorates the Grand Palais with Marquet in preparation for the World Exposition.
- **1904** First individual exhibit at the Vollard Gallery.
- **1905** Along with Derain, Marquet, Maurice de Vlaminck, and Georges Rouault, he exhibits at the Salon d'Automne, where the scandalized public labels them as wild animals, or *fauves* in French, giving the movement its name. Paints *Luxury, Calm and Voluptiousness* (Musée d'Orsay, Paris), presented in the Salon des Indèpendants.
- **1907** Paints *Blue Nude* (Baltimore Museum of Art, Baltimore).
- **1908** First exhibits in New York, Moscow, and Berlin.
- **1909** The Moscow industrialist Sergey Shchukin commisions the series *Music and Dance* (The Hermitage, St.Petersburg, see p.432).
- **1911** Travels to Morocco, then Tunis the next year.
- **1916** Paints *Piano Lesson* (Museum of Modern Art, New York).
- **1920** Designs the stage set for Stravinsky's *The Nightingale*.
- **1921** Paints *Odalisque with Red Trousers* (Georges Pompidou Center, Paris).
- **1923** The National Museum of Art in Moscow, now the Pushkin Museum, is inaugurated and Matisse contributes 48 works.
- **1927** Wins the Carnegie International Exhibition Award in Pittsburgh.
- **1939** Following the outbreak of the Second World War, he leaves Paris for Nice.
- **1941** Operated on for intestinal cancer in Lyon.
- **1944** His wife is detained and his daughter deported for collaborating with the Resistance.
- **1945** Exhibits with Picasso in London.
- **1952** Paints *Blue Nude* (Musée Henri Matisse, Nice).
- **1954** Dies in Nice on November 3.

Dinner Table

(1897)
oil on canvas
40 x 52.4 in (100 x 131 cm)
Stavros S. Niarchos Collection

Matisse discovered Impressionism through the painter, Émile Wéry, with whom he traveled to Brittany to work in the summer of 1895. He was enthralled with the rainbow colors he found on the coast. This work is an experiment in measured Impressionism, in which the influence of Pissarro is evident, as well as an incipient inclination toward the use of pure colors. The Impressionist brushstroke is visible, defined by the traditional order of tones and contrasts upheld by Gustave Moreau, who had been Matisse's teacher at the Academy of Fine Arts in 1895. In Matisse's first works, the use of chromatic ranges approaching Impressionism are combined with compositions of greater expressive intent.

Crockery on a Table

(1900)
oil on canvas
39 x 35 in (97 x 87 cm)
The Hermitage, Saint Petersburg

At the time when Matisse executed this painting, his style was evolving toward a simplification of all aspects. The force of his Fauvist works appears here in details such as the reflections on the white soup terrine, though the tones are still discreet. This paintings reveals the influence of Cézanne, from whom he adopted the ascending perspective line and graphic quality of the objects on the table. The square surface of the table is defined in soft contours, and the vertical side of the tablecloth is represented with little detail but in a brushstroke that describes its texture. There are many contrasts in the rather dark setting and the painter's aim is for the spectator to encounter a rich atmosphere by focusing on the table.

Madame Matisse: Portrait with a Green Line

(1905)
oil on canvas
16.2 x 13 in (40.5 x 32.5 cm)
State Museum of Kunst, Copenhagen

When Matisse exhibited his works with Derain, Vlaminck, Marquet, and Rouault at the 1905 Salon d'Automne in Paris, the public was scandalized and derided the painters, calling them wild animals, or *fauves,* in French.

In this portrait of his wife, there is a contrast between the intense colors and the woman's tranquil expression. A strip of green divides her face into two vertical planes, separating the side struck by the light from the one in shadow and organizing the face through the contrasts between tones.

Matisse also divided the background, which he painted in the two colors predominating in the figure—the red of the dress and green on the face—integrating the figure with the background and thus unifying the composition. The artist sought to create a strong contrast between the tranquil expression, typical of more conventional portraits of the time, and its juxtaposition with the intense colors.

Conversation

(1909)
oil on canvas
70.8 x 86.8 in
(177 x 217 cm)
The Hermitage, Saint Petersburg

Matisse's Fauvism was followed by a period in which he abandoned the search for three-dimensional effects and executed paintings with pure color radically simplifying the composition. This painting represents a couple conversing, though they seem frozen. The man, supposedly a self-portrait, is in a domineering position, while the woman—his wife, Amélie—is seated in a chair in the same blue as the background.

The window in the center is an extremely interesting element, since an entirely different view can be observed through it. Matisse plays with the tension of the atmosphere in the foreground and its contrast to the calm landscape visible through the window. Despite the predominating intense blue and the weight of the black, the work exhibits an excellent result. According to the artist, color is the most effective means of expression, as evident in this scene, in which saturated colors in the interior have emotional significance, and, outside, lighter colors create a feeling of intimacy.

The Dance

(1909-1910)
oil on canvas
104 x 156.4 in
(260 x 391 cm)
The Hermitage,
Saint Petersburg

This work, created as a diptych along with *Music* (The Hermitage, St. Petersburg), was designed for the house of the art collector, Sergey Shchukin, in Moscow. The artist designed a lovely symphony in three symbolic colors—blue (heaven), green (earth), and red (dance)—achieving great expressiveness through studied chromatic synthesis.

The shapes are abstract, as is the treatment of the three elements of the scene. Even the five dancers, with their harmonious lines and movement, are not an attempt to express a concrete moment in a dance but rather evoke the general concept of dance. Hence the artist did not make an effort to create elaborate figures. Instead, although the figures are clearly feminine, as their lines favor the necessary rhythm of the composition, they represent human beings in general.

The balance of color masses and compositional unity are remarkable. The figures appear as if they were about to jump out of the frame in their dancing frenzy, when in reality they are dancing around a central point in the composition. Balance is also achieved through the daring combination of intense colors, lending the scene great vividness. The nude figures of the dancers are fully expressive: elegance of lines, smooth bodies, rhythmic movement, sensual gestures and forms, and sublimation of the whole. The painting resembles a dream.

View of Notre Dame

(1914)
oil on canvas
58.9 x 37.7 in (147.3 x 94.3 cm)
Museum of Modern Art, New York

World War I broke out in August of 1914 and Matisse reflected his distress though the austere colors in his works and an even greater anxiety in his compositional sobriety.

In this work, geometrical simplification predominates in the composition, consisting of perspectival lines in a blue room leading to the focal point of the painting, a small green area. The range of colors no longer has any relation to his Fauvist period, his natural tones disappearing from his paintings. Instead, black acts as a dark, heavy element.

The war definitively influenced his works. His brother was detained, his children drafted into the army, and the family home destroyed during a bombardment. The painter took refuge in his work. Though Matisse preferred to keep out of social conflicts, his works express his sentiments on the different events he witnessed throughout the course of his life.

Matisse's contact with the Arabic world left its mark on the artist. The luxury and sensuality of the setting, and the general atmosphere in many of his works, reflect this influence, which he employed to break with tradition and create scenes imbued with exoticism and a certain mystery. This scene represents a room with a series of elements (setting, colors, juxtaposition of the nude woman with the dressed one, luxury, sensuality) that

Odalisques

(1928)
oil on canvas
21.6 x 26 in (54 x 65 cm)
Modern Museum, Stockholm

transport the viewer to a world lying somewhere between the real and the dream, poetry and desire, relaxation and passion, and the aesthetic and exoticism. The poses of the two women, the varied color range and vivid tones, and the manner of modeling the figures through direct colors are striking aspects of this suggestive work.

Blue Nude

(1952)
gouache on paper, cut and pasted
41.2 x 29.6 in (103 x 74 cm)
Musée Henri Matisse, Nice

After the complicated operation that he underwent in 1941 for intestinal cancer, Matisse began working on paper and in smaller formats. A good deal of the years he spent recovering were dedicated to illustration and textile printing until he was commissioned to decorate the Chapel of the Rosary in Venice, recovering his familiar style. For the artist, the success of his operation represented a second chance for creativity.

This work, part of a series known as *Blue Nudes,* was executed on white paper. The artist conceived the volume of the bodies as if they were sculptures. The contours of the limbs are meticulous and their spatial placement studied, balancing the masses within the painting and imbuing it with expressiveness. He contrasts the corporeal presence of the body with the two-dimensional, decorative effect. His work as an illustrator and printer determined the compositional nature of the painting, with defined color planes and clear outlines. In this series of blue nudes, the artist reached great expressive purity and demonstrated that an extreme economy of means need not constitute a problem in representing a subject as sensitive as a female nude.

PABLO PICASSO

Self-portrait, oil on canvas, 36.18 x 28.87 in (90 x 72 cm), 1906, Philadelphia Museum of Art, Philadelphia.

Picasso's oeuvre encompasses the entire trajectory of modern art. Rather than being contradictory, his works are a reaction to the constant queries of modern humanity about its identity. Who are we? Where do we come from? Where are we going? His Andalusian heritage, his education and artistic beginnings in Barcelona and his consolidation and expansion in Paris distinctly marked his life.

Highly talented, he was a genial artist who soon tuned in to the cultural and artistic atmosphere of the Catalan avant-garde, through which he consolidated his personality and gained everything he would need for his later evolution.

He developed a new style, Cubism, which was probably his greatest contribution to the history of art. It is also the style with which he most identified, since, in a more or less evident manner, it underlies nearly all of his earlier works. The majority of the artistic movements of the 20th century found some inspiration in it.

Picasso can be considered, not only the most diverse artist of all times—over 40 different periods have been identified in his works—but also by far the most prolific —his oeuvre includes over 35,000 works. It is impossible to classify Picasso. Picasso is simply Picasso.

- **1881** Born in Malaga on October 15. His father is a professor of drawing and a painter.
- **1895** Moves to Barcelona and enrolls in the Escola de la Llotja, where his father teaches.
- **1899** Sets up a studio in Barcelona. Draws at the Cercle Artistic. Meets Jaime Sabartes, who becomes a life-long friend.
- **1900** Changes studios in Barcelona, setting up a new one with Carlos Casagemas. Exhibits many portraits at the café, Els Quatre Gats. Travels to Paris with Casagemas.
- **1901** In February, he founds Arte Joven Magazine in Madrid with Francesc d'Assís Soler, a Catalan writer. Takes a second trip to Paris, where he exhibits at the Galerie Vollard. Meets Max Jacob. Breaks with Manyac. His Blue Period begins, which includes *La Vie* (see pg. 436).
- **1902** Spends the year travelling between Paris and Barcelona. Sets up his studio with Josep Rocarol.
- **1904** Moves to Paris. Settles in a shabby building known as the Bateau-Lavoir, or laundry barge. Meets Fernande Olivier.
- **1905** His Rose Period begins, which includes *Standing Naked Woman* (Mrs. Gertrud Stein Heirs Collection). Travels to the Netherlands.
- **1906** Spends a time in Catalonia. Begins his Black and Pre-Cubist Period, which includes *Seated Woman* (Roland Penrose Collection, London).
- **1908** Begins a long period in which he is continually travelling: Paris, Horta de Sant Joan, Cadaqués, Ceret, Sorgues. Begins his Cubist Period: *Les Demoiselles d'Avignon, Nude and Cloth* (Hermitage, St. Petersburg).
- **1913** Having broken up with Fernande a year earlier, he begins a relationship with Eva Marcelle Humbert, who dies in 1915.
- **1914** The outbreak of World War I catches him by surprise in Avignon. Paints a lot of Cubist works.
- **1916** Establishes a friendship with the poet Cocteau, with whom he travels to Italy in the following year.
- **1918** Marries Olga Koklova, a ballerina of the Russian Ballet. Begins his period of Representative Cubism: *Glass, Flowers, Guitar and Bottle* (M.H.Berggruen Collection, Paris).
- **1921** Begins his Neoclassicism and "Gigantism" Period: *Pablo dressed as Pierrot* (Private collection).
- **1927** Begins a series of intimate relationships with various women: Marie-Therèse, Dora Maer (1936), Françoise Guillot (1946), Geneviève Laporte (1951), Sylvette (1953), and Jacqueline Roque (1954). Produces an enormous amount of works in all sorts of media and artistic disciplines (ceramics, drawing, painting, engraving, etc.).
- **1967** Executes a series of erotic-burlesque drawings.
- **1973** Dies on April 8 in Notre-Dame-de-Vie (Mougins). Buried in Vauvenargues.

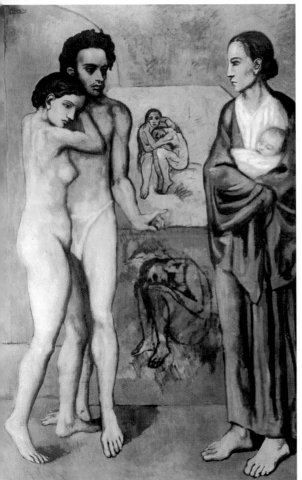

La Vie (Life)

(1903)
oil on canvas
(197 x 127.3 cm)
The Cleveland Museum of Art,
Cleveland (Donated in 1945 by the
Hanna Foundation)

Certain experiences, some financial difficulty, and the fact that he was using the same studio in Paris that he had shared with Carlos Casagemas, who had recently committed suicide, engulfed Picasso in sadness. This he reflected in his works as sorrowful women, beggars, destitute children, old paupers, and handicapped people.

He painted this work on his return to Barcelona, one of the most representative of this period; blue, black, green, and some yellow are the colors with which he represents an unfair, dark world. The figures here, helpless and frightened, have nothing. For this reason, they cling to the only thing they have left—life itself. The young woman embraces her lover, the mother her child, the lovers in the background one another. The woman in the drawing underneath them embraces herself—she has absolutely no one. Life is very hard when you are alone and have nothing.

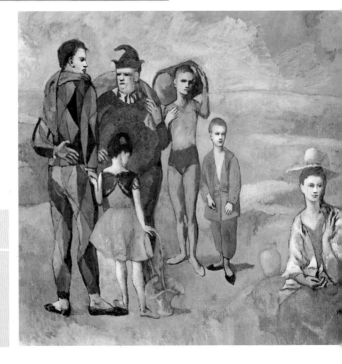

Family of Saltimbanques

(1905)
oil on canvas
85 x 91.8 in
(212.8 x 229.6 cm)
National Gallery
of Art, Washington

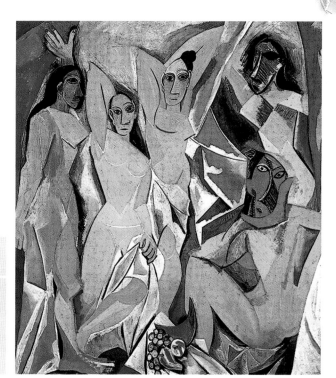

Les Demoiselles d'Avignon

(1907)
oil on canvas
97.5 in x 89.4 in
(243.9 x 223.7 cm)
Museum of Modern Art,
New York

This work instigated the Cubist movement. It was revolutionary in modern art, since, with its approach and the aggressiveness of certain lines and colors, it destroyed the classical Western concept of beauty. All of Picasso's friends were opposed to such audacity except D. H. Kahnweiler, an art dealer and critic.

The painting is an homage to a brothel on Avinyo Street, in Barcelona, and represents five women who worked there. Blues, pinks, and ochres predominate, reminiscent of the artist's previous Rose Period.

The faces of some figures are substituted by masks and their bodies are deconstructed into parts. The women are at once represented in profile and frontally in a three-dimensional space, a technique that would be called "simultaneous vision."

This work is also innovative in the relationship of the figures with the space surrounding them. The figures, objects, and space are all on the same plane, with the surface divided into irregular zones with disparate lighting. In the overall composition of the painting, the influence of Cézanne is clear, though it also refers to El Greco's *The Fifth Seal of the Apocalypse* (The Metropolitan Museum of Art, New York). The figures are rendered with great liberty, though, despite their modern lines, they are nearly all in classical poses.

The figure on the far left, portrayed frontally and in profile, recalls the art of Ancient Egypt. The central figures evoke prehistoric Iberian sculptures, and the two on the right, with their violent contortions, African art. This work is difficult to classify: it appears to be the swan song of Fauvism, but also the birth of Expressionism, and even a certain incursion into Futurism. It constitutes the threshold to two tendencies—Black and Cubism—in modern art.

The choice of subject matter and the color schemes of Picasso's paintings reflect his state of mind at the time when they were executed.

Several amorous relationships in 1905 changed his style. This is one of the most representative works from his Rose Period, during which he painted many circus themes. He had moved on to real yet less dramatic subjects and used a warmer, brighter color range (pink, garnet, and salmon) that lend his works greater optimism. Picasso was a frequent visitor to the Medrano Circus, which performed in his neighborhood. He found it to be a ripe source of inspiration that allowed him to express his present optimism on canvas.

The Guitar Player

(1910)
oil on canvas
40 x 29 in (100 x 73 cm)
Museum of Modern Art, New York

Along with Juan Gris, Georges Braque, and Fernand Léger, Picasso was one of the leading exponents of Cubism. This painting constitutes an eloquent example of it. *Les Demoiselles d'Avignon* (see p. 437) had marked the beginning of a path that an inquiring person such as Picasso could not abandon. Until now, the artist's objective seems to have been to find a new language for rendering a specific reality. But with Cubism, he entered a period in which he became interested in the language itself.

Finally, Picasso converted the means of attaining an end into the end itself. The painting has a strong artistic significance, and its geometrical Cubism, reveals how his search through flat painting led the artist to nearly total abstraction.

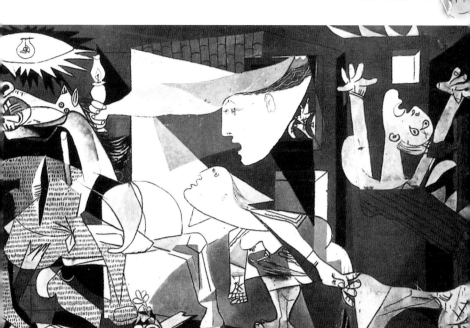

Picasso was in Paris when the Spanish Civil War (1936-1939) broke out. He was clearly against Franco, but at first he remained somewhat silent, only verbally mocking and ridiculing those who had risen against the legitimate government whenever he had the occasion.

The bombardment of Guernica on April 26, 1937, by the Nazi airforces' Condor Legion, was a formidable display of force and arrogance against a small, poor, and defenseless

Guernica

(1937)
oil on canvas
140 x 310 in (349.3 x 776.6 cm)
Museo Nacional Centro de Arte
Reina Sofía, Madrid

town, and it gave rise to a resounding scandal. This event inspired Picasso in the creation of a mural he had been commissioned for the Spanish Pavilion at the World Exposition in Paris that year. On May 1, he began working on it frenetically, brainstorming and executing a multitude of sketches and partial studies. He was torn between opposing interests that were difficult to reconcile: his subjective world, his particular symbols, his personal ideology, and the cruel, savage, and moving reality of the tragedy that had just occurred.

Painted in black and white and several tones of gray, with some blues and pinks, the work is a heartrending cry arising from the depths of desecrated humanity. It is the drowning of pain that can hardly be expressed, a visualization of broken and trampled universal values. It is the desperate cry of a land for its annihilated people. This cutting, profound message is conveyed in a highly balanced architectural language. The painting synthesizes all of the artist's periods (Realism, the Blue and Rose Periods, Cubism, Surrealism, Expressionism, and so forth), united by a strange magic singular in perfection. This lends the work transcendence and timelessness, and, despite referring to a specific event, it becomes a universal cry against the atrocities of war. Picasso could not have imagined that only two years later, the Second World War would give humanity the opportunity to demonstrate its ablitiy to surpass their mark in spreading horror and desolation.

Paulo Dressed as a Harlequin

(1924)
oil on canvas
52 x 39 in (130 x 97.5 cm)
Musée Picasso, Paris

For a time Picasso alternated Cubism with figurative works, but his trip to Italy, his collaboration with the Russian ballets, and his matrimony in 1918 with one of the ballerinas, Olga Koklova, brought a positive change, a breath of fresh air. Into his subject matter, he introduced a series of harlequins that comes to a close with this painting of his son, Paulo, at the age of three. The boy's expression and delicacy reflect the artist's fine sensibility and his tranquility of mind and spiritual balance at that time. It goes without saying that the painting has little to do with his Cubist works, but the artist was versatile and his artistic range very wide. He therefore used the style and technique he felt most appropriate to each work.

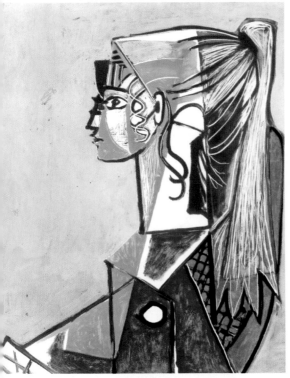

Sylvette

(1954)
oil on canvas
32.4 x 26 in (81 x 65 cm)
Private collection

Between the end of his romance with
Françoise Guillot in 1953 and the begin-
ning of one with Jacqueline Roque in
1954, Picasso had a relationship with
Sylvette, an attractive, dynamic, 20-
year-old model. As this painting shows,
Sylvette wore her hair in a ponytail in
accordance with the fashion at the
time.

The artist seemed to rejuvenate with
this woman. He renovated his style and
aesthetic and painted her from a great
many points of view, in which he maxi-
mized his creativity, artistry, and pictori-
al vision.

Once more, Picasso seemed to stand
before an imminent change. Although
the changes in his life contributed to
this constant metamorphosis in his art,
underlying these changes was a perma-
nent dissatisfaction with his works,
which he felt could always be improved,
and an interest in progressing on an
endless path.

The Artist and the Model

(1963)
oil on canvas
78 x 52 in (195 x 130 cm)
M. H. Berggruen Collection, Paris

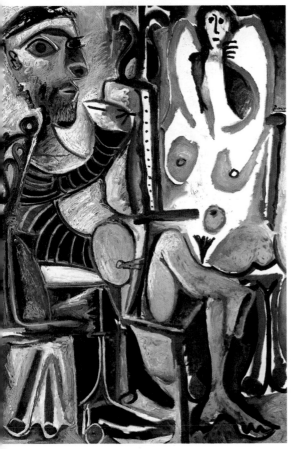

Picasso represents himself painting
before a model. This is a subject that
recurs throughout his career, although
the reason for it is not clear.

The model, who inspires his art,
exhibits herself before him. And he
exhibits himself both to himself and the
viewer. It is as if the artist were con-
stantly subjecting himself to an exami-
nation, making judgments on the path
followed, on his changing style, and on
the true value of his trajectory.

The artist has turned to line and
areas of color, and their undefined
nature has led him to evoke rather than
represent, in search of the evermore dif-
ficult encounter with himself and his
art. Although the painting has a dark
palette, the color range used is wide
and rich, and demonstrates complete
mastery over color.

AMEDEO MODIGLIANI

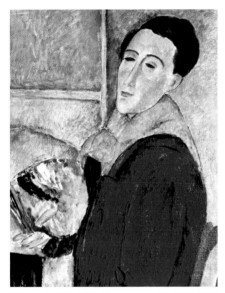

Self-portrait *(detail), oil on canvas, 40 x 26 in (100 x 65 cm), 1919, Property of Jolanda Penteado Matarazzo, São Paulo.*

Because his life was so brief, Modigliani produced few works. His style was a strange combination of Cubism, the Trecento, and the Quattrocento, and evolved very slowly. Carefully drafted and delicate, it is characterized by highly stylized figures in which the line is of utmost importance, creating outlines and defining facial features, emphasizing forms, and marking off areas that were later filled in with generally flat colors, with an abundance of ochres, oranges, blues, whites, and blacks.

In his oeuvre, two genres predominate: the female nude and the portrait.

Modigliani created a personal, unmistakable style characterized by an elegance that recalls Florentine painters in certain aspects—in composition, combination of colors, and the intellectual presentation of his subjects—though sadness, a certain melancholy, and desperation are also common features.

His delicate health, which gave him a mournful, melancholy character, his chaotic lifestyle, involving alcohol and drugs, and his premature death, followed by the suicide of his wife when she was told of his death, contributed to creating a romantic legend of this painter. Modigliani is a vivid exponent of bohemian life and the nocturnal atmosphere of the Parisian underworld that he so often frequented.

- **1884** Born in Liorna, descending on his maternal side from the Sephardic Jewish family of Baruch Spinoza.

- **1897** In early childhood, he falls ill with tuberculosis. In Liorna, he becomes a student of Guglielmo Micheli, a mediocre painter but an excellent teacher.

- **1903** Attends classes at the fine arts schools of Florence and Venice.

- **1906** Moves to Paris, settling in the Bateau-Lavoir, a shabby building on Montparnasse. Leads a bohemian life amidst hunger and poverty. Frequents the Colarossi Academy of Montparnasse. Spends time with Max Jacob, Utrillo, Apollinaire, Salmon, Picasso, etc.

- **1907** Visits Cézanne's exhibit, which strongly influences him. He is also influenced by Toulouse-Lautrec's art. Meets Paul Alexandre, with whom he develops a close friendship.

- **1908** Exhibits several works at the Paris Salon, which go unnoticed.

- **1909** Meets Constantin Brancusi, who encourages him to take up sculpture.

- **1910** After a rest in Liorna, returns to Paris, where he contributes some work to the Salon des Indépendants. His paintings are well received by the critics.

- **1912** Exhibits several sculptures at the Salon d'Automne.

- **1914** Begins a turbulent relationship with the British poet, Beatrice Hastings, which lasts two years. Thanks to the help of the merchant, Paul Guillaume, he manages to stabilize his financial situation.

- **1917** Meets Jeanne Hébuterne, a nineteen-year-old student at the Colarossi Academy, and they move in together. His first individual exhibit is held at the Berthe Weill Gallery. The nudes placed in the gallery's window for the exhibit cause a great scandal and the police force them to be removed.

- **1918** An exhibit of his works is held at the Hill Gallery in London. The merchant Paul Guillaume and the Polish poet Leopold Zborowsky, a friend of the painter, contribute to making his works known.

- **1920** Dies in poverty on January 24 in the Hôpital de la Charité in Paris. In desperation his wife Jeanne Hébuterne commits suicide the next day.

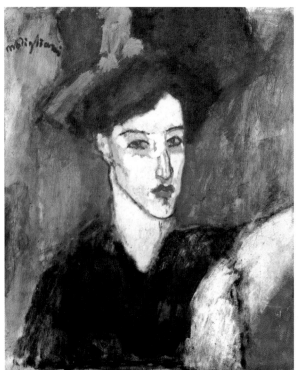

The Hebrew Woman

(1908)
oil on canvas
22 x 18.4 in (55 x 46 cm)
Private collection, France

Modigliani and Paul Alexandre met this woman, whom they called the Hebrew, in bohemian bars in Paris that they frequented. Her features, expression, and attire evoke the underworld from whence she emerged.

With an abstract background, the artist combines different brushstrokes in order to create a texture. The image of this woman, young, sad, and with little financial resources, is very expressive. Her elongated face, pallid complexion, features well drawn in a steady brushstroke, stylized neck, and dark colors of both the clothes and hat enhance her profound gaze, which constitutes the focus of attention of the painting, excellently balanced in color. Along with five other works, Modigliani exhibited this canvas at the Salon des Indépendants in the same year it was executed.

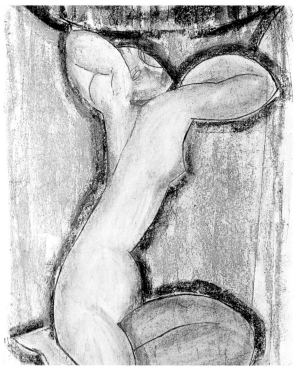

Caryatid

(1913)
pastel on paper
20.8 x 19 in (52.2 x 47.5 cm)
Musée du Petit Palais, Paris (Girardin Collection)

This nude corresponds to a period when Modigliani painted a number of caryatids, probably as a result of his propensity toward sculpture, a discipline that he had been encouraged to take up by the sculptor Brancusi several years earlier.

Here the line predominates, describing the contours and posing the figure in a series of unreal, affected contortions for the sake of overall aesthetics. He represents the female nude as the only element against a plain, abstract background. This evocative, idealized body is well structured and executed in an impeccable technique with minimal elements. The work reveals the artist's sculptural aptitude—it is almost as if it were a preliminary study for a sculpture.

Paul Alexandre

(1913)
oil on canvas
32 x 18 in (80 x 45 cm)
Private collection, France

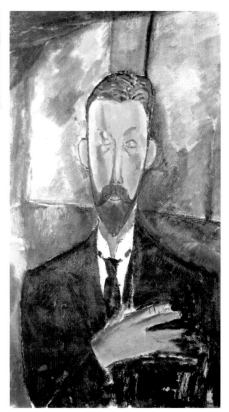

Paul Alexandre was a young art expert and collector, and a friend of Modigliani. Here, Modigliani places a large window filled with light behind the sitter. Nevertheless, it does not give rise to a backlit view of the figure, who is perfectly illuminated in a singular and technically rather unbalanced and scattered representation. The manner of representing the glass is curious, with its brushstrokes of varied pastel tones obtained through heavily thinned paint. Another, more compact type of brushstroke defines the walls and the sitter's attire.

The stylized face is executed in dark brushstrokes that define the perimeter and the texture of the hair. To model the face and mustache, Modigliani uses two color ranges whose intensity he varies accordingly. Some reddish and greenish hues on the face suggest the reflection of the daylight.

The figure's face is the center of focus, whereas the remaining elements, such as the hands, are only suggested. The canvas has the freshness of a sketch.

Seated Nude

(1916)
oil on canvas
37.2 x 24 in (93 x 60 cm)
Courtauld Institute Galleries, London University, London

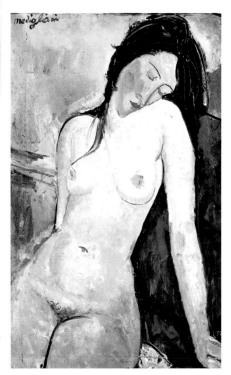

The stylization of this body enhances its sensuality. The woman's skin is youthful, light, and delicate, and she has turgid breasts and a fine waist exaggerated by the width of the hips, which give rise to robust thighs concealing her intimate parts. The woman is turning slightly to the side and attempting to hide her face, as if she were uncomfortable with her nudity and insinuating a gesture of modesty. This is emphasized by her red cheeks, strongly contrasting with the delicate ochre of her skin.

The artist has created an undefined background with large areas in different tones: blue to suggest the wall and a dark red representing the backrest of the chair against which she is leaning. The woman's candor is used to create a playful sultriness. The nudity of an innocent, modest young woman and the delicate sensuality of her tender anatomy combine to enhance the viewer's lubricious curiosity.

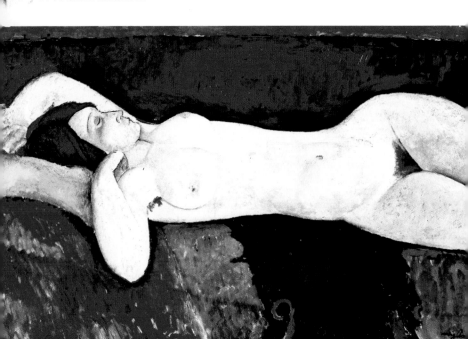

Nude Woman Sleeping

(1917)
oil on canvas
29.2 x 46.4 in (73 x 116 cm)
Museum of Modern Art, New York

This woman is reclining on a bed, fast asleep and unconcerned about her nudity, with her arms lifted to generously exhibit her breasts and entire anatomy.

Modigliani offers the spectator this image, with all of its sultry provocation, painted as if he were a voyeur, secretly watching the woman at rest. To create a high level of eroticism, he elongates the body and exaggerates her forms (breasts, waist, abdomen, and hips) to make them more spiritual but also more seductive. The skin suggests smoothness, and delicacy, and invites a caress. Its slightly rosy white stands out against the background of intense colors, with the predominant red suggesting passion and pleasure and constituting a clear reference to the libido.

The female nude is one of the most frequent subjects painted by Modigliani, especially after 1917. The more nudes he executed, the more he developed his style and the more explicit and daring the nudes became, their eroticism more striking and aggressive. This image represents a woman openly offering herself, lying immobile with her legs slightly apart and her arms above her head, uninhibitedly exhibiting her nudity, provoking the observer and nearly expecting a response.

Modigliani expresses his intense bodily desires and spiritual yearnings. The pose, face, and attitude of this young woman

Reclining Nude with Open Arms

(1917)
oil on canvas
24 x 37 in (60 x 92 cm)
Gianni Mattioli Collection, Milan

are the living image of passion, emphasized by the warm colors, flushed skin, rosy cheeks, and intense carmine lips. As if this were not enough, the body is placed on a diagonal to make it more incisive, part of the lower extremities are dispensed with in order to approximate the body to the observer, giving the impression that it is within reach, and it emerges from a background of several densely applied, intense colors (blue, red, black, white).

The language could be no more explicit, the intention is evident, and the expressive force is striking. With this nude, Modigliani is sincere with the viewer and offers us an image that incites our instincts and constitutes a clear invitation to enjoy this body. The language used is direct and striking, free of any conventions whatsoever. This painting, which the artist held in great esteem, hung in his studio during the last years of his life, as seen in a photo from the time.

Blaise Cendrars

(1917)
oil on canvas
24.4 x 20 in (61 x 50 cm)
Gualino Collection, Rome

Blaise Cendrars was the French penname of the Swiss writer, Fréderic Sausser-Hall (1887-1961). A tireless traveler, his poetry exercised a great deal of influence on the Surrealists, especially on Apollinaire. Drafted into the Foreign Legion, he participated in the First World War, where he was injured and his right forearm amputated. In 1917, he wrote "On a Portrait by Modigliani," which served as an introduction to the painter's exhibit at the Berthe Weill Gallery in Paris.

As if it were a caricature, the artist has selected everything that best conveys the physical image and especially the character of the sitter. The background is painted in a dark blue in loose brushstrokes, making the figure stand out and advance toward the viewer. Except for a few light lines, the entire modeling of the face is executed through soft shadows, and the complexion of the face is rendered in a single color range that varies according to the interplay of light most appropriate to each area. Intense tones were used only in the eyes and mouth, which resembles that of a woman.

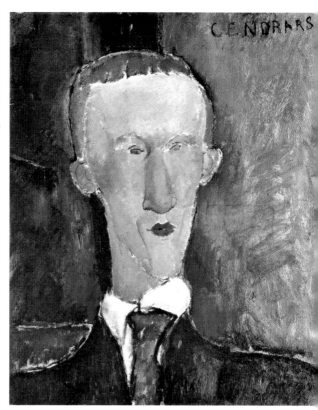

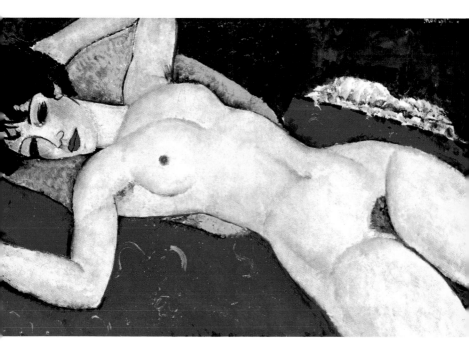

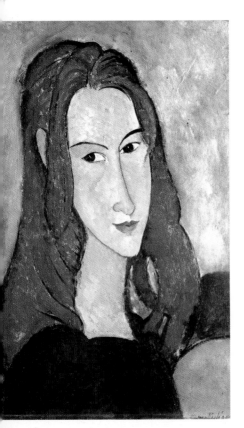

Jeanne Hébuterne

(1918)
oil on canvas
18.4 x 11.2 in (46 x 28 cm)
Private collection, Paris

Jeanne Hébuterne was a student at the Colarossi Academy in Montparnasse. There she met Modigliani in April of 1917. They fell in love and began living together at the Rue de la Grande Chaumière in Paris, despite the opposition of her family, as she was only 19.

Early in the spring of 1918, the artist's delicate health, Jeanne's advanced pregnancy, and the bombardments of Paris, in the midst of World War I, led the couple to move to the Côte d'Azur, near Nice, where they spent over a year.

That was where Modigliani painted this portrait. Employing his personal style, with a line defining the contours and principal features and the resulting areas filled with nearly flat colors, the artist created a painting imbued with candor, reflecting the woman's youth, tenderness, and femininity. She wears a captivating expression on her face. Modigliani demonstrates his feelings of love and respect toward Jeanne through the great delicacy in the treatment, the subtle softness in the modeling of the face, and a great deal of finesse and sensuality.

Lunia Czechowska

(1919)
oil on canvas
40 x 26 in (100 x 65 cm)
Musée du Petit Palais, Paris

Modigliani executed this painting in Paris, having returned from the Côte d'Azur in the month of May. In November, his wife, who had given birth to their daughter, Jeanne, was pregnant again and the artist was in very poor health (he was to die seven months later). During this time, he began executing portraits of his friends, among them Lunia. He had met her in 1917 through his merchant friends and patrons, Leopold and Hanka Zborowsky.

This portrait, with a great synthesis of forms, is executed in extensive areas that chromatically combine in the manner of a puzzle. The intense colors of the background and dress contrast with the white of the sleeves and the rosy ochre of the complexion. The position and expression of the face are precise, rendered as in a caricature. The painting manifests a tendency toward Cubism.

GEORGIA O'KEEFFE

Photograph of Georgia O'Keeffe by Alfred Stieglitz, 1921, National Gallery of Art, Washington DC.

Although her work reflects a varied iconography, Georgia O'Keeffe is best known for her floral subjects and the works she executed in New Mexico, featuring animal bones baked in the desert sun.

Her clean, precise, and independent style is based on nature and tends toward abstraction, with spectacular forms, colors, and representations. The accessibility of her works and their delicate sensibility conceal the strong character of this woman, who led a turbulent life and is said to have been romantically involved with Frida Kahlo.

She constantly experimented, moved by the desire to discover a new dimension in natural elements. She created abstract representations from their details, light effects, or figurative forms. In her works, light, smoothness, and a sensual atmosphere are the most distinctive notes.

She actively promoted the art of photography, and used it as an aid for finding points of view otherwise difficult to obtain from which to create representations.

Georgia O'Keeffe is a fundamental figure in the art of the United States, and she has influenced a great many artists.

- **1887** Born in Sun Prairie, Wisconsin, on November 15. Shows skill in the arts from childhood.

- **1905** Graduates from high school and enrolls at the Art Institute of Chicago, where she studies for a year.

- **1907** Enrolls in the Art Students League in New York, where she learns the principles of imitative Realism.

- **1908** Wins the League's William Merrit Chase Still-life Prize with the oil painting *Untitled (Dead Rabbit with Copper Pot)* (Georgia O'Keeffe Museum, Santa Fe, New Mexico).

- **1914** Begins experimenting with the Japanese technique of sumi-e, with brushes and inks, adopting a personal form of expression.

- **1916** Executes a series of drawings in charcoal, ten of which are exhibited at the vanguard art gallery, 291, owned by Alfred Stieglitz, an art dealer and photographer.

- **1917** Holds an individual exhibit.

- **1924** Stieglitz subsidizes her for a year so that she can paint in New York.

- **1926** She marries Stieglitz, her greatest benefactor.

- **1929** After settling in New York, she travels to New Mexico, where she finds a variety of subject matter for her paintings. She spends many summers in this state.

- **1949** Three years after the death of her husband, she moves to New Mexico, where she continues to paint until the late 1970s.

- **1951** Shares an important exhibit with Fernando Gerassi.

- **1979** Begins to have serious sight problems. Although this forces her to stop painting, she does not stop exercising her creativity and takes up sculpture.

- **1980** Her serious health problems force her to stop her artistic activities.

- **1986** Dies in Santa Fe.

Special No. 9

(1915)
charcoal on paper
25.2 x 19.2 in (63 x 48 cm)
The Menil Collection, Houston

This was one of the charcoal works that led Alfred Stieglitz to become interested in O'Keeffe's art. The work is striking for the dynamism with which the forms are interpreted in a dream universe of pure abstraction far from any reality. Nonetheless, it was precisely this basis of abstraction that would lead the painter toward figurative art five years later, when she assiduously began to dedicate herself to floral subjects. This evolution seems logical, as the forms tending toward abstraction suggest an organic world. The artist may not previously have recognized the abstraction inherent in the subject of flowers but simply felt an inclination toward them. This image, developed from a natural object seen in close-up, is filled with impressive forms and is very dramatic, demonstrating that nature conceals a thousand facets, which the artist must discover.

Within O'Keeffe's oeuvre, her early watercolors are striking for their distinctive brushstrokes and spontaneity, leading to a significant synthesis of forms. Color plays a major role in them and heralds her later oil works. In this small watercolor, the contrasts are very important and, although it is a landscape, there is a clear interest in organic matter, repetition, and rhythm. This appreciation of rhythm and composition were constants throughout the artist's works. Her interpretation of the colors in nature is far from realistic.

Dawn with Small Clouds II

(1916)
watercolor on paper
8.8 x 12 in (22 x 30 cm)
Heirs of Georgia O'Keeffe

Nude

(1917)
watercolor on paper
12 x 8 in (30 x 20 cm)
Heirs of Georgia O'Keeffe

This nude reveals certain characteristics of O'Keeffe's style. From the beginning, she demonstrates an inclination toward sculpture, an activity that she would take up in her later years, when her failing eyesight made it difficult for her to paint. In this foreshortened nude, the volume is described through contrast. First, O'Keeffe outlined the figure, then she filled it in with color and created the contrasts.

This nude is very interesting if compared with her later representations of vegetation. The figure is practically transformed into an organic mass of sinuous, sensual forms. This treatment, halfway between abstraction and figurative art, is the basis of the artist's artistic world.

Leaves

(~1923)
oil on glass
21.2 x 18 in (53 x 45 cm)
Phillips Collection,
Washington, DC

In 1920, O'Keeffe begins representing close-ups of plant details, from which she creates chromatic abstractions based on reflections and, above all, the observation of nature. Though she is considered a figurative artist, her tendency toward abstraction is a constant throughout her career.

In this plant motif, there is a marked interest in the synthetic construction of forms that recalls certain aspects of the Cubist ideology or even the Futurist aesthetic. The great chromatic contrast existing between the background and the leaf in the foreground, modeled as if it were made of fine velvet, lend the latter striking visual force. The variety of tones employed to describe details and define textures makes the work remarkably rich. The artist particularly focuses on the lines that comprise forms that favor abstraction, toward which she directs her interpretation of the leaves.

The artist's investigation of forms was not limited to plant subjects. She also executed extremely interesting paintings of the New York cityscape. Observing the city, she realized that its large masses had a great value in and of themselves, and that, if the proper frame was chosen, they could give rise to compositions with spectacular perspectives, as in this austere view of a street.

Here the perspective, transitions between grounds, and tonal gradations are elements of great aesthetic value. The painting is rich in colors and the light is described in a nearly unreal manner at an undefined time of day. As a study of perspectives based on volumes and light it is remarkable. The painting offers a "virtual" image, solemn and imposing. The same tonal differences, brusque transitions between grounds, and pictorial treatment are present in works by other artists of the time, such as Tamara de Lempicka.

New York Street, No. 1

(1926)
oil on canvas
48 x 29.2 in (120 x 73 cm)
Mr. and Mrs. Harry W. Anderson
Collection

Red Poppy

(1927)
oil on canvas
6.8 x 8.8 in (17 x 22 cm)
Private Collection, Geneva

Despite the small dimensions of this canvas, the flower is treated monumentally. Her series on flowers is among her most renowned work. The sensuality with which she imbues the subject is overwhelming, as she employs a dual, realist-erotic language in her work. Not content with the simple formal representation of the plant, she enjoys delving into its voluptuous forms, its plethora of exquisite curves, and a treatment of color typical of her art, rich in superb contrasts in which each tone is skillfully compensated for by the juxtaposing color.

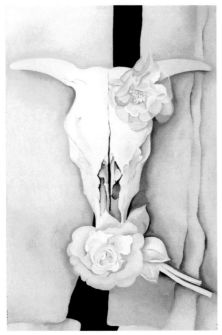

Cow Skull with Calico Roses

(1931)
oil on canvas
36.4 x 24.4 in (91 x 61 cm)
The Art Institute of Chicago, Chicago
(Donation of Georgia O'Keeffe)

At her very first visit, the state of New Mexico deeply impressed O'Keeffe. There she encountered a myriad of objects that constituted ideal subject matter, such as the skulls of dead animals, blanched by the desert sun. This centered composition is an example of a series of works focusing on the bones, jaws, and orifices of the skulls. Some are viewed in such proximity that viewers lose the notion of what they are seeing and the image becomes an abstraction. This iconography, directly related to the arid, sun-baked land, and her manner of representing it have inspired numerous artists.

EGON SCHIELE

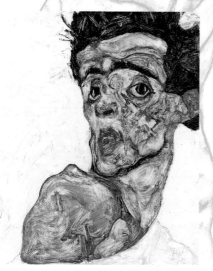

Self-portrait with Raised Nude Shoulder
(detail), oil on panel, 16.8 x 13.56 in (42.2 x
33.9 cm), 1912, Leopold Museum, Vienna.

Along with Klimt and Kokoschka, Egon Schiele
represented an important milestone for early
20th-century Viennese painting. Inquiring and
wholly unconventional, he soon broke with the
Jugendstil, the German Art Nouveau movement
of the late 19th century, adopting a tormented
style with a profound existential preoccupation
for the human figure. He conceived a dark
world, with strong sexual themes, explicit and
without taboos, in keeping with the theories
that Sigmund Freud would put forth shortly
after Schiele's death.

In Schiele's work, severe images abound.
There is a crudeness without concessions. The
brushstrokes are nervous, broken, and aggres-
sive, with a profusion of unreal colors juxta-
posed to emphasize specific aspects and make
the message more forceful. The poses are
always studied and the points of view singular,
with extremely complex foreshortenings and
surprising framings, superb draftsmanship, and
an excellent compositional scheme.

Schiele was tormented by existence, sex, and
the reality of life. His marriage and recruitment
to the army during World War I changed his
sentiments, affecting his style. After countless
setbacks, his work was reevaluated and his
fame grew enormously. Nonetheless, his indi-
vidual fate was cruel. Just when it seemed he
had a promising future, his wife and child died,
and three days later, he followed suit.

- **1890** Born in Tulln, in southern Austria, on June 12, the third son of an official of the Imperial and Royal Railways.

- **1906** Studies at the Fine Arts School of Vienna.

- **1907** Travels to Trieste and then establishes a studio in Vienna.

- **1908** Participates in an exhibit at the Augustine monastery of Klosterneuburg with 10 of his works.

- **1909** Participates with four works in the *Internationale Kunstschau,* an important exhibit presided over by Gustav Klimt. Due to differences with his professors, he leaves the Academy. Participates in the foundation of the *Neukunstgruppe,* or New Artists Group, for which he acts as president and secretary.

- **1910** Participates in the *Internationale Jagdausstellung* with a painting of a full female nude, purchased by the architect Otto Wagner. When Kaiser Francis Joseph sees it, he takes great offense. Travels to Krumau with his friend, Erwin Dominik Osen. In autumn, he exhibits at the Augustine monastery of Klosterneuburg again. Henri Bennesch acquires many of his works, now at the Albertina Museum, Vienna.

- **1911** Tired of the problems he has in Vienna, he moves to the village of Krumau with Wally Neuzil, a young woman he has met shortly before. The fact that he uses adolescents as nude models and lives with Wally out of wedlock creates many problems for him, so he moves to Neulengbach, near Vienna.

- **1912** Accused of seducing a minor and of show-ing his immoral drawings to minors, he spends 24 days in jail, which affects him profoundly. Obtains Klimt's help to sell his paintings.

- **1913** Enters the Association of Austrian Artists. Collaborates on the magazine *Die Aktion.*

- **1915** Marries Edith four days before he leaves for Prague as a recruit for the war. He is invited by the Vienna Secession to participate in the Viennese *Kunstschau* along with Klimt.

- **1917** After serving as a guard for prisoners of war, he returns to Vienna, where he decorates vari-ous military buildings. Commissioned to organize the War Exhibit. According to his wishes, he is given a post at the Imperial and Royal Museum.

- **1918** Through a Vienna Secession exhibit, he rises to sudden fame and is invited to participate in many exhibits. His wife, six months pregnant, dies on October 28 of typhus, which he also contracts, dying in Vienna three days later, on the 31st of the same month.

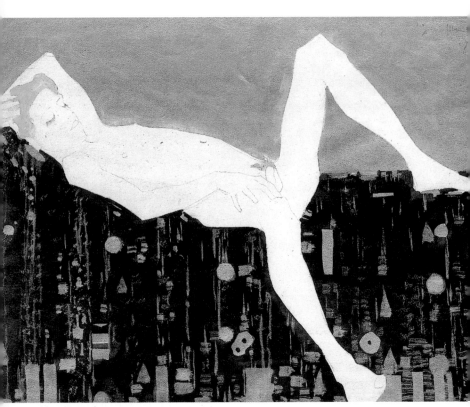

Nude Boy on Patterned Blanket

(1908)
pencil, gouache, glitter,
and India ink on paper
9.5 x 12.6 in (23.8 x 31.5 cm)
Leopold Museum, Vienna

Although the artist was only 18 years old when he painted this work, it is obvious that he had already fully adopted the ideas of the *Jugendstil,* the German equivalent of Art Nouveau. They are reflected in the ornamental motifs, the combination of India ink and glitter in the background, and the unreal colors in certain parts of the boy's body (the tenuous green on the body and the intense green of the hair and genitals). The decoration of the blanket on which he is reclining recalls Klimt.

The composition is divided into three large areas (boy, blanket, and background). He creates a chromatic contrast appropriate to their respective roles. Although this painting exhibits great talent and skill, compared with his later works, it shows that Schiele had not yet consolidated his style or technique.

The skin is smooth to enhance the figure's sensuality. The body is delineated by the dense color of the background and not by the defined, precise line that the artist would later use to outline his figures. This painting reflects the artist's interest in the human body, a constant in his artwork, almost always represented in a self-absorbed, ambiguous manner. They boy is sleeping, yet exhibits his body in a narcissistic fashion. The image cannot conceal a clearly erotic and provocative intent. This is a world that Schiele knows and interprets perfectly in most of his works with human figures, which constitute the majority of them.

This composition recalls a Byzantine icon, although the meaning here is tragic. The mother tenderly embraces her child, but this does not assuage the terror caused by what he is seeing. The expression on his face, the hair on end, and his small, rigid hand are unequivocal signs.

Schiele creates a background in black brushstrokes applied in all directions that totally absorbs the two bodies. From this dark sea only their two hands emerge, very different in structure and meaning, and their faces, in which, despite the light colors with varied tones, the stroke is forceful and aggressive. The paint allows many traces of the preliminary drawing underneath to show through.

Poet

(1911)
oil on canvas
32.2 x 32 in
(80.5 x 80 cm)
Leopold Museum, Vienna

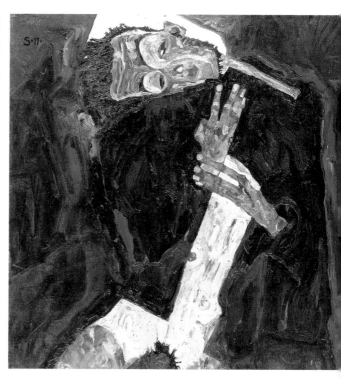

The figure in this work can be identified as the artist. Nearly bursting out of the space of the painting, the figure, partially nude in a dark world, radiates feelings of oppression, loneliness, and helplessness. This desperate situation is reinforced by the man's pose, with his head fully inclined, wringing his hands in a clear attempt to ascertain whether he is still alive.

He is semi-nude—his neck and shoulder are visible, as are his entire central thorax, penis, and one buttock. The painting is executed with harsh, aggressive brushstrokes with a great deal of paint that is applied in impasto to create texture in the background, clothing, and body. Particularly interesting is the brushstroke employed for the complexion, juxtaposing vivid, unreal, and vibrant colors. This work is like a cry for help in an extremely grave situation.

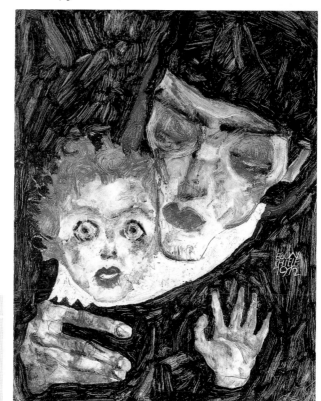

Mother and Child

(1912)
oil on wood
14.6 x 11.68
(36.5 x 29.2 cm)
Leopold Museum, Vienna

Small City

(1912-1913)
oil on canvas
35.8 x 36.2 in
(89.5 x 90.5 cm)
Leopold Museum, Vienna

This painting was executed following the artist's release from jail, at a time of great financial hardship and emotional distress. This city view is an invention, although Schiele used various motifs from Krumau, where he lived for a brief and turbulent period with Wally Neuzil. These include the Jodokus Church, the houses on the Moldau River, the Jesuit Seminary, and the city hall. With this series of elements, the artist creates an ancient, empty, dark city. Even the river flowing along the lower edge is dark. This clearly reflects Schiele's vision of existence. Nonetheless, his artistic skill is evident in the balance of the composition and the unity of the whole, as well as in the predominant chromatic harmony.

Female Nude Seen from Behind

(1913)
pencil and gouache on paper
19 x 13 in (47.8 x 32 cm)
Leopold Museum, Vienna

Although it resembles a sketch at first sight, Schiele's signature makes this a definitive work. It is an excellent example of his great skill in draftsmanship. The drawing, in which the line plays the leading role, is absolutely perfect. Everything is superb: the figure's profile, contrapposto pose, forms, and anatomical details; and its movement, the feet, the curve of the back, and so forth. They are enhanced by the fact that the work does not show the least hesitation or any sign of corrections.

The certainty and composure of the lines are complete. A striking detail that indicates to what extent his works were artistically conceived is the fact that the figure is not a simple, academic female nude seen from behind. It is a woman who is actually lifting her dress to reveal her nude back. This is a masterpiece.

The two nude women merge in an embrace, with their abdomens touching, while one of them places her leg between the other's legs and she, in turn, brushes her genitals against it, revealing a small area of pubic hair. They are two lovers in one of their encounters.

The fragment of clothing visible along the lower edge as if it had just been allowed to fall lends the scene spontaneity and completes the lower part of the composition. It serves the same purpose as the women's hair in the upper area, which reflects the color of the fallen dress.

Two Women Embracing

(1914)
charcoal pencil and gouache on paper
19.4 x 10.7 in (48.5 x 26.7 cm)
Leopold Museum, Vienna

The delicacy and candidness with which Schiele treats the human figure contrasts here with the hard lines and muscular forms. The outlines of the bodies are bold and sure, as are the lines describing details such as the spinal column, the folds in the skin, and some muscles. A rather common feature of this artist's work is the series of short parallel lines applied perpendicularly across longer lines for emphasis. The outlines are reinforced in dark brown paint to afford them more consistency and force. The forms, volumes, and relief on the skin are represented in short, tenuous, and chromatically balanced brushstrokes, although with reflections of unrealistic colors such as reds and greens. These delicate features serve as a counterpoint to the severity in certain aspects of the work. On the whole, the painting has balanced masses and the two figures, though independent, in reality form a single unit through their poses and the way their anatomies intertwine.

Female Nude with Right Leg Lifted

(1915)
pencil and gouache on paper
18.8 x 12.6 in (47.1 x 31.5 cm)
Leopold Museum, Vienna

From a compositional point of view, this pose is daring, unnatural, and awkward. The figure is on her side with one arm under her knee, giving rise to a series of varied, rhythmical lines. The outline is described through a steady line in pencil emphasized by a finer line in gouache, in which certain details are also executed, such as the hair, eyes, mouth, genitals, and boots. As an element of contrast, certain details have been treated with chromatic force and vivacity, for example, the hair, boots, mouth, nipple, and vulva. The whole is harmonious and suggestive, and the composition excellent. With regard to the pose, once more, Schiele shows his interest in sex, although it does not play a leading role here.

Edith Dying

(1918)
charcoal pencil on paper
17.6 x 11.8 in (44 x 29.7 cm)
Leopold Museum, Vienna

This is Schiele's last work. It shows his wife on her deathbed. Although it is dated October 28, the day of Edith's death, the drawing was executed one day before. The artist signed it so that it would be viewed vertically, but it was executed horizontally, which is how everything can be understood: the imminence of death, the woman's helplessness, her expressive, lost look, nearly a farewell, the locks of her hair on the pillow, the posture of her hand, and the mouth slightly ajar with feverish lips.

In addition to being an excellent drawing, this expressive and moving work is an example of great strength and emotion. It reveals Schiele's strong personality. Amid his desperation, this was the best homage he could give his wife. It is doubly remarkable since he had contracted typhus as well and was also dying. In fact, Schiele died three days later.

JACKSON POLLOCK

Self-portrait, *oil on marouflé paper prepared with gesso, 7.36 x 5.3 in (8.4 x 13.3 cm), 1930-1933, Mrs. Lee Krasner Pollock Collection, New York.*

Pollock was a key figure in the art scene of the 1940s and 1950s. He was an alcoholic, a womanizer, rebellious, violent, rude, and irreverent. And he became the most important frenzied neurotic on the American cultural scene. With such a background, his future did not seem very promising. Indeed, he appeared doomed to failure. Yet, despite his lifestyle, which often left him destitute, his legacy is profound. His Abstract Expressionism fulfilled the need to revitalize the artistic scene after World War II.

From the great Mexican Muralists, Orozco, Rivera, and Siqueiros, he assimilated the expression of Latin American movements and learned about new materials and techniques. He also worked with Automatism, a form of expression arising directly from the subconscious, a legacy from the Surrealists.

In the early 1940s, Pollock became the target of the critics, as he treated his figures with unusual violence. In 1947, he began to use his "dripping" technique, a radical new manner of painting without even touching the surface of the canvas. As would occur with Warhol years later, Pollock's talent was questioned until Peggy Guggenheim and her circle of critics began to praise his artwork. Despite his strange behavior and his abrupt mood

- **1912** Born in Cody, Wyoming. Has a hard childhood in Arizona and California.

- **1928** Begins his training as a painter in Los Angeles.

- **1930** Settles in New York, where he takes courses given by Thomas Hart Benton at the Art Students League.

- **1935** From this year until 1941, he works in the Federal Art Project, a subsidy program created by the Roosevelt government.

- **1938** To this date, his work, mostly regionalist scenes and landscapes, is characterized by its composition. After leaving the psychiatric clinic where he was admitted for schizophrenia, he begins to show an interest for semi-abstraction. His works reveal the influence of Picasso and of the Mexican artist, José Clemente Orozco.

- **1939** Becomes interested in Mexican mural painting when he sees a work that Orozco and Benton have executed in New York

- **1943** His first exhibit is held at Peggy Guggenheim's Art of this Century Gallery in New York. Paints his large work, *Mural* (The University of Iowa, Museum of Art, Iowa City) a painting with a personal style rich in composition and conceptually approaching Surrealism.

- **1944** The Abstract Expressionist movement arises, of which Pollock will become the emblematic figure.

- **1947** Leaves figurative art completely and begins abstract compositions in the drip method, a technique consisting of dripping or spattering liquid paints onto the canvas.

- **1949** *Life* magazine describes him as "the brilliant new phenomenon in American art."

- **1953** Completes *Falling Star* (Torcuato Di Tella Institute, Buenos Aires, Argentina), which reveals a gestural application of paint.

- **1956** Dies in an automobile accident on August 11. His work had already become a great focus of influence for his contemporaries.

changes, Pollock was one of the greatest artists to arise in the American art scene following World War II. Along with De Kooning and Rothko, he was one of the leading exponents of Abstract Expressionism.

Going West

(1934-1935)
oil on fiberboard prepared with gesso
14.3 x 21.2 in (35.8 x 53 cm)
Smithsonian American Art Museum
Washington, DC

Pollock's artistic career can be divided into six periods. Until 1938, his work showed significant influence from more traditional compositions, with subjects related to landscapes and genre scenes.

The treatment of this wagon train approaches Mexican Muralism, although the format is not exceedingly large. All of the elements—the sky, earth, and wagon train—are distributed in a composition of elliptical shape.

The artist reserved a predominantly cool color range for the upper part of the painting, whereas warm colors predominate below. The elements appearing (clouds, mountains, animals, wagons, and a person) can easily be identified. This is a far cry from his abstract works and has no specific subject matter. The forms result in a balanced and pictorially consistent work, in which curves predominate, the colors are well combined, and the modeling is meticulous.

Later, the artist began using increasingly larger formats. After his stay at the psychiatric ward, Pollock would show a great interest in semi-abstraction, and be strongly influenced by Picasso and the Mexican Muralist Orozco. He became interested in Surrealism and Jung's theories and, finally, in "automatic" painting and in freeing inner pressure, increasingly sacrificing figurative painting for the sake of abstraction.

In this work, Picasso's influence is evident, although Expressionism is also present. The figures are outlined in thick lines, the forms striking, and the muscles powerful and tensed, lending the whole painting a hard character. Contributing to this is the dense paint, the direct, naked brushstroke, and the position and gesture of the hands. The artist produces psychological

Naked Man with Knife

(1938-1941)
oil on canvas
50.8 x 36.5 in (127 x 91.4 cm)
The Trustees of the Tate Gallery, London

anxiety in the viewer with a strong compositional line, and a wise combination of curved and diagonal forms. Later he converted this very anxiety into pure abstraction, completely dispensing with the figure.

Despite the saturation of lines and forms, the painting is compositionally well balanced and its colors are harmonically combined. The artist was clearly evolving and his style would soon give rise to new, more daring expression.

Bird

(1938-1941)
oil on canvas, marouflage
on plywood
46.7 x 22 in (116.8 x 55.2 cm)
Mrs. Lee Krasner Pollock
Collection, New York

Slowly, and under the strong influence of Surrealism, Pollock replaced realistic figurative art with a free style in which all possible shapes are intertwined. Still close to certain Picassoesque approaches, he was already moving toward his own personal style that revealed his most abrupt side.

While creating works such as this one, he continued to paint figurative and formal works, so that his progress toward abstraction developed in parallel.

This scene does not revolve around a figurative description, but rather is based on an idea that pervades the painting: a woman giving birth to a man. The limits of the work tend to slowly disappear, although there are still some "classical" compositional premises, such as the subject's pose, according to which the distribution of weight and form is important.

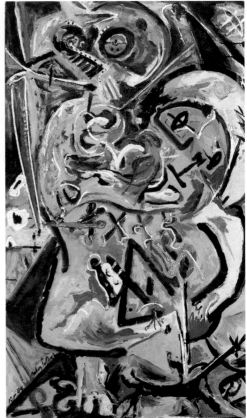

Totem Lesson I

(1944)
oil on canvas
71 x 44 in (177.8 x 111.8 cm)
Mr. and Mrs. Harry W.
Anderson Collection, Atherton,
California

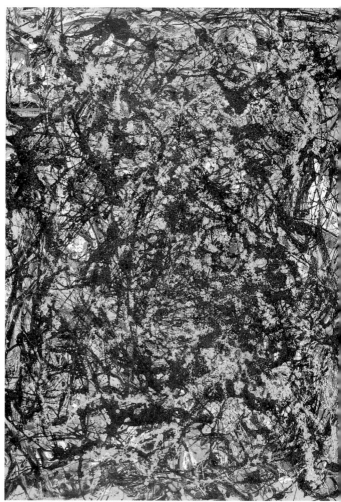

Sea Change

(1947)
oil and aluminum
paint on canvas
58.8 x 44.8 in
(147.1 x 112.1 cm)
Seattle Art Museum,
Seattle (Peggy
Guggenheim
Collection)

Thanks to the intervention of Peggy Guggenheim, Pollock became the most popular artist of the time. With her team of critics and a skillful marketing strategy, she managed to elevate a normal person, whose unrefined behavior and habits brought him social censure, to the category of genius.

Pollock presented himself as a radical artist. His sloppy image was identified with his work. His attire, a very dirty pair of mechanics' coveralls stained with the same lines and colors of his works, made him a living reflection of his creations.

In this period, he discovered the techniques that would elevate him to the category of creator of dripping and Action Painting, a term coined by the critic Harold Rosenberg. Dripping consisted of dripping and splashing paint onto an unmounted canvas on the floor. Paintbrushes are nearly dispensed with and sticks and spoons substituted. This form of work linked him to the "automatic" Surrealist movement. By combining direct action with the absence of contact with the canvas, Pollock created a new relationship between the artist and his work. The painter's immersion in his own work was complete, and the rupture with manual gesture would be substituted by whole body gesture.

As Pollock enters the world of abstraction, something arises that triggers his complete and definitive immersion into full abstraction. This something is Abstract Expressionism. Instead of the previous forms, in which areas of color were always outlined, the line acquires protagonism over the form it defines. At the same time, mass, color, and line alternate to create a network of emotions, an expression more intense than the description of an icon or figure.

The consolidation of abstraction is evident in the painter's choice of subject matter as well. Even in this work, more figurative than his remaining works from this period, a desire to break with the past is apparent.

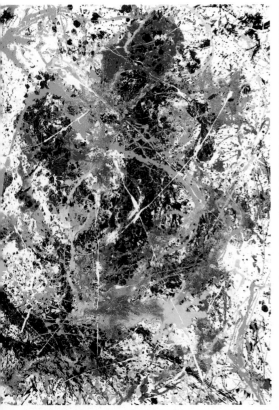

Number 31

(1949)
oil, enamel, and decorative paint
on canvas, marouflage on wood
30.7 x 22.4 in (76.8 x 56.1 cm)
Mr. and Mrs. Roy J. Friedman
Collection

When Pollock became involved in drip-
ping and Action Painting, the paint itself
became the most important factor for
him. The meaning of the work did not
arise when the painting left the artist's
studio but at the moment of creation,
when the action was executed.

Action Painting allowed him to create
infinitely. The matter of the placement of
the work disappeared entirely as Pollock
painted by moving around it and over it.
The idea of composition completely dis-
appeared.

Jackson Pollock finally became an
American hero when, on August 8, 1949,
Life magazine described him as "the bril-
liant new phenomenon in American art."

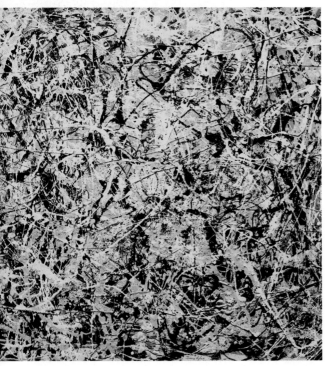

Number 4

(1949)
oil, enamel and decorative
paint on canvas, marouflage
on wood
36 x 35 in (90.5 x 87.3 cm)
Yale University Art Gallery,
New Haven (The Catherine
Ordway Collection)

Pollock's work gained
importance as it became
progressively more radical.
Formal priorities disap-
peared entirely and mix-
tures of media were carried
out with no guarantee of
durability. The procedure
was no longer more impor-
tant than the aim of the work. In this artist's oeuvre, the moment of creation, the moment in which
he moves into action and becomes involved with the canvas before him, is of utmost importance.
Nevertheless, there is an attempt, to harmonize, as demonstrated by the color scheme chosen for each
work, whether subconscious or not, and the use of a balanced palette.

ANDY WARHOL

Self-portrait, *acrylic and silkscreen on canvas*, 1966.

Andy Warhol was one of the most influential figures in late 20th-century art. He is considered the founder and most relevant representative of Pop Art, as well as one of the first to use large-format photographs as the basis of his oil, acrylic, and ink paintings. It was this technique that allowed him to produce a series of repetitive images, which he considered a symbol of death: "I admit that everything I do is related to death."

He never allowed his works to reveal his personality, and he was always reserved about his private life. He was so cold and distant that he converted himself into a commercial product.

His influence on contemporary art was essential, not only through his contributions to Pop Art, but also because his work provides a basis to many current movements that work with photomechanical images and the latest technology. Whereas in his paintings, he maintained a distant separation between the artist and the object, in his films, his homosexuality is apparent. *Flesh* (1968), for example, tells the story of a man who supports his wife and son through his work as a gay prostitute.

His work does not consist of direct communication. He never did anything personally, but rather directed, gave orders, and avoided any sort of responsibility. And he had a tolerant attitude toward everything.

- **1928** Born Andrew Warhola on August 6 in Pittsburgh, Pennsylvania, to parents from the Carpathian Mountains of Slovakia. His father first worked in construction and later in mining.

- **1934–1937** At six, he collects photos of Shirley Temple and Mickey Rooney. Suffers a nervous depression popularly known as St. Vito's disease. Reads Dick Tracy comics.

- **1945** Enters university and in summer works as a window dresser in a department store.

- **1949** Begins working as an illustrator for *Glamour* magazine. By accident, his name is published as Warhol instead of Warhola.

- **1952** Receives the Art Directors' Club Award in New York for his advertising illustration work.

- **1956** Participates in a group exhibit at the Museum of Modern Art in New York.

- **1957–1959** Establishes the company Andy Warhol Enterprises and purchases a small hotel on Lexington Avenue, where he lives with his mother. Meets the film director, Emile de Antonio.

- **1960–1961** Executes his first canvases with figures taken from comics: Batman, Dick Tracy, Nancy, Popeye, and Superman; and his first paintings of advertisements and Coca-Cola bottles. Meets Frank Stella. Visits the Leo Castelli Gallery and sees Roy Lichtenstein's paintings.

- **1962** Paints the Campbell's Soup can, the series on catastrophes, Elvis, and Marilyn. A group exhibit is held at the Sidney Janis Gallery entitled "The New Realists," and the Pop Art movement is born.

- **1963** Shoots his first long film, *Sleep*, which lasts 8 hours. Begins photography with a Polaroid.

- **1965** Meets the director Paul Morrisey, who will be a determining factor in the film production of *The Factory*.

- **1968** The feminist Valerie Solanis fires at Warhol with a handgun at his studio, The Factory.

- **1969** Due to the gunshot wounds incurred from the attack, he undergoes another operation. Founds *Interview* magazine.

- **1972** Begins executing portraits on commission. In subsequent years, he will produce more than a hundred of them.

- **1984** Executes paintings in collaboration with Jean-Michel Basquiat and Francesco Clemente.

- **1987** On February 22, dies in the New York Hospital during a gallbladder operation. Buried in Pittsburgh.

Superman

(1960)
acrylic and oil pastel
on canvas
68 x 53.2 in
(170 x 133 cm)

Warhol's work as a graphic artist and commercial illustrator led him to a impacting plastic style. The graphic piece, taken out of its paper context, is magnified. *Superman* is considered one of the first works of Pop Art, a style arising from popular sources. He took the image of a comic strip hero out of context and transformed it into a public icon.

Warhol incorporated the banal into his paintings, something which Rauschenberg and Lichtenstein were already doing at the time. It became the principal theme of his works.

He preferred inks that were entirely flat. Thus, he used acrylic, a new and revolutionary medium usually put to industrial use. By converting small format media, such as a comic book, into the size of a painting, he eliminates the original professional character of the reproductions. Nonetheless, he has not fully abandoned the pictorial and toys with drips and certain graphics. Deciphering the work of this artist is a real challenge, especially when, according to Warhol himself, "The meaning of my work is entirely on the surface—behind it is nothing."

Untitled (Cosmetics)

(1962)
lead pencil, oil pastel, acrylic,
and photographs on paper
29.4 x 23.3 in (73.7 x 58.4 cm)

In this period, Warhol imitates advertising images. This type of work, approaching Expressionism in its strokes, heralds what would become a consistent factor in his trajectory: an obsession for repetition.

Advertising systematically offers the possibility for repetition. This work is still visibly manual, something he will later completely dismiss in favor of mechanical reproduction.

Warhol proposes to the public that they adopt registered trademarks and commercial packaging as theirs, altering the meaning of the object until his works themselves becomes consumer products.

Warhol's predilection for cosmetics lasted until his death. In creating his own image, cosmetics lent him the appearance he sought. Hence, since he was part of his own art, he could emotionally dissociate himself from it.

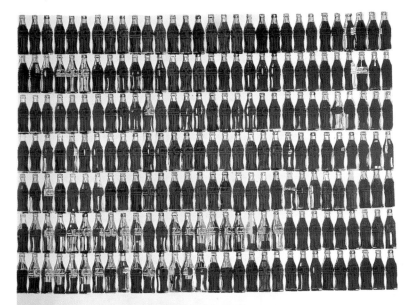

In the early 1960s, Warhol created The Factory, his studio, which, with its sex and drug parties, was the bulwark of alternative culture in New York. As a response to Kandinsky, the leading representative of Abstract Expressionism, Warhol began an insolent, rebellious movement free of subjectivity. His painting returns to figuration, with references to the Dada movement. He repeats the image of that famous bottle again and

210 Bottles of Coca-Cola

(1962)
silkscreen and acrylic on canvas
(208.5 x 266.5 cm)

again, meaninglessly. It is an object for its own sake, although he is somehow idolizing its existence. This painting does not only show banal objects—the manner of representing them is also important. This style is inspired by advertisements. Although Pop Art is understood as a criticism of consumer society, Warhol never admitted this. For him, his paintings were purely superficial and nothing more.

Atomic Bomb

(1965)
acrylic and silkscreen on canvas
106 x 81.8 in (264.2 x 204.5 cm)

Evoking the destruction at Hiroshima, Warhol again plays with repetition, here as a symbol of tragedy. In repeating the image of the atomic mushroom through silk-screening, he converted it into a symbol of the perpetual presence of death. Duchamp affirmed: "Repetition is the opposite of renovation. Therefore, repetition is a form of death."

Warhol, who had fully assumed this concept, used repetition of an image so that it would be recorded in the collective memory of society and become a popular, everyday image. His time working as a publicist allowed him to gain considerable knowledge on the semiotics of the image.

The predominance of specific colors would become a distinct characteristic of his works. Here he employs black and red, the colors of the Third Reich, through which he attains a brutal visual impact. Despite the superficiality and artificiality with which Warhol executed his projects, the printing was not identical, as he introduced significant variations in inking the plate. Each repeated image attained an individual value within the whole. Rembrandt had done the same with his etchings, making each reproduced image at once a unique work.

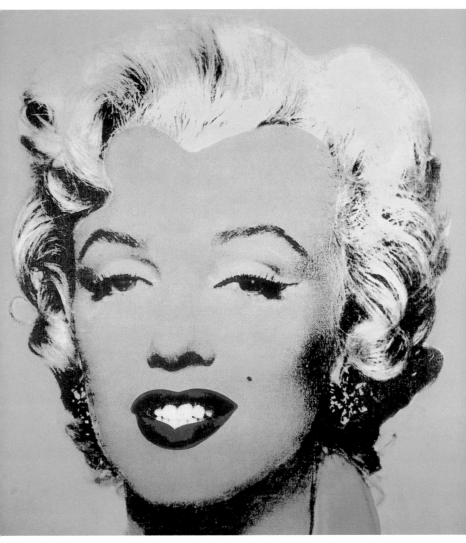

Warhol turned this photograph of Marilyn Monroe into a universal image that is still valid today. The photograph that he used as the basis of this work was from the 1950s. Warhol began using it in 1962, presenting it to the public in a great variety of colors and repeated in different ways. It was only two years earlier that the actress had died in strange circumstances.

Turquoise Marilyn

(1964)
silkscreen and acrylic on canvas
40.6 x 40.6 in (101.6 x 101.6 cm)

Warhol began coloring in different areas of the photo—first the lips and then the face. He varied the areas and colors ad infinitum. Directly converting the photograph into a silkscreen plate allowed him to play with variations. In addition to the black plate, he had others with which he printed the eye makeup, lips, face, hair, and background. The displacement of the register of every color mass such that they did not coincide with the facial features of the photograph introduced a new code of expression. Here, for example, it is the lips and the eyelid makeup that are slightly off, not coinciding with the photographic image. This added a gratuitous, superficial aspect to the image that was rapidly assimilated by the public and became very popular. But it also created many enemies, to the point where the Marilyn paintings were attacked by a radical feminist, who resented the conversion of women into purely commercial objects.

Andy Warhol

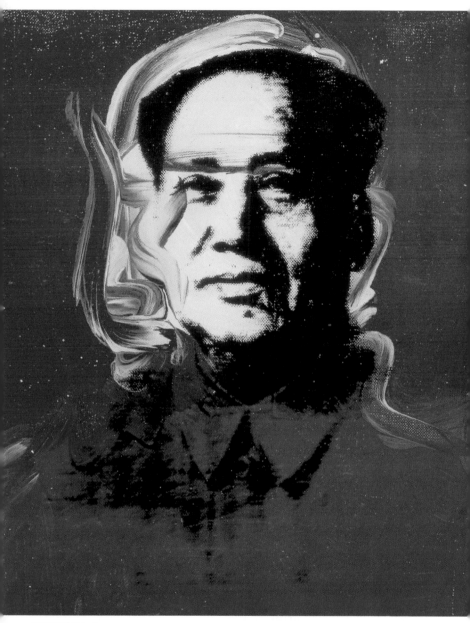

Mao

(1973)
silkscreen and acrylic on canvas
12.2 x 9.6 in (30.5 x 24 cm)

It was clear that Warhol wanted to convert everything he represented on his canvases into objects, rather than executing portraits. By doing this, he made them even more popular than that which they represented. The leader of the Chinese communist revolution thus becomes a consumer product, just as Elvis Presley did for different reasons.

Warhol even exploited his own image, through his graphic skills, his lifestyle, and the infamous parties at The Factory, his studio. He literally converted himself into a legendary figure for many young people and became a singular brand-name image to use for financial gain.

The artist was so keen to disseminate his works and capitalize on them that he became a real guru. He was rarely involved in the execution of his works, preferring to supervise them, while an army of assistants and collaborators, such as the company Chromacomp, worked on the images and printed them according to the artist's instructions.

He worked with artists as eminent as Jean-Michel Basquiat and Francesco Clemente, modifying canvases painted by the three of them. In 1994, he opened the doors to the Andy Warhol Museum in Pennsylvania, the largest in the United States dedicated to a single artist.

21 Giotto (1267-1337)
Pentecost . 22
The Lamentation . 23
The Last Judgment (Hell) . 24
The Meeting of Joachim and Anna 25
Madonna Enthroned . 25
Madonna and Child . 26
Death of Saint Francis . 26

27 Jan van Eyck (~1390-1441)
Cardinal Niccolò Albergati 28
The Virgin and Child with Chancellor Rodin 28
The Ghent Altarpiece (closed) 29
Eve (panel from The Ghent Altarpiece) 30
Portrait of Giovanni Arnolfini and his Wife 31
Portrait of Giovanni Arnolfini 32
The Virgin and Child . 32

33 Fra Angelico (~1395-1455)
Deposition . 34
Lamentation . 34
The Annunciation . 35
Entombment (Pietà) . 36
Saint Cosmas and Saint Damian Before Lisius 37
The Virgin and Child . 37
Saint Lawrence Receiving the Treasures of the Church
 from Saint Sixtus . 38

39 Masaccio (1401-1428)
Saint Peter Baptizing the Neophytes 40
The Expulsion from Paradise 41
The Crucifixion of Saint Peter 42
The Trinity . 43
Crucifixion . 44
Peter Raises the Emperor's Son from the Dead 44

45 Piero della Francesca (~1416/17-1492)
The Baptism of Christ . 46
The Flagellation of Christ 47
The Annunciation . 48
The Death and Burial of Adam 49
Duke of Urbino . 49
Hercules . 50

51 Giovanni Bellini (~1429-1516)
Entombment . 52
The Transfiguration . 53
Virgin Mary Among Saints 53
Allegory of Inconstant Fortune 54
Allegory of Prudence . 54
Doge Leonardo Loredan . 55
Pietà . 55
Venus *or* Lady at Her Toilet 56

57 Andrea Mantegna (1431-1506)
Altarpiece of Saint Zeno . 58
Saint George . 58
Saint Sebastian . 59
The Bridal Chamber (Camera degli Sposi) 60
The Dead Christ . 61
Madonna with Sleeping Child 62
Francesco Gonzaga . 62

63 Sandro Botticelli (1445-1510)
Saint Sebastian . 64
Portrait of a Man with the Medal of Cosimo the Elder . . 64
Primavera . 65
Pallas and the Centaur . 66

The Birth of Venus . 67
Giuliano de' Medici . 68
Lamentation Over the Death Body of Christ 68

69 **Hieronymus Bosch** (~1450-1516)
Tabletop of the Seven Deadly Sins and the Last Four Things 70
The Operation for the Stone (The Cure of Folly) 71
Saint John the Baptist in the Wilderness 71
Christ Mocked (The Crowning with Thorns) 72
The Garden of Delights . 73
The Carrying of the Cross . 74

75 **Leonardo da Vinci** (1452-1519)
The Annunciation . 77
Adoration of the Magi . 77
The Last Supper . 78
Mona Lisa (La Gioconda) . 79
The Virgin and Child with Saint Anne 80
Saint John the Baptist . 80

81 **Albrecht Dürer** (1471-1528)
Self-Portrait . 83
Lamentation of Christ . 83
A Young Hare . 83
Adam . 84
Eve . 85
Feast of the Rose Garlands . 86
Avarice . 86

87 **Lucas Cranach, the Elder** (1472-1553)
Crucifixion . 88
Venus and Cupid . 89
Adam . 90
Eve . 90
Pietà . 91
The Adoring Husband . 92
Martin Luther . 92

93 **Michelangelo** (1475-1564)
Nude fron the Back . 94
The Holy Family (Doni Tondo) 95
The Entombment . 95
The Creation of Adam . 96
Drunkenness of Noah . 97
Angels with Trumpets and Books (The Last Judgment) . . 98

99 **Giorgione** (1478-1510)
Portrait of a Young Man . 100
Reading Virgin . 100
The Tempest . 101
Three Philosophers . 102
Sleeping Venus . 103
Fête Champêtre, or Pastoral Synphony 104

105 **Raphael** (1483-1520)
The Nuptials of the Virgin . 106
The Crucified Christ with the Virgin Mary,
Saints, and Angels . 107
The Belle Jardinière . 107
Saint George and the Dragon 108
Ezekiel's Vision . 108
Adam and Eve . 109
The Transfiguration . 110

111 **Titian** (1488-1576)
Venus and Cupid with an Organist 112
Madonna of Frari . 113
Venus of Urbino . 114
Portrait of Pope Paul III . 115
Portrait of Emperor Charles V 115

Diana and Actaeon . 116

117 Hans Holbein, the Younger (1497-1543)
The Body of the Death Christ in Tomb 118
Erasmus of Rotterdam . 118
Venus and Cupid . 120
The Artist's Wife and Two Children 121
The Merchant George Gisze . 121
The Ambassadors . 122
Henry VIII at Age 49 . 122

123 Correggio (~1498-1534)
The Adoration of the Magi . 124
Venus, Satyr, and Cupid . 124
Noli Me tangere . 125
The Assumption of the Virgin 126
Danaë . 127
Leda and the Swan . 128

129 Tintoretto (1518-1594)
The Miracle of Saint Mark . 130
Joseph and Potiphar's Wife 131
Purification of the Median Virgins 131
Vulcan Surprises Venus and Mars 132
The Death of Holofernes . 133
The Origin of the Milky Way 134

135 Pieter Brueghel, the Elder (~1525-1569)
The Temptation of Saint Anthony 136
The Harvesters . 137
Hunters in the Snow . 138
The Beggars . 138
The Misanthrope . 139
Peasant Wedding . 140
Peasant Dance . 140

141 Veronese (1528-1588)
Age and Youth . 142
The Coronation of Mary . 143
Actaeon Contemplating Diana at her Bath 143
Allegory of Music . 144
Mars and Venus United by Love 145
Calvary . 146
Pietà . 146

147 El Greco (1541-1614)
The Disrobing of Christ (El Espolio) 148
The Burial of the Count of Orgaz 149
Saint Martin and the Beggar 150
The Resurrection . 151
Laocoön . 152

153 Caravaggio (1573-1610)
Rest on the Flight to Egypt . 154
Cupid Triumphant . 155
Bacchus . 156
The Supper at Emmaus . 156
Crucifixion of Saint Peter . 157
Conversion of Saint Paul . 158
Flegellation of Christ . 158

159 Peter Paul Rubens (1577-1639)
The Judgment of Paris . 160
The Rape of the Daughters of Leucippus 161
Perseus and Andromeda . 162
The Three Graces . 163
The Fur Coat . 164

165 Frans Hals (1580-1666)
Banquet of the Officers of the Saint George
Civilian Militia 166
The Marry Drinker 167
The Gypsy Girl 167
Malle Babbe 168
Portrait of an Elderly Woman with Gloves 168
Family Group in a Landscape 169
Stephanus Geraerdts 170
Regents of the Old Men's Home 170

171 Artemisia Gentilleschi (1593-1652)
Virgin and Child 172
Woman Playing the Lute 172
Susanna and the Elders 173
Judith Decapitating Holofernes 174
The Penitent Magdalene 175
Allegory of Inclination 175
Lucretia 176
Portrait of Gonfaloniere 176

177 Nicolas Poussin (1594-1665)
The Martyrdom of Saint Erasmus 178
Et in Arcadia Ego 178
The Massacre of the Innocents 179
The Triumph of David 180
The Triumph of Neptune and Amphitrite 180
Camille Delivers the Teacher of the School of Faléries
to his Pupils 181
Moses Rescued from the Waters 181
Lamentation of Christ 182
Winter, or The Deluge 182

183 Francisco de Zurbarán (1598-1664)
Saint Bonaventure on his Deathbed 184
Saint Agatha 185
Immaculate Conception 185
Still life 186
Hercules Fighting with the Lion of Nemea 186
Saint Luke before Christ on the Cross 187
Fra Gonzalo de Illescas 188
Saint Francis 188

189 Antoon Van Dyck (1599-1641)
The Crowning of Thorns 190
Susanna and the Elders 190
Diana and Endymion 191
Pietà 192
Silenus Drunk 192
Cornelius van der Geest 193
Equestrian Portrait of Charles I 193
Ladies-in-Waiting to Queen Henrietta Maria 194

195 Diego Velázquez (1599-1660)
Vulcan's Forge 196
The Surrender of Breda, or Las Lanzas 197
The Count-Duke of Olivares 198
Christ Crucified 198
The Toilet of Venus 199
Las Meninas 200

201 Claude Lorraine (1600-1682)
Morning in the Harbor 202
View of a Lake near Rome 203
Embarkation of St. Paula Romana at ostia 203
Landscape with Satyrs and Nymphs Dancing 204
Landscape with Dancing Farmers 205
Noon, or Rest on the Flight to Egypt 206

207 Rembrandt (1606-1669)
Dr. Tulp's Anatomy Lesson 208
Saskia van Uylenburgh 208
Danaë 209
The Adulterous Woman 210
The Night Watch 211
Bathsheba at Her Bath 212

213 Vermeer (1632-1675)
The Milkmaid (detail) 214
View of Delft 214
A Street in Delft 215
Woman Weighing Pearls 215
Allegory of the Art of Painting 216
The Lacemaker 217
The Astronomer 217
The Geographer 218

219 Jean-Antoine Watteau (1684-1721)
Woman at her Toilette 220
Jupiter and Antiope, or The Nymph and the Satyr ... 220
A pilgrimage of Cythera 221
Gilles 222
Mezzetin 222
The Italian Comedy 223
The Dance 223
Gersaint's Shop 224

225 Giovanni Battista Tiepolo (1696-1770)
The Sacrifice of Isaac 226
The Banquet of Anthony and Cleopatra 227
Olympus 228
Neptune Offers Gifts to Venice 228
Apollo Pursuing Daphne 229
Ruggero Delivers Angelica from the Sea Monster 229
Abraham and the Three Angels 230

231 Jean-Baptiste-Simeon Chardin (1699-1779)
The Skate 232
Woman in the Pantry 232
Saying Grace 233
The Attributes of the Arts 234
Still Life with Plums and Nuts 234
Jug and Peaches 235
Self-portrait 236
The Artist's Wife 236

237 François Boucher (1703-1770)
Hercules and Omphale 238
The Triumph of Venus 239
La Toilette de Venus 240
Resting Girl 241
The Naiads and Triton 242
Pan and Selene 242

243 Jean-Honoré Fragonard (1732-1806)
The Bathers 244
The Stolen Nightgown 244
Dream of Love 245
The Model's Debut 246
Dream of Love 246
Curling Up 247
The Fountain of Love 248

249 Francisco de Goya (1746-1828)
The Marquesa de Pontejos 250
Charles IV and His Family 250
The Nude Maja 251
The Third of May, 1808 252
Saturn Devouring One of His Son 253

Two Old Men Eating . 254
Juan Bautista de Muguiro . 254

255 Jacques-Louis David (1748-1825)
Paris and Helen . 256
Brutus and His Children . 256
The Death of Marat . 257
Intervention of the Sabine Women 258
Madame Récamier . 259
Mars Disarmed by Venus Before the Three Graces . . . 259
Apelles Painting Campaspe Before Alexander 260

261 Élisabeth Vigée-Lebrun (1755-1842)
Irresolute Virtue . 262
Marie-Antoinette . 263
Peace Leads to Abundance . 264
Julie Lebrun as Flora . 264
The Princess Luisa Radzwill Hohenzollern 265
Alpine Festival in Unspunnen 266

267 William Blake (1757-1827)
Story of Joseph: Joseph's Brothers Prostrate
 Themselves Before Him 268
Songs of Innocence: The Lost Child268
Marriage of Heaven and Hell (Print 10:
 Proverbs from Hell) . 269
Europe: A Prophesy (Print 1: Frontispiece) 269
Visions of the Daughters of Albion (Print 1: Frontispiece) 270
Newton . 270
The Number of the Beast is 666 271
Illustrations for the *Divine Comedy* (The Circle of
 the Lustful: Paolo and Francesca da Rimini) 272

273 William Turner (1775-1851)
The Pantheon . 274
The Battle of Fort Rock . 274
Venice: The Campanile and Doge's Palace 275
The Thames Near Walton Bridges 275
Snow Storm in Val d'Aosta . 276
Yacht Approaching the Coast 277
The Lake of Lucerne . 277
Rain, Steam and Speed, *or* The Great Western Railway . 278

279 Jean-Auguste-Dominique Ingres (1780-1867)
Virgil Reads *The Aeneid* to Octavia and Augustus 280
Oedipus and the Sphinx . 280
Madame de Senonnes . 281
Grande Odalisque . 281
The Small Bather . 282
Apotheosis of Napoleon I . 283
Turkish Bath . 284

285 Théodore Géricault (1791-1824)
Charging Chasseur . 286
Nude Torso . 287
Heads of the Executed . 287
Nude Woman Standing . 288
Raft of the Medusa . 289
Epsom Downs Race . 290

291 Camille Corot (1796-1875)
Avignon from the West . 292
The Galette Windmill . 292
Mornex. Morning Effect . 293
Landscape with Willow Trees and a Cow 293
Recollection of Mortefontaine 294
The Peasant Woman and Her Cow 294
The Studio . 295
The Woman with the Pearl . 295

The Mill at Saint-Nicolas-les-Arras 296

297 Eugène Delacroix (1798-1863)
The Massacre at Chios . 298
The Death of Sardanapalus 299
Liberty Leading the People 300
Aspasia *or* The Mulatto Aline 301
Women of Algiers in Their Apartment 301
Saint Sebastian Attended by the Holy Women 302
The Struggle of Jacob with the Angel 302

303 Honoré Daumier (1808-1879)
The Reader . 304
Drama . 305
Crispin and Scapin . 306
The Good Bottle . 306
The Laundress . 307
The Third-Class Carriage . 308
Two Heads . 308

309 Jean-François Millet (1814-1875)
The Log Splitter . 310
The Sheafmakers . 310
Winter: The Wood Gatherers 311
The Seamstress . 311
The Gleaners . 312
The Angelus . 313
The Shepherdess . 314

315 Gustave Courbet (1819-1877)
The Painter's Studio: A Real Allegory 316
Burial at Ornans . 317
The Wheat Sifters . 318
Woman with Parrot . 318
The Origins of the World . 319
The Sleepers . 320

321 Rosa Bonheur (1822-1899)
Wagon Pulled by Horses . 322
Study of Male Figure . 323
Meal During the Hunt . 323
The Horse Fair . 324
The Palette . 325
Kings in their Territory . 325
Buffalo Bill . 326

327 Jean-Léon Gérôme (1824-1904)
Cockfight . 328
Anacreon, Bacchus, and Cupid 329
Large Pool at Brousse . 329
Steam Bath . 330
The Examination of the Slave 330
Pygmalion and Galatea . 331
Women at the Bath . 332
Nargil Lighter . 332

333 Camille Pissarro (1830-1903)
The Road from Versailles to Louveciennes 334
Crystal Palace . 334
Spring in Pontoise . 335
The Festival at the Hermitage 336
The Shepherdess, *or* Girl with a Stick 336
Harvesting Apples . 337
Bather in the Woods . 337
Boieldieu Bridge in Rouen 338
The Boulevard Montmartre at Night 338

339 Édouard Manet (1832-1883)
The Absinthe Drinker . 340
Lola of Valencia . 340
Music at the Tuileries . 341

Le Déjeuner sur l'Herbe, or Lunche on on the Grass . 342
Olympia . 343
The Fife Player .344
Bar at the Folies-Bergère .344

345 **Edward Burne-Jones** (1833-1898)
Maria Zambaco . 346
The Feast of Peleus . 347
The Wheel of Fortune . 348
The Golden Stairs . 348
The Doom Fulfilled . 349
King Cophetua and the Beggar Maid 350
The Challenge in the Wilderness 350

351 **James Abbott McNeill Whistler** (1834-1903)
Symphony in White No.2: The Little White Girl 352
Variations in Flesh Color and Green: The Balcony 352
Girl with an Almond Tree in Flower 353
The Port of Valparaiso . 353
Arrangement in Gray and Black, No. 1:
 The Artist's Mother . 354
Nocturne in Blue and Gold: Old Battersea Bridge 355
Nocturne . 355
Nocturne in Black and Gold: The Falling Rocket 356

357 **Edgar Degas** (1834-1917)
The Longchamps Racetrack 358
The Opera Orchestra . 358
Dance Class at the Opera . 359
L'Absinthe . 359
Miss Lala at the Cirque Fernando 360
The Millinery Shop . 360
Woman Kneeling after a Bath 361
Woman Combing Her Hair 362

363 **Winslow Homer** (1836-1910)
Waverly Oaks . 364
Portrait of Helena de Kay . 365
On the Sandbank . 366
The Milk Maid . 366
Deer in the Lake: The Adirondacks 367
The Call for Help . 367
The Northeaster . 368
Key West, Hauling Anchor . 368

369 **Paul Cézanne** (1839-1905)
Boy in a Red Vest . 370
Paul Alexis Reaing to Émile Zola 370
The Abduction . 371
Afternoon in Naples . 372
Bathers . 373
Apples and Oranges . 374
The Bridge of Trois Sautets 374

375 **Claude Monet** (1840-1926)
Camille Dressed in Green . 376
La Grenouillère . 376
Impression: Sunrise . 377
The Bridge at Argenteuil . 378
Rouen Cathedral: Façade and Saint-Romain Tower . . 378
Saint-Lazare Station . 379
Houses of Parliament: Sun Breaking Through the Fog . . 379
Pond with Water Lilies . 380

381 **Berthe Morisot** (1841-1895)
The Harbor at Lorient . 382
The Cradle . 383
Chasing Butterflies . 384
Psyche . 385